SEMIOTEXT(E) FOREIGN AGENTS SERIES

This work received support from the Cultural Services of the French Embassy in the United States through their publishing assistance program.

Published by Semiotext(e)
PO BOX 629. South Pasadena, CA 91031
www.semiotexte.com

Special thanks to Noura Wedell.

Cover Design by Lauren Mackler
Design by Hedi El Kholti

ISBN: 978-1-63590-161-0

Distributed by The MIT Press, Cambridge, Mass. and London, England
Printed in the United States of America

Serge Daney

The Cinema House & the World

1. The Cahiers du Cinéma *Years 1962–1981*

Edited by Patrice Rollet, with Jean-Claude Biette and Christophe Manon

Introduction by A. S. Hamrah
Translated by Christine Pichini

\<e\>

Our gratitude goes first of all to Huguette Daney for the patience and the unfailing trust she granted us during the years of research that led to this edition of her son's writings.

We also thank the following people for their assistance, their advice, and, on occasion, their discoveries: Raymond Bellour, Alain Bergala, Christa Blümlinger, Alain Brillon, Laetitia Cardon, Emmanuel Crimail, René Duvernay, Bernard Eisenschitz, Fanny Garniel, Marita Kandaraki, Bill Krohn, Serge Le Péron, Jean-Luc Mengus, Jean Narboni, Claudine Paquot, Sylvie Pierre, Fabrice Revault d'Allonnes, Jean-Henri Roger, Elias Sanbar, Louis Skorecki, Serge Toubiana and Édouard Waintrop.

P.R., J.-C.B, C.M.

CONTENTS

Introduction by A. S. Hamrah

CINEMA IS NEVER ON TIME

Serge Daney has existed in English mostly in a kind of samizdat, translated and published online by dedicated cinephiles with blogs, whose valiant work for two decades has tried to remedy this essential critic's absence. While a short hybrid interview book, *Postcards from the Cinema*, did appear in 2007, in Paul Douglas Grant's excellent translation, the majority of Daney's writing has been unavailable in English in book form.

As Grant points out in his introduction to *Postcards from the Cinema*, by that year a "proper introduction" to Daney was already "so overdue that the very mention of this deficiency is itself becoming something of a cliché." That was and is the case, that it is long overdue. It had been the case since before Daney's death in 1992, from complications resulting from AIDS.

Grant traces "The History of an Absence" in the *Postcards* introduction, explaining why the work of this important French critic and editor has been so resistant to publication in English. Or, I mean, it's the other way around. Until this volume in Semiotext(e)'s Foreign Agents series, no US publisher dared to do it. It's a known fact that American publishers consider books of film criticism non-sellers, despite evidence to the contrary that there are many dedicated readers. The cinephiles who translated Daney and put him online knew that, first among them Laurent Kretzschmar and Andy Rector.

Parallel to that, it also sometimes seems as if everyone who has translated Daney into English, even just to quote him in an article, a

review, or an essay, at some point left the US to go live someplace else. Some of them came back, some move back and forth, but they have been wise enough, unlike those of us who can't translate from the French, to understand how on some level an engagement with Daney means a rejection of America and its hollow film reviewing sector. Better to watch all that devolve across an ocean.

At this point we are so distant from Daney that mentioning his absence can no longer be called a cliché. Bill Krohn and Jonathan Rosenbaum have kept Daney's name alive in English for two generations, but the cinephiles of the new Letterboxd era didn't learn they were supposed to miss him. Daney's prescient, fundamental engagement with the same issues facing us now can therefore come as news.

Christine Pichini took on a monumental task in this extraordinary translation of *La Maison cinéma et le monde I: Le temps des Cahiers (1962–1981)* into *The Cinema House & the World: The Cahiers du Cinéma Years, 1962–1981*, the first volume of Daney's collected work, and not just because the book is 600 pages long. Daney loved the American cinema but he resisted where it comes from. He inscribed that resistance into everything he wrote. His resistance as a writer is also a resistance to translation.

That's true right on the cover. Daney's title refers to Bengali cinema, specifically to Satyajit Ray's late masterpiece, *Ghare Baire*, from Rabindrinath Tagore's 1916 novel of the same name. Ray's film came out in the US in the summer of 1985 as *The Home and the World* and in France as *La Maison et la monde*, the same way the Tagore's novel had appeared in the late 1910s.

In the movie, Bimala (Swatilekha Sengupta) must choose between her husband, Nikhilesh (Victor Banerjee), and a revolutionary, Sandip, played by Ray's great actor, Soumitra Chatterjee, from *Apur Sansar* (1959, originally called *The World of Apu* in the US).

Bimala's choice is in some ways one between Western culture and her own, and between the radical and the commercial, just as Daney's was a choice between the West and the Third World (as the Global South was called while Daney was writing), between the radical and bourgeois, between Satyajit Ray and his film and Nicholas Ray's *We Can't Go Home Again* (1976), the last pairing mentioned by Patrice Rollet in his original preface.

But to call this book *The Cinema Home and the World* risked proving American publishers right. Though that is the more literal title, it is also awkward in English, and we already have the term "movie house" to describe the place that was Daney's true home. If the new title renders Daney homeless, such is the fate of the film critic in the age of streaming and the pandemic. Being forced out of his real home and relocated in front of the TV screen or computer was a trajectory Daney knew well, long before the existence of Netflix.

In 1988 Daney published his collected newspaper columns about watching television as a book called *Le Salaire du zappeur*, another hard-to-translate title based on a movie, in this case a pun combining Henri-George Clouzot's *The Wages of Fear* (*Le Salaire de la peur*, 1953) with a French word for someone clicking between TV channels using a remote control, "zapping" between them. The device and the person using it are the same thing, a "zapper."

In addition to everything else he accomplished as a writer, Daney was the best and earliest film critic to describe the differences between film and television. He knew that to understand the second required full knowledge of the first. He had a politics of television, something television critics do not seem to have in this new age of peak TV, which thinks it has performed the magic act of making the medium disappear.

Wherever and however this full knowledge began, it took form in 1962, as you will discover in this book, in a zine that lasted two issues, *Visages du Cinéma*, where the equally original and equally neglected-in-English Louis Skorecki was the publisher, editor, and only other writer. Daney's first pieces were on films by Howard Hawks and Otto Preminger, Hollywood giants from overlapping eras of film history, one all-American, the other an émigré, a refugee from Hitler.

Daney and Skorecki then went to Hollywood to interview other American auteurs, including Leo McCarey, Jacques Tourneur, George Cukor, Samuel Fuller, and Jerry Lewis. There they experienced what Daney called "the cruelty of Hollywood," witnessing McCarey's bitter senility and Cukor's contemptuous dismissal of Nicholas Ray. (Lewis and Fuller treated them nice.) These encounters with "madmen" directors, Daney wrote, explained how he was "able to learn to

breathe outside polluted France in American cinema, and at the same time I had no problem being furious in the '70s with American imperialism."

Daney became a world traveler on the cheap, covering film festivals in the Third World and behind the Iron Curtain as a contributor to *Cahiers du cinéma* in Paris. By 1973 he and the other Serge, Serge Toubiana, became the editors of the magazine. They evolved it from its revolutionary, Marxist-Lacanian phase of the late 1960s and early 1970s, returning it to more regular film coverage without sacrificing its political orientation.

Daney was perhaps the magazine's last great editor. While he was there, *Cahiers* maintained its opposition to commercial cinema without abandoning its analysis of it. Feminism and nascent queer theory came to the surface in his work along with anticolonialism, already present in *Cahiers* at the time. There was a difference with Daney, maybe because he was gay, maybe because he was also a popularizer, maybe because he was used to corralling so many other writers as an editor. He put it all together like no one else.

That led to a gig at Sartre's post-1968 leftist newspaper *Libération*. Daney comes to us as a critic who wrote more than his peers but who never dropped his standards or changed his interests for bigger publications or for his TV and radio appearances. He died too young, at 48 in 1992, the year Éric Rohmer's *Tale of Winter* came out. To put that in perspective, Rohmer had been a editor at *Cahiers*, too, was 28 years older than Daney, and outlived him by almost 20 years. A year before he died, Daney founded a new film journal, *Trafic*, that promised a return to committed film writing without commercial considerations. It was the beginning of a new period in the history of cinema, different than the televisual era he had described so well in the 1980s, with a different look and feel, defined elsewhere: Iran, Taiwan, *D'Est*, David Lynch, *Basic Instinct*. . . . He did write a startling piece on *The Elephant Man*, collected here.

Here and Elsewhere (1976) seems to be the most important of Jean-Luc Godard's films for Daney. He mentions it many times, even more often than Mizoguchi's *Taira Clan Saga* (1955). He makes sure to emphasize the *and* in the title. Godard and Anne-Marie Miéville's difficult attempt to analyze Godard's failure to join filmmaking in the

West with revolutionary struggle in Palestine opened a door for Daney. A door we can walk through now.

The question is whether Daney in translation comes to us too late. Finally having him in English in this form must not lead us to believe something has been fixed or repaired, even though it has at last appeared. Because it is so late, like this piece I'm writing, it cannot be a validation. Daney must remain an open question. "Cinema is never on time," he writes in one piece, then answers later that when it is good that doesn't matter, because then it is both "very slow and incredibly fast."

Daney is the same way. He was fortunate to arrive on the scene in the 1960s, but not too early in the '60s, at the twilight of the classic auteurs, when they were still making films but they were their last films. Their kind of cinema was dissolving, what appeared then was in low tide of the 1970s, when everything left behind was revealed and the cinema was "skidding toward a new world."

So much, then, in Daney's search for a new world, was not good enough for him—not Joseph Losey, Jiri Menzel, Glauber Rocha. He found the future in spaghetti westerns instead. He despised Louis Malle, Elia Kazan's *The Visitors* (he should have seen *Wanda*), *The Night Porter*, and *The Mad Adventures of Rabbi Jacob*. Like many at *Cahiers* at the time, he couldn't really accept the American and German film directors (the New Hollywood and the New German Cinema) who were his peers, though he was blown away by Francis Ford Coppola, so much so that he compared *Apocalypse Now* to *Wind Across the Everglades*. Ditto Hans-Jürgen Syberberg, perhaps the German filmmaker most like Coppola, whose work was equally controversial. Daney admitted there were people who didn't like Warren Beatty, predicted Paul Schrader's interest in porn, and identified Diane Keaton as the co-creator of *Annie Hall*.

He did all this while keeping one of his eyes (he identifies four) on the *militant*, stopping along the way at various stations that certain American readers, no matter how young, may recognize from grad school: the *carnivalesque*, the *cloacal, potluck, the territory and the map*, and *hic et nunc* (like in Gide's *Marshlands*, the product of another French scene).

Some stations only Daney knew about. Those ones are called *aesthetic minimum wage, desquamation*, and my favorite: *blobbing*. Let's stop at that one ourselves. It comes from Daney's short 1976 review of a forgotten horror movie called *Beware! The Blob*, a too-late sequel to the original *Blob* from 1958. This belated follow-up came out in the US in 1972, reached Paris in 1976, and was directed by Larry Hagman, the star of TV's *I Dream of Jeannie* and *Dallas*. Daney calls it "the anti-*Jaws*" and describes the end of each scene, in which characters are eliminated by the lumpy globule, with the phrase "they are blobbed."

Here is a key. Months later, at a film festival in Tunisia, Daney sees a documentary he doesn't much like. The film is normalizing certain political issues that should be dealt with by the cinema in a more meaningful and complex way. "French cinema is starting to 'blob' immigration," he writes, "to 'naturalize' it, to make it a theme like any other." Apart from what may have been a reference to Godard and Jean-Pierre Gorin's 1968 Dziga Vertov Group *A Film Like Any Other* (*Un Film comme les autres*), here we see Daney opening the door, he is showing us the *and*. From *Beware! The Blob* Daney takes something he can use, directly from an image, and applies it in a political context to another, totally different kind of film.

There are many filmmakers and films to discover in this book that have not yet been *blobbed* (Criterionized). Not translating Daney in book form has heretofore saved them from that fate. Since the only worthwhile things are the ones that no one cares about, let's try not to *blob* them. I won't even name them. They are inside. Daney let them in.

The Cinema House
& the World

PREFACE

In Serge Daney's *Persévérance*, during a monologue about his love of travel that doesn't seem to be talking about cinema, there is a strangely cinematographic moment that resembles a scene, both troubling and reassuring, in one of those films that he never desired to make. One February night in Ronda, he finds himself getting off a train he had chosen at random. Which way to go? He hesitates on the path forward. As a last resort, he lets himself be carried away by his circumstances. He abandons himself to a thin stream of travelers who decide for him. As they disperse towards the outskirts of the Andalusian city, they lead him through the deserted streets of a sort of universal suburbia that could be located everywhere and nowhere. And after a while, a mild *sartori* enlightens him. He realizes that he has returned. Without his knowing, the flow of wandering and the hidden spiral of his route had brought him back to the center of Ronda, caught him in the middle of a somewhat ridiculous crowd dressed up for Carnaval.

This short apologue has always irresistibly reminded me, but with the reconciled grace and gravity of an unexpected *happy end*, of one of the familiar anecdotes Freud used to describe the sense of the *uncanny* that he felt in a small Italian village after a "demonic" repetition compulsion had led him three times to the heart of the red-light district. Empty streets and painted ladies in both cases. An allusion by Daney to Fellini invites another convergence. But while for Freud, the labyrinthian effect inspires a panicked awareness of

perpetually returning to the same point, Daney's Ronda wandering demonstrates an unexpected, almost miraculous accord between abandon to the world and confidence in its power.

It is also, for me, the truest image of his relationship to cinema. Not only, as he suggests in an aside, and more *mezza voce* in the working notes of *L'Exercise a été profitable, Monsieur*, because watching films and traveling ("Traveling, not escaping or fleeing") amount to the same thing, or because, to paraphrase (his beloved) Paulhan, cinema gives us the world when we aren't in it, but more fundamentally because it suggests the basic philosophy of his cinephilia. Open and yet rigorous, this philosophy rests on an understanding of cinema that is jointly "ontological" and "structural," as he puts it, in which the true inscription of the world upon the film's surface is only made possible through the repetition of its traces in the martingale of meaning and interpretation. ("What had been collected, recorded once and forever is, at the same time, identical to itself as a system.") We could say that this paradoxical play between registration and repetition, wandering and return, dispersion and the systematic is the reason behind the desire repeatedly expressed by Daney to see a certain number of his articles republished in book form. Relating them in order to reread them. *La Rampe* (1983), *Ciné journal* (1986), *Le Salaire du zappeur* (1988), *Devant la recrudescence des vols de sacs à main* (1991), are all exemplary demonstrations of that obstinate desire. Daney was greatly affected by not being recognized as the cinematic philosopher that he truly was, something beyond simply a sworn critic. He was grateful to Regis Debray for having given him, before his death, a chance at television with *Itineraire d'un ciné-fils* (1992). More than simply putting a face to a name, for many it put a (comprehensive) mind to a (fragmentary) writing. The future of an art, cinema, quite literally formed a body with that of a man. For everyone watching those nights, he embodied the man of cinema.

Serge Daney, as a good journalist, wrote daily and urgently. The brio of his writings in the columns of *Cahiers du Cinéma* and *Libération*, the ferocity of his interventions combined with a heightened sense of relevancy all too often concealed, in the eyes of his most attentive readers, the common thread of his predilections, the more sustained bass of his cinephilia in which the Macmahonian permanence of his

tastes, acidulated by the Jerry Lewis zest, was always protected from the impermanence of his doubts (Mao never made him forget Mizoguchi), in short something like the invariance of his thinking behind the variations of his ideas. In his mind, the *montage* of texts elicited by the form of the book (that "editing" that is common to both cinema and publishing, from which the spark of meaning flies) drew out the more covert themes, the deeper foundations of the texts that are, as we know, more ethical than aesthetic.

Without ever disowning his critical history, including its theoretical and political drifts, with Godard and Straub as sole compasses to navigate the storms, Daney brought meticulous editorial attention and care to the composition of each of his collections. Exigency in the choice of articles, concern for their proper ordering, contextualization of their writing. The loving fetishism he brought to the titles, and even the sub-titles, of his chapters was occasionally at odds with the retrospective clarification of his thinking. That never occluded the importance of having a just perspective (somewhere between justness and justice) on his own history. Always, he wrote on the evanescent edge of the present, of an uncomfortable here and now, divided, in time and space, between the here (excursions to Parisian theaters) and elsewhere ("world cinema" festivals), between upstream (cinema that had "watched his childhood") and downstream (films that he followed, out of loyalty, "to television"). From one shore to another of the cinematic river (as in a work by Renoir or Ford), and in the wake of the films that he followed down or up, dreamily or frantically (as in a work by Laughton or Coppola).

With that triviality that sometimes characterizes current events, the critic must answer present to the arts of the present that were, for Daney, cinema, tennis or bullfighting (always live even when pre-recorded), must find the perfect metaphor that will instantly capture it, must make the right "pass" at his reader (an analytical and erotic term as much as it is an athletic one, it has been used and abused, often overlooking the fact that Daney, in *Devant la recrudescence...* and *Persévérance*, more modestly credited Jean-Louis Comolli—regarding the saxophonist Eric Dolphy—and then Jacques Rancière—regarding Jean-Luc Godard—with having passed him that identificatory figure of the *passeur*, which definitely no longer

works). And yet, he did not have to return every serve under the pretext of its being a symptom (Daney wasn't really Barthes, or even Sibony or Miller, Bourdieu even less): "Criticism only justifies itself if it responds to a desire, ultimately that of the critic" (*L'Exercise*...). That is the price of critical desire, at the intersection of at least one other desire, that of the filmmaker who genuinely wants to make a film, and not simply hold on to his position.

Serge Daney knew all the regimes and all the cycles of writing (monthly, daily, quarterly), from the slightly dandyish cinephilia of his 1962 début in *Visages du Cinéma*, the short-lived fanzine by Louis Skorecki, his classmate at the lycée Voltaire (whom he subsequently accompanied to Hollywood to interview the great dinosaurs of American cinema), to the background subjectivity (the double solitude of the long-distance runner and the player at the back of the court) asserted by his ersatz journal in the review, *Trafic*, that he founded with several friends in 1991, several months before he died of AIDS. Despite the kindness of Jean Douchet, he could not escape the inevitable obstacle course faced by every young recruit to *Cahiers du Cinéma*. That took him (after several dry spells in which he travelled the world, and a period of public silence in which even films were absent) from occasional freelancing, in 1964, to the position of editor-in-chief alongside of Serge Toubiana in 1974, revitalizing the monthly magazine after it had survived the Mao years. Only later would he find personal and professional fulfillment in *Libération*'s film section, which he began directing in 1981.

Daney never abandoned his critical desires, including the clandestinity that he always associated with cinema (and with homosexuality), where culture must have the elegance to pass only as contraband, and that went from his childhood visits, along with his mother, to neighborhood theaters to the title he chose, with Jean-Claude Biette, for his last review, nonchalantly highlighted by stencilled typography on its paper cover.

An appetite for the present as such, and it alone ("The present is for me a sort of absolute," he writes in *Persévérance*), attenuated by the filmic record, which also gives life its thrill, like daybreak heralding the reporter's take, ("The luxury of the one who has nothing, nothing

but those unaccumulating pleasures of the awareness of a new day beginning, the sun on one's skin, a café terrace, the parade of others passing by") is at the origin of two of Serge Daney's insights that have been most often caricaturized (in praise as well as reproach), the melancholy of the child of cinema and the death of cinema, in an oversimplified identification of Daney's keen sense of his own death with his sense of the impending death of cinema.

Daney did, however, in 1988's *Contreplongée*, a publication out of Strasbourg, contrast Demy with Wenders, the (active) melancholy of the present with the (more unproductive) nostalgia of the past. He returned to this repeatedly later on, in an almost obsessional way, in *Devant la recrudescence...* ("Nostalgia valorizes the lost object; melancholy knows that loss is the shadow of the present, its immediate aftertaste"), in *Persévérance* ("The cinephile is not nostalgic for a golden age either known or unknown, one he believes nothing to have equalled since. The cinephile is someone who, even while watching a film that has just been released, already feels that 'this will have been'") or in *L'Exercice...* ("Only 'idea.' Melancholy is not nostalgia. Demy's world—mine also, I suppose—is an *immediate melancholy*. There is no lost world, no runaway ideal, no lamented past. Simply because—perversion demands it—we don't want to know anything about the world we 'come from'—alliance vs. parentage, etc. Melancholy is as immediate as shadow"). We could multiply these quotations to infinity (and it would be helpful, occasionally, to relativize the overly-used trope of the *ciné-fils* (cine-phile/cine-son)[1] filmmaker, weighing the figures imposed by filiation, by transmission or by symbolic legacy that feel slightly stale, against the most sovereignly free gesture of the alliance with the real, the outside, the world), always because cinema principally remains that art of the present that enhances the awareness of the fragile and fugitive moment as it records it for all eternity on film's ribbon, and that proves to be, from the outset, ontologically, melancholic.

1. Translator's note: Ciné-fils is a pun which combines the homonym ciné-phile with the notion of filiation ("fils," or son).

What's more, the countdown to the death of cinema had, according to Daney, begun well before the countdown to his own death, as far back as 1981, when he left *Cahiers* for *Libération*, where he would nevertheless give the full measure of his critical talent and passion for film. This is paradoxical only for those who refuse to acknowledge what he meant by this. For there are ultimately two possible types of cinematic deaths, one that does not speak its name, currently practiced by the opportunists of mannerism (making cinema that misses reality) or of postmodernism (making contemporary art in search of a medium) who recycle ad nauseum the timeless images and exhausted history of a cinema they no longer know how to invent, and one belonging to Daney (or Godard with his *Histoire(s) du cinéma*), for whom "in its disappearance, cinema appears," an expression that Daney liked to repeat and an ontological turn that would have undoubtedly been familiar to Heidegger, whom he regretted not reading more of.

"I wonder sometimes," he adds in *Persévérance*, "if this theme of the 'death of cinema,' that had its hour of glory ten years ago—via Wenders's films—was not for me the condition by which I could finally live for myself, write, perhaps. As if it were necessary for cinema to disappear to move from a state of limbo to center stage, from night to day, from fog to light, in short, from 'we' to 'I.' In fact, more ironically, it's my death that will eventually be synchronous with the death of cinema!" The suspended question, the slight hesitation, the trembling that one wrongly imagines in Serge Daney's voice must not, however, mask the three cardinal orientations of his reflection:

—the *countdown*: if the tragic coupling of the countdown to the end of Daney's life with the countdown to the end of cinema so fascinated him, it is because his life's story, much like the history of modern cinema associated with it since their common birth, had begun to resemble that of a film in a profound way; Lang, by envisioning for *Woman in the Moon* (1929) the principle of the countdown that NASA would adopt several years later (fiction already paving the way for documentary), in fact defined the rule for the reception of every film, whose first, and often unnoticed, dramatization rests on the assertion of the anticipated certainty of its own

ending, even of any shot, irreducible to any kind of image by its retroactive passionalisation of time (here too, cinema is opposed to the visual).

—the *afterlife* of the death of cinema: like the death of God in Nietzsche, it has already taken place, it has, perhaps, always already taken place; that doesn't prevent us from continuing to make films and to write about them, but demands that we return to cinema's history, to return to its origins; each film now mobilizes cinema as a whole and a review such as *Trafic*, by treating the Ancients and the Moderns as equals, must be the vertical memory, also immediate, of that inevitability;

—the death of cinema as *thought*: Daney liked to throw out ideas, test them out on a friend, watch them rebound in conversation; he did it often, even and especially for the most serious ideas, with undisguised pleasure, sometimes in a playful, childlike way ("So, let's say that..."), just to see, like poker; concerning the death of cinema, there is naturally more; perhaps not a just idea, but just an idea, a regulatory idea that allowed him to strike at the essential, to radicalize his intuitions while bringing to incandescence his relation to a threatened cinema that was throwing off its last flames; like, in fact, the idea of the *eternal return* in Nietzsche, and even if this may cause some to smile, it is a question of a metaphysical affirmation (may everything return and may I be floored!) and not of a physical hypothesis (that of an infinite time dooming any world composed of a finite number of atoms or images to the vertigo of repetition); "the eternal return of the becoming-aware of the eternal return" (*Persévérance*); the denunciation of the abjection of the traveling shot in *Kapo* as the first and last word of his cinematic ethics, but also the shared desire, against the backdrop of Odysseus, with the Wenders of *Paris, Texas* or the Godard of *Contempt*, to "situate oneself exactly where the circle circles back on itself, where cinema is buried with the respect it is due, before the great narratives, may return." (*Devant la recrudescence...*)

The ultimate paradox, we may then understand, far from the sham of the media sphere and even if the future experience that cinema transmits ("the trailer that will watch us one day") has grown problematic; how that disenchantment of the subject that Daney

describes in his opening to the first issue of *Trafic* is also accompanied, mysteriously, by an unprecedented re-enchantment with the world.

Serge Daney wrote prolifically, particularly in the eighties for the daily newspaper, *Libération*, both in the moment and after the fact (he participated in the creation of "Rebonds"), and on wide-ranging subjects (cinema, television, media, but also sports and general information, political events and feature stories). Now it is time to really take the measure of that itinerary. This edition, which will be staggered over the course of several years, is not intended to be either critical or exhaustive. We have excluded some short pieces for being too dated, without ignoring the Maoist adventures of *Cahiers*'s "unlegendary period." We have also reserved for a later publication interviews Daney conducted with filmmakers, writers, and philosophers that appeared in the press or were broadcast over the radio in "Microfilms," his Sunday night program on France Culture, along with collective texts written with one or more partners (with Jean Hatzfeld, Jean-René Huleu, Jean-Pierre Oudart, Louis Skorecki, Serge Toubiana, etc.), anonymously (for the grouped fire of *Cahiers* in the seventies) or under a pseudonym ("Raymond Sapene" for his book, *Procès à Baby Doc*, or "Bill Chernaud," who he created with Gerard Lefot for *Libération*). It does intend to provide the quasi-totality of the articles that were not included by Daney in earlier collections (it was of course not appropriate or possible to break up the books composed by Daney himself in order to reproduce the material in a hypothetical Complete Works).

There are a few unpublished pieces among them (Daney always worked on assignment, sometimes given by others and sometimes given to himself). Most originate predominantly from the three publications he wrote for most consistently, *Cahiers*, *Libération* and *Trafic*, but we curiously discovered a large number of occasional, often inaccessible texts that had until now been scattered through books, catalogs or other more unexpected periodicals (sometimes aperiodicals). Daney did not know how to refuse an article to a friend, from any quarter.

This edition's design attempts, modestly, to respond to several demands that are contradictory only at first glance:

—to make visible, through a generally chronological presentation of texts, the formation, evolution, but also the permanence of Serge Daney's ideas and tastes during the 30 years of his life as a writer;

—to respect, by organizing into main sections whose dimensions and contents vary according to era (almost exclusively cinema at first, then a shift in focus to television and sports, and finally a deliberate return to square one), and whose titles are largely borrowed from Daney himself, the map of territories he charted (the film or literary critique, the author portrait, the festival travel journal, the sports commentary, etc.) as well as the velocities of writing that he had to adopt to cross them, from the lapidary note of a travel chronicle to the definitive evaluation of the "ten best films of the year" to the argumentative essay that goes far beyond "for" and "against."

—to make room for the possibility of the constant back and forth between cinema and the world, which is at the heart of his thinking.

Serge Daney encountered the world with the certainty, increasingly affirmed over time, that cinema alone had taught him how to look at the real, and that fiction (the best school for mise-en-scène) had taught him how to decipher documentary first and then, by extension, television and every other kind of image. To such a degree that when he founded *Trafic*, a cinema review that was without illustrations, without interviews, and without film critiques in the traditional sense of the word, he offered us the luxury of understanding the subtitle's *of* as that of a subjective genitive, a review *of* cinema and not *on* cinema, made entirely of cinema, infused with it: "*Trafic* contains cinema as a pen contains ink." Daney's confidence in cinema had become so great that he ultimately had no more need to speak of it, even if he continued to do so. Cinema lived within him, transported him, gave him the world.

Two notes in closing, one on the general scansion of this edition, which is configured in three eras (logical as much as chronological), the *Cahiers* years (1962–1981), the *Libération* years (1981–1991), the *Trafic* moment (1991–1992), and in four movements (four volumes, each one introduced by a long interview in which Daney provides an overview of his work), the other on the chosen title of these volumes as a whole, *The Cinema House and the World*. It does not appear, as such, penned by Serge Daney, but it emerged with

strength and clarity from his published writings, his private conversations, the public positions that he took, and the double patronage, East/West, of the two Rays that he so loved, Satyajit and Nicholas. He deeply admired the former's *The Home and the World* and was overcome by the latter's final work, *We Can't Go Home Again*. Of this last film he wrote that in it, cinema was "a home for images that 'no longer have a home.'" The cinema home, like the "Sirk home" that he speaks of in *Trafic*, and not the home of cinema (its official institutions), cinema as a home for the shelterless image, vulnerable to the inclemency of history and the world, but also a home base from which one may set off again once the wind of the image rises.

— *Patrice Rollet*

INTERVIEW WITH SERGE DANEY BY BILL KROHN

When did you join Cahiers du Cinéma? *What was it like at that time? What did you do when you weren't working for the review? What was May '68 like for you?*

In 1959, I bought *Cahiers* for the first time. It was number 99. The Lang special issue. It used complex, grandiose language to talk about Lang's American films, which were disparaged at the time by "serious" critics. I really liked that paradoxical aristocratism. After several years of diligent attendance at the Cinématheque (rue d'Ulm, then, after 1964, Chaillot), I got closer to some of the critics at *Cahiers* (Jean Douchet, especially). In 1963, along with two friends, I founded a review that produced two issues: one dedicated to Hawks and one dedicated to Preminger. It shows how at that time we defined ourselves almost exclusively in relation to American cinema, taking for its apogee what was actually its twilight. In 1964, with Louis Skorecki, I went to the USA to meet some filmmakers and do some interviews (Hawks, McCarey, Tourneur, Lewis, Sternberg, Keaton). That's how we "traded our way into *Cahiers.*" In 1964, a serious ideological and economic crisis rocked *Cahiers*. Rohmer had to surrender his position as editor-in-chief and he was replaced by Rivette and then by Comolli. At the same time the review was bought and taken over by a publisher (Daniel Filipacchi) until 1969, at which time, for principally political reasons, the review became independent again.

At that time, "being at *Cahiers*" didn't mean what it does now. There was no editorial committee and all of the important decisions were made by one or two people. There were lots of freelancers who occasionally wrote pieces that were or were not accepted, without their feeling that they were part of a global project because of it. It was like that until 1968. The review evolved considerably, abandoned its blind Americanism and adopted phrasing that was increasingly intellectual and theoretical. It was, in France, the surge of the great structuralist wave (and the first works by Christian Metz).

The staff at *Cahiers* experienced 1968 in different ways. For me, it was a very profound shock and the destabilization of every certainty. It seemed impossible to make or write about films as we had before. The ideas developed by the situationists on the "society of the spectacle" affected me deeply. Fundamentally, our way of being "affected" by '68 consisted of casting into doubt and bringing into play, in a slightly mystical way, what had been the source of our *jouissance*: the position of the spectator. At that time, I moved away from *Cahiers* and rejoined it only in 1971. In-between, I travelled extensively (in India and Africa). The review, it seemed, was becoming increasingly politicized.

There were significant changes in the magazine at the end of the sixties. How did they come to pass?

I think that the greatest development of those years was the introduction into *Cahiers* of an extremely theoretical way of talking about cinema. Very different, ostensibly, than the old cinephilia. There's nothing very surprising in that: for the first time, writers like Foucault, Lacan, Althusser, and Lévi-Strauss were transcending their usual audiences and being read by larger circles of readers who immediately began applying their theories in wild ways. Simply put, *Cahiers* was the first review to rush headlong in that direction, without precaution. That earned us sneers from "normal" (impressionistic and hedonistic) critics, who would not accept the use of "jargon" to talk about films (this was the era of the dispute between Barthes and Picard).

Then, after 1969, there was the wild application of Althusser and especially Lacan thanks to Oudart ("The Suture"). There was also the

influence of the magazine, *Tel Quel*. The *Cahiers* of that era played the role of exchangers: they introduced theory into cinema and cinema into academia. It was rather ironic, since none of us were academics at a high level, but rather bricoleurs. I think, incidentally, that that era is over. Academic discourse increasingly holds a monopoly over cinema and the next generation of "cinephiles" will be created in universities more than in cinematheques. We played a role in that mutation. Today, we find it important not to limit ourselves to academia. *Cahiers* has always occupied an uncomfortable and paradoxical place where it was possible to write about cinema and create cinema at the same time (see Godard).

The "new" Cahiers *was criticized for its relation to that legacy: you reread Ford, dissected Bresson, psychoanalyzed Bazin. Why was that necessary?*

Criticism was of course the ultimate homage, more or less acknowledged, that we paid to what we had always loved. We wanted to reread Ford and not Huston, to dissect Bresson and not René Clair, to psychoanalyze Bazin and not Pauline Kael. Criticism is always that: an eternal return to a fundamental *jouissance*. Why, speaking for myself, is my relationship to cinema bound up with *The Indian Tomb, Rio Bravo, Ugetsu, Pickpocket, North by Northwest, Paisan, Gertrud*? In the love of cinema, there is a dimension that the psychoanalyst is very familiar with called "the work of mourning": something has died, of which shadows, traces remain...

Furthermore, in the collective text on *Young Mr. Lincoln* we made a clear distinction between ideology and writing [*écriture*]. We were therefore very conscious of the danger (which we did not always avoid, by the way) of confusing ideology and writing. But, and it's very simple, the cinema that *Cahiers* loved—and always did love—is a cinema that is HAUNTED BY WRITING. That is the key that allows us to understand its inclinations, its subsequent choices. It is also explained by the fact that the best French filmmakers have always been—simultaneously—writers (Renoir, Cocteau, Pagnol, Guitry, Epstein, etc.)

"The cinema that interests us is the one that plays on what's outside the frame... the great filmmakers—Hitchcock, Lang, Mizoguchi, Tourneur, Dreyer, Duras, Straub, Godard—are those for whom direction, writing, editing hinge upon off-screen effects..." Why? And what about Griffith, Walsh, Chaplin, Hawks, Dwan, Renoir, Hellman?

That phrase, by Pascal Bonitzer, is a bit misleading in that it risks implying that we love those filmmakers exclusively. There are others, of course, including the ones that you mention. Actually, it's the same question as the one that preceded it and the one that follows (re: naturalism). The filmmaking that interests us is haunted by writing. Writing implies a separation [*éspacement*, or spacing-out], a space between two words, two letters, a gap that allows for a proliferation of meaning. Writing doesn't imply immediacy, but rather an eternal movement of "boustrophedon." So how can all of that happen in cinema? Spacing-out happens there too, but not in the invisible splices between frames; it's in the off-screen spaces. Every frame secretes its off-screen. There are different off-screens and various ways of playing with them. There are off-screens directed by the eye (fetishizing framing) and off-screens directed by the ear (the fundamental voice, the voice of the mother). There is a way for the voice to either prohibit or provide access to the image. Every important filmmaker addresses this problem. And so, when *Cahiers* became politicized, they increasingly took their examples from Soviet cinema in the twenties, but it was again to distinguish between Eisenstein (who "wrote") from Pudovkin (who "didn't write"), and that was the same distinction as the one between Hitchcock and Huston. Now, it very well may be that with people such as Godard and Straub, we have reached a limit-point of writing. They are filmmakers for whom an image is closer to an inscription on a gravestone than a publicity poster. And perhaps film's only remaining choice is to be either a poster or an epitaph. Writing, as we know, bears a relation to death.

Public enemy number one, still at large: naturalism. Why do you dislike it?

The hatred of naturalism is just as profound as the love for writing, because it is its exact opposite. Naturalism contains fakery, a

fundamental trick: the camera just happens to be there and turns the spectator into a voyeur. Naturalism conflates the repressed with the invisible. An example: for years, in French films, immigrant workers were never seen. Cinematically, they didn't exist. After 1968, immigrants participated in various struggles and became politicized: French cinema then became obligated to show them. And so, it began to show them, but as if they had always been there and one had simply forgotten to show them, when they had actually been repressed, and for political reasons. It's ethnological voyeurism. At *Cahiers*, we believed that the question was not only of "addressing an oversight" but lifting the veil on a repression: why had their image been missing? Cinema most often shows us people, events, milieus that are unfamiliar to us; there is no reason for it to give us the impression that they are there, *next door*. Naturalism (accuracy in description) is just one moment in the work of a filmmaker. If one doesn't move beyond naturalism, one will necessarily start asking the questions of cinema in promotional terms (as if there were no issue.) Unfortunately, that is happening more and more.

What happened at Cahiers *in 1973?*

The history of the years following 1968 in intellectual circles must be told. It's the story of a delay. 1970 marked the apogee of the "Maoist" movement in France (with groups like "La Gauche prolétarienne" and then *"La Cause du peuple"*), the moment of its greatest political inventiveness. After that date, the movement experienced a decline, first in its spontaneous ("Maoist") form, then in its dogmatic form ("M-L," Marxist-Leninist). Leftist ideas reached cultural circles only after a certain delay. Why? It was people who never belonged to the French Communist Party (like the writers at *Cahiers*) who were particularly affected by leftist thought. When the entire French cultural scene became politicized, it was natural to move closer to the FCP in order to evaluate its positions on art and culture. At first, that was the approach of journals such as *Tel Quel* and *Cahiers*.

The FCP, for its part, after having been seriously burned by debates in the '50s over "socialist realism," had given up any visible interference in the arts, and, at the same time, had renounced any

theory or study of the relationship between art and politics and, more precisely, of the literature of propaganda. But *Cahiers* and *Tel Quel* were journals that had fought to introduce new methods (that had emerged from structuralists) into the study of literary and cinematographic texts. And so there was an exchange of services: the FCP provided the militant ideal and the political ideas, and we provided the specialized avant-garde labor that the FCP desperately needed. But it didn't work. Because essentially, the Party's cultural politics were more cynical: on the one hand, entertaining certain researchers with "specific" questions (this was the era of Althusser and that notorious pair, science and ideology, the era of "theoretical practice") and on the other, infiltrating the cultural system and establishing cultural leaders within it, relays to disseminate exactly the same culture and relationship to culture as the bourgeoisie.

But the lack of political history on the part of the *Cahiers* staff meant that they couldn't be satisfied with being a laboratory cut off from the rest, with being isolated researchers or scholars. We had to experience the real (painful but inevitable for every French intellectual). And by "real," here, I mean in the sense of "*mauvaise rencontre, trauma*" (Lacan). We had to leave the space of cinephilia, take on concrete tasks, new interlocutors, etc. That sort of "old fashioned" commitment was essentially only a fast-forward of what must have been the political commitment of French intellectuals with the FCP since 1920. And we could only experience that repeat caricature through the intermediary of small "Marxist-Leninist" groups that, themselves, hysterically (like a son who criticizes his father for no longer being strict enough) lived off grieving for a Stalinist politics through a Chinese image-system. They furnished the group's super-ego and political literacy, and we provided a supposed "specific work on the cultural front." The reference to Mao's text (*Talks at the Yenan Forum on Art and Literature*) allowed us to avoid falling into a Trotskyist position that has always been lax and contemptuous towards art.

All of this culminated in the idea of the "Cultural Front," comprised of people like us who believed they were politicizing culture and ex-militant leftists who had understood their political failures and fled towards a "secondary front" where they could continue to intimidate other people as they simply negotiated their survival

(several years later, the most brilliant among them—Glucksmann, for example—landed on their feet in journalism and literature, striking a self-righteous pose). The result was this: artists were intimidated, inhibited by the burden of errors to avoid and tasks to undertake, and militants hid their lack of ideas and motivation behind an overly general discourse. This double blockade meant that the Cultural Front never worked. It evolved towards an increasing interest in an entire domain, one that had been neglected for many years: popular culture, the carnivalesque tradition, memory and popular resistance, etc. Here is where Foucault's importance can be seen. A film such as *Moi, Pierre Rivière* could never have been made without the issues advanced by the Cultural Front. And so the connection to cinema, after a militant detour, reaffirmed itself.

What have you learned from militant films? Why all of these imaginary journeys through liberated zones: territories, factories, prisons? Why is sound so important in these films?

I would say that the interest in militant films is as much an effect of cinephilia as of the political superego. In *Cahiers*'s cinephilia (as understood by Bazin) there is the demand for risk, for a certain "price" of images. In militant cinema, there is that idea of risk. Not metaphysical risk, but physical risk: risk of not being there at the right moment, risk of not having mastered the technique (militant filmmakers are amateurs), legal risks (Belmont and the *Histories d'A*) and even the risk that the film, once it is made and shown to the people it concerns (those who are a part of the struggle and not cinephiles), won't be liked by them, won't help them, won't be understood by them. *Cinephilia is not only a particular relationship to cinema, it is a relationship to the world through cinema.* I remember what people like Moullet and Godard said in the fifties: they learned about life at the movies. Cinema taught them how to live.

And the *Cahiers* cinephilia, the cinephilia of the "Hitchcock-Hawksians," has something about it in particular that relates—perversely—to the general public, because Hawks and Hitchcock's films were seen in their day by working class people and ignored by the cultivated people. It's a relation to the working class space

through forms that the people experienced and loved for fifty years. When I started going to the movies, I was very aware that that choice was very much connected to my hatred of the theater. I hated theater's social rituals, having a seat assigned in advance, the need to dress up, the parade of the bourgeoisie. In cinema—in the concrete movie theater—there is black, fundamental space, infinitely more mysterious. The sexual aspect, *prostitutional*, more specifically, is very much tied to that kind of cinephilia: look at Godard, Straub, Truffaut: they speak of nothing else.

To get back to militant cinema, if we've moved away from that, it's because it failed to provide that same kind of imaginary encounter with the public. Because they were most often only sectarian films, hastily created by people who didn't have the slightest concern for cinema. (There are exceptions: *Attica*, *The Massacre of Kafr Kassem*, *The Promised Land*). Today, I think that militant films have the same shortcomings as militant groups, they have the "madness of totality": every film is global, total. A truly militant cinema would be a cinema that would advocate [*militer*] as cinema, where a film would incite the desire to see a hundred other films on the same subject and in which there would be no cursory totalization. Such a militant cinema would have to break with the too-heavy models of commercial cinema. I've had friends who spent a year making a 16 mm film about a strike in a printing plant, at enormous effort, sacrifice, and cost, and by the time it was "released" the film was incomprehensible. The old militant cinema fails because it has no sense of its own economy. It's an enormous waste that doesn't see itself as a waste. It's too expensive, too long, too general, it takes up too much time in the lives of the people who make it, etc.

What we have learned from watching militant films is, precisely, *morality*. That is to say, the way in which the power represented by a camera (its ability to intervene, to interfere, to extort, to provoke—to modify the situation onto which it grafts itself) is or is not reflected by the filmmakers. Paradoxically, the films that denounce the power of the bourgeoisie, injustice, oppression, use for that denunciation means that are themselves totalitarian, flat, non-dialectical. And it is certainly through the voice (the voice-over, which is the principal recourse of all edifying cinema) that this operation of *forcing* of

images is performed. There is a moment when you realize that the point is not to agree or disagree with the explicit ideology of the film, but rather to see to what extent someone can stand by those ideas while respecting the audiovisual material that was created. It's a dialectical movement: in one way, the filmmaker—guided by ideas, tastes, convictions—produces certain material, but in a another way, that material teaches him some things by resisting him (minimal materialism). Straub is the most coherent in that respect. There must be confirmation of what one already believed and the affirmation of something new and unexpected.

Has your attitude towards Chinese cinema changed? You seem more inclined to critique it these days.

Chinese films have never really interested us. And we have never praised them or even liked them. The only one I've liked is *Breaking with Old Ideas.* I got a strange feeling from it: that this dancerly film that is so full of movement provided the visualization of an official ideology, as naive and as consistent and as total as the one found in certain American comedies, like those starring Debbie Reynolds, let's say. Europe, since its misadventures with fascism, no longer has the ability to establish—in the form of puerile images—a moral consensus (good conscience). I think instead that it's only imperialist countries who are able to figure—in the imaginary—moral consensus (the norm) and what threatens it (the smear, the scapegoat). Only imperialist countries can afford catastrophic films. The Chinese films I've seen function according to that model (as do Soviet films like *Bonus* that were made twenty years before *12 Angry Men*).

What do you object to in films such as Z and 1900? Are there examples of good leftist films made for the general public—in Italy, for example?

It's the issue of ideological and moral consensus in Europe today. *Z* and *1900* (and *Solemn Communion, The Question, The Red Poster, Illustrious Corpses,* etc.) try to unify the largest possible audience around a standard leftist imaginary. In order not to offend anyone, unification is created on metaphysical themes, devoid of any concrete

history: in *1900*, the revolution of the anarchist peasants from Emilie-Romagne at the beginning of the 20th century becomes in the film a sort of peasant uprising that anticipates the "Historic Compromise"; in *The Red Poster*, the snipers' actions become an episode in the FCP's struggle; in *The Question*, the courageous attitude of a militant communist (in disagreement with his party) becomes a sort of abstract courage to resist in general, etc.

So unification is always founded on a kind of amnesia and a wish to feed that amnesia with beautiful images (the red flags of *1900*). That amnesia is a phenomenon that is paradoxical but important to Franco-Italian intellectual life: those cultures penetrated by Marxism are also cultures in which the history of the workers' movement is not very well known, because history is written by political parties.

Furthermore, for those of us who are haunted by writing, like *Cahiers*, it's clear that writing *divides* while images unite (in communal fear or recognition). Today, in France, in the cinema, you must divide. And you can only do that by making *contemporary* films (not emotional renderings). For example, it's entirely possible to make a *trade unionist* into a fictional character, that's what Godard does in *How Is It Going?*, it's entirely possible to film the suicide of a young person, that's what Bresson did in *The Devil, Probably*. But those are contemporary films, that aren't engaged in the simulacrum of memory.

Why division? The reason, I think, is sociological. Cinema is less and less a form of popular expression and more and more recognized as "art" by the middle classes. Its educational work is finished (television has perhaps replaced it). It is increasingly seen by a petit-bourgeois audience that is relatively well-informed and it tends to play the role that theater used to play: a space of prestige, debate, parade, display. It's not at all certain that this new audience will be better than the old one. It is, at any rate, looser, less spontaneous. In fact, there is an entire machinery of language surrounding films (critiques, publicity, press kits, academia) which means that there is no longer any freshness in how they are received.

As for the question of knowing if there are any good leftist films made for the "general public," it seems to me that this question has two parts. 1. I think that films with "burning political themes" never

go very far, are superficial, because they are very general. They are not political films at all, but films about the politics of the coalition of the left in France (and in Italy), vague and reformist, imprecise and unifying, well-intentioned. They are films that could be described as "operational," meaning that they are immediately received and consumed as films that illustrate the politics of the united left. Their work is closer to that of a publicity poster than to work about the signifying material. 2. Conversely, for all the films in which one can read a real fascination with power conceived as manipulation (one of the great problems of European cinema is how to create a kind of "leftist cop," c.f. Rosi, Boisset), there exists a tradition of comedic films, mostly in Italy, in which the question of class and power is not ennobled and mystified but instead rendered trivial and ridiculous, common. For me, the only good "leftist" films have a carnivalesque dimension (c.f. Bakhtin) that is completely absent from French cinema, but present in a Risi (*A Difficult Life*) or a Comencini (*The Scopone Game*, *The Adventures of Pinocchio*).

The review has once again changed—an ill-informed reader might say it has "returned to normal": more photos, articles on all kinds of films, references to old American movies... What's happening now? What hasn't changed?

What hasn't changed?* There are pieces of an answer in everything I've stated above. There comes a time when you want to give up on the "passion for the Whole" and investigate (theoretically, too) the fundamental experience from which you feel authorized to write about film, and write for people who have different kinds of cinematic experiences.

Why are you interested in "underground" films?

When the French film industry fails, there will be room for an "underground" cinema in France. Like the one that already exists in

* Translator's note: words that appear in English in the original text have been signaled with an asterisk.

England. Until now, the big difference between France and the USA has been this: there is no bridge between American "underground" cinema and the film industry, while there has always been one in France. In France, it is always possible to make a difficult film and market it, even if the possibility is very slight. The crisis (the end) of the film industry has had very curious consequences: an acceleration of all the processes. For example, twenty years ago, you still had "serial" filmmakers in France, talentless but with plenty of skill, who made one film a year. That was "French quality." Those people no longer exist. Large companies are entirely ready to offer major opportunities to young talents coming from the avant-garde. The example of Chantal Akerman is proof of this. So there is, in France at the moment, a great *cross-fertilization*, rather than a segregation. It seems to me that that segregation has existed for some time in the USA due to *patronage* and the recognition of the function of art as an unproductive expense. We are interested in the "underground" as something that will one day be a reality in France, a "domestic" cinema. We have seen magnificent films, by Dwoskin and by Jackie Raynal. There are certainly plenty of others. Far less interesting are the critical discourses surrounding these films. *Without a doubt*, the position of the critic can no longer be justified in the case of these films, since they need no mediation, since they play, most of them, on primary processes. That's one big difference from the European avant-garde (the one that interests us the most, meaning Godard, Straub) in which all of the work on primary processes (on perception) only has real impact if it also relates to elements of thought, of signification.

Women's films: by women, or simply about women, about female sexuality...
What do these films show us? Why are they so violent?

Because we are talking about cinema, thus the ear and the eye, it would be better to talk about how women's cinema [*cinéma au féminin*] (made eventually by men) shows us what the imperialism of the eye (it's men who are voyeurs) has repressed: other methods of arrangement of drives in which what is seen and heard *changes perspective*. For example, I have said that militant cinema falters when it comes to the question of the voice-over (the protected voice)... just

as how we saw feminism emerge from the disintegration of "Marxist-Leninist" political groups, similarly in the breakdown of the voice-over we saw the development of an entire vocal experience, an experience that was driven by the feminine (Duras of course, Akerman, Godard, Ferreri). It's also one of cinephilia's limits: the rediscovery of the mother's voice heard from inside the body, pre-visual. Female limit of cinephilia. So, I think that the visual element has totally changed: in the three films by women that have impressed me the most: *Twice Upon a Time, Je, tu, il, elle, The lorry*, there is something extraordinary: the way in which the authors/actresses are on both sides of the camera without that having serious consequences. There is a calm violence in it—which brings into clearer focus the difference between the author/actress and the author/actor: look at Lewis or Chaplin. For them, passing from one side of the camera to the other risks transvestism, feminization, playing with that risk. Nothing like that happens with these women.

You're again speaking openly about "cinephilia"—in its hard form: the love of Tourneur, of DeMille, the last films of Fritz Lang... Do you see an advantage to that?

It's a particular kind of cinephilia. It doesn't concern the entirety of American cinema, but one part of it, often the most despised: Lang, DeMille, Tourneur, Ray... I remember, in 1964, we met Cukor and told him that *Wind Across the Everglades* was one of the most beautiful films to come out of America. He burst out laughing, laughter that revealed the contempt he felt for that film. We were very hurt, but we didn't change our minds. In American cinema, I think that is increasingly easy to see, as it grows distant, what interests us: it's always the same thing, the privilege of writing over ideology and not the other way around (Huston, Daves, Wyler, today Altman). It's obviously a paradox, for it led us to become interested in filmmakers such as Ford or Hawks or even Hitchcock, who are not particularly leftist. This privilege of writing over ideology is only possible in the framework of a prosperous industry and a real consensus. This existed in Hollywood until the '50s, a little in pre-war France, in Italy, probably (ital) in Egypt, in India, in Germany, and in pre-war

England. Outside of that industrial framework (industry and *artisanat*), the opposite occurs: the privilege of ideology over writing. Take the countries of the third world, including China. That cinephilia is historically datable; it has that mixture of industry and craft as its original ground. It isn't possible to resuscitate that. But in the precision of the writing in Tourneur, Lang or DeMille, there is an exigency that Godard, Straub, Kramer, Wenders, Akerman, Biette, and Jacquot have continued (I am deliberately citing the filmmakers whose films we're showing in New York).

You have recently said that the filmmakers who interest you now are all moralists. It is strange to hear words like "moral" and "tragedy" again. Why have they become so important now?

What is a filmmaker if not someone who, at any given moment, says, "I don't have the right to film that, or to film that like that!" And who thinks that it is his responsibility to make that decision, that no one else can make. One of the texts that made the greatest impression on me as a young reader of *Cahiers* was a text by Rivette on *Kapo*, the film by Pontecorvo. He described a scene from the film, the death of Emmanuelle Riva, killed against a barbed wire fence. Pontecorvo—at the moment of his character's death—moves the camera to reframe her face in the corner of the screen to make the framing prettier. Rivette wrote, "The man who created this tracking shot is worthy of the most profound contempt." More and more, there are two kinds of filmmakers: those who really feel that "everything has already been filmed," whose mission is to to begin from images that are already present, like a painter laying down a second coat of paint. And then there are those who always have front of mind the awareness that what they are filming exists outside of the film as well, it is not solely filmic material. Morality begins from there. Always the idea of risk.

More generally, morality is again becoming a living question because all of us have seen that morality doesn't exist for those people who think in terms of power (to take, to keep, or to dream about). Thus no morality on the left, or in Marxism. Morality is an individual thing; it's only natural that a return to a certain kind of auteur theory would reintroduce morality.

What has television done to our minds? What has Godard done with tele-vision?

It's a great mystery. I think that no one takes television seriously. Not the people who make it (all of whom are haunted by the films they aren't making; which means that the possibilities of video have been ridiculously under-explored and France continues to produce horrible, very expensive "dramas" that are neither cinema, nor theater, nor television). And not by those who suffer through it. TV is a cool medium from which people expect no kind of truth. Its main impact resides in the fact that it has become background noise that prevents us from hearing anything else. The catastrophic theories that would have us believe in television's power to dumb us down have been greatly, smugly exaggerated. Godard's contributions to television have been considerable. He revealed its operations, as he always does, through the absurd, through excess. He showed that the simple fact of letting someone speak for an hour straight can alone cause a breakdown, no matter what they say. He showed that television, far from making us passive, demands from us on the contrary that we produce work that journalists are not producing.

What about Jacques Rivette? You haven't talked about him for a long time.

We have been very unfair with Rivette.

What interests you at the moment in American cinema? Why don't you like Robert Altman? Have you seen Star Wars? *Etc.*

Kramer, Cassavetes, Paul Newman (why doesn't he do anything any more?), Dwoskin, Hellman, etc. As for Altman, I have the disagreeable feeling that he's a minor figure, very comfortable with naturalist language, who's gotten it into his head that he's in competition with Bergman and Antonioni. What's especially offensive in his movies is that the only thing we're asked to believe in is the director's genius. The author is always more intelligent than his test subjects, he always knows more than them, has it *over them*, but his knowledge is always

guarded. You don't find that kind of contempt in—I'm expressly choosing very haughty authors—Bresson or Antonioni because they completely scoff at "what-you-should-look-like-you're-thinking-to-seem-intelligent," meaning "*non dupe*" (in Lacanian jargon). The films of Schatzberg, Scorsese, Coppola, etc. *represent* a respectable and slightly academic tradition. Still, I have the feeling that there hasn't been any real innovation in American cinema for nearly twenty years.

What are your plans for the "Cahiers Week" at the Bleecker St. Cinema in New York? Tell us about the films you'll be bringing there.

There will be one day for two Godards, alternating: *Here and Elsewhere* and *How Is It Going?* Since the text is very rich and very dense, we will have to translate it and distribute it in advance. One day will be dedicated to "the return of fiction." How cinephilia seeps into the flesh and blood of the new filmmakers (Jacquot, Wenders). The third day, Straub and Akerman. The fourth, *La Cecilia* and *Anatomy of a Relationship*.

I was told that you will be bringing "an old Mizoguchi." Why in 1977, after everything that's happened, an old Mizoguchi?

We will probably not bring an old Mizoguchi. But that's exactly, after everything that's happened, what we should be bringing: he is just about the only filmmaker who has made Marxist films.

(*The Thousand Eyes* #2, New York, 1977)

PART ONE

IN FILMS' WAKE

AN ADULT ART

Howard Hawks, *Rio Bravo*

Culmination of an oeuvre that is no longer impossible to ignore, *Rio Bravo* may very well be, along with *Hatari!*, Howard Hawks's testament. Indeed, this humble Western is the conclusion of thirty years of cinema, its themes find their most perfect expression and Hawks becomes a master in the art of the fugue of which *To Have and Have Not* was only a sketch.

Rio Bravo is all Western, from the saloon whose doors bust open to John Wayne's awesome and lumbering presence; and yet, it could also be called an "anti-Western."

Every effort is made to show us that the Wild West is not as we imagine it to be: no longer is it a wasteland where adventurers duke it out but a calm and bourgeois town where adventurers no longer belong. The age of the pioneer has passed: in 1935's *Ceiling Zero*, Hawks observed the disappearance of a type of man that meant a great deal to him. Here, violence is regulated by the law, and the law is the sheriff, composed and predictable, an enemy of conflict. And so, what fueled the profound tragedy of *Dawn Patrol* is here overcome, the rules of the game accepted.

To see the film as a series of beautiful fistfights between extras would be a mistake; we must, instead, feel what each gunshot engenders in the men and the process to which they respond. It's in this sense that *Rio Bravo* is its director's most complex work: in *The Big Sleep* and *To Have and Have Not*, he discovered ambiguity, but with

Rio Bravo, which is in some way a remake of the latter, the lesson is assimilated, the circle complete.

The refusal of bombast and myth leads Hawks to a more precise, more scrupulous observation of the characters and the settings in which they evolve. *Rio Bravo* is "Daily Life at the Mexican Frontier at the End of the 20th Century," somewhat. But its realism responds not to a demand for the picturesque or for novelty, but to an imperative of a psychological order: in place of stylization, Hawks chooses certain slices of life; those offered to us here shine as much for their truth as for their urgency. Hawks does not distort the real: he chooses from it the gestures, the moments and places that will be the most revelatory; one gesture by Dean Martin (Dude) as he passes his hand over his face tells us more about his character than a thousand drunk scenes would have. We are permitted to imagine life in the town beyond what is presented to us; we even have enough reference points to do so. But Hawks fails to shoot a single unnecessary scene: he realizes authenticity through detail and scrupulous reconstruction in a select number of locations, chosen not for their particular interest or photogeneity but for the relationships that they sustain with the characters.

There are only a few sets and only a few characters, and one could say, ultimately, that each set corresponds to a character: Dude and the saloon, Chance (John Wayne) and his sheriff's office, Stumpy (Walter Brennan) guarding the prison, Feathers (Angie Dickinson) at the hotel. These connections are more than accidental; they revive and clarify the Hawksian concept of the set-as-prison, a concept that was first illustrated, in its most obvious form, by the museum in *Bringing Up Baby* before becoming the subject of *Land of the Pharaohs*.

Inside a town from which he cannot escape, each character evolves within his chosen setting. Inside a confinement that is imposed upon him, he seeks the prison that suits him best. Including even Joe who, after triggering a process that he proves incapable of controlling, soon disappears. For him, alienated by the desire for power and not very intelligent to boot, there is only one possible setting: prison.

Setting must therefore be considered as a key and a point of departure; each character tied to a location becomes unable to think properly, in other words unable to know his capacities and his limits,

to assess the actual value of other people and, thereby, to act intelligently. All of Wayne's mistakes in *Red River* come back to haunt him; as for Nellifer, she pays for her blind ambition with her life.

Having a clear awareness of the available means to achieve the goal one is fixed on is, quite simply being heroic. Through realism, Hawks offers us, after Dewey Martin and Monty Clift, the most complete image of heroism in the character of Colorado (Ricky Nelson).

If the character is the least fascinating of the lot, if the actor is occasionally irritating (as much as James Cagney, years ago), he nevertheless represents the ultimate phase of the other characters' pattern of progression. Freedom is, for Hawks, not being dependent on any particular setting (hence his predilection for large spaces) and being able to adapt to all of them. And we see Colorado shine as much inside the hotel (where he exposes fraud) as he does outside of it (the flowerpot strategy was his). He adapts easily to new environments; the ease with which he settles into his new life as a sheriff's deputy finds its conclusion in the scene with the song, after which he is definitively integrated into the group. On the other hand, Chance proves to be terribly awkward when he goes to the hotel; he even seems ridiculous, a catastrophe for the Hawksian hero.

And yet, Colorado is not the "hero" of *Rio Bravo*, whereas Cagney is incontestably the central character of *The Crowd Roars*; Hawks's interests shift towards Dude (a reprise of Eddie in *To Have and Have Not*) and particularly towards Chance who, certainly, is the director as much as Paul Biegler is Otto Preminger.

Every misinterpretation of this character stems from his being judged by his appearance rather than his actions; the examination of the latter leads us to an exact understanding of the character. It's not appearances but actions that teach us the most about Chance (as with the Pharaoh). His activity leads to failure throughout the film; Hawks's skill lies in presenting him sometimes at home, sometimes outside of it, master of his domain in his own environment but far more vulnerable as soon as he leaves it (just as the Pharaoh is kept in check every time he leaves his palace).

Knocked out in the saloon where later he will play only a secondary role during the "bloody beer" episode, caught in the trap of the "imposter Dude" in the street, allowing the man who killed Pat to

escape from the barn, he only pulls through with outside help (Dude, Colorado, and then Stumpy).

In fact, if Chance most often sets himself up to fail, it's because he considers himself strong enough to overcome every obstacle all by himself; this overestimation of his own powers is another form of alienation, more dangerous than Dude's alcoholism (because Dude is always aware of his own decline). It's this kind of notion that leads Chance to refuse Pat's help, an error that, inevitably, finds its implicit retribution in Pat's death.

What's important then, for Chance, is that at the end of the film he allows Dude to take care of him; from that moment on, he is healed.

If these assertions seem vague, remember the scene with the song; Chance is the only one not to sing, simply gives his friends an amused, protective look that says everything he needs to say. Notice, also, that Chance does not give up carrying a gun (symbol of his suspicion of other people) until the final scene. Lastly, he considers himself to be the most grounded and the most stable among them, the one who seems to have figured out women once and for all (based on Dude's unfortunate affair), the one who finds love (for Feathers could just as well have seduced Dude or Colorado).

And so, for Chance, the experience is as much moral as it is physical; in the final shot, he has relinquished his weapon and escaped his setting; he rediscovers the world with a new perspective that is no longer impaired by egocentrism.

In actuality, all of this was apparent from the first sequence; the first image we have of Chance is of a powerful character because he is shot from below, but that idea of power is contradicted several seconds later when Chance collapses, after being punched by Dude; the character's entire evolution is there, in that Boetticherian fall of a chieftain.

Dude's evolution, which is parallel and, one could say, complementary to Chance's, is more clear-cut. The passage from blindness (alcoholism) to insight (the soothing of a broken heart) occurs in an absolutely symmetrical way that is characteristic of Hawks's profound classicism.

Here, the shots are orchestrated relative to each other in a movement that could be described as dialectical: see, among others, the spittoon episode that replays in reverse, or even the humiliation that Dude suffers next to the trough that will only be expunged by his final

fight with Joe that plays itself out just next door. One movement cancels the other and, at the end of this checkered path, Dude, now recovered, will be able to accompany Stumpy to the saloon; we have come full circle, underlining once again the hermetic nature of the film.

Liberated, the characters seem to make a fresh start and everything tells us that they will succeed because the foundations were laid within the film itself and correspond exactly to Hawks's vision of human relationships.

If we have chosen a purely psychological approach to these characters, it's because Hawks remains a moralist, and because *Rio Bravo* takes the form of a moral itinerary. Certainly, this is not the first time with Hawks that a character is at the end of the film no longer what he was at the beginning; this approach even presides over the quasi-totality of his oeuvre. But in this sense, Rio Bravo is also a summation.

The path from blindness to insight by way of psychology leads to an ethic: oscillating between two opposite poles, the hero must refuse the immobility that will lead to his downfall (the Pharaoh and his thirst for immortality) and take action. This fear of a stalemate, this dread of paralysis has already been addressed in *Dawn Patrol* and *Ceiling Zero*; remember those officers reduced to inaction and rendered incapable of thinking as a result.

In a more delirious and simultaneously a more abstract form, *Bringing up Baby* tells the remarkable story of David (Cary Grant), who, from a fossil, becomes a man thanks to Susan (Katharine Hepburn), the incarnation of movement, hence life.

In *To Have and Have Not*, it is also a woman (Lauren Bacall) who brings Humphrey Bogart, trapped in a web of habits and menaced by a dangerous numbness, back to life. Feminine behavior is always based on provocation, but a provocation whose result returns to its source, modifying it in turn.

Lauren Bacall seduces Humphrey Bogart out of pure self-interest, provokes his "awakening" (he agrees to act and to help Frenchie) before he is finally caught in his own trap and transformed. That process will be repeated in *The Big Sky* and *Red River* before finding its most complete expression in *Rio Bravo*.

And if we must refer here to the art of the fugue, it is because each melody only exists in relation to the others by drawing upon them.

The gesture echoes to infinity before returning to its author and the film's perfection comes as much from the beauty of those gestures as from the fact that they exist in complete harmony with their motivations and their consequences.

For many years we could only see the results of a conflict between abstract forms; after *The Big Sleep*, it is as if Hawks wanted to go behind the acts whose ambiguity he had acknowledged in *Sergeant York*.

Lacking those formal prolongations that produced the limpidity of *The Big Sky* and *Red River*, *Rio Bravo* is a world that is complete unto itself and in which nothing is lost; it is a microcosm in perpetual evolution where everything contributes to an ultimate harmony that can be reached by banding together and helping one another.

Quintessentially dynamic, Hawks's cinema is nevertheless as classical as it gets. A maker of adventure films, he cultivates a taste for understatement and symmetry, according to the structure of his films a very particular care (which makes us once more deplore the cuts made to *Rio Bravo*).

To say that his is a cinema of movement does not fully capture that movement's form. It seems that at every level of creation, the work obeys a sort of internal pulsing, balancing, oscillation between two opposite poles. Balancing of characters, caught between two flames, and whose evolution, far from being linear, is always subject to relapse (Dude).

Oscillation between action and reflection on the action, which legitimizes the construction of *Dawn Patrol*, returns in the final shots of *Land of the Pharaohs* and is particularly visible in *Red River*: as it is performed, the act deviates from its original meaning, modifies itself, takes a different direction that will bring it to another conclusion.

The filmmaker's gaze obeys the same demands; a constant calling of the characters into question via humor (c.f. *The Big Sky*'s marvelous opening scene) creates the kind of detachment that lucidity requires.

Still, everything takes place between men, and in this sense Hawks is the most materialist of filmmakers: *Rio Bravo* is a self-contained world that is complete unto itself because salvation is found in mankind and not some transcendental power, and if the film's final shot echoes its first, it has, beyond any formal similitude,

a different meaning (unlike *Gentlemen Prefer Blondes*, our author's darkest film). Thus it is not a circle that we're speaking of here but a spiraling ring.

Finally, apart from an idea of which *Rio Bravo* marks the final expression, the beauty of the film perhaps comes also from somewhere else: ever since *Red River*, Hawks's heroes have been in their fifties and no longer young men. Nothing unusual in that, certainly, since the work reflects the man, but behind *Rio Bravo*'s perfection lies regret. *Red River*'s pioneers have settled near the Rio Grande; they have grown older, and it is no longer the splendor of the testament that touches us as much as the nostalgia of the lion grown old.

(*Faces of Cinema* #1, 1962.
Reprinted in the *Cahiers du Cinéma* Serge Daney Special, #458,
July–August 1992)

SCARFACE, OR THE PRICE OF SUCCESS

Howard Hawks, *Scarface*

Filmmakers are always loved for their minor, even mediocre films. Lang is only cited in tearful remembrance of *Die Nibelungen*, one concedes that Preminger succeeded with *Laura*, and Renoir is granted a single masterpiece: *Grand Illusion*. As for Hawks, cinema history speaks only of *Scarface*. Seeing this film again during the [Hawks] retrospective, it is easy to see what people like about this bleak gangster film, the picturesque charm of a world that was discovered slightly later on in France. Truth be told, it was only incidental in the director's career. It appeared during the pessimistic, even apocalyptic period that encompassed *Ceiling Zero* and *Dawn Patrol*. The theme of the will to power is sketched out within it, and it leads to a reversal of human relationships, the most tangible manifestation of which is the study of the clearly incestuous relationship between brother and sister.

The fact that Hawks has been identified with this film for so long reflects the misunderstanding from which the rest of the author's oeuvre suffers.

We may now return this film to its true place: it is a milestone in the history of a meditation whose conclusions are familiar enough to us that we need not dwell upon their origins.

(*Faces of Cinema* #1, 1962)

THE RULES OF THE GAME

Otto Preminger, *Advise and Consent*

> *"It is through our extended attention to the iridescent surface that we realize depth's reward."*— Gaston Bachelard

To his detractors, we admit that Otto Preminger's cinema is cold and, what's more, offers literary criticism no foothold.

None of the things commonly referred to as mise-en-scène, but an unforgiving and bitter gaze. Anyone who doesn't understand the ambiguity of that gaze after seeing *Laura* will not be convinced of *Advise and Consent*'s beauty, and will appreciate the path he traveled to get there even less. Saying that *Advise and Consent* is to Preminger what *Taira Clan Saga* is to Mizoguchi will not persuade anyone who shunned *Saint Joan*, so let us forgo such futile proselytizing and abandon ourselves to the pleasure of discussing a man we love, a man who is currently America's greatest living filmmaker.

Of course, his films are cold, but we too often forget that coldness is also modesty's weapon, and that's the word that suits a man who has on so many occasions brought tears to our eyes, whether by filming the sufferings of the Jews or Joan of Arc at the stake.

* * *

Exonerating Preminger of the sin of coldness and aridity simultaneously reveals the innovation and greatness of his contribution, and would have prevented a fair number of undiscerning people from being surprised by the author's wish to adapt *Exodus*, a decision that could only surprise those for whom coldness means the refusal of

schmaltz. No one has more compassion for people than Preminger, for their heartbreak and suffering, but unfortunately for some, he does not express that compassion through sentimental turmoil. And if Preminger belongs among the greats, it's because by endowing his characters with an authenticity and a truth that is rarely equalled, he then dares sacrifice the existence to which we so easily, and so naively, subscribe for the expression of an idea in whose service the actor must become a character and symbolic object.

* * *

A tyrant on set, Preminger had to be pessimistic in his themes in order to fully satisfy our critiques that are haunted by symmetry and always looking for formulas. His vision of the world is too complex to remain at such an elementary level, but the author's first move is to establish the abjection of the worlds he is committed to describing.

Similar, or rather parallel worlds, sects, bodies, circles of all kinds that are subject to the inevitable process of death and degradation. From the world of drugs to the world of politics, there is only the step from the particular to the general, from the event to its genesis. Just as in his final films Mizoguchi speaks less of the enslaved than the enslavers, the prostitutes than the pimps, Preminger steers quite naturally towards what are commonly called the big issues, to the great astonishment of those who, not seeing in this the culmination of an idea, believe they detect in it an additional deceit.

More than worlds, it's milieus that we ought to be discussing here, and the essence of a milieu is confinement. A banal concept, certainly, but it is the first step and foundation of the mise-en-scène, while legitimizing the importance of interiors throughout an oeuvre that is particularly rich with palaces, chateaus, apartments, game rooms, tribunals, and other enclosed spaces.

* * *

This helps us better understand the place and importance of *Advise and Consent*, Preminger's second film about politics after *Exodus*,

although it is its opposite. Entomology prevails over the epic without excluding it, for these are the two vocations of Preminger's art.

It is as if *Advise and Consent* is *Anatomy of a Murder* squared: it has that film's humor, justice, and most of all its documentary precision.

In fact, few artists are as respectful of the real as Preminger; his mistake has only been that he does not cut his slices of life in the usual way: the way of miserabilism. It is difficult to see how realism could be the prerogative of certain subjects but not apply to judicial or political life. Even those who contest the film's artistic value recognize its excellence as a document. There can be no doubt that to many, *Exodus* and *Advise and Consent* were breakthroughs.

Preminger's art is, at first glance, analytical, his purpose being to show a mechanism in action (in which case the script becomes a simple role-play); it falls within a quasi-scientific ideal based in observation, wherein any special effects would contaminate and nullify the project.

This art is not about liberation, or world harmony, but desperately seeking that step back from which great architectures are devised. Closed worlds, closed environments are defined as much by a preoccupation with order as by the desire to cut oneself off from the real; judicial norms, religious dogma, political mechanisms are the fruits of intellectual understanding, but reduced to themselves they become empty signs that continue after signification has been lost; consequently, the trial is a substitute for justice. If there is one word that is devoid of meaning in *Anatomy of a Murder*, it's justice, and anyway, how could justice exist, since we will never know if Barney Quill raped Laura Manion (Lee Remick)? As a result, the film assumes an exemplary value; the system will be practiced in a vacuum, and the one who knows how to utilize it best will triumph.

* * *

And so, how can we not think of these milieus as systems of a game with laws for rules? Preminger's entire oeuvre is a mise-en-scène of the "homo ludens" concept that is so dear to Huizinga. Sometimes the boundaries are blurred and the rules soften (*Anatomy of a Murder, Bonjour Tristesse*); sometimes, on the other hand, ingenuity and

freedom practically disappear (*The Court-Martial of Billy Mitchell,*
Advise and Consent). The game proposes and propagates abstract
structures, images of closed, preserved worlds in which ideal concur-
rences may be exercised. Structures that become models for behaviors
and institutions, they are not applicable to the reality that they refute,
but constitute as many expectations for a regulated universe that
must be substituted for universal anarchy.

It would be easy to make a list of these "parlor games" or "intel-
lectual jousts"[1] in Preminger's work. Games always conjure the image
of a pure, autonomous milieu in which the law, willingly upheld by
everyone, neither favors nor injures anyone.

But ignore or overstep the rule and the drama is shattered: the
game can't be played if the laws are not respected: refuse them and
the very existence of the milieu is at stake.

* * *

For, parallel to these regimented universes, these circumscribed entities
(and the image of a circle is the Premingerian figure par excellence),
are people who, to use Francoise Sagan's expression, grant things their
"exact importance." Reduced to an irremediable solitude, they
maintain an integrity when faced with the accidents of the real, an
intransigence that does not square well with the rules of the game.
They are of a different race, that of the virtuous, of those who are still
able to devote themselves to a cause: Alexei in *A Royal Scandal,* who
dreams of saving her country, or Robert Leffingwell, who dreams
only of serving his.

Wounded characters, but bright, moved by the need to give of
themselves and ruled by a relatively rare lucidity.

The drama begins at the exact moment when they throw them-
selves into that regulated, static universe based upon narrow (Seab
Cooley), self-satisfied (Gullion in *The Court-Martial of Billy
Mitchell*) or imbecilic (Stogumber) conservatism, a world in which

1. Cards (*River of No Return, The Man with the Golden Arm, Saint Joan, Bonjour Tristesse,
Advise and Consent*), roulette (*Bonjour Tristesse*), dice (*Porgy and Bess*), hopscotch (*Saint
Joan*), fishing (*Anatomy of a Murder*), chess (*Exodus*).

any infringement upon the rules of protocol, or the mystery of ritual, would be unthinkable.

<p style="text-align:center">* * *</p>

It isn't surprising that, in this context, Preminger was drawn to Shaw's *Saint Joan*, from which he made one of his clearest films. What is it about? The court of the Dauphin (Richard Widmark), a decadent, insular world of games, struggles to preserve its existence while a young peasant dreams of resisting the invaders and crowning the Dauphin.

The incompatibility of that routine and practical intelligence with active idealism feeds a vital and fatal conflict. The mise-en-scène becomes a means of coercion, the trial an ambush, the circle a trap: increasingly narrow circles around Joan (c.f. the farandole in *Bonjour Tristesse*, the precise moment when Anne [Deborah Kerr] is "trapped"), who breaks through the first but ends at the center of a raging mob. Order will be restored, but Joan will survive it.

Through machination, Cécile (Jean Seberg) causes Anne's death; Mouche (Eleanor Parker) uses subterfuge to hold on to Frankie Maclean (Frank Sinatra) in *The Man with the Golden Arm*.

In each case, we encounter a mise-en-scène whose goal is to limit the actor's autonomy and freedom to the greatest possible degree. Is it any surprise, then, that Preminger is so often focused on the trial? Is it not by definition a mise-en-scène devoted to eliminating personal initiative, determining movements and statements in advance?

<p style="text-align:center">* * *</p>

Along with the American political system, the functioning of a government agency inevitably interests our author. *Advise and Consent*, unlike *Exodus*, presents itself as an observation, a document, a gaze pointed at a scheme that unfolds in plain sight. A scheme whose complexity and importance escapes no one, especially not Seab Cooley (Charles Laughton), its symbol and guardian, intent on exposing whomever, by disrespecting the rules, threatens the game.

There are two ways to defeat the game, either by refusing or altering its rules. That means a fix, a rigging that corrupts the game

and threatens the world that created its rules. Thus the body must eliminate the foreign element whose will is to meddle with it. Cecile must drive Anne to her death. Seab Cooley must do everything he can to keep Leffingwell (Henry Fonda) from the post of Secretary of State.

Leffingwell is blamed for being an intellectual and for never having cooperated with Congress. In effect, like Joan, he feels the need to devote himself to a cause, to occupy the post for which he is the most qualified. But he belongs to that breed of idealists who have enough perspective to judge matters clearly and visualize their transformation. To eliminate him, Cooley resorts to a machination (Gelman's testimony), knowing full well that Leffingwell will be unable to base his career on a lie.

But as is often the case with Preminger, acts have unexpected repercussions; the president's persistence affects, as if by ricochet, Senator Brigham Anderson (Don Murray) who momentarily believes he has the situation under control before he is faced with the same dilemma and chooses the same solution: renunciation rather than duplicity. As for the young Van Ackerman (George Grizzard), whose unbridled ambition drives Brig to suicide, he cannot escape being ostracized by his colleagues; his mistake is less having refused to embrace the game than having tried to exploit its rules, to break with convention for his own benefit. Because he always goes too far, because he does not know, like Cooley, how to distinguish between what is and isn't part of the game, he often seems ludicrous, reminding us of another fanatic: *Saint Joan*'s Stogumber. Finally, it is this same stance that condemns the president, guilty of having used his position to introduce an outsider, thus threatening the solidity of the edifice he represents.

His death marks an endpoint to his efforts, pitting everyone against each other and confirming Cooley's victory. As at the end of *Saint Joan*, the order remains sound, and all those who defied it have vanished.

* * *

But stemming from these themes and opening up new perspectives, one idea is of major importance: the mise-en-scène.

There is of course Cooley who, as an excellent strategist does, calculates the moment when Gelman's (Burgess Meredith) testimony

will have the greatest effect, and there is also Cécile, driving force behind a drama whose locations she determines and actors she directs.

In this respect, with *Anatomy of a Murder* Preminger produced the most complex and exceptional film of his career. This film, whose subject is neither justice nor American society but mise-en-scène itself becomes, along with Lang's final films, a creator's reflection on his art and a filmmaker's barely-disguised confession.

We have noted the resemblance between Paul Biegler (James Stewart) and Preminger himself, but this seems to us to represent not a fortuitous coincidence but a genuine self-portrait that sheds light on the film and its maker. What is Biegler's m.o.? To bend to a reality that is completely foreign to him, to fit it into the frame of a trial and "the final order that it gives to appearances," to draw from it the truth, the one he has chosen to reveal. Note that he accepted the Manion case without knowing what it was about; how can we not think of the filmmaker, for whom every film is a new adventure? To devote oneself to pre-existing material, a murder or a novel, such is the art of the lawyer or filmmaker; not to invent *ex-nihilo*, but to obtain certain effects by certain methods, in other words, to *mettre en scène*. A task that requires all the more skill and finesse when subject to the rules of an unremitting game; a tribunal has its laws (which, as Judge Weaver good-naturedly remarks, change from one State to another), which one must respect if one wants to win.

Such constraints make Biegler's final victory even more admirable; his hand was mediocre, and yet he knew how to make the most of every card, which is every great director's privilege. Much has been said about fascination apropos of Preminger, particularly since hypnotism is one of his favorite themes, but isn't it the job of every great filmmaker to fascinate?

It will be up to Biegler to make Lieutenant Manion (Ben Gazzara), Laura and Mary Pilant (Kathryn Grant) play roles for which they are unprepared. Although by crosschecks we know how violent the lieutenant really is, Biegler makes him seem calm and measured. Remember the scenes in which he literally explains his "role" to him, making him figure out the only approach he can take. As for Laura, he turns her into something she is not: a good wife, a model woman. He even directs the way she dresses, if only to produce the startling

effect of taking her hair down in open court. Finally, he must convince Mary Pilant to testify, thus to play the game.

Equally impressive is the mastery with which he measures out and calculates the effects he wants to achieve, most often through humor that renders testimonies and adversaries ridiculous, and most of all through the coup de théâtre that wins him the verdict.[2]

Because he knew how to handle the rules of the game (and the judge is always there to determine what is permitted and what is not), Biegler captured the most difficult of victories. But don't we recognize an analogous virtue in Preminger? Like his hero, he must first exercise his art on something anterior and exterior to himself (here Robert Traver's best-seller) in order for it to reach the broadest possible audience. Given the exigencies of commercial film, and of the blockbuster, he could easily have sunk into vulgarity, but his greatness (and the greatness of all of the great American filmmakers) lies in having known how to play his cards right, how to make those exigencies his themes and his film a work of art.

* * *

But where the film is most remarkable is in that meditation on mise-en-scène that we sense in it. The creation always transcends its creator, who can only control it for a moment, mark it with his imprint before watching it walk away.

We will never know the truth about Laura Manion's rape, and the protagonists of that drama remain a mystery throughout the film. For a time, they "play" a version of that drama, the one imposed on them by their director, but it is as if their underlying realities were secret, unimaginable, and yet searing. Those who find *Anatomy of a Murder* cold might be surprised to hear us describe it as moving, but ice also burns, does it not?

For Preminger's art begins where Biegler's ends; there is Laura, suddenly miserable and alone, slumped on the stairs of her trailer in

2. This coup de théâtre is Biegler's and not Preminger's, as the second cut might suggest, a version whose distributors amputated a crucial scene: Parnell's excursion to Sault-Sainte-Marie.

front of an astonished Biegler, who suddenly sees the face behind the mask; there is the lieutenant's anger in face of the revelations of his cellmate, unfeigned and almost touching; there is Parnell (Arthur O'Connell), caught between Maida (Eve Arden) and Biegler, wondering if he can give up the bottle). Moments where time seems to stop, where the truth of human beings, until now only glimpsed, suspected, erupts for several seconds, precise moments where reality displaces artifice, life displaces the game.

Biegler's undertaking, like Preminger's, is destined to fail. The actors, reunited for a few moments like checkers on a checkerboard, circumvent their roles, distance themselves from their director: The Manion couple take off without paying their legal fees, and Biegler is hardly surprised.

This neverending task is no cause for despair. Fishing, or jazz music, would no doubt be preferable, but still, there is something exultant about it. Knowing and controlling the rules of the game, defining and directing the players makes a demiurgic mark, realizes, for a few seconds, the artist's vocation.

More than anyone, Preminger has understood fugue, sensed the fleeting nature of things, the complexity of human beings and the need to control appearances in order to make them enter into abstract structures. But in a fitting reversal, he perceives the danger in substituting sign for meaning. That is the drama that fuels this magisterial work, over which hovers an acerbic, nostalgic intelligence.

(*Faces of Cinema* #2, March 1963)

LIST OF THE TEN BEST FILMS OF 1962

1. *Advise and Consent* (Otto Preminger)
2. *The Elusive Corporal*, (Jean Renoir)
3. *Hatari!* (Howard Hawks)
4. *The Four Horsemen of the Apocalypse* (Vincente Minnelli)
5. *Merrill's Marauders* (Samuel Fuller)
6. *My Life to Live* (Jean-Luc Godard)
7. *Lust* (Jacques Demy)
8. *Experiment in Terror* (Blake Edwards)

9. *King of Kings* (Nicholas Ray)
10. *Ride the High Country* (Sam Peckinpah)

(*Faces of Cinema* #2, March 1963)

FRANK AND JERRY

Frank Tashlin, *Who's Minding the Store?*

As Tashlin's oeuvre—remaining faithful to its themes—moves towards ever-increasing harshness and cruelty, we ought to think about it differently : about what it reveals rather than what it indulges. In short, we ought to speak less about America, and more about Tashlin. It remains true that America is the subject of his films. Actually, America is their foundation: each new film requires that its filmmaker rebuild what he has just demolished. And the latest in this series (the best for some time) is no exception to the rule: exemplary in its subject, rigorous in its style, troublesome in what eludes it.

Tashlin has never been a tenderheart who reflects upon an inhuman world; when he wishes to condemn its artificiality, he has resorted—in good faith—to satire and caricature. Between the moment when he went after special effects and the moment he revelled in a return to cartoons, the distance was slight and the ambiguity already sizable: if the "American Way of Life" is a caricature of life, the same goes for the satiric genre: both only exist in relation to something that is already there. Tashlin only exists through and for the monster he has pledged to demolish.

Because he goes to war with artificial weapons, he has earned only fleeting success. The vision of a mechanized world that engulfs humanity has gradually pervaded and influenced his gaze, with the difference that complicity (which formerly connected him to the world of the "comics" denounced in *Artists and Models*) is now no longer possible. Between man and machine, inventor and invention, the relationship is no longer submissive but uncertain; what machines gain in autonomy, men lose in maturity. Tashlin pursues and captures this relationship with a tireless precision that makes his cinema a

cinema of cogs in which the only thing that counts is the passage from one sequence to another.

Betrayed by his own mise-en-scène, Tashlin finds himself caught in a mechanical trap (like the one that presides over cartooning, uniquely an art of cause and effect). But it is characteristic of every machine that it can be destroyed by the very movement that understands and assimilates it. It has its laws, it is a creation of the human mind, and what has been built can itself be destroyed. The only way to escape the vicious circle that encloses the work would then be to introduce something specifically uncontrollable into that predictable world: life. Anarchic behavior, creating itself anew at every moment, a subject of the greatest discord: in short, everything that Tashlin incorporates into his work with Jerry Lewis.

The role and importance of Jerry Lewis seem even greater when their evolution—parallel to Tashlin's—intersected by reunions, like this one, allows us to identify the moment that Lewis begins to reign over Tashlin's work. The moment Tashlin gives Lewis carte blanche is also the moment he reaches the limit of his art: he cannot invent life in its most anarchic form any more than he can really direct Jerry Lewis.

Here again, within the frame of a scenario that authorizes everything and excludes nothing (the department store), the duo have a field day: Tashlin sets up the pins, Lewis knocks them down. The pins fall amidst a chaos that hardly depends on them, and that could be called poetry or fantasy. Lewis misunderstands, completely innocently, the machinery of a world in which—in spite of himself—he creates only catastrophes. An object of curiosity (at the whim of Jill St. John) because strangely anachronistic, he is handicapped by a humanity whose weaknesses (but also whose strengths) he has absorbed, a humanity he flees through mimicry, the grimace, and a scandalous expenditure of energy.

Impervious and indestructible because he is not a creation, but the incarnation of nature, a force Tashlin unchains in order to exorcise his personal hell: the hell of being subject to the thing he condemns. And so, the only positive movement is, for Tashlin, destructive: this paradox best explains his own drama of not knowing how to grasp the human, but knowing how to realize its progressive disappearance or create monstrous, animal forms (Jerry Lewis). Always a bit behind or ahead of his objective (previously seen in

warmer films such as *Artists and Models*), sometimes closer to the object and sometimes to the animal, condemned to show what alienates mankind, to caricature, to cartoon.

And so bitterness and precision triumph in this last film. Only the purity of the drawing and the implacable movement that hastens each sequence towards its climax endure. And, behind the exasperation that rises, an admission at long last of a fear of sterility (John McGiver) that lends serious resonance to this "light-hearted" film.

(*Cahiers du Cinéma* #166–167, May–June 1965)

Mario Bava, *The Road to Fort Alamo* (*La strada per Fort Alamo*).

After his Scandivanian epic (*Erik the Conqueror*), Mario Bava, under the pseudonym of John Old, has moved on to the epic Western. What strikes those unfortunate enough to see this film is its desire for authenticity at all costs, its efforts to make us forget the artifice of the endeavor. Tiny details succeed, but cannot make up for a non-existent whole. And so, preoccupied with exteriors, the peplum and the Western coexist, but in a picture that is folkloric and shallow. If the map was made for the Union army, the territory has been covered in thousands of pepla. Nothing comes from this discrepancy, which is scandalous, and proves that Bava believes less and less in what he is doing.

(*Cahiers du Cinéma* #166–167, May–June 1965)

R.G. Springsteen, *Taggart.*

A story of vendettas and scores needing settling. We could mention the presence of several old themes that are dear to Springsteen (adventure, the Indians, gold mining). But honesty compels us to admit that these cannot save the film from a tedious and predictable monotony from which the beauty of a landscape, on occasion, emerges.

(*Cahiers du Cinéma* #168, June 1965)

Burt Kennedy, *The Rounders.*

The adventures and misadventures of Fonda, a horse, and Glenn Ford. This second film from Burt Kennedy illustrates the alternative that the Western currently faces. Either respect its traditional laws and devices, seize them in the interest of personal concerns (Peckinpah: *Major Dundee*, Daves: *Spencer Mountain*), or cast a cold and documentary gaze over what remains of the mythology of the West. That is what Burt Kennedy does here; he tells the story of two horse trainers, already anachronistic and displaced. But if their lives, their loves, their ambitions have something vain and ridiculous about them, it is not due to any complacency or histrionics on the filmmaker's part. On the contrary: where we expect emotional evocation or ironic parody, we are only invited to witness certain routine mundane gestures. No glorious past or future promise: simply men struggling with the haziness and inconsistencies of life. The strange distinction of Kennedy's film is that it has taken that void as its subject.

(*Cahiers du Cinéma* #169, August 1965)

THE GREATEST CONSPIRACY

Claude Chabrol, *Our Agent Tiger* (*Le Tigre se parfume à la dynamite*).

A film that was commissioned, filmed haphazardly, without chagrin but also without conviction, *Le Tigre se parfume à la dynamite* illustrates (in spite of itself?) Chabrol's singular fidelity to style. Even when he would like to be anonymous and commercial, far from his dreams and familiar demons, he *signs* his films, through caricature and wanton delirium.

And yet...caricature is for Chabrol—this, we know—something more than a way of making an impression, a tool of persuasion, an ability to be bold. If he manages to do all of these things, it's still not enough to create great films or to make him an author. Caricature is also when a perspectival flaw or a fault of the soul forms and deforms. Thus it makes room for all kinds of mistakes: false perspectives,

illusions that ought to be abandoned, prejudices that come at a great cost, shameful ignorance: everything Chabrol loves and condemns, everything that poisons the world, suddenly too beautiful, too exposed, too docile...

The advantage of "commercial" films such as *Tiger* is their ability to play, recklessly, that game that is the essence of the genre, and then end up at the purest and most unnecessary kind of madness (causes and effects endlessly linked but arbitrarily combined into one, which makes these films the very opposite of Hitchcock's). What the serious films tell us (*Les Bonnes Femmes* of course, but also the most over-looked: *Ophélia* and *The Third Lover*) is repeated by *Tiger* and *Blue Panther*: never has the surface of things been so empty and celebrated for its own sake, except when it has been celebrated only because it is empty—and false.

Impossible to capture life at its source. If there is a witness, there is a performance: every gesture then fundamentally becomes a portrayal, a revised and corrected version of life from which the mistakes and hesitations have been erased. Albin Mercier, because it's his vice, the *Tiger*, because it's his profession, always arrives *too late*. Too late to see things come into being, just in time to find in their place those too-beautiful harmonies that seem to have been arranged just for them, carnivorous plants that will engulf them if they don't uncover the conspiracy in time. There is always a con-spiracy in Chabrol's films, sometimes fabricated and unrealistic but always dramatic: Doctor Kha and the Orchid are its latest illustrations, the least veiled and the most banal. Between illusion and the return to clarity, there was until now an abrupt, tragic movement of recoil. *Ophelia's* hero measured the enormity of his error in an instant, like in those stories of Maupassant where the final sentence negates everything that came before. Between the witnessing and the per-formance that it "secreted," the thread suddenly made visible breaks and finally separates them, returning the witness to his regrets, the performance to its banality.

Our Agent Tiger says nothing new, but says it more rapidly. Now the movement of retreat that had been the drama, the painful neces-sity of the earlier films, disappears. Quite simply, each shot must contain the indication of its deceit, the proof of its inauthenticity

within itself. It need only be too beautiful, too calm; a too-precious framing reminds us of a postcard, or a shot seems like a déjà vu (for in fact, everything that the spectator sees has most often already been seen by a character outside the frame, and so must bear the traces of that gaze).

Which means that the film is a pure exercise in style, less effective than *Blue Panther* because it wants to move more quickly and seduce us less. In this world of genuine but ridiculous conspiracies (the same, when all is said and done, as the world of imaginary but murderous conspiracies), *every shot must expose itself.* For, in the end, the filmmaker has the right to consider cinema as the original conspiracy.

(*Cahiers du Cinéma* #173, December 1965)

WOODEN NATALIE [NATALIE DE BOIS]

Richard Quine, *Sex and the Single Girl.*

Richard Quine likes games of smoke and mirrors. He's at his best in them, even if his characters get a little lost, wind up not knowing exactly where they are, verge on tragedy before being saved at the last minute by their creator, a filmmaker as tender and vulnerable as they are. His latest films tell more or less the same story, and *Sex and the Single Girl* is just another version—neither much different nor more accomplished—of a situation whose possibilities he painstakingly explores.

Quine's scripts revolve around the same problem: how to reconcile professional work, an occupation, with the demands of a personal life? A pretext for sociological analysis (once again, of the "American way of life," maladjustment, etc.), all things that *Sex and the Single Girl* seems by its subject to include but are not, all told, its gist. For Quine always chooses occupations for his characters that are at the edge of artistic creation, when they do not directly concern it. Let's review: an architect (Kirk Douglas in *Strangers When We Meet*), a painter (Holden in *The World of Suzie Wong*), a screenwriter (Holden

in *Paris When It Sizzles*), and most recently, a cartoonist (Jack Lemmon in *How to Murder Your Wife*) followed by a "writer" (albeit a scientific one) in *Sex and the Single Girl*.

What counts—and this is why Quine at times feels so close to us—is the excessive weakness of his characters: they are too perceptive, too sensitive to adapt to the world that surrounds them, but also too determined to abandon it completely, to renounce the comfort of its seductive appearances. And so they pass ceaselessly from one to the other, always between two poles, between two exigencies: work to accomplish, work that, once completed, once it becomes official, external, will only betray them, and an intimate, secret life...

Sex and the Single Girl presents itself as a commentary of, a possible sequel to the book. Its subject is what might happen to the author of the book (a trendy best-seller) once the book has been published and given that its author is a beautiful young woman. Paradoxical situation, that the film, far from being an adaptation of the book, is instead a consideration of its own fate and the fate of its author. When the film begins, everyone is reading, has read or will read the book and, of course, wonders, "What about the author? What experience (or lack of experience, hence the French title) has she had to speak so decisively about sexual problems?" Once again, her professional activity cannot be separated from her personal life: everyone can see the threads that connect them and Quine excels in emphasizing them. That is how Helen Gurley Brown (the author of the book on which the film is based but also—in the guise of Natalie Wood—the heroine of the film) experiences it, a slightly cruel experience (but only slightly...) that will otherwise end well.

Richard Quine's films would probably be less exciting but more successful if their author shared his characters' hesitations and fears to a lesser degree. His are minor successes that concern major subjects. Not that Quine ignores the value of the subjects and situations he depicts, but he fails to meet their demands, whose seriousness he can only approach without ever really being able to confront. *Sex and the Single Girl* has the same limits, the same merits: a subject that could have made for an outstanding film, a style, a touch that makes it enjoyable and occasionally moving. Perhaps Quine has become more nervous, less lyrical since he made his masterpieces (*Bell, Book*

and Candle and *Strangers When We Meet*). In these, we saw what has always been the price of his art: a sweet melancholy, a way of suddenly rendering visible something we thought was impossible to catch: the intimacy between two people, the space that connects them and in which they reverberate... There is one strange and painfully nostalgic scene in *Sex and the Single Girl*: the one where Lauren Bacall and Fonda dance slowly, with tears in their eyes...

(*Cahiers du Cinéma* #173, December 1965)

NOTHING, AGAINST A BACKGROUND OF SOFT MUSIC

Jerry Lewis, *The Family Jewels.*

There is a scene in *The Family Jewels* where we see a man disown the costumes that define him, reject his disguises, challenge his enslavement to them once and for all. It is, of course, Uncle Everett, the clown, who knows that a public entertainer is no more a real man than a mask is an actual face. Lewis must have secretly enjoyed creating this character, who was thought *a priori* to be so similar, unlikeable, even obnoxious. But how is he different? Quite simply, Everett is less committed to his creation than Lewis: he is less compromised by his double.

As time goes on, Lewis departs from his persona more and more. *The Family Jewels* is about his present situation, his chances for survival. Another few years and that persona will become, with age, impossible and ridiculous. Before that happens, he absolutely must become himself again, distance himself from the mask. In *The Patsy*, Lewis, sure of his "happy ending," made the rounds of what he needed to do to earn it. That film turned towards the past. The future is *The Family Jewels'* concern.

We are skidding towards a new world. Strangely, it is *our* world, at once futile and familiar; Lewis ventures forth, still awkward, wondering if life is possible there. *The Family Jewels* is Lewis's return to the land of men, no longer in front of but among them. It is a serious film because the actor has never been so unsure of himself,

so threatened: he rejects artifice, makeup, magic, he appears as he is and for what he is, he runs the risk of becoming unrecognizable… For Willard is a completely normal man, who resembles every man, even Jerry Lewis…

These are difficult, hesitant beginnings: he hasn't yet cut all ties with the past. The mask at times resists and plays some of its old tricks (the service station sequence). But these are quotations, references to a universe that must be transcended, concessions to an audience that mustn't be too brutalized. Halfway between the old and the new, Lewis must, as much for himself as for his myth, change his skin without changing his audience.

The Family Jewels will be the site of that metamorphosis. Because there are two competing Lewises, there will also be two films, two audiences. And the "adult" audience—seeking caricatures—will be satisfied by six ineffable uncles, six Lewises, six bravura performances. Empty cast-offs intended for a public who expects them. For the real film plays out elsewhere, far from the grimaces and distortions, between the real Lewis (Willard) and the real audience (Donna). That is the real film, which is also the most beautiful, the most novel, the most moving. The more mundane and insignificant the dialogue and action is between Donna and Willard, the more serious the film becomes; the fewer things happen, the richer it is. And we begin to dream of the masterpiece that Lewis (and only Lewis) could make by filming nothing, or nearly nothing, against soft background music… The greatest simplicity, the ultimate discovery, invisible to everyone else, can only be understood by a child. By inventing the character of Donna, Lewis confirms what he has always said: only children understand him, because to them, unconcerned with second degrees, he doesn't pretend to be, he *is*. If Donna is the ideal audience, it is because she can't imagine the possibility of game-playing or deceit. Which also makes *The Family Jewels* a very simple parable (and above all, a plea). The audience is presented with different versions of the same man and asked to choose between them, while keeping in mind that the future rests on this decisive choice… Yet the audience is underestimated, for these are only monsters, albeit full of good will, too preoccupied with themselves to really think of their audience. It isn't fooled, and chooses the only figure not wearing a mask and who,

for that very reason, is out of the running. Scandal in the world of show business, but they will be defeated.

The masks collapse, the face triumphs in the end. But there is one small detail: Willard only wins over his audience on the condition that he deny himself, at least for a moment (but this is a vital moment), by making himself up as a clown. He is not yet entirely saved from that curse. To win over his audience completely, he must continue to play the fool a little, more out of necessity than vocation. This small concession doesn't bother Willard: tomorrow belongs to him…

<div align="right">(Cahiers du Cinéma #175, February 1966)</div>

FOREIGN BODIES

Blake Edwards, *The Great Race.*

A relatively disappointing film, *The Great Race* is nevertheless one that Blake Edwards dreamt of making for years, the pure cartoon that his previous films foreshadowed. Was he wrong to strive increasingly towards the cartoonish? *The Great Race*'s absurd gamble is the end of the road travelled by *The Pink Panther* and *A Shot in the Dark*. Sometimes, a false notion only reveals itself after it has allowed certain truths to come to light. We found those truths in the world that sprung to life before our eyes, with its fauna and its logic, simultaneously tender and uptight, in the two films starring Peter Sellers. But *The Great Race*, at once an accomplishment and a failure, illustrates that certain things only succeed as hints, double-entendres, implications, without Cinerama's assistance.

A director casts his net, more certain of the waiting than the catch. Blake Edwards's films thrive on one small, insidious question: how do people react? A mise-en-scène creates a condition: wait for a mellow drunkenness, a subtle distraction to open the doors to strangeness, maybe even, with a bit of luck, madness… Drunkenness plays an important role in Edwards's films (*Breakfast at Tiffany*'s and of course *Days of Wine and Roses*). It doesn't hasten, doesn't precipitate anything: it forms and deforms, slowly. Those who indulge in or

surrender to it don't lose themselves, but their shyness suddenly turns to humor, their irony clarity, their poise choreography. The filmmaker doesn't rush anyone, either: he knows that there will always be a privileged time and place where the unthinkable becomes possible and the impossible familiar. How, then, do people react? With gags, strange confessions, and gentle yearning...

Enter Edwards's famous wickedness. We owe him the tenderest films and the subtlest melodramas. All he had to do was nudge his fast-talking, vulnerable, slightly spineless characters (always the same, brilliant and bland: Curtis, Lemmon, Niven...) and observe their reactions. There are gags in sorrow, too, sometimes even to alleviate the suffering. But it seems more and more that there have been two veins in Edwards's work. And always the same question: how do people react? We know that this is, also, the essence of cartooning. Of course, that requires less tenderness, and more engineering. No doubt Edwards tried to save himself from a slightly self-satisfied melancholy, a cumbersome timidity: he just had to return to his work, but exaggerate the drawing, broaden the traits, tighten up the contours. Give his characters, instead of a colorless life to lead, a role to play and, in the end, a symbol to embody. At first, there was Clouseau. But he was still too human, too close to the filmmaker. Edwards needed the anonymity, the inconsistency of Leslie in *The Great Race*, dressed all in white, to represent the Good. Edwards, logical, simplifies to excess, erases and caricatures. Does cinema benefit? The answer lies on the other side of a detour, a detour that passes through the cartoon and its virtues.

Each and every week, with each and every new drawing, all year long, the cartoonist Copi presents the same character. A fractious but simple woman, with straight hair, sitting facing an empty space that becomes the stage for all sorts of incidents, each one more unthinkable than the last. Mind on alert, eyes straight ahead, there she sits, waiting to be ridiculed, wronged, overwhelmed... In the long run, her simple presence, her persistence in *being there* is enough to make us smile. Each week, with each new test, she discovers a little bit of our world: gestures, words, rationalizations, bribes that ultimately shape her experience, envelop her in what should really be called her "character," for she has one, and it is indomitable...

The pleasure of the cartoon: the mind that knows it will be surprised wonders how it will be done, then revels in knowing that it has for a moment been outdone. The unexpected always arrives, and in a more specific landscape every day; each adventure leaves an irrefutable mark. All the life—contradictory, complex—that seemed to have been denied to that crudely-drawn character (with just a few strokes of the pen) comes to greet her. And one day, the cartoon no longer has to be funny, effective, or understandable, for it has nothing more to prove, and even less to define; our complicity gives it life and makes us laugh, once again. At the end of the year, Copi (and we could also include Jules Feiffer or Don Martin) has invented not a cartoon but rather a world, just as opaque, demented and obscure as our own. Meaning (and this is the moral of this digression) that through repetition, the cartoon (or comic strip) acquires something it at first did not possess: *weight*, and so it rejoins the thing whose mission it was to simplify: life.

Life is exactly what Leslie and Fate have *a priori*, what they can't manage to forget. And yet Edwards, who has always loved lightness and ease in his characters, this time prefers them to be flat and unsubstantial, reduced to their outfits, less important than their colors, their costumes, their equipment. Obediently, they try to exist as minimally as possible, and their clunky and laborious race around the world mostly seems designed to prove that, in fact, there will be no surprises (with the exception of a few digressions and unexpected, fortunate encounters, such as the episode in central Europe, the duel, etc.).

Blake Edwards ultimately dreams of a world that has lost all substance, of weightless characters, eluding gravity, the dimensions of their world having become the frame of a gigantic cartoon. The lure that was the prize of his previous films ruins *The Great Race* by becoming its premise. It is easy to see how Copi's characters acquire the density they lack, but difficult to understand how Leslie and Fate could renounce their faces, their too-human expressions, their too-heavy bodies. In *The Great Race*—and this is exactly what Cinerama underlines and exposes at all times—despite all of their good intentions, Leslie and Fate are Curtis and Lemmon first, and the heroine Natalie Wood. And so everything that should be ignored

is more visible than ever before: the wrinkles of one, the hamming of the other, the vulgarity of the third, each encumbered by the body, that entropic life, which remains the cinema's primary material.

(*Cahiers du Cinéma* #175, February 1966)

POWER IN TATTERS

Roberto Rossellini, *The Taking of Power by Louis XIV* (*La prise de pouvoir par Louis XIV*).

1. To Montesquieu, who preferred to skip intermediary ideas, Rossellini might have replied (ten years ago) that those are the only ones that exist. Mise-en-scène didn't interest him. Why prove what one already knows, and why prove it quickly? The cinema that interests him (but we should be speaking in the past tense) isn't about effects to achieve but effects to anticipate. More humility enters into it, and at the same time, hubris: the certainty that it is correct to wait. Rossellini first proved the beauty and virtues of patience. There was hardly any mise-en-scène, at the most a *mise-en-présence*. Why organize, domesticate the space, designate a frame, unleash the actors within it and catch—as if by chance—their most intimate reactions, when every reaction is intimate? The "as if by chance" defines an entire kind of cinema, Cukor, Losey, etc., that moves from modesty to hypocrisy. For Rossellini, there is no modesty; the simple fact of filming is a violation and the rest (Anna Magnani's cadaver with her skirt hiked up, Francis kissing a leper, the sweat on a disfigured face) is literature. He is one of those filmmakers who reminds us that to accept cinema is to accept a certain way of being ignoble, meaning not being "noble." It's what McCarey (*Satan Never Sleeps*), Gance (*Blind Venus*) or Kazan (*America America*) also knew: it all always comes down to spectacle. A voyeur only justifies himself by assigning to what he sees (what he glimpses) the highest importance, the most indisputable seriousness. A voyeur who ridicules what he sees is unserious, and negates himself. Rossellini has kept watch, spied, waited, hoped, and scored: there is a miracle, tears on the edge

of a volcano and a declaration of love at the end of a trip to Italy. It's a beautiful story: Rossellini was already among the greatest.

2. To wait, reserve judgment, take everything seriously (no film-maker has been stripped of a sense of humor to such a degree), to see in every detail the reflection of the whole, in every gesture a sign of the times, at every moment the announcement of something infinitely devastating that the simple practice of mise-en-scène cannot approach. We know the result: everything is provisionally (and maybe permanently) located in the same shot, and judgment is suspended. Rossellini watches and asks us to watch: understanding is limited, judging is treasonous, for the final word is never spoken, the end point never reached. Everything is tied to the infinite, endlessly connected, evil is on the path to the good, error leads to truth, and vice versa. When we watch a Rossellini film, we know (or rather we feel) that if the screen were suddenly enlarged, we would see things that only its exiguity had kept us from seeing until then. We could never feel that way while watching a Lang film (except, maybe, *Man Hunt*). In other words, what has been filmed continues—in a clandestine way—to encircle, to influence what was filmed. The cinema is returned to its true place, rediscovers its highest function: it doesn't prove, it doesn't prioritize, it allows us to see. It's the opening shot of *Sansho the Bailiff*: the camera just happens to be there and the characters take a detour to pass in front of it. Or: the uselessness of framing. Wait, keep a watchful eye, experience miracles... There is something submissive, passive, that leads to the greatest risks. Flaubert's familiar phrase: if you look at a wall long enough... But how can the voyeur intervene without immediately becoming the director? We know that Rossellini doesn't want that: he is one of those filmmakers who, sooner or later, ends up not shooting their films. On his end, the voyeur is humble: he does not intervene but always makes a critical wager: that something will actually happen. His suffering begins when he is unable to determine the correct moment to withdraw, to shy away from the fascination of the spectacle. Anything could happen, one event follows another, acts accumulate upon acts, and nothing is alike, life is riddled with contradictions, only the unexpected occurs, etc. And so he must reach the end of his gaze, accept not understanding, hold to his wager until the moment when something is

produced that justifies waiting for so long. From this comes Rossellini's so-called "religious" films: there is no reason that life shouldn't contradict itself, and only a higher intervention can give it meaning, even a temporary one. We agree to call it "grace" and, while waiting for it to manifest, the glance of a cow is as valuable as that of a beautiful woman, traitors are not inferior to heroes (they are often the same) and a simple mind is as important as a superior intellect. Life gathers evidence in a case: one would like to adjudicate it, but Rossellini asks that we wait a while and God (or attrition, fatigue, extreme restlessness) states what is.

3. For the voyeur (and every filmmaker is a bit of a voyeur, by definition) everything is serious, everything is foreshadowing. The most trivial gesture, the most innocent glance takes place on a path, and the poorly paved spots lead somewhere, too. The voyeur must accept everything or change his profession. Rossellini first convinced us that everything in our world was a sign, but added that we had lost the code. It's what he continually illustrated: that his characters' motives were incomprehensible and that only the incomprehensible happened: that a child committed suicide, that a woman believed herself pregnant by Saint Joseph (she was wrong but those who condemned her were not right), etc. And there's more: every mode of being is a ritual whose meaning has been lost: the gestures (although the simplest) of the "Fioretti" monks are thoroughly foreign to us...

Signs but no meaning, footprints but an uncertain path. Man at first feels, then would like to understand, translate, have the final word. Rossellini is a little like this man: at first he was the most sensual of filmmakers, and today, without having betrayed himself, he is the most intellectual, or he is at least fascinated by ideas, by their power of incarnation, by their power full stop. Some works advance via disavowal; Rossellini (marked by his astrological sign of tenacity, Taurus) advances via addition. Rossellini's work reminds us of a tower whose foundations initially had to be excavated, in anguish and obscurity, amid mud and filth, with the vague hope (the gamble) that there would one day be a summit. Rossellini has reached the summit of the tower: there he discovers that his personal problems (what are also called obsessions, themes, etc.) mean nothing next to

the panorama he sees and that overarching gaze in which things finally assume their true place, and he, at the center of it, passing from the territory to the map. Mystification is finite, waiting is no longer relevant; replacing feelings with corresponding ideas is enough.

4. To travel the opposite path, to pass from the idea to the sentiment, to embody, to demonstrate, to teach: everything that Rossellini once disdained has now become his cinema, undoubtedly less personal because he moved from the particular to the general, from immodesty to distance, and because he understood that there were only general problems (an approach that Godard takes, but by skipping steps). Certainly, his first attempts are not entirely convincing: *India* is a sketch, admirable in places, and *The Iron Age* is boring. Rossellini can't really talk about current affairs (and yet they are the only issues that fascinate him). The past suits him better, where understanding is easier and the stakes less high. Hence the past is the ideal frame: *Vanina Vanini* was a rough draft, *The Taking of Power* the final...

Why Louis XIV? Precisely because of signs. If Rossellini resisted the mise-en-scène so much, it's because it is a language (so little but already too much) and life is already the most complex of languages. What he previously proposed to our fascinated gaze he now presents to our intellect. He no longer thinks the code is lost; he retrieves the letters. Of course, he isn't sure of being entirely right: one may think otherwise about Louis XIV, but the hope of understanding persists, along with the right to judge, to interpret. Unexpected reconciliation with Montesquieu: R.R. skips the intermediary ideas because he knows where he is going. He has always filmed mises en scène (ceremonies, mysterious rituals where there can be no question of judgment); now he films the etiquette of Versailles and hazards an explanation. Where is humility, patience, the awaiting of the world? We witness the passage from religion to politics, from the ineffable to the precise (But it goes without saying that politics was always there in the background and we can see in *Fioretti* a beautiful film on efficacy and its means).

5. Apropros of politics, some are up in arms over the filmmaker's noticeable attraction to an absolute monarch, to a Sun King. This is true, but of no real importance. First of all, apprenticeship is a beautiful subject, there can be no argument there. Next, the film advances

a thesis that, far from flaunting the opulence of the kingdom, explains it and, in doing so, strips it of any power to fascinate. Ten years ago, Rossellini would perhaps have centered a film around Versailles and the spectacle of the court; today, he shows both sides. During the (extremely beautiful) costume-fitting sequence, Louis XIV becomes aware of the political role of a certain ritual, of a set of signs for which it will become the sole justification. In that sense, one could say that this film is to Rossellini's oeuvre what criticism is to a film: it sheds light on what was previously implicit, speaks about what had been kept silent. No filmmaker has achieved such awareness of his art. It is no longer a matter of experiencing the etiquette's spectacle but under-standing it: it is about neutralizing the nobility that was still dangerous after the Fronde by compelling it to live on parasitically at Versailles, by forcing it into ruin and hence making it lose all political consciousness. The real politics, the kind whose effects cannot be filmed, whose work is invisible, are entirely in Colbert's extended tirade that exposes his agenda. Anyone who wants to know more need only read a good history book on the subject. As for the king, his role is at once very simple, slightly stupid and yet essential: he flaunts him-self (without any particular inclination or talent) so that no one will be able to stop looking at him. He is there to put up a front. Mean-while, Colbert and several others make France into a modern country. The king enjoys a domain in which he is without rival, the domain of the mise-en-scène. But, as we all know, that is a futile thing.

(*Cahiers du Cinéma* #186, January 1967)

Leslie Stevens, *Incubus*.

Father Sinistrari is definitive: "Incubii have no fear of exorcisms, no veneration for sacred objects; they are hardly frightened by their approach." (*On the Demoniality of Incubi and Succubi*, p. 20.). Thus Leslie Stevens's film has only a limited documentary value. And yet for that very reason it could have been captivating and truly original. What remains is two films in one—with none of *Private Property*'s charms—a parable and a horror film, both failures. Either the

camera seems to disengage from what it presents, or it obscenely clings to its subjects. As if Stevens had persistently sought out an ideal position, without ever finding it. Consequently, the film's occasional charms do a disservice to the whole and the film is far less than the sum of its charms. Lastly, it perhaps has this trait, common to every film that deals with the Unknowable or the Strange: the final triumph of the forces of light comes only from our powerlessness to adequately imagine darkness.

<div align="right">(Cahiers du Cinéma #186, January 1967)</div>

THE END OF ETERNITY

Wojciech Has, *The Saragossa Manuscript* (*Rekopis znaleziony w Saragosie*).

"Death (its allusion) makes men precious and pathetic. They move us because of their phantom condition. Every act may be their last, and every face is on the verge of dissolving like the face of a dream. Everything among the mortals has the value of the irretrievable and perilous. Among the Immortals, on the other hand, every act (and every thought) is the echo of those that preceded it in the past, without visible origin, or the faithful presage of others who will repeat it in the future to a vertiginous degree." —J.L. Borges[1]

Wojciech J. Has has tried to capture this "vertigo." We know what comes next: overlapping narratives, paramnesia, eternal returns, gardens with bifurcating paths, eroticism, etc. Thus from narrative to narrative, *The Saragossa Manuscript* amazes and then bores us a little. (But it is true that this boredom is accompanied by a certain fascination and a jubilation—effortless—of the spirit.)

1. The film's failure is first a matter of distances. It is out of the question for Has to be overcome by the vertigo he is attempting to

1. Adapted from James Irby's translation in the New Directions edition of Borges's *Labyrinths*, 1964.

reflect; he maintains an elegant and ironic detachment from narrative to narrative, neither too close nor too far away from his hero, just as the latter endures his misadventures without passion but not without curiosity. Elegance: the character's useless gestures are accompanied by complex but gratuitous camera movements. Irony: the time has come to identify it as a Polish constant: the love of gags, the taste for the ridiculous, the sense of fastidious observation (in Skolimowski, Polanski, Munk, or Gombrowicz, who summarizes and surpasses them all).

2. It is next a question of principles. During the meal served by the Kabbalist, a scholar (who, curiously, refers to Quevedo) remarks that the infinite can be defined without being understood (Paulhan: the thing that allows us to understand all numbers is a number we don't understand). Borges observes that the concept of the infinite corrupts every other concept. We could add that it is necessarily superior to, and stronger than anything (be it tale, testimony, or film) that tends to manifest it, comment on it, or embody it. What good is depicting the idea of the eternal return? You doom yourself to a handful of repetitions, then points of suspension… Dull, boring, and gratuitous repetitions, after the first surprise. And how can that boredom, that gratuitousness not jeopardize the film itself? Wojciech Has, an artificial and certainly minor filmmaker, has succeeded in making a gratuitous film about gratuitousness; meaning that he has failed. Any film about futility should be serious and rigorous. ([Resnais's] *The War Is Over*).

3. The pathetic, the hazardous, the lost cause: it is because we could die at any moment that art becomes possible. Death bestows gravity and importance upon the thing it surrounds (life), and the camera's frame operates much in the same way on the shot it contains. What it limits becomes perilous (because a lack of time—of space—forces us to choose). What is not limited—hence infinite—is irrelevant. If there is no more choice, then there is no more risk of error; if you have all the time in the world, art disappears. In a remarkable novel, Isaac Asimov imagines an "experimental" reality that is only a possible version of the real, an ongoing experience organized remotely by a superior society, the Manipulators of Time, who exist outside of time and space. One experience can always be cancelled, replaced by another. Reality is one experience, sometimes a

mistake, sometimes a success. Consequently, man's choice no longer signifies, and his art only slightly more so (cf. W.J. Has).

(*Cahiers du Cinéma* #187, February 1967)

CERTAIN DEATH, OR, IN PRAISE OF GEOGRAPHY

Jean-Daniel Pollet, *The Horla* (*Le Horla*).

1. *Love of geography*. Consider the example—often cited as a source of scandal—of those people who set out on a journey to the end of night with a book under their arm (a tourist guide or personal diary). Those for whom the real is a promised land, something concrete that must be conquered, and for whom every film is a kind of journey, an eternal push and pull between ideas and feelings, the territory and the map. Travel filmmakers, travelers themselves, always in the heat of final preparations, itineraries, and new beginnings (straight away, we could reference an entire swath of young French filmmakers: Rohmer, Resnais, Demy, Rouch and, as it happens, Jean-Daniel Pollet).

Their cinema is like the performance—in slow-motion—of a body diving into water (What else would we expect from a film-maker? This ranges from *The Human Pyramid*'s remarkable prologue to the most recent Robbe-Grillet, which is its anodyne caricature). A body that will dive into the water knowing every-thing there is to know about the temperature of the water, the height of the diving board, and the art of swimming. Despite his knowledge, we often see him drown; life's slightest gesture is enough to overwhelm him, to render every precaution useless and the realities to embrace ever more rugged. But we know that great travelers only ever make their preparations for the pleasure of seeing their plans thwarted. Open to any and all surprises, ready for any chance occurrence as part of the experience.

"Men of risk and daring navigation": no departures without baggage, no travels without a diary, no experience without a private journal, no film without an idea—or a prejudice—to begin with. Filmmakers who endlessly rediscover America while looking for the

East Indies, but who would have discovered nothing without that setback, and who, once they realize that, always prepare their "next mistake" while leaving it up to life to put everything back in order, or disorder, and to create, in so doing, their cinema.

2. *Waiting, forgetting.* Jean-Daniel Pollet is thus someone who cannot intervene. He seems to be always warning us that what he is filming is not his oeuvre; he would be the most surprised of all if that were the case. He would rather be the beauty's cantor and not its creator. The temporality—infinite suspension—of his films is not an artistic effect but rather like a law of nature, a slightly occult law that demands a waiting period before things speak. Pollet's camera is a microscope that never stops focusing. It allows things to speak, even when withdrawn into their silence, it is about allowing them to live even if they are worn away, corrupted by time... For that is the tragedy: that truth and death are both a matter of time. To move towards one is to be conquered by the other. It's with time that the gaze grows more true; it's with time that the object of the gaze rots. The filmmaker becomes someone who renders the weight of life through the certainty of death. Pollet would then be a filmmaker of the inexorable: everything moves towards a great void that is death and life only really begins in view of that gulf. Art, cinema, then consists in rushing towards it in slow motion. The real is a perishable commodity...

What wears away, what ends, endlessly... Pollet is the filmmaker of the final moments "before..." He films between the death sentence and the death. Everything is deferred, agony imminent, the last word before the great silence. Making a film consequently involves stalling for a little while, delaying the exit: but without any grand illusions, since only what must happen, happens. We were speaking of voyages, and here is the most serious of them all: it's always about the seriousness of departures, of final poses (even in the case of a clearly satirical film like *Rue Saint-Denis*). What's essential is to die of one's death, of the thing that has been secreted like a venom one's whole life. Nothing in common here with death according to Godard, a banal and insipid accident, terrifying because it cannot be believed. We should instead cite Rilke: "Back then, we knew—or perhaps only suspected—that we contained our death as a fruit

contains its stone." And so every wave breaks and dies on the sand according to its own design. All that matters is to imagine the future cadaver underneath the barely-present body (that is why Pollet used Françoise Hardy in *Devil at My Heels*), the rictus beneath the smile. Out pours an art that is morbid and pure, echoing Astruc (*Évariste Galois*), Zurlini (*Family Diary*), or even Ludwig (*The Gun Hawk*): a cinema of movement's decomposition, and the decomposition of bodies when the camera makes love with cadavers…

3. *The last men.* Later on, Rilke writes: "You have your death, and the awareness of it gives you a singular dignity, a quiet honor." Pollet's characters are (young) solitary men. They know they will eventually disappear, and they are all the more captivating because of it. We must always accept that they have a private, hidden life, one that they conceal out of shyness or withhold out of pride. But they profit from the credit that every man enjoys in the face of death (c.f. Genet). The camera can go no further than their faces and they can go no further than their silence; if they speak (*Le Horla*) it is only to contradict themselves so much that things become confused. What makes them act (*As Long as You Get Drunk…*), run, or desperately struggle (*Le Horla*) is their concern. The filmmaker (and hence the audience) knows nothing more.

They remind us a bit of that character in *Johnny Guitar* who, when mortally wounded, sadly remarks that it's the first time anyone has ever paid attention to him. So much so that we are allowed to doubt them and their secrets. Are they chewing up the scenery, are they empty and hollow (but what is hollow is deep), concerned only with "expiring beautifully" after an elegant decline, a photogenic decadence? They would then have the courage of cowards: tirelessly preparing for their disappearance, constantly talking about journeys without ever really going anywhere…

In a story (aptly entitled *The Secret*), one of Jun'ichirō Tanizaki's characters confesses: "And I designed the idea that by simply slipping away from the world and creating an artificial secret for myself, I could give my life a certain romantic note of mystery." This deception isn't much different: the actors agree to pose, the filmmaker agrees not to question them. They are there to be filmed, not understood. It is understood that under these conditions the camera has

nothing to add, for it is the first witness, hence the first accomplice. As for Pollet's characters, they like to consider themselves the "last men": Francisco's death is the death of Montelepre, hence the end of a world. Terzieff's madness is the arrival of Horla, hence the disappearance of man. Death is, as we see, their best alibi.

4. *Stones.* But what about civilizations? We know that they are mortal. Pollet confirms that they are dead: walking along the Mediterranean, he sees only ruins and ashes. Signs whose meaning has been lost and all the better, for the secret that matters is the one brought to the grave and the reliable witness the one who is always there, who stays silent. Pollet films stones as he films men, perhaps with greater fervor. It is difficult to impose silence on a man; it is difficult to make a stone speak. This is where Pollet seems most gifted (*Bassal*). Men like to chatter: indulge, emote, endlessly comment... Men are perhaps—c.f. *Le Horla*—only an accident of landscape, deeply imperfect, vulnerable and transient, handsome if they stay silent, irritating if they justify themselves...

Would it be cynical to claim that stones are superior to men? It would be utterly scandalous. For they are also, as we know, simply accidents of landscape on the traveller's path. Because of them, we can, with impunity, think about something else.

<div align="center">(Cahiers du Cinéma #188, March 1967)</div>

FLEISCHER'S PARADOXES

Richard Fleischer, *Fantastic Voyage.*

An auteur without an oeuvre. Richard Fleischer's films reach us in a strange way. We like them individually, but look down on them as a whole. Is there an oeuvre there, or even an auteur? If so, how do we explain that no one has ever noticed? Do we conclude that *Twenty Leagues Under the Sea, The Girl in the Red Velvet Swing, Bandido, The Vikings, Between Heaven and Hell* or *Barrabas* were a series of flukes, of happy accidents? That's unlikely. Fleischer's situation is therefore unclear: neither an artisan nor an author, rediscovered and forgotten

at regular intervals, compelled, finally, to attempt his own vindication (*Cahiers* #186), Fleischer is a filmmaker who has created films without creating an oeuvre.

Themes without an auteur. Second paradox: Fleischer is not an auteur but he always talks about the same thing. Namely: systems of justice, the reassignment of punishment and reward, and the powers of intelligence. It's all moral dilemmas, contradictory testimonies, hidden motives, bizarre motivations. We learn that to judge is reckless, for, as Octave puts it, "Everyone has his reasons." Identifying them is enough. With a bit of patience, we ought to be able to explain everything and suspend judgment indefinitely, into oblivion. Fleischer's most beautiful films (*The Girl in the Red Velvet Swing, Between Heaven and Hell*) are also the ones whose vision is the most difficult, not to mention the most disappointing. We begin by judging the characters, deciding who is right and who is wrong, and as the film continues, the issue loses its urgency, recedes and disappears. We are surprised as we follow the movement (thesis and antithesis) of an impersonal, impartial, and slightly cynical way of thinking, concerned with explanation, endless justification, and all of it for nothing (or for the simple pleasure of intellectual joy). Here we see the powers of the intellect, and its limits: it only illuminates in hindsight. Fleischer's films never conclude, and if they progress, they destroy themselves. That is to say, they lead nowhere, ruling in favor of no one, abandoning the spectator to his disappointment, the girl to her swing, and the filmmaker to his purgatory. The orgies of the intellect (as we well know) leave only mild resentment behind.

P.S. You may have noticed that there was little mention here of *Fantastic Voyage.* This is because Fleischer's artistry exists in it only as a filigree, or a blueprint. We will only mention that 1) In it, cleverness replaces intelligence. 2) A film that depends on a single (and beautiful) idea would only inconvenience Fleischer, who prefers an abundance of contradictory ideas. 3) In a purple passage that lasts too long, it quickly becomes routine and yields only a vague intellectual malaise. 4) Conversely, everything that announces the "climax" of the film is perfectly realized. Notice, in this regard, how the first shots of the plane landing in darkness are by far the film's most beautiful and uncanny.

(*Cahiers du Cinéma* #188, March 1967)

Vilgot Sjöman, *My Sister, My Love* (*Syskonbädd*).

Some landmarks for Sjöman.

1. We see in this film a series of variations on a sentiment that is relatively rare in cinema: diffidence. Sjöman, a late bloomer, raised in Bergman's shadow, systematically chooses "taboo" subjects in order to force himself not to recoil from them, to see them through. His characters say too much or too little, dissimulate out of fear, move forward on a dare. If they speak too much, it's so they can be sure they have said enough. If they stay silent, it's for fear of being misunderstood. Thus calculation and diffidence are always conflated. They themselves get lost, and the film becomes clear only in hindsight (sign of modern cinema, perhaps).

2. If we accept the idea that Sjöman casts fresh light upon an old fable, then consider the consequences. On the one hand, everything is a sign, omen, symbol and warning. It all plays out in the opening scenes, ends before it has begun (the subject is not incest, but how to live with incest), and everything and everyone we encounter are only markers along a road (an excellent use of supporting actors). But is there a road? If so, the road is to suffer and stay silent, await punishment (Count Schwartz). But what if there is no road? Protest and plan for the future. The film (the filmmaker and his characters) oscillate between resignation and ambition. If reality is to be invented, one must live one's life, improvise, make the film.

3. The film's underlying subject is ultimately the symbol (a constant, as we know, in Swedish cinema) and the proper ways to use it. Do we scorn or fear them? The ambiguity lies in the real itself. Only a few characters, locations and props: what you are looking for is always under your nose. The characters must learn to read their surroundings: every face is an open book, but there might be nothing in it to read. Since Stiller, we have rarely seen a filmmaker discover, patiently, the beauty of faces in this way, like something to earn, to conquer. Must we read reality, or invent it? Vilgot Sjöman's characters are only as unhappy as they are because they feel they are perfecting their curse or inventing their misfortune.

(*Cahiers du Cinéma* #188, March 1967)

Luigi Comencini, *Misunderstood* (*L'Incompreso*).

In Florence, a man who has just lost his wife lives with his two sons, the older of whom, Andrea, is eleven years old. He is the consul, and their mansion is sumptuous, with a bevy of servants and a chauffeur who drives Andrea to school every day. The film is in color (Armando Nannuzzi), and the composition, the landscapes, the sets and the children, are uncommonly beautiful. And yet, between Andrea and his father, a rift continues to deepen. Misunderstandings take hold and, after miscommunication leads to miscommunication, we reach the final accident, half-suicide, half-swagger, from which Andrea will eventually die. Reconciliation under the oxygen tent. The father meant well but was blind, the son was more vulnerable than he had appeared to be. As always, only a tragic conclusion gives them weight, *a posteriori*. It is difficult to talk about this film, which is chicanery itself. At the press conference, Commencini denies having made a melodrama. He said that the book was too sentimental, etc. That is a joke. *Misunderstood* is—with more skill, more ellipses, and a sense of "polish" that far exceeds what we normally see—a melodrama in the great Italian tradition. (It's useless to want to "rehabilitate" the genre: almost all of the great Italian films are melodramas.) The situation only becomes messy because of Comencini's position. He is more than an artisan but far less than an auteur. He knows what is acceptable and what is not. He distrusts melodrama because the genre has a bad reputation, but at the same time, he doesn't go against it. He tries to get away with this by saying that he wanted to study child psychology. Useless hypocrisy. He is one of those people Pascal describes who knows either too much or too little. At the same time, his craftsmanship and skill are stunning. This has several consequences. When a filmmaker is not personally affected by what he "directs," when a film is for him only a situation to be depicted as effectively as possible, we automatically reach a certain cynicism that is all the more powerful because he is oblivious to it. The filmmaker doesn't recognize the seriousness of what he is handling, he sees only problems of stage management, of "maximum return" on difficulties and emotions that he does not question. That cynicism, the indifference of the man who is "doing his job" takes on a strange resonance towards the end of the film. We get the feeling that Comencini

kills a child because it's written that way in the script, that it will make for a moving scene (it does; how could it be otherwise?) and that he has absolutely nothing to do with it.

(*Cahiers du Cinéma* #191, June 1967)

Joseph Losey, *Accident.*

A new twist on perversity, deception, fascination and cowardice. Along the way, we recognize Losey's characteristic tics and tropes: gazes that are empty, sometimes ambiguous, often globular; mascot actors who are at long last reunited (Bogarde and Baker); sex between teachers and students, fascinated and fascinating, etc. At an English university cast in pretty colors, a professor, still young (Dirk Bogarde), needlessly complicates his life. He silently loves his student, Anna, whom one young man courts and a third has already seduced. Out of cowardice, because he is incapable of playing a real role in the story, Bogarde gradually becomes confidant, organizer, matchmaker. He feels as if he is pulling the strings while in fact he remains passive. Bogarde's character ends up being compelling because Losey's cinema is increasingly in his own image. A cinema invariably marked by the quest (simultaneously fascination and distrust) for the natural, the spontaneous, the first degree. Qualities which, we must admit, have escaped Losey since his arrival in Albion (apart from occasionally searing moments: *Chance Meeting*). Thus only artifice remains, in all its forms, from the comic strip to a certain "English accent." While watching Bogarde, we see how that alchemy operates, how the natural becomes contrived, how honesty becomes an ulterior motive, the evident becomes devious, etc. We may find this artifice either moving or unbearable in the second degree. *Accident* is a vain and over-stylized film of relentless aesthetic stringency. Every scene centers around a tiny "significant detail" briskly emphasized by a zoom. And yet, the overall impression is flaccid (a slackness that tenses up at random), if not ludicrous.

(*Cahiers du Cinéma* #191, June 1967)

Mikhail Shapiro, *Katerina Izmailova*.

A Shostakovich opera, rightfully unsung and certainly unnecessary to wrench from oblivion. Lady Macbeth, the abandoned wife of Izmailov, her feeble husband, bores herself stiff and eventually indulges in a frenetic affair with a muscular yet refined moujik (he knows how to read; she does not). The worst misfortunes befall them: she is rejected, deported to Siberia, etc. Chubby and forlorn, Galina Vishnevskaya, the famous diva, is grim and bored in the role. The principle of the film appears to be to film something, at all costs, while Galina V. keeps her mouth open. Which can be tedious. Mikhail Shapiro then employs the well-worn method of superimpositions and blur, over-lapping colors with blacks and whites. A veritable art of filler. One marvels only at the means deployed (stereo sound, 70 mm) to embellish a story that the charms of intimism would have transcended.

(*Cahiers du Cinéma* #191, June 1967)

Jiri Menzel, *Closely Watched Trains (Ostre sledované vlaky)*.

Towards the end of the war, in a small railway station in the provinces, the deputy—a lewd man—swats at the bottoms of loose women while the young Milos, the hero of the film, discovers love and its problems. Specifically, a case of "ejaculatio praecox" that he confesses to everyone with naiveté and sorrow. Despondent, he slits his wrists. He is saved. In the meantime, the station's deputy—orgiastic but a member of the resistance—receives an order to blow up a train full of German merchandise. A mysterious emissary brings the dynamite: a charming young woman, whom Milos sleeps with. The next day, finally feeling like a man, Milos demonstrates an unex-pected sang froid and detonates, all by himself, the explosion of the train. A machine-gun shoots him down. We recognize some familiar constants of Czech cinema (Forman, Passer, etc.). It has the same gaze, critical and knowing, neither too malicious nor too generous. The same cleverness that serves as intelligence, thin-skinned and superficial. The same atmospheric lighting, somewhere between a

cabaret and entomology, in which everything drowns softly in self-indulgence. Menzel has the distinction of never raising his voice (choosing a resolutely monotone, neutral tone) and of casting the same gaze, cold and amused, over everything. That dryness is both its value and its limit, which is quickly reached.

(*Cahiers du Cinéma* #191, June 1967)

Jean-Louis Roy, *The Unknown Man of Shandigor* (*L'inconnu de Shandigor*).

A scientist who severs himself from the world, sinks into madness and raises a Beast in his swimming pool who might be his double, a network of spies about whom we know nothing except that they're bald and embalm their dead while their leader, Gainsbourg, whispers "Bye Bye Spye" at the organ, sequences shot in Barcelona against Gaudi's ludicrous backdrops, a "Canceler," diabolical invention that can neutralize an atomic bomb... All of these ideas can be found in the script of *The Unknown Man of Shandigor*, a likable and captivating Swiss film. Unfortunately, the craziness remains on the level of concept rather than execution, which is otherwise decent. As for Jean-Louis Roy's overt ambition to make a comic-strip film, it is courageous. But it is strange that no one asked the question of whether the comic strip, when translated to the screen, loses its essential charm (if only that of being *drawn*). If only because cinema's realistic vocation (by necessity, twenty-four images per second are "heavier" with reality than a single fixed and stylized drawing) can never really accommodate a drawing's lack of realism. Hence, despite some good moments, the film's slightly clunky side.

(*Cahiers du Cinéma* #191, June 1967)

Glauber Rocha, *Entranced Earth* (*Terra em Transe*).

In Eldorado, a disadvantaged province of Brazil where political instability, poverty, and illiteracy run rampant, Paulo Martins, the film's

hero, a poet and revolutionary, is desperate. Because his circumstances are complex (an effect intensified by a chaotic and obscure narrative style), and he has the unfortunate tendency to attach himself to weak and corrupt politicians, nobodies and demagogues, his efforts end in chaos, and he dies while shouting his "impossible poem." With the theme of the amateur revolutionary now a given in young cinema, this avatar is a figure characterized primarily by confusion, violence and frenzy. Since Glauber Rocha deals more with characters and paradigmatic (even typical) situations, the film's "action-adventure" side gains traction while political thought loses its rigor. What's more, other problems arise that minimize politics even more: the (father-son) relationship between Paulo and, as it happens, the one man he must destroy, the reactionary leader Dom Parfirio Diaz. There will be many shots fired towards the sun. Towards the middle of the film, Paulo Martins, who has often wondered about the tenuous power of poetry in these troubled times, announces that the "flowers of style" no longer interests him. The same cannot be said for Glauber Rocha, who seems committed to having at least one concept per shot. Concepts that are, incidentally, most often brilliant, but their accumulation quickly becomes tedious (the film lasts nearly two hours) once we realize that they lead nowhere, but are meant rather to emphasize, embellish, convey the crisis (it is tempting to say, "stall"), the stagnation in which the characters are mired. Consequently, nothing is done in a simple way, and the film becomes a series of flourishes "for nothing" (or that illustrate that nothing, which amounts to the same thing). Aestheticism, indulgence, affectation creates, every so often, and especially at the beginning, some nice effects. It is as if the characters, incapable of actually experiencing the situation, begin to act it out, mimic it. Hence the restless, fevered, nervous character of the performances. And it is right when he abandons any notion of plausibility or concern for accuracy, when he returns to allegory, and then opera, that Glauber Rocha seems the most gifted. We need only look at his masterful use of the Brazilian language: speeches, quotations, proclamations, litanies, and vociferations, all artificial forms of language that, when knowingly orchestrated, occasionally unleash a kind of grandeur.

(*Cahiers du Cinéma* #191, June 1967)

Uri Zohar, *Three Days and a Child* (*Shalosh yeoman veyaled*).

From a Zohar out of whom no one expected to see another Book of Splendor, a relatively nice surprise. First of all, *Three Days and a Child* is an unusual screenplay, what we could call a "beautiful idea." A student in Jerusalem, Eli, slightly cynical and pretentious, lives with Yael, whom he doesn't really love. He is haunted by the memory of Noa, his first love, who married another man several years before. One morning, he receives a telephone call from Noa's husband: the couple has left the kibbutz, and are coming to "study" in Jerusalem. They ask Eli to watch their son, who is three years old and would get in the way, for several days. Eli accepts. And so Zohar slowly tells what is a relatively good story about love and madness. But he tells it in a convoluted way. The child is both provocateur and comforter, scapegoat and instigator. Subsequently, the relationship between Eli and the child is portrayed with an accuracy that is all the more satisfying since it would have been easy to slip into mawkishness or pathos (depending on whether we pity the hero's dark thoughts or the child's innocence). In this way, every impulse, diluted, constrained, is eventually subsumed by cozy bossa nova music, just shy of apathy. To speak of love and madness is perhaps an exaggeration: their shadow only passes now and then.

(*Cahiers du Cinéma* #191, June 1967)

Allan King, *Warrendale*.

At Warrendale, "emotionally disturbed" children are treated with strange (and, as it seems, controversial) methods. The idea is to keep the sick children from withdrawing into themselves, into their solitude, no matter what. To shatter their ivory towers and leave no emotion unarticulated or repressed. In other words, emotional release as therapy. For one hundred minutes, the children—through fits and outbursts—"express themselves," which means that they give their emotions free reign: anger, joy, hatred, hysteria... The

monitors limit themselves to restraining them physically (a staggering task). Towards the end of the film, the cook, Dorothy, whom everyone loves, suddenly dies. The monitors decide to take the risk of telling the children. This revelation leads to an even more violent scene than the ones that preceded it. After the funeral, the children return calm and happy (but for how long?) to Warrendale. Allan King's sensitivity must first be praised, along with his surety, qualities that are all the more difficult to find in cases such as this, where habitual notions of decency (which generally produce the most indecent consequences) do not apply. The children's eyes and faces are not blacked out, as they are in certain TV programs; instead, on the contrary, every effort must be made to remind them that they are "in the world" and have no right to cut themselves off from it. Because he takes his premise to the limit, King, surpassing the small, scattered beauties that would have satisfied less demanding film-makers, achieves the rigor of observation.

(*Cahiers du Cinéma* #191, June 1967)

Jorge Sanjinés, *Ukamau.*

The first "Indo-American" film, as the director had hoped it would be. Rumor has it that he is in prison. *A priori*, a film that depicts a tribe—near Cuzco—that speaks a language (similar to Quechua) that has virtually disappeared and alongside which the Spanish language appears as intrusive, a film that sides with the Bolivian Indians against their mestizo farmers, is both original and fearless. The story couldn't be simpler: one day, a mestizo, Ramos, kills the wife of an Indian who had gone to the fair because she resisted his advances. Before she dies, the woman has time to whisper the name of her attacker to her husband. Still, the man does nothing and life continues, becoming increasingly difficult for the Indians. Ramos, slightly worried, reassures himself. One year later, after waiting for the right moment, the Indian man surprises Ramos in a bleak and barren desert, starts a fight with him and stones him to death. Such a display of patience on the character's part is admirable;

unfortunately, that kind of patience is impossible on the viewer's part. The film will charm those for whom the hieratic is synonymous with simplicity. For everyone else, it will seem interminable.

(*Cahiers du Cinéma* #191, June 1967)

Wim Verstappen, *Joseph Katus* (*De mindergelukkige terugkeer...*).

Or, "The unhappy return of Josef Katus to the city of Rembrandt." Josef Katus returns to Amsterdam to die. He has travelled all over the world, and sold his winter clothes in Paris to return home by train. In Amsterdam, he reconnects with friends, is followed by the police and plagued by a mysterious ailment. He will eventually die from it. Until then, he lives on borrowed time, a provisional, day-to-day existence, encounters, vagrancy in the city. (It is not often that Amsterdam and its irksome beauty is shown in this way onscreen.) He meets a young Jewish woman and tells her about his travels, he meets Provos and demonstrates with them (but he does not believe in their philosophy, and when he marches with them, it is only in the literal sense), deals a little LSD, cons everyone he meets and dies without knowing why he is being followed. Verstappen's great virtue is to have played—with brio—two different cards. On the one hand, he denies himself nothing that could make Katus's fate dramatic, even pathetic. The devices are on full display: the return to the homeland, a solitary and wanted man, impending death, etc. Such strong situations are a constant. All they need is a muted, menacing score, much like the one used by Goldman in *Echoes of Silence*, which the film often invokes. At the same time, he embraces the pleasures and even the overuse of a hand-held camera and a direct cinematic style. Which means that he never loses sight of his hero, follows him everywhere and constantly, covering his encounters and obstacles along the way. So much so that the film is simultaneously ineluctable and open to chance (a little like Rouch), a foregone conclusion whose every move is improvisational. It's the movement of life itself, of the final week of Josef Katus in which almost anything can distract him

from his fate and almost anything can plunge him back into it. Nothing he finds on his path will be irrelevant.

(*Cahiers du Cinéma* #191, June 1967)

Yukio Aoshima, *The Bell* (*Kane*).

Four young men and one woman take a trip to the seaside, ready for hijinks and some fun. One of them, while scuba diving, discovers an enormous bell. They decide to raise it to the surface, then hoist it against the cliff. After a number of failures and several near-death experiences, they finally get it to ring while the girl, exquisitely indifferent, eats ice cream in a remarkably improper way. The bell breaks away and falls back into the sea. Rather than being a parable about the beauty of effort or the myth of Sisyphus (which the author had perhaps also intended), it leans on the relative safety of the gag. The characters barely speak; everything is visual. We think of *nonsense*, of Lester's first films (less zany), of Polanski's first films (less acerbic). The film is constantly on the verge of drama and gravitas, but never settles there, and consistently relies on a supplementary smile, intended to safeguard a reasonable degree of joy.

(*Cahiers du Cinéma* #191, June 1967)

Palle Kjærulff-Schmidt, *Once There Was a War* (*Der var engang en krig*).

During the war, in occupied Denmark, a young man (Tim) discovers a variety of things, including love. He casts an innocent gaze over a troubled world, then a troubled gaze over a mundane world. It's a delicate subject, and Kjærulff-Schmidt prefers suggestion to tackling it head-on. Modesty wins out, but by being too modest he reveals absolutely nothing. The filmmaker strings together, without favoring any one in particular, short scenes, tableaus in which the quotidian and the obsessive answer one another. But these snippets, portraits of a middle-class family that is neither overly sordid nor overly

distinguished, lack the power to describe the great mysteries whose surface they can only scratch. By not wanting to rush anything, always speaking a bit "aside," Kjærulff-Schmidt has made a film not about awakening to life but about the day-to-day existence of a Danish family and typical adolescent turmoil. As if someone had found a child's diary, and filmed it word-for-word, but too late, after one's heart was no longer in it.

<div align="right">(Cahiers du Cinéma, #191, June 1967)</div>

Jörn Donner, *Rooftree* (*Tvärbalk*).

Rooftree is a strange film, striking primarily because of its total refusal of the slightest effect, in the script as much as in the direction. To such an extent that its austerity is somewhat boring. But this determination to keep the volume low, to allow a few very simple sentiments to crystallize and then unravel, eventually opens the door to something else. Four characters: Leo and Inez, bound by a past sexual relationship, Magnus, an aimless young painter who has desired Inez for some time, and Noomi, a young Jewish woman originally from Hungary, still haunted by life in the camps while living at the heart of a prosperous Sweden. Noomi is for the others a subject of curiosity, fascination or an excuse for vague regrets. Her character is based upon an actual sentiment in Sweden, one that Donner deserves credit for addressing: the bad conscience of a nation that has managed to live for one hundred and fifty years without experiencing war. Noomi fascinates Magnus but it's Leo who falls in love with her. So far, nothing very surprising, and we witness a predictable exchange of partners. But suddenly everything changes. Leo divorces, leaves Inez to Magnus and devotes himself entirely to Noomi. She gradually surrenders to the love affair, but falls gravely ill. Leo goes to see her every day at the hospital... One is tempted to say that the material doesn't amount to much, but the film adds nothing to it. There are only characters who talk, explain themselves, provide endless commentary and never act according to what they say. The more they talk, the more their speech seems like a code, a

convention, a way of being with others, miring each in solitude. We ultimately get the impression that their lives have been decided for them, somewhat randomly. They, with unperturbable seriousness, resign themselves to it. Hence, perhaps, a certain vibrato.

(*Cahiers du Cinéma* #191, June 1967)

LESS MINUS LESS EQUALS MORE

Jerzy Skolimowski, *The Departure* (*Le Départ*).

1. There is a scene in *The Departure* in which Jean-Pierre Léaud and his accomplice, also a male hairdresser, pass for a maharajah and his secretary. We realize relatively quickly that this is a hoax (played for laughs), but it is hard not to believe—even if only for several seconds— in the existence of said maharajah. Those several seconds could summarize Skolimowski's entire art: a man tells marvelous stories and realizes his tales with a wry smile, mocking the gullibility of his audience. What good would mockery be if it weren't accompanied by at least an equal ability to make things "plausible"? Those who mock their own speech must first be smooth-talkers. Otherwise...

2. In *The Departure*, a young man from Brussels dreams of participating in an automobile rally. As expected (it is a Skolimowskian constant), an older and wiser woman becomes, for no apparent reason, his partner and companion. After an exhausting day (discussions, shopping, fighting, a rape attempt, work, meetings, etc.), the hero rents a hotel room. The next morning, he is awakened by the noise of passing cars: he's overslept, he's missed the start of the race. What's powerful about this story is that at no point do we predict its ending, although logically speaking it is the only possible outcome. When we reach the final scene, we say to ourselves, "Of course..." but it is too late. Skolimowski has concealed the threads of his story even more deftly in *The Departure* than in his previous films. And so he proves that he can succeed at almost anything: for example, a commercial film...

3. At the same time, *The Departure* is a gratuitous film, less audacious than *Barrier*, less sovereign than *Walkover*. There are several

reasons for this, all of which are secondary: the dialogue is less slick (Skolimowski does not speak Belgian), the photography (Kurant) is slightly muddy, etc. We must consider this film an exercise in style, and recognize in it the risks of art for art's sake. It would be improper to blame Skolimowski for having too much talent. He has the right to make one or two films in the same vein as *Walkover*, given the beauty and importance of that last film.

4. Skolimowski's characters are especially stubborn, attached to an idée fixe given that the world is constantly shying away from their grasp. They live in a perennial state of waiting for an important event, a decisive test, things that never arrive or go badly when they do. Leaving only a frenzy that is all the more intense because it is strictly entropic. There will be no end point, no definitive lesson but all parodies are allowed. The provisional is the only reality, the only value and perhaps the last. Fleeting certainties, unknowable (disguised) points of reference, the world continues on its course but something (but what?) is out of place. This natural is suspect as well: a dream that the dreamer already knows will soon end. Moments in which everything is suspended, temporary, incomplete (moments which Gombrowicz says are the search—temporary—for "immaturity").

5. Let's return to the maharajah. Skolimowski's taste for pranks, for gags, is clearly Polish, surely a schoolboy hangover, definitely a serious thing. If every film ultimately turns out to be a "mystification," much ado about nothing, and false rigor for a real sense of the void, it goes without saying that every shot, at every moment, may be *rigged*. What at first seemed spontaneous may suddenly reveal (in a traveling shot that advances or retreats, or a zoom) its adherence to a premeditated plan. Everything is legible on multiple levels: *Walkover* and *Barrier*'s lack of realism and weirdness become explicable, realistic, in a certain way. Dream and reality engage in a quid pro quo, and afterwards they look remarkably alike. Think of *Barrier*'s opening sequence. Who will dare adjudicate on anything after that?

6. Skolimowski's concern: to convince us of both the obvious and arbitrary nature of cinema. Any shot might simultaneously belong to two or three possible contexts in which it could have varying yet plausible roles. This is solely about not limiting meaning; not making "meaningless" films but, on the contrary, making *too much*

meaning. What counts is disorientation: for several seconds, to no longer recognize the world or the Place de Brouckère, to no longer know if this world is even meant for us. To doubt everything for a second, and not acclimate. We acclimate less quickly to things when they have double or triple meanings. That is what films tell us (better to flounder around in all of those meanings than to arrive somewhere). It's also the way they are narrated (better to stir up all those meanings, all those registers...). Skolimowski is the man who says: look at this character, if I film him from far away, it's a musical comedy, if I film him close-up, it's a melodrama, even closer, it's cinema-verité. All of these things are true. We each choose the one that appeals. I choose them all.

(*Cahiers du Cinéma* #192, July–August 1967)

Věra Chytilová, *Something Different* (*O necem jiném*), *Daisies* (*Sedmikrásky*).

In *Something Different*, two women, after repeating the same task ad infinitum (the housework or the parallel bars, what's the difference?), forget the meaning of their gestures, their purpose. Certainly, they have nothing in common, except perhaps this sudden inquiry, a moment of pause between two habits, two routines. As they discover that their lives are empty and hollow, wasted, they dream idly of "something else" (of abandoning the housework or the parallel bars, it doesn't make much difference). That's when Věra Chytilová offers them freedom, the opportunity and power to break free, to open themselves up to a world of possibilities. Through dark humor as much as actual distress, we then watch these two women return to their lives, to their ennui. And what if there's something else? What if the alternative is even darker, even more uncertain? The door left ajar once again closes: the athlete (Eva B., world gymnastics champion), now a professional, trains young students (the final, remarkable shot), and the wife does not become the Emma Bovary of Prague: she has to fight to win back her (weak) husband and her household (with no illusions). Be happy with what you have, the film seems to say, it's all you'll ever get...

But that is an unsatisfying moral. Which may explain *Daisies*: rejected in Venice, overlooked in Paris, still banned in Prague. Now with considerable means at her disposal, Věra Chytilová wanted this film to differ from its predecessors, and from every other film, in every way. Her refusal (an obsession that she shares with her heroines) to limit herself to a certain kind of cinema is equalled only by the tenacity and seriousness with which she pursues her concept. So it is easy to see how *Daisies* diverges from *Something Different*: madness follows austerity, arbitrariness follows discipline, an orgy of colors follows gray. The inconsistencies in the story, the strangeness of the setting feel effortlessly modern, as does the extremely original use of photography (it is impossible for anyone who has seen it not to acknowledge Kucera as one of the great cinematographers of our time). Thus it is open to every kind of experience. But at the same time, the opposite of, commentary upon, and sequel to *Something Different*. Another door opened, then closed.

In a riot of color, two young girls bitterly complain that nothing ever happens, that nothing means anything, that the world is senseless. And so they decide to become "degenerates," scandalous, reckless and insane, phony and provocative. They indulge in the systematic subversion of all their habits and ideas: the subtitles even speak of perversion. That's a very strong word. Subverting meaning is fine if there are ideas to subvert to begin with. Perversion (Bresson's *Pickpocket*, for example) means choosing to live in opposition to the world because one has decided that it's other people who are backwards. That requires an intelligence and particularly a power of imagination that these girls do not possess: their venture thus has no impact or weight: light gags, minor scandals, passwords... In one beautiful sequence, they collide with the quiet indifference of a gardener who, perhaps, has not even seen them (immediately they ask themselves: Do we really exist?). Here, we perhaps approach something resembling perversion: looking at the world from impossible angles in order to catch in it the most simple things (and rediscover its beauty). That's sort of what happens in *Daisies*: as the two girls become, because of their willingness to be bad, touching and slightly ridiculous, daily life, the "normal" world (including the men they ridicule) seems more and more touched by nobility and majesty. That

was perhaps Chytilová's premise, but it is clear that hers is not a simple position. The austerity of *Something Different* and the anarchy of *Daisies* are not solutions. Too many reference points erode their existence, but their total lack is discouraging.

<div align="right">(Cahiers du Cinéma #193, September 1967)</div>

CINEMA AND ADVERTISING

Billy Wilder, *The Fortune Cookie*.

1. If Billy Wilder has something in common with his characters, it is an extreme concern for efficiency. Hence their schemes and his art, which is often accused of vulgarity, meanness, and other indignities. We do not dispute the fact that Wilder is infamous. And there is also his love of deception, prostitution, fraud, themes of which he is the sovereign poet, the towering master of his medium. *The Fortune Cookie* confirms all of this. Wilder has not changed. Neither has his little world of admirable low-lifes and honest idiots: the first distill laughter into its lowest form, and the others preserve that share of "emotion" that validates the self-indulgent idea that there is "tenderness behind the viciousness," when in fact they are merely two faced, the ultimate consequence of a passion for efficiency.

2. That's where American cinema came from, and that's how it recedes from us, a little more each day. Its law was of *maximum return*. More than a law, an aesthetic: the conviction that everything, always, may be used, and that a good film is primarily one that exhausts a scenario's every possibility (laughter, fear, tears, etc.). That's the beauty of these films—a most innocently perverse beauty—indifferent to the material they churn, the demons from which they are born, the image they validate of the world and the civilization that was given to them once and for all. Their only concern is to create a feeling, an emotion, whenever the opportunity arises. McCarey has said that filming a couple of old men being executed in a church (*Satan Never Sleeps*) is a wretched thing, but that he could, after all, through a certain kind of framing, add a sense of beauty. It

is touching when a young girl describes her heartbreak (*The Bells of Saint Mary's*), but if she happens to be ugly and ridiculous as well, we get two sentiments in the place of one. Invaluable gain.

3. What Levi-Strauss calls "intellectual bricolage" comes to mind: all available means are used, but how did those means become available? Every possible opportunity is seized, but where did they come from? The bricoleur is no more responsible for his improvised tools than the American filmmaker is responsible for America. This lack of a personal view (or slight, or at great peril) on the material they're working with made Americans admirable bricoleurs, and America itself the greatest of American auteurs.

This is not inconsequential. It is clear that the principle of maximum return is automatically accompanied by a *cynicism* that the greatest American filmmakers have gradually begun to use to their advantage: a harsh discovery, but one that is full of lessons. Admirable storytellers, for whom a shot and a gaze is enough to create an entire world, they are too convinced of their abilities; they no longer see their limit. Excessive efficiency is efficiency's demise, just as how beyond a certain threshold, sentiments no longer add up—as McCarey wanted them to—they only annul themselves amidst great confusion. American craftsmanship and skill was a way to leave no empty spaces in their cinema, because everything, from the last prop to the last extra, could be used. Meanwhile, "European" cinema learned how to open its oeuvres up to those spaces—to excesses and inoperable silences, a kind of accursed share that was impossible to do anything with. It was a wise policy, since emptiness laid in wait for American cinema as well: when too much cinema silences cinema, each film becomes a diabolical race to say nothing.

Several recent films demonstrate that disorder and unintended modernism. *Gideon of Scotland Yard, In Harm's Way, The Chapman Report* (and perhaps Billy Wilder's future films) offer the spectacle of absolute mastery, a sovereign gaze, just and rigorous, focused on several worlds simultaneously and whose result is nevertheless total entropy, where everything abuts against itself and the world falls back on its impersonal movement.

4. Wilder is not there. Not yet. But it is worth noting that his universe is efficiency itself, a world in which everyone tries to sell

themselves at the best price and under the best conditions. Prostitution has been the central theme of Billy Wilder's recent films: involuntary (*The Apartment*), light-hearted (*Irma la Douce*) or joyful (*Kiss Me Stupid!*). And if prostitution depends on advance publicity, cinema has, admittedly, long been that publicity's ideal vehicle. It is therefore not surprising that *The Fortune Cookie* is a film about mise-en-scène. But on the one hand, Wilder is confident enough in his abilities not to feel the need to be efficient at every moment; on the other, Wille Gingrich, a sublime scoundrel, is constantly showing off, as if he knew he were being watched (and the film proves that he is right), the ultimate ham, but viewed with some detachment. That detachment, that margin— Wilder suddenly dissociates from his characters, is less concerned with being expedient than with explicating expediency, presenting its processes—puts everything back in its proper place and the film back within the film, sees cinema from the wings, the opposite of maximum return, its other side. But it goes without saying that cynicism has the last word: now, efficiency is a matter of maligning efficiency.

(*Cahiers du Cinéma* #195, November 1967)

THE UN-DOING

Otto Preminger, *Hurry Sundown.*

1. For some, Otto Preminger's greatest films are films about creation. This is not without reason. And yet, it would be more correct to talk about the impossibility of creation. Several masterpieces came out of this impossibility, then several films that verged on madness, and now the bitter insignificance of *Hurry Sundown*. Preminger has indeed addressed creation, but a strange kind, unsatisfying, unnatural, astonishing only for the *sum total* of the energies set in motion. Not an impulse that assures everyone and everything in their place, an undivided flame that leaps forward without regret and that analysis cannot reach. Preminger is not about that kind of creation, even though it has been his greatest concern: the desire, the obsession to provoke, to describe an *innocent* creation. In the films that earned him

his reputation (*Fallen Angel, Laura, Whirlpool*), that innocence was that of the insect who gets caught in a web, who doesn't know how close he really is to the spider, innocent because hypnotized, trapped, a puppet, a blind phantom creator, a creator because he is blind.

2. To film is to make *incompatibility* manifest. That is the law that eats away at Preminger's cinema, the imperative on which it builds, shines in all its brilliance and consumes itself in vain. To film two characters is to highlight their differences, make it intolerable. And so, it's the space that brings them together—that separates them—that is the subject of the film (and of the much-touted "mise-en-scène"), a space maintained (*Anatomy of a Murder*) by an absolute irony (the power of discrimination) when an all-consuming sensuality isn't relentlessly breaking it down (*Bonjour Tristesse*). Constrained by a script and by the demands of a "story," to share the same space, people brush up against each other and draw from that contact—given, accepted—the assurance of their curse as the greatest of pleasures, pleasures that are perverse and without reward, the madness of proximity, until their gaze glazes over, until a cold rage is unleashed—in vain. Associations, disturbing and unnatural, relationships without relation or relating, a door that frigidity leaves open to rape, impotence leaves open to orgies. People are different. Sometimes filming is a reconciliation: with Renoir, with Ford, differences, once filmed, no longer exist: the space they share becomes their new home, common ground, the first of their shared subjects. Preminger is gifted with the opposite skill: those who pass in front of his camera withdraw from each other, destined for the fragmentation that is their code, or an awkward and imperfect embrace that will return them more certainly to their fragmented condition.

3. The art of the "mise-en-scène" has not been—as we once carelessly thought—a universal panacea or a privileged way of making films. Mise-en-scène is also the expression of a lack—to create around the characters, mired in their solitude, victims of their indifference, the space of their common prison: an architecture of emptiness, a looming abyss. The "fascination" exercised by Preminger's films is the effect of that distance that one perpetually seeks to minimize, until the gaze and its object merge. But that conflation—which would be maximal proximity—is out of the question (unless as it will subsequently

appear in death, destruction, the apocalypse). But that confusion—
that cohesion—is also the role of the artist: the happy abolition of
differences, the reestablishment of communication, the consumma-
tion of desire. While shooting *Exodus*, Preminger is at the very heart
of his creation: the victory of cohesion over the fragmentary. We
should take seriously the scene in *Exodus* where we see Ari Ben Canaan
deliver the eulogies for Karen and Taha, whom everything divided,
and who will share the same ground, the same grave: the shot of the
two coffins, of such different sizes (an untenable distance that, truly,
"gouges out" the eyes) is, for Preminger, the most loaded of images.

4. The art of the mise-en-scène thus consists in articulating that
space that invariably creeps in between two people, two moments in
a film. It is the cement of an edifice in which no two stones look
alike, important because it—and it alone—guarantees the edifice's
solidity. When this power, this bonding (also called skill, savoir-faire)
is lacking, the entire work is reduced to the realm of fragmentation
and detail (*Hurry Sundown*). Post-1960, Preminger is that man who
no longer seeks fusion, cohesion, except in death or annihilation.
Terrible excesses of strangeness ensue: because people are fragments,
able only to be juxtaposed, the world must be patiently reconstructed,
the entire world, beginning from those pieces. A paradox that
could be summarized as: describe a crowd where one could, at any
moment, call each person by their name.

5. A decision that is not inconsequential. Its essence: a man is a
fragmented thing, unlikely to have a harmonious encounter, filled
with rage, capable only of rape or dissipation. The rest, i.e. the direc-
tion that Preminger's work has taken for the past several years, is only
an attempt to justify that truth by giving it plausible frames. Hence
"major themes": the episodic and the unfinished are hardly threatening
if they are guaranteed by the scale and mystery of a major theme for
which fragmentation is the rule and the only means of description.
No one owns a complete set of causes and effects, even in the highest
spheres of politics (*Advise and Consent*), the Church (*The Cardinal*) or
the army (*In Harm's Way*). The view from above, as it withdraws from
its object, is reassuring: a crowd that contains only familiar faces.

6. Another consequence: the films undergo—in their very struc-
ture—a parallel evolution. Each scene is no longer expected to have a

relation to the whole, except in a very distant way, like a kind of relay. The film as an ensemble of elements, a sum of energies, is also threatened by fragmentation, a series of links that ignores where the chain goes—if there even is a chain. In *In Harm's Way*, we see half a dozen dramas and personal problems that seem to precipitate the attack on Pearl Harbor. It is clear that in Preminger's mind, the calculation was reversed: he had to find something enormous enough to justify the gratuitous violence of those dramas, their impossible resolution, their arbitrary entanglement. And so, as the fragmentary tightens its grip, it demands a more general frame, a more universal resolution.

7. One could argue that this is a dishonest calculation. Surely, Preminger once gave—gave himself—the illusion of addressing certain major subjects, but that illusion no longer holds; the pretexts have ceased to be plausible. And so the racial problem neither explains nor is explained by *Hurry Sundown*, but it is a frame—appropriately explosive—in which another violence may unfold, the violence of a couple that anticipates its own undoing (as it is said of something that comes undone). If the film is shocking, it is because it is no longer possible— in 1967—to talk about Blacks as Preminger does, and if he misspeaks, it is because the problem is for him only a specific example of the rule, the rule that is, as we know, the refusal of some to offer themselves to others in order to preserve the wretched awareness of their difference.

8. There is one other thing. *In Harm's Way* was a beautifully directed film. The artfulness of the cinematography, the speed of the execution, the choice of certain actors, the mise-en-scène, and Preminger at the height of his powers gave the film the necessary binder to guard, *in extremis*, against fragmentation. *In Harm's Way* was the false sum of true elements. It is not so for *Hurry Sundown*, for the affliction that corrodes the characters eventually attacks the film itself. Fragmentation, entropy, a lack of sincerity plagues every shot. The characters' moral failures correspond to the film's return to chaos, to detail, to images without a film. The silences in the text have devoured the text, the interstices prevailed over the stones, and as for that space that nothing can fill, you might as well set it ablaze. In that respect, too, the work is undone.

(*Cahiers du Cinéma* #196, December 1967)

Claude Chabrol, *Who's Got the Black Box?* (*La Route de Corinthe*).

In the prologue, an illusionist crosses the Grecian border, is searched, arrested, tortured, refuses to talk, swallows cyanide. It's not impossible that Chabrol has in this introduction placed the key to something that properly has no key. He has become an illusionist to the point of showing his tricks without believing in them. Aestheticism? The connections to A.H. (*Torn Curtain*) are indeed profound: same distance between the voyeur and his object, distance that is the source of tragedy and beauty; the dissatisfaction and absolute necessity of the mise-en-scène, the same idle and hence perverse characters, the same inexpressible secrets that cinema can only grasp through an orgy of cinema. But A.H., sure of his goal, takes time with his methods while C.C. exploits these methods and forgets A.H. Preciousness? It's rather that Hitch has closed the doors behind him, slamming them shut, leaving Chabrol behind, an illusionist without illusions, bearer of a glittering, empty trousseau. Nothing here that we don't already know: that a character is never so moving and true as when he is lying or pretending that solemnity and frivolity, tears and laughter, belong to the same shot, the same gesture (example: Jean Seberg stroking—with evasive affection—the forehead of the villainous Khalidès), that the world is only the world when it is slightly beside itself... The illusionist is no longer one when it's the world that's become an illusion.

(*Cahiers du Cinéma* #196, December 1967)

Don Siegel, *Invasion of the Body Snatchers.*

One of the most beautiful themes there is: a man not only vanishes, but is replaced by his double. As it must, the direction (Don Siegel), which is quite decent, inspired, even, falls far short of everything that the concept (Daniel Mainwaring) advertises and implies (several years before Ionesco!). Everything unfolds as if it were difficult to talk about what hasn't yet happened (including the end of the world), which isn't surprising. More surprising is that sci-fi films are precisely the ones in which the sense of the strange is the least troublesome, the idea of the

Other domestic and routine. They are in fact most often reactionary films in which the hero defends against coming out of his shell, and ends up bitterly and confidently assuming the humanity that we (totalitarian regimes, let's say) had wanted him to refuse. As for Don Siegel's film, it begins as a relatively remarkable portrait of daily life in a small American city (Santa Mira). Most successful are its first scenes that only hint at the mystery in the midst of routine gestures and mundane conversations. As the mystery becomes clearer and hence loses its mystery, the film itself loses its power and honestly, the giant pods are not very frightening. Far from it. But Siegel's ability to describe the "family circle" is not insignificant. To make the shocking even more shocking, it's best to focus on a hermetic—let's say familial—environment in which even the slightest deviation from habit assumes disturbing proportions (disproportions). Hence the end of the world is always something that happens to a family, and intimacy, the condition of something that surpasses intimacy. While shooting *The Birds*, Hitchcock never lost sight of this simple rule (which he uses to his advantage, making that intimacy a possible cause of the cataclysm). Which creates a certain distance between Hitchcock's absolute masterpiece and Donald Siegel's decent film. From Santa Mira to Santa Bodega.

(*Cahiers du Cinéma* #197, January 1968.

Jan Troell, *Here Is Your Life* (*Här har du ditt liv*).

Adolescence is a worthy subject, although it is a far from easy one. First because it is always reduced to a certain number of "awkward" situations whose consequences include: for the filmmaker, recourse to a style that is itself awkward and mired, and for the audience, a slightly dewy, protective gaze. Next because its apprenticeship always concerns the same things: amorous, or political initiations, etc. So much that the film becomes a bit of a variation on a familiar theme. That's what Jan Troell must have thought as he struggled to bring Eyvind Johnson's novel to the screen. He asked only formal questions, questions of packaging, as it were. They boil down to this: every scene begins with a partial (incomplete) and partial (biased) detail that

"hides" the main idea for a moment, in the same way that leaves hide the tree and the tree the forest. The film becomes a series of enigmas—plastic, "poetic" or dramatic—a collection of false leads continually sacrificed for the straight and narrow path. Nothing is left ambiguous, at most there is the shadow or the beginning of something new (developments, digressions, displays of bravura) that Troell makes shine for only a moment. All latent and vague things that barely hinder the functioning of an honest but impersonal film. It remains to be seen if the story of a "normal" adolescence (meaning a certain age of life) can be an interesting subject: in great films, adolesence has only been extreme: pathological (*Fists in the Pocket*) or exemplary (*Taira Clan Saga*), not an era of life, but life itself.

(*Cahiers du Cinéma* #197, January 1968)

Ernst Lubitsch, *Bluebeard's Eighth Wife.*

1. In a department store, a rich American businessman (G. Cooper) aims to buy a pajama top. The store wants him to buy the complete set, but he can't bring himself to do it. A voice—off camera but crystalline—is heard: "I'll buy the pants." It's Claudette Colbert. In the film's final scenes, the businessman suffers a nervous breakdown. He's put in a straitjacket, and C. Colbert—all smiles—rushes at him. In between, the heroes—according to a very Lubitschian principle—continue to suspect one another of being bought and of replacing true feelings with dishonest calculations.

2. We discover what can only be called Lubitsch's little world: virile women and cowardly men, panicked terror of facing the future, scenery in luxuriously bad taste, etc. We notice the appeal to culinary gags—here, the onion-scented kiss (Lubitsch is one of the rare filmmakers, it is worth noting, who makes cooking a dramatic element, cf. the consequential meats in *Angel*). Finally, the recurrence of mascots such as Edward Everett Horton, a Lubitschian actor par excellence, who is always remarkable and here, as he does elsewhere, plays a ruined, heinous nobleman who succeeds in selling Cooper, wealthy but uncultivated, a Louis XIV bathtub.

3. *Bluebeard's Eighth Wife* is a minor but endearing film, both for similar reasons. Minor because it is vulgar and frivolous. Endearing because it is completely implausible. If the film "works," it's really because of an optical illusion, for its accuracy (which is great) only exists for the duration of the screening, the effect of a frenetic momentum that, leaving one neither the time to breathe or to reflect, allows us to accept the unacceptable (i.e. if Horton wants to enter an asylum, the simplest way is to bark at the door). Lubitsch has rarely come so close to zaniness, to the wackiness celebrated by the Marx brothers, for example. Made by a man who is confident about himself and his merchandise, the film is no longer about focusing on a flame that consumes itself, but of gathering up, here and there, left and right, the sparks.

(*Cahiers du Cinéma* #198, February 1968)

Ernst Lubitsch, *Cluny Brown*.

1. Among remarkable films, we may distinguish between: a) those that give the impression—obvious and delightful—of the power of cinema (and cinema alone); b) those, on the contrary, in which cinema seems always to be lacking, lagging behind the world and itself, arbitrary and stiff. Nicholas Ray might have been talking about those films (which would be modern ones) when he said (*Cahiers*, #127) that he had always had the feeling that "we are only scratching the surface of the extraordinary adventure that is cinema." In that case, it is only a matter of marking the location of what is not yet or no longer there, or even of indicating the relief by the hollows, presence by absence. Unlike Lubitsch's other films, whose hidden face it resembles, *Cluny Brown* is a hollow (deep) and empty (remarkable) film, the only one that has made a performance (and what a performance!) of what others have avoided, for Ernst Lubitsch, who has tirelessly slaved away at giving the impression of sumptuous abundance and plentitude at every moment, loathed emptiness. And even as we watch his characters feverishly experience their worlds, collectors of pleasures for whom every second is theirs to conquer, the filmmaker directs all of

his energy towards filling that empty space to the maximum, filling that suspended period of time that is sometimes called a film. We recognize in it the aesthetic of maximum return. We also recognize the hedonistic morality that Jean Douchet (*Cahiers*, #127) spoke about with such certainty. But at the same time, as a result (for how to accumulate these pleasures?), we forget Lubitsch's films as soon as we've seen them (we know only that we have enjoyed them), in the same way that a meal, as wonderful as it may have been, cannot satisfy us forever (a scandalous possibility if there ever was one). This is also Lubitsch's greatest concern: that everything must always be redone (hence three monotonies at least: plots, shots, and characters), that a film must redo everything that the ones previous to it have already accomplished, that the pleasure should be intense but the film remain open, that the entire oeuvre should be a sort of permanent spectacle (Guitry once said, "I would like to be the one, the only one to make pieces that the entire world would listen to all of the time.") The filmmakers of ephemeral pleasure must endlessly repeat themselves, for if not, in time everything works out, which is to say that everything vanishes. This also evokes Ford's cynicism, or especially Hawks's, for whom one adventure never stems the tide of adventures (it isn't surprising, therefore, that Hawks is the filmmaker of repetition, the one most destined to plagiarize himself). Cynicism: Hawks erases a name on a slate, Ford says, "The world moves on," and as for Schultz, he is blunt: "Five hundred years from now, who will know the difference?"

2. But then it becomes surprising that Lubitsch made films anyway. A paradoxical oeuvre, if only because it exists. A film, we think, is the revenge of the limited on the without-limit. Before the first image, there was nothing; after the final shot, there will be nothing. What is important to see—all of life, in fact—finds refuge in-between, and the filmmaker is condemned to the most exorbitant of powers: ending it. And yet, here is a filmmaker (Lubitsch and other cynics) who thinks of an ending only as a suspension, of time as provisional, and theories as contradictory. A film ends nothing, compels nothing, says nothing. Observe the caution (cowardice?) with which Lubitsch not only recoils from marriage (or its consummation: *Bluebeard's Eighth Wife*) but also from physical relations, going so far as to make a film about their possibility, always deferred (*Angel, Trouble in Paradise*, etc.) One film

can only promise another film. *Design for Living* and *Angel*, those two masterpieces, are enormous parentheses in which the richness of every detail has as a consequence the inconsistency (or rather, the evanescence) of the whole: either by an overly rapid rhythm (the first) or by an extreme deceleration (the second, and also *The Broken Lullaby*). These films close up on themselves perfectly, beautiful but entropic. Films that are only films, carrying their law within themselves, otherwise useless (meaning it is useless to think we can talk about these films either in relation to their author—who is merely the supplier— or to their spectator—who is merely the consumer). Thus cinema is a luxury, a gratuitous activity, but then, paradoxically, the more gratuitous the film, the more thoroughly constructed it must be. The problem is less creating a coherent world than making it believable, in spite of everything. What matters isn't filming Ninotchka or Angel at the exact moment they embark on their futures, but to give the impression that we have seen those scenes, ever promised, never filmed. Lubitsch's cinema recreates life, just as cinema gives the idea of movement, through a phenomenon of retinal persistence. These are little more than shadows, that sometimes say more than shadows do, and sometimes far less (*Cluny Brown*, in particular).

3. A wanderer who is undoubtedly an impostor, a man of exquisite taste, defender of an art of living that burns itself out and disappears, and a young girl, a crazy ingenue lacking manners or taste, an amateur plumber lusting for a respectable life, Adam Bielinski (Charles Boyer) and Cluny Brown (Jennifer Jones) share for a short time a screen where they are united by a screenplay fantasy. Toward the end of the film, Bielinski suddenly decides to marry the young woman, who doesn't refuse. In the final shots, after Bielinski has—as they say—hit it big by writing a bestseller, they're very well-dressed and seem very happy. What strikes us about Cluny Brown: a) the story is unbelievable and the characters' relationships are barely described; b) Lubitsch, for once, has done nothing to disguise this lack of rigor. There are no more red herrings: what doesn't exist between the characters (for they are only shadows) doesn't have to be faked. *Cluny Brown* is the product in its package, pleasure without the forced smiles (did you think happiness was fun?), cinema without the advertising. The opposite of cynicism isn't tenderness, but indifference.

Thus it isn't Bielinski and Cluny who are poignant (although there is something touching about their attempts at happiness), it's the fact that a film exists—a bit of celluloid (1946)—named *Cluny Brown*. Cinema is indeed a luxury, the first of them all, a victory over the void. And it is as if the film itself were now suffering the same perils that it had previously only talked about. *Cluny Brown* does talk about pleasure, but a pleasure that has vanished or not yet arrived. It seems available, but it has been somehow lost, or become a vague projection. What we see looks like something that's happened between shots in other films: life advancing randomly, time wasted joylessly.

(*Cahiers du Cinéma* #198, February 1968)

NO GOOD DEED

Vilgot Sjöman, *I Am Curious (Yellow)* (*Jag är nyfiken—en film i gult*).

In which the French censors are responsible for turning an open work into a gaping wound. We will not address its second version. Suffice it to say that its emasculated result disappointed this critic as much as it did the pornographer. But the unedited version inspired commentary. It contains "erotic sequences whose frenzy never ceases to shock us." No doubt. But also: "Sjöman is a serious man, who portrays his era seriously." Probably because to him, filming is such a serious and *uninnocent* thing that it can only be earned, conquered after overcoming some obstacle.

Obstacles. It's for their sake that a film ought to be undertaken. They are the origin of Sjöman's films just as they are their limit, a limit he refuses to transcend for fear of finding himself charged with the useless freedom that we have seen is the subject of all of his films. And so it is not a paradox to call him serious, even puritanical (filming not out of love but out of a concern for propriety—in the sense of what is "proper" to do), for he needs taboos most of all. Sometimes the taboo is the theme itself—incest in *My Sister, My Love*—but more often what inevitably offends the censors are the details (*491*). And if the censors give up, Sjöman is the one to place obstacles on his path that

will make him difficult, hence make him legitimate. *I Am Curious* is at once the story of the failure of a plain Jane (Lena) in 1967 Sweden, a story destined for all kinds of mutilations, and the product of a difficult and joyless shoot. The film becomes *obstacle number one*, a necessary chore, that thing that is neither a mirror of life nor behind the scenes of art, but the proof of their incompatibility.

There are also obstacles on a minor scenic level, as if they were necessary to move the plot forward. Jevtusjenko faces a hostile crowd: his microphone doesn't work. Börje makes a visit to Lena's father but only has eyes for the daughter. Later, while walking through an abandoned village, the two protagonists talk about different things at the same time... Always impediments, interference, as if life were censoring itself: two actions hide each other, one (but which one?) always intended to hinder, hide, or enhance the other. Without this principle, there can be no scene, no film, no cinema (hence the importance of shooting itself, in that a shoot is by definition the space of the convergence of rival realities, reality and fiction, actor and character, etc.)

We see then that, indissolubly linked to what he denounces (censorship, comfort), in other words a moralist above all else, so serious that he becomes miserable, cheerlessly trampling on taboos that gradually give way, reclaiming for each film its share of impossibility that good conscience requires, Vilgot Sjöman resembles a modern filmmaker—in that he constantly questions cinema's powers—but he gives modernity a theoretical and lifeless vision that leaves at best the bland aftertaste of a good deed (in capital letters) performed under duress.

(*Cahiers du Cinéma* #199, March 1968)

Richard Brooks, *In Cold Blood*.

It's hard to know where to place Richard Brooks, 1) because ambiguity (is mankind good? is mankind evil? both, perhaps) has always preoccupied him, 2) because another ambiguity, one belonging to American cinema, nullifies his film (or almost). Confusion of which Brooks would be the (perfect) victim, rather than the perpetrator.

Between the monstrous true story that obsessed Truman Capote and the laborious psychological film that Richard Brooks has directed lies that massive recovery work that is the essential quality of American cinema. The subject's power was that two events (a murder, then the execution of the murderers) were equally incomprehensible, arbitrary and unacceptable: Brooks's work was to fill in the gaps, multiply the explanations, in short pass from the "irremediable" nakedness of the events themselves to a good Hollywood screenplay. The film is named *In Cold Blood* and in it we see two petty thugs assassinate four people in a hysteric rage. Such a discrepancy (the way in which film was released to the market) is surprising enough. But it undoubtedly reveals something more serious: American cinema's inability to assume a coherent message (particularly in "message" films), whatever it may be, the impossibility of saying something precise, the eternal appeal to metaphor and implication. Why? Because American cinema relies entirely—and without remorse or distrust—on the truth of the spectacle, a truth that we know is almost useless, as it has no other end but itself. Brooks believes that the more he translates things into images (to the point of indefensible flashbacks where the Brooksian desire to explain at all costs has something pachydermic about it, evoking the "prediction of the past" that was so dear to Paulhan), the more truth he will achieve. A strange calculation. It's not that the Spectacle is Evil (even though it has become so, somewhat, on this side of the Atlantic), it's that it is at the core of the message of American films (on this point, we may look to the films of Leo McCarey), a message that excludes all others, betrays them, renders them strange and ambiguous. An ambiguity that Brooks seemed on the verge of mastering, at least in his only great film (*Elmer Gantry*), before he sank into triviality (*The Professionals*). *In Cold Blood* illustrates American cinema's problem with engagement (if only in its desire to "make people think"): violent films against violence, militaristic films against war, racist films against racism, etc. *In Cold Blood*, designed to disturb, reassures, designed to bewilder, dots every i (and uses a hammer to do it), having wanted to say that A ends up at B, out of innocence, stupidity, or sincerity, what's the difference…

(*Cahiers du Cinéma* #200, April–May 1968)

THE PINK DESERT

Pier Paolo Pasolini, *Teorema.*

It is increasingly clear that a film only ever tells the story of its own genesis (shooting, prepration, production).

The originality of *Teorema* is that it lays this little-known phenomenon bare.

How? By no longer voicing—implicitly—the method of its fashioning but by becoming—a rarer thing—*the metaphorical account of its viewing.*

Why? Because with Pasolini, one determines the other, as every film is degraded, contaminated in advance by the reactions it is sure to generate, includes them all in order to evade them. Hence *Teorema* is a film that almost doesn't exist, a tautology that shows only the faces of the people who are watching it, at the moment that they watch it. A film to which the question of value barely applies (is it good? is it bad?). Ultimately: a mirror facing the audience that returns us to our condition as travellers. In order to speak appropriately about *Teorema*, let us (us too) posit a theorem: *The visitor (T. Stamp) = the film (Teorema), the family = the audience (you, me, etc.).*

Hence a reading on two levels.

Before

We note that the family is anonymous: no first names, no last names.

But while anonymous, it is still of a type: bourgeois, idle, dissatisfied. A fragmented family: each member is shown alone, outside of the house, in silent, black-and-white shots. The audience is also, by definition, anonymous. Yet it is a *certain kind* of audience: the kind that has time to kill and eight francs to give to the Médicis studio.

The audience: a provisional and artificial community surrounding an object, a pretext, a film.

Before they enter the theater, the audience members are merely stray individualities, scattered through a dull gloom, dissatisfied, as they have come to feast their eyes (or souls) while sitting in the dark.

And so we speak of the audience as a "large family."
A furtive and rediscovered unity—because of a film.
Guilty of passivity, the family (the audience) waits.

During

One day, a terse and mysterious telegram (the announcement of a scandalous film) arrives.

No question of avoiding it (*Teorema* is a must-see film).

The family welcomes the guest (the audience stampedes towards *Teorema*).

And so, now that the family has come together (the audience assembled) for the first time (at the meal), the visitor may arrive (the film may begin). Colors—real life—appear.

But which visitor? (Which film?) Let's name some more concordances: scandalous, perhaps, but pretty to look at, seductive.

We also note that those who hate *Teorema* are shocked that anyone could find Stamp so beautiful.

The visitor is not without his charms—nor is *Teorema* a badly photographed film, offensive to the eye.

The visitor's personality is hardly brilliant (in fact, he doesn't have one)—and neither is the film's "style": meteoric, but neutral.

Better still, neither of them take the initiative; it's the family who throw themselves into the visitor's arms, the audience who has come to feast its soul (or eyes), who project their fantasies onto *Teorema*.

Militant passivity: they want to be assaulted.

The visitor and the film *lend themselves* to those plans—they are hardly contrarian: accepting every liaison, in every sense of the word.

After

Until now, the parallel has played itself out nearly exactly.

The family faces the visitor just as the spectator faces *Teorema*.

The relationship—it must be noted—is sexual.

We can see a sort of Pasolinian *ars poetica* in it (this is fairly obvious).

But also a relatively apposite perspective on the condition of the film's spectator: a man in a hardly innocent darkness.

Yet we find that once the visitor has left, the film continues.

The family is returned to its solitude; the public *will* be.

But in this delay, this time lag, there is room for a second act: no longer the metaphorical account of the film's viewing, but the *anticipation of reactions* (critical commentaries)—once the viewing is complete.

Have we ever seen a more reflexive film?

The desert

The visitor's departure (the film's end) leaves the family in complete disarray (the spectator perplexed).

Unglued—meaning that nothing binds them any more.

The lights come back on, unity is once again lost, the house (the movie house) deserted.

Each person then tries to understand what has happened to them (what they have seen).

For each particular fate (religion, art, sex), one type of interpretation (according to a religious, artistic, sexual grid).

How can we not see that the different interpretations of *Teorema* are *already* the different paths that those who have gone through the same experience (the family, now splintered) choose when it ends?

As if Pasolini didn't know that people would speak about his film in either religious (the father, the maid, grace, Catholicism, etc.), "artistic" (the son, modern art, art films) or pornographic (the mother) terms. Without speaking of those who refuse to speak (the daughter, aphasia). We enter into the domain of *commentary*, where no one is wrong, or right.

We then observe that a film that so directly takes interpretation as its subject ought to have exempted its audience from attempting it.

Particularly if the author shows them (ironically?) how it should be done.

We also observe that interpretation is a privileged theme for Pasolini, whether it be *The Gospel* (already itself…) the riddle of the sphinx or the language of birds.

Always—we must interpret.

Hence the desert—the (Biblical) image is clear: God has withdrawn and started writing, that infinite movement, without end and *without guarantee* of interpretation.

A desert where every route is always possible, for none were ever charted.

Pink?

Everything would be fine if this parallelism—which we have decided is the point of the film—could be followed through to its end.

But is this possible? (No, of course.)

Pasolini can, with some credibility, show his spectator before and during the screening, but he knows what happens *after* a scandalous (but only slightly scandalous) film: a ripple in the water's surface, the ten best films of the year, cine-clubs, culture…

In short: the utmost futility.

For the same movement that scatters the family with no hope of return scatters the audience as it leaves the theater, already talking about *Teorema*.

On the one hand, the family is forever broken, driven to extreme solutions.

But the audience?

Because it is certain that the audience will return to the cinema (will not change), we cannot see this parallelism through.

Teorema will not be the very last film.

Thus the family's fate is for Pasolini a reflection of the audience's reaction—but a disproportionately magnified, exaggerated reflection—in short, *utopic*.

In the second half of *Teorema*, we think: how beautiful it would be if a film had an action.

The family is the symbol of a good audience—it will no longer go to the movies.

But what is symbolic is always fragile—appropriation (reaction) lays in wait.

And so?

Finally the possibility of seeing *Teorema* as a reflection on the role of the filmmaker.

Pasolini, for example.

Too intelligent to be without remorse, purveyor of drugs (art films—also and especially).

Too complicit with what he opposes.

Doomed to please, even (and always) *for the very last time.*

(*Cahiers du Cinéma* #212, May 1969)

Tang Shu Shuen, *The Arch* (*Dong fu ren*).

It is possible that *The Arch* is a film of a rare sensitivity and that Miller finds it sensual. We will not debate that here, but because Mizoguchi and the eternal Orient have been persistently cited, we are rather surprised that the debate has remained there, more concerned with the bottle (with its label) than with intoxication. But if *The Arch* resembles *The Empress Yang Kwei-Fei*, do we think that Tang Shu Shuen approached her film in the same way that Mizoguchi approached his? If so, we would be wrong. Mizoguchi turned towards Japan's past, which he knew well and which inspired him to make a certain genre of films (admired in the West for "their slowness and their subtlety"); Tang Shu Shuen, a Formosian, raised in contact with the USA, exiled from a divided country, refers 1) to a historical past as a sort of revenge of the present; 2) to a traditional cinema (as a revenge of what?). One will object that she doesn't completely succeed and that the (limited) interest of *The Arch* is precisely that, for Tang, as for us, in 1969, Mizoguchi and "the dated Orient" are always out of reach, out of *this* reach.

(*Cahiers du Cinéma* #214, July–August 1969 1969)

Sergio Leone, *Once Upon a Time in the West* (*C'era una volta il West*).

Once Upon A Time in the West marks the apogee (and perhaps the decline) of a series of films by Sergio Leone whose relevance is a priori enormous: they form the first even slightly consequential attempt at a *critical* cinema, meaning that they are no longer engaged with *reality* (even if the recourse to historical truth—which Leone knows well—has a strategic value), but with a genre, a cinematographic tradition, a global text, the only one that has known worldwide distribution: the Western. That is no small thing.

How is a critical cinema possible? Many years ago, Americans abandoned the beatific and racist Western (DeMille), after which, beginning in the fifties, came an onslaught of humanitarian (Daves) or crepuscular (Ford, Peckinpah) films. Criticality, but not a critical

cinema. That could only be developed from the outside. But from where? From one of the few countries exhibiting a serial, parallel, traditional and popular cinema: Italy. Or, more precisely, Cinecittà right when the peplum begins to falter, undermined by parodies (again, Sergio Leone). This is the key: not that some demiurge decided one day to create a critical, subversive and vaguely political cinema, but that this cinema is *primarily* (or in the final analysis) the product of an economic evolution. For Cinecittà, it is solely about re-investing characters, sets, extras and capital in a new film genre. It is about amortization. These base, grossly commercial origins make (will make/would make/will have made: time will tell) the Italian Western great. For two reasons (at least). 1) Because until now there have been bad reasons for liking B movies and they need to change. Let's admit that in certain countries where film constitutes an enormous industry, the B movie stakes out a kind of *lumpen-cinema*, adored in a snobbish, contraband way (in a sort of cinephilic workerism), unable to claim any *quality*, or even a clear awareness of the elements (themes, situations) it handles because that (awareness) is reserved for quality films: Zinnemann, let's say, rather than Dwan. 2) Let's admit that something is possible in Italy today that Hollywood was unable to accomplish: the awareness of that lumpen-cinema, effecting, under the mask of old forms (hence without rejecting its popular character), a euphoric work of deconstruction. "A force would not survive if first it did not borrow the face of the previous forces against which it struggles" (Nietzsche).

Such work can be completed on one condition: that the Italian Western retains its *mass* character. It is no longer about succumbing to the unitary obsession, demystifying an entire tradition, an entire set of conventions and reflexes in *a single film*. The practical results of such an operation are nonexistent even if the films are beautiful (c.f. Tourneur). This means that the Italian Western must be produced en masse and for the masses. And this despite the biggest hurdle: its co-optation by quality cinema (the art film, the bourgeoisie), which is the case, today, with Sergio Leone.

As for the methods of this work, they are beginning to become familiar (but we must admit that they have only been seriously utilized in Leone's films, and in those of the mysterious Sollima). They

consist of sometimes revealing what the classic Western obscured, sometimes in exaggerating what it revealed. The power of Leone's films is in *extenuating* the habitual rhetoric of the Western, in making overkill the equivalent of a negation. In that respect, it would be interesting to show how, to the traditional Western based on displays of bravura (*High Noon, The Tin Star*), Leone opposes an interrupted series of high points that reciprocally annul themselves: a minimum of meaning corresponds to a maximum of intensity. It is also interesting to see how this cinema claims a *choice of methods* (instantly called gratuitous by a conformist group who should urgently read the decisive texts of J.J. Goux), how at various times strategic use is made of beauty (actors and landscapes), of justice, of one narrative style or another (ellipsis or great length). (And this in the case of Sollima and the magnificent *The Big Gundown*). Etc. As for Sergio Leone, who was barely mentioned here, it is *equally* possible to begin to decipher an *oeuvre* that is already heavy with tics and tropes.

(*Cahiers du Cinéma* #216, October 1969)

Primo Zeglio, *Killer Goodbye (Killer, adios).*

The best Zeglio film in some time, even if Fanny Rand only dies (strangled by a silk stocking) an hour and a half into the film. Where Leone ruins (by taking it to the limit and *beyond*) the usual division of characters into good and bad, Zeglio (along with a nascent, slightly picaresque strain of the Italian Western) *falls short* of it on purpose: gradually erasing, as the film progresses, said division (an erasure that was at the heart of several of Dwan's great and somewhat forgotten films). As a result, the characters, neither good nor bad, lose interest and seem rather surprised (and even slightly embarrassed) to be embarking upon such a complex (and dangerous!) adventure. Each new scene forces the feeling that anything (and nothing less) could happen, but anything, once it's happened, doesn't feel like much.

(*Cahiers du Cinéma* #217, November 1969)

Pier Paolo Pasolini, *Pigsty* (*Porcile*).

This new *meaning making machine* implements a relatively simple play on words: the words *corps* [body] and *porcs* [pigs] in an anagrammatic relationship, two different distributions of the same letters, of the same Letter (we will see which one), just as *Porcile* presents itself as the double narration of a single event.

1. What do *Porcs* and *Corps*—besides letters—have in common? Both are objects of desire: bodies are made to be loved and pigs to be eaten. But on one condition: that they be despised because of it. Especially if they are—as is the case here—*entirely* dedicated to pleasure, "prostitutes": every body part is (more or less) erogenous, every body part can (more or less) be eaten. We recognize the Christian morality that makes resentment the condition of desire, the backdrop of Pasolini's entire oeuvre. *Corps* and *porcs* will therefore be the object of the same occultation, the same depreciation: hidden, corralled, denied, reviled, censured. Too familiar a tale to dwell upon.

2. But, in *Porcile, a young man, instead of loving bodies, eats them; another, instead of eating pigs, loves them.* A mistake of language and thus of film. Their transgression is first the fortuitous result of an inversion of terms, of misreading, an error of dissemination for which Pasolini assumes every consequence, attentive to the obligatory emergence of (at least) one meaning. The scandal is not so much the gravity or horror of the themes that are addressed, but that they (cannibalism, zoophilia) are raised unnecessarily, in *jest*.

3. "I said: God, if he knew, would be a pig. The one who will push this idea to its limit (he is probably dirty and 'unkempt' right now), how human would he be? Beyond and overall...farther and farther out... he will have himself, himself in ecstasy above the void... And now? I tremble." (Georges Bataille).

4. Condemned and on the verge of death, Clémenti, in a magnificent moment, effectively says, "I killed my father, I ate human flesh and I tremble with joy." Furthermore, Léaud's father gladly compares himself to a pig. If we agree to see only the image of the Father behind *Corps* and *Porcs*, the two elements of the allegory become clear, but inversely so. In the first, nothing prevents us from seeing in Clémenti's character Christ *refusing* to be the son of God: instead of

offering himself to the faithful (the eucharist), it's he who eats the others (and even garners several disciples). Strange reconciliation between the crucified and Dionysus. The death of Logos corresponds with the death of the Father, hence the silence of a film without words. On the other hand, in the Léaud episode, logos, discourse, logorrhea triumph; through his love of pigs, Léaud affirms his submission to the father (a Nazi). He will also be devoured.

<div align="right">(Cahiers du Cinéma #217, November 1969)</div>

George Cukor, *Justine.*

1. Durrell's admirers will be disappointed by the singular *flattening* job that has been performed on the first movement of the famous quartet. And they will be right (to be disappointed) and wrong (to have hoped for anything). That the book's qualities didn't translate well to film doesn't really matter. But by trying to illuminate what was in shadow, to edit what had been abundant (we see neither Clea, nor Scobie, no mention is made of Arnauti's journal), to make things perfectly clear, to draw from a book that demands to be read on multiple levels a story that is dull and linear, intended for simpletons, the authors of this digest have realized the *opposite* of their project: they have made the book ridiculous. This is all the more inexcusable because the choice of actors is rather good and, in certain cases, excellent (Karina, Noiret and especially Bogarde). We refer fans of the quartet to Durrell's statements in these very *Cahiers* (#185): "The high cost of filmmaking obligates the director to think about the crowd. It's a drug for the masses... The general idea is to take someone else's masterpiece (a novel) and crucify it. The modern filmmaker is never so happy as when he is urinating on someone else's work."

2. Cukor's admirers will be disappointed by the singularly *anonymous* work of their author (despite a few flashes) and they will be right (to be disappointed). They will say, of course, that Cukor—having replaced Joseph Strick at a moment's notice and shooting a film that he hadn't wanted (only consented) to make—can't be held responsible—but is that *really* adequate reason? Take a relatively

personal filmmaker, skilled in disseminating, from film to film, the idea of a "world," a world saturated with sexuality, terribly rich and precise, that includes transvestism, women seen as objects or as frigid, shabby or lost characters, the confusion of minds, bodies and sexes (all culminating in an apex of cruelty with *The Chapman Report*, but already in evidence in the very unknown *The Model and the Marriage Broker*). Fine. This filmmaker (George Cukor), big budgets at his disposal at the end of his career, is compelled to shoot subjects that are tailor-made for him, *model* Cukor (*My Fair Lady*, *Justine*), but from which he creates almost entirely impersonal films. Their failure thus obliges us to ask with greater rigor *what kind of successes* were had with *Camille* or *Gaslight* or *Sylvia Scarlett* (which we maintain is one of the most beautiful films ever shot).

3. Believing that the great American filmmakers speak only through implication, through watermarks, we (thematic critics) eventually hypothesized the things (sexual things, obviously) they seemed to be saying. And yet, those things weren't actually very interesting, for once they became explicit (c.f. again most recently, Mankiewicz's *The Honey Pot*, a reflexive film if there ever was one), they seemed quite tame. They only had value *because* they were implicit. Watermark means: a figure visible as a transparency through the thickness of certain papers. But how is this kind of vision possible? How do we articulate these two elements (the paper and the watermark, the manifest and the latent) that have no existence or value *outside* of that relation? It is naive to think that as it "evolves," a work such as Cukor's would end up explicitly stating what it had until then only implied. Assuming that, rendered more lucid by age or the evolution of cinema that surrounds him, Cukor wants to reap— *head-on*—the lesson of his oeuvre, to push logic further, to be his own critic and heir, he could only find success by dynamiting a certain way of making films (Hollywood's), a way that is his own and *outside* of which he has *nothing* more to say. Certain films (such as *The Chapman Report*) have been able to give some idea of that kind of revolution, a return to zero, but at the expense of a complete *hopelessness* in the context of which *Justine* now seems vapid and irrelevant.

(*Cahiers du Cinéma* #217, November 1969)

Stanley Donen, *Staircase.*

To explain the acclaim surrounding this film, a few remarks:

1. *Staircase* does not mark a major break for Donen—no matter what he says—simply the return—with extra bitterness and rigidity—to an older reverie that has been somewhat abandoned these past few years, and to which we owe some great films (*Kiss Them For Me*, *Indiscreet*) where frivolity was the most profound thing and nostalgia the most certain. There, he was *already* talking about aging (and more eloquently), about the need to create an ending, the intolerable choice that one day must be made: whether to grow old alone—or with other people. We saw in those films (*It's Always Fair Weather*) great friendships that dissipated because they weren't sustained, where absence was synonymous with forgetting and presence with embarrassment. Fifteen years later, and on the condition of moving from the (already ambivalent) theme of friendship to the more direct theme of homosexuality, Donen finally places himself on the other side of the mirror, his mirror: for *Staircase* only demonstrates what his earlier films had to conceal in order to remain light-hearted musicals. Is that enough to call it a major break? Ultimately, Rex Harrison's sway in his step is perhaps the most terrible critique of Fred Astaire's, and the prologue the most derisory homage to musical comedy, but that is still not enough. Donen should make a second *Singin' in the Rain* that explains why, after a certain point, musical comedy (from the fifties, *his*) was no longer possible.

2. That said, it may be that homosexuality is still a taboo subject. And so we see the *use* of such a film: to return the seen to the already-seen [*déja-vu*], to say that a couple is always a couple and that those people are indeed human and unhappy. Didn't we know that? Any film that gives such a feeling of regained security deserves to pass as a masterpiece.

(*Cahiers du Cinéma* #217, November 1969)

Barbet Schroeder, *More*.

Drugs are certainly not the real subject of this film; they are, at most, its calling card. *More*'s postponed release, simultaneous with Cayatte's, will allow symmetry aficionados to compare the two: one will be true (authentic) and the other false (manufactured). It is obvious that Barbet Schroeder's film is infinitely more *true*. But what is cinema's truth about drugs?

1. Can we be sure that we are right when, speaking about drugs, we make them a means *towards* something, a bridge towards something else, the key to a beyond, a stage in a personal itinerary, a richness that comes to compensate exactly for the need that one *already* had (such a forecast of the past is seductive, but isn't it always *afterwards* that need begins?). Not that all of this is false: it is, *at the moment*, the only way that the act of drug-taking can be represented, the only (very ideological) reasons we have at our disposal, for it is true that we prefer to justify our actions for inadequate reasons rather than for no reason at all. But why would these reasons be the same for someone making a film about drugs? And if that is indeed the case, wouldn't it be because he approaches his activity (filmmaking) in the same way that his characters do theirs (drugs)? Didn't Mourlet write about cinema: "Every oeuvre tends towards complete wantonness: diamonds and screams and dances of joy"? It remains to be seen...

2. What is certain is that we thereby condemn ourselves to fall back into a well-known problematic: the *Quest*, where drugs fill the box left empty by Adventure, Love, God, Art, what have you. Hence a general feeling of familiarity towards a film that seems to argue that this is nothing new, that drunkenness hasn't changed, only the bottle. Thus we have removed every tool we have for actually talking about drugs, right at the moment when the phenomenon—because of its very generalization—threatens to change its meaning before our very eyes. Also at a time where curiously a review (*Les Muses!*) sells by proclaiming that art "isn't expensive." Neither is D, thanks.

3. That said, *More* has another—more specific—subject. For if the film seems so naively engaged in that problematic, it gives itself—by taking responsiblity for it—the means, if not to escape it, at least to designate it *as such*. Let's see if it succeeds. But that implies that we

understand this mock-Luxembourgian film as a great German film (à la Murnau) that is less about drugs than about a certain way of encountering them—fatally—when one comes from Lübeck and goes towards the sun. It could be that Stefan has—like Hyperion—the feeling of leaving Kiesinger's gray and greasy Germany for a newer, happier Greece. He likely sees himself as the last of the German romantics, oscillating like Ulrich between mathematics and the "other state," bearer and victim of those unitary dreams, all of those dreams that made and unmade Germany. Let's say that Stefan has read (at least) Hölderlin, Novalis, Nietzsche and Musil. And that cultural invention will make him see his life as fate, his misery malediction. Because he endures it without ever questioning it, at no point can he ever escape it. His voyage to the South is a false voyage, an illusion. He finds in Franco's Spain and in Dr. Wolf's features the things that he had fled. Conveniently, Doctor Wolf, who was (who is) a Nazi, deals drugs. We suppose that he too has read Nietzsche, as wrongly as Hitler did, no doubt, but that (and the tourists), is also, is *still* Germany. *More* is the story of settling scores. It stays in the family.

(*Cahiers du Cinéma* #217, November 1969)

Sam Peckinpah, *The Wild Bunch.*

What can today's Hollywood *do?* Reiteration, reconstruction, but certainly not criticism. We leave that to the Italians. By criticism, we mean the examination of what make yesterday's foregone conclusions possible; this implies that we find ourselves (somewhat) on our adversary's territory. Sam Peckinpah was born on that territory: an auteur late in coming to a cinema without a future, but one of the rare few to appreciate that lack of future from the start, to make its statement (*Ride the High Country*) and its imperative (*Major Dundee*) *personal,* to take charge, at the moment they in turn become clear, of the contradictions of an entire cinema.

C. Depèche, writing about *Major Dundee,* has noted that it "does not have, strictly speaking, one storyline, but two, three, or more, intertwined. For here, everything is immediately abandoned,

most often for its exact opposite." (*Cahiers*, #168). Arguably, in *The Wild Bunch*, we see this process intensify: everything is immediately *parasitized*, that is to say, deferred, turned inside-out by everything that, by remaining exterior to it, coexists with it. In this sense, despite its length, the film says nothing that wasn't already in the sequence before the opening credits. Let's note: 1) The increasing appeal, in all of commercial film, to these types of introductory sequences, actual previews for the film within the film that, by trying to introduce the picture that follows in several minutes, give such a perfect idea of it that the picture itself becomes pure entropy, assimilated before it is even seen; 2) That there could be no better way for the authors of these films to demonstrate the futility of their products, and if it is true that Peckinpah wanted to make that futility a personal theme, 3) It comes *too late*. His problem is the problem of the generation that preceded him (Huston's, Ray's, or Preminger's) and that, unable to reflect upon its relationship to Hollywood (as a specific approach to making films, to money and ideology), had to metaphorically pass that inadequacy on to the themes it addressed (failure, derision, the entropy of all human enterprise, of every mise-en-scène, etc.).

In this film, as in in the others made by our auteur, the time provided by detours and parentheses ought to be time for reflection, if not understanding. But what must we understand? What lesson does Deke Thornton (Ryan), who becomes the film's first spectator through a trick in the screenplay, learn? Something relatively mundane, in truth: that before it framed a mythology, the West was a political struggle, in which good and bad, bandits and bounty hunters served interests they didn't understand, played the game of people they didn't know. If Pike Bishop (Holden) and his bunch still occupy the center of the film, if they are still its "heroes," it's no doubt out of habit and a concern for profitability (we know that ever since Hawks, *professionals* sell better than loners), but also because they accrue value as an example. Simply put, the meaning of that word changes: they are no longer an example to follow, but they are to be *made an example of.* All of the novelty of Peckinpah's films resides perhaps in this semantic shift. This has formidable ramifications that transcend Peckinpah's individual case, and can be

recognized in every film today that still centers on the actor's *presence* (cf. in France, the films of J.-P. Melville and an entire concept—idiotic—of virility), or on the nostalgia of that presence.

That presence was inseparable from an idea of the Hero, emanation point of all passion and worth, master of the game but himself out of play. Once the hero is included in the (political) game, caught in a web in which only the collective (hence the impersonal) matters, what's the use of continuing to get "top billing"?

This undoubtedly serves to reestablish, through the group, what we thought had been overcome. Admiration for the hero is replaced by a sort of sympathy mixed with pity for the anti-hero, admirable for moving unfazedly through a story that he will never understand and of which he is the victim, graced with a presence that is henceforth without an object, individualistic down to the slightest bat of an eyelash but already insignificant, ridiculous, destined certainly to disappear, from which he draws more pathos than you could imagine. A (suspect) pathos that seems to be the hallmark of Hollywood's most recent productions (see Brooks and even Penn): on its end, the "cinema presence" aesthetic makes clear what it really is: an art of *paranoia*.

(*Cahiers du Cinéma* #218, March 1970)

George A. Romero, *Night of the Living Dead.*

Not enough attention has been paid to American cinema's persistent, underground love for the apocalypse. As if too much self-righteousness could only be extended by evoking the most definitive horrors, horrors accompanied by a certain kind of pleasure, as we had previously seen in the films of DeMille (or in King's *In Old Chicago*, Van Dyke's *San Francisco*), a filmmaker of catastrophe and disaster, themes whose remarkable severity cannot be overlooked and whose yield is not insignificant, as the photogeneity of total destruction is complemented by the secondary benefits of the characters' rehabilitation (those characters who survive it, at least), characters who, after having been broken, are more sublime and human than they ever were before.

Major natural disasters and the crucibles that a shallow society deserves: such was the case with DeMille, as it was later with Hitchcock, or with the low-budget sci-fi films suddenly made possible, towards 1950, by the idea of an atomic end, the abrupt mutations of nature in revolt, aberrant and monstrous, the always possible eradication of mankind, etc. (*Five*, *Them!*, *Body Snatchers*, etc.). And yet, here as elsewhere, the apocalypse was a disappointment because mankind, having been stupid enough to deserve it, was also smart enough to stop it, opposing it with a united front from which, all differences having been temporarily erased, an overwhelming sense of humanity emerged. Humanity per se, meaning not monstrous.

If it is true that Romero intends to keep his distance from that cinematic tradition, we must acknowledge that he begins by respecting it. The script contains no surprises: as an unanticipated aftereffect of a botched space probe, the brains of the most recent dead are reactivated, and the cadavers take advantage of their return to life to feed on living flesh. Appropriately, the generality of the phenomenon is rendered by the choice of an exclusive space—an isolated house that is attacked by the monsters overnight and eventually invaded—that is connected to the outside world only by a television set. After a brutal night, while the living dead die again, the film's hero and sole survivor, a Black man (Ben), the director and heart of the resistance, is mistaken for a zombie and is killed. This would simply be a ludicrous joke if the following shots didn't contain photos of his corpse on the front page of the newspapers, photos of a model zombie.

Here, then, we have a simplistic, tacked-on ending that does little to convince us. Because of it, we are suddenly miles away from the pleasant feelings we had anticipated, and forced to question the real subject of the film, which clearly is not zombies, but racism. Because of it, a retrospective reading of the film seems legitimate. And yet, such a reading, if we were to attempt it, would have nothing to draw upon, wouldn't mitigate the film's heterogeneity, heterogeneity that is the force of a film whose conclusion serves as an answer to a question that hasn't been asked, the denunciation of a problem that was poorly stated. For not only is there no mention of racism in the film, but during the most violent clashes between Ben and Cooper (white and despicable), it is frankly unbelievable that Cooper wouldn't resort to

using racist slurs. Instead, it is as if throughout the film the characters and the filmmakers consider Ben as simply a man, nothing more, without his skin color causing any problems for even a second. The problem is assumed to be resolved, even transcended. And it is assumed that the spectator will blindly follow, thrilled that he may enjoy his tolerance and generosity of spirit at such a low cost. Everything seems to allow for a humanizing reading of the film that Romero absolutely facilitates before he parasitizes it and calls it what it is: a way to invoke the monstrous in order to avoid speaking about the simple differences that exist between men, to obscure them by confronting them to a difference as enormous as it is imaginary.

One might say that this gives too much credit to Romero, whose film is clumsily shot, awkwardly acted and as for being scary, completely ineffective; it is enough for us that the film produces this call to order.

(*Cahiers du Cinéma* #219, April 1970)

Francois Truffaut, *The Wild Child* (*L'Enfant Sauvage*).

With Truffaut, with each new film we demand to discover a "tone" that would be his own, and for which *The 400 Blows* would have supplied the first model. But what is a tone? How do we treat a word that is so recklessly used that it becomes synonymous with the ineffable? That Truffaut find it essential with each new film to invent a new style of *credibility* seems vitally important and directly concerns *The Wild Child*, despite the fact that he needs it so much, for it is also clear that Truffaut will spare nothing to wring that credibility's neck.

It's easy, apparently, to shudder at a phrase such as *enfant sauvage*. The catapulting of the two words lends a sense of fact to incredible connotations. But once those words are spoken, who would have imagined *that* particular way of running, those scars, those screams? Have no doubt: the audience who invests in seeing a major humanitarian film is not very different from those characters who, in the film, are enchanted by the fact that the savage is able to appreciate the capital's beauty. Why shouldn't it surprise us: we are not accustomed,

critics along with everyone else, to seeing feral children. Thus a dangerous consequence: the spectator simultaneously discovers and does not discover, *sees and does not see*, for at the precise moment he sees the shot of the child galloping on all fours, he says to himself, "Of course, even though I never could have imagined it, the scene could hardly have been filmed any other way." And so the film plays on the gap between two words that create an entire agenda, always exact and always slightly prosaic, essentially: Itard's text. A gap to which we must return, because Truffaut always returns to it.

Second consequence regarding "tone." It is impossible, despite Itard's warning, for Truffaut's images always to be on the same *level* of accuracy. For he has never seen a feral child either, and his direction has little to draw upon, and a feeling runs through the film that it is a reconstruction, as faithful as possible but also arbitrary, that there are moments where the child is more "feral" than others when he is not "feral" enough, when the question arises of the documentary (truth) of the slightest gesture. Because, and this has no doubt always been at the heart of Truffaut's work, for the feral child's every step, an entire gamut of gestures are possible, plausible, acceptable, not only one. There is not only *one* correct word, one correct gesture, but every word, every gesture possesses a margin above and beyond which it no longer belongs to the film, a margin in which there are an infinite number of positions. Hence the constant impression of discrepancies too minuscule to be described, of slightly divergent accuracies, of a *zone of uncertainty*. A "tone" is perhaps nothing more than this.

We've caught a glimpse of this condition: that the referent not be too tyrannical, that for such an exceptional situation we only have a few pages by Itard. If *The Wild Child* is an important film for Truffaut, it is because for the first time nothing escapes that condition, in the film's conception as much as in what is writ large within it. For what is it about? What is the goal pursued by Itard in the film, a goal so essential that nothing is said about his final failure: to compel the child to establish an equivalency between the word (written and spoken) and the thing (shown), to compel him also to fill a gap, yawning when the film begins, less so when it ends.

But that's not all. Itard learns of the child's existence from a newspaper story. Immediately, and *without even having seen him*, he forms

his project (and later on, consistently affects that he does not see him, or sees him as if by chance. Re: on such a denial, see J.-P Oudart's article). In Truffaut, we recognize this eagerness, this rashness as the impetus for all fiction. Intersubjective relationships are always created as fantasies, outside of any actual seeing, any real encounter. Jules and Jim fall in love with Catherine, whose "archaic" smile they know before they have seen her because they've seen it on a statue; the Bride murders men she doesn't know; Belmondo marries a woman he knows only from a (fake) photo in *Mississippi Mermaid*. Each film stages the *temporary lack of a referent*, the momentary eclipse of every guarantee and its slow reinscription in the film as it progresses.

Credibility is then the major problem 1) for Truffaut vis-à-vis his audience and his (enviable) position of being an (humanitarian) auteur; 2) for certain characters (the Siren/the Child) forced to imitate a model they do not understand and that they—they too—must reconstruct in order to occupy for good the empty space into which the fantasy of the Other (Belmondo/Itard) invites them. It's a question of learning a text by heart, of being able to recite it perfectly, not of understanding it (perfection is not truth): ultimately, the characters of *Fahrenheit 451* become their text, filling in, as much as possible, the gap between a *written promise* (here books, there a statue, photographs, a newspaper) and the *play* in which it is kept. Passage from writing to speech, from the role to the actor who assumes it.

Truffaut offers two outcomes for this passage that only seemingly oppose one another. Sometimes the actor never manages to become his role, usurps the empty space for a moment before being chased out of it (Catherine in *Jules and Jim*, Denner in *The Bride*, Deneuve at the beginning of *La Sirène*). Or else, the gap is filled *in extremis*: the actor and the role become one, everything that had been disjointed finally coincides: fantasy and reality, signified and signifier (Deneuve at the end of *Mermaid*, the Book People). In both cases, what is sought and always *gained* is a stabilization, the definitive anchoring of meaning in a single sign or in no sign at all: the space is left forever empty or forever occupied. With *The Wild Child*, Truffaut ceaselessly dangles two possibilities (Child/Feral, Capable/Incapable) and concludes with an ending that is deceptively open to two outcomes, equally valued by the filmmaker, equally indifferent.

Notes

1. Indeed, what should be at stake: a definition of the "human" is precisely what Itard's experience and Truffaut's film preserve, because they make it the norm to which the child's behavior is compared. From then on it hardly matters if he is "recovered" or "rejected." At best we could say, picking up from G. Deleuze (speaking of Platonism in *The Logic of Sense*), that Pinel takes the child for a simulacrum and Itard for a copy that one should be able to mistake for the original.

2. We have merely sketched out one similarity in the operation of several of Truffaut's recent films: the cinematic effects of this last film adhere to that state of *calm panic* in which every reference point vanishes for a time. One thing is certain: that the referent is never lost for long, that the gap is quickly filled between fantasy and the reality that comes to take its exact place for the greater good of civilization. But this return to normalcy tends to come from an increasingly faraway brink: the feral child is no longer the malajusted kid of Truffaut's first films. The question remains why a filmmaker, by dint of reassuring himself, is on the brink of losing himself and winning us. (This will be when the Book People burn).

(*Cahiers du Cinéma* #222, July 1970)

Jerry Lewis, *Which Way to the Front?*

1. In *Which Way to the Front?*, something that had been at work in Lewis's previous films is finally realized, something that explains this particularly strident and disagreeable film in which none of Lewis's former tendernesses survive. It is clear that Joseph Levitch is at a turning point, and that today he is closer than ever to that impossible dream (to be one man, to pull himself together and/or choose, to no longer double himself). But this time, didn't choose, once and for all, to be the human, a too-human victim that films such as *The Nutty Professor* or *The Ladies' Man* all valorized *in extremis*; he has preferred—and this choice should surprise no one—to be the strong man, the self-made man, Jerry Lewis "the producer." The era of the

split personalities that were so easy, so jubilatory to play and to pick apart has faded irrevocably into the distance. The wasteland expands. And while Lewis still offers (himself) a few antics, it is no longer so much to reassure his audience, for (and this has been overlooked) those shouts, grimaces and rumblings intevene only twice during the film, at the start, in response to the word, *Rejected*.

2. Rejected by what? By a system (the army) that has no need for illustrious names, only bodies (in the sense of raw meat) it can use to wage war. And yet—and this is the decisive novelty of *Which Way to the Front?* within the Lewisian paradigm—the Lewis of this last film is reduced to one word, a brand, a Name. In other words, "acceptance," a familiar theme for Lewis, means: to renounce the body and be only a name, what that name promises, if it promises anything. "Byers" sounds like "buyers" (a plural that indicates that while doubling is no longer visible, it still exists somewhere, and Lewis's mask (waxy, tragic) in the first shots is there to prove it). On the other hand, this Byers bears a III, meaning that he only inherits this name— he is himself insignificant as a body—along with a fortune so colossal that he can do nothing but manage it (squander it, in fact). In his previous films, Lewis succeeded, at the end of the story, in getting people (women, the powerful, the audience) to consider him as a Body, subject, interiority, intimacy, etc. Here, nothing of the sort: he can only learn to behave according to the rules of a game that no longer belongs to him, since, strictly speaking, *he no longer has a body* ((the latter having been "played" by the trio, Byers III = the three "Byers" = Hackle, Bland, Love), he will not repeat his mistake (show up for the army's medical visit, volunteer as a body and then lose any possibility of language), and because he is only his Name, he will act according to the meaning of that Name: a buyer, he will buy.

3. From that point on, the film progresses according to a certain logic. (We note, without going into too much detail here, that the analogy of Lewis/the film to be made and Byers/the war to be waged functions throughout the entire film.) Only the elements of war that can refer to filmmaking are preserved and presented: the construction of costumes, the choice and purchase of accessories, roles to learn, rehearsals, etc., not to mention Byers's use of documentary films that he projects aboard his yacht. An incredible, unbelievable story, but an

incredulity that, for Lewis, takes a new style: not the minute and "realist" arrangement of a system that the intrusion of the actor-Lewis will gradually turn into lunacy, but rather an implausibility (it would be better to say: discontinuity) that seems equally divided between every element of the story (for example, the presence of a Black man in a German uniform causes no problem at all). Not only does Lewis not seem to worry about the hinges of his narrative (it is no longer prevented, but circumvented, avoided, ignored), but he seems to leave the very principle of diegesis to chance, the question: how (with what right?) do we move from one thing to another? He asked that question forcefully in previous films because there it was a different kind of passage, from one agent of a divided personality to another (hence flourishes such as the transformation *in plain sight* of Love into Dr. Jerry at the end of *The Nutty Professor*). Now, this doubling is neither the explicit subject of *Which Way to the Front?*, nor the motivation of its narrative.

4. But why such an obvious slackening? Because Lewis/Byers took his role seriously. What do they want from him? What he is able to give: his Name, and the Dollars promised by that Name, the infinite possibility of exchange (shots of foreign currencies, and women loaded aboard his yacht). The story no longer follows a linear progression in a homogenous space, but solely through the intervention of one of these universal equivalents: language, money. None of Lewis's films have played so much with language, words and their games; none of Lewis's films have so overtly dealt with money and all the power that it gives (a longer examination is necessary of the "Jewish" characteristics finally affirmed in the film, in two opposite directions: Byers's physical appearance/a decorated German soldier's Name: Levitch). No film has been as close to naming the complicity of money and power: the word is gold.

5. Thus it is through the transformative power of words that Lewis/Byers makes his way towards and across the Front. He (master of language, he keeps records) establishes collaborations by *simultaneously* naming and paying (the Japanese who also appeared in *The Blue Gardenia*, and then Love, Hackle and Bland, to whom he gives checks after calling their names). By speaking the same language as General Buck (repeating his sentences), he tricks him (Buck = Dollar).

No resistance to the kingdom of words is possible or even imaginable; no instruction or password can hold. But a mistaken Name is enough to cause the eruption of the cruel reality of war (Anzio rather than Naples). And that reality is unquestionably that of the Body, that body that Lewis seems to have definitively lost and against (to) which the film is directed (dedicated). If Kesselring is defeated, it is because he is only a body (hence the difficulty Byers-Kesselring has in facing his role: whisky and beer before the staff meeting, sudden entrance of a woman in heat). When Hitler is defeated, at the end of a magnificent scene, it is because he is only a Body, hence the ballet, the reference made to Eva, to cooking, the overt masochism, etc.; Byers-Kesselring-Lewis-Levitch may in an unbearably cynical way mimic those mad bodies in order to destroy them (but for how long?). He has won, meaning that what he has lost is unspeakable:[1] his Word is gold: (Deutsch) *Mark My Words.*

(Cahiers du Cinéma #228, March–April 1971)

Jacques Demy, *Donkey Skin (Peau d'Âne).*

Donkey Skin's "itinerary" consists of traveling from one castle to another castle, with a cottage in between. Yet her journey is not shown (or rather—c.f. the slow-motion sequence—it is hidden from view). Why?

Because that journey's progression is no longer connected to one particular subjectivity (Donkey Skin, Demy or even Perrault would have *wanted* something), but to a system of entrances and exits whose model is presented at the very beginning of the film: the donkey and the gold. Progression is only on the condition of a) coming out of something, b) coming out of it in an "other" form. In other words, every passage generates a metaphor.

Which simultaneously supplies a "thematic" (container/content, parents/children/, setting/character and also, dirty/clean) identifiable in all of J.D.'s films and, for the first time with *Donkey Skin* (hence

1. The drama of the subject in the Verb is that he faces the test of his lack of being (Lacan).

In Films' Wake / 123

the film's relevance), something like the formulation of a principle according to which a story can progress, a character appear, a film get made, the understanding being that it is less a matter of passing from one shot to another than passing from one narrative plane to another, each decisive moment being a change of envelope.

But on what basis are these "mutations" possible? It is as if content that belongs to the same series (the clean series or the dirty series) as its container (i.e., the princess/the first castle), in order to separate from it, to be delivered from it, must insert a second envelope between that container and itself that belongs to the other series and acts as insulation. The fairy's mistake is believing she can perform the first displacement, the princess's escape, by making the king give her sumptuous gowns, a strategy that proves ineffective because they belong to the same, "clean" series. Donkey Skin cannot leave her father's castle until the gold-donkey-castle sequence is replaced by its princess-donkey-skin-castle replica.

The film's second "location" is the cabin in the middle of the forest. It is here that the filmmaker, once the system is set in place, lets it operate with the greatest discipline and the greatest freedom. Every element of the film is inscribed twice there, once in the "clean" sequence and once in the "dirty" one, which results in a generalized *cleavage* that is announced and almost parodied by the parrot presiding over the location's borders. If by cleavage we mean a certain kind of hinge across a *single* surface, that is exactly how we must see the perfect coexistence of the princess and the scullery maid, the opulent furniture and the filthy cabin in a single shot. As if the cabin between two castles, in the middle of the forest and the film, were the privileged space, the location of the film's *folding*, where everything that appears elsewhere in the form of an alternative (either/or) is simultaneously present (and, and…), a space "off-limits" and almost "off-film" where we are able to look either backwards or forwards because in mirrors, actual frames issuing from the frame, the king, and then the prince, appear.

A question: Donkey Skin cannot leave the cabin unless someone comes to look for her. Why? It seems that as in the first case (gold/donkey), she must emerge first in a metaphorical form (ring/cake) that serves as a model for her, that anticipates and allows

her actual passage from the cabin to the second castle where, removing her skin, she immediately finds herself in a direct relationship with a container of the same series as herself.

Which raises the question, "What has been *gained* at the end of the film," apart from the creation of three couples in place of two, matched by age? We could note that the first castle is an enclosure and the second a site of passage. We could attempt an ethnological reading that would recognize in Donkey Skin's narrative the passage from an endogamous system to an exogamous one. That is at least the meaning of the fairy's song, a questionable song that may very well be a trap (for the story does not originate from "civilization's laws" but the fairy's very specific desires). In fact, the film's final shots are located in a wide open space (neither castle, nor forest) where the three couples (dressed neither in blue, congealed blood, nor red, blood that flows, but white: sterility) figure as pawns, finally reduced to a pure value (in the linguistic sense), on an ideal chessboard.

So, for the first time, by attending to the fairy tale's conventions, Demy can systematize the demand that runs through all of his films: that characters, films and, ultimately, the images of those films must emerge from somewhere, a somewhere that, itself... Film production: ever since *Lola*, plot has been auto-referential and presented as something that reproduces itself. It then simply becomes a game (*Umbrellas*, *The Young Girls*) of restoring a closed circuit of references in which every deviation is configured as a variant, in which the Same eternally returns. Character production: either through parent/child relationships, or one character occupying a space left empty, playing the role of another, etc.

We said that the metaphorical system turns on a clean/dirty axis. Every container pregnant with content becomes dirty. It is not too much of a leap from there to the theme of childbirth, of the pregnant woman or the teenage mother, a recurrent theme in J.D. A pregnant woman is immediately marked (even in her own eyes: Deneuve in *Umbrellas*) as dirty. She is dirty because the only way of acknowledging the birth of the child would be, according to the "cloacal theory," inseparable from the ignorance, in this case the foreclosure, of any sexual act.

A question now arises that we must—for now—ask in its most general terms:

1. If every element of a film no longer has to refer to a pretext (the only "referent" of an image only ever being the filming device aimed at that image), how do we recognize its appearance, its transformation, its disappearance?

2. The film must expose—somewhere and in its own way—its law, its model. The guiding principle no longer being: how to pass from one shot to another but rather how the answer to this question is already sketched out, indicated, inscribed within the film.

3. An inscription that will always be "aside," metaphorical, analogical, not a hidden nucleus or scale model but a representation of how the film operates *within the film itself.* In the "classic" cinema to which Demy is one of the last remaining heirs and that currently feels urgently necessary to learn to read, this representation is always identifiable in the narrative and the "themes" that nourish it, particularly the theme of human reproduction because it is ultimately according to that analogical mode that the problem, which can be summarized as follows, could not be posed: the child, like the image, is created, is born.

Of course the solutions vary: in Renoir, for example, so much of the focus is placed on production (which he always identifies by a sexual act) that the product (film, child, film-child) is very quickly neglected, abandoned, removed (the famous "fear of responsibility" in *A Day in the Country*, the extreme scarcity of children in Renoir's films, etc.) Conversely, in Lang, every shot risks becoming pregnant with another at any given moment, either through axis matches or a system of a screen within a screen (the caves in *The Indian Tomb*). Demy adopts a different system that consists, in the cabin sequence, of disseminating the elements of the two series, so much so that each shot seems subject to an amoebic scissiparity.

Let's quickly note that this immediately refers to an asexual system of reproduction. In J. Demy's films, never, anywhere, is there a sexual act. Fathers are always absent, lost, which makes the king's desire for his daughter in *Donkey Skin* less mysterious: paternity does not exist. This has serious consequences: offspring have no access to the paternal metaphor, no primary repression, meaning that said offspring, caught in a dual relation, can never really break from the container. At the very most, the child will change it: the Mother, the Setting, the City, etc.

Note: this coupling, as one might suspect, eternally returns. Thus, in *Donkey Skin*, the importance of food. It also returns through the exaggerated cleanliness of the shots, cleanliness that evokes cinema advertising, where the image *as* product always runs the risk of overshadowing the image *of* the product.

(*Cahiers du Cinéma* #229, May 1971)

Joseph Losey, *The Go-Between*.

1. The fact that *The Go-Between* won the Palme d'Or at Cannes only seems innocuous. Although the film doesn't teach us anything about Joseph Losey, its success, the murmurs of approval that have followed its release should encourage us to ask a few questions. For example: what is an academic film today? How does one tell a story in 1971 and be praised by the festivals?

2. This question can only be answered once we better understand how the stories function that "classic cinema" familiarized us with—teleological but complex. This work, already underway in these pages (*Young Mr. Lincoln, Morocco*, etc.), must continue. Let's assume for the moment that in any story, the reason for moving from one thing to another may very well reside in what is still called a "character," because a "character" is a signifying element with significant properties: it establishes relationships between different locations and extras; itself mobile, it sets things in motion: in short, it *engages* [*embraye*].

3. The biases of classic Hollywood cinema toward transparency, the refusal of montage (in a limited sense) as an attack on continuity (a guarantee of "truth"), force the narrative to depend on the displacements—presented realistically—of certain extras. "Cinema-vérité" has itself never managed to escape this necessity (see *The Punishment*). In *The Go-Between*, whose frame is continually encumbered by a bric-a-brac of realistic notations and insignificant but authentic details intended to prove that a social analysis is in progress, Leo Colston is primarily a messenger between the foreground and a depth of field that is often only fields, perfectly green, crossed diagonally, nervously.

4. It goes without saying that not everyone is able to engage. It is not even certain that this role must always be performed by the same character (it is actually quite the opposite). The key is that there is no narrative outside of the mise-en-scène of a desire that plays out—interchangeably, interminably—in scenes involving sex, knowledge and money. As for the person who *bears* that desire, he must never have access to what it promises. *In any event* (and this is where we see the naïveté of Losey's film), the messenger never understands the content of the message. And so, the question that the film dangles in front of us—will the child learn what sex is all about?—is a bogus question. It's been quite some time, when the film begins, that Leo Colston wants nothing to do with anything. The proof is in that "other" knowledge, magic and parodic, and the way he recoils when Ted decides to speak. (Nothing more suspicious than the story that the elder Colston *himself* creates about his childhood, a story not about the primal scene but an effect of hindsight. Beware those bleeding hearts who still think the soul of a child can be sullied).

5. Thus it is with a complete lack of awareness that Losey has chosen Hartley's novel, a story of what archetypically constitutes every story, the thing without which it functions poorly or hardly at all, and which we propose for the moment to call the function of *shifter* [*embrayage*]. The reasons for this choice, although not conceptual, are no less imperative and personal, inseparable from the Loseyian concept of *childhood as under-development and/or/thus mutation* (*The Boy with the Green Hair, The Lawless, The Damned,* etc.). Leo Colston effectively has no access to knowledge, or sex, or money *because* he is a child (and can be used by Marian and Ted because he is castrated, which is heavily emphasized by the scene in which he injures his knee by crashing into a chopping block with an axe planted in it).

6. We mustn't blame only Losey for what is currently a widespread phenomenon: the difficulty of constructing a credible narrative today. If it is difficult to commit to abandoning narrative, it is also unsatisfying to entrust oneself to a story's magical, resolutory value (after all, Losey knew Brecht). One might even conclude that a narrative as complex and rigorous as, let's say, *The Woman in the Rumor* (Mizoguchi) or *The Leopard Man* (Tourneur) could no longer be

made today, by anyone. Less because of a lack of skill than because a narrative today has (for reasons that still need to be elaborated) less need to bring into play—and hence obscure—the overdetermination of its elements. Today, everyone (apart from a handful of idiots) knows that a narrative is created neither innocently nor casually.

7. And so we note, with a sort of complicit furor, several cogs in the machine that have been complacently hypostatized, like that function of engagement [embrayeur] that is so difficult to see at work in older films but that becomes the subject of a film such as The Go-Between. The gasps of satisfaction (even if tinted with shock or dismay) that have accompanied films such as The Wild Child, Murmur of the Heart, Death in Venice or The Go-Between simply indicate that it is more profitable than ever to concoct stories in which the function of engagement rests entirely on the narrow shoulders of a child (on childhood as the central theme and the primal scene as teleology in reverse, see also The Clowns and The Conformist).

8. The child-phallus, so small that he can go anywhere, but so "pure" that he understands nothing, allows the spectator, seeing what the child does not see (i.e., Margaret Leighton's glottis) or seeing him not seeing (or seeing poorly, and then becoming absolutely pitiable), to delight in imagining himself in the alternate roles of master deceiver and mystified victim, the "purity" of the child being nothing here but a myth that allows for repressed homosexuality to make its return. But while Visconti, caught in the same problematic, theorizes it by relating it to the process of paranoia, casting over Venice the gaze of the master who knows he is mad, Losey, who was clearer in the era of The Boy with the Green Hair, believes that he is obligated to re-mark in terms of social relations a photologic process whose purpose has always been to obscure them.

(Cahiers du Cinéma #231, August–September 1971)

Elia Kazan, The Visitors.

1. Two American soldiers rape and kill a young Vietnamese woman who might be a Vietcong. A third reports them: they go to prison.

The same men, demobilized, in the USA: one rapes the young wife of the man who reported them.

Hard to say if the young Vietnamese woman was really a Vietcong. Truth is ambiguous and gooks all look alike. Hard, too, to say if she enjoyed being raped: they didn't give her a chance.

Conversely, the young American woman calls herself a pacifist, a "radical": she protests unremittingly against the war in Vietnam, truly belongs to the other side, opposition from within. That's at least what she thinks before she is "visited." One could argue that she didn't dislike being raped; the proof is that would have done it for free. Anyway, she climaxed, that's clear.

This first parallel escapes no one (although no one has learned anything from it). There is a second to which the bourgeois, liberal critic—in his eternal stupidity—is blind.

On one side, Elia Kazan, diabolical engineer of extremely efficient suspense, catches the spectator in *his* trap, tells him two or three disturbing things, makes him endure (makes him an accomplice of) a lengthy distillation of violence.

On the other side, the bourgeois, progressive, antifascist critic, the one who opposes American imperialism or the one who weeps over the horrors of war, wavers before this film-that-is-reality-itself, a film that is well-structured enough that it seamlessly appears to all as a direct consequence of the Vietnam War. Once again, reality becomes the critic…

During her rape, the wife forgets about her convictions; during the screening, the critics forget they are "on the left." It's a strange sort of leftism, and strange convictions, Kazan says (*and this is his thesis*) that make being delectably "disturbed" a point of honor. What do the critics say? "We leave depressed but with our hats off" (G. Jacob), "You're caught, the film won't let you go" (J.-L. Bory). Kazan is congratulated for knowing how to dot every i: *it's only natural*, men and women on the left always let themselves be had.

2. The stupidity of the critic doesn't come out of nowhere. Forever incapable of taking a real (critical, theoretical, political) step away from the Hollywood model, still entirely occupied by encouraging its moans of ecstasy, how could he correctly evaluate what, in a product such as *The Visitors*, *seems* to mark a break with

that model? Having always underestimated the rule, how does he not overestimate the departure from it, the exception?

First illusion: a famous American filmmaker shooting in 16mm, at home and in the snow, cannot produce a reactionary film. After reading the idiocies of Chapier (author of *Salut, Jerusalem*), it is clear that Kazan's break with the straightjacket of large-scale production is considered *analogically* to be progressive. We don't know what our heart should embrace: the project's familial spirit, the use of non-professional actors, the humility of the Auteur surprised to be working without a net, at home, etc.

Second illusion: Kazan's typical "courage" compels him to make a film on/at the margins of/about (we don't know exactly) the Vietnam war, a war about which, we are well aware, nothing or practically nothing has appeared on American screens; Kazan is thus credited with another severance, another type of progress: he breaks with the limits and conventions of the (otherwise moribund) "genre film." While in a classic war film (such as *The Green Berets*), war is justified in the final analysis by the presence of the "war film" rubric, in a modernist film such as Kazan's, the referent (the collateral without which the spectator would be investing in a vacuum, taking a loss) undergoes a transformation: it becomes concrete, historical. It is not internal to "genre," to cinema; it comes directly from social practice.

In accordance with his principle that courage finds its opposite in cowardice, Kazan has understood that placing his film entirely in the shadow of a referent as crushing (and for the Americans: current, traumatic, emotional) as the war in Vietnam was paradoxically *the best shelter*. Making everything outside of it monstrous and intimidating was the best way for the film to peddle its junk, junk that consequently seems alternatively exemplary and ridiculous, exemplarily ridiculous, the tip of an iceberg we assume to understand, the fortuitous consequence of an outside that is all the more crushing because it is obstinately absent, unseen, the consequence of an outside that encompasses and exceeds it.

Hence the extreme timidity, the puritanism, of the critique that falls into the trap, as if *The Visitors* had become part of the war in Vietnam, as if we had to suffer through it, and that to read it (to read the film as it was made, in a specific way, at a specific time, and by specific

people) would be useless or sacrilegious, that to do so would be to gloss over the war. But this non-reading (with the exception of two clear critical interventions, G. Lenne in *Télérama* and particularly Mr. Kiejman in the censured show, "Vive le cinéma") does not prevent the film from voicing its disgusting refrain, from making it clear that (among other things) the internal politics of the USA is in complete accordance with its external politics. Same enemies, same methods.

Film-about-the-Vietnam-war-shot-in-16mm, *The Visitors* doesn't forego anything essential to the Hollywood model, anything that still ensures effective ideology. Its hot political topic, its streamlined technique, its suddenly marginalized position allow Kazan to do what has never really been done before: to use the formal device of Hollywood cinema (and the ideology that it transmits) *knowingly*, to propose a scaled-down, efficient, economical model of what no longer works very well anywhere else (and especially in Hollywood).

The formal device: a certain idea of narrative, of the place of the spectator, characters and representation, of continuity and transparency, of figuration and engagement [*embrayage*], of the visible and invisible, of evidence and ambiguity.[1]

Knowingly: for a cause that, to say the least, is not progressive.

And one must be as naïve (naïve?) as Maurin to see the Kazan problem as "the problem of an auteur who, by mixing contradictory elements in his characters, ends up obscuring a share of his concerns and his intentions." As if obscuration hasn't always been Kazan's concern! Only the extreme slackening of the ideological struggle that he does not pursue causes the revisionist Maurin to seek to reach the center *without critiquing it* (and to label *centrist* the most devious part of the right).

3. What makes the story of *Visitors* possible? Certainly not the Vietnam war, doubly absent from the film because it is neither figured in it nor made the object of any discourse. *The Visitors* is the abstract analysis of an abstract situation, a potluck where you can bring your own food, even if you throw up.

The Visitors' narrative comes from a *doubt*, a doubt as to the identity of the young Vietnamese woman, doubt that the two soldiers

1. "I'm attached to everything in America, even the right-wing tradition...such as John Wayne." (interview with C. Glayman in *Télérama*.)

have neither the time nor the ability to clear because "all Vietnamese look alike," because they don't wear their ideologies on their faces. Every ambiguity, deception, error is possible: let the adversary flee or fire on his allies. What seems problematic for Kazan is not so much the rape or summary execution, which are common practices, it's the risk of raping or executing the "wrong man."

The wrong man: someone afflicted by appearances. This is full-blown Hollywood cinema, full-blown metaphysics. Under the play of shadow and light, a continuous desquamation sheds the trappings (whatever they may be: uniforms, garments, ideas…) to lure us with a beyond more real, more naked, more profound, which itself, etc. But what Kazan's film allows us to better understand is how that desquamation that Bazin (c.f. "L'écran du fantasme," *Cahiers* #236–237) attributed solely to the powers of the camera, of an eye that, objectively, sees more and more, is in fact the product of a desire, a will, in service of an ideology, a politics. *What Kazan proves to us is that the fetishism of the "ambiguity of the real," naturalism, the "as if by chance," and "real life" require what seem to be their opposite: intervention.*

An intervention whose every connotation we ought to include. Intervention in Vietnam, intervention of the filmmaker: film considered as interrogation, as torture. If history's skin falls off in rolls of film, it's because it has been made to fall. Each fallen piece of film is a lie, a shameful and despicable travesty.

For Kazan, Vietnam's specificity is precisely that and nothing else. Vietnam (like "human nature") is cleaved: there is both the good and the bad, mixed up, confused. And if vision can no longer differentiate, *in a time of war*, there are always ways of *making one talk*. And since some persist in lauding those filmmakers who "make the real speak," (in all likelihood so that reality critiques) let's direct them toward this film that shows what making something speak really means.

We can also see that there isn't much difference between Hawks (who wanted to make a film about Vietnam) and Kazan: in Hawks's films, the hero, thanks to his subtlety or his powers of observation, always knows how to outsmart the tricks of his disguised adversary. But Hawks excludes what Kazan emphasizes: a fascination for combat if it is unjust, for inequality if it is "natural." Kazan suggests something along the lines of: is it really wrong to summarily rape (and execute)?

Kazan never stops answering this question that, of course, he doesn't actually ask (the film must show everything but say nothing). He answers first through the intermediary of his placeholder in the film: the elderly writer. He is a significant character, shown in the film's opening shots alongside a sheet of paper on which we can clearly see the word, "Renegade." Kazan is too aware of what he is doing, and knows that we are aware of it too, to have innocently left this mark. We must on the contrary believe that this inscription acts as a quasi-signature, as a furtive confession. For a long time now, Kazan has quit exonerating himself. For a long time now, he has tried to prove to those who still listen to him that they—they too—are would-be rats, potential trash. Paulhan called this familiar argument the "argument of the similar"; it consists of saying: "You are an other" and adding in a low voice: "So I am not one."

The elderly writer, then, while watching an American football game on television with the two soldiers, after a night of heavy drinking, makes a speech, one of the film's only speeches, that is something like a first answer to the question. He says that the greatness of sports is always knowing *who* the enemy is (not what he wants, what he is thinking, but *where he stands*): all you have to do is look at the color of his jersey. Unlike life, full of false appearances and objectionable disguises (how can we be shocked by torture or summary execution after that?) the stadium offers the ideal image of an apartheid that is only a game, a violence that is "soundly" given free reign.

And yet, this speech is nothing other than a *denial*. It is because he holds on to it that the elderly writer is so ridiculous, that everything escapes him, that he is continually forced to sublimate his desire (incestuous for his daughter, homosexual for the young soldiers). He has not understood that the new wars, infinitely more perverse than the old, make this speech even more naïve (as naïve as the Westerns that we imagine him writing, nostalgic confrontations between Whites and storybook Indians).

Every war today kills far more than the official enemy. Kazan's entire demonstration attempts to prove (by the episode of the second rape, for example) that stray bullets always reach potential culprits.

Which makes even more idiotic (an idiocy that seems incurable) the praise often given to Kazan for having avoided "simplistic

Manicheism." It is Chapier, Cluny, Tristan Renaud, etc. who are simplistic. How can they not see that Kazan only charged the character of the elderly writer with lapsing into simple Manicheism to distract our attention, to make us believe that he, Kazan, is well above all that? For he needs that obsolete and metaphysical theme in which everyone is an agent of the fight between good and evil, darkness and light (and what's at stake in that fight). Manicheism isn't avoided, it is *generalized.* As a result, every problem, including political problems, are only specific cases of a single rule: all of us are executioners, all of us are victims.

Take for example the elderly writer. Clearly, this is a paternal, fallen, disqualified figure. This mediocre writer, this *has-been*, earns a lot of money, and this suspect wealth (made by writing war novels) allows him to own a house that has every appearance of a peaceful haven. And when the visitors arrive, they think the house belongs to the young couple. The visitors are struck by the image of brazen material success in the same way that the audience is struck by the image of domestic bliss presented in the film's opening shots. No one mentions that the couple only live in the house as caretakers, that the house belongs to the father. When this omission is corrected, it is too late to erase the idyllic portrait painted by the opening shots. The spectator is—and the film functions in this way at every level—*presented with the fait accompli.* Kazan's trick is making us forget, or at least making it difficult for us to imagine, that the young couple have nothing of their own, that they live in the father's house, that house that is a metonymy for America, where, taking advantage of the exaggerated affection that is consistently heaped upon them, pacifists are also parasites (another of the film's many Poujadist themes.) Whereas on the other side, the visitors who have nothing, whom we know have committed crimes but also know are victims, victims of a "civil" society that never acknowledges its killers, that fails to recognize them (hence the habitual crocodile tears shed by the right). Who profits from whom? Who exploits whom? Kazan ensures that every asset a character might possess has its flip side in weakness.

To this simplistic Manicheism is substituted another more insidious and radical one that gives every appearance of being commonplace and natural. Within it, the terms that oppose one

other are, for example: violence and non-violence, acts and ideas, executioners and victims, men and women, active and passive (and each character is the theater of these oppositions, where theater implies sudden dramatic effects). *The Visitors* offers a relatively good example of a constant metaphorical slippage along this chain, a chain which we know brings every major ideologeme of fascistic petite-bourgeois ideology into play.[2]

(It is thus insufficient to view the film as a document on "the traces left by the war in Vietnam in certain strata of the American middle class" (Maurin) if we don't vigorously fight against the specific way in which those middle classes fetishize these traces.)

Thus, two observations. First, the weight of sexual overdetermination on each opposition in the chain. Next, the importance of Kazan's familiar themes: whistle-blowing, denial, betrayal. *The Visitors* proves that these two are linked. And if idealist cinema has always tried to titillate the spectator with simulated transformations (again, see "L'écran du fantasme"), Kazan proposes one of the most radical figures for this simulacrum. In his films, One only becomes the Other through self-denial (as in how Johannes becomes Joe Arness at the end of *America America*), a denial that is only ever an *inversion*, the transformation into an unknown and repressed other, always-already-there because participating in a cleavage inherent to "human nature." We could speak more bluntly of repressed inversion, repressed and repressive because it presents itself as something it is

2. For Kazan, every discrepancy between acts and ideas is a source of scandal, not a motif of study or interrogation. At stake in this fascistic ideology is the status of what we can hardly call theory: reflection, let's say. Either ideas redouble actions exactly (or serve as their preview: the visitors say what they are doing) in which case they are purely redundant, or else they don't exactly *correspond* (the elderly writer, the couple, don't do what they say and vice versa) and as a result, are totally disqualified. Kazan's extreme skillfulness is in the service of an apology of obscurantism. We are reminded of Lelouch's *Money, Money, Money,* with Lelouch presenting himself at the outset as a lunatic (understandably), and Kazan, as a renegade (as everyone knows).

Another couple whose pertinence is *internal* to the ideology in question: the opposition of violence/non-violence. Not a reflection on what constitutes violence in a society (and for which physical violence is not a special case, precisely the most spectacular), but opposition between physical violence and an intellectual violence, insidious and hidden, whose model is, for Kazan, whistle-blowing. What makes this opposition feasible is that all physical violence has sexual aggression as a model, and all abstract violence has impotence as a model.

not: political. Political repression is performed by sexual repression, in the interests of erotogenization at every level.

Denial, desquamation: it's actually the same theme, the same story of "masks falling off." Everything is preordained from the film's opening shots (beginning with the spectator), the conditions that will lead to the final violence are already met. What do we see in the opening shots? In the early morning, through a window, a man and a woman are waking up: the woman brushes aside the hand of the man caressing her with an exasperated look. We don't yet know what it is about, but the film is already placed under the sign of the woman's dissatisfaction.

It is relatively well-known these days that any narrative, whatever it may be about, is the playing out of a desire. On the screen, in the movie theater. In the movie theater: the spectator who waits for something to "happen." Kazan begins his film with an extended depiction of conjugal bliss, flawless and ahistorical. What else could follow these idyllic images but, inevitably, risk, malaise, danger, everything that was *already* inscribed by that hand gesture?

Placing the spectator in the position of a voyeur, making him an accomplice. An increasingly anxious, worried accomplice (unable to invest in slippery, slithery, ambiguous characters), who must be urged to no longer bear the suspense but—reactively—to want to be finished with it, to aggravate, precipitate it, even. *The Visitors* is constructed in such a way that the spectators must sooner or later disassociate themselves from the "positive" characters (the couple) and confusedly wish for what then seems to be inevitable: the rape. In short, the spectators must, also, *abandon their convictions* over the course of the screening.

They are aided considerably in this by the film's key scene in which Martha, a pacifist and (hence) unsatisfied, talks with the soldier in the twilight. A key scene not because of what it teaches us, but because of how it draws together the conditions for Martha's rape. Martha must—*in a power play*—keep from overwhelming the soldier, admit that she doesn't know what she's talking about, and start to dance. The *plainclothes* soldier and the woman who has just given up her ideological trappings. Kazan doesn't bad-mouth pacifism, he doesn't even claim that a woman, having a sex, could scarcely have any ideas; he simply shows us that ideas must be renounced—as soon as desire is taken into account.

For what would be left of the film's object lesson if Martha hadn't surrendered? Nothing, or almost nothing. Suddenly, by simple amalgamation, contiguity, it is as if the rape, abstract, faraway, horrible, is justified, explained. As if it recurred, but in *slow-motion*. As for the famous slippage from the political to the sexual that belongs to American cinema, Kazan could (in another time, with more courage, under another political regime) articulate it like this: you may not be my political enemy, but even if I'm wrong for raping you, you can't tell me you didn't like it: a good Vietnamese is a dead Vietnamese.

(*Cahiers du Cinéma* #240, July–August 1972)

Marco Bellocchio, *In the Name of the Father* (*Nel nome del padre*), *Slap the Monster on Page One* (*Sbatti il mostro in prima pagina*).

"Self-aware hero of an explicit struggle or unaware hero of an implicit one?" This question that we've asked about the positive hero is finding answers from all sides—especially from Italy. The rise of class struggles, the need for engaged filmmakers to present them, and to involve "characters" in them, poses a series of questions both to them and to us. We can address their answers along two axes:

1. The utilization of the film scene as a scale model of the social whole. Thus, the necessity to inscribe *every* class within it.

2. The use of a relatively new type of character (and actor), such as Montand or Volonté.

One scene that summarizes and allows for a reading of every other, *one* "first-class" [*hors-classe*] actor who, from one film to another, *plays every role in the class struggle*. Volonté is here a worker, there an industrialist, Montand a leftist intellectual or CIA agent, etc. These two great drivers of *unification* form the backdrop common to every "political" film, French and especially Italian. From this common ground, filmmakers can become increasingly engaged in an analysis of concrete situations that no longer hide actual historical referents. The strength of Italian filmmakers is that they are no longer afraid to "call a spade a spade," unlike the French who remain shy or allusive as soon as politics comes into play.

In Italian cinema, Marco Bellocchio's two most recent films, one an auteur's film (*In the Name of the Father*) and the other a commercial film (*Slap the Monster on Page One*), may be his two most advanced films so far, the first for its meticulous description of a scene (of an ISA)[1] in all its determinations, the second for the creation of the character of Volonté, a "monster" in terms of a "sacred monster," a relatively successful simulacrum of the positive hero.

To say that these two films are "advanced" in no way means that their political content is advanced. We mean that unlike Rosi or Petri, filmmakers who are progressive, humanistic, and therefore necessarily vague and ambiguous, Bellocchio affirms in his two films the absence of any positive alternative to the crisis that has rocked Italian society and the rise, for him irremediable, of fascism. That is the message of these two films. Such avowed pessimism drives the "art" film (*In the Name of the Father*: theme of the apprenticeship to power and fascination with fascism conceptualized as a *deliberate choice*) as much as it does the "commercial" film (*Slap the Monster*: theme of a profession's relationship to power and fascination, with fascism conceptualized as an *inevitable fate*). In both films, the same class analysis justifies this pessimism.

Note that this is one of Italian cinema's strong points, compared to the French: to attempt a global perspective on Italian society, to begin from a news item, not in order to lure us with a furtive political backstory (as Chabrol does in *Wedding in Blood*), but to trace back to root causes. Nevertheless, the breadth of this "gaze," be it over-arching, analytical, or prophetic, should not excuse us from asking the question: what is the class position that controls this gaze? To forgo this question would be to fall into the revisionism that thinks that "from the moment an artist looks at the world, only good can come of it." In Bellocchio's case, his pessimism, even his nihilism, reflects the position of a rebellious petit-bourgeois. To this general trait, add the specifically Italian characteristics that give to this rebellion its coloration and its objects: blasphemous anti-clericalism and a sexual throughline, indissolubly linked, with the family as its hinge (*Fists in the Pocket*). Bellocchio also has his own specific determinations, as a radicalized petit-bourgeois intellectual, long-linked

1. A reference to Althusser's concept of ideological state apparatuses (ISAs).

to the Italian Marxist-Leninist movement and no doubt disappointed by it.

The parochial school of *In the Name of the Father* is simultaneously:

—the condensation of various ISAs at the heart of the Italian Church, at once a religious machine and an academic machine, at once ideological and repressive (in the form of sexual repression, especially) directly linked to the dominant classes (the college is reserved for the least gifted children of the bourgeoisie or the rural rich);

—a metonymy for the *entire* Italian social scene.

We will focus less here on the first aspect, in which Bellocchio's talent is the most undeniable, than on the second, which elicits a two-fold reading of the film.

We must first note that the school is in a state of crisis from the outset. That crisis (it is unclear whether it is revolutionary or simply growing pains) refers to present-day Italy: economic crisis (the end of the boom), political crisis (the weakness of the current political machine) and ideological crisis. The college is too old, obsolete, inadequate, even anachronistic and abnormal, and clearly needs to give way to another modern and renovated school that would better suit its needs. Bellocchio's great strength here (as opposed to Loach or Damiani) is that instead of filming "subjects in crisis, trapped in a machine that crushes them with indifference," he chooses to film subjects in crisis in a machine that is itself in crisis. So much so that the scenarios he films can always be interpreted in political terms.

From the start, the film establishes an important distinction between the characters: those who are aware of the crisis that pervades the school (and themselves along with it) and everyone else, mired in their fantasies and incapable of having even the slightest sense of perspective, the slightest sense of awareness. This conscious/unconscious opposition is essential for Bellocchio. We could even say that for him this contradiction takes precedence over the political contradiction. It explains his tendency to dream up characters who choose fascism consciously. In that ideology of "do whatever you want, but at least know that you are doing it," that "whatever" is precisely never whatever (*cf.* Argoud, dans *Français, si vous saviez*). In *In the Name*, the conscious characters are three in number: Angelo, the future "fascist" or the fascist of the future, filmed by Bellocchio

as a fallen and fascinating angel, closely linked to the figure of the Father (rebellious angel); Franco, the ideologue of the left, closely linked to the figure of the Mother, the eternal subordinate whose only weapons are his good intentions and his vague attempts at action; and Salvatore, the class-conscious worker, an enigmatic character who "falls from the sky" into the narrative.

The crisis of the system (the parochial school) takes two forms over the course of the film: the students are "out of control," the teachers are on strike. On the one hand, messy, confused grievances against a repressive and debilitating system and, on the other, a struggle for better working conditions. The film could be summarized as follows: the two movements do not come together, do not coalesce and fail, go their separate ways.

Why this failure? It's here that Bellocchio's choice of the parochial school model reveals itself to be less innocent, less neutral than it seems. The ongoing double reading that allows us to read Italy's crisis into the school's can be performed in both directions. The college has this distinction: placed entirely under the sign of deterioration, it brings together two groups: the students and the staff, who have this in common: both are on the side of the irrational, the unconscious. The students: degenerate sons of the bourgeoisie or the landed aristocracy, adiposogenital, deformed, psychopathic, moronic, are, as it were, "finished" by the machine. The staff: degraded constituents of the lumpenproletariat, hired thanks to Christian charity, ex-convicts, disabled, mendicants, imbeciles, are completely managed and exploited by the college. If that is the class analysis developed in the microcosm of the college, we must admit that it brings together a lunatic bourgeoisie and a pathological working class, two unconscious and irrational masses over which a small number of conscious elements attempt to have some control.

Angelo, Franco and Salvatore want to intervene in the school's crisis. But they have different goals. Angelo promotes a student uprising with the aim of radical reform, of making the school an efficient, rational, modern machine. Salvatore represents the pathetic attempt of a working-class leader who is lost in the lumpen, a character primarily intended to balance out the power of fascination that Angelo represents. Franco understands too late that

he must bind the two revolutionary movements together, and fails miserably in doing so.

Why this failure? We have the feeling that Franco and Salvatore are up against something over which they have no influence: the irrational, unpredictable, telluric aspect of mass uprising. If Angelo seems like the only non-loser of the film (hence something like the winner), it is because he dominates the rational/irrational contradiction (and he dominates it because he experiences it intensely: at once angel and devil). Champion of efficiency, of productivity, of planning, fierce adversary of superstitions and of waste, he is equally able to give voice (and to speak) to everything that is indistinct, primary, in others. See in this respect the scene where he confronts Franco about his views on the theater piece they are producing: Franco would like to make it a means of ideological struggle, of critique, of denunciation; Angelo defends the contention that it should, on the contrary, terrorize the audience.

We must then take the film's final shot seriously. In it we see Angelo leaving the school, behind the wheel of a car. Beside him, Tino, one of the school's workers, who has spent the entire film in a state of sustained delirium (delirium fed by science fiction and comics). We could say that Bellocchio, through a "subtle" traveling shot that slowly pulls back, establishes critical hindsight relative to what it shows. But we no longer believe very much in the critical authority of these kinds of methods, which instead resemble denials. Particularly when the filmmaker does his utmost to eliminate any other conclusion from his film. Angelo and Tino's complicity is seen as a class alliance that the natural leader and the lumpen-proletariat enter into together, the alliance of imperialist, technocratic rationality and imbecilic irrationality. To reach that point, Bellocchio must, using the equation school=Italy, present the bourgeoisie as crazy and the masses as pathological. Having placed all of his analytical elements in this optic, Bellocchio infers the ineluctable character of fascism.

With *Slap the Monster on Page One*, passage from an abstract model to a concrete situation, passage also from the auteur film to a commercial film. But the message remains the same. The ineluctability of fascism is reinforced at the end of *Slap* (shot of the advancing sludge). The class alliance that we saw draw to a close in *In the Name*

of the Father (technocratic fascism/manipulated lumpen) becomes a reality. The icy and inhuman businessman finances the fascist militia, realizes Angelo's program: to terrorize the bourgeoisie with traumatic mise-en-scènes. The instrument of this terror is no longer the theater but a large-circulation newspaper that, far from reporting on reality, makes it up out of whole cloth. To the subjective alliance between Angelo and Tino corresponds the alliance of objective fact between the businessman (who owns the newspaper) and the actual perpetrator of the rape (a reader of the paper who is trapped in complete sexual and religious alienation, to say the least). The machine is no longer the school but a part of ISA information: a major daily newspaper (here too, in the description of how the newspaper functions, "how information is made," Bellocchio is simultaneously efficient and brilliant). Finally, a common point of both films: corresponding to the character of Franco we have Roveda, the young, upright journalist who believes in the objectivity of information and democracy. Roveda, lacquered, stereotyped, Hollywoodesque, is filmed by Bellocchio without even a trace of sympathy. He may be the one who discovers the truth, the one who becomes aware, but we sense that he is fighting, with inexcusable naïveté, a rearguard battle that will have little impact. For Bellocchio, Roveda is not, cannot be a positive hero.

For it is indeed positivity that remains in question in this pessimistic film. And that is where the contradiction that Bellocchio must resolve resides. On the one hand, he wants—he too—to frighten his audience by showing them that fascism is near and inevitable. But on the other, he knows that such a message (entirely negative) plays differently in an auteur film versus a commercial film. In the auteur film, the lack of positivity is compensated by the fact that everything is seen through the eyes of someone (the auteur) who becomes the film's principal referent and, if you like, a sort of positive hero (positivity of the utterance). In the commercial film, the auteur must cede to the conventions of the genre—and "political" cinema has become a genre—and the need to include positive characters (positivity of the enunciation). In other words, to anchor, to direct the desire of the spectator who has come to see the "confrontation of good and evil," Bellocchio must reestablish a sort of "relative positivity" in his film, or levels of negative heroes.

This is of course not a formal problem. Or rather, it is through the auteur film/commercial film contradiction that we may grasp how Bellocchio's nihilism and catastrophizing are not perhaps as radical as they seem. We have seen that (as opposed to Costa-Gavras) he does not base this "relative positivity" on the "sincere democratic" character, the journalist who is a lover of truth, Roveda. At the same time, we note that two elements in *Slap* are absent from *In the Name of the Father*: the newspaper boss (Bizanti, played by Gian Maria Volonté) and the leftists.

We might be tempted to think that Bellocchio, previously a militant of the extreme left, would make these two elements the bearers of positivity. That would be logical, but impossible. In fact, if he were to make his film from their point of view, meaning from the point of view of the proletarian revolution, Bellocchio could no longer defend the theory of inevitable fascism.

We might think that, without adopting their political line, Bellocchio—like Petri or Costa-Gavras—will present them as a moral force, generous and even symbolically positive despite their confusion and inefficacy. This is not the case: the leftists are simultaneously filmed as objectively troubled and confused and as subjectively vicious. Ultimately, the presumed assassin is not the author of the crime, but he may as well have been.

This method of reducing the leftists to the spectacle of their unrest (a spectacle that we see being anticipated and utilized by Bizanti from the film's first scene), *of never inscribing their system and their political discourse*, in short this method of morally and politically disqualifying the leftists means that not only do they not bear any trace of positivity in the film, but that nothing prevents us from thinking that through their blind violence they play Bizanti's game.

The debility of sincere democracy, the negativity of the leftists, the absence of the masses (who are not shown except during an MSI demonstration), the icy inhumanity of the big businessman. Only Bizanti remains. To say that he is a positive hero would make no sense. The phenomenon is more complex than that, and is analogous to that denial that accompanies every screening of the film: "I know, but still." Bizanti is dishonesty, cynicism, the intoxication of the masses in service to big capital, of the fascistic bourgeoisie. This the

spectator knows and never forgets. But Bizanti is also the professional, the journalist, the man who is certainly self-made, still capable of carrying out his investigation. This the spectator sees and cannot forget because every other character in the film is outside of any profession, any social practice.

Finally, this essential fact: Bizanti is the only character *who truly has a voice* [*avoir la parole*]. Take the key scene in which Roveda, becoming aware of the role that he plays, demands accountability. At that precise moment, Bizanti's skill is not justifying himself but attacking Roveda's naïveté. And attacking him politically. Instead of reassuring Roveda by saying, "But yes, we are objective," he says, "We too are fighting the class struggle!" He makes a Marxist argument that Roveda neither expects nor understands. The fascist can, himself, speak about class struggle because he is cynical and sharp enough to recognize that it exists, while the sincere democrat definitely does not want to hear about it. What interests Roveda is the freedom or objectivity of the press, terrain on which Bizanti has no problem humiliating him. The same thing happens in the scene between Bizanti and his wife, who is implied to be a relatively stupid bourgeois. It is obvious that at that precise moment everyone in the theater is "on Bizanti's side," knowing all the while that he is a "fascist." Bellocchio has managed to transfer the spectator's desire onto Bizanti (= Volonté).

Let's assume it to be plausible that a man like Bizanti could exclaim, "We too are fighting the class struggle!," let's assume that the new, technocratic fascism borrows bits of lines of reasoning and slogans from Marxism (even though we see that more as one of the effects of Bellocchio's "ideologism," an effect of the conscious/unconscious contradiction). What is important is that *no one else in the film* makes that kind of argument, especially not those people who should logically be making it: the leftists.

We have seen that the leftists in question are characterized by the fact that they don't speak (unless they are screaming: the scene of the confrontation with police), but act. They are reduced to the image of their gesticulation. Ultimately, once could say that it's Bizanti who benefits from the argument that the leftists do not make: it would be an entirely different film if Bellocchio had filmed an actual political debate between him and them.

It isn't very difficult for Bizanti, the only "man" in the film, to become, for lack of anyone better, the only possible "hero." He becomes more complex as the other characters become more simplistic (This is the same process as the one that controls the evolution of the relations between Montand and the Tupamaros in *State of Siege*). He even begins to acquire a sort of distance from the industrialist, a degree of autonomy laden with both threats and hope. As if he wanted to imply that, "condottieri" of modern times, he were richer, more complex than those classes whose interests he defends.

We must address a notable absence in the social scene of *Slap the Monster on Page One*: the revisionists. Here is where the ambiguity of Bellocchio's project reveals itself: by absolutely excluding them, he thinks he is demonstrating that he considers them to be negligible or non-revolutionary forces, in any case incapable of altering his portrait of Italian society (the leftists are split by masses who are attracted by the MSI). He may be the first victim of this excessive disregard. For in a film whose every element is negative, one anticipated and obstinately absent element is very likely to appear to be positive. Especially since the P "C" I could adopt the thesis that the film develops and *that belongs to it*: the leftists are the objective quartermasters of fascism. For the P "C" I, better to be absent from a film whose every protagonist is negative, better to be inferred. Once we know that it is because of Volonté (cf. *Écran 73*, #12, p. 17), who himself sympathizes with the P "C" I, that Bellocchio did not include the Party within the film, we conclude that, in the end, Volonté, in the film as in real life, is the film's true beneficiary. In the film, we have seen how. In real life, because *Slap* is, today, legible *above all* as revisionism. However radical Bellocchio's "desperation" may be.

(*Cahiers du Cinéma* #245–246, April–May–June 1973)

André Harris and Alain de Sédouy, *Français, si vous saviez.*

These authors have *one* idea: that the French, for fifty years, have also had only *one* idea (they're looking for a father). The thesis of the film is permanence, and this permanence is a particularly unfortunate

Oedipus complex: as soon as they get in trouble, the French rely on a father who takes advantage of that opportunity to betray them. The power/citizens opposition becomes a father/citizens opposition, and the problem of the legitimacy of power drowns in the problem of the legitimacy of the father (of his "references"). This blunt use of psychoanalysis has the effect of making history (the development of objective oppositions) at once illuminating (the French follow one single idea and we know which one) and totally muddled (they follow it through ever-changing situations). Chance and necessity, idée fixe and inconstancy, those teats of bourgeois ideology join to make history a kind of pathetic stagnation, a series of unfit fathers.

We must condemn this concept of history that dates at least from Bossuet or Guitry. Those who don't give themselves the means to grasp the objective development of contradictions speak of the "versatility" of the masses (too much change), and blame them for having only one idea in mind (not enough change). Too much or too little change? In fact, the authors are incapable of grasping, of analyzing, what changes and why. They don't have the means. First, because where there was class struggle, they saw (it's right there in the title) the "French who don't understand," not the division within the struggle but unification in ignorance. Next because the only conceivable contradiction in their system is non-coincidence; it's because the French don't know what they want, because they "contradict" themselves, that the unfit fathers take advantage of them. The root of all evil is in people's heads, in the play of their subjective contradictions. And that is the idealistic perspective that commands all of Harris and Sédouy's work.

The trilogy's success has several causes. And if it is true that it inscribes the return of petit-bourgeois ideology (in its Poujadist version) to French screens, we mustn't minimize the *work* (specific work) performed by the authors. They knew how to cast their old junk into "modern" forms that incorporate the cinematic achievements and mutations of the past fifteen years, making them serve their project: questions of the referent, of investigation, and montage.

These are problems that *every* filmmaker today needs to confront if they want their films to *intervene*. Let's say broadly that the referent is the way in which the film's relationship to truth is conceptualized, that investigation is a way of finding truth, and that montage is a way

of provoking it. But what truth are we talking about? The petit-bourgeoisie, the one that always demands more truth (to "shine a light on"), always simultaneously demands fewer contradictions. For them, that is the truth, the reabsorption of contradictions. Contradictions between men, contradictions inside of every man. If all men have one idée fixe (the French, for example, are seeking a father), each man must also have his own idée fixe. One idea to which he is *faithful.* That is the truth that Harris and Sédouy seek, that is the search that drives their work, their method.

Let's take one example where this method is easy to identify. When they try to make Benoît Frachon (or Duclos) say *the same thing* as in 1936, what are they doing? They resolve the problem of the referent in their own way: instead of referring each statement to the concrete, historical situation in which it was produced, they refer the second to the first. The presentation of the two fragments allows for the short-circuiting of any political analysis: *it's the well-known trick of one mirror reflecting another mirror.* As if the fact that a man who contradicts himself after a thirty-year interval could teach us anything about what is really in play in that contradiction!

What is the function, then, of montage? Not to make contradictions palpable but to deny them. Placing two fragments together doesn't, for Harris and Sedouy, allow for the emergence of a wild, new or unanticipated meaning, it only puts the second to the test of the first. The only question that interests them is the question of fidelity (of a man to himself, of a fragment to itself): Is Argoud faithful to what he said ten years ago? Yes. And Duclos? No. This is not a political analysis, but a pseudo-analysis with political effects. For in this (formal and ideological) system, it should come as no surprise that those who come across best on screen are men "of their word," whereas real politicians, who must analyze the concrete situation, seem like scoundrels once the situation is rased from the film. Argoud, for example, may be mistaken politically; it appears that this isn't the authors' concern. Their concern is that since Argoud does not contradict himself, he must possess an element of truth.

What is the function of investigation? Hardly to sustain, to provoke contradictions. Simply *to make the real speak,* but while knowing what it must say: it must repeat itself. Harris and Sédouy's

investigation is very clearly a police investigation: the truth doesn't matter; what matters is that the statements, the confessions, correspond. That will always produce an "appearance of truth": repeating something gives it weight. An investigation meant to discover nothing (just as montage isn't meant to produce anything), only to recover what has been lost with time.

Referent, montage, investigation: these words have little content in themselves. We see here how they can hinge upon and contribute to serving a bourgeois point of view that holds up the prospect of history's body only in in order to pursue its imaginary rumination.

(*Cahiers du Cinéma* #245–246, April–May–June 1973)

A SINGULARLY SILENT POTLUCK

Michelangelo Antonioni, *Chung Kuo—Cina*.

On one side, a country that opens itself up to the outside world ("so that the foreigner may serve the country"), that wants to be seen and doesn't hesitate, to that end, to play the prestige card (by inviting a famous filmmaker, for example: Antonioni). On the other, the French bourgeoisie through its information machine, its journalists, its thinkers. They would like very much to talk about about China (they need to promote Pompidou's trip) *but in their own way.*

Anything else would be surprising. It is normal, inevitable, that China's image, the images brought back from China, would in turn become a political issue. For everyone: a land they must occupy.

Following a slew of books, articles, films, and television programs, Antonioni's film locates itself *from the start*, whether it likes it or not, on this terrain.

Eternal China

There are always two ways to discredit China. Two intimately connected methods. One is to revive the ghost of the "yellow peril" (China looms, menaces). The other, more subtle, slightly old-fashioned

but effective nonetheless, is to refer to "eternal China." This second method currently prevails.

Impossible to deny the facts: China's beginnings, its global influence, the famous "everyone gets enough to eat," etc... The only ones still feeding the yellow peril myth are France's extreme right wing and Soviet jingoists. What do the bourgeoisie and its China "specialists" say? Something like: "Look at China. Although Communist, it's the eternal China, the one we've never understood, eternally fascinating and eternally different." What did Barjavel, the bard of Pompidouism, say while praising Antonioni's film? "Come in, take a seat, and watch! It's a trip to another planet." Discuss China? Yes. But to *keep it at a distance.* An unbridgeable distance, a radical difference. Like science-fiction, or a zoo.

The filmmaker of "incommunicability"

A great filmmaker, a well-known aesthete (*Chung Kuo* is, of course, a beautiful film to watch), Antonioni is also considered to be a filmmaker of "incommunicability." Whether filming the peasants on the Po plain or American youth, it is specifically that establishment of distance that interests him: holding fast to the surface of things, finding them incomprehensible (not giving himself the means to understand them) and making them—in the end—beautiful fetishes. Aestheticism and "incommunicability" often go hand in hand.

And yet, China is exactly the opposite: communication restored, the battle against egotism and its neuroses. How will the filmmaker of difficult communication film a country for whom communication is not the central problem? Is Antonioni talking about China, or is he also keeping it at a distance?

Choosing

They will say (it has already been said): it's good that a film has been made about China, one that puts aside politics and its stereotypes, Marxist-Leninist jargon, scholarly explanations. It's good that a filmmaker chose to show us what he saw with his own eyes, with total innocence: day-to-day China, on the ground.

Of course, presenting China, "making it visible," is an essential, inescapable moment in the filmmaker's work. Likewise, it's good to

respond to the public's curiosity. But there are many ways to respond. Politics, in a film, is not only political discourse, it is also and especially the *choice* of what is shown, the order in which it is shown (montage), the relation between what is shown (the image) and spoken (the sound), etc. Antonioni will always be able to say: I only filmed what I saw, in the order that I saw it; he has only assembled a sumptuous potluck.

Two examples

To a potluck, one brings what one likes, not just any random thing. There are a certain (limited) number of *idées reçues*, clichés about China currently in circulation. And even if the film strives to be innocent, the audience itself has its own ideas about China (right or wrong, informed or not, clear or vague, conscious or not, that isn't the issue). Let's take one example.

One of the most ingrained ideas about China, an idea on which the bourgeoisie feasts, is the "manipulation" of the Chinese by the State and the State by Mao. Read Peyrefitte: his admiration for Chinese leaders comes from the idea that acupuncture gives them considerable means of ideological persuasion over the masses. Does the film help to resist this idea? No. Does it reproduce it? Judging from the final scene of the film, yes. It shows a performance of automatons playing music for an enraptured audience.

Of course, the word "manipulation" never appears in the commentary and Antonioni can always hide behind the fact that he actually witnessed the performance. *But it is one thing to see it, another to film it, and a third to make it the final scene of the film.* It leaves the audience with an unexplicated, diffuse idea of death and the mechanical. The complete opposite of the film's opening scene: a difficult birth, but life.

Who speaks?

All of this is said without being said. The filmmaker speaks and does not speak. He is not the one who speaks, who makes the film, who chooses the scenes, it's reality itself that speaks. That's at least what they would like us to believe. But let's take a second example. When he films a sporting event in which children run a relay race,

Antonioni lets the image run without adding any commentary: again, it seems as if he's letting reality "speak for itself." The French audience concludes from this that competition does exist in China, after all. But what the filmmaker neglected to indicate in his commentary is that during the race, the children are chanting the slogan, "Friendship first, competition second." In the absence of sound, a false image (a false idea of sports) is established for the audience. A lie, but by omission. Who is manipulating whom?

Restoring sound

There are two soundtracks. The one belonging to the real (what the Chinese say, what they could say) and the one belonging to the film ("neutral" commentary). And yet, Antonioni's potluck is singularly silent. The Chinese have no lines: they are extras in a film about China. Having them speak (as they do in the film by Claudie Broyelle and Françoise Chomienne, *Shanghai au jour le jour*, for example) would certainly have been interesting. But then the film would have lost its "zoological park" aspect, and it would have been harder for Barjavel to say that it was about "another planet." Because the Chinese, when they speak—about themselves and their problems—are not afraid to do so in political terms.

China is not a miracle

Allowing the Chinese to speak would immediately allow for a discussion of the *struggles* of the Chinese people. A film that, in 1973, says practically nothing about the cultural Revolution can only reinforce the idea that China's success is due to a sort of miracle, a bit like how one speaks of Japanese, German, or Brazilian miracles. See Peyrefitte, Schuman, Chaban, etc. They are happy to talk about China, but on the condition that it is seen as an established fact, a given with no history, a new variation on eternal China, a China without struggle, without revolution.

Skin and bone

They will argue: the struggles of the Chinese people are not Antonioni's subject. We argue only that a thing can be inscribed in a film without it becoming its subject. As for the actual subject of

China, we more likely find it in the scene in which he films, at great length, a poor, remote village whose residents have never seen Europeans. A key scene because of the emphasis that Antonioni places on tracking faces for the slightest sign of fear or worry, the complacency with which he asks how he and his crew are perceived by the locals. It's all there: incommunicability, distance-taking, World Expo exoticism, the zoo.

Barjavel is indeed right to speak of another planet. And how could another planet relate to us? Ask us questions? Challenge us? That China has become a paper tiger. "You take a tiger's skin, not its bones," quotes Antonioni, no doubt to justify the "superficial" side of his film. But not to make a bedside rug out of it (even a beautiful one)!

<div align="right">(Libération, 4 October 1973)</div>

BECOMING FASCIST

Louis Malle, *Lacombe Lucien*.

Pompidou said he was tired of the whole heroic mythology of the Resistance. Here is a film that arrives just in time to appease him! Listen to Malle:

"There is, in every one of us, a shadow zone, inaccessible to our conscience, that often makes us act against our reason," and, later on, "I am increasingly fascinated by the inexplicable..." (interview in *France Soir*).

Suddenly, no one even dares to ask Malle the only question that matters: does this film about the French position towards fascism in 1944 help us to understand and confront fascism, today, in 1974? This is not an idle question: fascism is far from dead, there will be other Lacombe Luciens, equally "inexplicable," and we cannot always invoke a "twist of fate" in their defense (when, in the film, Lucien is recruited by the German police, it is by accident, because of a flat tire on his bicycle).

A very real question. Many people are interested, young people especially, in *knowing more* about the occupation, about how the public experienced it, about all of the forms of resistance and collaboration. Why does a young boy from the country become a member of

the Gestapo in southwestern France in 1944? Why not? He's not necessarily a bad lot. It all depends on your point of view.

How does someone become fascist? Malle offers a twofold response. On one side are those who have *chosen* fascism. They are no mystery: heinous, slimy, stereotypical. On the other, Lacombe. Lacombe who, throughout the film, issues no judgments or ideas (a peasant has no ideas, that's understood, isn't it, Mr. Malle?), merely plays with his new-found power, innocently. Lacombe, or "innocence": Lacombe, the young peasant, outside of History.

And yet, it is not because Lacombe Lucien "understands nothing about 'isms'" (*dixit* Malle) that he escapes History, that he *doesn't make it*. Malle's concept is a strange one: the people who make History are those who express ideas, and everyone else are merely victims. Rather an outdated, reactionary concept, *c.f* Camus, the absurd, Ionesco and company. On one side, the trash of History, on the other, those who are confused. Trash gets thrown out; the confused can apologize. Scratch the surface of the fascist and you will find the man. Enough of this idiotic philosophy!

A final word about the film's release. The day of its première, Baroncelli stepped away from his "cinema page" in *Le Monde* to tell us about the film *on the front page*. What he wanted to make us understand (he did the same thing to us with *Cries and Whispers*) is that there are certain films that we "take with us," that are events in themselves, films that call for consumption and mass debate. Baroncelli is not only great advertising for the film, he also prepares the debate, maps out the terrain, designates the target: Death, in *Cries and Whispers*, here, "human nature." Which goes to show that the bourgeoisie also conducts its mass debates!

(*Libération*, 7 February 1974)

Jorge Semprún, *Les Deux Mémoires*.

Of course, we are pleased to see Santiago Carrillo, the head of the Spanish Communist party, put Soviet aid to the Republicans into perspective. Of course, it is not irrelevant to hear from a former

leader of the POUM—even if he has grown old. There is a great wealth of investigative material in Semprún's film. And yet, this film, released at the same time as the assassination of Puig Antich, leaves us wanting more. Worse: it leaves a bad taste in our mouths. Raw material is one thing: the way it is organized is another. In other words: *montage*. Semprum could have made his images (principally interviews) say very different things. The shots of the elderly militants could have been emotionally moving or instructive. By accumulating them without hierarchizing them, by making a sort of sad logorrhea out of them, Semprún imposes—insidiously—the idea that the common ground of all of these speeches, regardless of their content (an anarchist or a Falangist) is the *old age* of the people making them. As for the young people in the film, exiles and the children of exiles, it is clear that they demonstrate the opposite failing: they speak of a time they didn't experience and a Spain that has become the stuff of myth. Semprún performs a strange sleight-of-hand trick: he reproaches the old people precisely for being old, for being former soldiers, rigid and senile, and he reproaches the young people in his film precisely for being young, for not knowing what they're talking about. When I say "reproach," I don't mean that Semprún articulates this reproach; his montage does it for him. Putting both sides back to back: a strange approach for someone who pompously announces towards the end of the film that he had intended to be a listener, a neutral receiver. Even more neutral than the narratives, since he neutralized what was said.

Neutrality: is it possible? By accentuating the "generation gap," does Semprún help us to illuminate the present? What use is it to invoke 1937 if it doesn't serve to better understand 1974? Not that Semprún should have made a different film, or spoken in the abstract about the current struggles of the Spanish people. But he could have at least organized his film in such a way that it presented those struggles, even implicitly. A film that comes of out exile and indulges in it, *Les Deux Mémoires* refuses to discuss anything else. We are not asking for the exiled to speak for those who are currently fighting (in 1974 in Spain), we ask only that they say: they are fighting.

(*Libération*, 28 March 1974)

Pierre Granier-Deferre, *Creezy (La Race des Seigneurs)*.

An absolute flop. *Creezy* tells the story of a politician (Delon, never believable) whose appetite for power leads him to betray two things: his political ideals (yesterday the MRP,[1] today the CRP[2]) and his lover (an *amour fou* for an objectified woman). Avoiding all blame, eyes full of tears, he hangs on and ends up winning a ministry position.

All of this unfolds in a troubled France, teeming with the riot police, a Sacred Union France, where the release of a film such as *Creezy* plays a part. The poster—itself more successful than the entire film—*already* functions as an election poster. It shows Delon's silhouette, in triplicate: one blue, one red, and in the center, one white. Ever since Malle and Cavani, we know that Mankind exists not only in black and white, but in shades of grey. With Granier-Deferre, we learn that the French are neither blue, nor white, nor red, but a bit of all three. Can this multicolored neither/nor speak to the guts of the centrist, Lecanuetist electorate? It's doubtful, given the weakness of this film. A twofold weakness:

Weakness on the level of the description of the *bourgeois political machine*. This is an area in which French filmmakers have a lot, if not everything, to learn (from the Italians, for example). Granier-Deferre is ill-served by Delon, whose stiffness and mugging evokes the gangster/cop more than it does the politician. When he yells to his chauffeur from the back of his black sedan, "Louis, to the Elysée," we assume he'll be doing anything there but politics.

Weakness on the level of the view of *politics* in general. It's a naive viewpoint in which politicians are overwrought beings, created and destroyed by women, public men who complain about not having a private life. Let's be clear: watching Delon-Dandieu's double life, there can be only one response: public life, private life, same bullshit!

One final thing: the fact that a filmmaker as rank as Granier-Deferre has been propelled to the forefront of the French cinematic scene proves at least one thing: panicked, nattering, and in crisis,

1. Mouvement Républican Populaire (Popular Republican Movement), a Christian-democratic political party dissolved in 1967.
2. Centre Democratie et Progrès (Center for Democracy and Progress).

the bourgeoisie no longer even has (in the cinema) the time to choose its lackeys.

(*Libération*, 18 April 1974)

A SLEEPING MAN: HOW TO WAKE HIM?

Georges Perec and Bernard Queysanne, *The Sleeping Man* (*L'homme qui dort*).

One morning, a young man doesn't get up, gives up the social rituals of his meager existence. A student, he won't take his exams, won't open the door of his little room to friends who have come asking for news. From then on, he "withdraws" from the world, becoming the unsung hero of his personal rituals—asocial, pointless wandering, routes known only by him. Having become indifferent to everything, he plunges into the anonymity that the big City (Paris) allows, the "anonymous master of the world" that he creates and destroys according to his gaze (only drive: *to see*), every mooring breached, with schizophrenia on the horizon.

Such is the story of this *man who sleeps* (but who dreams), the story of a *divestment*. He isn't the one telling the story (neither on-screen nor in voice-over), but a Voice allows us to hear it, describes it for us. She (she: it is a woman's voice) narrates the drift. She addresses *us* while interpolating *him*. It's a well-known ruse (think of Giscard's election poster with father and daughter): there must, between sound and image, between her and him, be space for the spectator's desire. Desire to be an accomplice, to be inside the film in the same way that the *man who sleeps* is inside the city. The film, the City: two labyrinths, two jungles.

Every class has its dreams
The film's first quality: the logic, the coherence of this "delirium," its clinical, documentary aspect. Never (since Resnais) has a city, the site of detour (and diversion), been so well-filmed. Not the social city—that encumbered space, stagedd by the bourgeoisie. For someone who lives "in autarchy" (Lacanians would say: for someone who

is the phallus), the City is that heart that always envelops him with the same indifference, indifference between the overview and the detail, between the wide shot and the close-up (hence the film's structure). Possibility for the eye to read and elect, without choosing or prejudging. A cloaca from which it is best never to emerge.

The film's second quality (undoubtedly less deliberate): that divestment that causes a young man to feel himself to be everything and nothing (master of the world, but an anonymous master), that delusion that could easily be called "paranoic" (because it is) is established, described, "rendered" successfully enough for it to be completely impossible to respond, "Look! It's the insane ramblings of a skilled worker!" (or a peasant, or an aristocrat). In other words, *that insanity has a class dimension.* Dare we say it: it's a petit-bourgeois delirium.

Petit-bourgeois because that dream of the "anonymous master" condenses (in what's called a "compromise formation") what is painful, intolerable for the intellectual petit-bourgeois: his impossible dilution (disappearance, dissolution in the great whole, in the city, the crowd, the masses, etc.) and his impossible affirmation (power over the great Whole, over the City, the crowd, the masses). In short, his *historical* condemnation. The man who sleeps does not sway; he stays where he is and where he is from; he dreams, and his dream resembles him.

Marginality

And yet, after a certain point, the Voice (but where is she speaking from?) disassociates from that dream that she affably (Perec's text is beautiful) describes. Sound rebels against the idleness of the image. A great reckoning is *simulated.* The Voice begins to lecture the mess that the "hero" of the film has become. She cruelly evokes everything that the first section repressed: misery, economic and sexual, the proximity of Others, their misery, etc. It is no longer the City as a body, but Others as monsters: the opposite of the *same* paranoia. While the hero wanders around the city, the Voice reaches a conclusion, restores things to their proper place, allows the repressed to return. Once the film is finished, its authors (G. Perec and B. Queysanne) resolutely condemn their hero's behavior (flight, withdrawal). They find it sterile. But as for proposing a positive alternative, they're not

willing to go that far. The man who sleeps may as well go mad, kill himself, wake up, find that Jesus loves him or join the Front Rouge: that's not their concern. It's up to the audience to choose. Another potluck: here you can bring your own food.

If *The Sleeping Man* is an interesting film, it's because it proposes its own vision, its version of what is currently becoming *the* subject of all French cinema: *marginality*. Like *Lacombe Lucien*, like the hero of *Going Places*, *The Sleeping Man* doesn't face history but traverses it incomprehensibly, stupidly. Problem: can there be a *leftist point of view* (that isn't Marxist orthodoxy) on this type of subject? A question to ask Foucault, for example, or Pierre Rivière…

Second important point: the question of *critical hindsight* that a filmmaker may have in relation to what he presents. The word "hindsight" is hazy. Look at something, pull back, pull back even further. What do you see? The same thing, with a wider frame, slightly less significant, but that same thing, the same *fetish*. This is not critical hindsight, but the work of a housewife who arranges things to see if they look pretty, prepares herself to leave, and then stays. Hindsight is not "gained" by a smooth backwards tracking shot, but by radically displacing the angle, the point of view. In order to find the angle that makes us see *and* understand, there must be a radical break.

(*Libération*, 9 May 1979)

OBSCURANTISM

Barbet Schroeder, *General Idi Amin Dada: A Self Portrait*.

During screenings of the film, *Idi Amin Dada*, there are two soundtracks: one that belongs to the film and one that belongs to the theater (the audience's reaction). Listening to the second removes any doubt that the film, as it has been made, can *only* function (be seen, be liked) if it activates its audience's latent racism. This doesn't mean that the film or Barbet Schroeder's remarks contain racist statements (that would be too perfect, too simple). We argue that this racism is not the evil, unanticipated effect of a weak and irresponsible way of thinking

(which is, elsewhere, true), but that it structures Barbet Schroeder's entire project from the outset. *Idi Amin Dada* is part of the grand Bazinian tradition (Bazin the metaphysician, not the "social" Bazin) *whereby the filmmaker* (the Master of Technique, technique implying the West, colonialism) *pays for his right to film* (a moral right: we are in the realm of bourgeois humanism) *by running the risk of being destroyed by what he films.* Bazin gives headhunters as an example (Jivaros); Barbet Schroeder makes the risky journey to Kampala. This "right-to-film" is a power that is always won against another power: the power of cinema (whose metaphor is the camera) against political power (the exotic animal, hence unpredictable). Same concept for Barbet as for Idi Amin: power is always excessive, abusive.

The film has authorized, produced, two interpretations. The first—the one that has made the film a success—belongs to the plainest and most unambiguous racism. It consists of making the character of Idi Amin a general equivalent, a *type*. The (crass) ignorance and prejudices of the average French viewer make numerous typings possible. Idi Amin may function as the Ugandan, the African, the African chief, the Chief full stop or even the Fool. Whatever the resulting matrix may be, it can only lead to a racist (Africans are animals, whatever their rank) or Poujadist (all chiefs are idiots, whatever their color) reading. It goes without saying that B.S. takes no responsibility for these readings that he allows but does not assume. It is up to us then to demonstrate that *he allows for no other interpretation.*

For another reading to have been made possible, Uganda would have had to function as something other than a general equivalent for Black Africa. Idi Amin would have had to function as something other than a "Ugandan type" (or even as something other than its sole inhabitant, since he alone is filmed). Most of all, the viewer would have had to have the wherewithal to distinguish between 1) the issue of Amin's personal madness (paranoia, etc.); 2) the issue of the "aftereffects of colonialism"; 3) the issue of the structures of traditional African power.

It is here that the "technique" of cinema-vérité, of the direct at all costs, *encounters* its content perhaps for the first time: the subjects it has to treat, the subjects it has to film.

What is cinema-vérité? A metaphysics of the undecidable. A cinema of the undecidable can only be passionate and non-reactionary if it

tells us about things we are already familiar with (for example, when Buñuel tells us about the bourgeoisie and neurosis); but when applied outside of the (bourgeois, imperialist) West, to objects we are unfamiliar with, it can only lead to obscurantism.

When someone (Amin) is presented as being the Other and when it is implied that that Other is clearly mad, how can we imagine that the viewer is able to distinguish between those two alterities, *how can he see the variation, when he is unfamiliar with the norm*? It is only in a fundamentally racist system that the Other and the Fool are equivalent, and it is indeed that system that begins to function with *Idi Amin Dada* (*c.f.* the film's mass success, success that is chilling). Cinema vérité, and this is its paradox, is an unlikely accumulation, a heap, of sensitive material that always moves in the direction of obscurantism, hence of dominant prejudices.

We admit that we are tired of the entire issue that was created and carried by the Nouvelle Vague and that continues to straddle the fence between fiction and document, nature and artifice, subject (filmmaker) and object (actors), obsessional manipulation and acting-out* hysterics. These are the enduring metaphors of the type of "power" that can be exercised by the petit-bourgeois artist, should he "theorize" his ghetto. We admit that our patience is wearing thin …

Which brings us to the second interpretation, less common, more "sympathetic" and no less contemptuous, that no longer emphasizes the *opacity* of a triple alterity (an African chief, a madman—all things that the spectator is not), but the "after effects of colonialism." In this reading, Amin becomes transparency itself: through him, through the ridiculous joke of his "black" power, read the traces and the effects of a colonialism that does not want to be erased. The ex-colonized are no longer the "burden" (as Kipling says) of the white man but his "remorse." It involves another, subtler form of racism: in it, the Other is only ever the disturbing mirror of our own defects, it has no existence of its own, it is we who provide it—even negatively—with an identity. As if, behind the abuses and excesses of black power, there were nothing but colonialism's trace, as if, before and after colonization, something specifically called *African power* had never existed.

Does this mean that a third reading, centered around the question, "How does power function in Africa?" were possible? We have shown

that Barbet Schroder's film as it was made prohibits this reading, but would it have been possible if the film had been made in another way? In other words, does a leftist point of view on the "subject" of B.S.'s film exist, and if so, who has it? It is significant that one of the rare voices against the film—pulsating with indignation—was Philippe Decraene, an Africanist. Significant for the way in which the theme of "African power" is an object of study, of even specialized study, and nothing more, meaning in no way is it an object over which a leftist perspective could prevail on a mass level. The scholarship of Africanists will contribute to this perspective, but it will not be enough.

Meanwhile, B.S.'s film performs on a different stage from its apparent subject: the stage of common, everyday racism. There is no space on that stage for the neutrality of scholarship; it's a free-for-all, and every punch is a low blow. To the question asked elsewhere in these pages, "In what name do we write?," and to the answer that we propose: "In the name of a leftist perspective, as it already exists in reality," we must add this: that, sometimes, the very project of a film is entirely structured by bourgeois ideology, that it never emerges from it, that it marks a territory that is entirely in the enemy's hands from the start. Nothing can be gained by crossing into that territory.

(*Cahiers du Cinéma* #253, October–November 1974)

THE PROMISED LAND: AN INVISIBLE FILM

Miguel Littín, *The Promised Land* (*La Tierra prometida*).

By the time these lines appear, Miguel Littín's film will have, as they say, "left the screen" in Paris, and will only be showing outside of the city. To dedicate our first article on cinema to a film that can't even be seen might seem like a provocation. It is one, in fact. That one of the most beautiful films of the past several years has been snubbed, not seen, not welcomed, is a serious thing. We must question why. And so we begin…

If we were to summarize what the press has said about *The Promised Land*, it would sound something like, "It would be unforgiveable not to go and luxuriate in those gorgeous images of Chilean repression." One

side of the criticism emphasized pleasure (Littín is a great filmmaker, a Verdi socialist) and the other side, Chile itself (it's far away, it's sad, and— Thank God!—it's finished). These two approaches to showering the film with flowers short-circuited and resulted in this: no one went to see it.

Commercial failure

Why? because, for the film's native audience (cinephilic and political petit-bourgeois), that short-circuit between *activist charity* and *cinephilic pleasure* was very bad news. We'll go see *The Promised Land* because it is Chilean or because it is beautiful, but not both. Result: (serious) commercial failure. As for Chilean cinema (charity), "they've been there, done that," and this particular film arrived too late. As for cinephilia, better to indulge without guilt or complication, in right-wing "apolitical" films made by Sautet or Peckinpah. Actual bloodshed is *morally* opposed to cinema's tomato ketchup. Between charity and spectacle, an underhanded competition culminates in the "spectacle of charity." But behind that, there is the same impotence, the same defeatism, the same conclusion that all is lost, finished, played out, that there's nothing left to do, nothing left to think.

The reason so often given for why the film was rejected is that it was intended for a Chilean audience and not a French one. It's true that the film as it was seen in France after Pinochet does not function as it did in Chile before Pinochet. But saying that is one thing, and understanding what that difference *entails* is another. Odds are that those people (those critics in the first place) who refused a political reading of the film (in Paris) haven't the slightest idea about what the film represented (about what it *would have* represented) in Chile, about the richness of the context in which it took sides. Result: they speak of "artist's prophecy" when the filmmaker is committed, and of "religious folklore" when he stages popular culture.

"You have a history"

One of two things is possible: either the film is a passive reflection, which necessarily comes *afterwards*, once it's all over, once there's nothing left to do but remember, or else a film, under certain conditions, can *organize* its "audience." These conditions were partially fulfilled in the Chile of Unidad Popular. Cinema was a new field with little

reactionary involvement. A film could be an active moment for the ideological organization of the masses, a space where they could regain control of their culture and their history, a place *to embody* a new ideology (body: sounds and images). We know (although it has been seldom discussed) that Littín, who was close to the MIR, wanted to relate, in his cinematic *work*, actual protagonists of the class struggle to the question of their artistic representation, their cinematic image. Cinema is an invaluable medium for saying to those who fight (*and who were then also fighting against reformism*): you have a history.

There has been little talk of aesthetics regarding *The Promised Land*. Probably because of the same puritanism. As if there were nothing to learn from the form of the film itself, from its narrative method, from the perspective it adopts to make *one* history (that of José Duran and the peasants of Palmilla) enter into the history of Chile (from Marmaduke Grove to Allende) and that history into the Great History of Global Revolution, in order to ensure that those histories *communicate*. For aestheticism begins when we think that History has already been determined.

Because the film was received this way in France, it was *not seen*, pure and simple. It suffered the worst possible fate: although it specifically fought against the forecast of the past, and teleology, it was seen as a beautiful, useless object. But it could be useful, provided that we investigate the question that will certainly be the most important question of the year (meaning that we will revisit it in these pages): *How do we film History, and for whom?*

(*Libération*, 18 November 1974)

THE WORKING CLASS STAGE

Luigi Comencini, *Somewhere Beyond Love* (*Delitto d'amore*).

There is in *Somewhere Beyond Love* something that has disappeared from French cinema: the representation of the "working class." The factory as work site but also as theater, as a "stage," is something that a good Italian filmmaker like Comencini has no trouble filming.

A Spaghetti Western hero (Giuliano Gemma) is quite convincing as a trade unionist, and a PCI cell, graced by a large portrait of Gramsci, is as good a location as any. A story, even a photo-novel, can unfold there. In Italy, at a time when monopolies are increasing their pressure, filmmakers find it easy to film politics. In France, where monopolies are just as active, nothing of the kind. Movie screens are covered by pitiful images: we are reduced to reading the politics of *Borsalino and Co.*, encrypted in Delon's watery gaze; a singer/song-writer (Yanne) poses as an analyst and a hack (Granier-Deferre) easily passes for a clinician. A hypocritical, disguised, puritanical cinema. In Italy, a filmmaker who was even the slightest bit political would refuse to handle a script that doesn't discuss the crisis of the bourgeois institutions, the weakness of the State, the transference of power and the fighting spirit of the workers. Risi, Petri, Monicelli, Comencini (not to mention Bellocchio, Leto, the Tavianis), each in their own way, discuss only one thing: the *Historic Compromise*. Better still: they stage it. Did you see, in Monicelli's *We Want the Colonels*, the comic triumvirate of PC-PS-DC courageously oppose fascism?

A difficult marriage

Somewhere Beyond Love's politics is not really the love story, strictly speaking. That story tells us that it has become difficult to love one another, that tradition is a heavy burden, that factories kill. Rather, politics speak *through* the love story. Comencini needs a sentimental, erotic motive to present another difficult marriage: the one between Berlinguer's "historic compromise" that acknowledged its class collaboration, and one little phrase that says that it "is right to revolt," in short, the one between revisionism and leftism.

North and South

Question: How could a worker from the North, a young, serious union leader, become completely unhinged and shoot the factory boss? Answer: because he loves Carmela, and Carmela is dead. What does Carmela represent? In one sense, everything that Nullo is not: a woman, an immigrant from within the country, Sicilian, naïve, apolitical, unpredictable, lively, generous. What does she represent *politically?* The Southern proletariat, the one who has fought the

most difficult battles in the FIAT and elsewhere (read Balestrini's *We Want Everything*).

At the time of the Historic Compromise, an "intelligent" PCI, serious filmmakers, and a remnant of neorealism, are able to stage this genuine love story: Nullo and Carmela, North and South, a man's discourse and a woman's language, a Marxism that comes from on high and a revolt that has been brewing for a long time. But a serious price must be paid: Nullo is only able to revolt, even irrationally, if Carmela disappears from the film, if she dies. "Reformism + passion = revolution," that is the humanist, recuperative content of Comencini's film.

Like a photo-novel

It is a beautiful film nevertheless. Why? Because Carmela's character is not only the occasion, the pretext, for Nullo's final revolution (according to a familiar model: *she* is crushed, hence *he* revolts). Because Carmela's character *exists*. Not in a plaintive and fatalistic mode (of the *Love Story* variety) in which Carmela simply trembles like a wounded bird in an inhuman world. Especially not in a "sociological" mode of an "implacable" analysis that would present her as entirely alienated, below the threshold of awareness at which we start to take people seriously. Instead, Comencini knows how to film the fact that, using the *codes* available to her (familial codes, "popular" culture codes, familial repression, the stupidity of the photo-novel), Carmela *thinks*. It is true that she lives her life as if it were a photo-novel, but she lives it like someone *creating* a photo-novel, not like someone reading one. The best screenwriter of the film, *Somewhere Beyond Love*, is Carmela.

(*Libération*, 4 December 1974)

MILITANT CINEMA'S THEORETICAL PROBLEMS

Gudie Lawaetz, *May 68*.

One can only see a symptom in *May 68*, and it is unclear whether it amounts to much more. It is therefore not a value judgment that it

invites us to pronounce (is it a good or bad document? exhaustive or not? objective or not?) as much as a reflection on its very conditions of possibility. What *made* it possible? It is through the *unfolding* of a triple conjuncture, of a triple series of motives, that an answer may emerge. In the texts that follow it, Gudie Lawaetz's film (symptom, pretext; it doesn't matter) is only ever something that tells us it is *time* to ask the questions it assumes are resolved: questions of militant cinema.

The *political conjuncture*, first of all, allowed it to *happen*. It refers us to the class struggle in France, six years after 1968, and to the decline, as a political force, of the organized left. *May 68* was a fiefdom, a memory, a *reserve* that the left primarily inherited and because it was made to function as emblem, master and implicit signifier, primal scene, it became a wasteland. Today, there is nothing to prevent discourses presumed dead, mortally wounded or permanently disqualified from invading, or simply occupying, that land. Still incoherent, the discourse of the right (in film: Krieg or Fouchet), still mollifying, that of the left, now unified (in film: Séguy). Provided that it returns with the indeterminate label of "events," *May 68* can be discussed by everyone, takes its place in the doxa of authorized discourses. Symptom of the ongoing takeover bid on leftism (its ideas but also its material foundations; its images, for example).

The *ideological conjuncture* allowed *the film to be made quickly*. It refers us to the ongoing debate over History.

Everyone participates in this debate. Everyone must redefine their active, positive relation to the past. We see, pell-mell, Giscard's pilgrimage to Mont Mouchet, symposiums on the Resistance, "retro style" and, in opposition to it—but also triggered by it—the resurgence of what even yesterday was dormant: popular memory, filmic memory, archives. Finally, for professional historians, *last but not least*, the reappraisal of the historian's "metier."

The *cinematographic conjuncture* allowed this film to find the sounds and images it needed with relative ease. And to find them right where they were: in the hands of (ex-)militant leftist filmmakers. It refers to the particular history of militant cinema and to the questions inherent to it: What can an image *do*? What can it be made to

say? What does it mean to *inherit* images taken by other people? And inversely, what does it mean to *convey* one's own images? Until now, the focus has always been on the immediate efficacy of images. Gudie Lawaetz's project unintentionally puts something else on the agenda, that the *archive*, the weight of preserved images, their efficacy, their "meaning" held in reserve and now problematic, is also a material force, a challenge.

The press has not failed to note that the novelty of *May 68*, the film, reflects the fact that the "events" of *May 68*, while removed from our immediate history, are not yet "a thing of the past." To evoke them was to forego scientific rigor and seriousness (not enough perspective), as well as the impulses and outbursts of lived experience and of polemics (too much perspective). It was to situate the film in a new, unprecedented, ambiguous temporality. (To convince us of this, we need only remember how long it took for any documentation of the Algerian war to appear onscreen).

What's happened is that the period of time between what is immediate and what is warmed over, what could be called the *cooling-off period,* has been considerably reduced. This brings a new, important fact into play. Less time is required for History, History made into signs, to be consumed.

That is why *May 68* is itself a (minor) event. It writes a tepid History, without waiting for it to be "settled," to "settle back" into the anterior past of periodization (it was *before*), of trauma (it was horrible, *fascinating*) or of doxa (it was *like that*). No one says (as with *Fascista*): "Because History has been settled, you may revive those horrific images, risk-free." But we expect that another (silent) commentary will accompany the film: "Because they were able to make a film about it, History must already be settled." Doxa no longer guarantees the film's innocence; the film, by its very existence, suggests that History, perhaps, has been settled, and *contributes to creating a new doxa*, actual conformism and the stereotypes of tomorrow.

To which attention must be paid.

(*Cahiers du Cinéma* #256, February–March 1975)

Boaz Davidson, *Lemon Popsicle* (*Juke-Box*).

This Golan-Globus production is a scam: after being roped in by the names of numerous rock stars, including Bill Haley, the audience realizes too late that those stars only appear on the record player at parties where boys cruise girls in an insipid narrative that resembles *Grease* but is even less likable, set in Tel Aviv and sometimes in a kibbutz. He loves her but the other guy gets her pregnant. He helps her get an abortion but still she chooses the other guy. The girl is silly and life is hard and aesthetically, the film is below aesthetic minimum-wage. It doesn't help that it sounds, feels, and smells entirely American, and reflects the producer's unforgivable love for the lowest elements of the USA. In the future, beware of Golan-Globus productions.

(*Cahiers du Cinéma* #296, January 1976)

Jeannot Szwarc, *Jaws 2*.

Not really a sequel to *Jaws 1*, since in Amity, inexplicably, everyone has forgotten the great white filmed by Spielberg and needs a great gray, filmed (with far fewer resources; this shark looks like a complete has-been) by Jeannot S., to refresh their memories—since theirs are so short (promoters greedy for cash and gilded youth hungry for sex). The least mediocre part of a film that is mediocre from beginning to end revolves around the Brody character (Roy Scheider, rather good), whom everyone thinks is a nut and who, having mistaken a school of sardines for a shark, even doubts himself for a second, loses his job, and knocks back an entire glass of Jack Daniel's. Unfortunately, the audience, who has already seen, in the sequence before the credits, the shark sink its teeth into two underwater photographers (should we view this as a metaphor for the film?), knows what's going on and starts to wish—it's the ruse of the script—for the shark to come out into the open, for the skeptics to be filled with shame and for Brody, who in the meantime has become a sort of Ahab, to be recognized as the greatest of cops and the greatest of fathers (he saves his disobedient children). In this kind of fiction, where you need a shark to convince

your children that their parents are worthy of being parents, there is little to like and even less to reassure us.

(*Cahiers du Cinéma* #296, January 1976)

SOUND(HER), IMAGE(HIM) / VOICE(HER), EYE(HIM)

Jean-Luc Godard, *Number Two*, (*Numéro deux*).

Which could also be written as: Sound (Her)/Image (Him) or, more precisely: Voice (Her)/Eye (Him). For by speaking of "sounds and images" in the abstract, we forget to mention that *the body* is also and especially at stake. The Godardian body is what receives, houses the eye, it is the image. The image is the man's domain (even if—*Number Two*—only the foetal void remains), that to which he *answers*. He answers to it as a filmmaker (the crushing majority of filmmakers are men), hence as a voyeur. Cinema, voyeurism: matters of scopic pulsion, of the erectile eye, *the business of men until now*. But he only answers to it because someone is talking to him about it. Someone: a voice, an off-screen voice, always a woman's voice.

The woman's voice as an oral penis. She articulates the law, but a bespoke law, one that submits images, these images to itself (to him). In the second half of *Wind from the East*, it's a woman's voice that teaches and draws the lesson: "What to do? You made a film. You analyzed it. You made mistakes. You corrected some of them. Maybe now you know something more about the production of sounds and images, etc." Same device in *Here and Elsewhere*, where again a woman's voice translates, unpacks, restores the images that we have just seen, that flew by too quickly (out the window, as they say). This assignment of roles also plays out in the theater of *Tout va bien*. She (J. Fonda) works in radio (the voice: political commentary). He (Y. Montand) works in cinema (the image: advertising films). That voice only talks about the significance of current events ('68), about History, about the meaning of History. That image is of prostituted bodies wriggling around for the greater glory of Dim pantyhose and the shame-addled pleasure of the man who films them. Through the voice,

History barges in on the images as something that tears them apart, marks them, subjugates them to the law. Through a woman's voice.

The man's body is a protruding eye, the woman's body a voice that incessantly intervenes, questions. *Number Two*: the same goes for how bodies are arranged while making love, for *posture*. "Why do you always want it like that?" asks Sandrine (neither on nor off-screen: she is merely positioned for Pierre's eye—and for the camera's). *But Sandrine's voice only speaks of one thing: the image she is in and the position she occupies there. Utmost proximity between bodies and thoughts: the anchoring of what is said in what is seen.*

Godard's strange feminism: he places the woman (the voice, sound) as the one who articulates the law (thinking that carries a big stick, from which we will have understood that it has a phallic character) and the one who gives life. Perversion. It isn't clear if feminist advocates will be satisfied by this "position" that men no longer want, by this "power" they want to abandon. Women don't necessarily gain anything from it (even if the man reaps the benefits of masochism: being the director who says how he would like to be punished, what kind of *cruel matronage* will be performed). They didn't gain anything from it in the era of *La Chinoise* and *Wind from the East* when they were substitutes for a discourse (Marxist-Leninist) that no one wanted: the voice of Anne Wiazemsky (and the bourgeois subject she implied) made it so that no one was able to identify with that discourse and that truth.

(*Cahiers du Cinéma* #262–263, January 1976)

SING THE CODE!

Jean-Louis Comolli, *La Cecilia*.

One phrase is never heard in *La Cecilia*: "I told you so!" I told you that it would end badly, that it would never work, because," etc. If there's one thing that doesn't interest these experimenters, it's discussing the experience (success or failure?), evaluating it—in other words, starting from resentment. No belated triumph of insight over blindness, no crushing of dreams, no fault-finding. At the film's most

tragic moment, when the colony burns and disbands, oh well! Even then, the fatal phrase will not be uttered.

Does this mean that Comolli is stupid? That he believes, with as much naiveté as his characters, in the viability of their anarchist colony, and that he films its failure without understanding its causes? Nothing supports this conclusion. Evidence of Comolli's intelligence, meaning his knowledge of historical context (c.f. his own text in our last issue), is abundant; they make up a network of notations (on the "outside" of the colony) which forbids the spectator, no matter how much Marxism has rubbed off on him, from thinking he is more intelligent than the author. It is clear that, even beyond the colony's internal contradictions, its external contradictions (the history of Brazil) are such that the Cecilia experience was doomed—from the start.

From the start, let's not forget. It is patently obvious that the colony is against everything and everyone, beginning with Malatesta, who writes in the newspaper, *Critica sociale*: "Rossi is a deserter." And simultaneously, because the land was awarded (only to Rossi) and not earned, Cecilia was arguably lost from the start: its story is only ever the story of its own redemption. Hence, no ambiguity. Simply put, it is not only Comolli who knows exactly how to situate (take in proper context, as they say, blah blah blah) the Cecilia experience (its objective and subjective conditions of possibility), it is Cecilia itself, *if it wants and when it wants*, that can at any given moment measure the discrepancy between its dreams (the contradictions it accepts to show itself) and the reality (which, it's clear, it wants to know nothing about: it ignores Brazil and the Brazilians, with the clear conscience that belongs to every colonist: they occupied lands that were empty).

On that basis, it's impossible to confuse *La Cecilia* with the films (intelligent, but a completely different kind of intelligence, the show-business kind) made by the Taviani brothers. P. Bonitzer has shown how, in *Allonsanfan*, the audience sees those other experimenters, the Sublime Brothers, through Mastroianni's disabused eyes. Lucky audience! There it is in line with History, (following in the right direction, that is, in line with fiction, with history with a small h), enjoying the touching and Guignolesque spectacle of what (those whom)

history has rejected: renegades or fanatics, the Brothers in question. With Comolli, nothing of the sort. He didn't arrange for balcony seats for his audience. The course of History interests him only moderately. *La Cecilia* is not the story of a wager or a calculation, but of a redemption and a headlong rush. "*O, Italian exiles!/To adventure we go/ Without tears or regrets.*"

One thing about *La Cecilia* is bound to be striking: the film presents itself as a veritable collection of contradictions. They're all there: man/woman, peasant/worker, practical/intellectual, etc. I think, though, that these contradictions translate into *figures* more than they do situations, figures in the sense of dance figures or compulsory figures. These figures need extras [*figurants*] in order to be *played*. And that game is Cecilia's very experience, its survival time.

One of the game's mandatory conditions is met at the outset: the land is assigned, not conquered. Suppose for a moment that this land had been won by a battle, a war, a calculation: it then would have been produced between men and locations, discourses and practices, more weight, more memory, more resentment: more *anchorage* (c.f. Ford, whom Comolli admires and, with the greatest respect, parodies here). Instead, unleashed onto a playing field that was allotted to them, our colonists have only their words and their songs to anchor themselves: their only common good is their *language*.

Anarchy's language is rich. It is comprised of songs, operatic arias, bits of doctrine, citations from Bakunin, peasant proverbs, etc. *Anarchy's language is not doublespeak.* It is simultaneously popular and intellectual, simple and complex, full of dreams and defiance. It expresses itself, recites, rants, sings; it does not speak. The entire Comollian approach consists in making the language of anarchy not a site of communication (of debate, of analysis, of contradiction, of reproach, of "I told you so!") but an intransitive space, the common element of *jouissance*, the common ground for peasants and workers, for intellectuals and illiterates. Language allows one to say that things aren't working, but it's also the element into which what isn't working disappears as soon as it is said, *because* it's been said.

Some examples? When Luigi (Luigi the worker, Luigi-Robespierre) protests against the idea of voting (which seems to him to open the

door to the worst kind of Parliamentarism), he doesn't address Loren-zini as one subject to another, he doesn't blame him, he shouts a quotation: "Our country is the entire world/Our law is freedom/And in our hearts rebellion." He rebels, certainly, but remains within the law. Sometimes a sudden stop occurs, the limits of language are reached. When Rossi says, "You know, the land belongs to the people who work it," Rocco, the peasant, replies, "So what?" When Lorenzini asks him to elaborate on the idea that "the modern state is nothing other than the realization of the old idea of domination," Alfredo responds, laughing, "Sure, I could. But I don't want to!" The language of anarchy recognizes nothing outside of itself: there are simply moments when it no longer applies.

There is in *La Cecilia* a refusal of active, original speech, a refusal of "first-time" effects (another film that is repulsed by naturalism). Anything that can be restated, repeated with pleasure is preferable to what can be improvised with difficulty. In this film without effects and without affects, what ends up being moving is each character's relationship to the common code, what he does with it. There is, Jakobson says, a function of language (that he calls *phatic*) by which (Hello?) the address is ensured (Hello, yes?), the communication channel remains open (Hello, I'm here?) even if nothing happens. *La Cecilia* is a phatic film.

If I had to summarize the film in one sentence, it would be: "What you're saying... could you sing it?" Could you make it a text, a quotation, a dogma, a lesson? But also: an opera, a dazibao, a theater, a tune? The anarchist law—neither God nor master—is above all "neither God nor master of language." It's the search for what language usage has, *hic et nunc*, legal force. Today it might be pedagogy, tomorrow song, and later on, theater. Who knows? Rossi no more than anyone else.

Perversion in *La Cecilia*? The code has become the mother tongue; the colony's only desire is to live, to move, to play within it. The maternal body, not the land awarded by unfit fathers (Pedro II, Rossi), but the language in which the law insists and runs like a jackrabbit.

(*Cahiers du Cinéma* #264, February 1976)

Jean Genet, *A Song of Love*, (*Un chant d'amour*).

Compared to this silent film, produced in 1950 by the writer Jean Genet and banned for the following twenty-five years, most films with "love" in the title are likely to be seen for what they are: a sham.

A Song of Love is the story of three holes. A sort of scale model of the absurd machinery through which the eye (*the eye of the warden and the eye of the spectator, alike*) believes that it subjugates what it sees...

Between two prisoners, a wall, and in that wall an imperceptible hole through which only a straw, lovingly culled from a filthy mattress, can penetrate. A hole too small even for a peephole, just large enough for one man to exhale, through the straw (sign of union, copulation), cigarette smoke into the other's mouth.

The second hole, between the prisoners and the warden, is the warden's peephole, through which he apprehends his prisoners (his scopic objects), white-hot, in the throes of the most violent desire.

Between the guard and the eventual spectator (of this film that was banned for so long), the screen itself is the final skylight, a rectangular hole that opens out on to the carceral space and through which the spectator can dock with what he sees.

There is in this film an idea, pursued with the greatest tenacity, a sort of story of the eye (but not at all a story of the glory of the eye). Every time the spectator risks being satisfied in his position as a voyeur, the glaucous and concupiscent eye of the guard intervenes, *like a call to order*, with an abrupt reverse shot. Every time the spectator, forgetting his position, his *posture*, prepares to enjoy what is playing out in the little theater of desire (blind desire: they cannot see each other and touch only in a waking dream, but they can hear each other, breathe together), he is quite simply transformed into the guard. Guard of the prison, guard of the performance: inescapable figure of suspense, the very condition of the song, condition for the song to occur in space—and duration (the song *endures*).

What's more, when the guard, terrifed by his own desire, enters one of the cells to have his way with one of his prisoners, it has nothing to do with the figure of the "torturer-who-shows-his-victim-he-wants-to-be-abused." That asinine image, very *Night Porter*, rests on

the rather narrow idea that it's entirely easy to force *one's pleasure* on someone. In *A Song of Love*, more simply, the guard-voyeur operates as the instrument of the prisoner's desire, an instrument whose existence the prisoner completely denies, that he nullifies as subject, that he takes as prosthesis.

What is a spectator? Nothing more than the *warden* of his images. Whatever copulation goes on between them does not concern him.

(*Cahiers du Cinéma* #264, February 1976)

Jacques Demy, *The Pied Piper*.

With this English film, beautiful and inexplicably unprecedented, Demy refines his mythology. In the wonderful story of the Pied Piper of Hamelin, he finds everything he needs to add one more chapter to the "Tales of Causality," for that is what he is about—and only that. Where do things come from? Where do children? The cloacal theory is just one step away from the cloaca itself, since this medieval story is about rats (and children). Where does disease come from? Plague? The debate that is at the heart of the film, a theological debate, ought to be taken seriously. Either God has sent the plague to punish mankind (and so what need is there of rats?), or else it's rats that carry the plague. It's this last thesis that the Jewish alchemist Melius, figure of scientific progress (the first in Demy's cinema) wants to prove, alone against the world. He chooses rats over God and burns at the stake. The town is then infested by plague, crossed in every sense by by the real agents of the plague, the rats. But in an obvious paradox, they are also agents of life (carriers of genes as well as germs) because children dressed in white who already have the secret of their birth behind them escape the epidemic, led out of the city by the Pied Piper (played by the singer, Donovan).

P.S. The film's non-release, followed by its delayed and botched release, indicate the cowardice and couldn't-care-less attitude of that practice of *dispatching** still called "distribution."

(*Cahiers du Cinéma* #264, February 1976)

Jacques Doillon, *A Bag of Marbles* (*Un sac de billes*).

Jacques Doillon's film obeys a proven principle. Submerge the audience (quietly), drown it in self-pity (with the theme: how young they are! how adorable!) that is all the more powerful because that self-pity is exactly what is forever *forbidden* in the film. In it, the two heroes—two young Jewish boys fleeing through France—are never identified, called out, recognized for what they primarily are to the audience: children. Not by the Germans (for whom they are only Jews), or by the smuggler (for whom they are a source of revenue), or by the farmer or the Pétainist bookseller (for whom they are free labor); not even—and the entire trick of the film rests in this—by their parents and older brothers who, in order to toughen them up, (mis)treat them as adults. There's nothing left for the audience in 1975 to do but reestablish the denied signifier: *childhood* in every shot, in every scene of the film. The camera, since it is always trained on the young, helps considerably to parse that timeless youthful freshness from the complications of History. (By the way, Doillon confirms that he has the perfect mix of talent and laissez-faire attitude to depict the new-look familialism that "French quality" so desperately needs.)

(*Cahiers du Cinéma* #264, February 1976)

Jacques Rouffio, *Seven Deaths by Prescription (Sept morts sur ordonnance).*

We could write off Rouffio-Conchon-Girod's film by saying it takes us back twenty years, back to Cayatte. And yet we know that Cayatte's cinematography consisted of the inexhaustible mise-en-scène of the "moral dilemma." The Cayattesque saga was all about masters who are suddenly afraid of getting it wrong. Masters: those who, in a bourgeois society, have moral and/or material responsibilities: judges, lawyers, teachers, doctors. Thus it dramatically supported the depoliticization of the (actual) problems it raised by reducing them to social cases and morality tales. But it also provided us with the only imagery of minor masters (= authorities) that cinema made

available to us. Cayatte, to be sure, is someone who can't get over seeing bourgeois institutions lose their grip.

Nothing, or almost nothing, challenges the medical Order in Rouffio's film. *Seven Deaths by Prescription* is among those films (dubbed, out of laziness, "progressive") that are borne by the questions that they ask more than they are the bearers of those questions. The challenge, the "crisis" in the medical institution, produces the film, but the film says nothing about that crisis. Simply put (and this is where the film actually intervenes, where it either has an impact or it doesn't), the film gives that crisis a *frame*, types its actors, confronts the problem of admitting new figures into an extended family of stereotypes (for example, the character played by Vanel, a mixture of the famed surgeon Lortat-Jacob, an old gangster, and a *deus ex machina*). That's what the film plays out and plays upon. Like every film intended for a broad audience, and thus having something to do with the imaginary, it is a success or a failure, good or bad, effective or ineffective to the extent that it constructs new types, to the extent that it reactivates, reevaluates, renovates the imaginary of its audience, its reserves.

During the investigation conducted by one doctor on the suicide of another doctor, there is a moment where he must extract the truth from those who know it: the policeman and the psychiatrist. Bearers, one of the knowledge of objective facts, the other of subjective determinations. Let's say that in a film driven by leftism (such as *Cancer*), the investigation into the "medical world" occurs from the point of view of the non-doctors, the sick. A foundational challenge, on the fault line between the sick body and the medical corps. In a soft-progressive film (*The Hospital*, by P. Chayefsky), it is ultimately the boss who courageously poses the most radical questions. Rouffio's film, perhaps as a result of the simplification and excesses of the script, extends beyond the limits of a film about "the medical world." There is a medical corps (a "body" that defends itself, that secretes antibodies), but there is no medical "milieu." The proof? That between simple surgeons and the boss and his family (his gang), there is no common element of a profession, of dialogue, of a direct relationship (other than an aggressive one: surprising scenes in which Vanel is brutalized). Contradictions

internal to the medical have no space of their own: medical power (what, in medicine, is most abjectly connected to power: the State Board) is immediately relayed by other commands, other bodies: the police and psychiatry. The slight merit of the film is that, *through exaggeration*, it has dotted those i's.

(*Cahiers du Cinéma* #264, February 1976)

RESERVES

Milos Forman, *One Flew Over the Cuckoo's Nest.*

"The moonlight that haunted Althusser at Tsinghua University or the Sorbonne: the workers don't need our science, but our revolution: threat of a serious job crisis on the philosophical market."
—Jacques Rancière

With whom, with what, do we *identify* in cinema? The answer is simple: with violence. Let's put aside the question of knowing who identifies *mostly* with characters, with filmic figures (it is in a star's nature to have a monopoly on violence: see Belmondo's tired-of-having-to-kill expression in the giant poster adorning the front of the Rex movie theater), and who identifies *mostly* with the violence associated with the camera, whether it be of the pen (violence of writing, cruelty of denotation) or of the gun (the screen of fantasy, hunter = filmer, hunted = filmed). There is another dividing line for us to trace, one that identifies itself (differently? but differently how?) with violence *according to whether it is legal or legitimate.*

To tether an audience of spectators to *legal* violence (that of the Law, of its representatives, its officials) or to violence that demands a strengthening of that legality (militia, peaceful men transformed into vigilante monsters, cops avenging a friend), is to contribute to the spectators' fascination. By making them desire normality, normativity, and quickly normalization. In fascist ideology, it's the norm that acts as both nature (normal = natural) and culture (normal = traditional). We know how that ends.

Tethering an audience to *legitimate* violence is characteristic of progressive films (which we have also called, at *Cahiers*, modernist). These films are characterized by one basic assertion, vague but inescapable: the right to *resist*, to refuse to resign oneself to everything that bullies Mankind (which, consequently, earns a capital M), the right and the duty *to say no*. Here we come to the space of Forman's film.

The question that these films ask and that they resolve in the spectator's place (and also to safeguard his place)[1] is: what kind of violence is not only tolerable for me, but also *desirable*? From what *other* do I accept that it come to me, to what *good* other do I accept to delegate it, beyond (and because of) my impotence as a spectator? For that identification-delegation of violence is not addressed to simply anyone. It changes. It is even what we call ideological context.

What are the best vectors today (1976) of righteous violence, of this power to say no, of being radical? One response: the mad (I intentionally leave the word as imprecise as possible). See the success of *The Enigma of Kaspar Hauser*. That is of course no accident. It is becoming common knowledge almost everywhere (in the West as in the East—and Forman comes from the East) that power has renounced what it, throughout the 19th century, established: the distinction between criminals and the mentally ill.[2] It treats one like the other, and vice versa.

There are two ways to quash the overwhelming impact of the word "madness," and two ways to quash the normative violence of psychiatric nosography. We can generalize it and do as Forman does by reproducing the old imagery of the "ship of fools." This is actually Hollywood's solution to the cinematographic treatment of madness: *the world is a stage, the stage is a world**. There are no madmen because the whole world is mad, no asylums because the world is an asylum.

1. *Cuckoo's Nest* is a relatively reassuring film. There is no serious reason for the critic or the public to act as if simply watching this film throws them into unspeakable crisis. These pretenses are not sincere. If the film must be "defended"—a film that, in fact, no one has attacked—it's because it renders euphoric a leftist imaginary that—since Sergio Leone fell silent—particularly needs to be perked up. Nothing more, nothing less.
2. This distinction is becoming the favored subject of those who are interested in the relations between cinema and history. See Allio's (upcoming) read of Rivière. Given the (prior) read of Vacher by Tavernier (*The Judge and the Assassin*). On this point, we want to highlight our disappointment: it's about brining these questions to a well-known scene: "French quality" cinema, contemporary with the moment of the Common Programme.

Open door to metaphysics (rather stale), but also an open door to the carnivalesque, to the ridiculous, to revolution. Thus madness is neither a "subject to be treated" (which Forman claims not to have done) nor a "social case to focus on." It instead becomes a frame, a cabaret scene in which the hero is let loose: not crazy (locked up because of the maliciousness of other people: *Suddenly, Last Summer*) or a faker (*Shock Corridor*). A generalized indeterminacy is produced (who's faking? maybe everyone!), a pleasure generator, the pleasure of non-accountability that spares nothing and no one. In the theater, during *Cuckoo's Nest*, you feel the playful connivance of McMurphy's supporters and of his team. Transmutation of revolt into pleasure, of illness into euphoria. *Cuckoo* is a disarming film. It knits together, in the theater, a collective that accepts experiencing its loss of power, its abdication and its gain of sanctity in a hallucinatory way. Demagoguery.

The other way, we suspect, has nothing to do with that. It consists not in relocating (to the tune, familiar since 1968, of "We are all…"), but in relentlessly dynamiting *both* the word *and* the thing, in blowing up the material cage of madness, by connecting the camera to another space, one that is even less feasible, of all the *real* experiences that rescind the "walls of the asylum": Deligny/*Ce gamin-là, Le Moindre Geste*, Basaglia/*Fit to Be Untied*, Laing/*Asylum*, Mannoni/*Vivre à Bonneuil*, etc.

Forman's solution plays with walls. Outside? Inside? McMurphy's role (Jack Nicholson) is to play (and get off on) this double possibility. In the other solution, the place of the camera, and hence that of the spectator, cracks along with the walls of the asylum. The question becomes: *Where am I, me, among them?* A question that doesn't exclude the bad run-in (the mentally ill in the factory of *Fous à délier*) and requires that we overcome it.

The smooth operation of Forman's film is due to the implementation, from its opening shots, of the basic arsenal necessary to feed the audience's imagination: *a reserve and a shifter [embrayeur]*. The asylum acts as reserve: reserved people, placed in reserve, a reserve of aggressivity and violence, Indian reservation. The shifter, McMurphy, is someone who could be called a "man on the inside": "our man in the story," "our man in Havana." McMurphy's role consists of successively representing every possible and desirable position the spectator

could find himself in when facing imprisonment, or any kind of confinement. He can escape or stay, fake it or participate, act like a diabolical child (voting for watching the game on television, then acting out the match) or a model patient (the boat trip). And so the film provides great pleasure for a leftist audience experiencing, outside of cinema, and with increasing difficulty, its relation to education (to cultural labor) and its inevitable result: imprisonment.[3]

The trick of the film lies in this: during the entire first section, we are left free to believe that McMurphy is the master of the game (since, as a good narrative shifter, he holds the key to the inside/the outside, sees the way to escape the playing field). It's the others who seem pinned down like butterflies. After the "ship of fools" episode that legally places him at the mercy of the institution, McMurphy discovers, *at the same time as the audience*, that the other patients are there largely on their own free will, that they could leave if they so desire, while he no longer can. Kafka's aphorism that opens Welles's *The Trial* comes to mind: "No one else could enter this door. This door… was intended only for you, and now … I am going to close it."

From that point on, the film can become a metaphor (another reason for its success) for *every* space not only where power is exercised, but where those who endure it adapt to it, can no longer imagine life outside of it (resignation, hospitalism). A Gulag, who knows? McMurphy's mistake then becomes more obvious: he used his freedom (*the very freedom the spectator delegated to him, the freedom to say no, the right to be violent*) to play the Good Samaritan, the scout leader or cultural ambassador. Problem of the leftist intellectual: he wanted to help people *forcibly*, when he could only give them the gift of his enthusiasm and his collapse.

That's when the Indian steps out of his reserve. He appears *in extremis* as the real pretender. It isn't revolution he needs, but something else: time to recompose his strength. The operation by which the audience became attached to the film (delegating its violence to McMurphy) reproduces itself *within* the film: McMurphy delegates

3. For a large fraction of the film's audience—students, leftist educators—*Cuckoo's Nest* has the advantage of finding—and being the first to do so—a scene and a fantasmatic resolution for a situation that is less and less viable, sustainable, in the real: that of the educator, the facilitator, the manager.

his violence to Big Chief. His own benevolent other is the maternal, colossal figure of the Indian: the developing world.

Only, Big Chief doesn't make the same mistakes as McMurphy. He knows he must leave nothing behind, he can't keep his man on the inside,[4] he has to strangle him, break his neck. He knows (and Forman pretends to know it with him) that he must put an end to reserve, and to reservations.

<div align="right">(Cahiers du Cinéma #266–267, May 1976)</div>

ESPERANTO CINEMA

Roberto Rossellini, *The Messiah* (*Il Messia*).

1. Jesus, who gets annoyed over the slightest thing, chases the merchants from the temple with a whip made of ropes. A doubly anticipated scene because it figures in both the film's screenplay (by Rossellini) and the original screenplay (the Gospels, supervised by God). In the next shot (after a cut in a film that has very few of them), Jesus, in close-up, wipes his brow covered in sweat. A little gag. But the audience, believing in the dignity of the film, doesn't laugh. The same shot, by Buñuel, would have had them rolling in the aisles.

2. In these two shots, what makes us smile is the irruption of a *reflex* (of a natural gesture: Jesus is a man, after all; he tires easily) that is also an unexpected gesture (from a God, we don't necessarily expect those kinds of small authentic details. The same goes for John the Baptist's slight movement of surprise as he prepares to pour a little water from the Jordan on the head of a candidate for baptism whom he has not yet seen and suddenly recognizes: it's Jesus! These images are tainted by a certain *absurdity* that also makes them valuable (and that has always been at the heart of R.R.'s cinema). Absurdity tied to the *resistance and minimal reflexes of the bodies of present-day actors* superimposing themselves on the biblical imagery, necessarily poor and Cecil

4. The audience has grown hardened in recent years: it can watch *everything*. Except its own ruined position.

B. DeMille-ian, that we we have, *nolens volens*, in our heads. Bodies fending for themselves, left undirected (c.f. Caprioli, clownish in the role of Herod, whom he plays as he played Salumi in *Tout va bien*).

3. In that absurdity, we find all the *humanism* for which Rossellini has over the years become the indecent bard. Rossellinian humanism is of the trivial kind expressed in this epitome of excuses: we're human, *after all*. After all. After the end of the world. In 1976, absurdity consists of reclaiming as a positive project what we call, at *Cahiers*, Espéranto cinema. The notorious "erasure" of the filmmaker becomes an axiom. Generalized transparency. The filmmaker chooses neither his subjects nor his media. When it comes to media, Rossellini's modernity was to declare that cinema and television are the same thing, that no distinction exists between them because there is *only*—after all—*communication*. (Godard has drawn other lessons, much less ecumenical than R.R.'s from the same refusal to allow himself to be confined by the question of specificity). As for "subjects," he announces with pride that he chooses them not according to his whims or personal views, but to a sort of objective necessity that requires him to address the great moments (the great men) in the history of Judeo-Christian thought, from Socrates to Jesus, from Alberti to Marx.

4. Behind this claim of communication for communication, we can see (not without disgust) the most tepid form of a kind of communion of secular saints (in the element of Culture for all: film as Communion host) or an essentialist farce. Something like an audiovisual *Encyclopedia Alpha* that would communicate only the idea of communication, the imperialist idea of a facile and obligatory communication. We could also conclude that *The Messiah*'s audience does not exist, that it is intended for an audience yet to come, an audience of survivors of the catastrophe that, according to R.R., awaits the West. He works for that audience. A bespoke dream of an audience, delirious and didactic, for whom the history of the West would be as opaque as the dance of the honeybees is for us.

To create archives and manuals for that audience is to speak Esperanto once we are sure that there is no one left to understand anything about anything.

(*Cahiers du Cinéma* #266–267, May 1976)

Perry Henzell, *The Harder They Come*.

This Jamaican film is not only "cool," it allows us to say two or three things about that slightly moldy chestnut that is the *debate* about "popular cinema."

The story. Ivanhoe Martin, driven from the countryside by poverty, comes to Kingston to try his luck. Work, exploitation, more squalor. But Ivanhoe is convinced he can sing. He records a song "The Harder They Come" for a fat man named Hinton who calls the shots (and who asserts that he calls them) in show business (reggae, etc.). Ivanhoe's mistake: he wants to distribute his record himself; the disc jockeys, who are terrorized by and depend on Hinton, refuse to play the record. Disillusioned, Ivanhoe (who is forced to cave and sell Hinton his song for next to nothing) becomes a ganja (the local name for cannabis indica) dealer and finds himself caught up in another type of exploitation. New snare, new web. After trying to go into business for himself, and killing several police officers, becoming public enemy number one (his song becomes a hit), hunted, missing, and omnipresent, he ends up getting himself killed in the purest tradition of the *Shaft*-style thriller.

It is two films in one. One is a sort of folkloric travelogue, a trip through Kingston's underworld, against a reggae background.

The other exposes the objective conditions in which Ivanhoe struggles. The first film is relatively light, bordering on frivolous, sloppily filmed (almost Esperanto), an excuse for catchy music and local hits. The second, imbricated in the first, is the rapid and uncompromising exposé of power relations (devices, repression, duplicity, schemes) that exist in a city like Kingston: relations between the police, show-business, drug traffickers, etc.

What is the sign of a popular film? Not only the fact that it is seen by a large number of people (which is characteristic of commercial film in general). Nor the fact that it tries to extract a popular essence of the masses and construct a lovable symbol of that essence (that's the dream of militant cinema), but that it possesses the two dimensions I've attempted to describe. One is of *denunciation*, entailing only the courage to tell it like it is, call a spade a spade, a cop a cop, corruption corruption. The other, of *carnivalesque*: the

people not only struggle against the establishment or silently resist, they also *parade before power* and parade with what they have at hand (the ambiguous cultural forms they take pleasure in: music, mythology, that "mass culture" they impose and that is imposed upon them).

Jamaica is a long way off. European cinema is a long way from Jamaica. It is interested in something completely different and, thereby, no longer captures anything popular. To the simple and *always possible* denunciation of power (how it functions, how it works and makes us work, how it's going) it prefers complicated investigation (à la Rosi) and the paranoiac question *par excellence*, the one that asks of power, "Who is doing the manipulating?" (and that question, via its continual asking, ends with the evanescent metaphysics of the great equivocal man: Mattei, Luciano, etc.). To the carnivalesque, it prefers droning on about "dominant ideology" and whining about the alienated pleasures of the impoverished masses, who are always manipulated. It isn't surprising that, under these conditions, a popular cinema would be, at least in France, virtually *nowhere to be found.*

(*Cahiers du Cinéma* #268–269, July–August 1976)

Roger Pic, *Mao's China* (*La Chine de Mao Tse-toung*).

A naïve myth persists: images are made to be seen and sounds (including that particular breed of sound that is commentary) to be heard. Incurable naïveté. In a film such as the one made by Roger Pic (*Mao's China*), the commentary (which, incidentally, is dull and pre-dictable) is—the paradox is clear—intended not to be heard. It's not that the film is poorly made, it's that it was made with only one goal: to pass by, the way that storks pass by: neither seen, nor heard.

On the telephone, it is no longer rare to hear, on the other end of the line, music (preferably smooth and hip). Isn't it time we ask ourselves what we are being told with this music? We aren't being told: listen to this (it has no use value: it's just a signal), we are being told: wait (exchange value: promise of a response to a question you

haven't yet asked, promise of exchange). The music of answering machines exorcises the threat of a silence assumed to be frightening; it also marks the imminent enunciation of the person who will answer; finally, it—according to its style—emphasizes your correspondent's brand image (the image he wants you to have).

This is more or less the position taken by the commentary in Pic's film about China. It is intended to produce a global effect of "we know what we're talking (to you) about and you know quite well that we know." Why ask for anything more? Who's going to protest that he didn't understand, that he wasn't given enough time, that the rush of images and commentary plunged him into a kind of stupor perforated by certain recognizable markers along the way: images (rare, magnificent) of the Long March, a young Zhou Enlai, Mao's wives: eyes on the surface of the audiovisual soup.

We mustn't be afraid to say: *these films are made to not be seen.* That is their function. To provoke in the TV viewer a guilty, hallucinatory effect (he tells himself that if he has learned nothing, examined nothing, it's probably his own fault: he should have been more attentive). In turn, television, the great educator, chomping at the bit to pre-empt the death of the Great Helmsman, demonstrates that it is already able to cover the event. In other words, to recover it. Its key function being not to educate, but to forever reaffirm its monopoly.

People will say: yes, but that's true of all commentary (or almost all). (Yes, but it isn't true for *Land Without Bread, Here and Elsewhere* or even van der Keuken's very interesting films). In the particular case of Pic's film, the thing is simply a bit more unacceptable. Because its subject is grandiose, because the archival documents are rich and previously unseen (in the second half, literally fabulous images: riders and masked horses surging under a mushroom cloud, Zhou Enlai's peasant dance, rare speeches by Mao). Because it seems that Pic pushed the fear of silence to the point of accompanying his images, on top of commentary, with a kind of incessant background noise, the rustle of crowds, muffled cries, unanimous breaths, the rumble of History, that become a somatic frenzy for nothing.

(*Cahiers du Cinéma* #268–269, July–August 1976)

Bruno Muel, *With the Blood of Others* (*Avec le sang des autres*).

Latest poster in support of the Common Programme. It's clear that Bruno Muel's goal isn't really to draw our attention to the words and images of the workers he films (his subject: the Peugeot factories at Sochaux, the working conditions and repressive tactics of the employers) but to *connote* the FCP as the only authority that, off-screen, and *on the condition that it never be named*, could give these words and images any meaning. The principle of the film being not to pretend to gather information about the workers' membership in the FCP or CGT [General Confederation of Labor], or to cover their experience with the leaden shroud of an *off* discourse that would rationalize it, but to maintain, between the film we are watching and the line we suspect is behind it, a zone of *incertitude* such that the film would not be incompatible with that line. That modesty is tactical, and that tactic is a matter of *advertising*.

We must therefore critique the film not only because it is a propaganda film, but because it is—*as a film*—not a serious enterprise, as if Muel, after having assembled certain materials, refused to take them into consideration, refused to do what every filmmaker worthy of the name does: *to confront what, within the material itself, resists him*. Abdication as an artist, also as an audiovisual worker, as someone who works "with the sounds of others."

For what do we see? Image-wise, one question: how do you film an assembly line? Muel's answer: by fragmenting it. On one side, the workers (occasionally throwing a Bressonian glance towards the camera). On the other, machines (incomprehensible, also fragmented, but like all machines, as soon as they are filmed, eroticized). And it is not because the sound is set at too high a volume (probably in an attempt at realism) that we feel anything about the functioning and experience of the assembly line. On the contrary: the same images could serve to valorize the factory within the frame of an industrial film (a tribute to the forces of production).

As for the interviews, the workers' voices are shot through with fatigue, exhaustion, ennui, disgust with work. With work *in general*. Muel, while crafting his poster, must avoid two things, no more no less: 1) asking workers questions that are too political (are they

members of the Party or the union, their hopes, their convictions, *their ideas*); 2) giving free reign to a discourse that risks being even the slightest bit libertarian, radical anarchist and—which would be worse—*anti-productivist*. The workers' language must be beneath any thinking and any revolution. All that can provoke is moderate speech, a plaintive speech about the "time to live." With one notable exception: the young worker who talks about his mutilated hands, but *off* (and why *off?*).

Moral: the filmmaker assembles material *that he doesn't take into account* (even though he preselected it). He accepts that the FCP's line establishes itself in the lacunae that his film half-heartedly creates. Not because the line in question is the only one capable of giving this material meaning, but because it is the only *credible* one doing so (it can only handle one, long-standing image: that the FCP is the party of the working class). What the film acknowledges, essentially, is its profound disinterest for its subject, and beyond (and thanks to) that disinterest, the current necessity for the FCP to retrieve both the factories (to be managed) and the workers' despondency (to be managed as well).

(*Cahiers du Cinéma* #268–269, July–August 1976)

Larry Hagman, *Beware! The Blob.*

The anti-*Jaws*, or: how an *objet a* becomes a big fat mess. A red, gelatinous mass (the blob) swallows everything in its path. In this indiscriminate binge, in this force of indifferentiation, it isn't too difficult—for anyone who has finished high school—to recognize Capital. A cynic, the blob differentiates itself from the great white shark in *Jaws* by the fact that it has no moral dimension. Instead of inspiring a sacred union against it, instead of allowing men to quiet their (sexual) appetites and their conflicts (of status) for a while, it only, wherever it goes, sharpens the contradictions between them, leaves them intact throughout (they are two in number: young/old, cops/non-cops), always ready to resurface. And if, as in every disaster movie, the blob intervenes to prohibit human sexual activity (at the

beginning of the film, a Black couple say sweet nothings to each other: they are blobbed; later on, a hairdresser and a hippie flirt and banter during the shampoo: they are blobbed…); it sublimates nothing. While the film is not ideologically abject, it is not any less of a failure. Once again, a parody is less effective than what it parodies. Also, Hagman's mistake was believing that he could *film* the blob. For we have another name for the blob, which swallows everything, shot after shot: off-screen.

<p align="right">(Cahiers du Cinéma #268–269, July–August 1976)</p>

Akira Kurosawa, *Dersu Uzala*.

I will speak[1] more extensively about *Dersu Uzala*, Akira Kurosawa's Soviet film, when it is officially released in France, with the title—simpleminded—of *The Eagle of the Taïga*. This beautiful film retrospectively sheds light on *Dodes'ka-den*, with which it otherwise has no relation. The version screened at the Empire, twenty minutes of which were amputated by the Soviets, was applauded, most likely because of Kurosawa's presence there (he gave a press conference) along with his actor, Maksim Munzuk. I fear that that applause may have sealed a misunderstanding that the film, as long as it is misread, allows. For it can in no way be reduced to the discourse it has created.

One might fear the worst from a Soviet-Japanese coproduction initiated under the aegis of Gerasimov, the most academic of Eastern filmmakers. Kurosawa's renown is such that the stalest Esperantist projects have been able to be built upon it (remember the mishaps in the USA several years ago, when the production of a film about Custer had to be abandoned). Even the filmmaker's own words ("Today, with the risks that pollution poses all over the world, every man must think of nature, and live differently") were far from encouraging.

That is not the case. This story of friendship between the Russian explorer Arseniev and the Asian hunter-guide is something

1. See Serge Daney, "Un Ours en Plus," *La Rampe* (Paris: Cahiers du Cinéma/Gallimard, 1983), 89–94 (editor's note).

very different than the reconciliation between Whites and Asians on either side of the Ussari, against the background of Brezhnevian humanism (a subject that, when seen from the Soviet side, is far from innocent), different even than communion with nature. It is about saying, with fearsome tenderness and peace (*Dodes'ka-den*, again), that there can be no reconciliation (even though there may be love). The word for non-reconciliation in Russian is *neprimiriannye*. And in Japanese?

(*Cahiers du Cinéma* #272, December 1976)

THE EIGHT MAS

Alain Tanner, *Jonah Who Will Be Twenty-Five in the Year 2000* (*Jonas qui aura 25 ans en l'an 2000*).

We find in *Jonah* the two great pretexts for reverie that we have come to expect from Alain Tanner: the *charcuterie* (the blood sausage used in history class echoes the sausage links in *The Salamander*: their mission is to incarnate time, working time and the work of time) and *topography* (Switzerland as the center [*milieu*] of the capitalist world, the midpoint [*mi-lieu*] where every boundary intersects, utopia). But there is, in relation to the films that precede it, something more in *Jonah*: as if it bet on being as educational (first reference to Rousseau, *Emile*) and exhaustive as possible (second reference to Rousseau, the Encyclopédie). What is *Jonah*? A Swiss entrelac, a drawing on a wall, a baptismal name, a reflexion on sausage-time[1] and whale-space, a

1. Time. It's the leitmotif of the film, the thing the eight Mas endlessly discuss. It is always about time remaining. It would be more correct to *speak of tenses*, like they do in grammar class. *Jonah* would then be an infiniite series, a peculiar collection of future anteriors. Some known and familiar (time of a pregnancy, of a prison sentence, a history class, a turn of the roulette wheel), others less obvious (time of property speculation, of the catastrophic extinction of the whales), others even more strange (time of the tick that can wait eighteen years before falling upon a red-blooded animal, time of semen's reflux towards the forehead in a tantric sexual variation), etc. Like every utopist, Tanner reifies time (the sausage theme), but after having disseminated it in infinite *temporalities*.

philosophical tale, the trace of a generation? Certainly, the tableau vivant of an "intelligentsia without attachments."

A generation is portrayed within it, with precision, detached tenderness. A generation, not a family. *Jonah* is not a unanimist narrative, a *Vincent, François, Paul and the Others* of the extreme left, insofar as unanimist narratives (which are also pro-family narratives) give conflicts (generational and class conflicts) only *one* stage on which to perform their resolution (from *The Slap* to *John's Wife*). Tanner, like in that other film that also comes from the heart of Capital, *Milestones*, only films *one* generation but on *multiple* stages, the generation that, having been born in 1968, will soon be ten years old.

An educational exposition, a tableau in which no figure is missing. And yet, *Jonah* is a film without a moral, lacking that slight edge of knowledge that a filmmaker may wield over his subjects. *Jonah* is an educational film without a lesson, an encyclopedic film without a conclusion. Tanner, it's clear, doesn't know any more than his most enlightened character does (Rufus-Matthieu). He doesn't fake that knowledge. That's where the *strangeness* of his project resides, the slight perversion that causes it to escape (just barely? perhaps) any unequivocal, militant, moralizing reading (it's the same thing). It's also what approaches a definition (that renunciation of metalanguage) of what a *contemporary* film is.

Filming a generation differs from filming a family in several respects. Within the family, the stage on which the question of each subject's origin (the primal scene: the parents' desire) and place (the Oedipal theater: the assumption of his sex) will be re-enacted has already been established. Transmission of name and of role. Within the generation, there's a sort of perverse displacement in relation to the family. A generation is not only an an age group, it is also a group of experiences and discourses. A political generation *defines itself* as being born at such and such a moment, not from the parents' desire, but from a fold (in the blood sausage) of History. It creates its own birth certificate. In that sense, a generation always proclaims itself, sooner or later, to be lost in the way that a foundling was lost, at first. The eight protagonists of *Jonah* decided that they were born along with 1968, just as those in *Milestones* were born with the Vietnam

War or Charles la Vapeur (R. Bussières) with 1936. The origin, we can see, is necessarily a myth. Which Tanner knows.

Max, Matthieu, Madeleine, Marco, Marguerite, Marcel, Mathilde, Marie have this in common: they all begin with Ma. They begin with code. This Ma (of May '68) is also the Ma of the *maternal* element. The eight Mas gather together only once, towards the end of the film, around a table, at the end of a meal. They are there less to celebrate their alliance and collaboration (which everything suggests is extremely precarious) than to decide on the *first name*[2] of the baby who is about to be born. That's when the camera, while awaiting the answer, traces a circle around them that takes, quite precisely, the form of a whale. Their experience will have consisted in trading the bad mother (against whom one does not rebel, Swiss society[3]) against the good mother (that cloacal whale whose organs they represent and that continually haunts the film, that whale that, while a mammal, does not give birth but *spews out* a little man, Jonah).

To choose one's origin: that's utopia. In *La Cecilia*, a generation emerges from of a book and returns to it. In Demy's most beautiful films (*The Young Girls of Rochefort*, for example), generations coexist, but only by chance. If a naive reading can be made of *Jonah*, it would see the film as an example of the successful transmission of political experience from one generation to another. In the final shot, the child crayons over the incomprehensible figures of the past. No legacy. Because utopia is not the future (even probable—object of futurists— or hidden in the present—object of dialecticians), but the arbitrary projection into the future of what *pleases* us in the present: an extended

2. The first name is not the name. That is to say, it is not the Name-of-the-Father. It takes the name of the maternal side, whispered by the whale. There is a lot to say about the use of first names in recent films, either to cement a consensus, *Vincent, François, Paul and the Others, Bob & Carol & Ted & Alice* or to disseminate it (above and below communication: *Louison, Jean-Luc, Marcel, René, Jacqueline and Ludovic*. Episodes of the 1976 TV series, *Six fois deux/Sur et sous la communication* by Jean-Luc Godard and Anne Marie Miéville.)

3. *The Big Night* comes from Lausanne, just as *Jonah* comes from Geneva and Sonimage productions from Grenoble. Cinema of border dwellers, hence the only one in a position to typify "leftism" if leftism is the obstinate search for frontiers and thresholds, the revelation of their changing design. The absence of a political scene (limited to Ziegler, the only known Swiss political figure), where a reformist left would allow for the bipolarization of opinion and votes, allows only radical fantasies and their *in vitro* application.

childhood (c.f. Pascal Kané's text on *La Cecilia, Cahiers* #265, p.21). It is the triumph of code (of writing) over master signifiers (the mastery of which access to the symbolic depends). It is, exactly, the collective, arbitrary, programmatic choice of a first name that a being not yet born will adopt. The desire to originate oneself, beginning from a word chosen at random (in the dictionary: *Dada*) or drawn from another (Kurt Schwitters and the *Merz* of Commerzbank). Third reference to Rousseau: the *Essay on the Origin of Languages*.

Does this mean that *Jonah*, as document, evidence, tableau vivant, slice of life and of history (that belongs to us), has no value? Certainly not. It is actually the first time that within what is commonly known as the System (another whale), a film about the post-'68 years rings true. But we mustn't make the film say something that it keeps silent about, or expect more from this whale than what it has to offer. Nietzsche liked to say; "Every new idea progresses in disguise." There's nothing new—in 1976—about the ideas of the eight Mas. One need only buy *Libé* every day from the same kiosk (and read it) to recognize them, now rather doxal. No surprises. Each idea has had, since 1968, its history, its bearers, its hour of glory. All of French/Swiss leftism's activist themes are there: doubts (school, the Party), the so-called "secondary" fronts of the struggle (ecology, space, [homo]sexual and tantric liberation, prisons, etc.). To say that these ideas are not new does not take anything away from their strategic efficacy; it only reminds us that they don't allow us to predict anything in the immediate future, new fronts, new challenges. For if anything defines leftism, it's its unpredictability. Throughout the world, resistances are scattered. "Resistances," Michel Foucault writes (*The Will to Knowledge*, p. 96), "do not derive from a few heterogeneous principles; but neither are they a lure or a promise that is of necessity betrayed. They are the odd term in relations of power; they are inscribed in power as an irreducible opposite. Hence they too are distributed in irregular fashion: the points, knots, or focuses of resistance are spread over time and space at varying densities, at time mobilizing groups or individuals in a definitive way, inflaming certain points of the body, certain moments in life, certain types of behavior."

Tanner's brilliance is in having understood that it is not only new ideas that progress in disguise, but also "new representations." *Jonah*

is one of the first re-presentations of what French (but not Swiss) cinema has avoided for ten years: those things—and those people—who have changed since 1968. Like *all* representation, it is funereal, even though it involves neither a burial nor a sell-off. That is why we mustn't take Mattieu's bicycle voice-over too literally (or see in it a potential message).[4] He may give the illusion that he is pulling the strings of other people's desires, of being their memory. But in fact, if one thing is absolutely not an issue in *Jonah*, it's the eight Mas' "desire." By a sleight-of-hand trick (shots in black-and-white), Tanner presents them quickly enough that we don't ask the question (that conversely informs Francis Reusser's *The Big Night*): "But what do they want, deep down, these eight Mas?" In place of desires, they have fantasies or caprices, always regressive (killing time by shooting an alarm clock, trudging through a sewer, getting eaten on, going to bed "with two girls," etc.)[5] From the moment Tanner pretends to define each by his "most secret desire"—which is always child's play—the philosophical tale becomes possible. From there too, the "sexual relations" between the characters are struck with a certain irreality, as if they didn't occur, or as if they only occurred between quotation marks.

There are hardly any desires in *Jonah*. Instead, there is *jouissance* to maintain (whales in peril) and the small pleasures of the code. That is to say, the *variations*. Going to bed with two girls instead of one. Or even what opens and closes this cinematic whale: an increase in the price of cigarettes.

(*Cahiers du Cinéma* #273, January–February 1977)

4. Matthieu is a living simulacrum. A traditional hero since he is located twice historically, as a worker and as a father, twice the orthodox transmitter of life and of revolution. And yet, the film continually displaces him in relation to this double function. A worker who is transformed into a teacher through a detour working the land, father deprived of his paternity by a detour through the collective, making him the (future) teacher of his son. The transmission is twice denaturalized by a miraculous resorption of two massive contradictions: worker/peasant and manual laborer/intellectual. All of *Jonah* functions in this way: orthodoxy, plus a slight *excess* that, without ruining it, suspends it.
5. Marco, the history professor, has one desire. Not to be loved by Marie, or to "go to bed with two girls" (ludic red herrings), but to expose Marie, the worker, to present/exhibit her to his students, making her an exposed subject. A cruel scene that says, in passing, what the desire of the educator (and likely the filmmaker-Tanner) is about. The theme of education is the most *cutting* theme of the film, the one on which we come to grief.

Jean-Pierre Lefebvre, *L'Amour blessé*, Bill Daughton, *Corner of the Circle*.

Sound, in cinema, is *in* or *off*. We have written about this primary difference repeatedly in *Cahiers*. But there is another difference, one that a film such as *L'Amour blessé* adopts as its subject: the difference between sound that is EMITTED *in* (live) or *off* (recorded). Once filmed, a "radio show" is exactly the opposite of an emission. Not the work of the voice, the shortness of breath, the muscles in action and blood rushing to the head (everything that has been the material of Straub and Huillet's cinema, especially in *Othon* or *Moses and Aaron*), but the stubborn presence of an immobile and modest subject: the radio station. A subject seldom filmed (given the importance that it has in daily life), as if it endangered something essential to cinema: (visible) proof that the sound we hear was indeed emitted. (Emissionless voices do exist, such as the robot Hal in Kubrick's *2001*, as do voiceless emissions, metaphorically figured by the bodies of silent film actors.)

A transistor shares top billing with the actress Louise Cuerrier in *L'Amour blessé (confidences de la nuit)*. The theme is announced with the opening credits (by a voice over that suggests a documentary as much as it does a thriller). It is about solitude in a large modern metropolis (Montréal). Solitude = a peopling of voice over (and noises), the generalization of the *off*. At the door of the image (inhabited by a solitary woman) come knocking all of the sounds that in cinema jargon are called "wild tracks." Double solitude, radical disjunction of the emission and what is heard. A woman returns home (tired, no doubt, from work), takes a bath, makes a cup of coffee, listens to a radio show, calls into that show, hears herself talking on the radio, is recognized on the air by her ex-husband, who threatens her and comes knocking at her door (maybe), finally falls asleep listening to the noises made by her neighbors who, after a heated argument, violently make love.

The transistor (like the mirror, the screen, or light) is one of those objects that blows up the strict (but impossible to find once you start looking for it) cleavage between what is *in* and what is *off*. In that it allows us to grasp, better than the panoptic camera (of *Grand Soir*, for example), what power is at the end of the 20th century: a

machine that atomises, isolates, and singularizes, that unites only in the form of surveys (and yet, surveys are the triumph of "one by one"). In that sense, Lefebvre's film speaks of important things, discovers a continent that has been seldom filmed.

Where, then, does our disappointment come from? Perhaps from how difficult it is to film strategies of power (and alienation) solely from the point of view of their points of application: solitary and mystified victims. From the perhaps insurmountable difficulty of making ideology a filmic subject. Lefebvre has not chosen between film noir (which includes dramatization, pathos) and crude observation. Sometimes he captures a performance from Louise Cuerrier that resembles Anne Bancroft's desolate humor in *Seven Women*, sometimes Delphine Seyrig in *Jeanne Dielman*. What doesn't work in *L'Amour blessé* is that the spectator watches the actress perform gestures that she makes every night (her performance suggests weariness) only once. And, while the repetition of the same situation, the same gestures can be "performed," it can also be filmed *as such* (at the risk of boring the audience). What allowed Chantal Akerman to go all the way with her subject was her refusal to exempt the audience from repetition under the fallacious pretext that it will have understood that repetition was the subject. From there, from *Twice Upon a Time* (title of a remarkable film by Jackie Raynal), the fiction was able to emerge, as if in its pure state.

Conversely, repetition is filmed *as such* (and carries the same risk of boredom) in *Corner of the Circle*, an American film by Bill Daughton, screened in an adjacent theater to *L'Amour blessé*. This other film "about solitude" was also shown in an empty theater, or almost empty, with an atrocious film-to-audience ratio.

We have already acknowledged and described the film and its merits (see Louis Skorecki in his report on Toulon 75, *Cahiers* #262–263, p. 120). Strangely, this modest film (New York, night, 16mm, an ambivalent homosexual, an affair cut short) stumbles upon problems similar to those of *L'Amour blessé* and resolves them with greater discipline. First by making repetition the film's driving force (two nights, two apartments, etc.) and by giving rise, in extremis, to a bit of fiction in its pure state. The hero's *acting out*—which answers to Jeanne Dielman's stroke of the scissors—consists in standing

naked at the window and incurring—as in *L'Amour blessé* and to his great panic—assaults and insults from the other side of the door. It is in this *acting-out* and not in the quotidian that repression *and* resistance can be read.

As for the sound, its poor quality is truly admirable. While in *L'Amour blessé* the recorded voices are overdone, unrealistic because caricatured, in *Corner of the Circle*, those emitted voices, the dialogue's direct sound, resonate as if they were recorded, not in a neutral mode (as in *Pickpocket*, which the film evokes, i.e. with an uptown accent), but in a terrorized one. It is one of the film's merits that it has managed to film *in* those people who speak *off*.

(*Cahiers du Cinéma* #273, January–February 1977)

Arnold Antonin, *La nayif nan péyi kout baton.*

Or *Naïve Art and Repression in Haiti*, or even: *Can a CIA Agent Be a Patron of the Arts?* (The answer is, obviously, no). Second film and first medium-length film (50 minutes) by Arnold Antonin, and the logical sequel to *Ayiti men chimin libete* (*Haiti, The Path of Freedom*. Cf. *Cahiers* #258–259, p. 109).

The first film strove to unravel, strand by strand, while leaving nothing in the shadows, the brand image of the Duvalier and post-Duvalier regimes. It was also the first Haitian film ever made, and the first attempt to write the history of Haiti from the perspective of the fighters (the activists of the *Organization Revolutionnaire 18 Mai*) and on behalf of those with a stake in seizing that history (beginning with a great number of Haitian exiles). A lot for one film. For a *single* film. It showed, placed in historical perspective, along with what has in France been only slightly (and mis-) understood—Macoutism, Papa Doc-racy, blood plasma trafficking, poverty and terror—those things that have been largely ignored: the American occupation from 1915 to 1934, the French "presence," Duvalier pleading with the Americans to "Puerto Rican-ize" the country, etc. Something very *strong* kept the film from being unpalatable: the presence of the activists that inspired it, their seriousness, their conviction, the fact

(quite simple but too often overlooked) that as opposed to many French activist films that subscribe to an optic of probable defeat, this film was *one* moment in a prolonged struggle. An indispensable moment, an overview.

The second film chooses one issue from that overview: the "naive art" aspect by which Haiti's brand image has recently been "enriched" around the world (an image managed in France by Jean-Marie Drot's TV programs and books). Its most interesting section is the one that retraces the history of that art, i.e. the history of a mystification.

In 1943, a certain Dewitt Peters, an English professor smitten with painting, the cultural envoy to the American state department in Haiti, founded a "Centre of Art" in Port-au-Prince where he trained naïve painters, gradually imposing on them folkloric subjects and an awkward and repetitive technique, creating around them a marketplace whose capital is naturally New York. The ideology that presides over this imposition of naïve art (which Haitian painters, tormented by poverty, will reproduce in an accelerated fashion once the country becomes touristized) is rather crudely summarized by Mrs. Elvire Wilson Price, an American collector: "We want to return to humanity's childhood through naïve art. Haitian naïve art is magnificent; I adore it. It's one solution on the level of the image to the global ecological problem. You Haitians are a happy people. You're always laughing. If someone gives you a banana, you're happy."

This historical reminder has the virtue of stripping that mythology now being formed around Haitian naive art. It does not, however, resolve the different problems that it presents.

It's a question of *geneaology*. "Who appropriates what and to make it serve what goals?" First step: Dewitt Peters appropriates certain decorative pictorial principles existing in Haitian houses and, in the name of a slimy philanthropism, imprisons the painters in a sort of artistic reserve, artificial and mercantile. Second step: Haitian painters define themselves in relation to that naïveté that was imposed upon them (but not parachuted). The film is, in my opinion, too allusive when it comes to the relationship of the painter to the order; it demonstrates its prostitutional-tourist aspect, but not the fact that it *still* has something to do with pictorial practice. Third step: political activists now take that "naive art" element into account

in their continued work with the masses. Here, necessarily, the film is at its most abstract, because it can only point to a reminder of Leninist principles with respect to art: the necessity of engagement, of selecting between two aspects of tradition (the still living and the already dead), of the debt to what modern and foreign techniques of expression have produced, of the assurance that "we understand that new things always astound us, always inspire fear. We don't forget it when an artist comes to us with something unusual." The film deserves credit for not legislating more than it is able, for not being *too* ahead of the concrete situation that it *reveals*.

(*Cahiers du Cinéma* #273, January–February 1977)

A LONG WAY FROM LAWS

António Reis and Margarida Cordeiro, *Trás-os-Montes.*

Towards the end of the film, a man teaches his son—a little boy—the basics of fishing. The boat glides over the calm waters, the camera frames the overhanging rocky shores, also calm. A voice (the child's) then makes itself heard. It says, "Alemanha…" A voice over—but it does not declare, does not question; instead it dares, dreams out loud. Then, in kind: "Espanha…" What the image *indicates* in effect is Spain, within reach, behind the mountains' screen. But the voice that says "Espanha" does not speak more loudly than the other, does not correct it. Because Germany is also there, in the child's enunciation. Later on in the film, the rhyme will be fulfilled: the reading of a letter sent by a father, from Germany, where he has emigrated. Hence it is not one *or* the other, but both countries simultaneously, each reduced to a word. There is Spain, which is the *off* of the image, *beyond the gaze* and Germany, which is the *off* of the sound, *below the voice*. A zone of dreaming and anguish separates and connects them, what we call a "shot."

Estrangement is the subject of the film that Antonio Reis and Margarida Cordeiro have made in the province of Trás-os-Montes (hence the film's title) in 1976. In the dual sense of the state of being far away (exile) and the act of becoming estranged (losing sight of,

and then forgetting something). Estrangement, Reis and Cordeiro gradually tell us, *is* the history of northeast Portugal. It is the distant, incomprehensible and incomprehensive domination of the Capital (Lisbon) over Trás-os-Montes. To such a degree that Laws, enacted by the Capital, never reach the peasants, who wonder: do they even exist? In a key scene, Reis translates an extract from Kafka's *The Great Wall of China* into dialect, key because we have seen the problem tragically repeating itself, in reality, in 1976. Estrangement that de-cultures the province, severs it from its Celtic and pagan past, folklorizes the crumbs of popular culture in the form of postcards. Estrangement of the peasants from the cultivated fields and the pastures, first towards the region's mines (a magnificent scene in which Armando, the child with the spinning top, visits the abandoned mine, soaked from the rain), then towards America (the father, never seen, suddenly returns from Argentina and leaves again just as quickly), finally towards the Europe of factories and chains, França, Alemanha.

The estrangement (or its opposite: rapprochement) that interests the authors of *Trás-os-montes* is produced in the *hic et nunc* of the *present*. It isn't the bleak excavation of the buried, the mourning of lost time or the exhibition of treasures that are treasures meant for no one (unless for a necrophiliac public, à la "Connaissance du Monde"), it's an operation that is more demanding by far: it draws our attention to what in the shot (a zone, remember, of dreams and anguish) refers to an *elsewhere* and thereby constructs, bit by bit, what we could call "the filmic state of a province." And to do this, Reis and Cordeiro certainly don't start from the *fact* of Trás-os-Montes' official existence (geographical maps or Lisbon bureaucracy) but from the opposite: from the digging, from the rending of each "shot," like that aforementioned river that carves out its bed between Spain and Germany and that flows, then, towards Portugal.

Estrangement is not only a theme (about which we could blather on, demonstrate our understanding, bungle some critiques), it is also the *material* of the film, *Trás-os-montes*. The muted enunciation of each shot utters the same question: do degrees exist in *off* spaces? Can something be more (Alemanha) or less (Espanha) *off*? In other words: what is the status—the quality of being—of what *leaves* the frame (of what it expresses and what it expels)?

You will surmise that the answer is this (and on it an entire *jouissance* of cinema depends): in the *off* space, there are no degrees. *When you are away, even if you're only next door, in the cinema, you are lost forever.* That summarizes, in a typically obsessional formula, the dialectic of *in* and of *off* in modern cinema. And we should add, for the indeterminacy to be complete: *and if you do come back, how will I know it's still you?*

The "seamless dress of reality" that Bazin dreamed of is always cut by the frame, by montage, by everything that *chooses*. But even if patched (mended) by a reverse angle that stitches it up, it is inhabited by a fundamental horror, a malaise: what shot A revealed and shot B retracted may very well return in shot C, but in disguise, with no proof that it hasn't become something else. Everything that passes through the limbo of *off* is susceptible to returning as *other*. As narrative and representative as they were, people such as Lang or Tourneur (continued today by Jacquot or Biette) only filmed because that other, that doubt at the heart of the same, was possible, generator of horror or the comic (c.f. Buñuel's principal jurisdiction). It may seem like I have forgotten Reis's film, but this is not so. A case in point is the film's stunning final scene in which a train pierces the darkness, followed, one could say, *forcibly* by the camera that does not always differentiate it from the darkness and that endlessly rediscovers it (*fort/da*), either in the form of smoke (for the eye) or the form of whistling (for the ear).

For Reis, there are no more degrees in temporal estrangement than there are in spatial estrangement. No more short-term memory than long. Everything that isn't there is, *a priori*, equally lost—and so, equally important to *produce*. Rupture with a linear, gradualist concept of loss (of vision or of memory) in favor of a dynamic, heterogeneous, material concept. For *production* means two things: one produces a commodity (through one's work) and one produces a piece of evidence (when one must). Cinema = exhibition + work. That is why, despite their erudition, Reis and Cordeiro constantly behave as if they've just learned what they are about to communicate to a viewer who is also completely in the dark. We must take Reis seriously when he talks, in an interview, about a "tabula rasa." And it is unclear if this attitude is not, in the final analysis, preferable to the

one that works from the knowledge or supposed knowledge of the audience, when it isn't working from a common doxa (the generator, like all doxa, of satiated laziness, particularly destructive in leftist narratives). I am rather inclined to think that it would be better—no matter what side of the camera you're on—to put into practice the Mizoguchian adage: wash out your eyes between every shot.

<div align="right">(Cahiers du Cinéma #276, May 1977)</div>

Emile de Antonio, *Underground.*

I would like simply to graft some reflections onto this film that our friend Louis Marcorelles has already discussed (in an interview with Emile de Antonio, *Cahiers* #272).

There are three kinds of images in *Underground*:

1) those in which we see the Weather Underground activists filmed, for obvious security reasons, *from the back*—backs that speak, since the film was made to embrace their discourse;

2) those in which we see the film crew, reduced to three people (Emile de Antonio, Haskell Wexler, Mary Lampson) who film themselves *from the front*—silent faces, mute and attentive faces, for they are only there, they and their "questions," to make answers possible;

3) about the third kind of images—stock shots—I will say more later on.

The first two kinds of images determine an *arrangement.* This *arrangement* is exactly the opposite of the one set in place during a typical interview (TV-style) in which those who speak are facing front and those asking the questions are *off*, or filmed from the back. Another difference: during the question/answer game (the interview) as it usually rolls along, a certain search for truth is *simulated* and most often achieved in the form of "reality effects," meaning the illusion of increased intensity that the arrangement itself produces and that refers only to itself (and very rarely to those who pass through that arrangement, those who lend themselves to it or find themselves trapped by it).

Nothing of the sort in *Underground*, in which de Antonio, Wexler and Lampson place their camera (and their craft) in the service of the

activists and expect no other truth from recording their discourse than the one assumed by that discourse. They will take on nothing of what that arrangement produces *nonetheless*: effects of the third meaning, born from those "speaking backs" or the enigma of "listening faces."[1]

The arrangement would be frightening (because of the loss of any referentiality) if there weren't a third type of image—archival documents, "stock shots*"—to conveniently authenticate and tie together the whole. Stock shots in which we can read traces of the group and its members in the media, as well as historical traces, more vast, of American protest movements for the past ten years and longer: Black movements, radical white movements, etc.[2]

There is (for example), a very powerful moment in the parade of these stock shots: a speech in which Malcolm X says the most raw and least misleading thing a leader could say to those whom he influences: *I don't want you to do things you wouldn't have done anyway** (I am quoting from memory).

This archival shot carries with it great emotional power, *stock emotion* in a sense. Mixed in with this *stock emotion*, one question

1. De Antonio's neutrality is entirely relative. During his interview with Marcorelles (p. 39), he makes these stunning remarks: "What we didn't know is that they never interrupt each other. Also, when we started filming, it was very strange. I said something like: 'Tell me a little about what that's about' and someone started speaking and no one cut him off. Haskell and I, we looked at each other: something wasn't working. Same thing with the second reel. I said to them, 'I don't understand what's going on.' And then they told us that it was a principle they had, to never interrupt each other; when they make a collective decision, one person speaks until he or she is finished, then another, then another. So I told them that we couldn't make a film like that, that we'd have to do it differently. And it changed."

It's a matter of ensuring that this self-portrait of militant extremists be, for an American audience, credible. That it conforms to a certain type of debate in which someone says "I" and people cut each other off. There is more than an intervention in this: it's a trick. But not so much because Antonio asks them to "speak differently" than because he doesn't allow us to guess (unless someone asks him the question) that he's doing it.

2. Americans' familiarity with the media, the trust they place in it (cf. *Network* or *All the President's Men*) is such that they make use of it even though they are questioning it. Since it is rather the opposite in Europe, misunderstandings occur.

1) *Most of all*, it takes patience, cunning and courage for de Antonio (or Cinda Firestone with *Attica*) to gather the documents they need for their cause. They know that those documents exist somewhere. Consequently, Americans are, in their meticulous, whistle-blowing investigations, a hundred times more effective than the Italians (who have a tendency to metaphorize everything) and a thousand times more effective than the French (who are narrow-minded and spineless on this front). It's true: A *Hearts and Minds*, an *Attica* would be unthinkable in France. And that's a shame.

continued to haunt me: what is—*in the film called Underground*—the status of such an image? To what does it refer? Several readings are possible:

1) It is an emblem, a poster, that actualizes the myth of Malcolm X.

2) It is a chronological index. It serves to locate the era we are currently discussing ("this was the era in which Malcolm X made that kind of speech").

3) It is a way of indicating the agreement, or the sympathy, or the admiration that the Weather Underground has for Malcolm X's political positions (and to raise the issue of the convergence of struggles at the same time).

4) It is, more simply, there because they were there, that night, in the audience when the speech was made...

Nothing in the film enables us to resolve the issue. So much so that I wonder if emotion—*stock emotion*—comes from that very indeterminacy that suddenly lets me directly latch on to that image and forget how it affected, and what it signified for the other (the other, here, is as much de Antonio as it is the *Weather-Underground*). Doesn't that emotion arise at the exact moment the implicit contract that ties me to the filmmaker (the one who says: you want to watch? ok, watch this—*this thing I have chosen for you*) is severed and I am free to have a direct, dual, *imaginary* relationship with that image of Malcolm X (no coincidence that this is the constructed image of a thought-provoking leader)? It's a very broad question, one to ask of every film, and especially of militant films.

For in relation to the arrangement that I described earlier (the face-to-face interview, reversed) the stock shots always play a role in

2) But this leads—because of the very fact of that confidence and that familiarity—to confusion between *archives* and *memory*. It is not because American TVs have a stockpile—among millions of others—of images of the "Days of Rage" that those days are alive in the memory of those who are fighting or resisting *today* in America. For some time now, the impersonal archiving of blockhouses exceeds and discourages the personal archive of a memory. The media makes us amnesiac. We loved *Milestones* for this reason: it used singular bodies and what they had garnered from memory (but also from forgetting: forgetting is also useful) and not the certainty of the presence—somewhere—of a stock of authenticating images. It is in that sense that we prefer *Milestones* to *Underground* and *Underground* to *Portugal*, the film that R. Kramer and P. Spinelli made about post-April 25 Portugal in which, cutting corners, they wanted to short-circuit two moments: archive and memory. (But more remains to be said about *Portugal*.)

Underground that I would describe as *coverage*. In at least four senses of the word:

—military sense: the barrage of stock shots covers the assault of a few: the *Weather Underground*'s praxis refers less to its current condition of possibility (or impossibility) but to a nostalgic imagery. Who remembers the "Days of Rage" today?

—fiscal sense: financial coverage. *Stock-shots* (these conflicts took place) guarantee the present (there will be more conflicts),

—journalistic sense: coverage in the sense of the profile, the "front page" of a newspaper or a magazine,

—the popular expression: to cover oneself.

When, then, will we begin to make archival documents play another role than one of "guarantee"?

(*Cahiers du Cinéma* #276, May 1977)

Johan van der Keuken, *Springtime* (*Voorjaar*).

"My point is that the filmed image, as I'm trying to make it, is a sort of collision between the field of the real and the energy I use to explore it. It's active, aggressive. Somewhere, halfway through, a high point is reached, and this is also the filmed image." (Van der Keuken).

In this search for the "high point," Johan van der Keuken, author of the North/South triptych (presented in 1976 at the Semaine des *Cahiers* and comprised of *Diary*, *The White Castle* and *The New Ice Age*), creates a *tension*, tension between the filmer and the spaces in which he operates (hence his name, *operator*), tension between various filmic blocks, collected here (the North, rich and white) and there (the South, poor and not white).

In *Springtime* (*Voorjaar*), the blocks brought in play are drawn from a single continent: Western Europe in 1975, gripped by economic crisis, anxious, prospectless. Amsterdam: we see a Dutch worker who has been laid off (he is at home, with his family, and is taking it badly, as a complete disenfranchisement: "I no longer feel like a man," he says, as he considers the possibility that his wife might be the household's breadwinner). Paris: we see an intellectual, alone or nearly so,

rather cheerfully explain how the crisis happened. Amsterdam: we see a retiree reconstruct the history of a small island that was threatened by financial speculation and saved by community activism. Frankfurt: we see a young German woman, at home, play a recording for us of her father talking about his past as a German communist and the oppression he suffered, then explain to us that she is the victim, in turn, of *Berufsverbot* (a professional ban), which she is not handling well. Amsterdam: a day in the life of a factory worker.

As opposed to the North/South triptych (which necessarily played on exoticism), *Springtime* searches for a narrower referent—Europe—the common point of these five blocks. And this common point, the "high point" of Capital, concerns space. *Space is becoming scarce*: that is what haunts van der Keuken. The most tangible effect of the development of Capital is that it imposes upon everyone the feeling of being played *here* in an *elsewhere* that they have absolutely no control over. Fortini: "You are not where your destiny is determined." When the unemployed worker analyzes his layoff, he knows quite well that somewhere in the world, in another space, there are other underpaid workers (in Macao or elsewhere) who are doing *his* work (thus he is replaced twice, once by his wife at home and once by a Chinese worker whom he will never see). The question of here and elsewhere was not invented by Godard (*Here and Elsewhere*) to hurt Hennebelle, it was imposed by Capital. With one decisive difference: Capital ignores the AND. It tears apart one space from another, entangles them, parasitizes one by the other. Therein lies the basis of all racism: not that the *other* exists, but that no AND exists to think about him (this is how European workers are trained against immigrants). Capital disaffects every space by screaming and shouting at communication (ideology of "connection").

If space is becoming scarce, if geography is finally on the verge of politicizing itself—cf. the journal, *Hérodote*—if we can say that the era is over in which, against history, domain of the harsh rule of death and the future, a perverse geography perpetuated itself that allowed for immortality and utopia, the very least that a filmmaker-traveller (such as van der Keuken, as are J.-M. S. and J.-L. G.), a man of borders and thresholds, could do is to be aware of what he is doing when he *adds himself* ("active, aggressive") to what he films. When he

inscribes somewhere that he is at the heart of those threatened, haunted spaces, like a *clandestine* passenger (a body and not only an eye).

Something has always struck me in films that present—as documentary or fiction, it doesn't matter—work on an assembly line. From Karmitz (*Comrades*) to Petri (*The Working Class Goes to Heaven*), no filmmaker has refused the pleasure (and the ease) of gliding along the factory's open, empty spaces: rows, hallways where we can imagine the circulation of those who survey the work, hands and stopwatches behind their backs. In *Leçons de choses* (second program of *Sur et sous la communication*)[Godard], we briefly see one of these shots—that occur in industrial films as often as in leftist narratives—in which a camera glides effortlessly along a row of workers as if it were a corridor in Marienbad. The image is immediately condemned as belonging to a "porn film." Which it is, in fact. Because the camera is, at that precise moment, in the same position as pornography: *the position from which performances are evaluated and failures—or sabotages—are surveyed.*

There is something very important about this, something to which we must return (assuming that, one day, we have a discussion about what, in the cinema, is pornographic). For now, I can articulate it in a very simple form: *the camera occupies a position that could always be the position of someone in the film.* The camera that follows an endless tracking shot along the assembly line is in the position of the foreman (of course, it is not restricted to it, and it is not impossible that one could, from this position, subvert it). The camera that glides between a classroom's rows is in the position of the supervisor or the teacher. In Ivens and Loridan's *The Football Incident*, the camera is almost always facing the students, as the thing before which they are summoned to appear, just as Ivens and Loridan are now siding with Hua and against the "band of four." In other words: when space becomes so scarce that circulation within it is totally regulated and coded in reality, how could we think that in film (despite the inexhaustible *off* space) we could dispense with acknowledging that during the shooting ("active, aggressive")?

A moralist, like every filmmaker who matters (to us) today, van der Keuken cannot be accused of ignoring this question. The proof is in, for example, the first section's stunning ending in which we see

what the unemployed worker is talking about: the acceleration of the textile industry's pace, or in other words: how do you make a pair of pants in less than twenty minutes? The way in which van der Keuken the cameraman passes from one worker to another, in abrupt movements that are neither new framings nor re-framings but *reflexes* in which despondency, claustrophobia, horror can be read (somewhat like the constant lack of continuity in Dwoskin's *Behindert*). This is one way of not being "in the right place," of moving beyond pornography (and of confronting obscenity, which is a very different thing), a way for the camera to knock into what it films.

<div align="right">(Cahiers du Cinéma #276, May 1977)</div>

THE LOUD-MOUTHED CINEPHILE

Woody Allen, *Annie Hall*.

Why does Alvy Singer fall in love with Annie Hall? Because unlike the shy Miss Portchnik (Alvy's first wife), Annie reverses the order of things and, in the lobby of a tennis club, makes the first move. She does to Alvy what Alvy does to the audience: she pulls the rug out from under his feet, pre-empts his answers and literally takes the wheel, in her Volkswagen that she drives like a racing car.

Alvy Singer makes a living off of always having *the first word*. Telling his jokes. Seducing women. Evoking the lost memory of Annie Hall. He holds a monopoly on speech, and thus on discourse and criticism, on denials, slips of the tongue and the interpretation of them, on lies—that is the sense, programmatic, we get from the entire first scene. And yet, this monopoly never appears to be a permanent given; for the narrator, a New York Jewish modern Scheherazade, the film continues to call it into question. As if the audience, taking the place of anyone in the film (a passerby, an extra) had the power to challenge him, as Annie Hall once did.

In this relentless, music-less film (or better yet: without any conceivable music), Alvy Singer/Woody Allen's soliloquy is the fundamental, inescapable, unchanging reality (at a constant pitch, as in

that beautiful scene where Alvy complains to his friend about being the victim of antisemitism and where the dialogue begins over an empty frame, connective tissue in the background from which the speakers, first minuscule, grow larger as they approach). But if Allen, sound-wise (as an actor), thrives on the cabaret and music-hall, Allen, image-wise (as a director), relies on cinema and its history. He is not merely a cinephile-filmmaker as so many are today, including in America; he is a filmmaker working from what, in cinema, matters to us now: that every image involves a point of view, that every point of view divides, and that every division is productive. (He is in this way very different from Mel Brooks, who triumphs by remaining within the boundaries of filming a cabaret revue, c.f. *The Producers*, in my opinion his greatest film.)

In Woody Allen's previous films, we have seen incessant, brilliant, unpredictable dialogue and strict, unvarnished, slightly lacklustre images (with no "*cinema-effect*")[1] that *do not overlap*. They contain a plethora of words and a paucity of things. This rarefaction of images and particularly of angles is theorized in *Annie Hall*. The purpose of the image is not to prove or illustrate the dialogue, but to do just the opposite, while systematically playing with resources outside the frame, to actualize—where and when we expect it the least—*what threatens to take the upper hand over the dialogue*. It's the image that places itself, so to speak, *off*, that opens up to the unconscious of what is expressed, to the literality of what is expressed, as in the scene where Annie splits from herself while making love. The image and its *off*-camera infinities are, paradoxically, where we should search for… the last word.

There are at least two schools among the great American comedies (the talkies, anyway). On one side, those who wreck communication by mistaking things for words (the Marx brothers) or mistaking words for things (W.C. Fields). On the other, those who believe in communication, in the message, in the last word: Chaplin, Lewis. The latter have in common: a) as actor-directors, they accompany their passage from one side of the lens to the other with an obsession for doubling, be it moral (the good and the bad: Dr. Jerry

1. A reference to Jean-Louis Baudry's *L'effet cinéma* (1978). Baudry's work incorporated the concepts of both Louis Althusser and Jacques Lacan.

and Mr. Love, the tailor and the dictator) or sexual (the lure of drag: *A Burlesque on Carmen*, etc.); b) as great partisans of noble values, they deliver humanitarian and well-intentioned messages; c) in their assumed dialogue with the audience, they always have the last word.

Woody Allen doesn't really belong to either of these schools. He adapts to neither the solitude of delirium (that forecloses the other) nor the false, narcissistic couple (that manipulates the other). Compared to the great humanitarians (who are also great sadists), he represents ridiculous and parodic repetition. In place of ensuring the delivery of a message *in extremis*, as one plays a trump card, he reels off his theory of the world right at the beginning of the film, when no one had asked him anything yet.

Thus the audience, huddled in the shadows, is not only, as they say, "called to bear witness" (that is the kind of complicity, but more naïve, that belongs to *Omar Gatlato*), but is also blocked in its claim on having the last word. *Annie Hall*'s audience is not the same audience that Chaplin or Lewis's films require: it is not in the position of the great Other, the public-King-who-is-always-right, there to be seduced (even when—c.f. *Monsieur Verdoux*—there is resentment), they are a little other, condemned to oscillate, like everyone else, between mini-certainties eroding against a background of nebulous beliefs.

One of the best scenes of the film, a sort of Allen-esque *ars poetica*, is the one in which Alvy waits in line at the movie theater to see *The Sorrow and the Pity*. The audience moves, in several seconds, through several states. First, they're simple voyeurs. Then they're asked to take sides between Alvy Singer and the loud-mouthed cinephile (after all, aren't we also that cinephile?). Finally, they're spectators again (but spectators who almost took action) when Alvy "produces" in the frame, like pulling a rabbit out of a hat, the one who gets the last word over everyone, Marshall McLuhan in person. "What is the referent?" Woody Allen seems to be asking us. *What, outside of the frame, guarantees the frame?* Anyone.

A rare thing occurs in *Annie Hall*. It's what I call "star-sharing." For Woody Allen, it is not about creating with Diane Keaton/Annie Hall a feminine double, both vulnerable and maternal, through which the comic/man becomes even more unique (in the sense of an "only child" [*fils unique*]), but to create alongside him, and this is more

difficult, an other, *a* woman. What is strongest and most moving about *Annie Hall* is neither that Annie Hall is understood—and only understood—through the desire and fantasies of the American male (for whom she would be the more or less rebellious creature, establishing the audience as the beneficiary of that rebellion's performance), nor that the film shows us the couple "objectively" in a sort of Cayatte-like *vie à deux*, but that Annie Hall obviously exists outside the film, that she is not an enigmatic character but, more realistically, incomplete. And that the distance between her and Alvy, in the final shot of the film, without any tremolos reminiscent of "Brief Encounter" (this is more of a "Long Liaison") is, in terms of distance, measurable. This proves how high Woody Allen's comedy can soar.

(*Cahiers du Cinéma* #282, November 1977)

Ingmar Bergman, *The Serpent's Egg*.

Bergman may say that his film ought to be read in a present-day context, but it is tough to overlook the Germany of 1923 (which isn't comparable to the Sweden of 1977, not really, even from the point of view of someone who doesn't pay taxes). There is even less cause to dehistorize his film because this one, unlike *Shame* or *The Silence*, cannot be read as an abstract meditation on the human condition because it is endowed (a rare thing with Bergman, undoubtedly due to the demands of large-scale international production) with a historical referent, much like, more or less, a film that is clearly superior to it: *Cabaret.*

But where *Cabaret* materially implies the rise of Nazism within a show or a song (*Cabaret* is not "a musical comedy *plus* serious human issues" but those serious issues as they are *also* musical comedy), where Bob Fosse rethinks the "genre," Bergman, outrageously building on the supposed knowledge of his audience, produces a film that is more mired in the prevision of the past than anything we've seen in a long time. So much so that we have to ask how far back we need to go in Germany's history (Bismarck, Luther, Othon the Great?) to escape from the zone called "the rise of Nazism." This is exhausting

(the rétro antics of Cavani on Nietzsche or Russell on Mahler certainly haven't helped matters much).

This prevision of the past presides over the entire film. In it we see the hero, Abel Rosenberg, a foreigner several times over (an American in Germany, Jewish, child of the circus, alcoholic) reach a sort of radical alterity that transforms him—in the voice over of the final shot—into a sort of wandering Jew. Everything that happens to Rosenberg happens in the dual form of *nothing will ever happen to me/I know—I have always known—that something was going to happen to me.* The alcoholism he drowns in allows for another obsessional turn of the screw: has it already happened to me, or must I still be afraid? See, on this point, the scene in which, while being grilled by the policeman, he is suddenly "struck" by the idea that he is *only* being accused of all of these crimes because he is Jewish, and where the violence of his reactions and the frantic escape towards the trap (in which he locks himself) have a sense of "I know—but still."

Same situation for the audience, who know all too well where the film is taking them (the rise of Nazism), but that the filmmaker (the Master), forced to rediscover their presumed knowledge in the form of bad encounters (the butchered horse, the looting of the cabaret) in moments when, so to speak, he relaxed his attention a bit, let down his guard. *Fear* (fear of being surprised by what one already knows, fear of being afraid) becomes for Abel Rosenberg, as for the audience, the film's motor, what makes them flee forward, towards the horrible *but familiar* end, the apocalypse they secretly long for because it will curb the traumatic moments of what is a significantly twisted narrative.

We must therefore see *The Serpent's Egg* as a sort of *retro ideological* serial, perhaps a genre of the future. In a serial, what's at stake is always a secret, heavy with collective consequences, recorded in individual bodies. The great serials were contemporaneous with the fears they presented (Lang, of course, but also Gance or Feuillade). There was no hindsight. For Bergman, forty years later, it is no longer about secrecy but the procession, one by one, of clichés about the rise of Nazism (everything that answers to the hideous word, *ideologeme*, discreet signals of ideology). The "serial" aspect, on the other hand, is the most successful and surprising aspect of the film (final

confrontation between Rosenberg and Vergerus, film screening, cyanide, etc.) insofar as the entanglement of the biographical (Vergerus and Rosenberg are childhood friends), the sentimental (Vergerus loves Rosenberg) and political discourse (Vergerus, mad genius, future Mengele), is integral.

The Serpent's Egg, a notably reactive film, is an anti-narrative of the left. The (police) inquiry, the investigation, the determination to solve the mystery aren't driven by a desire to find the truth, a desire for information and clear vision, but by *fear*. The tight-lipped Abel Rosenberg (promoted, because of his quasi-muteness, to the role of shifter) doesn't want the truth (which he has always known), only *his* truth, which is seeing evil, face to face, urgently, and sustaining the spectacle. That is what he achieves at the screening of Vergerus's films in which he nearly sees himself. Bergman's poetry: showing something has only one meaning, which is to conjure fear.

This is theorized perfectly by the policeman played by Gert Fröbe in the scene where he tries to explain to Rosenberg that fear is the only thing that makes him a hard-working policeman. In fact, he says, if the whole world were to go on with their daily tasks, zealously, even, as if it were business as usual, perhaps we could avoid the worst, not by confronting it but by not spending time thinking about it, hence not fearing it and, who knows, not succumbing to it. A film about the *active* nature of fear. A program of resistance that couldn't be more minimal.

(*Cahiers du Cinéma* #285, February 1978)

Herbert Ross, *The Turning Point.*

1. Deedee (Shirley MacLaine) and Emma (Anne Bancroft) are dancers and friends. They rehearse for the same role, a decisive one for their careers. Who will win it? Deedee then gets pregnant by Wayne, an uncertain homosexual, and marries him with the dual aim of avoiding the litmus test (will she or Emma land the role?), and providing Wayne with proof of normalcy in the eyes of others. She gives up dancing and starts a family in which two out of three children,

following the familial narrative, pursue dance. In turn, Emma, sacrificing everything for her career, becomes extremely famous.

Almost twenty years pass. During a national tour, Deedee meets the company again—and Emma. They exchange empty truths: you have a family, children (how I envy you!), you've made a career as an artist (how I envy you!). In other words: one dances, the other doesn't. Emily, Deedee's daughter, follows the company to New York to study dancing. Deedee—chaperone—follows her. Emma, on the cusp of ballet's age limit, has several roles suddenly taken away. She advises the choreographer to replace her with Emily, whose talent is clear and to whom she has decided to serve as "coach." Emily has a fling with Yuri, the Russian ballet star (the stunning, vaulting Baryshnikov) and Deedee a short-lived liaison: mother and daughter grow distant. A gala marks the end of the film: Emma's adieus to the stage and Emily's triumph. A blowout of an argument between the two women ensues: they move from insults to punches to mad laughter. One sentence, the only one that could possibly wrap up the story and end the film, is finally uttered: a confession from Emma's lips: "You were so good then that I would have done anything to win that role." To which Deedee responds, in tears, that she'd been waiting to hear that phrase for twenty years.

2. *The Turning Point* begins where most melodramas end (the emotional reunion, the rediscovered solidarity) and from there, it goes back, with a stubborn consistency, to Emma's "little phrase," sign of a new separation. This fossil of a melodrama, filmed solidly but without ingenuity by Herbert Ross, is therefore a melodrama in reverse, or rather a melodrama *fulfilled*. Emma's little phrase is not so much a secret that's buried in the past (the film is saturated with bogus secrets that haven't the *slightest* importance) as it is something that, for not having been *uttered* at a specific, identifiable moment, forms a nebula of desires for at least two generations, afflicting Deedee and Wayne's personal fate. For it is clear that the children are forged by the mystery of their mother's true desire (dancing?), by that remorse of never having had confirmation that, in the eyes of the other, of that rival whom she loved, she *counted*.

3. *The Turning Point* touches on that element of truth that melodrama carries with it and that I would define as follows: melodrama

is still the only genre (literary, theatrical, cinematic—popular, at any rate) in which something of the symbolic grid in which we are caught and that makes us children of language can be inscribed: in essence, *parentage* and *filiation*, the transmission of names, places and desires. The decline of the melodrama (the last great American melodramas were created by Minnelli—*Home from the Hill*—McCarey—*An Affair to Remember*—and especially Sirk—*Imitation of Life*—and date from twenty years ago) goes hand in hand with the rise of a cinema that privileges, rather than symbolic determinations, socio-economic determinations ("leftist narratives," etc.). The "sane" reaction to melodrama, therefore, that of the spectator who doesn't "fall for it" (but who falls for something else, the belief in "context," for example) has for a long time been to sneer at it. A more culturally informed reaction, somewhat kitsch, consists in loving melodramas while specifying the degree to which (the second, the umpteenth) one loves them (then one can speak of "over-the-top" melodramas). It's either too much contempt or too much credit. First of all, melodramas always make us cry (and at Ross's melodrama, we bawl), which is no small thing. And the laughs that they trigger, be they clever or bold-faced, are not just *any* laughs. You have to hear the *insane* laughter of Shirley MacLaine and Anne Bancroft at the end of *The Turning Point* to see the degree to which an accomplished melodrama can also inscribe within itself the possibility of laughing at itself.

4. That laugh, rising straight from what Bataille called the "comic absolute," that non-agressive, almost ridiculous laughter that we also hear in films such as *Sylvia Scarlett* (Cukor) or *Five Fingers* (Mankiewicz) and also, even more undecidable, in Mizoguchi (*Princess Yang Kwei Fei*). It is laughing *in the face of life*. Not "life" ideologically valorized as opposed to death (life as an advertising theme, the "when you love life, you go to the movies" kind), but life as it suddenly appears as this *rebus*, made of enigmas and evidence, twists of fate and marvelous coincidences, detours and delays (the very principles of melodrama) in which, through code, the irreducibility of a *desire* can be read. Imagine the last sentence of the last scene of Bresson's *Pickpocket comically*: what a funny path I must have taken to reach you! *The Turning Point* is all about an entire family tied to the work of the mother's mourning and the realization of her desire

through her daughter, to the detriment of her old rival. It is especially about the impression that the characters are *repeating* something.

I began by telling the story of the film, beginning not with the experience of the characters and the audience (who, in the case of melodrama, always coincide: the audience doesn't know anything beforehand about the characters they are given to understand, each has his or her own reasons and all simultaneously—very democratic) but with melodrama's limit: an absolute, teleological knowledge about what ties the living to the desires of the dead and those present to the desires of those who are absent. Meaning, in more Lacanian terms, the Symbolic.

5. Melodrama leans on the Symbolic (and uses all of its combinatorial games) but evades the cruel character of the Law. It seems that melodrama, historically contemporaneous with the institution of the monogamous petit-bourgeois family and its inevitable Oedipal triangulation, had the function of reassuring those families by telling them about what was haunting them (family relationships, always), and by dangling in front of them the image of the family reunited, reunified, with the family photo (where no one is missing) as the horizon line. To such an extent that melodrama's characters, subject to the great law of the Imaginary, can be broken down into two categories: the present and the absent, those whom we can see and those (lost, abducted, dead, disappeared, believed dead, etc.) we speak about.

One step further and melodrama topples into *ghost story*, once it abandons that present/absent distinction for another: *living/dead*. Or rather, once it grants the dead the possibility of returning to the living, to reclaim, by and large, their due.

(*Cahiers du Cinéma* #288, May 1978)

Mario Monicelli, Dino Risi and Ettore Scola, *The New Monsters* (*I nuovi mostri*).

The key to these *New Monsters*, or rather to these three auteurs' concept of their project, is furnished by the final sketch of the film. In it we see Gassman and Tognazzi, who previously appeared in Dino

Risi's *Monsters* in 1963, running a diner. A snobbish group of cus-
tomers arrives. Greasy, hirsute, unkempt, Gassman takes their order
(soup "à la disgust"), rushes into the kitchen and sideswipes the cook—
Tognazzi—which triggers a gigantic fray. They throw all the food they
have at hand at each other's heads—the raw and the cooked. Once this
bravura (which is also a domestic quarrel: these monsters love one
another) is complete, they regain their composure and hurriedly fill a
few bowls. Gassman combs his hair and serves the customers, who
pounce on the heterogeneous slop with snobbish cries of glee, certain
that they have discovered authentically popular cuisine.

Here we have a metaphor for the role that Italian cinema—espe-
cially "Italian comedy"—plays in French cinema's imaginary. That
circle of customers is us, or rather, those people who attribute to Italian
cinema all of the qualities they know are lacking in French cinema
(audacity, gall, a sense of the social, mischievousness tinged with
seriousness, a Bakhtinian carnivalesque, etc.). And these approximate
chefs are the ones who create Italian cinema, who try to keep it alive
despite a severe crisis and a marked decline, by *managing* that image,
concocting filmic slop that will always be good enough to export.

Let us spin, or rather, toss, what began as a culinary metaphor.
The quality of its ingredients, more than the inventiveness of its
recipes, has been Italian cinema's most invaluable feature. Ingredients:
the screenwriters (Age, Scarpelli, Amidei, Scola, Flaiano, Cecchi
d'Amico, etc.) and the actors (the list is too familiar to mention).
And very secondarily, the directors who are rarely auteurs (apart from
Comencini, the only one to have a consistent moral and ideological
perspective on what he films.)

The idiocy of a generalized auteur theory, now a marketplace of
signatorial effects, has led the French public (the diner's customers)
not only to discover the Italian cinema of the 1960s ten years too late
(*A Difficult Life*: 1961, *Misunderstood*: 1966, *On the Tiger's Back*:
1961), but dressed up as a cinema of auteurs, where there was an
enormous *cottage industry*.

For it is indeed auteurs, which also means *perspective*, that Italian
cinema lacks. On the one hand, an undoubtedly unique ability in
cinema today to make a show out of just about anything (to use any
and all available means), and on the other, a kind of cynicism born

from the impossibility of interpreting anything. That is what allows for the premise of a film comprised of sketches: to create, by the mere fact that one never concludes, the *effect* of intelligence.[1]

<div align="right">(Cahiers du Cinéma #290–291, July–August 1978)</div>

Andrzej Wajda, *Man of Marble* (*Czlowiek z marmuru*).

1. Is a Polish leftist narrative possible? I don't think so. The Eastern version of the leftist narrative is what I would call a cinema of "the thaw" (films like *Bonus* or earlier films such as *The Cranes Are Flying*). A different genre, a different calculation, a different aesthetic. It isn't about making the audience aware of the more or less covert machinations of power (ideally the State, the Mafia or the CIA) through a fearless investigation led by the righteous (junior magistrate, intrepid journalist, honest cop) but something else entirely. It is about the *mourning* of an entire people, about their unspoken relationship to Stalinist politics and its aberrations. Politics and aberrations in which everyone was caught *in their own biographies*, the naive as much as the clever, the executioners as much as the victims, the saints (like Birkut, the bricklayer, the man of marble) as much as the un-believers (the filmmaker, Burski, who constructed his image). "The young," Wajda says, "need to know why their parents are so nervous, why they lie, why they do so many things they shouldn't, and why, from time to time, we discover that they've done tremendous things that we've never heard about before." It is less about awareness as it is about putting things in order. As opposed to our leftist narratives (which assume an audience that is "above all suspicion"), a cinema of mourning knows that its audience is weighed down by History, forever marked by it. There is more "fiction" in the biography of a single Polish citizen of Wajda's generation than in Film Polski's entire post-war output.

1. An effect that is all the more ludicrous that Italy, between 1961 and 1978, seems to have completely fallen into monstrosity and has become an incomprehensible, uninterpretable country.

2. A leftist narrative is only possible when there is enough free-
dom to begin one (condition upon which a narrative can come into
being) and enough freedom to form a contract (condition upon
which an inscription can be authentic). It is, however, almost impossible
when the traditional catalysts of truth [*embrayeurs*], the intellectuals
and artists, have at some point become massively subjugated to the
political sphere, dressed up as "combattants on the ideological front,"
in other words, liars. Servitude that is more or less voluntary, dealing
that is more or less duplicitous, conscience that is more or less guilty:
on the spectrum of the nuances between dissidence and collabora-
tion, read Zinoviev (*Yawning Heights*). But still. How can cinema—a
contemporary of the first large-scale manipulations of the masses
(those that had as an object the human species and its future: from
the superman to the new man)—a contemporary and an accom-
plice—accomplice *by the very fact* of its realistic vocation that
obviously dooms it to all sorts of deceptions; cinema, without which
the bodies-beyond-sex of its stars would never have been offered up
so easily to mass worship; how can the cinema that created so many
lies liberate itself from the terrible suspicion it carried along with it?

3. That is why the real issue of *Man of Marble* is not
Stakhanovism (a great subject for disillusioned Marxologists) but
rather: how to *rehabilitate* the cinema, that cinema from which—in
the East perhaps more than anywhere else—no one seems to expect
a grain of truth. Wajda's film constantly demonstrates this suspicion.
Two examples: in one of the film's key scenes, between Agnieszka and
her father, he lets slip, gently and ironically: "You filmmakers..." Or
even, when Birkut jabs at a cameraman who has come to film him
while he's going to vote: "So, you're going on with this circus?"...
with all of the contempt that a worker (whether powerful or not,
Polish or not) can have for people who—both literally and figura-
tively—"are making their movies." Contempt which Wajda tells us is
largely deserved by the film establishment in present-day Poland,
judging from his rogues' gallery of the embittered editor, the con-
fused bureaucrat, the happening and coquettish filmmaker (Burkis),
and don't forget Agnieszka, whose motivation from the start is nothing
less than pulling off a scoop, with American effects (symbolized by
the wide-angle lens: like all Eastern filmmakers, she ogles the West),

an awful lot of swagger and a good deal of cynicism. For it is one thing to reveal the truth about yesterday's travesties, another to entrust that truth to a medium (film) that has been considerably disqualified. More than ever, the medium is the message.

4. Therefore the double narrative (the film within the film) does not seem to me to be merely a Cassenti-esque trick with no intention of seeing either story through to its conclusion, but the method that Wajda invented to attempt cinema's rehabilitation: to change the message and repair the medium, as one repairs a skewed machine. That's the direction Agnieszka's journey takes. To the extent that she grows fond of her character, she approaches her "subject" (in both senses of the word). To the extent that she approaches her subject, she abandons her grandiosity and wide angles, before being gradually dispossessed of her power as a filmmaker, losing it completely at the moment when she decides (having finally realized—thanks to her father—that perhaps this Birkut does exist). As if, at the moment when she finally becomes a filmmaker (= someone who respects her subject), it was only right, logical, that she be deprived of her camera. As if the rehabilitation of cinema goes through a moment of non-cinema, a departure point from which the filming (again) becomes possible. The alliance between Agnieszka and Birkut's son ideologically seals a sort of generalized reconciliation; present and past, filmer and filmed, intellectual and worker, man and woman. A sleight of hand trick, too good to be true, by which Wajda, after having destroyed the house, *salvages what he can*. And so it isn't irrelevant that his central character is a young woman (whose tomboyish side echoes the feminization of worker characters in the past). Agniesza's view of the fifties (which, Wajda says, plays the role for young Poles that the thirties plays for us, and we can see why: both are totalitarian decades) is necessarily a retro view, meaning a gaze that eroticizes, that can finally directly enjoy, without sublimation, the fallen idols of yesterday's cults. Agnieszka's sexual journey undoubtedly provides the key to the film: she proudly straddles the statue of the man of marble, whose son she meets at the end of the film in flesh and blood, and who (in the final image) places his hand on the nape of her neck. Disjunction between the statue of the father and the body of the son: Agnieszka comes between them, who inherits *from them both*.

5. *Man of Marble* is no *Citizen Kane*, any more than *Bonus* was *12 Angry Men*. It is characteristic of films of "the thaw" to be formally old-fashioned and academic, giving a strong impression of déjà-vu. As if Wajda were caught, more than he would like to be, in what he tries to keep at a distance (efficiency at all costs, bluster, cynicism). And yet, with *Man of Marble*, I am tempted to appeal to a type of argument that rarely prevails in *Cahiers*, one of "context." If it is relatively easy to state the importance of the film, the political event that it represents in Polish life (which is what criticism has generally done, focus on what is most evident, most sociological), it is much more difficult for us to *evaluate* it. The importance of such a film comes from the fact that with it, *something is finally said.* The important word here is not "something" (its revelations are not really revelations) or "said" (the time is ripe for it: if Wajda doesn't say it, then someone else will), but "finally." Unlike leftist narratives that are always intended for an ideal audience who "knows nothing," films of "the thaw" are always intended for an audience that knows more, much more at any rate than what he could learn from cinema. This reverse situation creates a particular aesthetic, unique to films from socialist countries, that we must one day describe. It isn't only that these films lag behind Western films, whose conventions they discover twenty years later; it's that *they lag behind the moment when they should have been made, and the cinematic language that was prevalent at that moment.* Behind all of those things that have "finally been said"—but that we have always known—we hear uttered in the silence, "Whew! finally, someone has dared say it—say it for us— that's it!" That is how the art of mourning is reduced to an aesthetic of "Whew!"

(*Cahiers du Cinéma* #295, December 1978)

Ingmar Bergman, *Autumn Sonata.*

Imagine *Autumn Sonata* on television, in prime-time, screened just before a talk show dedicated to mother-daughter relationships (currently a major topic). Everything that makes it an antiquated and

dull film would then start to "function": the systematic recourse to close-ups (by which Bergman dispenses with domestic quarrel stage-craft in favor of a dramaturgy of facial reflexes), Nykvist's hazy photography, the oversimplification of certain symbols (the third woman: the invalid), were *already* designed in relation to television (the serialized broadcast of *Scenes from a Marriage* was a national event in Sweden). Not because television (and its audience) is dumber than cinema (and its audience) but because it allows for a sort of participation (even imaginary) on the part of the television viewer: the possibility for him to *speak* after the film (especially after a film that only presents two linguistic conditions: aphasia and flood). We can easily imagine the film being followed by a debate (between experts in matters of the soul: strict but fair), a debate interrupted by phone calls by TV viewers who side either with the mother or the daughter, etc. There would be congestion of the legal channels of communication and "eavesdropping" in general.

Bergman's is a strange path. A Swedish filmmaker, first unknown and then very well-known in Europe, then famous all over the world, became, after being a local filmmaker, the epitome of "arthouse," one of the rare few to expand his territory to the international stage (meaning America) and the only one to have become the *mass* filmmaker of the bourgeoisie. Today, he too is experiencing a *shift* in relation to the cinematic medium, and even as the least of his films is greeted as an event of immeasurable importance, he is no longer producing interesting cinema. He is not alone in this: the gulf between the system/cinema and its objects/films continues to widen. Which is why watching *Autumn Sonata*, in the cultural church service atmosphere of a movie theater, is utterly asphyxiating.

(*Cahiers du Cinéma* #295, December 1978)

Stanley Kramer, *Judgment at Nuremberg*.

In the "message films" of the sixties (Preminger, Stanley Kramer), the principle was roughly the following: assign the most prestigious actors of the star system good or evil roles in stories where good and

evil are clearly opposed (most often in the setting of a trial). It was therefore necessary for some to "sacrifice themselves" to play the dirty roles, because without that sacrifice, the film—the commercial enterprise of the film—would not come off. Preminger knew how to use that *play* between the guilt of the character and the star's unalterable goodness better than anyone by making *defamation* his favorite theme. In *Advise and Consent*, the radiance of the stars (Henry Fonda, Don Murray) remains intact despite the roles they are given to play (an *ex*-communist, an *ex*-homosexual—whew!); it is even heightened by having run the risk of contamination, as if the star could have been sullied by the role after all. Although less devious, a flat and predictable filmmaker, Stanley Kramer functions in the same way. So much so that the (TV) viewer of *Judgment at Nuremberg* (the judgments date from 1945–46, the film from 1961) can only oscillate between two positions: sometimes he is the witness—amused, emotional, furious: it depends on his relation to images—of Lancaster's efforts to typify the former Nazi, sometimes of those, equally heroic, of Tracy to look at him with a pensive and vicious stare. On one side (the fictive side, the side of "roles") the antagonisms are irrevocable, mortal. On the other (the side of filmic materials, the side of the "body"), creates an echo chamber. That is precisely where the ideological nature of the film resides: *what "echo chamber" does that create?* Against whom? against what?

In *Judgment at Nuremberg* (I'm speaking of the film as it was made, not of the discourses authorized by the seriousness of its theme) we find this echo chamber in the final scene where Tracy makes a brief visit to Lancaster, at his request, in prison. Kramer is careful not to press the scene to its logical conclusion: mutual esteem and appreciation of two jurists who are also, in spite of everything, righteous: the old, provincial American judge, straight out of a Chesterton novel, and the brilliant co-writer of the Weimar Constitution, straight out of a novel by Musil. But the fact remains that the entire film comes down to this, and Kramer had to gradually depart from the primary division of Germans vs. Americans in order to form a new division inside of *each* camp. On the American side, the judge's increasing solitude versus his political entourage and especially versus the prosecutor, played by Widmark. On the German side,

wrong-headed silence followed by sensational declarations made by Lancaster, who refuses a defense that would use the methods of the young German lawyer portrayed by Maximillian Schell. The real dividing line of the film, as in the vast majority of American films, in fact (I'm thinking of Ford, especially) opposes politicians to the righteous. The purity of the *idea* of justice to realpolitik. The losers in the film are not so much the elder judges who compromise with Nazism as the two high-powered ideologues, American and German, Widmark and Schell, whom we see utilizing one-upmanship and leverage (Widmark shows a film about the camps, Schell employs Nazi techniques to interrogate a witness) because they are uncertain, at the decisive moment, that they will stand firm (and that is what happens to Widmark). The film says, sadly: trials are held too late, we're already in realpolitik, in the reversal of alliances, in the Cold War; the ideologues are going to have to retrain themselves and the righteous, coincidentally, have no future.

But those losers are winners, cinematically. In his one-on-one with Tracy, Lancaster, in a crewcut, heavily made-up, his eyes moist and metallic, says only one thing—*but he says it with his body, with his star body, and that, the public understands perfectly*—"I'm Burt Lancaster, the actor, don't you recognize me?"

(*Cahiers du Cinéma* #295, December 1978)

Charlie Chaplin, *Limelight*.

Calvero (Charles Chaplin) appears at the Middlesex under a fake name and, for his (secret) comeback* on the boards, sings "The Sardine Song." The audience leaves, boos, drives him offstage. Even though it is a working-class audience, a ghetto audience, the kind that loved Calvero when Calvero was Calvero.

Later on, after being discovered panhandling in a pub, Calvero is easily persuaded to be the headliner and beneficiary of a gala given in his honor: there he will appear under his real name. His friends, and even the woman who loves him (Claire Bloom), pay for audience members in order to avert a disaster. The upper crust of society, the

"crowned heads of Europe," are all there, in the hall. Surprise: Calvero's act makes them laugh. Exhilarated, he repeats "The Sardine Song," which this time is a great success. We know the rest: the musical number with Keaton, the fall into the bass drum, the farewells to the public ("I'd like to continue, but I'm stuck!") and his death: Calvero dies a success. The honor and moral of the film remain intact: one musn't wallow in misery, one must perservere, love one's audience and one's life.

But for us, the (devastated) audience of the film, *Limelight*, things aren't so simple. Why is "The Sardine Song," which makes the audience at the Middlesex flee, a triumph in front of the crowned heads? Why does the long and not very funny number with Keaton unfold in icy silence, why isn't it punctuated by laughter? Since it's impossible that Chaplin forgot to introduce ambient sound into the scene, this remains a mystery. Of course, we have some answers: there is the fact that Calvero had a drink before going on stage, something that he failed to do at the Middlesex. There is the paid audience. There is also the fact, a more serious one, that the popular audience at the Middlesex was probably a better judge of comedy than the crowned heads. In which we can detect Chaplin's fear in the 1950s of losing his poorer audience—which made him—and of only being appreciated by the rich—who spared nothing to undo him.

But these are not completely satisfying explanations. The indeterminacy of Calvero's final performance (is he really funny?) shouldn't be attributed to Chaplin's carelessness with respect to sound, but to his profound knowledge of cinema. Even if he never discusses cinema and if, unlike many comedians, including Keaton (*The Cameraman*), he is the complete opposite of a filmmaker who studies cinema, Chaplin demonstrates a deep knowledge of the difference between stage and set, between theater and film. A terrible, abysmal difference. In the theater, the audience knows what to think of the performance and also knows how to express it. You can't trick that audience, you can't intimidate it, you can't force it to laugh. At the movies, this will never entirely be the case, even and especially in extreme cases where the difference between the two arts seems to disappear: in scenes of pure acting or the film of a play. At the movies, each of us in our solitude never really know what we think

about what we're seeing because we never really know what we're seeing. Included in the moments that most directly touch upon the heart of cinema are these moments of *indeterminacy*: when we expect Calvero to make the audience scream with laughter and we, the film's audience, hear only silence, we are encouraged to rule internally on the value of something that has been produced for us while, simultaneously, that judgment is nearly impossible for us to make. A double bind, a schizophrenia that belongs to cinema, the infinite possibility of believing that black is white, and vice versa. I remember one of these great "movie moments," as they say, in a Welles film entitled *The Immortal Story*, in which a young sailor asks Jeanne Moreau how old she is and she responds, shyly, "I'm seventeen." It's an understatement to say that at such a moment, we accept it as a convention or a game, we are moved (and we enjoy that emotion) by the sacrifice we make of our ability to judge for ourselves, which is essential to theater but, with cinema, willingly exchanges itself for something invaluable: participation in the film, meaning solidarity with these intermittent and flat beings who are the "characters."

If *Limelight* moves us, it is because Chaplin knows that cinema is not theater, that footlights and stagecraft become bizarrely distorted when they are filmed—in other words, deferred—and projected—in other words, reserved for everyone and for no one. If *Limelight* is a film that loses none of its power on television, it is because Calvero looks at us as if, from the darkness in which he is immersed, he tried to recognize, in us but also through us, every audience to come. We are, in front of the TV box, one of those audiences that *he looks at but does not see*. And he knows that. That is the situation (the fundamentally asymmetrical nature of the relationship between the actor and his audience, in cinema[1]) that he consistently illustrated by telling (most often) love stories in which the other is disabled (blind, paralyzed) and smothered by the gaze that delivers her. Think of the end of *City Lights*: Chaplin looks at the florist as he looked at her when she was still blind and could not see him. And indeed, he doesn't just look at her, but fulfills a unique, irreplaceable kind of vision, once and for all:

1. It is relatively easy (who does it better than Bazin?) to talk about the character of Charlot, mime and myth. It is relatively difficult to talk about Chaplin the *filmmaker*. That is what we must begin to do.

he sees her looking at him. That florist, a metaphor for the audience, is also us: we see him and he doesn't see us but often he looks at us as if he saw us and, suddenly, it is we who no longer see him.

That is what makes Chaplin's serious films[2] so real, so present, the films in which he delivers a message: the little tailor's speech in *The Great Dictator* or the sulphurous declarations of Verdoux at his trial are, like Calvero's act, without guarantee, without response, even without counterpoint: the position is there, but it is empty. Whatever I may say to you, I speak from a place I'll never be again, a place you haven't yet reached.

(*Cahiers du Cinéma* #297, February 1979)

Francois Truffaut, *Love on the Run* (*L'amour en fuite*).

Those (like myself) who weren't much older than Doinel/Léaud at the time of *The 400 Blows* find it very difficult to imagine how, 20 years later, *Love on the Run* affects those younger people for whom Léaud is only an actor, an actor who looks a little like Truffaut in *The Green Room* and who is not what he is for us: a star*, the only one created by the New Wave, the only body to have passed (from Truffaut to Godard, from Eustache to Skolimowski) from unnhappy childhood to cinephilic adolescence, and from cinephilia to leftism—until the final throes of the latter. Today, in an equivocal move, Truffaut *reclaims* Léaud in the sense that he re-engages him and reclaims what belongs to him—and what always has. With this reprise, Truffaut follows through on what we have come to understand about

2. *Limelight* is not a seductive ruse, a phony farewell film. Certainly, Chaplin outlived Calvero by twenty-five years and made two more films (*A King in New York, A Countess from Hong Kong*). But two films by someone who had *already* said his goodbyes and who who never returned. *A King in New York* is a cold and cheerful demystification of every trick of seduction, from advertising to propaganda, whether it is selling toothpaste or extolling communism. It is the unique power of Chaplin's cinema, his incredible luxury of having been—in the fullest sens of the word—biographical and contemporary. Biographical because he treats each subject only one time (including his own death, in *Limelight*) and contemporary because, beyond its former detractors, *A King in New York* is, today, a current film.

his films, that they are not about vindication (it is a mistake to see *The 400 Blows* as a film of revolt, à la Vigo) or the freshness of youth (a mistake not to have seen, from the shot of the crematorium in *Jules and Jim*, the morbid inspiration of his films). We had to wait until Truffaut, having gradually affirmed his position (a prodigious career such as his), felt strong enough to shoot, in the style of the great American masters, between two entertainment films, a shamelessly serious (and destined for relative commercial failure) film such as *The Green Room*, to understand that with him it is all about—as it is with the entire New Wave—the *cult of the dead.*

A cult that does not come without a certain *idealization*, whose procedures *Love on the Run* push even further. An idealization that has nothing to do with a preference for deception or a refusal to see things and people as they are. On the contrary, Truffaut (who admires Renoir, whose slogan was "everyone has their reasons") idealizes in the sense that he suspends all definitive judgment, as James does in his novels. What is *Love on the Run* all about? Why all these flashbacks, grafts, inserts, this "twenty years later"? Among other things: take the character of Colette (Marie-France Pisier), of Doinel's mother in *The 400 Blows* (Claire Maurier), or of her clandestine lover (Jean Douchet) in the same film: these are more or less criticized, negative characters, seen in a unilateral fashion (always from Doinel's point of view, from the victim's), without much time or space to exist *independently.* And yet, it's all there, the great lesson (of Renoir, of Hitchcock, of Lubitsch…) is this: even the most minor character must exist on its own, even if only in *one* shot. Truffaut, at a certain point, was forced to shoot a lot of material in order to give his characters a chance to return, randomly, and to return in a different light, far removed from any Manicheism. Colette, the slightly snobbish adolescent of *Love at Twenty* paid dearly for her frivolity and hasty marriage: the death of her child, her divorce, the return to her studies, made her the independent, seductive, and vulnerable woman that the actress Marie-France Pisier has come to play today. Consequently, the image of the present modifies the image of the past, which is no longer definitive. Similarly, the character of Doinel's mother's lover, that mustachioed fellow who appears in only two scenes in *The 400 Blows*, becomes "Uncle Lucien" (Julien Bertheau), a character who is entirely

unique, and entirely moving (c.f. the magnificent scene in the cemetery). Finally, and especially, Doinel's mother, one of the toughest characters in all of French post-war cinema, evoked by the one who has remained loyal to her, takes on, as they say, "weight": a bad mother, perhaps, but also a "little bird," in love with love, an anarchist (!), who dies young, buried at the cemetery of Montmartre, and finally earns a first name—Gilberte. More than a cult of the dead, it is the filmmaker uttering a pathetic "Don't judge!" on behalf of his creations, refusing that they might escape him, or worse, be poorly judged. Therein lies all the generosity of someone who "takes the audience into account," proposes stories and characters to them, and the mad desire to continue to have all power over them—*always for their benefit*. The filmmaker's paternity extends to an endless paternalism, a retention characteristic of the New Wave that consists in taking back those things (and people) that had been given.

In *Love on the Run*, the final film of the Doinel series, Truffaut assures us, a sort of endpoint is reached: the primordial character, filmed once and for all in the first film, the mother (the mother, model of *every* woman, c.f. *The Man who Loved Women*) enters the kingdom of the dead, those about whom there is nothing more to say, nothing more to idealize, nothing more to *save*. This is, of course, a bit too good to be true. Child martyrs return in fiction, like insistent bad dreams or indelible regrets (c.f. *Pocket Change* or here the fact that the lawyer wants to defend a parricide). An endpoint because when this process of idealization is complete, Truffaut finally imagines a film where there is no longer a *single* negative (or even unlikeable) character, and runs the risk that his system, having achieved its greatest perfection, might waste away, having no new regrets to cultivate.

(*Cahiers du Cinéma* #298, March 1979)

Sergio Corbucci, *Odds and Evens* (*Pari e dispari*).

The usher at the Paramount-Bastille tells me that she likes to watch from the back of the theater so she can hear the audience's laughter

better. They laugh, in fact, at *Odds and Evens* like they laughed at the Trinity Trilogy or at the first readings of *Lucky Luke*. Bud Spencer and Terence Hill, his little brother, the last picaresque couple alive in cinema (and happy to be so), pass through plots and places like simulacra, right wrongs yet don't believe in reason and emigrate from the Italian Westerns that revealed them to a more expensive, more esperanto production signed Corbucci, a well-known director. And in that laughter that so pleases the usher at the Paramount-Bastille, that laughter that is always easy but never vulgar, one of the last cards of popular cinema (understood here not in the sense of the "general public" but in the qualitative sense of the "people") is being played, a card that has been oh so often played and that is, while faded, almost indestructible. It's the same sort of question asked of every cinematic body (of every hero): *what do you know how to do?* Terence Hill, the parodic, overly blue-eyed star, is stronger and smarter than the rest: he talks to dolphins, slaps fifteen people with a single smack and beats an insipid Greek reputed to be the best poker player in the world. This infantile rhetoric of one-upmanship, of *I dare you!* is never without an equal sense of derision (see Leone's first films). Because the Spencer-Hill characters, the giant and his "little brother," busy only with taking care of each other, entirely outside of the world of women and money (they win millions but give all of it to an orphanage), will forever be contemporaneous with our preadolescence (the famous "latency period"), meaning pre-Freudian and pre-Marxist. Which also explains the laughter.

(*Cahiers du Cinéma* #298, March 1979)

Warren Beatty, *Heaven Can Wait*.

Confirmation—very slight—of that unwritten law of American cinema: actors most often demonstrate, when they go behind the camera, if not talent (Lewis, Cassavetes, Newman) then certainty (see Brando, Ray Milland, and now Warren Beatty). Beatty, the consummate author of *Heaven Can Wait*, manages his character rather well, a wonder-boy puritan who succeeds at everything, even death. This

mini-meditation on the immortality of stars will be insufferable if you don't like Warren Beatty as an actor, but it is not without truth, for it is clear at the (entirely Borgesian) end of the film that the price of immortality is an absolute loss of memory. We would like to point out to Grisolia, the author of a contemptuous note that appeared in *Le Nouvel Observateur*, that 1) This film has little to do with the first *Heaven Can Wait*, from 1943; 2) That film was directed by Lubitsch; and 3) It was anything but mediocre.

(*Cahiers du Cinéma* #298, March 1979)

Werner Herzog, *Nosferatu the Vampyre* (*Nosferatu, Phantom der Nacht*).

Nosferatu (Klaus Kinski) is primarily a *novelistic* being who triangulates the relationship between Jonathan (Bruno Ganz) and Lucy (Isabelle Adjani). Not only does he feed on blood, but he feeds on the blood of the woman who desires the man he desires. He pushes the couple's love into the suspense of desire: Nosferatu cannot die, he lives only for desire, he is the dark side of that God whom Lacan says is *supplementary* in the woman's *jouissance*. Thus (already seen in Murnau) that surprising melange of familiarity and distance, between near and far, the Black Sea and the Baltic, the monster and his "victims." Murnau, still close to that puritanical society that produced the myth of Dracula (first England, then Germany), logically opted for a self-righteous ending, appropriate to that society (sublimation of desire in the sacrifice and undoing of the desire-monster). Forty-seven years later, Werner Herzog, a sure thing in the film auteur marketplace, clarifies his sympathy for Nosferatu and for the infinite (and infinitely wretched) movement of desire. Hence the vampire's poorly-controlled moans of lust in the face of his prey. Hence also the final image of the film in which we see Jonathan take over from Nosferatu and take his place, once he is finally dead. But by unfolding—even if only slightly—the myth, Herzog plays for high stakes. Myths, as we know, only operate if they are ambivalent and contradictory. And at this game, Herzog loses. By making Nosferatu, after Aguirre, Kaspar Hauser and Bruno, someone who

hangs onto the world only by a thread (by the unbreakable thread of his madness, of his monomania), by accumulating verismo details, spotlights, and the slow-motion flight of bats, he proves faithful to himself, that is, to what he knows we know that he knows how to do and, consequently, he does it less and less well. Signatorial effects in the absence of urgency or logic. Herzog's *Nosferatu* enters into that detestable category of films conceived as "coups," where the addition of known names and cultural references is supposed to seem extraordinary. Actually, no. In this case, it totally misses the mark. The extreme laziness with which Herzog re-reads, copies or cites (it doesn't really matter) Murnau and the myth of Dracula encourages us instead to ask two questions. One is general: Why does cinema no longer produce myths? The other, particular: Why has Herzog regressed to such a degree? (How far we are from his first short films and from *Signs of Life!*)

(*Cahiers du Cinéma* #298, March 1979)

THE MILITANT ETHNOGRAPHY OF THOMAS HARLAN

Thomas Harlan, *Torre Bela*.

Torre Bela is first of all an extraordinary document, the kind that is sometimes produced in the center of a struggle or an extreme situation, when the determination to "continue to film" prevails over all of the ideas, preconceived or not, of the person filming. Aficionados of the "real" and cannibals of "*captured live*" (among whom we count ourselves) will be astounded by Thomas Harlan's film. Rarely have we seen more clearly the making and unmaking of a unique collectivity in its own right, itself made up of singularities, caught in a political process for which it is the blind truth, the point of utopia.

But there's more. *Torre Bela* presents us, materialized, embodied, leftism's key political and theoretical ideas from these past ten years. "As if we were there"—but clearly, we no longer are there; no one is there any more, we see the flesh on which yesterday's discourses fed, the images over which the sound was "turned up too loud": public

speaking (chaotic: one day the film will be used to study farmers' slang and the Portuguese language), popular speech (and its stuttering), an armed population (the MFA's strange soldiers), popular memory (with its bitter stories), the construction of a leader of the masses (Wilson) and suspicion towards its heroes (again, Wilson), contradictions at the heart of the people (men/women...) the cynical and stupid speech of a class enemy (the astonishing interview with the Duc de Lafoes), etc.

Of course, all of this comes too late. We believed in all of it, but now, it's over, and then the film appears, in hyperrealist precision, like a probe at the heart of what once was and the hallucinatory spectacle of what we believed in (the people, their autonomy, their revolution). Of course, we must no longer believe blindly in it if we are to begin to see it, just like we had to not see it at all to continue to believe in it. This "discrepancy" between belief and what has been exhausted is perhaps the truth of those rare "good militant films." We had to wait until the slogans ceased to reassure us for the images, finally, to arrive. But in a devastated landscape. The life of Torre Bela's popular commune ends the year in which the film, finally completed, "comes out." Thus the only relation we still have (us, or Harlan, or anyone) is of ethnographic cannibalism (and isn't ethnography our own proper cannibalism?) or perverse aestheticism (*Torre Bela* as utopia, as another utopia).

That is cinema's way. *Cinema is never on time.* And a *fortiori*, the cinema of intervention, the only kind whose existence depends on taking the time to establish its material, will never be finished on time. The filmmaker thus finds himself in an impossible, even louche situation, one that he might enjoy, regardless of the conventional piety of his discourse. Whether it is Moullet having the luxury to finally complete a didactic-militant-and-third-world film right when no one knows what do with one anymore (while everyone wanted one when no one knew how to make them), or the strange temporality of the Ogawa experiment, redoubling real atrocity with an interminable and equally atrocious film, or even Godard taking five years to edit a film about Palestine, it's the same point of arrival, the same Pyrrhic victory, the same Parthian arrow, the same revenge of artists on political bosses and activists: here is the meat of the ideas

that you thought you had, here are the referents of the words you misused, the proof that what you were talking about (without being able to see it) did indeed exist: we're showing it to you now only because it's over. This perverse dialectic of belief and exhaustion is currently the last word of so-called "documentary" film (from Flaherty to Ogawa, from Rouch to Harlan, from Ivens to van der Keuken): a gaze that is all the more acute—sharp-edged, even—because it fixes the trace of something that has no future.

(*Cahiers du Cinéma* #301, June 1979)

Manoel de Oliveira, *Doomed Love* (*Amor de Perdição*).

Doomed Love is the third film that Manoel de Oliveira has devoted to the theme of "unrequited love." The first two, until now unknown in France, are *Past and Present* and *Benilde*. *Doomed Love* is the literal adaptation of a book of the same title, attributed to Camilo Castelo Branco, one of the great Portuguese writers (1825–1890) of the Romantic era. The book has already been adapted twice for the screen, the second time by António Lopes Ribeiro who was, incidentally, Oliveira's producer for *Aniki-Bobo*. *Doomed Love* (1861) is a bit of an exception in Camilo's considerable oeuvre: neglected by its author (who wrote it in prison and claims—we are told at the end of the film—to have never opened it afterwards), it has become one of the most popular works in Portuguese literature.

Which probably explains the film's bad reception in Portugal, guilty of having meddled with a national monument, of confronting the text of the book with images (few films, in the history of cinema, have pushed the examination of the relationship between what is presented and what is seen so far), in short, of having pulled the film in the direction of novelistic truth [*vérité romanesque*] rather than romantic deceit [*mensonge romantique*] (in the words of René Girard). The same hostile reaction was evident during the debate that followed the screening of the film at the *Semaine des Cahiers*, on the part of A. Coïmbra Martins, Castelo Branco specialist and ambassador to Portugal in France: the film was simultaneously too

long (more than four hours) and too dense, not disheveled enough, even a bit cold.

Manoel de Oliveira attributes this negative reception in part to the negative influence of Brazilian serials currently airing on Portuguese television, some of which are hundreds of episodes long. Thus *Doomed Love*, broadcast in six episodes of fifty minutes each in black and white, is a disappointment. It is also a disappointment to the Portuguese film profession, which is less surprising, given that said profession has always been puzzled by its only great (and troublesome) filmmaker (now seventy-four years old). The project would not have been made without the complete support of several filmmaker friends, such as Antonio Pedro Vasconcelos. A general atmosphere of ill will seems to have pervaded the shoot, which was disrupted on several occasions. They even say that the film had difficulties obtaining the quality premium that exists in Portugal.

It is true that *Doomed Love*, with its budget of nearly two hundred million centimes, is a monster to Portuguese cinema economically as well, since it cost approximately five times the price of an average film. Oliveira had to give up 35mm and shoot in 16mm Eastmancolor. The film was blown up. The film's producers were, along with the Portuguese Cinema Institute, the Portuguese Cinema Center (cooperatives), Cinequipa, and Portuguese television.

In the forced choice of 16mm, Oliveira saw, despite a loss in image definition, the possibility for gain in stylization and suggestive power. A filmmaker who has always distanced himself from naturalism, he made the choice to shoot in the Tobis Portuguesa studios and had sets made for locations he had originally scouted. Location scouting was the first thing he did. And in fact, apart from the dialogue, Castelo Branco's text contains very few scenic indications, which is where Oliveira stepped in, opting for the studio and reconstruction, with its risks of unwanted noise and an unqualified workforce (to paint the sets, for example). He carved out the film and chose the actors based on these sets, and then on the text. The actors were, for the four principal roles, amateurs; the others (whose acting was a bit more emphatic) generally came from the theater. Oliveira chose them based on their voices, the way they read the text, their ability to memorize long passages. And only then did he consider their faces.

According to his own words, all he did was "adjust" the actors to the text.

That text, followed to the letter (with a Rohmerian precision, Rohmer whose *Perceval* Oliveira admired, a film whose theme is somewhat similar to *Love*), is the story of the thwarted love between Simão Botelho and Teresa de Albuquerque, two young people from two noble and enemy families of Viseu. Thwarted and impossible love, experienced to the bitter end by the heroes, with a quiet determination that nothing, especially not the families' efforts to plan their undoing (or to save them despite themselves), can diminish. It's the theme, dear to Oliveira, of the suspension of laws and social norms and their replacement by ones that the heroes themselves forge and obey to the point of death or madness. In the end, Simão kills his rival (Teresa's cousin), is ostracized, rejected, thrown in prison, and left with only one friend, a blacksmith by the name of João da Cruz whose daughter, Mariana, is hopelessly and permanently devoted to Simão. Condemned to death, then to exile, Simão sets sail right when Teresa, who has entered into a convent, dies. He dies in turn and his body is thrown into the sea. At that moment, Mariana who had followed him on the boat dives into the water and drowns while clutching his body. Up from the water rises a handful of letters, Simão and Teresa's letters: the subject of *Doomed Love*.

The film's duration could be an obstacle to its distribution, or even a challenge to the enthusiasts of "filmed cinema" (an expression coined by Biette in this same issue). Oliveira insists that the film be seen in continuity. For once, this is not a matter of the author's caprice or of terrorism: *Doomed Love* is the rare film that takes duration as its very subject. Like every great film, it is simultaneously, as Rivette once said of Rossellini, very slow and incredibly fast. One searches in vain for the slightest connnective tissue in this film where the text's unfolding is of a pair with a constant reinvention of space. Of filmic space.

It is clear that we will return, in *Cahiers*, to *Doomed Love*.

(*Cahiers du Cinéma* #301, June 1979)

Jacques Doillon, *The Hussy* (*La Drôlesse*).

During the Cannes Festival, television repeatedly aired excerpts—always the same ones—of Jacques Doillon's *The Hussy*, one of the French films in competition and the future winner of the Prix du jeune cinéma. While watching these excerpts, I wondered if when it comes to coding the "new natural" (infinitesimal kinks, winks of the eye), Doillon weren't decidedly the best, or rather the *best situated*. That effect of the "freshness of youth" that French cinema, probably because it knows itself to be fundamentally stale and dry, is expected to regularly produce (the New Wave, Lelouch, Pascal Thomas, Diane Kurys, Doillon's *Touched in the Head, Et la tendresse?...Bordel!* etc.) has found another master. One who, furthermore and fortunately, recently proved with *The Crying Woman* that he couldn't be limited to that sort of mastery and that he was able, through *exaggeration*, to rediscover the great French naturalistic filmmakers (I am thinking of Demy, Pialat, Eustache, Vecchiali, Rozier: the list is a long one).[1]

Then I saw the film and I didn't like it. So it was tempting to compare what worked in *The Crying Woman* to what didn't in this annoying and not very funny [*drôle*] *Drolésse*. Although the films were produced at the same time, it seems to me that they represent two possibilities of French cinema, and even of cinema full stop. In *The Crying Woman,* the auteur-actor Doillon, caught between two women plus one (the little girl), runs the risk of not being able to control *all* of the effects elicited by the device in which he traps himself, not unskillfully. A device in which each person wins and loses and each has their own weapons: Laffin has the excessive naturalism of hysteria, Politoff has the excessive experience of professionalism, Doillon has the rigid humor of playing "neutral" (neutral: neither one nor the other)—and all three in front of a camera that, consequently, can no longer guarantee the audience *a good seat*. Also, at certain points of what is great cinema, the space *between* them, an

1. But the major naturalistic filmmakers are not the minor masters of naturalism: nothing formal about them, no commercial hyperreality, but a fundamental questioning of the undecidability of *human nature*, meaning, in the final analysis, of the mystery of sexual difference. C.f. *A Slightly Pregnant Man, Women Women*, or *A Dirty Story*.

"among-five" if we count the child and the camera, begins to emerge. Nothing of the kind, unfortunately, with *The Hussy*, where Doillon, the camera, and the spectator (blended together) are, if not the masters, at least the beneficiaries and, in the final analysis, the profiteers of a traditional face-to-face between two kinds of actors. In *The Crying Woman*, the auteur, actors, camera, and spectators are scattered across material that is relatively rich, heterogeneous enough for them to lose and find themselves within it, one by one and each for himself. Watching the film resembles an experiment somewhat, meaning something incommunicable, and Doillon's tricks, once the tables are turned, to remain the master of the game despite everything that's happened, become one element among others. In *The Hussy*, it's entirely the opposite: the camera is always there for the spectator to turn a profit—I would like to say a "freebie"—of naturalness, signification, corporeality, whatever, something that silently signifies (and this silence is, for me, deafening): I am here for you and only you, you are not lost or alone in this sleazy and thankless story, this story of children-among-themselves, where you can never be—except in your most hidden fantasies.

One might object that Doillon is not unaware of the audience's voyeurism, that he inscribes it within the film through the red light of the "surveillance machine" that François constructs. But I see this instead as the sign, the wink of the eye, with which the filmmaker suggests to his audience, casually and in passing, that he is neither innocent nor is he deceived. The "surveillance machine" has no other function outside of this denegation. In a film such as *The Hussy*, the engine of the film is never the characters' truth, the enigma that creates them, but this effect of non-deception, forged between the Auteur and his audience on the backs of the characters, it is that complicity of "those who know better" that needs, in order to pull the wool over their eyes, the naturalness of those over whom they have the upper hand. Following the model of advertising's rhetoric exactly.[2] And so,

2. In the fades to black in *The Crying Woman*, we "saw" the weak point of Doillon's cinema, which is the *sequencing* of moments in the film. Hence the televised excerpts of *The Hussy* ring relatively true while the film, seen in its entirety, seems like a series of power plays. That's because cinema obeys an economy of advertising fragments, seductive fragments that can only be juxtaposed because each one is, in itself, definitive. (...)

when Madeleine explains towards the end of the film (to François who, apparently, understands none of it) that she drew a *maison pour rire* [a "house to laugh in"] on the ground and specifies that it is not a *maison pour de rire* [a "pretend house"], it is obviously not Madeleine Desdevises or the hussy who is speaking, it's Doillon who places "in the mouth of a child" what could serve as a good definition of his cinema. A cinema in which one spends one's time "distinguishing oneself," a cinema of the "almost." A cinema that is not unrelated to what Bonitzer called, apropos of Malle, (and *Pretty Baby*, another film that involves children) the "not really." A *maison pour rire* is not a *maison pour de rire*, and this slight slippage contains all of the distance that Doillon tries to establish between a dated and old-fashioned cinema from which he must discretely distinguish himself (such as *Forbidden Games*, the evergreen paradise of childhood love, where the children play at being adults: guaranteed success) and a more modern cinema, slightly Freudian and post-leftist, which one must be a part of if one doesn't want to seem like a hick.

I imagine that a screenplay such as *The Hussy* is written with two lists in mind, one with traps to avoid on one side, and things to indicate at all costs on the other. It's a strange game. It's a strange game when the children aren't really children, when the younger of the two is not who we think she is, when the kidnapping isn't really a kidnapping because the kidnapper and the kidnapped "play" their Brechtian story and experience it as a game, when they hide but not really because the attic is next to the "landlords," when there is indeed sexuality (infantile for Mado, blocked for François—which

(...) That is why I am not sure that we were right to praise the modesty and intimacy of Doillon's film so highly, compared to other large-scale paranoiac productions (such as *Apocalypse Now* or *The Brontë Sisters*). In fact, given the thinness of its effects and how it partly sidesteps its subject, *The Hussy still* seems like an inflated blockbuster where there was only material for a short film or a publicity spot (a rough and sophisticated version of a Woolmark ad.) That the film has been, given its low cost, a successful commercial operation proves only Doillon's intelligence and the relative stupidity of large-scale productions, but absolutely not that there was—as is the case for most large-scale films—appropriateness or coherence between the film's economy and its subject. That said, there is undoubtedly, as they say, a "niche" for this kind of cinema, and Doillon has enough talent to occupy it. It is also perhaps the final chance for French cinema to sell its brand to the foreigner: that folklore that the USA likes so much: the quality, claustrophobic psychological drama.

helps matters) but there is "cuddling" off-screen, when there are lots of adults (parents, police) but they aren't really enemies, just a hostile and stupid presence in the margins of the film (strange, how their local accents are ten times stronger than the childrens'!). The police also form a completely unexpected *deus ex machina* because it falls to them, during a final scene that is yet another power play, to be particularly insensitive and unsympathetic exactly when everyone else (actors, auteur, audience) is reveling in tenderness and sentimentality. In 1979, with a subject as dicey as child kidnapping, I am inclined to find a film that signifies everyone except the police too good to be true and slightly demagogic. I even see in it a sign that while Doillon may be in love with his filmic material, he isn't much interested in his film's subject.[3] Despite its being a serious one.

It is hard to find a real consideration of *The Hussy*'s subject in the chorus of praise that welcomed the film. Let alone in the content. No coincidence. The little masters of the *not really* willingly gloss over their subject, circumvent it, sacrifice it to the idea, more immediately profitable, that they could address it if they wanted to. This in contrast to the major "deviants" who are inclined to take their subject seriously, with a stubborn kind of innocence. On the theme of the

3. Even before the "screenplay crisis" that they say—quite rightly—is undermining French cinema, it seems to me that we must talk about a crisis of "subjects," a crisis of the very idea of a subject, of a subject to be "treated." The majority of French filmmakers remain beneath their subjects, shoot around them, imply that they are all-knowing, and ask to be credited in advance for their supposed knowledge. Hence the weakness of the fictions, given that the only fiction is the supposed knowledge of the author. But, we are beginning to understand, major subjects are only appropriable in fictions. To take one recent example, we had to wait a very long time, an entire generation, for the green light to be given to the fictionalization of a subject as serious as the Nazi extermination camps, with *Holocaust*. Excepting pulp fiction and lumpen-porno films, reviews such as *Historia* did not wait for this green light to make a privileged site of fiction and fantasy out of that impossible site, that representative prohibition, the very site of the imaginary. These fantasies shock us (they are anything but reassuring), these fictions disrupt us (the *Kapo* effect); that does not prevent them from being inescapable. Obviously, if we concoct our fictions from the front page of the *Nouvel Observateur*, we risk nothing, we only risk encountering the reflection of our noble soul or the echo of our metalanguage. When Paul Vecchiali began shooting *La Machine*, a story about child abduction and pedophilia, he wasn't afraid of risking a message film, à la Cayatte, and if *La Machine* is, in the end, the opposite of a Cayatte film (who was, by the way, responsible for a terrible flop on the same subject), it is not because he failed to actually make a message film, it is because he multiplied the messages, without overlooking the one, unacceptable and not accepted besides, where the pedophile, like R. in Ōshima's *Death by Hanging* (another splendid "message film"), declared his passion.

abduction of minors, see *La Machine* (Vecchiali), *Alice in the Cities* (Wim Wenders) or, more recently, *Jail Bait* (Fassbinder). These are films that emerge from common opinion. Not informed opinion, but mass opinion, where it is frightening: in the headlines and polls on the front page of *France-Soir* or *Bild Zeitung*, where the abduction of children and pedophilic passion feed the fantasies of the masses, not only the insular chamber music of French arthouse cinema. There is benefit (and modesty) in not being too "above all that," when a clear majority of French people demand the death penalty for "all that," when they aren't calling for a lynch mob.

It's easy to argue that this isn't the film's subject or Doillon's problem, that he deserves credit for limiting himself to presenting human relationships without any demonstrative desire. Curiously, the filmmaker's lack of opinion regarding his subject, his disengagement, is increasingly brandished as a standard, as if escaping from the traps of the "message film" were the ultimate achievement, the unsurpassable horizon of cinema today. A weak agenda. Particularly because it is never realized. I believe there is an implicit argument (not an incorrect one, incidentally) in *The Hussy*, an argument that aims to demystify, de-dramatize, by suggesting that these stories about "child abduction" are not what we think they are, neither as sublime nor as monstrous, because in the final analysis, it is clear that every couple, even the most disparate, illegal, outside of sexuality or anomic in the world, produces *normality* as naturally as it breathes. "Every couple is normal," the film seems to say: in Madeleine and François, across the remnants of childhood or extended adolescence, we can already imagine an old, embittered couple, the husband bringing his paycheck home to his wife and her calling him "papa." This is perhaps Doillon's ideological calculation, relatively similar to Malle's (the mother-son incest in *Murmur of the Heart*). If an abduction were *only that*, the flawed and poetic fabrication of just another couple, then presenting it onscreen would be enough to make the silent cinema-going majority recognize their mistake: they had fantasized unspeakable difference in place of something that was merely banal.

But this is a naïve calculation, as is every discourse about the "right to be different." It actually supposes that the other is intolerable

because of his difference. A mistake, because exactly the opposite is true. What majorities refuse to minorities, the normal refuse to the abnormal, the One refuses to the Other is, more deeply, the "right to be alike," the idea that beyond certain superficial differences, others are—horrors!—*like them*, that like them they are articulate and sexualized beings. But the other's difference is reassuring. It is primarily the background from which intolerable similitude stands out, as if in relief. That's why we love differences, we fetishize them, we encage them, we make museums out of them and hold conferences about them. It explains the ethnographic film festivals where we are enchanted by the compulsive discovery that savages (substitute: the insane, children, animals, it's all the same thing) are indeed men, like us. It also explains naturalist cinema and that impression of the freshness of youth that we have never much liked at *Cahiers*, probably because its redolent young flesh is only flaunted so that it can be renormalized. That's sort of the job of a film like *The Hussy*: to normalize ("naturalize," as they say about a foreigner) subjects that are still a bit taboo, while taking advantage of the fact that they were taboo only yesterday: in brief, to reassure us. Given Doillon's talent, we have to hope that he takes the opposite route, that of *The Crying Woman*, which is to alarm us.

(*Cahiers du Cinéma* #302, July–August 1979)

Francis Ford Coppola, *Apocalypse Now*.

When it comes to an extraordinary film such as *Apocalypse Now*, the wisest thing is to begin with what struck everyone who saw it, namely its disappointing side, the failure, even, of its final section. All of us, when confronted with this kind of film, become spectators "in the first degree" and even rather good critics: we are astonished by it or we are not. I would just like to point out here that the film is the story not of one, but of two, three, or even four *ascents* upriver and that if, as Blanchot says, "the Apocalypse disappoints," it's because it is in its nature to disappoint. To all that river carries, there is no possible ending.

First ascent. From Concrete to Abstract: War

The history of cinema goes hand in glove with the history of war. The French army was one of the first operators of the Lumière brothers' invention. Once it became global, waged by everyone against everyone, war drove all of modern European cinema, from *Rome, Open City* to *The Carabineers*. Bazin has written about the delight taken in the "spectacle of urban destruction" that he called the "Nero complex," for which he considered cinema to be the privileged site. In America, cinematographic techniques and the technology of war were of a pair: killing and filming "progressed" in tandem. The film viewer gradually became accustomed to being a *survivor*. This is the viewer whom Coppola is pursuing today, the one who escaped massacres—or who returned from them—as he presents the most modern of wars, the one whose image has not yet faded away. From the Vietnam War, Coppola keeps only what makes it a new kind of war (but a newness that integrates the old: trenches, javelins) and erases everything that might refer to a certain timelessness of war. None of those scenes then, so frequent in Hawks, Walsh or Fuller, in which soldiers talk—about war, for example. None of those soldiers' speeches about the horrors of war *in general* (as in Walsh's *The Naked and the Dead*, which records the debate over antimilitarism) or the legitimacy of a particular war. Useless, then, to look for a position on America's engagement in Vietnam in *Apocalypse Now*. Just like *The Deer Hunter*, the film participates in the business of political amnesia, except that with Cimino, it's from the point of view of a reactive withdrawal and with Coppola, the historical dimension is short-circuited at the outset by a direct passage from the physical to the metaphysical, through a screenplay inspired by Conrad. And at the same time, *Apocalypse Now* bears witness to the Vietnam War, insofar as it is not the simple repetition of Korea or the Pacific, by showing—for the first time with this kind of intensity—what *technologically* makes it an *other* war. When, in The *Naked and the Dead*, a field burns, it creates a beautiful image for the audience; in *Apocalypse Now*, when Willard and his men meet up with a battalion preparing to napalm a field, it is primarily a spectacle for the characters in the film. No pauses, then, no down time, but a constant acceleration, changes in

speed, ellipses at the very heart of the scenes. Sound—a particularly manipulative use of the Dolby effect—plays a prominent role, not by anchoring the image, making it more intelligible, but on the contrary, by tearing it open from the inside, by keeping it from becoming a refuge for the audience, by inspiring fear. In other words, no more off-screen. The effect is completely breathtaking. The sequence most often cited as the best in the film (correctly, in my opinion, and I will return to it) in this respect is the helicopter battle. Why? Quite simply because, like Fabrice at Waterloo, we understand that we have never really *seen* a helicopter. We find ourselves below signification: a helicopter is a helicopter, nothing more; an explosion an explosion, a death a death. Too quickly, we meet objects that mean nothing to anyone, but that kill. War is primarily that concrete, too concrete place. I suppose that if Coppola had ended the film before the Kurtz chapter, he would have exposed himself to widespread outrage, and the film's distributors (who, in this case, are often producers) would have refused to show it in theaters. Conversely, film critics (us, for example) would have found the film admirable because it was formally appropriate for the unintelligibility of war, a war seen from below, without "ascent." And yet, the double bind that Coppola has not been able to escape is this: the audience (and millions are needed to make the film profitable) come *at first* for the war scenes, but they find accepting this "at first" difficult: they need an ending, a dénouement, of intelligibility that will retrospectively justify those scenes. Ultimate meaning as cover for the *jouissance* of non-meaning. As for Coppola, he wanted this final section, even though we know that it was a struggle for him to decide exactly what it would be. There is a moment when, after going upriver, we pass from the concreteness of war (things in the flash of their being-there, in their mortal irruption) to abstraction (things that begin to signify, sometimes heavily, to support something beyond themselves). Here is where the film runs aground. As if it were impossible (or else, he needed more time) to lead the audience from its stupor towards another relationship to the film in which it would be invited to begin to "think for itself" again. Thinking is either shocked or stimulated, meaning it is either retained or disseminated. Coppola has not really made a choice. Plus, while he is

an extraordinary engineer, while he films military operations with real skill, with actual machines and actual bodies, as soon as the image becomes over-signified and the story metaphorical he is much less at ease. Of course, this play between suspension and the dissemination of meaning is the gamble of really big movies, monster-films (for films that stupefy, expand interpretations, that *don't conclude*: see Tati, Fellini and especially Kubrick, who is magnified when compared to Coppola). The paradox is this: these films can now only be made in places—the USA, perhaps the USSR, empires in any case—where it is forbidden not to draw a conclusion, not to *edify*.

Second ascent. From Father to Son: the Godfather

But the river carries something else. It carries, for example, what every narrative is based on: the ascent towards the essence of filiation, of sons towards fathers, of Oedipus towards Laius. Curiously, John Milius's screenplay reminds us of a very small film, a masterpiece, generally disregarded overseas: Nicholas Ray's *Wind Across the Everglades*. There too, a character is removed from civilization and reigns over a group of outlaws and wrecks at the heart of a kingdom that's both splendid and nauseating: the Florida Everglades. There too, a young man is progressively caught up in the horror of what goes on in that realm, horror that he is fully aware concerns him. With Ray, an ecologist ahead of his time, birds are massacred; with Coppola, it is more serious. A turbid friendship binds two men: the older intimidates the younger but will finally be killed by him. After the murder, the younger suspects he will never be the same. "Horror!" Willard says in the final scenes of the current version of *Apocalypse Now* before getting back into his boat. He has discovered the horror of filiation, the passage through mimetic violence (he begins to resemble Kurtz), etc. But that passage is rigged. The real subject—with Coppola, as with Ray, as indeed with Welles in *Mr. Arkadin*—is uncovering of the homosexual bond, insofar as it is fundamental to all society, to all "fraternity," hence to all war. But this bond is not so easily severed. There is indeed an Oedipal situation, but it is seen from the perspective of the myth's great forgotten one, Laius. A Laius who

would have disguised his suicide as a murder to strip Oedipus of the fact of it. If we discover anything at the end of the ascent upriver, it's that the father was not really killed: he had wanted to die all along and waited impatiently for his murderer. Horror, then, but not the one we had thought. Of course, in Coppola's film, this entire section is somewhat theoretical, because we don't actually believe in the identification between Willard and Kurtz. It was much stronger in *Wind Across the Everglades*, with Burl Ives and Christopher Plummer, even though they are more limited than Sheen and Brando as actors, because Nicholas Ray was a great filmmaker. The false father, the "rigged father" of *Apocalypse Now* is Brando, someone who enforces a protectorate rather than a law, a "godfather" rather than something else; in any case, a living myth. For upstream of *Apocalypse Now*'s river is also old Hollywood. Coppola belongs to a generation of filmmakers who are doing their work while their ancestors are still living, and who know it. A generation that began in France with the New Wave, when Godard literally inscribed Fritz Lang's name and body (in *Contempt*), and who have recently arrived in America (see Truffaut in Spielberg's film). There too, we could say that Brando's killing is an infinite operation—by virtue of the very particular position Brando holds in the American industry: he is a little like the Kurtz of that industry—infinitely disappointing, as well.

Third ascent. The One and the Other: America

Yes, *Apocalypse Now* is an exceptional film. It is also an average American film of the post-Vietnam era. American cinema lately has centered around the theme of the presence of the Other within ourselves. Other in the sense of "*alien*," the title of America's biggest hit of the summer. "Us" is, of course, once more, the American who abusively considers himself to be the universal equivalent of the human species. Except that "being" American is never very obvious or very simple (I won't dwell on the *melting-pot** and other myths), and it seems like one is always ready to do just about anything to be *even more* American (anything: see Kazan). Ideologically, the concern of all of these films (*Alien, The Exorcist, The Deer Hunter*, even *Close Encounters of the Third Kind*)

is to make Americans even more American by having them exorcise an Other (evil, in general) that haunts or inhabits them. The novelty of these films, their power, too, is that they decided to no longer skimp on the means (technology, again) to demonstrate the other, the *alien*, within ourselves. Previously, it was mostly B movies that attacked this theme (in the fifties, around anti-communism), but with meager resources, limited to weak special effects or writerly manipulations (the Tourneurian off-screen) that only shocked viewers who were very naïve or very sophisticated (cinephiles). The decision to show the unshowable is fairly recent. There are different versions. With Cimino, the Asian is responsible for waking the monster that was sleeping in us: he is killed while being shamed for having awakened the monster: a familiar story. With Ridley Scott (*Alien*), the protean monster literally surges up from the human body and occupies the spaceship like a cancer whose unpredictable metastases are petrifying. With Friedkin or Kubrick, we have more coded, literary themes, of the devil or the double. As for *Apocalypse Now*, it has what is probably, at the level of the screenplay, the greatest literary dignity (Conrad). There, one and the other, Willard and Kurtz, are of the same species, the same race, the same country, the same training (the Army). And yet, one of them has become a monster. A monster with whom he must identify. Coppola ascends the river of civilization to barbarism, not the barbarism of others, but the one that we originated from, that all of civilization originated from, on the side of the paternal horde. If that ascent is also cut short, it is because Coppola didn't really choose between surrealist insanity and ethnographic cruelty. The "people of the abyss" who adore Kurtz are not credible enough for this final section's apogee, the parallel slaughter of Kurtz and the animal sacrifice, to generate the sacred horror that we find in Pasolini (in *Pigsty*: "I killed my father, I feasted on human flesh and I tremble with joy...").

Fourth ascent: The Show and the Showman: Coppola
 Coppola may not be as profound a filmmaker as Kubrick (to stay with the heavyweights). His treasure hunt leads nowhere, really; it disappoints us. And yet, he is an extraordinary entrepreneur of

spectacles, and *Apocalypse Now*'s greatest success is that other ascent upriver that leads Willard to Kurtz from spectacle to spectacle, almost from "show to show." That is where Coppola is often a very great filmmaker. What he retains from the war, from that war, is that for those who waged it (on the American side) it became a spectacle without a director. Nothing can come out of this war that is no longer discussed, no longer understood, except show business tableaux vivants. Willard—embodied completely by Martin Sheen—is the spectator par excellence: *everything that he meets is either experienced, or deliberately staged, as if it were a performance.* This ranges from the quick shot of Coppola filming himself as a television journalist to the final phantasmagoria, products of Kurtz's delirium, with the young Black soldier on the boat singing "Satisfaction" in between. It is true of Dennis Hopper, entangled by cameras and photographic equipment, who is like Kurtz's first assistant, his court jester and griot. It is obviously true of the extra-ordinary scene of the performance staged for the soldiers (for a moment, I sensed that Coppola had touched upon the essence of war: on a floating dance floor and in a cloud of pink smoke, the nocturnal exhibition of a handful of women for a horde of young men, as if in a dream). It is true of the truly apocalyptic scene in which everyone mistakes Willard for the officer in charge. But it is especially true of the extraordinary episode of the helicopter battle and the character played by Robert Duvall. If this is the best scene of the film, it is because it creates the right mix of the "real" (the being-there of things) and the "spectacle" (being desired by some-one). Duvall is not the *deus ex machina*, the demiurge, that Willard seeks; he is a bricoleur. He can only bombard a village on a whim or make soldiers surf. He is like an anticipation of Kurtz (except that he seems far more convincing to me), Kurtz who, at the end of the river and at the heart of chaos, is the last director who still has actors to direct, a kingdom to decorate and an audience who will listen to him read the poems of T.S. Eliot. But Coppola is clearly, like Duvall's character, an entrepreneur of spectacles rather than a visionary—like Kurtz.

And so, "the apocalypse disappoints us." In Lacanian terms, we could reproach Coppola for having attempted the impossible: to

film the unrepresentable phallus. Even Brando's bald head doesn't suffice. But it is as much out of calculation as out of naiveté that he *had* to make the film this way. For while he succeeded in shooting the film exactly as he wanted to, despite innumerable impediments,[1] he was simultaneously forced to make a film of an almost standard length, with a real ending, etc., out of what was an enormous amount of filmed material. Perhaps he lacked the power to assume a lavish economy to the very end, to earn *the right not to conclude.*

<div align="right">

(*Cahiers du Cinéma* #304, October 1979)

</div>

FROM ONE *ROSIÈRE* TO ANOTHER

Jean Eustache, *The Virgin of Pessac I* (*La Rosière de Pessac I*) (1968), *The Virgin of Pessac II* (*La Rosière de Pessac II*) (1979).

1. More than ten years have passed between the filming of the two *Rosière de Pessac* films. In December 1979, thanks to Channel 2's cine-club, French television audiences will be able to see the two films in the space of a week. Journalists have already been invited to screen the two films privately *one after another*, which is, in my opinion, the way they should be seen. A ten-year gap becomes a week, and then no time at all. "It's the idea of time that interests me," Jean Eustache says. Few filmmakers have so obstinately maintained one of the New Wave's greatest audacities: that a film would not be of standard length (the fateful hour and a half), that it would take the time to produce and grasp its subject. Each Eustache film is a challenge, a particular torsion of time. Not because of a desire to provoke or experiment at any price, but

1. Coppola runs the risk of becoming the Kurtz of the profession. He has managed to circumvent the rules of Hollywood production, to go at it alone—which is unpardonable. He is in the midst of building, with American Zoetrope, a kingdom with capricious rules where he is owed everything by everyone. A kingdom where the rules of the marketplace go hand in hand with a system of allegiances and debts that is more in line with something like the mafia than the industry.

because his fundamental subject is repetition. As much Don Juanism (or the pick-up: *Bad Company*, *Le Père Noël a les yeux bleus*) as repetition compulsion (neurosis: *The Mother and Whore*, perversion: *A Dirty Story*), or the survival, somewhere in France's heartland (in Pessac, the filmmaker's native city), of a festival where an archaic rite is still performed: the *fête de la rosière*, a celebration of the virtuousness of young girls.

2. Most likely because cinema is itself repetition (Guitry used to say that actors in films "have played" their role), filmmakers have seldom ventured to make repetition their subject: rites, ceremonies, festivals, everything that, even when it's as absurd as the *rosière* of Pessac, has something to do with the sacred. Or if they do, it's done as polemic or apology, out of bigoted piety or the desire to deconstruct it (which aren't completely incongruous). Jean Eustache is one of the rare few to attempt the move: he is not afraid to bore us (his repetition is austere, his irony cold), he does not encumber himself with ideological precautions ("I cast no moral gaze, no critical gaze on what I film"), he seems to think that rituals and festivals do not belong solely to "primitives" and "*National Geographic*." But how do you film something that is repeated, if not by repeating the filming itself? All of modern art has at one point argued: saying that something repeats itself (but only saying it) has nothing strictly to do with the fact of repeating it (without saying anything). That is Eustache's entire wager: he repeats (once every ten years) something whose nature is to repeat (once a year). From the two films realized in this way, he creates one, out of their juxtaposition. The film provides a slightly surreal feeling of exactitude that is worth investigating. In a regular film, even in a documentary, rituals and ceremonies are all the more credible (and more ideologically active) when they do not repeat. Otherwise, their self-evidence gets lost, they become obtuse, enigmatic, preposterous. This is because the temporality of the festival needs secular time in order to fully exist and to play its role, which is one of scansion. For that scansion to no longer occur, reduce that secular time (dead, secular time) to zero. This is what Eustache does: between the two *Rosières*, between the two festivals and two films: nothing. Consequently, the temporality of the ritual,

for lack of dialectalising itself, passes entirely into the space of the profane. That is, the *profanable*.[1]

3. That is why we should believe Eustache when he claims that he did not intend to critique what he films. That is not what motivates him. It is clear what a critical (Parisian and mocking) gaze would focus on: the gross manipulations regarding which candidates were chosen, the political use of the festival (especially in the context of 1968), the hypocrisy on all sides, the reactionary and ridiculous nature of the discourse, etc. All of these elements can be found in Eustache's films with a quiet acumen, which suggests that these two *Rosière de Pessacs*, the one from 1968 and the one from 1979, constitute one of the great filmic documents on contemporary France: a document in the sense that everyone can come to learn something from it. But we also see what a purely critical, demythologizing approach would have missed: by reducing the festival to *what it signifies* or those to whom it serves, to its meaning or its function, it would have, as they say, "thrown the baby out with the bathwater," glossed over the object for the purpose of the critique. That is where Eustache is more shrewd, and more exacting as well. By repeating repetition, he provides the means to critique the festival whilst continuing to show it in its entirety, in its opacity. More an acupuncturist than a surgeon. An opacity that is indeed inevitable: even if we were to understand the meaning and the function of these festivals perfectly, that sociological knowledge would not exempt us from this enigma: we can never really know what is going on in the heads (and the bodies) of their actors. Beginning with the virgins themselves. In this, Eustache is faithful to his own universe, a more Bazinian than

1. Repetition is, ultimately, the most radical critique. One only has to sequentially arrange the images that are meant to recur from time to time (once a year, a month, a week) in order to create that space of profanation, that disrespect through excessive respect. It is, for example, the operation recently attempted by Raúl Ruiz on television (*Histoires de France*) in relation to historical TV dramas (*La camera explore le temps*, etc.) The progression of half-a-dozen Joan of Arcs in a single image says more about the stereotypes of the History of France—as told to children—than any demystification would. But also, with Ruiz as with Eustache, these de-ritualized images (the series they belonged to has disappeared) become very precious documents (about the gestures and performance of actors on television, about a certain human material).

natural universe in which many things depend on the purity of young girls. The curiosity of boys, to start.

4. De-ritualized because it is repeated, the festival returns to the profane, to the one at a time, to the enigma of each individual accepting, *nolens volens*, to play a small role in a *tableau vivant*, a cautionary and antiquated scenario that is willed by no one. That is what is profanable. Hence respectable (morality never loses its rights). The filmmaker's question is less, "Do I believe it?" than, "Do they?" There can be no simple answer to such a question. The two most obliterated, the most "sacrificed" characters of both films are the virgins themselves. Impossible to know what they think, what they make of what happens to them, how the ritual affects them, touches them. Much more than the study of a social phenomenon or even the power plays between the filmmaker and the mayors,[2] this is most likely the question at the origin of Eustache's project (echoing another that pervades *A Dirty Story*: what are the ogled women thinking?) Curiously, we never ask this question of an ethnographic film, even though it's the very question on which ethnographic cinema is based. We accept the foreignness of ritual dances (African or other kinds) in the name of the idea that they have a meaning, that is, a global meaning, transcending each individual dancer. That the individual is entangled in these rituals is one thing; that he is reduced to those rituals in the eyes of a foreigner who is unfamiliar with those rituals is another, serious thing. Eustache, a filmmaker who refers only to France (France as a tribe), pursues an ethnographic oeuvre (in the most general sense of a relationship to the *other as profanable*).

5. One word in closing. Again and again we hear the tired but enduring argument that French cinema has become anemic, intellectual, literary, narrow and cruel. Particularly since the New Wave. Before, it was supposedly generous, collective, *bon vivant* and popular. This is a great exaggeration. We mustn't confuse French cinema

2. On the relationship between political leaders and their public image on film, see the interview with Raymond Depardon in this issue. In the case of *Rosière*, especially the 1968 version, there's nothing more comical or instructive than the game of seductive tricks played between the UDR mayor at the time and Eustache, who passes himself off as a television director. It's because the mayor is the only one who understands the importance of the media for his public image, of the place of the camera and the microphone that he spins the spider's web that Eustache catches him in.

with American or Italian cinema. The curse (but also the genius) of French cinema is based on the fact that in France more than anywhere else, minorities, folklores, and ghetto cultures have been cut down, destroyed. The impossibility of staging the contradiction between dominant culture (bourgeois, literary, Parisian) and dominated cultures (Pagnol was the last one to defy it) drove French cinema *at best* to invent a sort of ethnographic vocation. It is difficult to see how virtually all major French filmmakers, from Tati to Duras, from Pagnol to Godard, from Guitry to Pialat, from Cocteau to Rouch, from Renoir to Eustache, could be accused of being *bon vivants* who racked up popular successes, for they have always been marginal figures who were haunted by other art forms (theater and literature, particularly) and who racked up commercial failures. A paradoxical and uncomfortable situation, always—one that continues.

(*Cahiers du Cinéma* #306, December 1979)

Andrei Mikhalkov-Konchalovsky, *Sibiriada* (*Siberiade*).

Faced with a megafilm such as *Siberiade* (originally four and a half hours, now three hours and twenty-five minutes and a winner at Cannes, its budget was that of eight films and took two years to shoot), we find ourselves in a strange and slightly ridiculous situation: simultaneously caught in a vortex of images, overwhelmed by its number of characters and complications, moved and finally overcome "by attrition," and yet we are never really lost or concerned, never really off the rails, always on familiar territory. This is because Soviet cinema has become, out of political necessity as much as inclination, an *allegorical* cinema. In such a cinema, we do not expect the audience to move from perceiving a spectacle to questioning what that spectacle means (as in *Apocalypse Now*); we ask them instead to enjoy the incarnation—more or less successful, skilled, convincing, etc.—of meanings that are already coded and familiar, legal, official. Hence the feeling that we often get from many Soviet films (or films from Eastern bloc countries): we never really see what we see, but always and primarily *what it signifies*.

Signification is cordoned off before and after each scene, each shot, leaving few chances for either to exist independently (even the famous "third meaning" that Barthes talks about in Eisenstein has been cut down). *Siberiade* is no exception to this sad rule: a *shashlik* of authorized meanings, filmed with talent (and a good deal of blasphemy) by Andrei Mikhalkov-Konchalovsky.

In the great historical frescoes made in the USSR (and this one is occasionally stunning, less stifling and more modern than Bondarchuk or Gerasimov, but more calculated and less wild than the films made by Dovzhenko's widow [Yuliya Solntseva] such as *The Enchanted Desna* or *Chronicle of Flaming Years*, which we suddenly want very much to see again), there is always a double referencing. An historical referencing and a symbolic referencing. On the one hand, major scansions of official (hence mythic) Soviet history that include an entire series of before-and-afters (before and after October, before and after the war) and the inevitable impasse after the fifties and the end of Stalinism. On the other, the cycle of transformations of the Russian land, subjected to the fire of History and contact with other elements. We too have become accustomed (if only through the mediation of European revisionist art of the *1900* genre) to this double referencing that makes the vision of these great frescoes comforting, "cushy," I would even say. Nevertheless, there was a time when Soviet filmmakers, out of leftism, an excess of sacrilegious zeal or writerly concern, attempted to blend this double referencing into a single logic where the ruses of History and the metamorphoses of Russian land would become indissociable. In *The General Line*, that's what the whole story of Martha's skirt is about, on which the future of the revolution, the collectivization of land, the repair of the tractor, the progression of the story *and* the transformation of Martha herself suddenly depend. That time is long gone, and its lessons are for now obsolete. Today, in Soviet cinema we have on one side the History of the USSR that has become a flat chronology and a backdrop (that M.-K. now scrolls through using stock shots*) and on the other, Russian land that has again become a metaphysical or religious category. Writing no longer dares to tie them together.

Siberiade: in a taiga village (Yelan) an elderly, outcast farmer (Afanasy), guided by a star, constructs a road straight through the

forest that at first is used only by bears. This road passes through the terrible swamps, dark and lethal, called the "devil's mane." It then falls to Afanasy's son (Nikolai, the positive hero), and then his grandson (Aleksei) to discover both the truth and *their* truth at the heart of these swamps that are in fact naphtha, oil. At the end of the film, just as in *Giant*, the oil gushes and the wells burn against the sounds of Pink Floyd-like music. It's relatively original that Aleksei's character (played by M.-K.'s brother, the filmmaker Nikita Mikhalkov), despite or because of his heroism (war hero, working hero: he dies in the final inferno), ruins his life. In a beautiful scene, this Soviet "man of marble" bitterly realizes that "only the country needs him." The sole purpose of his death, the insidious avatar of another Astra operation, is to move the audience and, in the film, several high-ranking bureaucrats who are "not too cut-off from the masses" in Moscow.

Is this a critical, daring perspective, a risk for Mikhalkov-Konchalovsky? A dissident M.-K.? That is perhaps what they would like us to believe. And yet it is difficult to consider *Siberiade* as anything other than an officially sanctioned film, and to not see in M.-K. someone whose mission it is to prove to the world that young Soviet auteurs are in sync with modern international cinema. *Siberiade*, from this perspective, is a film that is easy to critique. We could also critique it on behalf of the films that M.-K., given his talent, would have made (or tried to make) if he had avoided risking becoming the regime's gilded griot. Iosseliani has written about it in this way (*Cahiers*, #305), and his critique is unavoidable. Nevertheless, it runs the risk of making us forget that if *Siberiade*, despite its mini-audacities, is a great, pious fresco, it is not only because it is impossible for a Soviet filmmaker to say *everything* (or even to *say* anything at all: embargo on subjects, impossibility of addressing them), but also because Soviet cinema, because of its particular genius, is fundamentally an *iconolatrous* cinema, ignoring the distrust of images. A cinema that illustrates beliefs, and that believes in illustration more than it does in beliefs, to the extent that illustration can be performed in a country where the circulation of information, the media, by being blocked, twisted, starved, has preserved a certain freshness in its relationship to images. Similarly, it is insufficient to

say that war films or historical frescoes have become the official genres of Soviet cinema in order to exclude contemporary subjects; it is also because in these image sequences, piously created by filmmakers who are more non-believing with every passing day, a nation that has been particularly shaken by History is trying to live *decently* with its past (but decency has nothing to do with truth).

The question we must ask of this *Siberiade* is instead: how does M.-K. attempt to escape piety and pretense? We know that there are two ways to avoid both: either by an increase or decrease in fiction, via documentary or simulacrum. The best Soviet films in recent years are, for us, films in which the fiction has been decelerated by the untimely, unplanned, unreferenced irruption of documentary notations. See Panfilov's *I Wish to Speak*, Shengelaia's *Pirosmani*, Iosseliani's *Once Upon a Time There Was a Singing Blackbird*. It makes sense that the Western critic would favor these films that are, by the very fact of their modesty, by their willingness to anchor themselves, the most difficult to make (and to have accepted), as well as the only ones that teach us something about daily Soviet reality. But there is another possible exit, by way of simulacrum, one which we often get the feeling this *Siberiade* is trying to use. In the history of Soviet cinema (c.f. Eisenstein's *Ivan the Terrible*), iconolatrous zeal has always been an antipathetic, cunning, duplicitous strategy for playing images with power. There is a bit of this hypericonolatry in *Siberiade*, the Soviet equivalent to American hyperrealism. One could argue that M.-K., despite his talent, plays and loses on this field. For in addition to the reasons outlined above that limit the scope of his operation (meanings that always exist prior to the work of illustration) there is the USSR's technological lag behind the USA when it comes to hyperspectacle. Unlike Coppola, M.-K. cannot see spectacle all the way through to the end. Whereas *Apocalypse Now* simultaneously questions the becoming-spectacle of wars and the most accomplished, the most sophisticated spectacle that the international film industry is currently capable of, *Siberiade* is doubly defeated: prohibited from questioning the spectacle (because its images are pious) and prohibited from making it even more spectacular, from raising the stakes (because its technique remains traditional). So much so that in *Siberiade*, the peaceful coexistence of

two image empires, a 35 mm film blown-up to 70 mm, saddled with antiquated, radiophonic sound, is at once too much and too little.

(*Cahiers du Cinéma* #306, December 1979)

Pierre Granier-Deferre, *The Medic* (*Le Toubib*).

The film begins with two cataclysmic events: 1) The "medic's" wife has just left him. 2) The Third World War has just broken out (between unknown, anonymous powers). Very quickly, however, it seems that the two events are connected. The war has only broken out to give the medic, who has become a military surgeon (the film takes place entirely in a field hospital), new—more universal—reasons to despair, to cause him to hit rock bottom of said despair and—who knows?—reconcile himself with life. Will he speak? Will he share? Will he trust? Will he love? Will he kiss the heroine, a young nurse, who is far less despondent than he is? The stakes, clearly, are high, and a world war is not too inordinate a backdrop. Delon's hieratic acting, almost as if he were in a silent film, or trained in the school of Melvillian Nô, is entirely functional here. Four characters support the "doc" and try to cheer him up, or, at least, to ease his ordeal. The chief physician (Michel Auclair) sounds like an addled blowhard, a Brechtian canteen worker (Catherine Lachens) exhausts herself with one-liners, a devoted friend (Bernard Giraudeau) suddenly dies on the operating table. As for Harmonye, the young nurse (Veronique Jannot), she is only loved because she has been stricken with an incurable disease (although she doesn't know it). The moment the doc decides to save her, she dies a horrible death. In the final shot, Delon lets loose a horrifying scream alongside her bloody corpse.

The film is terrible but evokes pathos. Granier-Deferre's direction is terrible and flat, as always. Delon evokes pathos, but verges on terrible. He polishes his image as a star, for he is, undeniably, one of French cinema's very rare stars. A star is someone who can only be adored at a distance or in effigy, for contact with him would either be disappointing or fatal. In this sense, Delon is a star, squared: there is

a phobia of contact and of promiscuity in him, a horror of the idea of being manipulated, directed, a completely terrifying "noli me tangere." *The Medic* is the story of a man who jinxes everything he touches, someone who—like a good obsessive—"cuts himself off from everyone else." The result is that 1) left undirected, Delon is bad (the last two films for which his phobic dimension became the actual subject of the films were Losey's *Mr. Klein* and Zurlini's *Indian Summer*, films made at a time when Delon still allowed himself to be directed; 2) Delon is a bad conductor of the story (in the sense that wood is a bad conductor of electricity) because he absorbs and dampens everything; 3) consequently, any secondary character in the film (id est: *everyone else*) is more interesting than he is, from the canteen worker to the boss, from the best friend to Marius the dog. The strangest thing is that I sense, in *The Medic* some vague awareness of this state of affairs, an imperceptible and stilted wit; Delon knows that his greatest sacrifice, the only one that reaches the level of his paranoia, is to constantly fill the entire screen all the time in order to allow everyone else, in the rare shots where he does not appear, to be more interesting than he does. The ultimate sacrifice.

(*Cahiers du Cinéma* #306, December 1979)

SCHROETER AND NAPLES

Werner Schroeter, *The Kingdom of Naples* (*Il regno di Napoli*).

A film with a strange career.[1] But it is a strange film. *The Kingdom of Naples* is like nothing we have ever seen before, and every comparison, even to Werner Schroeter's previous films, falls short. Is it a leftist narrative, a kitschy melodrama, a decadent *fotoromanzo*, the history of a city, an opera in a minor key or, quite simply, Schroeter's first "realist" and "narrative" film? *The Kingdom of Naples* is all of

1. It took two years for the film to find a distributor in France. In the meantime, the film was seen in nine festivals and won awards in five of them (Taormina, Chicago, Brussels, German television, Orléans). The strange career of an increasing number of films that have been rewarded more than they have actually been seen.

these simultaneously, the *disenchanted* parade of every major narrative that has sustained post-war Italian cinema (the film's action takes place between 1943 and 1972: thirty years, or a generation)—seen from the site of disenchantment itself: Naples. Only one character in the film: the residents of a poor Naples neighborhood, the via Marinella, in the winter of 1943, the same day the Germans leave the city and a first child is born to the unhappy Pagano family. On the surface, a single, linear progression, the chronology of Italy's official history, with the significant moments we are familiar with: the resistance, the economic boom, the Historic Compromise, etc. And yet, the film is not a leftist narrative: it does not try to understand the articulation between historical (collective) events and specific biographies (as does, for example, *French Provincial*). Nor is it interested in the residents of Via Marinella, because they are too removed from or against the current of History. Not that the Pagano family and their friends (Valeria, her daughter Rosa and her new husband, M. Simonetti, the French prostitute Rosaria) live outside of History, just the opposite, but they already have a history, one that is specific to them and that is of the *poor* (in Marxist terms, we would say the "dominated" or "exploited," but that is not exactly the same thing). And ultimately, it doesn't much matter that the men entrust their hopes to communist ideas (better tomorrows, etc.) and the women rely more on "their own powers" (meaning, most often, on their own bodies): they all live their lives according to the steadfast storyline of the poor: *we'll get through it*. And for every one of them, that hope will be trampled.[2] I spoke earlier about "disenchantment": disenchantment is not the deception, rancor, or the lucidity that comes from disillusion. A disenchanted thing is the same as it was before except that it no longer is, it no longer will be as it was: a charm, a

2. "Get through." But there is no escape. The sets are apartments that open onto nothing (even the splendid view of the sea at the Paganos' house is there for no one). The most beautiful of these sets is the red curtain inflated by the wind behind which Rosario stands, and that reveals only a crevice in the wall. To "get through" absolutely is to die. The deaths in *The Kingdom of Naples* (Mama Pagano, Rosa) are recitatives, expanded, affirmative moments, acts. We think in a neighboring problematic (that of compassion for the meek) of Kurosawa and of that scene in *Red Beard* where Mifune demands that the young doctor witness the death of a moribund old man as if it were the most beautiful thing in the world.

certain intensity, a song will be lacking. There is pessimism in Schroeter, but no resentment. What interests him are those situations in which one must have hope in order to live, and where one must continue to live when one no longer hopes. That is why the apparently implacable chronology of the film, the succession of dates in enormous mauve numbers, has something ironic about it, as if it were a challenge to the characters' ability to "follow." There is the time of History and the time of biography, and between the two, sometimes, nothing. Rosa, the young girl who is sold by her mother to a Black American soldier for a sack of flour, will never be the same.[3] For her, no History, barely a biography. When she dies (she dies twice: because she does not want to live, because she lacks the medicine that could save her), it is her mother's turn to go mad. Time also stops for her.

Arrested time freezes faces, resists or instead encourages wrinkles, ghosts the body. There is a non-realistic conception of the body and its transformations in *The Kingdom of Naples* that probably comes from Schroeter's passion for opera. As opposed to Hollywood melodramas in which the art of makeup was used to provide the audience with the *jouissance* of a transformation. With Schroeter, bodies and faces seem subject, not to biological erosion, but to an interior and misunderstood law that suddenly throws them into decrepitude or that preserves them for a long time—too long a time—as shadows, identical to themselves. This is not a reassuring concept; it disturbs, it seduces, it interferes, too (it resists the linear, the narrative, with all its power). It is incomprehensible without the question that is asked at a certain point of every character: what (what disaster, what happiness) are you surviving? The question of disenchantement itself. *The Kingdom of Naples* simultaneously contains characters who don't age (Rosaria, Valeria, Rosa) and those who age gradually (the Pagano father, Massimo). There are also children growing older, which requires a change of actors (one of whom, in the character of Vittoria,

3. A situation recurs throughout the film wherein one person is *deceived* by another. The Pagano children are deceived, one by the Communist ideal (handshake between the young Massimo and M. Simonetti), the other by friendship (handshake between the adolescent Vittoria and the extraordinary character of the factory boss, la Ferrante). In this game, everyone loses, and the deceivers come to a bad end.

is pretty implausible). We see—fetishism requires it—that it is the men who carry the marks of biological aging, while the women, even when destroyed, remain unalterable.[4]

As I said, it's a strange film. And yet, entirely traditional. Except that it involves an *other* tradition, little-known in France and to which Schroeter, even though he is German, belongs: *verismo*. In Italian culture at the end of the 19th century, in literature and opera, *verismo* was the response of the South to the North, an ironic debasement of the official, unifying, self-righteous History imposed by the North and a sort of malicious pleasure taken in describing everything through the lens of an unsparingly detailed determinism. The South, Sicily, Naples are *verismo*'s locations. In Naples, not only is there a dialect and a theater (Dario Fo, etc.), but a sensibility, a way of seeing the world. *The Kingdom of Naples* is simultaneously the *kingdom* and the *reign* of Naples, of space and time, the place where the codes, the genres, the figures are converted into masks, downgraded, strip off, fall away, a bit loosely. The place where noble ideals are thrown on the scrap heap. If Italy since 1945 (the year Schroeter was born) has been the privileged site from which to observe the dreams and fictions of post-war Europe, Naples is, in Italy, the best place to understand the underside of those dreams and the discreet collapse of those fictions. It's a dimension that can only be called (even though the word has been tarnished) *carnivalesque*. And in fact, the film ends with a carnival figure, with Rosaria's death, a dry and obscene image.

(*Cahiers du Cinéma* #307, January 1980)

4. Instead of a family, the film is the story of a group of neighbors. It is more about alliance than kinship. This remains forever uncertain. When examined more closely, it is clear that the most important character is the female midwife-become-prostitute who dies in the final shot of the film: Rosaria. It is she who brings the Pagano children into the world, it is with her that Massimo learns about love and she whom he will find dying at the end. This improbable, frivolous and stubborn character also has a carnivalesque quality: it's death, and death loads the dice. Examining it even more closely, we remember that slightly before the birth of the first child, she pops her head in the window to announce *victoriously* to the men waiting for her below, "non è anchora nato!": he's not born yet!

Philippe Vallois, *We Were One Man* (*Nous étions un seul homme*).

In 1943, on a Lot-et-Garonne farm, a young French brown-haired man (escaped from an asylum) and a young blond German soldier (who has lost his army corps) meet, become friends, fall in love. An intense love, in the forests and in the fields, but a love with no tomorrow: the war and the words, "the end" lay in wait. The film is made up of various elements whose juxtaposition produces nothing. The war as a backdrop remains a backdrop. The gently marginal ideology (we think of Genet, except in Genet it's never gentle) barely escapes sentimentality. Which leaves, curiously, beyond any concern for "being realistic," the film's true subject: a sort of documentary on the efforts of the actors (and the filmmaker) to band together and put on a show for one another about seduction. This aspect of the film discourages, ultimately, any criticism. The film has no other audience than its own actors. That's what the only *character* in the film, the young fiancée, suggests. It is with her gaze, simultaneously indulgent and puzzled, that the spectator is invited to identify. That said, Serge A. has a way of crossing the entire depth of field in great, over-excited strides that is all his own, and Piotr S. a very particular way of being outpaced.

(Cahiers du du cinéma #307, January 1980)

Bertrand Blier, *Buffet Froid*

You come away from *Buffet Froid* thinking that, despite everything, it exists. Despite what? Despite Bertrand Blier's dreadful, desolate, hyper-reactive vision of the world, despite the terrified misogyny, the schoolboy dreams reminiscent of Brassens (think "Les Copains d'abord") where women are either hysterical or vigilantes (remember the terrible *Femmes Fatales*). How does it exist? By a certain kind of audacity that consists of reconnecting with the old tradition of nihilist cabaret. From the café-théâtre of *Going Places* to the little theater of the absurd of *Buffet Froid*. At its best (the very first scene in the metro between Serrault and Dépardieu), there are Beckettian

accents (Serrault's powerful voice, with a knife in his belly, as he discusses his death), the idea being that although it has become easy to kill one another, it has become impossible to get angry with one another. The wager, obviously, is making a large-scale commercial film with such meager fictional material. The story nearly loses steam and is only saved, in extremis, by one-liners. This film (Blier's best) confirms that French cinema becomes endearing (but quickly clingy?) when it thinks of itself as a cinema of shorts, literary, made of sketches, with nothing to develop. In the case of *Buffet Froid*, as rancid as its world view and ideology is, one feels, almost always, a real desire not to film haphazardly, not to put the camera just anywhere, to create an image. The strange rigor and concern of the phobic moralist. Panzer's cinematography, glossy, at times reminds us of Ferrari. And then, the terror that the filmmaker feels when confronted with the promiscuity of bodies, the rage to have to film them (and kill them) affects the film with a shudder that is not just for show. As they say, something *comes through*.

(Cahiers du du cinéma #308, February 1980)

Yasujiro Ozu, *I Was Born, But...* (*Umarete wa mita keredo*)

A family moves into a new neighborhood in the suburbs, dreary and poverty-stricken. The mother stays at home and the father is a low-level office worker. The children—two boys, around ten years old, inseparable and mischievous—are rejected by the other children. Bullied, taunted, beaten up. Terrified, they skip school until the day their father, having found them out, punishes them: from then on he accompanies them every morning to school. One day, while visiting the son of their father's boss, the brothers discover that the boss is an amateur film enthusiast who films his employees and invites them to come and watch the films at his home. The children watch a film in which their father, ordinarily so serious, clowns around to entertain his boss. Shock: the paternal image collapses. Back at home, explanations, then crisis. The father, in desperation, tells them that he earns the money he needs to feed them by working for that boss.

Appalled, the children immediately go on a hunger strike. The next day, starving, they abandon it. Reconciliation? On the way to school and the office, they come across the boss's car stopped at a railway crossing (the neighborhood is criss-crossed by innumerable trains that run in all directions). The father is uncomfortable. The children motion to him that he may go and greet his boss. A gesture of gratitude from the father—who obeys. Finally, now embraced by their classmates, the two brothers begin to play with them and discover that in the absence of wealth, they have their intelligence, which allows them, even by cheating, to win—at least symbolically—at their games.

First off, the film is very funny. The comedy is based on the great Ozuian figure of *repetition* (gestures, looks, behaviors) and on the child-actors' characterizations, rather like McCarey's: miniaturized humans, simultaneously zany and serious, the younger relentlessly imitating the older. The parents already belong to another cinematic age, to the social drama: they are extinct, lifeless. The generation gap repeats itself here as a gap between two cinemas—the burlesque past and the psychological future—between which the Ozu of the end of the silent era necessarily oscillates and which he makes his subject, in the fullest sense. *I Was Born, But…* is already a great film about cinema because it is when they are confronted by an image *on film* of their father (an image filmed by his boss, which doesn't help matters), an image of an unserious father, of a clown-father, a child-father, that they become aware of their social condition (they are not rich) and of their future (they will become their father because he still resembles them). A curious stage, where the cinema plays the role of the mirror. From there, the film, which could have been just another domestic comedy, becomes, without unnecessarily shifting its tone, more serious. The (almost painful) culminating point is reached when the children authorize the father to greet his boss (deferentially). A very powerful moment, of which there are few examples in cinema (except Italian ones: think of the end of *The Bicycle Thief* that Bazin is so fond of, without the pathos). But what does this mean? That the children accept the social order? That Ozu advocates the repugnant acceptance by the oppressed of their oppression? We can't entirely exclude that reading. But it remains too reductive, too "ideological."

If the film, at that precise moment, is touching, it is not because the children have discovered the existence of social classes, but because they glimpse what can only be described as the *social bond*, Ozu's central subject. There is a moment when the children discover in their father an "other themselves," an other child, *comical because dominated*. The social bond exorcises this identity, but never to the point that it makes us forget it completely (by virtue of that banal but true concept that the artist is someone who hasn't managed to sever himself from his childhood). And it matters little what the social bond *seems* to be made of: entirely arbitrary and reversible roles (parents, children), rigorously meaningless ceremonies (marriages, burials), etc. The situation, essentially, is this: *only* children (more or less old, more or less powerful) exist, although no one has ever known what desire (foreclosure of sex in Ozu) or operation (apart from mimesis, multiplication) they are the product of. A completely perverse situation. The film has two titles in translation: *And Yet, We Were Born* and *I Was Born, But…* And yet *what*? But *what*?

(*Cahiers du Cinéma* #311, May 1980)

Jean Girault, *The Miser* (*L'Avare*).

Giddy from the hype that sees him as the perfect Harpagon, Louis de Funès has co-directed a hideous *Miser* with Jean Girault that falls far below aesthetics' minimum wage. Thus he has lost any opportunity he may have had to join the ranks of Cinema History, failed to move past square one, and missed the twenty million franc mark. Bludgeoned, both schoolkids and the masses are shunning this tedious flop. *The Miser* will not break even: there is, then, some kind of justice. For those who would like to draw a lesson from this failure: 1) *The Miser* is not a very good play; Harpagon is the least convincing of Molière's monomaniacs. 2) Filmed with Girault/Funès's approximate sluggishness, its comedic effects become incomprehensible. Finally: if one of commercial cinema's current trajectories is to hitch itself to the great classics (novels, operas, theater…cinéma), one can only be struck (here of course, but also in Gaumont's *Don Giovanni*) by the absolute

lack of ideas that preside over the manufacture of these cultural lasagnas: suddenly, facing actors who sing, scream, recite, the directors no longer know where to place the camera, as if the notion of acoustic space had not yet been discovered. Watching this "filmed cinema," we're a little nostalgic for good old filmed theater.

(*Cahiers du Cinéma* #311, May 1980)

James Ivory, *The Europeans.*

Henry James and James Ivory have this in common: they always ask the same question. Who is barbaric, and who is civilized? The answer is never what we think. From *Shakespeare Wallah* to *The Europeans*, with the very beautiful *Autobiography of a Princess* in-between, Ivory has latched on to characters who, caught in the game of mirrors between metropolis and colonies, old and new worlds, savagery and culture, alienate their desire. Hence a typically novelistic irony, if the novelistic is indeed, as René Girard has said, the story of desire's alienation (see James and also the Thomas Hardy of *Tess of the d'Urbervilles*). In *The Europeans*, Americans raised in Europe arrive in New England to try their luck. Instead of the new world they had imagined, they find themselves confronted with the *revival** of old puritanical Europe. Caught off guard, the coquette (Lee Remick, very beautiful but not very convincing) fails where her younger brother succeeds.

It has been said that the film is at best a television drama, which is not untrue. In fact, it is the first "real" film by Ivory and his producer and partner Ismail Merchant, prestigious enough to represent Great Britain at Cannes (even though Ivory is American), hence watered down enough. Watered down not only in relation to Henry James but to Ivory himself. Hence a certain academicism, too many beautiful landscapes, a "restraint" in the acting that doesn't reflect the violence observed throughout all of James's dialogues, in the codes, the politeness, the good manners. Here, the image distracts from that violence, psychologizes it. One step further and we would find ourselves in the intransitive, in Marguerite Duras's territory. Ivory did not want

to take (could not take?) that step. Thus *The Europeans* is a minor film that makes us want to discover his older films. Still, at two or three moments (Lee Remick's malaise upon her arrival, the old woman's visit) something of James shines through. Which is no small thing.

(*Cahiers du Cinéma* #311, May 1980)

Peter Fleischmann, *The Hamburg Syndrome* (*Die Hamburger Krankheit*).

What makes *The Hamburg Syndrome* unpleasant is that the filmmaker and his screenwriter (Roland Topor) subject the audience to the same passive, stupefied ennui that descends upon the characters in the film. They probably told themselves that said audience, incapable of distancing themselves from the film, incapable of experiencing it shot by shot, would identify in advance with the authors' supposed project (what could they possibly have wanted to say?) and suspend all judgment from there. Blackmail by the author, then. Irritating. Or else, they expected that the gravity of the material (a mysterious illness decimates a population and a police state uses it to strengthen its grip on its rudderless subjects) would prevent anyone from taking them to task. Blackmail by the subject, then. Also irritating.

What also makes *The Hamburg Syndrome* unpleasant is that it gives away the creators' approach. They seem to have no other motivation than to make the film more radically devoid of hope or possibility than any previous film in the genre (a genre that incidentally is fairly outdated, from Camus to Ionesco, Matheson to Romero). Every character who might have become the "hero" of the film (a clear-sighted doctor, a radiant mystic, a young innocent girl) is sacrificed in the script to the authors' concept of their pessimism (which doesn't rise past Arrabal's level—he plays a Buñuelian, sniggering, indestructible invalid). Conformism of the smart aleck, exactly where others (Bergman: *Shame*, Godard: *Weekend*) have shown us real horror in the face of horror.

(*Cahiers du Cinéma* #311, May 1980)

Steven Spielberg, *1941*.

Spielberg's greatest film? His most logical, at any rate, if not his most honest, since its only ambition is to demonstrate the savoir-faire of its author-entrepreneur. Which, when it comes to filming objects, high-powered aircraft and catastrophes, is clear. We know the film's point of departure: in 1941, a Japanese submarine (commanded by Mifune) is spotted off the California coast and causes an inordinate panic. From there, *1941* is an ambitious attempt at a *burlesque blockbuster* whose failure (the film is not *very* funny) is more interesting than Spielberg's previous films. First because burlesque, more than terror (*Jaws*) or science fiction (*Close Encounters*), gives Spielberg's misanthropy (to say nothing of his misogyny) free reign. In *1941*, there's nothing left but objects gone wild and clowns, the funniest of whom is certainly John Belushi, the aviator with the wet cigar. And then because burlesque allows Spielberg to think about cinema, about *his* cinema. Indeed, the film begins with a quotation of the opening scene of *Jaws*, except that in place of the shark that comes to menace (and then mend) the human race (*id est* America), a submarine comes to menace Hollywood (*id est* cinema spectacle).

There's something strange about watching a filmmaker so immediately use his power (Spielberg has only made five films) to quote himself, parody himself, relativize himself. As if, between his *savoir faire* and his lack of "things to say," Spielberg himself signalled an abyss. An abyss that should make us curious about his films to come.

One note in closing about the film's failure. There is a necessary contradiction between burlesque and the blockbuster. Burlesque breaks, wastes, respects nothing. The blockbuster spends a fortune on sets, exactitude, and extras. It's not for nothing that blockbusters, since Griffith or DeMille, have been *inspirational*. They adapt their subjects to their means. You can't ask the audience, with impunity, to witness the construction of a system and the irreverent wreck of it at the same time. You have to choose. You can't, with impunity, cut off your nose to spite your face. (There are other examples of this double bind: *Playtime* or Stanley Kramer's *It's a Mad, Mad, Mad, Mad World.*)

(*Cahiers du Cinéma* #311, May 1980)

Laurent Perrin, *Scopitone*.

The characters in *Scopitone* are old twenty-somethings who do not change in a landscape that does. Around them. Despite them. Post-post-post-leftists play at being squatters, barely romantic parasites. The only light comes from the vitrines of electronic pinball machines. The good thing about *Scopitone* is that it functions as a film that is short, and not as a short film. Which is an entirely different thing. Its shortfalls are as interesting as its bravura moments, its minor cinematic ideas are as seductive as its major, serious themes. Finally, the desire to create *credible* characters is paramount. The film is indeed from 1980. Sauvegrain as a romantic and wizened *could-have-been* is quite good, and Martine Simonet is perfectly marvelous, once again. *Scopitone* "comes out" at the Marais along with two other films (which, sadly, are more beholden to the traditional rule governing shorts: one film, one idea): Pascal Rémy's *La Confesse* and Jean-François Garsi's *Milan bleu*.

(*Cahiers du Cinéma* #311, May 1980)

Paul Schrader, *American Gigolo*.

We have seen a generation of young Turks in France who have laid claim to American cinema. Will there be a generation of young Americans whose films expand upon the shock they felt when they discovered modern European cinema? That quid pro quo is a bit too good to be true, but how do we not mention it in the context of *American Gigolo*, since the film is expressly placed under the sign, if not of the cross, at least of Bresson's *Pickpocket*, from whom Schrader borrows many elements (especially the ending)? Homage, but homage to what, exactly? In 1959, Bresson turned cinema upside-down, not by depicting a spiritual journey (that had already been done) but by taking it seriously cinematically ("how does a young man become a pickpocket?"), which made sense only if the spectator was transformed into a *witness* of that *how*. Needless to say, the public refused to be placed in that position and the film was a

commercial failure. We were witness to a documentary, to the manufacturing of a pickpocket. Nothing was withheld of its technical apprenticeship: the language of hands and the impassivity of the gaze, fragmented bodies and ambiguous touches, etc. A micro-landscape, fantastically spectacular, was suddenly rendered visible. All of this is well-known, and we would be embarrassed to return to it if Schrader didn't seem to rely so heavily on Bressionian references. But not only is *American Gigolo* not as good as *Pickpocket*, not only is it different, it is exactly the thing against which a film like *Pickpocket* could have, at one moment in the history of cinema, been conceptualized, or even directed. In Schrader's film, we witness the emasculation of a theme that is endlessly discussed, rarely shown, and never *inscribed*. Everything takes place within the conventions of the screenplay, and well above the belt. Obviously, a serious *American Gigolo*, "*à la Bresson*," would logically be a "hardcore" porn film, and it is clear that Schrader neither wants to nor can make that film. But how can his spiritualist message (vice as a path towards grace) come through if vice is unfilmable by him? If his relationship to vice is so moralistic? So vicious? How can he be so inconsistent?

That said, Schrader's cinema is what it is (he is a relatively flat filmmaker but he is making steady progress: *American Gigolo* is his best film to date); it represents the return of the old, lurid fictions of twenty years ago for which Preminger remains unrivalled. But what never ceases to amaze us is America's hallucinatory capacity to appropriate everything. Including and especially those things that America ignored. A decidedly limitless capacity to empty out forms of all content.

(*Cahiers du Cinéma* #314, July–August 1980)

Rolf Lyssy, *The Swissmakers* (*Die Schweizermacher*).

This comedy that has so thrilled the Swiss is more of a documentary about the way the Swiss see themselves and the forms in which they agree to be made a laughing-stock. *The Swissmakers* are two special agents who investigate candidates for Swiss naturalization (Why do

they want to become Swiss? It's never explained). One is a relentless, intractable, puritanical and humorless boss. The other, his subordinate, is a sweet, gentle dreamer, secretly nonconformist and a rebel (in the end, he becomes somewhat of a hippie). The thing is, both are creepy, and together they make us Swiss-phobic. All of the slightly harrowing scenes (interrogations of future Swiss citizens: an Italian, a Yugoslavian and a German) are filmed from a most unimaginative and *crude* point of view.

(*Cahiers du Cinéma* #314, July–August 1980)

James Goldstone, *When Time Ran Out.*

Feeble rehash (But isn't a rehash always feeble?) of *The Towering Inferno*, produced by Irwin Allen. Here, it's a volcano that devotes itself to spewing some lava on a four-star hotel that a developer, mad with ambition, has built on a Pacific atoll. Naturally, this developer is the only slightly interesting character in the film (he cheats on his waspy wife with the island's princess), but he dies. Only one good scene: the (very) old Burgess Meredith, recalling his days as a tightrope walker, saves a young girl by making her cross a river of lava on the edge of a rickety bridge. Otherwise, we would like to cry out—along with Marguerite Duras—"May the world be destroyed! [*Que le monde aille à sa perte!*]."

(*Cahiers du Cinéma* #314, July–August 1980)

Walerian Borowczyk, *Lulu.*

How to explain the shameful inanity of this *Lulu* (even while taking into account it's director, Borowczyk's, abdication)? I imagine this: in a Chabrolian orgy, Borowczyk invents a parlor game in which the losers, as punishment, are forced to act out Wedekind's *Lulu.* They clear away the scenery so the actors, tipsy and lewd, don't trip as they "play the scene," which is closer to jogging than actual acting. Of

course, they keep only the moments where fits of giggles haven't overtaken all of the "actors" and no one has forgotten their lines. A nitwit is priceless in the role of the fatale *Lulu* and Doctor Schoen's improvised death is irresistible. Alwa masturbates with audacity while Lulu dances. A guest who doesn't make much of an impression at first makes everyone scream with laughter while playing that old Geschwitz-dyke-who-only-gets-what-she-deserves "à la Sapritch," etc. It all ends in Jack the Ripper's butcher shop and in the final scene—message?—we see Schigolch in poverty-stricken London eating a revolting pudding. All with poor sound quality and music that's closer to *Carmen* revisited by Yvette Horner than to Berg.

I can imagine only one hypothesis that would explain Borowcyk's "reading" of *Lulu*. It is clear that he doesn't want to trouble himself with the myth and that he wants to make *Lulu* into a soft-core *Nana* against an Austro-Hungarian backdrop of decadence and lifestyles. But he is no more Ophuls than Wedekind was Schnitzler, and his sophomoric reading is reductive, nothing more. It is often said that pornographic films are sad, and that is true. But what's sad is their incurable honesty (organs, nothing but organs). As for cultural porno, it is grim.

(*Cahiers du Cinéma* #314, July–August 1980)

Georgiy Daneliya, *Autumn Marathon* (*Osenniy marafon*).

A translator, forty years old, caught between his work, his wife, his mistress, his friend and his neighbor (Potapov from *Bonus*, who here camps up the uninspiring character of a tyrannical drunk). Endowed with a particularly weak ego, he accumulates lies and set-backs (recalling *Once Upon a Time There Was a Singing Blackbird*, without the poetry) and ends up losing everything. Crisis, moment of truth, dry spell, interior exile? Not at all. His world, which seemed to have unraveled, comes together again on foundations even more rotten than before. It is to the film's credit that it doesn't try to save anything from that disenchanted world. Nonetheless, its nihilism leaves a lot to be desired. If History is always-already-told,

if small individual histories are only series of *idées fixes* and jags, if the proclivity towards interior life is simply the result of a housing crisis, we begin to wonder about what the primary recipient of this (Soviet and average) film might glean from this collective tableau in which nothing stands out, and everything is equally bleak and Sov-colorized.

(*Cahiers du Cinéma* #314, July–August 1980)

Stanley Donen, *Saturn 3*.

The most surprising thing about *Saturn 3* is that we can still recognize something of its author/producer, Stanley Donen, in it. He has not made a good film, certainly, but he has not managed to make an entirely impersonal one, either. On a space station, far from Earth and close to Saturn, the aging (but he knows it) Kirk Douglas and the zombie-like (but she doesn't) Farrah Fawcett have concocted a little world "à la Donen" for themselves: close quarters, a hideaway, a parenthesis in a dry and hostile universe (we cannot but think nostalgically, of *Kiss Them For Me?*) But happiness is fleeting. A crazy man (Harvey Keitel) arrives with his robot, who isn't much saner than he is. It all ends rather badly. The spectator never stops asking one single question: Why did Donen, who, obviously, hates the very idea of science fiction, make this film?

(*Cahiers du Cinéma* #314, July–August 1980)

Marco Bellocchio, *Leap Into the Void* (*Salto nel vuoto*).

Despite the congratulatory buzz, then the two prizes at Cannes, the latest Bellocchio is unconvincing. Certainly, the filmmaker's talent remains intact and this *Leap Into the Void* is rich in filmic events big and small, which make it never boring, but rather *fastidious*. Events such as Michel Piccoli's "leap" at the end of the film: light, free, and unexpected, but with exactly that strain of

ostentatious "understatement" that currently seems to be the sign of a cinema that is *threatened by academicism*. My first conclusion was: "Bellocchio, academic auteur of the '80s?" The logical evolution for someone who'd been a rebel in the sixties. One need only witness the trajectory of the original R.R. (Rebellious Radical) figure in his films, whose model is forever Lou Castel in *Fists in the Pocket*, and whose most recent buffoonish spinoff is the character played by Michele Placido in this film: the showman of his own rebellion.

That said, I think that the film's fastidious aspect also comes from somewhere else. Bellocchio's cinema is very close to a neighboring art: animation. His talent has always more or less been to laboriously animate inert material, improbable and uncultured (remember the performance staged by Beneyton in *In the Name of the Father*, just to terrorize an audience of young children). His subject is animation, more precisely American cartoons: heterogeneous beings are nevertheless bound together, condemned to live inseparably. Impossible to unwind. The brother and sister of *Leap Into the Void* may be well-observed, astutely "animated"; they are no more emotionally moving than Tom and Jerry or the Road Runner and Wile E. Coyote. They form a couple whose very indissolubility is source material for gags. Bellocchio's entire mise-en-scène moves in that direction, up to the use of that horrible "Italian" dubbing that is closer to a world of noise than of speech. As it is in animation, the scene is always destroyed and always intact, always resounding and always mute; catastrophe leaves no trace. No trace in the spectator, either, unfortunately.

(*Cahiers du Cinéma* #314, July–August 1980)

William Wiard, *Tom Horn*.

For a good half hour, the film evokes good old-fashioned B movies: same sobriety, same ellipses, same concern for small, realistic details. Unfortunately, the character of Tom Horn (Western-hero-out-of-touch-with-the-modern-world) isn't very interesting, and McQueen's performance, more constipated than it is hieratic, doesn't help. False

advertising leads us to expect an apocalyptic ending. There isn't one. Tom Horn is unjustly accused, condemned, sacrificed to the modern world, and hung. What's more, he knows it, and emboldened by that knowledge, he casts over everyone (including the spectator) a look of contempt disguised as modesty.

(*Cahiers du Cinéma* #314, July–August 1980)

Paul Aaron, *A Different Story* (*Un couple très particulier*).

As *L'Officiel des spectacles* more or less put it: "A homosexual and a lesbian see their destinies meet." He has blue eyes (and cooks) and she has green eyes (and is a little frumpy). Their common destiny is to discover the charms of normalcy, then sink into it body and soul. At the end of the film (she cooks and he has a mustache), they have become so uninteresting that the film's authors, as if seized with remorse, rush the ending. This Operation Astra on the back of a vapid permissiveness leaves us entirely Californiphobic.

(*Cahiers du Cinéma* #314, July–August 1980)

William Friedkin, *Cruising*.

Here we had material for a salacious comedy, à la Billy Wilder. Judge for yourselves: in New York, leading an investigation into the S/M world, a detective passes as homosexual, dresses in leather, goes cruising in bars, gets seedy and a bit crazy and goes down the path towards an act from which he is repeatedly rescued by the screenplay. A Zorro-screenplay. Al Pacino, astray in this faux *gay hardcore*, goes to a lot of trouble for nothing. Friedkin, burned by the gay furor that disrupted the shooting of the film, seems to play this card: "I'm showing it but I'm not judging or condemning it: listen, I get it." Friedkin is very cool. Problem is, he doesn't show it. Not really. His well-intentioned and vaguely sociological tolerance doesn't go very far because his subject (scandalous as it is) interests

him not cinematically but *ideologically* (a little like Schrader, another specialist in fraudulent descents into hell). One last thing: *Cruisin'* does not mean *La Chasse* (that would be *Huntin'*) but *La Drague.* That says it all.

(*Cahiers du Cinéma* #317, November 1980)

Ingmar Bergman, *From the Life of the Marionettes.* (*Aus dem Leben der Marionetten*).

This is an important film and we will return to it. It belongs to the theoretical, *thankless* vein of Bergman's work (*Winter Light, The Rite*). It concerns an investigation (but led by whom?) surrounding a sexual crime. How does a young, bourgeois man who has "every reason to be happy" become something like Jack the Ripper? The event is explained by its consequences as much as its causes, by what follows it as much as what precedes it. But "causes," "consequences" mean nothing in this world in which, once again, Bergman revolves around his major obsession, his cinema's "black hole": the irreducibility of the present moment. In this investigation led by no one, in these pages torn from the book of Satan (Hell is not other people, it's facts, fodder for the doctor or policeman, the illusion of a *hic et nunc*), we try in vain to grasp the present. The murderer, walled up in his prison, escapes everyone, escapes himself. The present is what has been put out of reach and, consequently, endures. The rest is suffering, including suffering for the spectator, whom the film does not spare. Bergman has always made his spectator *travel* between two limit-positions: the voyeur (for whom everything is a spectacle) and the doctor (for whom everything is a symptom). But, the symptom leads to endless interpretation and the spectacle is reabsorbed in bottom-less consumption. Bergman has been a modern filmmaker (a great symptomologist) and has remained an old filmmaker (the director of a "little theater"). Things got complicated when it became clear that *they amounted to the same thing*: a face in which everything is a symp-tom becomes a scene in a play and the excess of dialogue, irony, and scenes of married life becomes a symptom. Greater peace for the

spectator who has simultaneously become the "subject supposed to know" [*sujet supposé savoir*] and the ultimate beneficiary of the marionettes' performance.

(*Cahiers du Cinéma* #317, November 1980)

Claude Zidi, *Inspector Blunder* (*Inspector la bavure*).

Axiom: Coluche is a great *cinematic* comedian. What is a great comedian? Primarily someone who doesn't square with the cinema as it is typically produced, a foreign body, a challenge, a treasure trove of new scenarios. One of two things: he either invents or inspires a cinema that suits him, or he bends the genres that are already in place. In the past, a great comedian was also a great director, or else he had a fantastic alliance with one (McCarey with Laurel and Hardy and even Peter Sellers with Blake Edwards). In France (except for Tati), there have been great comedians whose cinematic careers were null and void (Fernand Reynaud, Raymond Devos). It's a shame. Because it's a waste. The waste of a waste (because comedy is also the best way to waste).

Coluche has such a strong onscreen presence (like all actors who come from cabaret) that we are not bored by *Inspector Blunder,* and of course we laugh at it. And yet, although it is not a terrible film, it is a weak one.

A great comedian can be great in a minor film, unforgettable in a flop. The comic actor even represents a cinematic limit: up to a certain point, he is as he is, to take or leave, unchangeable, indifferent to cinema's magic. And the spectator-masses who make him a success understand this very well, have always known it. It's the most decisive blow against an auteur theory.

That said, must we love *Inspector Blunder* because of it? Must we, to everyone's surprise, defend it? No. Because the film keeps none of its promises, because its material is deceptively caustic, because Depardieu goes to a lot of trouble for very little reward, because by being so loaded, Dominique Lavanant's character is not funny, because Zidi's filming is adequate but flat, and finally because the

screenplay is seriously weak. At one point, when the blunder has been discovered and exposed, it seems as if the film were on the verge of something: we do not know what Coluche understands about what is happening to him. This confusion could have been productive (as it is with that other figure obsessed with blundering: Clouseau/Sellers), but sadly, it is only an unacceptable flutter in the script, an unintentional slackening. The authors tried to conclude a caustic film with a boy-scout ending in which Coluche, as in Fernandel or Rellys's old films, turns out to be a bogus village idiot and an actual hustler. Miserable.

Which leaves us to dream of a Coluche whom cinema takes seriously.

(*Cahiers du Cinéma* #319, January 1981)

Gérald Calderon, *The Risk of Living* (*Le risque de vivre*).

This film fits within a tradition that it doesn't really try to reinvent: the wildlife film. That tradition requires that the amoeba be filmed only within the frame of an obligatory script that leads, as we all know, to the great apes and the *homo sapiens*, simultaneously the conclusion of evolution (its *happy ending*) and the spectator of the film (its target). It's too bad for the amoeba (or the paramecium or the kangaroo, to say nothing of the giant flying fox), for they are only ever understood through difference, or through their responses to common biological imperatives (predation, reproduction). In that tradition, only animals *plural* may be filmed, in single file, in no particular order (any order is good), a little like how it is done (unabashedly) in television. Calderon follows a battle between manic ants and blind termites with a flight of frigate birds vying for a fish. It works, but we start dreaming of what, for once, the study of a single species' behavior could be: we could then separate what approaches human behavior from what has nothing to do with it. We could leave behind the "narcissism of minor differences," we could make ethnological progress. That would be nice. Sometimes, when *The Risk of Living* notes in passing that nature, far from being

rational and functional, includes aberrations or inexplicable compli-
cations, a fictional element restores value to the images: the coupling
of a spider with a male three hundred times smaller than she, or the
tiny bird who constructs a giant nest sparks our imagination (while
the predatory tricks of antlion larvae vaguely terrify us). Similarly, the
notion that marsupials only survived in Australia because the conti-
nent's isolation protected them from the attacks of better-adapted
animals introduces contingency and historical data that makes the
image of these pathetic arboreal kangaroos suddenly endearing. At
moments such as these, we escape the heavy teleology that is the
mark of the genre. That said, *The Risk of Living* is visually a magnifi-
cent film. The cinematography is so sophisticated that one might
forget everything above, and surrender to the spectacle of a prodi-
gious repertoire of forms, of an abstract bestiary that goes nowhere.

(*Cahiers du Cinéma* #319, January 1981)

THE MONSTER IS AFRAID

David Lynch, *The Elephant Man.*

It's the Monster Who Is Afraid.
This film is strange in so many ways. Beginning with what David
Lynch does with *fear*. That of the spectator (ours) and that of his
characters, including John Merrick (the elephant-man). In this way
the first section of the film, up until the move to the hospital,
operates a little like a trap. The spectator becomes accustomed to the
idea that he must sooner or later endure the unendurable and look
the monster in the face. A coarse burlap sack, pierced with a single
eyehole is all that separates him from the horror he suspects. The
spectator entered the film, following Treves, through voyeurism. He
paid (just like Treves) to see a *freak*: this elephant-man alternately
exhibited and prohibited, rescued and beaten, glimpsed in a cellar,
"presented" to savants, taken in and hidden at the Royal Hospital of
London. And when the spectator finally does see him, he is all the
more disappointed that Lynch then pretends to play the classic

horror film game: night, deserted hospital corridors, the witching hour, the rapid flight of clouds beneath a leaden sky and suddenly a shot of John Merrick bolt upright in bed, in the throes of a nightmare. He sees him—truly—for the first time, but he also sees that this monster who is supposed to terrify him is himself terrified. It's at that moment that Lynch liberates his spectator from the trap that he initially set (the trap of "more-to-see"), as if he were saying, "it's not you who matters, it's the elephant-man; it's not your fear that interests me, it's his; it's not your fear of being afraid that I want to manipulate, it's his fear of inspiring fear, the fear he has of seeing himself in the other's eyes." Vertigo switches sides.

The Psalm Is a Mirror

The Elephant Man is a series of dramatic turns, some funny (the princess's visit to the hospital, as a "dea ex machina"), others more troubling. We never know how a scene might end. When Treves wants to convince Carr Gomm, the director of the hospital (played magnificently by John Gielgud), that John Merrick is not incurable, he asks Merrick to memorize and recite the beginning of a psalm: barely have the two doctors left the room when they hear Merrick recite the *end* of the psalm. Shock, dramatic turn: this man that Treves himself believed to be a cretin knows the Bible by heart. Later, when Treves introduces him to his wife, Merrick continues to surprise them by showing them a portrait of his own mother (who is very beautiful) and by being first to extend a handkerchief to Treves's wife, who has suddenly burst into tears. There is a lot of comedy in the way that the elephant man is inscribed as the one who always *completes* the tableau he is a part of, signs it. It is also a very literal way, not at all psychological, of moving the story forward: by leaps and bounds, by a signifying logic. That is how John Merrick finds his place within the portrait of (high) English society, Victorian and puritan, for which he becomes a sort of touristic *must*. He is something that society needs, something without which it is incomplete. But what exactly? The end of the psalm, the portrait, the handkerchief, what are they, ultimately? As the film progresses, it becomes increasingly clear that for those surrounding him, the elephant-man is a *mirror*: they see him less and less, but they see themselves more and more in his eyes.

The Three Gazes

Throughout the film, John Merrick is the object of three gazes. Three gazes, three cinematic eras: burlesque, modern, classical. Or: the carnival, the hospital, the theater. There is first the gaze from the bottom, of the lower classes and Lynch's gaze (hard, precise, abrasive) upon that gaze. There are bits of carnival, in the scene where Merrick is made drunk and is kidnapped. In the carnivalesque, there is no human essence to embody (even in monster form), there is a *body* to laugh at. Next there is the modern gaze, the gaze of the fascinated doctor, Treves (Anthony Hopkins, remarkable): respect for the other and bad conscience, morbid eroticism and epistemophilia. By caring for the elephant-man, Treves saves himself: it's the fight of the humanist (à la Kurosawa). Lastly, there is a third gaze. The more well-known and celebrated the elephant-man becomes, the more time those who visit him have to make a *mask* for themselves, a mask of politeness that conceals what they feel at the sight of him. They go to see John Merrick to test this mask: if they show their fear, they will see its reflection in Merrick's eyes. That is how the elephant-man is their mirror: not a mirror in which they can see, recognize themselves, but a mirror to learn how to perform, to dissimulate, to lie even more. At the beginning of the film, there was the abject promiscuity between the freak and the showman (Bytes), then there was the silent, ecstatic horror of Treves in the cellar. At the end, it's Mrs. Kendal, star of the London theater, who *decides*, while reading the newspaper, to become the elephant-man's friend. In an unnerving scene, Anne Bancroft, guest-star, wins the bet: nary a muscle in her face trembles when she is introduced to Merrick, whom she speaks to as if he were an old friend, going even so far as to kiss him. The circle is complete; Merrick can die and the film can end. On the one hand, the social mask is entirely reconstructed; on the other, Merrick has finally seen in the other's gaze something entirely different than the reflection of the disgust he inspires. What? He cannot say. He takes the height of artifice as truth and, of course, he is not wrong, considering we are at the theater.

For the elephant-man nourishes two dreams: to sleep on his back and to go to the theater. He will realize both on the same night, just before he dies. The end of the film is very moving. At the theater,

when Merrick stands up in his loge so the people who are applauding him can see him more clearly, we don't really know what's in their eyes any longer, we no longer know what they see. And so Lynch has managed to redeem *one by the other*, dialectically, the monster and society. But only at the theater, only for one night. There will be no other performance.

<p align="right">(*Cahiers du Cinéma* #322, April 1981)</p>

THE OUTSTANDING FILMS OF THE DECADE (1970–1980)

Tristana, Dodes'ka-den, Parade.
Here and Elsewhere, Milestones, Einleitung.
Kings of the Road, Boy, Entire Days in the Trees.
Salò.
Six fois deux, Hitler: A Film from Germany, La région Centrale
(Michael Snow).

1. Let us succumb to the infantile pleasure of lists. And we immediately realize: the sixties and seventies were rich, adventurous, generous. And not only in film. For fifteen films from the impoverished seventies, there were fifty from the vibrant sixties. Have movies gotten worse? The word is spreading.

2. N.B. *Scripta manent, filma incubent*. Films only exist in our memory. We must distinguish between: those that are declared important and are quickly forgotten, those that we thought they didn't like precisely because we liked them, those that make their way silently, unnoticed, those that are thought of tenderly (like people are), those that we liked because we like the people that like them (and vice versa), those that we almost missed, those that we begin to suspect we missed, etc.

3. Twelve films plus one, still unclassifiable, P.P.P.'s *Salò*. Three films times four. A semblance of logic.

4. First off, three films at the end of well-rounded careers, films by "major filmmakers" without anything testamentary or academic about them. Films by free men—who play. Buñuel plays with the

logic of the story, Kurosawa with the interweaving of stories, Tati with the dissolution of the story subject to the video-effect.

5. Three political, leftist films (radical and puritannical), from a decade that hasn't stopped burying its bodies and that has seen it all. Three films that question cinema's political effects. Propaganda (Godard), militancy (Kramer), engagement (Straub). At *Cahiers*, these films were often travel companions, or even something saved for a rainy day (although an Arabic proverb says that even if you put something away for a rainy day, you still need an umbrella to enjoy it …)

6. Three nostalgic films, looking backwards, the gaze turned towards the road travelled, the lost childhood—our own, that of cinema. Three films about space, frontiers, lost territories: empires (Ōshima, Wenders), colonies (Duras, Creole filmmaker).

7. Three previews, three "flashes" of tomorrow, of what our relationship to filmed bodies might become in the postmodern era (multiplication of media and forms). That body, seen too closely (Godard, again), rigged (Syberberg), vanished (Snow).

(Jumbled) Comments

8. All of these films come from five or six countries. No new "national" cinemas in sight. The hero of the sixties (the array of impoverished countries dubbed the "third world") is stagnant in the seventies. Unequal exchange: poor countries are also lacking in images of themselves.

9. Almost all of these films have had a difficult, marginal, sometimes paradoxical production history. That would not have been the case ten years ago (a film as challenging as *The Eclipse* was normally produced). We are witnesses to the *erosion* of the cinema-machine, to the headlong rush of the industry (where the industry still exists), to the disappearance of the series (A, B, C, etc.) Consequence: a cinema comprised of untracked prototypes, of non-renewable "hits": a frame in which no experience (or even "business") can accumulate.

10. *Late seventies* event: the discovery of Ozu (who died in 1963). We seem to understand something of Ozu, but the cinema machine that allowed an Ozu to work for forty years with the same motifs, as a painter does, with a popular audience, is *behind* us. Duly noted.

11. The crisis of cinema, (also) the sixties' leitmotiv, is nothing other than the crisis of the industry. The function of modern cinema (from Rossellini to Godard, from Bresson to Resnais) was to challenge—from the inside—a classical model assumed to be in good health. Today, arising from all sides, a plaintive and embittered, nostalgic and vengeful cry: what have we done to our plaything? Have we not broken it? And accusing the Nouvelle Vague of having murdered cinema...

12. Will the cinema-machine reproduce itself from above or below? Born at the bottom of the social ladder, the cinema raised itself up: it became bourgeois. Film became a cultural asset designed to circulate (the establishment of a mass cultural industry and network was the major event of the decade) and to be evaluated. Consequence: the framing of films by discourses and the alignment of those discourses with what dominates them: advertising; the inadequacy of outdated, specialized reviews (including *Cahiers*) that no longer know how to perform a job for which it seems there is no longer any use (to gamble, evaluate, make a determination). The very image of this critical crisis: the slew of stars and the few negative reviews each week in *Pariscope*.

13. American vitality. The machine knew to reproduce itself from below, via television and Z movies (don't forget: Coppola got his start working for Corman) and from above (via hyperspectacle and technology).

14. In France, this was the decade of funding based on projected ticket sales + Gaumont. Decline of the very idea of "production." One wants to save cinema "from the top," through prestige, culture, auteurs. Mistake: that yields the weak *Don Giovanni*. Pyrrhic victory of the old "*auteur theory*" of the yellow *Cahiers*: a myriad of young filmmakers—although increasingly less young—who only have their "auteur" status, more or less propped up, to take comfort in. Television doesn't seem to have played its role in the reproduction of the machine. No "filmmaker factory," no collective movement.

15. End of the seventies: cinema buffs predominantly recognize themselves in Woody Allen's *Manhattan*. A young, urban, educated audience that suddenly agrees to recognize itself onscreen. Sociologic logic, the cinephile becomes a possible comedic type.

16. The films in *Nouvelles litteraires'* standard list are not bad: they recognize a certain gentrification of taste. In the elimination of irritating films, the *Positif* taste wins out.

17. For the first time, cinema approaches a decade without discourse, without strategy, without prophetic flights. We would be wrong to take this tepidness for wisdom. Filmmakers have always had (more or less crazy) ideas about cinema and its future, about the transformation of its forms, etc.

18. Today, the voices of those who continue to think that the cinema is "the art of our time" are growing increasingly faint.

<div align="right">

(*Cahiers du Cinéma* #308, February 1980)

</div>

PART TWO

AUTEUR THEORY

DONSKOY RETROSPECTIVE

Marc Donskoy's cinema—as it has been revealed to us by the tribute that the Cinématheque Française devoted to him—strikes us by its singular love of life. Its somewhat emotional tenderness, its attachment towards everything living, its fondness for children: all things that barely deviate from the clichés of Soviet cinema, and Donskoy would be nothing to us if, for him as for the greats, cruelty were not the condition of that tenderness, suffocation not the lot of life and tragedy the requirement for happiness, even if it means paying with life itself.

Because he believes in the final blossoming of life, Donskoy focuses on everything that bridles and smothers it. Existence, febrile and precarious, forever threatened, captured in the uncomprehending faces of children, leads us closer to Griffith than it does to other Russian filmmakers. There is a desire to portray this blossoming through everything that upsets or delays it—and, thereby, everything that gives it weight: political pressure (*Mother*, 1955), the description of a stifling (the trilogy based on Gorky, 1938–39) and condemned (*Foma Gordeyev*, 1959) world, the chronicle of a martyred village (*Rainbow*, 1943), and even the tragic legend of divided lovers, when the injustice of man joins that of fate (*The Horse that Cried*, 1958). One common theme throughout the films, and the filmmaker's major preoccupation: only when things are lost or yet to be gained do they truly exist: thus, happiness.

A similar intention presides over form. If constraint is the only thing that gives blossoming value, discontinuity will be equilibrium's

only promise. Hence an art whose modernity is striking: founded on oppositions, tonal ruptures, complex constructions that could easily be described in musical terms. The filmmaker goes so far as to puncture his films with interior rhymes, camera movements, responding to no other necessity than of establishing a network of entirely musical correspondences (*Mother*). An art whose culmination, past breakages and discordances, is a note, a melody, in every instance an outburst: life's final triumph: the ultimate ride in *How the Steel Was Tempered* (1942), the rain of leaflets in *Mother*, the liberating battle that closes *The Rainbow*.

The fact that these tendencies sometimes turn against Donskoy, that, in his lesser films, suffocation leads to ennui, does not detract from his achievement, but only proves that with him, as with every inspired filmmaker, beauty always seems to be awarded as an "extra," independent of formulas.

Thus it is between elegy and cruelty, between *The Horse that Cried* and *The Rainbow*, that we should position Marc Donskoy, if it is true, according to his own words, that we must know how to hate to be able to love.

(*Cahiers du Cinéma* #154, April 1964).

ALLAN DWAN

Discreet to the point of going forever unnoticed, endlessly equated with what he thoroughly is not, Allan Dwan is neither the last survivor of the great era of the Triangle (the author of the famous *Robin Hood* with Douglas Fairbanks) nor the indefatigable drudge, the very symbol of "B-movie" directors. Or rather, he is more than that. Throughout an extensive (and inconsistent) output of films that are low-budget, performed by third-rate actors, marked by a lack of means, something emerges that must be called by its name : a certain outlook [*un certain regard*] on the world.

Modesty and patience are its qualities: an accursed filmmaker, Dwan makes malediction the subject of his films. A strange malediction whereby no one is ever judged according to their motives.

We routinely recognize Dwan as one of the traditional representatives of the adventure film; and yet, it's the point at which adventure becomes diluted and wasted where his films become valuable. The point, also, at which the filmmaker suspends plot progression and substitutes for it interminable digressions. Dwan's films are made from these digressions, these parentheses: a film that begins with a violent scene becomes, ten minutes later, a familial melodrama or a light comedy. We had misjudged Dwan: if we forget the thread of the plot (or rather, if they're so barely concealed), it's to better uncover the threads of the plot, the real one, the one that forms within the intimacy of beings.

A secret art, Dwan's art would be so by its modesty alone, by its refusal of exhibitionism, even if the heroes did not claim for themselves that same desire to stay silent, that same concern for safeguarding—at the very heart of violence—the intimacy of personal dramas. Demand for a modesty where misunderstandings weigh more than indiscretions, where miscomprehension is favored over the display of sentiment.

The real problem arises, then, not in the twists and turns of the plot but every time the heroes' intimate lives are threatened. Each lives with his secret, the thing that belongs solely to him and from which he draws the gravity of his words and actions. Losing this secret is a bit like losing his reason for living, his justification in the world. Hence the relentlessness to preserve it. To prevent his friend from marrying a tramp, John Payne is ready, in *Tennessee's Partner*, to take the greatest risks, to sacrifice everything, even that friendship. In *Surrender*, in a similar situation, there is a permanent divide between the hero and the sheriff who pursues him: at no moment does the sheriff understand the other's true motives, even when he kills him at the end of the film. And again, in *Slightly Scarlet's* friendship between two redheads, Rhonda Fleming stops at nothing to keep her sister's past a secret. Personal vendettas are pursued to the bitter end (*Cattle Queen of Montana*) and, in *Sweethearts on Parade*, what is for others only a simple meeting is for the hero an emotional reunion. And so, always, actions will be misinterpreted, their deeper reasons left unfathomable, but for Dwan, it's that secret, that possibility of intimacy that matters the most.

And so, beyond the inevitable misunderstandings, the final scenes of *Tennessee's Partner*—our author's masterpiece—best reflect that recovered complicity, that secret that is finally shared, definitively refused to others. The movement of Dwan's films is thus: to compel his characters who are too shut down, too vulnerable, to slowly open up. Each film then is, to some extent, a story of a secret and its elimination, somewhat; either you guard it to the grave, or you share it with others.

A simple relationship is established between creator and creations; the latter would like to rush ahead, cross the screen without looking around themselves: a gunfighter has no time to lose, but a filmmaker has all the time in the world. *The Restless Breed* is exemplary in this regard, another story of a secret vendetta. From the moment Scott Brady decides to avenge his father, the filmmaker strives to put in his path anything that might delay or distract him: a priest, a dancer, an old sheriff who begs him to let justice run its course.

Therefore, the digressions, the lost time, the jumps in tone are no longer the caprice of an undisciplined filmmaker but the test by which the importance of his secrets is measured. The shortest path between two points is no longer a straight line; meandering is what's necessary; the film becomes a long detour between the offense and the reparation. With every new encounter, the filmmaker seems to forget his film and the characters their projects: in this vast "hollow," anything can happen, and chance becomes the accomplice of the filmmaker who serves and is served by it.

Which explains how Dwan, able to use anything and everything, makes the most of a lack of means: conversely, it is unclear if, were he to make a blockbuster, he would preserve that part of invention that he needs.

An accessible cinema where the unexpected always occurs, where everything is a motif to explore. Discoveries the simplest of which is this: time is the most precious commodity; you need to lose a lot of it to understand its value. No wonder, then, that Dwan, doyen of adventure films, is also the one who distrusts them the most.

(*Dictionnaire du cinéma*, Éditions universitaires, 1966)

JOHN FORD

Sometimes a work only exists to conjure the always-hidden peril on which it is based. A peril that is also a privilege: the gulf from which every great work is constructed. A peril whose initial power and intensity the finished work is bound to conserve: the risk that is exorcised as it takes form, but that is also described by that form.

To speak of fragility, of risk apropos of Ford, seems inappropriate. What has struck us thus far is instead its power, its vitality, its lack of complexes: here, it seems, is an oeuvre that, above all, asserts and substantiates. From what secret drama, what flaw, could it originate? But that would raise the question of whether a work that does not touch upon the tragic could be vital to us today... In cinema, as it is elsewhere, there can be no great oeuvre without great danger.

In fact, a slightly detached admiration, a slightly self-conscious respect has made Ford a strangely misunderstood filmmaker. Nevertheless, a recent retrospective organized by the Cinémathèque Française that uncovered old masterpieces (*Wagonmaster*) and crowning achievements (*Cheyenne Autumn*) has made 1964 John Ford's year. Now that we have been persuaded that he is even greater than his legend, we must seek out the John Ford beyond the myth, with fewer precautions and greater passion. Ford cannot be reduced to a certain Golden Age of adventure films any more than Hawks or Walsh can. And while his subject is adventure, it is primarily the kind of adventure that exists in every work, in every creation, closer to us today than it ever was. Likely because it is the fate of the classics that they must evolve, propelled by the excesses of their own logic, into the most modern art.

If John Ford's oeuvre strikes us by its determination to leave nothing ambiguous, it is because ambiguity is its foundation, because indeterminacy is precisely what supports it. Facing the fluctuations of the real, Ford tried from film to film to maintain the existence of a group, a privileged and coherent milieu: an ensemble that could, at best, become a microcosm in which everything signifies and where nothing is lost (*Stagecoach* being its most obvious illustration). Ford is only at ease when he is bringing to life a group whose existence represents, at the heart of the most unbridled adventures, the assurance of a stability worth preserving.

The Western and the war film consequently become favored genres: from *Submarine Patrol* to *They Were Expendable*, with *Drums Along the Mohawk* in between, the purpose is always the same: a handful of men thrown into dramatic adventures. And yet, the real drama is somewhere else: when the risk of a schism at the interior of the group threatens to destroy its harmony. One example, one of the most beautiful among many: the family scattered and divided by the war in *The World Moves On*.

From there on, the wish to create a coherent and particular world—particular, hence coherent—led Ford to shoot elsewhere: Ireland. Then, the desire to feel connected led him to create connections, to forge new ones. Like John Wayne in *The Quiet Man*, Ford knew very little about Ireland, and drew from it only its most superficial aspects. Which we would be wrong to reproach him for: far from trying to understand Ireland as it is, Ford found enough material in folklore to reconstruct a unique and irreplaceable world. What does authenticity matter when it is about constructing *his* world, the one claimed by him? Against the anonymity of people and things, brazen folklore is still the best antidote.

But slightly further off, more threatening than this anonymity, lies a realm that has yet to be either deciphered or acknowledged, everything that cannot be grasped at first glance: *the realm of the stranger*. Nowhere else, with no other filmmaker, are the theme and concept of the Encounter better embodied than with Ford. In those films where characters and relationships barely evolve, where the twists and turns of the plot are easily predictable, the only real adventure exists entirely in encounters or discoveries where everything—hate or friendship, war or peace—plays out and commits itself in the space of a moment and the time of a glance. Remember *Wagonmaster*, where encounters are the only things that can happen to the Mormons in their pursuit of land. Similarly, in the recent, beautiful and very Fordian *Young Cassidy*, a man's life consists of a series of decisive encounters. Ultimately, every encounter is primarily a reunion (happy ones, in *Four Men and a Prayer*), and *The World Moves On* must be seen as one of the author's most outstanding films, in which two characters complete a love story that their ancestors began two decades earlier.

That, then, is a more intimate adventure, but one that also understands its seriousness and risks. For what remains unknown cannot remain so without threatening that familiar nucleus that Ford ceaselessly describes and defends. We see him systematically side with minorities, from the Irish in *The Rising of the Moon* to the Indians of *Cheyenne Autumn*, with the pioneers of *Drums Along the Mohawk* inbetween. It's the only logic that can reflect a political and social philosophy about which much has been said without understanding its reason, which is of a purely sentimental and poetic order. Ford will always be on the side of *minorities who organize*, simultaneously a defender of order and a *cop-hater**. What then will the relationship of a minority be to the stranger who surrounds him? To make him familiar by accepting, assimilating, or even annexing him.

Between hospitality and conquest, the oeuvre's first movement takes shape, a full-scale opening to the world. But this is a conquering opennness; hospitality sets a trap in which the stranger eventually allows himself to become domesticated, becoming in turn familiar thus inoffensive. Hence the itinerant actors of *Wagonmaster*, whose oddities, once they are recognized and familiar, eventually complement their hosts'. With this last film, the auteur's most beautiful in our view, the Fordian adventure and what it teaches us emerges: a movement that is alternately forward and backward, alternately open and closed, it presents Man and the Stranger, each fascinated by the other, their encounters, combat or confusion.

Throughout the encounters, these annexations always respect the particularities of the stranger: they are still the most non-threatening way to make him identifiable, to remove him from the realm of the indeterminate. The Fordian universe is one of "distinguishing marks." But in this recognition that only sustains the gaze and engages in habit, there is no real and intimate understanding—for that would then lead to other uncertainties of analysis and introspection. What the characters draw from each other, what Ford demands of his actors, is the assurance of an invariable and familiar presence established by certain, heavily drawn traits (the importance, in Ford, of mascot-actors: Ward Bond, Carradine...)

This slight distortion of vision, intended to render things simultaneously familiar and unique, through their own singularity, is

demonstrated by the way in which the actors are meant to be understood: not through what they have in common, but on the contrary, through what is irreconcilable between them. Hence an inclination toward caricature because of the way, even falsely, it irremediably distinguishes them from each other; a new strategy to fight against anonymity and protect against the meanderings and incertitude of psychology. And even when folklore mingles with the stylization of caricature, we reach, with *The Rising of the Moon*, stylization's outermost point.

This stylization reveals the other side of the coin: instead of opening to the world so that it may better absorb it, the group, the minority, cuts itself off from the world in order to better live on its own. Between these two temptations (one of autarchy, the other of incessant exchange) Ford's cinema unfolds, and not without tragedy.

On the one hand, the desire to neutralize the unknown by assimilating it carries risk. The risk, among others, of depleting the unknown and becoming, as such, an integral whole that can no longer define itself. That self-definition, that proof, is accorded only to minorities and always in relation to a more fluid and less unified majority; the minority that sets off to conquer the world sooner or later finds itself obliged to redefine itself. In order for the minority to preserve its identity, the thing that makes it unique, it must sooner or later bring an end to its expansion, close itself off to the outside, fall back on its knowledge. That is to a certain degree the lesson of *Wagonmaster*, which consistently asks if the new can be welcomed without demolishing what has just been constructed. The real subject of the film is not really whether or not the Mormons will reach their destination, but rather the limits beyond which hospitality changes character and becomes the risk of intrusion, when the gaze is overwhelmed by the thing that it gazes upon.

But conversely, while the group cannot open up too much lest it lose itself in the indefinite totality, it runs, by closing itself off, a risk that is equally great. Attached to the frameworks that protect it from accident, tense and reactionary, trapped by stagnation, immobility and complacent mediocrity, lacking direct contact with the real, seeking to preserve stability inside a specious movement. And so, the Fordian world oscillates: if too open, it is invaded, if too closed, it languishes. Its domain is therefore one of exchange.

Being defined by those two risks is really the oeuvre's drama, the thing that simultaneously threatens and enables it. And as it progresses, it confronts a reappraisal of itself, not without a secret grief. It's something more than the adversities of the group and its collective misfortunes, it's this, which is more serious: the ties become loose and the group falls apart, corroded from the inside. From *Stagecoach* to *Cheyenne Autumn* with *The Searchers* inbetween, we have the questioning of a world.

It is as if the Fordian universe had lost the power to guard against its infiltrations as much as its leaks—and isn't that interpenetration the deeper subject of *The Man Who Shot Liberty Valance*? The vision of a world whose very integrity is threatened has inspired Ford's most beautiful films, the most devastating of which is undoubtedly *The Searchers*. In that film, an aging community of pioneers, by searching for one of its missing, abducted members, attempts to safeguard its unity; an exemplary scenario that Ford will return to five years later, but this time without hope: if the desert prisoner is finally found, reintegrated into his world, there will be nothing left to attach the young Comanche of *Two Rode Together* to the community that was once his own. From then on, Ford's intent will no longer be to elaborate a balanced world in the abstract, but to observe its erosion, its dispersion.

This is above all the fear of no longer recognizing things, of no longer being able to name them—because ultimately, for Ford, creation is only that unique and decisive gesture—giving things a name—of watching people grow old, of no longer feeling attached. Nothing can keep the John Wayne of *The Searchers* from leading, far from home, a solitary and adventurous existence. And what Ford discovers simultaneously with individual adventure (which will be the lesson of *Cheyenne Autumn*, the final lifeline, if communities founder) is precisely that entirely new solitude, evidenced by *The Searchers'* final, all-black shot. And the prolongation of that shot will be sought in a film such as *The Wings of Eagles*: everything that was once familiar suddenly becomes terrifying because it is unnameable, unknown. Everything that was once obvious is reappraised, everything must be relearned, down to the smallest gesture. A world that had considered itself solid and autonomous returns to being a game of chance; a filmmaker and his heroes consider their past: the work becomes reflexive.

Hence the retrospective character of the final films that seems only to exist via some resurgence of the past. A universe that disintegrates, losing its independence and becoming legend as its heroes disappear, from Frank Skeffington of *The Last Hurrah* to Tom Doniphon of *The Man Who Shot Liberty Valance*, but also the Indians of *Cheyenne Autumn*. Behind the scenes, life reveals itself, but as suddenly useless and without landmarks, as *Two Rode Together* describes: a life with no ideals, that the filmmaker, renouncing magnification, captures even in its downtime, and especially there: hence the admirable scene in which Widmark and Stewart chat by the river, confronting their existences, measuring the void.

By using radically contrary methods, Ford's two final films reach the same conclusion. With *Donovan's Reef*, a complete openness gives the film a hodgepodge quality and the apparent insignificance that goes along with it. An accomodating film where everything is on the same level, where the filmmaker confines himself to citing and evoking without ever passing judgment. A world without illusions or ulterior motives; things have lost their importance; a fight has nothing or no one at stake, and if the gestures remain, the reasons behind it are forgotten. The characters have given up defining themselves in relation to some community; their long-standing complicity is now just two steps away from reiteration and senility. They no longer count on anyone but themselves: egoism is their final card. As for the filmmaker, he never felt so young: returned to the simple joy of filming.

Deep down, *Cheyenne Autumn* says nothing different. Only the methods have changed: maniacally precise framing, control exercised over every shot result in a "post card" aesthetic. But, of course, there is much more to this than aestheticism: in their mad desire to rediscover their land, several hundred anachronistic Indians want, in a final surge, to remember who they are and to make the strongest, most irreducible impression. But even for the filmmaker, they are *history*: behind the camera, Ford, making them pose, registers the sadness and hardening that's overwhelming him. Before they disappear, they would like to appear in their best light.

(*Dictionnaire du cinéma*, Éditions universitaires, 1966)

ERIC ROHMER

First quality of Eric Rohmer's cinema: patience. Not only in a man who is confident enough to assert himself—after one full-length film and several educational films—as one of the "greats" of the new French cinema. But also in an oeuvre in which everything leads back toward this primordial virtue: knowing how to wait, learning how to see; which is, through cinema, one and the same thing. As if the world were nothing but an immense repertoire of lessons of things we've never really fully explored.

We learn nothing from our first impression. But behind the neutrality of appearances—in Rohmer, nothing is ever emphasized, and is privileged even less—there is a lesson to learn, an order to discover, a truth to reveal. This slow maturation will be the temporality of the film itself, meaning that, far from excluding down time and details, it is only made possible through them.

So the principle is simple: catapult ideas against experiences, scrupulously observe the result. Experience for Rohmer is a bit like what it was for Hawks: the only reality, stating what is possible and what is impossible, refusing one, seeking to exhaust the other. Any idea that hasn't been experienced—meaning embodied, filmed— does not exist. Even characters: for them to agree to *see* something, they need a journey, an initiation, a test after which they will have earned what they already had but what needed to become more interior to them. In *The Sign of Leo*, wealth must be earned by a test of poverty that demands everything be rediscovered, hence seen more clearly. Same situation in a less serious register in *The Bakery Girl of Monceau*.

Experience demands the greatest honesty, plenty of scruples, meticulousness. Rohmer is a filmmaker obsessed with geography, cities, maps, stones, everything that offers the impersonal resistance that makes human adventures more exceptional.

But fiction is always a cheat: it must disguise, arrange its effects. It's entirely the opposite with Rohmer's educational films in which he rediscovers the passion for precision, the hatred of blur and entropy, the beauty of reasoning and the inevitable aspect of any experience. In *Les Cabinets de physique au XVIIIe siècle*, which may

be his masterpiece, merely by filming a physics experiment, step by step, he produces the most basic emotion. And also the strangest, assuredly, since it is borne from exactitude alone.

(*Dictionnaire du cinéma*, Éditions universitaires, 1966)

MAURITZ STILLER

The most famous, with Sjöström, of Swedish filmmakers and the author of one or two cinema "classics," but also the one to which that label applies the least. His oeuvre has neither the solidity nor the pretensions of classicism, and it tends more towards the fragility of reason and its aberrations than it does the rigor of a hermetic world.

Every Stiller film is the story of a seduction. The narrative, always suspended, obeys no other law: dead time, interminable shots reveal—as if in slow-motion—how someone gradually comes to answer to a vague call that forces him outside of himself. And yet, that call that he cannot shy away from doesn't designate a route to follow; it isn't about that thirst for real adventure that belongs to American cinema and, instead of adventure, we must see in this sum of hesitations, of rapid decisions followed by abrupt regrets, something more fragile: *wandering*. Some have given fragility a stable and certain image, but they have betrayed it a little. Stiller, who did not have that power, has another distinction: delivering his characters to the call of that wandering, and losing himself in watching them live.

The characters sometimes trigger, sometimes bear that force that pushes them eternally forward. Everything that fastens and restrains crumbles, everything becomes an invitation to travel, fascination with the unpredictable. Hence, his two "aquatic" films that are among his most beautiful, *Johan* and *Song of the Scarlet Flower*, which is perhaps his masterpiece, are about wandering heroes: adventurers sure of themselves, of their youth, their power of seduction, condemned to appeal to everyone but give themselves to no one, only to that movement that always pushes them further away.

In their wake, the women suddenly discover that call to adventure to which they slowly succumb. On their faces and in their

gestures, the camera registers that slightly worried frenzy, that effusion of the soul for which they are ready to sacrifice everything: their certainties and their comfort. For in incessant movement, every certainty is abolished, every security vanishes. Only the one who accepts to lose himself in the heat of flight and the proximity of danger can surrender to this momentum.

But an actual curse can also doom those who were once protected to wandering, and return to chance the ones who felt protected from it. One of Stiller's most well-known films, *The Saga of Gösta Berling*, is also one of his most outstanding. The entire film is merely the repetition of a single event: a character is suddenly cast out, rejected by his people. It begins with Gösta Berling (Lars Hanson) to whom, despite his vocation, the seminary doors are closed, and ends with Elizabeth (the young Greta Garbo) being driven away by her husband. This is not only coincidence, but the systematic will on the part of the filmmaker to deprive everyone of the illusion of false security. Sooner or later, one must prepare to return to the path; the characters have no right to cheat their destiny, which is to wander, and all that is comfortable then becomes a sign of ruin.

Whereas wandering, delivering oneself to chance, protects the wanderer from its dangers and allows him to enjoy it completely. It even seems that the characters, available to everything that presents itself, welcome encounters and dangers with the same joy. What matters for them is, at the heart of the danger, to find great joy, the most intense happiness at the heart of great fragility. A small boat that the tide threatens to capsize (*Johan*), a sleigh chased by wolves (*The Saga of Gösta Berling*), are so many occasions to deliver oneself completely to forgetting the self and identity, to exceed the limits of one's fear. Losing sight of who they are, with no defense or reference point against fate, compelled to accept it entirely and eager to approach the essential moment of the gravest danger and the greatest ecstasy: the moment of foundering.

This total availability, willingness to deliver oneself and allow oneself to be overcome, finds its endpoint in *The Blizzard*, which is, in a certain sense, if not the author's best film, at least his most excessive one. In it, self-forgetting leads to madness: intelligence no longer opposes any resistance to the solicitations of the outside

world. The hero, having lost all awareness of his existence, no longer separates the real from the imaginary: open to everything, meaning incapable of making a choice. *The Blizzard*, which tells the story of his recovery, marks the second movement of Stiller's oeuvre, parallel to the first but in the opposite direction: after the perilous spells of wandering, the need to return to the self. Wandering must find an end. It must also be exhausted in order to find peace. At the end of *Gösta Berling*, the Ekeby castle is reconstructed, sign that the curse has been lifted. At the end of *Johan*, one must return home and, in *The Blizzard*, find reason again. *Sir Arne's Treasure* is perhaps most exemplary in this regard: the famous sequence of the burial in the snow is beautiful and moving because, in a ritual and theatrical way, it suggests someone who is finally secure, who has found in death the only possible peace while in the distance the sun finally appears, melts the ice that cracks and becomes the sea again, symbol of all wandering.

A delicate filmmaker, Stiller always keeps between these two exigencies: the call to adventure and the nostalgia of repose. In this slightly vague romanticism, it's interesting to see what Gide said about Hermann Hesse: "I find the same indecision of the soul; its contours are elusive and its aspirations, infinite; it loses itself willingly in imprecise sympathies, ready to welcome any encounter; not determined by the past enough to consider submission itself a goal, a reason to live, the anchoring of its floating ambitions."

But this would be meaningless if Stiller's style weren't subject to the same forces, attracted by the same inclination. The characters' hesitations are shared by the mise-en-scène: the time that they lose is the time the camera takes to observe them more closely. Those entanglements, those lost shots, that apparent lack of rigor belongs to an art that doesn't desperately seek to signify, but rather to modulate ceaselessly certain rare agreements and certain privileged situations.

Mise-en-scène, in Stiller, pays little attention to sets—barely glimpsed even in a society comedy such as *Erotikon*, where the characters' momentum always counts more than the environment in which they are inscribed—and even less than symbols: it only follows the characters' movements patiently, without haste or a desire to magnify what is self-evident. What makes Stiller the least "silent" of

silent filmmakers is the profound requirement of his art, which is to reveal, not cede to that furor for expression at all costs. The only challenge is not translating something in cinematic terms but putting an end to the spectacle, immediate and fascinating, that it generated. Because it only wants to look, this mise-en-scène becomes shockingly modern: the infidelities to an aesthetic of the past become the merits of the present.

(*Dictionnaire du cinéma*, Éditions universitaires, 1966).

PRESTON STURGES

The subject of Preston Sturges's films is, first and foremost, ease: the ease with which dreams are realized and reality dissolves. The extraordinary transparency of his gaze and the accessibility of his characters continually allows for that passage from one world to another, so we may discover that they're not all that different, and freely exchange their traits. It's impossible for Preston Sturges to make fun of his characters: they are too vulnerable; what interests him, rather, is making them move from one world to another, making them realize their most cherished desire and convincing them that, behind the mirror, nothing is fundamentally different. Every film becomes, then, the story of a disillusion.

But who's to blame? The characters, who hold their ideal so close? Their dreams are simple, simplistic, even: comfort, social success, power. Nothing they can wrest from hard work, which compels them to place all of their hope in Providence. Ambitions so limited, dreams so sensible, that an advertising contest (*Christmas in July*) or a stroke of luck (*The Great McGinty*) is enough to fulfill them. After which, the world continues, with nothing really having changed. Succeeding in this way, without having gone to the trouble of really trying, exposes oneself to the possibility of finding the victory hollow.

And so, the fault perhaps lies with the director, in having too much sympathy for his creations, in his lack of critical demand. A real world that faces so little resistance is already somewhat of a

fantasy world; a fantasy world that can be so easily penetrated is somewhat like the real world. That a character, through the spells cast by the script, may pass from one world to the other, is no longer important. The same inconsistency, the same lightness of movement colors dream and reality equally, and gives Sturges his style and his method.

Where is the borderline? And what value is there in crossing it? It's these questions that Sturges's best film, *Sullivan's Travels*, tries to answer. An autobiographical film and a film about cinema, about how inordinately easy it is to pass from the real to the fictional, a reflection on that ease that makes voyeurs out of us. By clearly stating the necessity of making a choice, even a partial one, Sturges continually demonstrates that fundamental deceit by which each side always claims to pass to the "other side of the mirror." And so, its lesson in modesty makes *Sullivan's Travels* the only great, serious film of its director, serious because it has found an obstacle in its own image.

(*Dictionnaire du cinéma*, Éditions universitaires, 1966).

WELLES TO POWER

About Falstaff, Welles says, "He's fighting a battle that's already been lost." And also: "I don't think that he's looking for something. He represents a value. He is goodness." That strength and genius—universally recognized—celebrate only hopeless causes or grandiose downfalls, that a man like Welles, exercising an undeniable influence on those around him, portrays only fallen men (admittedly vanished from the heart of the power machine, yet used up by life, betrayed by their own) is a very surprising thing. A strange curse, that a man with too much power can only come to a "bad end." And yet, from Kane to Falstaff, from splendor to simplicity, from an unseen corpse to a carried coffin, it's the same story, that of a man who bears his own power badly.

Cinema tends to describe how a certain character (and behind him, often the filmmaker) acquired such power, the power to speak,

to act, to choose, et cetera. These are perhaps the most beautiful films (such as *Taira Clan Saga*, *The Elusive Corporal* or *A Mother's Heart*), full of "twists and turns" that directors escort their characters through because the simplest is not always the most natural thing, because some detours are richer than straight lines, some failures more noble than victories, et cetera. But the way in which his power is won (sought, earned, seized) is precisely what Welles addresses the least. It is the witches who create Macbeth, and Quinlan's intuition that drives him forward. Welles's films begin where others end; when all has been won, the only thing left to do is unlearn everything, towards death, yesterday Quinlan, today Falstaff.

2. Welles's oeuvre, faithful in this respect to Shakespeare, is a reflection on the very idea of Power, that excessive freedom that no one can pursue without facing degradation and ridicule in the end. Power is an evil that gives life only to those who don't yet have it. Theirs are bold endeavors, efficient and astounding actions, well-conceived conspiracies: men of the future, born to "crush the kings," who are given the chance, at least once in their lives, to turn the world upside down. Kings have other concerns: their victory is automatically without prestige, like a repression, a useless remembrance of the past. Failure is the only adventure that remains for them.

Absolute power destroys real power, condemns it to futility. "If there is a sense of the real," says Musil, "there must also be a sense of the possible." And a bit later on, "God himself no doubt prefers to speak of his creation as potential." In power that is too great, the possible corrodes the real, condemns it in advance: one action is never more necessary than another; good and evil, interchangeable, are equally indifferent. A man who at twenty is master of the possible, like Citizen Kane, ends enslaved by his caprices, gradually reduced to a power without object or echo, to insane and arbitrary activity, expensive and useless, that never completely engages him but increasingly alienates him from other people (building the career of a chanteuse who cannot sing, or amassing collections at Xanadu). He who is capable of the most does the least, or works in the margins of his power. Comedy thus demands that a prodigious expenditure of energy yields a rigorously useless life.

From film to film, as the oeuvre progresses, as Welles grows older, the sense of the ridiculous intensifies to the point of becoming the very subject of the film (*The Trial*) that Welles considers his best. Everywhere, always, power is in the wrong hands. Those who possess it don't know enough (Othello believes Iago, Macbeth is the victim of a play on words) or know far too much (Arkadin, Quinlan, the lawyer Hastler), each acting in vain in an excess of naivieté or intelligence.

3. John Falstaff's life is a commercial failure. Just before dying, he remarks that his friend—the doddering but prudent Robert Shallow—has been more of a success, and he promises to cultivate his friendship. Only his sudden death, which no one could have predicted, saves him from the final disillusion. Falstaff was not born to receive, but to give—without judgment, or hope of reciprocation—or, if he has nothing to give, to give "himself" (as a performance). Welles calls this wastage Falstaff's goodwill and Falstaff himself remarks, "Not only do I have a mind, but I give it to others," which is a nice definition of genius). That Falstaff—whom Shakespeare mostly intended to be ridiculous—becomes an emotionally moving character when imagined and portrayed by Orson Welles is not terribly surprising. His death is not the disappearance—mysterious and legendary—of a Kane, but a stark, bleak event in which we must read, although it goes unmentioned, the end of a world. "If you have fun all year," says the young prince, "having fun becomes a chore." What is Falstaff guilty of? Not of having squandered his power, really, since as a comedic character, he barely had any, and lacked courage and authority besides. Perhaps of using speech, that parodic power, excessively, of having made from it interminable histrionics, tedious and unnecessary, in which talent, if there is any, asserts itself for nothing. Most certainly of having survived such scandalous dissipation of his energies for so long (his wordplay between "waste"—expenditure—and "waist"—his stomach). And, what is even more serious, victim more than culprit, he also misuses his emotions, when he chooses as a friend the very person who will betray him.

4. Welles's oeuvre is singularly rich in abuses of trust (*The Lady from Shanghai*) and betrayed friendships (*Othello*). The complicity—strange and scandalous—that occasionally binds Falstaff and the

young prince makes increasingly visible something it silently over-
looks: the difference in their natures. But they would not be
fascinated with each other if they did not feel so radically opposed,
symbols of two complementary and enemy worlds, two sides of the
same coin. On one side, Falstaff, who lives in his past, what he once
was, in the entropy of a deliberately spoiled freedom. On the other,
the future Henry V, who is no one yet, who will perhaps be a great
king if he discovers that exact relation between the effort he must
exert and the goal he must attain, the austerity and rigor that render
power useful.

<div style="text-align:right">

(*Cahiers du Cinéma* #181, August 1966)

</div>

NOTE ON RAINER WERNER FASSBINDER

In the Fassbinderian cybernetic, we find:
—characters driven by a single motivation: social climbing (often
a question of petits bourgeois eyeing *more* bourgeoisie);
—other characters, more rare, who pay the price for this prevailing
ambition. Petra von Kant, Emmi and Ali, Fox, Hans (the merchant
of four seasons) are bound for a certain kind of sainthood. As for
Mother Küsters, we must take her ascent to heaven entirely seriously.
It is always, for R.W.F., about *assumption*, never awareness.

Why? Because these social climbers (all but one) have, as they say,
no hidden agenda. They articulate their schemes, their base calcula-
tions, their sullen egotism. They leave nothing for the spectator to
speculate upon, suspect, interpret. They express the pettiness of their
desires with a dull and obstinate cynicism.

—There is, in the Fassbinderian cybernetic, a sort of *trans-
parency* in the relation of desire to discourse (hence, no
unconscious) and discourse to acts (hence, little ideology). No one
lies, although everyone tramples over everyone else in the end. In
Mother Küsters, the obstinacy with which the two daughters (one
spiteful and surly, the other, the chanteuse (Ingrid Caven), sorry
and morose) pursue their idée fixe, abandon and betray their
mother, culminates in a gag. A gag that springs from the logic of a

cartoon or a photo comics: the *inability to escape* (one's nature, one's class, one's law—take your pick).

—The pleasure that R.W.F. takes in delivering the spectacle of his troupe of petits-bourgeois from the BRD, caught between formica and television, drunk with respectability and self-advancement, allows him to pass as a political filmmaker. In fact, the spectator, who needs only a millionth of a second to see through the characters and their contemptible goals, is put on notice to use the rest of his time—"leisure" time—either to repeat to himself (if he is on the left): "You can never escape your class, you can never escape your class, you can never..." or to become aware of what's oozing from the screen: the obtuse meaning, kitsch effects (but then, goodbye, political superego!).

—It is not at all clear that R.W.F.'s films are about alienation and thus a probable, possible, or desirable liberation. What's heinous about *Mother Küsters* isn't really the fact that he denies every form of political action (the wait-and-see attitude of the communist party, the adventurism of the leftists), but that he takes that denial as a pretext to depict an ascent to heaven—and a canonization. If R.W.F. is the slightest bit political as a filmmaker, it's on a thematic level: he knows how to *behave badly* and make social climbing (a theme that had disappeared from the screen, but not from life) a cinematic subject worthy of attention.

—Conversely, I think that R.W.F.'s interest in what he films, the source of his desire, his *objet a*, is something both more modest and more precise: it is what I will call an *aesthetic of the gaffe*.

—One example: In *Mother Küsters*, the grotesque moment when Ingrid Caven invites her mother and brother to see her début in a nightclub. The chanteuse: 1) sings horribly and off-key; 2) exploits, without even a hint of shame, the story of her father's suicide; 3) casts a vacant and indifferent gaze over the room where, dumfounded, her mother and brother, believing neither their eyes nor their ears, fascinated by the horror of it, are there, at the end of a zoom shot that tracks them down in the darkness. So it always goes in the Fassbinder system. If the characters state their motivations out loud, that induces, statistically, monumental blunders, colossal errors, abyssal lapses of finesse and tact: in short, gaffes. A divergence from the

melodramas to which R.W.F. lays claim, for in classical melodrama, gaffes are impersonal: blows of fate (Sirk) or rolls of the dice (Demy).

—There are at least three levels to the gaffe: 1) denotation: saying precisely what shouldn't be said, the wounding word, the letter; 2) connotation: that *letter*, if it wounds, does so because it is imbued with truth: the gaffe is a symptom; 3) third meaning, the obtuse meaning: something—between the wound and interpretation—remains: materiality, the body of the blunderer, his satisfied thickness, his stupidity. The gaffe, suddenly, opens an abyss between enunciation and what is enunciated, an underhanded vacillation, an incomplete *fading**. It is this abyss that Daniel Schmid excavates and works when he brings one of R.W.F.'s plays to the screen. But the gaffe is not a lapse or a Freudian slip. Those reveal the unconscious while the gaffe merely indicates the influence of the pre-conscious. In a sense, R.W.F. is a filmmaker of the pre-conscious (there are few).

—The gaffe is the Fassbinder system's fuel: the calm and trivial placement of foot in mouth, twisting the knife entirely innocently in the wound. Hence a strange sadism formulates itself: "Isn't it true that I didn't hurt you?" In this, R.W.F. is not very Brechtian. Brecht was interested in *gestus*, living tableaus that have meaning *only* for the spectator. In *Kuhle Wampe*, the wife doing the household finances and the man, next to her, reading a newspaper story about Mata Hari out loud are completely unaware of the fact that they are *creating a tableau*. Whereas in the gaffe, there is a truth that must be stated, but not assumed.

—It is instead to Barthes's third meaning, the obtuse meaning, that we should draw our attention. "But I myself feel this slight trauma of signifiance faced with certain photo-novels: 'Their stupidity touches me' (this could be one sort of definition of the obtuse meaning)." Unfortunately, in Fassbinder, the third meaning, the excess of materiality of which the gaffe is only the fictional revelation, is increasingly put on display for its own sake, at his subjects' expense (see the recent and ridiculous *Chinese Roulette*). An obsession with purity (which sends one subject to heaven) takes precedence over contradiction (which has cast so many of us down to earth).

(*Cahiers du Cinéma* #275, April 1977)

NOTES ON THE FILMS OF MANOEL DE OLIVEIRA

1. Manoel de Oliveira's status

In French criticism: regularly rediscovered. In *Cahiers*: mentioned by Bazin (#73), Bontemps (#159. *The Hunt*) and particularly Biette (#175) who sketches, in 1965, a first portrait of the films that were known at the time. In Poitiers (1977), to close the *Rencontres*, the greater part of his oeuvre is screened, with de Oliveira in attendance. He is indeed "Portugal's greatest filmmaker," but here's the thing: Portuguese cinema doesn't exist—or almost doesn't.

In Portugal (filmmakers and critics are often one and the same): the great man, the obligatory reference, the must-see. In its first issue (1975), the *CinéMa* film review asks him for an interview and writes in the margin: "The need to conceptualize and practice a cinema in opposition to the machine of images and sounds in which the bourgeoisie reflects the relations of production and the ideology that 'justifies' them, to move forward in the implementation of a resolutely anti-capitalist and anti-imperialist cinema, on every level, of production, theme, form, distribution, does not involve accusing Manoel de Oliveira of being a product of bourgeois, idealistic, reactionary Catholicism, but involves discussing his practice, which is progressive in the context of bourgeois film practices in Portugal." Indeed.

A difficult benchmark, nevertheless. Oliveira (like Reis) comes from Porto and has little to do with the Lisbon intelligentsia. His Catholicism, itself perverse (I will return to this point) does not make him a filmmaker who is *a priori* friendly to the left. His isolation from the very beginning (his first film, *Labor on the Douro River*, dates from 1931), the artisanal demands of his films, the fact that he is not a filmmaker by profession (he is a small businessman) make him a reference point, but not a model. Portuguese cinema's remorse, he has been granted considerable resources late in life, and is currently shooting an adaptation of a famous novel by Castelo Branco: *Doomed Love.*

It isn't at all certain that the image of Oliveira as simultaneously "the only and greatest" Portuguese filmmaker, a romantic exception, a divine surprise, etc., ought to be encouraged. He finds himself in a situation and embodies the truth of it: an historical situation where the only imaginable cinema is an industrial cinema (serial,

coded) but in a country (Portugal) where that industry has not managed to establish itself in time, or to last (Salazarism having *smothered* everything).[1] A marginal figure (who didn't necessarily want to be one) such as Oliveira is the logical product of this kind of situation (such as, let's say, Dreyer in Denmark).

In fact, there is a *harmony* between this situation and what the films of Manoel de Oliveira tell us. He is one of those filmmakers (Buñuel is another) who cannot work without *codes*. Codes of all kinds: social conventions, stereotypes, filmmaking norms, etc., since all of their effort consists in circumventing them. A paradoxical situation (that depends on a perverse structure, the only one it encourages) in which the filmmaker must, with every new film, start from scratch, begin by setting in place—and for only one film—a machine that it will only operate only in order to jam it up. Impossible to label Oliveira, who brings as much passion as indifference to "approaching" every genre: realism (*Aniki-Bobo*), documentary (*Rite of Spring*), news item (*The Hunt*), drawing-room comedy (*Past and Present*) or filmed theater (*Benilde*).

2. The averted catastrophe

A famous but seldom-seen film, *Aniki-Bobo* (1942) was noticed by Sadoul, who saw it as the invention—on its own behalf and independent of Italy—of neorealism by Oliveira. In 1977, we're more apt to think that if if the filmmaker has his allegiances, they aren't to be found in realism, neo- or not, or in a certain type of character or milieu, but in an *obsessional structure* that presides over all of his films and is reflected in what I will call the theme of the averted catastrophe. That the nature of this catastrophe is of a sexual order is stated more bluntly in the most recent films (without becoming any more convincing).

Aniki-Bobo introduces, in the streets of a city that resembles Porto, a gang of children whose war cry is, precisely, "Aniki-Bobo!" One is a bully (Eduardinho) who is already a young man and another (Carlitos) is blond and sensitive: the hero. The two compete for

1. It will be 1938 before the regime becomes sufficiently interested in cinema to produce a "Portuguese Journal," news stories seen and reviewed by the Secretary of National Propaganda. In 1941, Lopes Ribeiro, the strong man of Portuguese cinema, committed to the regime, tries his hand at the ongoing production of films. He directs one good comedy (*Le Père tyran*, seen at Poitiers) and produces *Aniki-Bobo*. All of this will be short-lived (the lowest point of the crisis is in the fifties).

Terezinha, the only girl in the group. The first with a kite, the second by stealing a doll from a tailor's window ("The store of Temptations") that he gives to Terezinha (and that they look at together for a long time, in a magnificent scene, a veritable "window-phase"). Later on, during a fight, Carlitos lunges to push his rival over a cliff, right at the exact moment when he falls *on his own* and plummets down the hill (obsessional, this realization of desire without it being acted upon, c.f. Buñuel's *The Criminal Life of Archibaldo de la Cruz*). He falls (dead? wounded? unconscious? we won't find out until much later) several centimeters away from a railroad track, right when a train is passing. At the end of the film (after order has been restored), Carlitos and Terezinha walk away, framing—as if it were their child—the doll, each holding one of its hands.

What is striking about this film from 1942 is the definitiveness of its views. I can see at the very least that: 1) The parents are deliberately absent. The adults we meet are introduced one by one, as singular beings. 2) The children live adult dramas and act like adults. There is (as there is in McCarey) a constant denial at work in the film: *I know* (that they are children), *but still* (and if they were sexualized?). The averted catastrophe is the phallic threat represented by Eduardinho (the train that passes *alongside*). Carlitos's victory is anything but a return to parental order (or its anticipation), it's already its simulacrum, one beyond idiocy. There is a strong chance that the then-dominant ideology in Portugal (the new Salazarist state, like all fascist states, required well-behaved children, united families) knew the extent to which the film ridiculed it. In *Cidade de Tomar*, in January 1943, critiques such as this one appeared: "This film is a shameful insult to childhood innocence and parental carelessness. It is a veritable monstrosity."[2]

3. The Stump

One of the questions that haunted the debates at Poitiers following the screening of each film was this: Is Oliveira an optimist or a pessimist? Each film seems to lead to this question and all of them shy away from it (it's a strange question, besides, more of a *demand*

2. Cited by Alves Costa in a piece about Manoel de Oliveira appearing in *La Revue du cinéma*, #314, p.37.

made of a master who is supposed to know, a *demand* that we be reassured by the filmmaker.)

It's because, just like Buñuel, Oliveira refuses to have the last word, preferring instead the pirouette of the *undecidable* (another obsessional figure). No *happy ending*, no open ending, but a double bind every time, a play on words that destroys the film's entire structure. In *A Caça* (*The Hunt*, 1962), a fairly well-known short film presented at the Semaine de *Cahiers* in 1977, Oliveira succeeds best at refusing to answer to this demand. We know the film's storyline: the restless wandering of two idle adolescents in the marshlands: they pretend to hunt (but they have no guns), quarrel, lose sight of each other until one is found sinking in quicksand and crying for help. Men spring into action, come to his aid. They find him covered in black mud, sinking. They make a chain to free him. A man cries out for someone to grab on to his hand, and extends what he has in its place: a stump.

This take on humanist doxa ("if all the men of the world would *join hands*") is *literal*, Buñuelian and negative (we think of the end of *The Milky Way*, where Christ meets two blind men on his path and only heals one). But at the same time, the play on words works to *suspend* the moral, not to negate it. We need the (signifying) stump to signify the hand. Furthermore, the stump—at once a false hand and the absence of a hand, echoes the doll of *Aniki-Bobo*, which is also held by the hand (according to the now famous equation: castrated man/fetishized woman).

4. The millefeuille and the end of the world

In *Acto da primavera* (*Rite of Spring*), Manoel de Oliveira starts from reality: the Passion play (Auto da Paixão) performed every year during Holy Week by the villagers of Curalha (Trás-os-Montes). The text, in dialect, was codified in the XVIe century and the staging takes place outside.

We can see its value for the filmmaker: he is able to work with a *multilayered* story in which one can read both (but not simultaneously) the Passion play and its appropriation by the Portuguese people of Trás-os-Montes, first in the sixteenth century, which explains the language and the costumes, and then year after year until now, until the unique bodies of these present-day villagers: their stilted violence, their

rants, their industrious fervor, what they can control and what escapes them, etc. To complete this signifying millefeuille, Oliveira adds the presence of the film crew and several scornful and frivolous tourists. From there, everyone is free to interpret the entirely *on the level that pleases them*, like an archeological dig or an *ice-cream**.

The film is striking (it resembles nothing we have ever seen) but disappoints as it progresses. For Oliveira plays his most metaphysical cards.

The scene of Christ's resurrection is missing from the Curalha villagers' performance. Oliveira compensates for this absence by introducing images (*stock-shots*) of modern wars and mushroom clouds at the end of the film, which are then followed by images of trees in bloom. The Poitiers audience again demands some reassurance. Should we focus on the flowers or fear the atomic mushroom cloud? The filmmaker's response here is humorless, which probably refers to a religious problematic of grace. The averted catastrophe (nothing less than the destruction of the human race) here receives a somewhat Sulpician interpretation.

For the villagers who have loaned their bodies and their acting to this film are also the losers in the story. The dialectic is absent. From the dual aspect of their popular performance (negative: alienating grip of the Catholic religion; positive: cultural resistance to interior colonization), Oliveira exhibits the material without making it his *subject*. Instead we get the feeling that he is primarily the parasite of what he films, always placing the camera in paradoxical and unpredictable locations, making us the clandestine beneficiaries of a series of signifying aleatory effects, created by the blundering of these villagers who inflict the law upon themselves.[3]

5. *The power of the dead*

O Passado e o Presente (*Past and Present*, 1971) is the author's most puzzling film. It is a drawing room comedy, presenting a completely

3. Before concluding that Manoel de Oliveira covers up (with abstract and ecumenical Christianity) the material—rich, magnificent—that he had revealed (the concrete religion of *these villagers*), we must grant that he revealed it. And wonder that it is often idealistic, religious filmmakers who have enough of a taste for adventure and reality to camp out on territory (here, of popular culture and its debacles) that one would assume to be haunted by Marxists, or at least leftist, progressive filmmakers, etc. And yet, in Portugal or anywhere else, that is not the case.

inept and artificial bourgeoisie, filmed using broad camera movements that snake their way through sets without doors, glitzy and sumptuous. It is Oliveira's most *structural*—and perhaps most ambitious—film.

A woman (Vanda) lives in a state of perpetual misalignment with the events in her life. Her husband, whom she despises, dies in an accident; she takes another whom she gradually begins to despise, and begins to worship the first. The second husband can't stand it, and kills himself by throwing himself onto a bed of sage. The wife is courted by the twin brother of the first husband who turns out to have been the first husband all along (it was the twin brother who actually died in the accident). The marriage, even after it is patched up, ends abruptly and Vanda starts worshiping the second husband, etc. One result of this perpetual mourning, among others, is that Vanda has no sexual life (the phallic threat is thus, once more, avoided).

An ambitious film, because it attempts to describe an institution (bourgeois marriage) from the inside. To its sterile and misaligned couple, it opposes another, unmarried but overwhelmed with children. We return to the idea already beginning to take shape in Aniki-Bobo: the Law excludes the phallic threat that can only exist outside of the Law, in which case it would no longer be a threat but, in accordance with Christianity, grace (myth of the Immaculate Conception, the explicit subject of Oliveira's next film: *Benilde*[4]).

This is because the material is the kind that resists. It resists because it is ambivalent, a poor conductor of ideology or preconceived ideas. In the more or less folklorized remnants of popular culture, there is at once the affirmation of *pleasure* (pleasure of acting, of amateur acting: overcoming stage fright, dressing up, triumphing over an imposing text) and *resistance* (resistance of a pagan core to a superimposed Christianity, etc.). It is that resistance, that pleasure that it would logically be up to Marxist filmmakers to *sever* from their fanaticism and resignation (Fatima is not far away). Only Pasolini seems to have the heart to undertake this debate (and to run its inherent risks: paternalism).
4. *Benilde or the Virgin Mother*, 1974), the last film of Manoel de Oliveira to date. A film ostensibly so dated that it was snubbed by the post-April 25th Portuguese audience. I didn't get a good enough look at the film at Poitiers to rule on the matter. Deliberately against the current, the film to a certain extent explicates the thematic already at work in the previous films. A given setting (presented in a striking opening shot) will serve as a closed location for a narrative that, precisely, speaks only of that: imperviousness—evoking Rohmer's *Marquise d'O*. In an isolated house, a young girl finds herself pregnant. A madman who is possibly the baby's father lurks around the house (we do not see him). Unless it is a new version of the Immaculate Conception… (even here, the dice are loaded, since the madman could very well be an instrument of God, etc.)

Opposition of the Contract (cohabitation) to the Law (marriage). The mode of *jouissance* is completely different: in cohabitation, there is the arbitrary, a leap across the sexual, a confusion between the big other and the little other, and in the institution, it takes three: "We live, in institutions, under the surveillance of the dead."[5]

<div align="right">(Cahiers du Cinéma #276, May 1977)</div>

JOHAN VAN DER KEUKEN, THE CRUEL RADIANCE OF WHAT IS

Strictly speaking, there are no shots in Johan van der Keuken's films, only *fragments*. Not the parts of a future whole and especially not pieces of a puzzle to assemble. But fragments of *cinema*, meaning carrying with them, inside, them, on top of them, including (that's the whole point) the trace of an extraction outside of the real, an imaginary operation from which they are the enigmatic remainder. There is something surgical about these fragments, which comes not only, in van der Keuken's case, from his past as a photographer (his first collection was entitled *Mortal Paris*) but also from his position, his *posture*, rather, of cameraman, of man-camera or camera-become-man: the eye riveted to the viewfinder of a too-heavy camera, the eye that sees and simultaneously chooses, that is to say cuts, slices through, like a laser beam. There is an extreme, tyrannical attention to everything that frames, and the feeling experienced ad nauseum of *too much framing*, everywhere, always, which means that the only thing left is to over-frame, reframe, un-frame. And what constitutes the fragment, of course, is first this: the frame that isolates it from the rest, that returns the rest to off-screen's limbo. Then, the fragment fixes our gaze, appropriates it and, in turn, looks at us. Severed from the whole, the cinematic fragment makes eyes at us.

When it is said that the fragment makes us lose the whole, that whole constituted by "all that remains," it is irrespective of the rest of the world, of the rest of the world's images, the indefinite remainder of everything that could just as well have come *to the same place*. The

5. Using Pierre Legendre's expression in *Jouir du pouvoir*, p. 97.

fragment is also something that the professional documentarian must avoid at all costs, whose mission is to make us forget even the idea of the *arbitrary* in his choice of images. The paradox of Johan van der Keuken who, if he becomes well-known, will be inevitably classified as a "documentarian," is that he has made films against himself, as one swims against the current, against that part of himself that settles for the facile beauty of images. Out of his cinema, van der Keuken has made a strange machine that de-stuns, de-stupefies, a war machine fighting against the enigma of arrested motion, against photography. Not by "denouncing" the deceptive seduction of images, but rather through excess (so much so that the plastic sumptuousness of his last film, *The Flat Jungle*, has something discouraging, even sickening about it). And he could only assemble this machine by doing everything in his power to make us witnesses and accomplices to that imaginary operation (extraction, grafting) that molts the image into a fragment.

The fragment is affected by two possible becomings. A fetish-future and a dialectic-future. Either it is complete in itself, makes us forget the rest, stuns and stupefies. Or else it is only one point in a process, a link in a chain, a hinge to something that is not it but that works with it (on what? on meaning, always to come, on the last word, never uttered). But the opposition only appears to be determined. Or rather: it is only encountered, sharply felt, in the films of authors who are the mystics of true inscription, with whom, in addition to J.-M. S. and J.-L. G.,[1] we must count JvdK. With them the oscillation between the two futures of the fragment is experienced with the greatest violence—and greatest seriousness. Sometimes the petrification of time in an image, fetish that opens the door to jouissance (perverse), sometimes the stages, the phases, the entre-deux, the dialectic that covers desire. It is with them (and with Eisenstein, of course) that we see most clearly *at what point, in film, the desire for the dialectic has always been in league with the exorcism of the fetish.*

For don't we call dialectical that filmmaker's trick of endlessly retracing his steps back to his own productions, his images, to pretend to see them transformed, become "other" (altered by the gaze of

1. Jean-Marie Straub and Jean-Luc Godard. On true inscription, see Bonitzer's text (*Cahiers* #264) and Narboni's (*Cahiers* #275).

the spectator—that rival), and to give himself the right to return to them, "in the guise of the dialectic"? The refusal to abandon them, the refusal to manipulate them, the shame laid on the spectator for having misread them, the need to make something of them, is one single operation, but in several stages, like the gesture of the painter who "steps back" from his canvas to see it differently (detached from himself, as if someone else had made it), before the silent order to return to it is intimated (and, between two touches, the mantra is precisely: *don't touch!*) That is how his productions become the objects of his thinking, that is how the two becomings of the fragment commingle in a detour of back and forth.[2] I think of Godard, "obligated" to return to certain moments of his film (*Until Victory* becomes *Here and Elsewhere*) like someone returning to the scene of a crime, or of Straub-Huillet filming a book they read and filming the author of that book reading today what he wrote yesterday. Or even of van der Keuken remaking *Blind Child*.

There is an expression that summarizes van der Keuken's cinema, its form and content, fairly well: *unequal exchange*. It describes a political reality that is the final word on the relations between rich and poor countries (a reality that van der Keuken has placed at the center of many of his films, including the North/South triptych) as much as it is the status of every cinematographic fragment. Every fragment is *reclaimed* (simultaneously victory, extortion and extraction) *from something else*, cruelly, arbitrarily. Unequal exchange creates the fragment but in return, the fragment distracts from it and tends to act as a fetish. Unequal exchange can be seen in the condition of filming (extortion of the "surimage") as much as in the choice of locations or framing. Through this omnipresent dimension of unequal exchange, a moralization of the film/spectator relationship is created (the possibility that a film could be abject). We could go so far as to say that every fragment (everything that results from a decision, a choice, a throw of the dice) is *unjust*.

2. It can only be a back-and-forth. It is, ultimately, impossible to be ruined by the fetish (that would mean being cruised by his own images, like in Wenders). Endlessly deferring meaning in the name of the dialectic is, as they say, taking one step forward and two steps back. Hence, in *Fortini/Cani*, the retroactive play of signifying units, the interrelation of every fragment, the difference of the final word does not prevent the film from ending on one of Marxism's fetish phrases (one that is about the concrete analysis of a concrete situation.)

And this unequal exchange, if it cannot be abolished (it is inevitable), must at least be made present, must mark the images and make the spectators aware of their responsibilities. "Every shot," Fargier correctly (*Cahiers* #289) writes, "even before being incorporated in a sequence, is already stratified during the filming by the marked collision of the real and a gaze." For fifteen years, van der Keuken's films (and this is their political dimension) never stop proclaiming: *every exchange is unequal.*

Unequal exchange (1): filmer/filmed. Van der Keuken illustrates, in the most radical way, how the impossible reciprocity between filmer and filmed is manifested in the act of filming itself by making *infirmity* one of his preferred themes. Faced with the blind (see Fargier's text on *Herman Slobbe*), the deaf (in *The New Ice Age*, Dutch workers are made deaf by factory work), those who have no personal living space (in *Four Walls*, a short film about the housing crisis, it is impossible to stand up—see *Cahiers* #289, p. 20: "Restrictive spaces"), faced with all of these perceptual limitations, there can be no "right place" for the filmmaker. Unequal exchange, dare I say it, gouges out the eyes.

This is where van der Keuken commits himself, risks something. He doesn't turn away from these extreme situations (which he clearly favors), nor does he wrap them in the abject discourse of assistance for the "disadvantaged." He pushes the search for the "wrong place" further. And if the right place, in film, is the one where we forget our bodies, the wrong place, that of the moralist, is the one where we remember our bodies. To bring out the essential character of unequal exchange, we must first bring out the two poles of exchange, *which means that we must bring out the filmmaker's body.* I return to van der Keuken's remarks and the clarity they demonstrate on this point: "The camera is heavy...its weight matters, which means that its movements cannot be made gratuitously; every moment counts, has weight..." For us, the spectators, it is doubly so. We can only have a true connection with those being filmed (all disabled, in some way, because they are filmed) when we also have a relationship to the working pain, the (physical *and* moral) discomfort of the filmmaker.

The ethos of a filmmaker is always the search for a *triangulation*: filmer/filmed/spectator. It is always, insofar it implies a filmmaker's posture (or an exhibition, a pose), indissociable from a dimension of

scandal. The identification of van der Keuken with Herman Slobbe is scandalous (the exchange is excessively unequal) because it is scandalous that the difficulties of a filmmaker's work would be made to echo with the existential difficulties of a young blind man. Just as it is scandalous that Godard tries to make a young welder understand that the gestures of his profession are also the gestures of writing, writing being Godard's profession (*Six fois deux: Y'a personne*). *But these scandals are precious.* For it is with this condition (the emergence of the filmmaker's body) that *Blind Child* nullifies everything it could have been (from naive humanitarian documentary to shameful voyeurism) and ends up giving us *access* to Herman Slobbe, insofar as he also exists outside of the film, with his projects, his toughness, and especially— this is its greatest scandal—his relationship to *jouissance.* The film ends on a strange "every man for himself" note that makes no sense because, for the last twenty minutes of the film, every man has been (entirely) for the other, in the spectator's eyes.

Unequal exchange (2): here/elsewhere. Why would there be cinematographic fragments, if people exist for whom there is nothing to see or hear? This question, as we have just seen, helps to highlight, almost absurdly, the unequal exchange between the filmer and the filmed, and consequently the arbitrariness of all fragments. There are other questions, also present in van der Keuken's films, that relate more to his ideological and political choices, to his rigorous anti-imperialism. Why film here, in this country, if the key to what is being filmed is somewhere else, in another country, on the other side of the world? In the three films he dedicated to the relationships between rich countries and poor countries (the North/South triptych), there is no more of a "right place" than when he takes infirmity as his subject. Particularly because he knows that the exchange between rich and poor countries is *increasingly* unequal. It is one single reality—imperialism—that, simultaneously, makes people dependent on each other, binds them (looting, the unequal sharing of the resulting crumbs) and increasingly exoticizes them (folklorization). Imperialism also allows the filmmaker to interweave various fragments: an *ice-cream** factory in the Netherlands, a slum run by the left in Peru, a supermarket in the United States, fishermen in the Balearic Islands, etc.

This play of here and elsewhere continues, even though the third-world sensibility (and rhetoric) of the seventies has given way to a certain disenchantment. During the war between Vietnam and Cambodia or the Moroccan intervention in Shaba, it is first in Europe (*Springtime*), and then in his own country, the Netherlands (*The Flat Jungle*) that van der Keuken pursues the dialectic of here and elsewhere. In this narrowing of the political horizon, this passage from macro to micro, it's always the same search for *chains* that animates the filmmaker, that nourishes his back-and-forth between the fetish (the link that makes us forget the chain) and the dialectic (the chain that wants to know nothing about its links).

What is confirmed, then, is an *ecological* sensibility, already present in the triptych and that is probably—for van der Keuken as for all of the moralists of true inscription—the only way to save the politic. This means: follow chains other than the chains of economic exploitation, follow the thread that connects the animacules of Waddenzee to the mariners and the mariners to the nuclear power plants. There is, in this dialectic of nature, a politicization of the idea of *environment* that in turn enables us to cross the line between here and elsewhere, not only between continents, but also between things that are immeasurably close, in the same location, ultimately in the same shot.

Unequal exchange (3): this/that. This is the third operation, which consists of indicating the arbitrariness of the fragment in the act of filming itself (thus it is essential that van der Keuken is his own cameraman). It consists of displacing our attention towards the borders of the frame and what is immediately out-of-frame. "When I shoot, sometimes, I try to go and look just to the left or the right, and then if something very insignificant or extremely significant comes in, then I'll come back to it." In this strange practice of deframing, it is as if the fragment has split before our very eyes, become detached from itself, produced the time of a hesitation, in a sort of oscillation, the cruel arbitrariness of cutting through the perception of the very thing it excludes (beyond the border, *out-of-bounds*). The exercise of a right to examine, certainly, but of a very particular kind. For what is produced in this back-and-forth movement is not the dramatization of what's out-of-frame as a supposed reserve of what threatens or stuns the frame, but what Bonitzer calls (in his text on deframing, *Cahiers* #284) a "non-narrative suspense." Its function

would instead be to insinuate a doubt, a suspicion as to the frame's legitimacy (I could film this...but also this, alongside it, just as well...). The fragment dramatizes itself, comes unglued from itself, to signify that it is a throw of the dice (arbitrary, chance) but also a power play.

And yet, in the final analysis, van der Keuken's struggle to dialectalize the fragment (we have alternately seen an intersubjective dialectic, a historical dialectic, a dialectic of the border and what lies outside of it) stumbles on the fragment's irreducibility. From the film fragment, the fetish. Speaking, apropos of Nietzsche, of fragmentary speech, Blanchot writes: "a unique, solitary, fragmented speech, but a fragment that is already complete in its morcellation and belonging to a flash [*éclat*] that refers to no shattered [*éclatée*] thing." It is no accident that Blanchot points to the *flash* [*éclat*] of the fragment, immediately adding that it refers to no *shattered* [*éclatée*] thing. Nor to any illuminated thing. For the flash leads us to the light. Rosolato (in *La Relation d'inconnu*, p. 25) writes about the fetish: "The dullest, the dirtiest objects, always have this ability, demonstrated in a way that's even more striking in that it imposes itself, conversely, through a shine that only exists and arises as a result of the allure bestowed upon them by their role as fetish." And in fact, for van der Keuken, light, the dissemination of its sources and luminous points, is based on a sort of intimate illumination. We could compile an extensive list of an entire range of luminous points, rings, circles. Brilliant jewels or brilliant refuse, ranging from the glimmering of a revolving door (*Four Walls*) to a slice of bloody meat. Eyes embedded in a wall or stones that see (*Lucebert*). The empty eye sockets of blind children (first version), doubled by an opening *of the iris*, on innumerable television sets, turning off or turning on. That light, that materialization of the point of the gaze, is not an effect of lighting, but rather of a *graft*. A graft of light in the fragment. A quick shot in *The Spirit of the Time* shows a newspaper report of the successful grafting of a baboon cornea in South Africa. The newspaper clipping itself takes the form of an eye. This grafted light that marks out the empty place of the eye, sometimes literally, *also* turns the fragment into a fetish, meaning an impossible object in which we can gaze at ourselves.

(*Cahiers du Cinéma* #290–291, July–August 1978).

HANS JURGEN SYBERBERG

In Rome, in the spring of 1979, I asked Hans Jürgen Syberberg if he was interested in the idea of taking charge of an issue of *Cahiers*. After our return, we began to assemble photos and texts—his, mostly. Now, in March 1980, we can announce the appearance of a special edition. A book, more than an issue of the magazine, a collection of materials, of new pieces in the Syberberg dossier— unending, unfinished. Including, as demonstrated by the photo on the "front page" of this edition, a thread that weaves the work together, a theme that travels through it, of *childhood*: cinema's childhood, as well as the filmmaker's.

The issue opens with the filmmaker's travel diary from California, from the summer of 1979 and his meeting with Coppola, the bright idea of a place in the world where filmmakers can speak to each other, and that concept of utopia (utopia and projects) guides the second part of the issue: answers to surveys, a "video-memories" project, original materials for his next film (*Parsifal*). But it is the "filmmaker's profession," the practicalities of technical choices

(frontal projections, marionettes), the genealogy of forms that is the subject of the third part, including an unedited interview illustrated by numerous photograms. This section closes with a reference to origins: of the cinema (Edison's studio), of the hero (Rosebud's snowball), and of Syberberg himself. It introduces the fourth section, more serious, composed of *Fragments*, pages torn from the filmmaker's travel notebooks and printed alongside images of his childhood in a Germany in ruins, in the East. Thoughts on history, on mourning, Germany and its cinema, etc. The issue ends with a selection of texts about Syberberg previously unpublished in France, with the goal of broadening horizons: extracts from the essay that Susan Sontag recently devoted to him, testimonials by other filmmakers (in the present: Coppola, in the past: Sirk), short texts by Moravia, Heiner Müller, etc. It is from Müller that I will borrow, in closing, a quotation that summarizes Syberberg's importance in the cinema of today: "Just as the mirage of the horizon fades away, fiction's lies are revealed, the gesture that hollows out chronology brings the story to the surface, the irruption of the third world in history wrests from conflicts their true nature: Syberberg practices euthanasia at the bedside of the fictional film; the lids of its coffins are dynamited like mineral layers, and from theater, from Wagner and Brecht, a shifting architecture is created that forms the protoplasm of a total art. The end of the dream factory: cinema's solitude."

(*Cahiers du Cinéma* #309, March 1980)

NICK RAY AND THE HOUSE OF IMAGES

I remember a time when, in one of the four cafés on the Trocadéro, someone (some film buff) would argue that X or Y might be the greatest filmmaker in the world, but that Nicholas Ray had made the most beautiful film in the world. Some nights, it was *Bitter Victory*, other nights *Bigger than Life*. There was always Nicholas Ray vs. everyone else, as if a privileged link existed between him and cinema, which it was up to us to safeguard. We already knew that his was

not an easy career, that it would be destroyed. Even more than Welles, Ray had the profile of the big *loser*. Except that losing is sometimes winning. Pathos? Facile romanticism? Yes, but we also knew—he said so in an interview in *Cahiers*—that for him cinema had only just begun, that we had only glimpsed it, that it would surprise us. Strange remarks for a Hollywood filmmaker. Remarks we shouldn't have forgotten. Presented at Cannes in 1973, resdiscovered after his death in 1980, smuggled in and scheduled to be screened in English at the Action-République for a week, *We Can't Go Home Again* tells us that we were right. We were right to put him "aside," for the filmmaker who no longer shoots circles back, posthumously, a cinematic loop. A unique trajectory: he is the only one to have pursued his two favorite objects—cinema and youth—on their most recent adventures. From his exile, from his retreat, at the beginning of the seventies, he was the only filmmaker of his generation to bear witness *in vivo* to what youth and the cinema were becoming. And not because, for lack of anything better, he surrendered late in life to "experiences," but because he is one of those filmmakers who can only be contemporary. Which is why Godard liked him so much. Which is why, in our imagination, Ray didn't age, any more than cinema did. *We Can't Go Home Again* is simply another Nicholas Ray film, dated 1973. Another film about youth, post-'68 youth, chatty and generous, drugged-out and pragmatic, violent and sentimental. Another film about education, Ray's great theme, with, this time, the filmmaker presented onscreen for what he is: a name, a faded glory, the film professor who made, once upon a time, *Rebel Without a Cause*. Another film about fathers who aren't fathers, who fake the Oedipus complex, imitate their death, tie knots that can no longer be severed. Ray, the Gordian filmmaker: at the end of the film, he hangs himself in front of his terrorized students, in the dark of night, in a hayloft. The off-camera voice of the hanged man murmurs to one of the youths, "Take care of each other." How can we not think of *They Live by Night*? Another film about the impossibility of return, about headlong flight, about the lack of a home. But this film is unique: in it a filmmaker disintegrates and recomposes the very material of his film. The screen is colonized by smaller images that vibrate, coexist, blur. Cries and confessions float on a black

background but that black background is sometimes the shadow of a house, with a roof, the kind that children draw. No longer a house for characters, but a house for images "that no longer have a home": cinema. You can't go home again... in 1977, the first *Semaine de Cahiers* was in full swing in New York, at the Bleecker. I learned that Ray—who was teaching a block away—had just left the theater during the screening of *Number Two*. I ran after him. We were introduced. He didn't like Godard's film: too severe, intellectual, self-destructive. I chuckled to myself. He himself, he added, had made a film like that, before Godard, but the reels had been lost somewhere, while re-editing. In 1980, his widow, Susan Ray, came to Paris with the film in tow. She wanted to finish it, reassemble it, add some things, in keeping with Ray's wishes. Was she correct in doing so? I'm not certain. What is certain is that no cinematheque in the world should sleep soundly knowing that it doesn't have a copy of *We Can't Go Home Again* in its bunker.

<div align="right">(*Cahiers du Cinéma* #310, April 1980)</div>

LOUIS DAQUIN

I knew Louis Daquin when he was the director of the IDHEC [Institute for Advanced Cinematographic Studies], at the end of his life. It was a relatively happy time. The facilities at Bry-sur-Marne were almost humane. The Daquin-Douchet curriculum was flexible and warm, and Daquin had for a long time ceased to be that figure who, just after the war, weighed so heavily on the organization of French cinema. An ex-FCP man in the cinema, he couldn't help but reflect upon that thing (dogmatic passion) that had so possessed him but that, in return, didn't benefit him much. After a certain point, Louis Daquin stopped making films, lost his relation to what he believed he had dominated: cinema. He wrote two books, one a long time ago (*Le cinéma, notre métier*) and another, in which he enthusiastically tried to make his point, that fails to really convince us. No, it is not for his ideas about cinema, or for his convictions, that Daquin will endure, but purely because his films in the 1950s confirm that the

author of *The Mark of the Day, Maître après Dieu, Frères Bouquin-quant* and *Bel Ami* was a good French filmmaker.

This can be proven. We only have to watch the mini, very mini, homage (two films that will appear at the beginning of November) that television will devote to him.

(*Cahiers du Cinéma* #317, November 1980)

SATYAJIT RAY IN NANTES

Three of his films, and not minor ones (*The Music Room, The Big City, Charulata*) will be distributed in Paris in 1981. Finally! That is what Satyajit Ray seemed to say, traveling through Paris and agreeing to spend the day in Nantes, invited by the Festival des Trois Continents, during a press conference in the lobby of the Hotel de France. He knows that his oeuvre is not well-known in France but plays the game as a gentleman, slightly gracious and slightly exasperated. His presence is all the more welcome since the Festival dedicated its retrospective this year to the cinema of South India, and since two important filmmakers (G. Karnad and A. Gopalakrishnan) were there. Ray is—in every sense of the word—a long way from South India. Unlike others (M. Sen, S. Benegal), he has almost always refused to shoot his films in a language other than his own, Bengali, the language of great literature. He is faithful to that Bengali culture, a rare example of a successful semi-colonial culture, and he proves it by responding to questions in perfect English. The questions are sometimes very naive and he must have already answered them millions of times. Still, we learn that he has not abandoned a project coproduced in Hollywood on which he has done a lot of work, that he is confident in the future of Indian cinema, despite everything (despite the decline of Bengali cinema, for example), that if he refused to be a jury member at Cannes it's because they only sent him an airline ticket in economy class (this as a little anecdote). Nothing really new, apart from Ray's presence itself, very tall, very impressive, with a serious and chiselled face. I learn something personally: for a long time now, he has run a magazine for children, which he

inherited from his father and for which he has written innumerable stories for adolescents, the only ones that he tried to translate into languages other than his own. It's his way of not losing touch with the Indian public. About Ray, and about India North and South, we will speak more extensively in the next edition of *Cahiers*.

<div align="right">(Cahiers du Cinéma #319, November 1981)</div>

THE CRITICAL FUNCTION

THE CRITICAL FUNCTION (1).

How do we "intervene" on films? How have we, at *Cahiers*, envisioned "film criticism," the journal's principal historical legacy? There have been two types of answers, two eras, two tendencies, one hiding the other and both tarnished by a certain dogmatism.

Tendency 1: to equate aesthetic criteria and political criteria. We say, "Every flaw on a formal level must necessarily relate back to a flaw on the political level." And, on the pretext of reminding those who are prone to forget it of the "non-neutrality" of forms, we fail to examine the content they are charged with; we forget about outlining that content in political terms; we leave that task to others.

Tendency 2: to try to place "the political at the center." We no longer leave it to others to adjudicate upon political content. But, in fact, we judge that content solely by the script and in light of the orthodoxy of Marxist-Leninist theory, conceptualized more as an ultimate referent than as a guide for action, even critical action.

It is difficult, obviously, to consider aesthetic criteria *neither as equal* (analagous or equivalent) to political criteria, *nor as automatically flowing* from it, but as secondary. This difficult reality is one which we must confront.

For example, we must ask ourselves (something we have not done) regarding progressive films (for it is these films—from *Z* to *State of Siege*—that are our primary concern): how do we critique them *effectively*, how do we make them progress even further and we along with them, how do we provide concrete, simple tools to those

who are utilizing these films today, be it by positive or negative example, in cine-clubs or the MJC,[1] etc.

This question, which should serve as the fulcrum of our "film criticism" work, has been left hanging for too long. This text is a preliminary statement of the problem. Others will follow.

To write about films (to perform an intervention) is perhaps, in the final analysis, to establish the way in which, for each film, *someone is saying something to us*. In other words, the relationship between two terms: the *utterance* (what is said) and the *enunciation* (when it is said and by whom). People will say that this is stating the obvious. That every Marxist knows (as part of his ABCs) that the dominant ideology belongs to the dominant class and that a film is yet another tool for the bourgeoisie to impose upon us its vision of the world. But that knowledge remains dead, dogmatic, stereotyped and—as we know by experience—inoperative as long as we are unable to grasp, for each film, *how* it is imposed.

Even here in these pages, we have had the tendency for some time to seek this "how" in a place where no one, apart from an extreme leftist mystic, would find it: in the basic system, or in dramatic structure, or in the configuration of a movie house and the seats that it assigns. It's not that we were wrong, that all of that was false and that we ought to abandon our work in those directions. It's that by specifying obstacles that *seemed* to relate to the nature of cinema itself, we condemned ourselves to finding ourselves deprived and disarmed, as soon as we had to intervene concretely in one particular film or another.

Today it is urgent that we provide the means, including the theoretical means to *grasp the particular, specific relation that each film maintains between utterance and enunciation*. Particularly in borderline cases where this relation seems blurred, where mystification is at its strongest.

Regarding films in which the utterance predominates: In a documentary or in a television program, a discourse is maintained but

1. MJCs ("Maisons des Jeunes et de la Culture") are an association of local youth groups that were founded after the Second World War; they offer cultural, educational, and community programs for young people.

appears to be so neutral, objective, that no one in particular seems to be maintaining it. In this case, it is our responsibility to reaffirm emphatically, while providing evidence, that there are no, there can be no utterances without enunciation, no historical truths without historical context, no discourse without someone to maintain it (and maintain it within a system).

Regarding films in which enunciation predominates: in a film made by an auteur, a discourse is indeed being delivered, but by a figure who is so cumbersome (the auteur) that the discourse fades into the background. In this case, we must emphatically reiterate that behind the auteur and his rich subjectivity, a class—ultimately—is always speaking. And a class has objective interests. There is also no enunciation without utterances. Let us note in passing that these two aspects may easily coexist, as they do in Antonioni's recent film about China. An excess of neutrality (no one speaks but something specific is said) or an excess of subjectivity (someone speaks and says nothing). These are two *denials* that we must recognize for what they are. That said, they are not symmetrical; they require different weapons for the fight: the false neutrality of Bortoli's commentary on a television program about Stalin cannot be approached in the same way as the false "drift" of Bertolucci's latest film.

But these are extreme cases. Between the two we find a mass of films that still fall under the title of "critical realism," "progressive" films among them. The very phrase, "critical realism" proves how necessary it is for filmmakers to think as much about their utterances (realism) as their enunciation (criticism). In these films (whether *R.A.S.* or *Lucky Luciano*, and we can be sure that others will follow), the boundary between the scope of the utterance and the scope of the enunciation is always moving, indecisive, blurred. A blur that allows these films to function.

Take *R.A.S.*, for example. There is the time of the utterance (1956. The Algerian War. The recalled reservists.) and the time of the enunciation (1973. France. The Debré law. The "army crisis" and the youth movement.) Even if, at a distance, the utterance seems most important, you can't escape the fact that every scene of the film is legible on both levels, able to be read according to one axis or another, depending on the choices, the options of the person reading it. Let's

be clear: this double reading is not what bothers us. Obviously, a film about the French army during the Hundred Years' War must necessarily be viewed in light of Massu and de Joybert's army. It's not a double reading that bothers us, *because a double reading is inevitable.* It is the position of the filmmaker in relation to that double reading that is problematic, a position that allows us *in specific cases* to draw a demarcation line between a reactionary, progressive, or revolutionary filmmaker depending on whether he denies it, plays on it without owning up to it, or is truly responsible for it. (*To be continued.*)

(*Cahiers du Cinéma* #248, September–October 1973)

THE CRITICAL FUNCTION (2).

The people and their fantasies

Let's begin with a naked fact: commercial failure. unwanted failure for René Allio, who expected to reach—if not the masses—at least the petit-bourgeois audience who, *at the very same moment*, made *Cries and Whispers* a triumph. And so we cannot explain this failure by saying that it is an art film, of the ghetto, inaccessible. Such excuses, brandished for so long, are no longer acccptable. The important, latest phenomenon, is that great commercial success can in fact be had with films made by auteurs,[1] difficult, or even traumatizing ones. C.f. Bertolucci, Ferreri, Buñuel, Bergman. Not Allio (who is, nevertheless, well-known).

Let's begin with another fact. For us (and for many leftist critics), *Rude journée pour la reine* is an important film, a film that "sees" us, particularly because, using sounds and images, it also *critiques*

1. The auteur film, as bewildering as it may be, does not destroy the imaginary relation (dual relation) between the spectator and what is inscribed onscreen. In this relation, it is only ever *another eye*. Alongside the luminous beam that carries the images, there is the glass eye of the projector, the (absent) eye of the camera, the actual eye of the spectator and the (absent) eye of the auteur, the master. Four projections, *at least*, in one. One could claim for the spectator, the only actual character in play, a sort of hysteria: that the discourse of the Other taking place *for him* depends *on him*. That if he leaves, everything will go just fine without him.

something. Some time ago, *Tout va bien* was also a commercial failure, another film that was, in our eyes, important, another discrepancy between our critical perspective (I should say, our *interests*) and that of a disappointed audience who objected to it. A discrepancy that can no longer be chalked up to the brilliance of an avant-garde filmmaker and the feeble-mindedness of the audience because, wanting to say to that audience that they have been deceived, Godard yesterday and Allio today seek quite naturally to say it to a *larger* audience.

Common point of both films: ideology. How do they see it? A bit like something that allows—like the formation of a compromise—the condensation of that which—*it seems*—can be inscribed as is on the screen: politics and sex, class struggle and desire. Ideology becomes the "common place" where two types of discourse that have been prevalent since 1968 ("Everything is political," "Everything is libidinal") may circulate freely. For it is true that while ideology refers to the *political* power of one class over another, the fact remains—and this is a trait that belongs to it alone—that it *gives pleasure.*

Ideology gives pleasure. Ideolog*ies* give pleasure. But stepping out of ideology does not mean stepping out of desire, trading its illusions for the (scientific) profit of an overarching gaze or an unhappy (pleasureless) conscience. Pleasure does not only exist where one is blinded.[2] So what happened with Godard, and even with Allio? Their more or less acknowledged, more or less assumed refusal to envision the Other of bourgeois ideology led them—de facto—to conceptualize ideology as *something from which you "emerge."* From which you are torn, your eyes filled with tears, your illusions

2. New misdeed of the famous couple, ideology/science (as it continues to function implicitly): it is a castrating couple. In *Wind from the East*, Godard and Gorin tell us: cinema gives you pleasure and yet it's an actual war machine that the bourgeoise has erected against you. Let's subject it to critique. But once scrutinized, what about pleasure? *As if another organization of drives, of desire, weren't also a problem for proletarian ideology!* Result: the only conceivable desire is tied to the past, to "before the revolution" (see Bertolucci's evolution). As if we could still take pleasure in lost illusions, as if the old cadaver of the bourgeoisie could still give us a thrill. An entire "decadent" cinema assures us of it, but we don't believe it. In fact, our illusions are still left to lose, the cadaver still left to be killed.

exhausted. It is as if there were only one territory that were entirely invested by the dominant ideology and one could dream of nothing better than escaping it, radically changing it (a "cut" in the direction of science) or retreating into ideologically neutral zones (desire) or liberated zones (marginality). It's a bit like the story of Jeanne and her childhood dream, of the blue of the sky finally recaptured. The sky is a surface on which one may—like the blank page[3] that Mao talks about—write the newest and most beautiful things. Degree zero of positivity: everything is possible.

Two things are absent: politics (per se) and the *other* ideology, the one forged by the exploited classes in their struggle. In *Rude journée pour la reine*, that struggle forms a sort of backdrop, or background. It makes sense that it doesn't appear in the body of the film. If it did, the liberation won at the end might be read as the liberation of politics as well. Whereas by maintaining politics in an implicit state, Allio leaves us free to imagine that after the final image it could— *also*—inscribe itself on the blue of the sky.

"Emerge from the dominant ideology." *Rude journée*'s brilliance is that this positivity duplicates itself, that it has two bearers. Two positive heroes: Jeanne and Julien. On the one hand, Jeanne, between the bourgeois dream and *her* own dream, between that recaptured dream and—who knows?—a new attitude. On the other, Julien, between his projects and his actions, one being the obstinate and seamless execution of the other. This duality, this double system of positivity, is the strongest part of Allio's film, its most beautiful ruse. Because what we would like to know, which creates a problem, is precisely the opposite.

1. What will Jeanne *do*, once she's reclaimed her dream?

2. What does Julien *dream* of, the rebel, the realist, the fighter?

An indispensable question. How do we *effectively* combat the dominant ideology if it isn't opposed by another ideology? If one isn't able to draw upon its origins, its victories, its linguistic spaces and provisional

3. It's the theme, so precious to Allio (*The Shameless Old Lady*), of *old age* that allows us to turn this page. Ambiguous theme: Jeanne gradually arrives at the conclusion that her childhood dream has been stolen from her, that a dream has been imposed upon her of a woman who doesn't resemble her. But that *woman's* life will end; she is threatened by old age (the film is narrated from Jocasta's perspective). There is something perverse about the film: Jeanne abandons her dreams but she must also abandon what they were tasked with disguising.

auras? If merely the phrase, "proletarian ideology" inspires fear, as it does the F.C.P.? How do you not find yourself caught in a problematic of alienation, of ideology, like the one from which you "emerged"?

How can a film combat the dominant ideology? By confronting, within the body of the film, the concrete reality that serves as its foundation? Yes, but not only that. If that were enough, a film such as *The Man from Acapulco* (by Phillipe de Broca) would be subversive. But what do we see in *The Man from Acapulco*? Two series, registers that are clearly opposed (miserable reality/sublime fantasy) and linked by the Belmondo character, a powerful catalyst [*embrayeur*]. Does this mean that in this *system of referrals*, reality critiques anything and everything? Is the ridiculous dream (pulp fiction) disqualified from being juxtaposed with its concrete, formative conditions in the novelist's mind?

We say: no. We could even argue that the opposite is true: there is a reciprocal *valorization* of the two terms in which we no longer know who has authority over the other, who is performing the critique and who is being criticized. We could go even further: for some, the pleasure (even raging, scandalous) found in the idiotic aspects of bourgeois ideology (as it spreads, for example, in advertising or in the press) is reinforced by the fact that they *know* exactly what's going on. The pleasure of not being conned. How smart one feels in front of advertising! You need only hear a message such as, "Coca-cola, today's answer to thirst, love what is true, now or never..." to be able—by deconstructing it—to move through all of Western metaphysics...

And how we would love to share this intelligence! "We" being the intellectuals, the specialists, the critics, us, and Allio, too. "We" are on the left. Suppose "we" observe that the alienated masses continue to buy *Nous Deux*[4] or turn *Rabbi Jacob* into a hit; their first thought will be more or less this: whereas I am able to swallow these ideological products as is without being bothered (because I know that the bourgeoisie is speaking through them and I can decode, translate, and hence neutralize its discourse), the general public will be deceived, duped, stupefied. We must then come to their rescue, demystify the noxious product, bring the real, the concrete, into a

4. *Nous Deux* is a widely popular weekly magazine created in 1947 which specialized in romance stories told through the use of photographs. The genre is referred to in English as photo comics or photonovels.

scene that's been encumbered by bourgeois mythology, advise the masses not to "forget themselves" at the movies, demand on the contrary that they find themselves there, themselves and their problems.

This noble mission, in general, fails. It fails because it never crosses the intellectual's mind that the masses, as they consume those products concocted for them by the bourgeoisie, that subculture that aggresses *and* pleasures them, *secrete their own antibodies.* This point is likely the most essential one that faces us today. Resistance to the dominant ideology does not consist, from the point of view of the consuming masses, in placing the object (an advertisement, an image, a film) at a distance, recognizing that it is false, rebelling against all of its lies, dissecting the object and preparing to fight against it. That scenario is only ever an intellectual fantasy that projects onto the masses *its own* point of view and that never truly understands *what the mode of appropriation of the dominant ideology's products by its victims* entails. And that mode of appropriation is qualitatively different from what it is for an intellectual, for a specialist, for the very reason that the masses don't have to *produce a discourse* on these objects.

It fails because of the fact (which constitutes the greater part of ideological oppression) that even though he is the bearer of discourse, the intellectual, the specialist, the semiologist, the expert (even a red one) has a *specific* point of view about these products. In order to add (as Barthes says on the subject of structuralism) "intelligence to the object," he needs to respect that object, arrange it, prepare it (in the culinary sense), reproduce it in the same way that a mechanic dismantles a motor or a magician performs a trick. Representation, in the sense of "iconic figuration" as well, is thus an important stage in his work. It is a representation (a new presentation) in view of a discourse (demystification). *Conversely, the representation of an object on which they have no discursive hold is, for the masses, an empty problem.*

What is the bourgeois dream (and also the revisionist dream) in terms of culture? To democratize culture, facilitate "access," encourage the masses to give a discourse on what the culture produces, an enlightened discourse, a specialist's discourse. To give them speech but only on the condition that they speak about objects they haven't created and in a language that doesn't belong to them. Corollary: that they remain mute about their own cultural or creative activities. A

bourgeois taste exists for factory workers, which is all the more tenacious because they are sheltered from any critical discourse.[5]

What do we know about the mode of appropriation of this subculture's products by its target audiences? What do we say when faced with the response: it's not important, it's only a movie, it's a joke? Is it effective to demonstrate, to illustrate quietly, that even while laughing, we're playing the bourgeoisie's game? What do we know about forms of "resistance" to the dominant ideology? Not much. A filmmaker who doesn't ask this question (and we don't mean Allio, who asks it all the time; cf. *The French Calvinists*) runs the risk of starting from *his* own point of view and staying there, unilaterally, the point of view of discourse's guardian, someone who has interiorized the division of labor and who needs, in order to dismantle an object, to flatten it, represent it.[6]

Representing representations. A difficult task. The spectator must not only recognize what is going on, which is not easy, but distinguish between the images that "critique" and those that are critiqued, accept that cinema is a "*metalanguage*," that a sound can critique an image, an image a sound, etc.

It is to consider the problem of *identification* as already resolved. The spectator isn't seeking recognition. No one identifies with his own image. The screen is a cage that imprisons desire. A "hysterical" desire.[7] What is sought is an Other through which one will be able to imitate discourse. In the mind of the leftist intellectual, this Other may very well be the proletariat, or even better, the proletariat who is in the process of becoming aware (hence our love for *Rude journée pour la reine*, our sensitivity to its accuracy, its truth which is also our own).

5. How does the split between the amateur and the professional function *for the bourgeoisie*? How is it experienced by amateurs? To act, paint, sing *for one's own pleasure* would mean to reside in a ghetto, the accursed share troubling no one, existing outside of the double circuit of money and *discourse*. The art of amateurs has no exchange value. Nothing remains of its consumption.

6. What does Dario Fo teach us today? That the dominant ideology does not first distance itself to then be critiqued by the struggling masses. But that they *return* (detour *and* return to sender) to their masters.

7. "Hysteria" here is only a descriptive term that refers, not to a nosography, but to the problem—political—of the mode of existence of the proletariat's discursive forms (including criticism). Imitating the discourse of the other means, too, that you aren't able (not yet!) to maintain it yourself. The hysteria of the oppressed does not mean the same thing as that of the oppressors. It does not *treat* itself in the same fashion.

But it would be useful to understand the concrete reception of these films in greater depth. Investigative work, in its most modest sense.

Today (which cannot anticipate tomorrow, or *elsewhere*, see China), the image of cinema, despite (or perhaps *because of*) its promotion as an object of a discourse and of an education, continues to possess such power of *assertion* that it can only, in the best of cases, enter into a system of referrals, auto-referential and autovalorizing. *One image cannot critique another image.* This assertive power is not metaphysical, it is only the opposite, the consequence, of the spectator's silence. Silence in the hall during the film, silence after the projection. Who *speaks* about cinema today, apart from critics?[8] This assertive power confers upon the film a sort of positivity of fact, a naked power to affirm. Until further notice, *the film, like the dream, does not know negation.*[9]

(*Cahiers du Cinéma* #249, February–March 1973)

THE CRITICAL FUNCTION (3).
ON UTTERANCE AND ENUNCATION

Who says what? Where and when?

"Nevertheless, in any class, in any class-based society, political criteria must come first and artistic criteria second."

—Mao

1. An idea to destroy

We must abolish this popular misconception: the concern that "positivity" (the positivity of a message or a hero) belongs only to propagandists, party men, sectarian and Zhdandovian dinosaurs. It is nothing more than outdated and tiresome obstinacy to demand

8. We must stop pretending to believe that a film has to power to divide all of France, or even an audience. It has to do with a theatrical exigency, Brechtian perhaps, that is tricky to apply to cinema, *mute art, tel quel.* You can—a sign that contact is always possible—hurl an insult or a tomato at an actor on stage, but you can only ever walk out of a movie.
9. Conversely, it feeds only on *denials.*

conscious heroes, explicit messages, and a specific political argument; it is edifying (in a religious sense) and, as they say, "heavily didactic." In its place, in 1974, bourgeois filmmakers (Malle, Cavani, etc.) operate according to a sort of "decoding," to such a degree that they no longer even try to prove anything at all. Fascinated by the inexplicable, they in fact no longer explain anything, remaining content—supported and valorized by servile criticism[1]—to "dare to show" what only yesterday was concealed (sex and politics and what passes for the privileged site where they meet: fascism). They are praised for their courage, and people are grateful to them for doing away with Manicheism and offering them, in a delicious suspension of meaning, tragic dossiers of the kind that television is forever reopening: the Occupation, racism, fascism. Their positivity ultimately resides in the fact that, in place of generally accepted explanations, they substitute either a lack of explanations or a glut of them. Too many or too few.

We do not intend to replace *their* "ambiguity" (another fetishistic word) with *our* certainties, be they Marxist-Leninist or otherwise. To re-establish, in response to Malle, the nobility of the Resistance (which he does not deny) or in response to Antonioni or Yanne, the spectacular achievements of the Chinese people (which they fully acknowledge—just like Peyrefitte) is a correct but defensive approach, a minimal approach. For ambiguity is not the absence of knowledge or a sort of precarious knowledge (in which case it would be enough—armed with superior, even absolute knowledge—to fill in the blanks) it is *another* type of knowledge. Malle and Co. are not filmmakers of the inexplicable (despite their inner conflict), they are filmmakers of the *inexplicit*. The inexplicit is not the opposite of positivity; it is one of its forms (and a dominant one, even).

This can be stated in another way: every class possesses its own style of ideological struggle, its own way of conveying its view of the world, its (positive) ideas. Positive: that is to say, effective, appropriable, usable. Bourgeois propaganda isn't created in the same way that revolutionary propaganda is, nor information, nor criticism, nor art.

1. Example of "impressionable" criticism: Bory (on Cavani): "Where reason shows itself to be powerless, where logic collapses, where morality is beside the point, where darkness, the unconscious, the unavowed and the unavowable prevail, how can you analyze? It's better to show."

The idea that must be destroyed is this: that positivity is a special case or an aftereffect of the past. There is no split between the "system" (art or commerce, or art *and* commerce) on one side, and "militant" films (politics without art or commerce) on the other. Positivity is not the exception, but the rule. *All* films are militant films.

2. A film is always positive for someone

A class communicates its positive ideas, its "natural" understanding of the world. That means that it establishes them (when it comes to cinema, places them *en scène*) in such a way that they are not only legible, recognizable, but appropriable, able to be transformed into something else, into material power, for example. Take ideas such as, "Who knows why people do what they do?," or "There's something of the torturer and the victim in all of us"—two fashionable, retrograde stereotypes; while they may in fact assume the form of negative or indecipherable formulations, they are nevertheless positive ideas *from the point of view* of the bourgeoisie and its immediate interests.

And these ideas are all the more harmful because they aren't made explicit in the body of the film. The hystericized spectator draws "liberally" from the lesson being whispered in his ear, cuts along dotted lines he cannot see. In return, the film's implicit discourse (re: the raw uses of connotation, see *infra* P. Bonitzer's text) unleashes an interpretive delirium in the spectator that makes him forget the poverty and banality (sometimes stupidity: Cavani) of the lesson.[2]

Why is the question of positivity not (not only, not exactly) the question of meaning, of signification? Because the question of signification is, taken by itself, a meaningless, insignificant question. At *Cahiers*, our rallying cry has been, "A film is not something to be seen; it is something to be read." Absolutely. But that reading, that search for "discrete elements" here, "bits" of information there, is not very useful (apart from nurturing academic rumination and feeding semiologists) if we don't know what's happening on the receiving end. The critic knows how to read a film; he must also know how

2. This is the case for advertising where, as P. Bonitzer has suggested, the manipulation of the advertising message appears less and less as a shameless conditioning technique but demands to be recognized, studied, *desired* as such. Advertising knows all about desire, hence the signifier.

others, non-readers, read. And to know that, there's only one method: surveys. For it is not only about reintroducing the receiver into communication theory, neither an abstract receiver (the audience in general), nor even a concrete receiver (a given social group, a given individual); we must consider that the receiver is also something other than a receiver, that he—*just like the film he is seeing*—is caught in the class struggle, is an actor within it. The question of positivity (For whom? Against whom?) is based in that struggle and its vicissitudes. And based in that struggle, we may begin to respond.

3. 1974: Even for Pariscope,[3] there are political films

For whom? Against whom? It's not our dogmatism or our inclination for clear-cut oppositions talking. For while this question, the one of positivity, is never asked by the bourgeoisie (that would mean asserting the class nature of its power), it is forever *answering* it. And today more than ever before. In 1974, throughout *every* layer[4] of the entire system of film production and distribution, in France and certainly in Italy, right-wing filmmakers have taken the initiative. With films that are reactionary, dated, fascistic (or weak, fascinated by fascism, thus—and this is what's troubling—incapable of *struggling* against it), Malle, Oury, Yanne, and Co. have launched an ambitious program (politically, ideologically, *formally*): to propose a new image, a new characterization of France and its inhabitants, the French, to represent onscreen the "average Frenchman" and his two Others (the two objects of his increasingly overt racism): those who are not French (foreigners) and those who are not average (the excluded, the marginal). In other words: bourgeois ideologues and artists are working diligently to establish a new image of the *French people.*[5]

3. Pariscope: organ of the lumpen-intelligentsia. Desperately tries to imitate intellectual debate on the Parisian scene. A Filipacchi publication.

4. Throughout *every* layer. Nothing would be as false as opposing auteur films to the commercial ones. This division exists but it is secondary. From *Lacombe Lucien* to *Chinois a Paris*, via *Le Fuhrer en folie* (Philippe Clair), it's about the same ideological current.

5. Which does not happen automatically. A class, when even in power, does not discover its active ideologues overnight, in relation to this or that situation. It too must work, or rather, cobble something together. And one cobbles something together from one's heritage: here, a certain tradition of French cinema (Pascal Thomas lays claim to Renoir) or a reassuring academicism (Malle, Granier-Deferre). A return to cinema history, yes, but an *acritical* return.

Consequence of this landslide (the death of Gaullist ideology, the death of Pompidou, the crisis of humanist bourgeois discourse, the obligation to fix it): we can no longer limit ourselves to critiquing mainstream cinema as we have for years, shaming it for not "sticking to reality," neglecting certain subjects, excluding or repressing others. It's no longer a simple matter of repression. It's not enough to reproach bourgeois filmmakers for not talking about politics, or sex, or work, or even History, since *they* are the ones taking about these things today. The bourgeoisie can easily hold a (bourgeois) discourse today about something that only yesterday it obscured: it can film sexual debauchery if it preserves its monopoly on a normative (educational) discourse about sex. It can anchor its narratives in History if it empties that word of all content. That is how Malle's "decoding" operation works (sex: *Murmur of the Heart*; History: *Lacombe Lucien*; conditions of the working class: *Humain, Trop Humain*.)

Faced with this decoding, "progressive" filmmakers are weak, lost. An example: How do you explain the fact that, at the same moment, two films like *Lacombe Lucien* and *Violins at the Ball* (*Les Violons du Bal*) can become commercially successful? Because they resurrected for the general public a part of France's recent past that had been buried or mystified for too long. And yet, the two films don't occupy the same territory, don't fight against one another. The humanist denunciation of racism in Drach's film would only have an impact against a cinema that suppresses racism, that refuses to speak about it. Then there would be an interest in, and urgency for denouncing it, even abstractly. But that denunciation, in light of Malle's film, appears as what it actually is: humanitarian and inoperative. For what Drach must suppress (class contradictions) in the name of his abstract humanitarianism, Malle affords himself the luxury to inscribe it (Lucien, the illiterate peasant boy, etc.). What Drach erases, Malle exaggerates. For it is obvious that this inscription does not make Malle a progressive filmmaker (any more than it does Kazan with *The Visitors*): for him, class contradictions are no different than other contradictions, always surmountable and absorbable in a metaphysical, universal vision in which they become accidents, particular (historical) cases of

an ahistorical cleavage: the eternal neither-black-nor-white of "human nature."[6]

Consider this: fascist ideology—and this is one of its specific traits—*recognizes* the existence of contradictions, of class struggle (most often to condemn it, to "overcome" it.) *Understand that today, the struggle must concern itself with point of view and no longer only choice of subject.* As our Italian comrades in *La Commune* remind us: "It is not enough to oppose the false information of the bourgeoisie with counter-information; the information we provide must propose a different idea of the world." For filmmakers of all stripes, in this nearly open combat, on the level of their *craft* as filmmakers, a *single* problem emerges: HOW CAN POLITICAL STATEMENTS BE MADE CINE-MATICALLY? HOW CAN THEY BE MADE POSITIVE?

4. Utterance/Enunciation (once again, and to be continued)

There is another name for this political mise-en-scène: enunciation. It consists of the articulation of two principal terms: the *bearer* of the utterances (who speaks? who who has the floor?) and the *territory* on which they are brought into play (where and when? in what context?) The nature of the relationship between the utterance [*énoncé*] and its enunciation [*énonciation*] establishes the film's positivity (*whom* does it serve?). That is why criticism is not about redoubling the film with a complicit or, as Barthes puts it, *cosmetic* discourse. It doesn't even mean unravelling or laying it out. It means *opening it up* along that imaginary line that runs between the utterance and enunciation and allowing us to read them against each other, in their problematic, disjointed relation. Not to be afraid of destroying their fictitious unity (the "present" of cinematic projection) where they're given to us.

6. There are two ways in which bourgeois ideology does not think about, glosses over, contradiction. Either by not seeing it anywhere (universal harmony) or by seeing it everywhere (universal contradiction). It's the second solution that Malle zealously chooses, an application that makes Lacombe Lucien almost touching. One would like to announce, as in a film, in alphabetical order: torturer/victim, country/city, culture/nature, desire/law, son/father, man/woman, jewish/non-jewish, peasant/bourgeois, Resistance fighter/collaborator, etc. One could say that excess is the enemy of the good and that all of these contradictions are not on the same level. But that is where Malle succeeds in his sleight-of-hand trick: making us believe that we're witnessing an analysis. For him, not only all of the contradictions of the capitalist mode of production are there, but they are all principal! It is clear that under these conditions, and with the inability to hierarchize, Malle and his heroes will never understand anything.

No utterance without enunciation. This is not wishful thinking, but the reality of every discourse, of every fictional film. It is what allows us to avoid the trap of a "content-based" criticism (the trap set for militant criticism, one in which it is often caught). For a critique of content that only assesess the truth value (or falsity) of utterances, that overlooks how those utterances function in the organization of the film will find itself singularly powerless, ineffective (and quickly reduced to outrage or dogmatism) when it must intervene in day-to-day ideological struggles. "The belief in the intrinsic power of the truthful idea" is not enough, no longer enough, was never enough to lead a struggle (either political or ideological) to victory. As S. Toubiana reminds us, regarding *La villeggiatura*: "Just because a character makes a righteous speech doesn't mean that the film and the auteur's discourse reclaim and assume responsibility for that discourse."

For what characterizes discourse, a statement, is that it can be made, quoted, repeated, *carried* by anyone. Between these three terms, utterance, bearer, and territory, there is no obvious, natural relation: it is always a *combination*. In a future text, we will try to *describe* some of its figures. The list is long and varied: utterances without bearers, badly delivered, or delivered too forcefully, lost, stolen, hijacked utterances, etc. But there is one figure of this combination that we encounter every day: when a (politically) true utterance is co-opted by its worst enemy, on a territory where that utterance becomes the loser.

One example (among thousands): not very long ago, l'ORTF presented a short film about prisons. As the camera fluidly panned over the white walls of a model prison, the off-camera commentary adopted *for itself*, and in its own words, a number of claims and questions that had been posed *elsewhere* (elsewhere: everywhere except on television, in CAP[6] for example) by the prisoners. A "content-based" critique would be satisfied by that and see in it, justifiably, the effect—reading into the film[7]—of the prisoners' actual struggle, without which television would never have been compelled to make

6. CAP (Certificat d'aptitude professionnelle) is a vocational education that takes place after middle school.
7. Inscribe, read into. This cliché ought to be considered historically. One example: when Resnais was shooting *Muriel* (1963), the Algerian war and torture were off-limits to filming. Reading into that prohibition, giving it consistency in the form of an empty

the film in the first place. But isn't it obvious that there is an *intrinsic* difference between this kind of film and *Attica*? A difference that could be briefly summarized as follows: not only are the prisoners in *Attica* the bearers of true *utterances* that speak the reality of that revolt, of every revolt, that speak it against the lies of the authorities, but they are also the ones for whom the utterances are true (and appropriable for the mobilization of *their* impending struggles); they are their "correct" bearers. In the end, they bear them on a territory (the occupied yard that, once it is filmed, becomes a set) that they built themselves, a mise-en-scène, creating the material conditions for their enunciation, "directing" a great film.

(*Cahiers du Cinéma*, #250, May 1974)

ANTI-RETRO (CONTINUED) AND THE CRITICAL FUNCTION (CONCLUSION)

Two false couples

I would like to return to *The Night Porter* and to one scene in particular, located towards the end of the film. We see the night porter (Max) meet his friends (Hans and Co.), who like him are former Nazis and who like him are liberating themselves from guilt—forgetting the past—social reintegration. More precisely, Max *appears* before them, because he has scores—regarding the liquidation of his past, which is tied to theirs—to settle. The scene takes place at the top of Saint Stephen's Cathedral, in Vienna. On Hans's side, icy seriousness; on Max's side, in contrast, irony and derision. To cut short the interview, which weighs on him and promises to be fruitless, he parodies a Hitlerian salute to which the others—reflex or return of the repressed?—respond, giving him time to slip away.

and all the more troubling signifier ("Muriel," to be precise), lifted the veil on the ruse. This is what revisionist critics forget when they read anything into anything. A tidy, manipulative reading of a inscription that threatens no one is no longer a ruse but a compromise in which filmmakers (and critics) agree that they no longer have to define themselves (define their practice, their weapons) when faced with what a political power prohibits being filmed.

At this *precise* moment in the film's development, the audience *knows* a certain number of things about the night porter. We have seen him find his favorite victim again "by chance," reconnect with her, etc. Having been placed in the position of voyeur (another eye), we *know* things about Max that the others (for example, Hans and the others) do not. We are the masters of this story that is told only for us. Hans and the others *are doubly wrong*: first, because they were Nazis and remain so at heart (they still desire power); second, because they are unable to see, know, suspect anything about "what's going on" with Max, in his head or in his apartment (his "interior"). Double inferiority. One refers to content; the other refers to the mise-en-scène of that content *in and through* a narrative. The spectator, on the other hand, is *doubly right*: first, because he is not a Nazi, and second, because he is able to see, know, and—who knows?—understand the mad love between Max and Lucia. Double superiority. One refers to a clear conscience, the other to the reaffirmation of that clear conscience *in and through* a narrative. Suppose there were a law that we ought to know, a law applied to the fictional economy: a narrative (the web of events that are seen, understood, implied, everything that establishes the *internal knowledge* of a film) is not only a mystery for the actual spectator, but also, in the imaginary space where he encounters them, for the fictional "characters" themselves, shadows that, also, want to know more, see more.

This knowledge (about the film, internal to the film), this mastery, this clear conscience *comes at a price*. Let's return to the scene at the cathedral. The spectator *must choose* between Hans, the neo-Nazi seeking a return to society, and Max, the ex-Nazi who is willing—fairly romantically—to die for it. He will side (whether he is aware of it or not matters little) with the one who "assumes" his Nazi identity and rediscovers his humanity[1] (Max) over the one who

1. There can be no retro mode without a debate about human nature, without bourgeois humanism. No such debate without the preliminary repression of class distinctions. In Cavani, this takes the form of a neutralization. It is necessary that Max was socially dominant (connected to Nazi power) and Lucia the victim of that power (dominated socially), and the opposite is also necessary (Max a night porter, and Lucia, who married rich). The effect of "human nature" is produced by a certain way of inscribing class struggle as a simple struggle for position, a game of foursquare in which the one who loses wins. This is easy to prove a contrario: the story of *The Night Porter* played by a proletarian couple would inspire laughter (c.f. Reiser in *Charlie Hebdo*), and in the upper classes, boredom.

represses his Nazi identity and hence seems entirely inhuman (Hans). He will side with madness and humor over primness and asceticism, with the victim (previously the torturer) over the killer (previously *and* currently the torturer). *The entire film, in a sense, must arrive at this choice,* make it seem natural, clear to us. Refusing this choice (in the darkness of a movie theater) would mean refusing to see the film, refusing to enter it, to be that extra eye. But as we know, the film has had a large audience: 336,107 tickets sold as of September 3, 1974.

Not so long ago, a television series, "Les Dossiers de l'écran," dedicated a program (a film and then a debate) to Count Ciano. The pretext was that the countess of the same name—Mussolini's daughter and Ciano's widow—had—finally !—agreed to participate in the debate. The film preceding it was the feeble *The Verona Trial,* by Carlo Lizzani. The question it raised was to what extent Ciano, fascist but Germanophobic, had distanced himself from El Duce (who executed him). Already in the film, when forced to choose between an absent (but all the more present because of it) Mussolini and a weakened, human Ciano, plagued by doubts and uncertainties, it's difficult for the television viewer not to "sympathize" with the lesser evil of the two, meaning with Ciano (even though he certainly would have "sympathized" with Mussolini if the choice had been between him and Hitler). In the debate that follows, no mention is made, directly or indirectly, of the Italian resistance. It is as if the principal contradiction were between Mussolini and Ciano, the latter representing *from within fascism,* everything the Italian people resisted and fought against fascism. Let us also add, for the record, the widow Ciano, who said completely frivolous things during the debate, nevertheless had the final word, affirming that fascism (although she did concede, "Maybe I'm stupid?") had been, and continued to be, "the best thing for Italy." Which P. Cardonnel rightfully railed against in a recent letter to the editor in *Le Monde.*

Either/Or

What do these two examples (Hans and Max, Mussolini and Ciano) have in common? They PRESENT A CHOICE (an obligatory choice, an imposed arbitration) BETWEEN THE LESSER EVIL OF TWO

TERMS (preselected from within the enemy camp). The principal contradiction (the real one in relation to which we must situate ourselves) is displaced and crosses over into a single camp, that of the enemy. Knowing who, between Hans and Max, Ciano and Mussolini (and we suspect that the list is endless, that these false couples are innumerable: Hitler could be opposed to Röhm, Nixon to Wallace, Guy Lux could be weighed against Michel Droit or *Pariscope* against *Ici-Paris*, etc.) is the lesser evil becomes the only question asked and, quite rapidly, the principal question. The important thing is that in the displacement of the contradiction, the spectator *gains* something, a gain that is of the order of realized desire: an overarching, privileged position, a release from History, the right to enjoy the spectacle of contradictions between the major figures in this world, the right to choose between them. (As it goes for the entire concept of History "for the people," Historia, etc.) Nothing's more fictitious than the right accorded by a fiction. The viewer, manipulated, joins the televised housewife who chooses, between two piles of laundry (by smell or by touch, I don't remember which), the whiter pile and ignores the fact that she is doubly mise-en-scène: by l'ORTF on one side and by a corporation like Unilever on the other that affects—at its core—a competition that is all the more frenetic because it is an illusion.

We are saying: the spectator's knowledge comes at a price, control has its underside in submission. This submission does not exist solely in cinema: we choose between two presidents, two answers, two names, two detergents, with always the same *either/or*, always forgetting that we can *refuse* to choose between *those terms*, demand other, more equitable terms that better conform to our interests. For there is only ever one question: knowing *who is asking the questions*.

Let's go a bit further. It is characteristic of bourgeois ideology to ask us, about everything of (or without) relevance, to "choose." It is characteristic of the "retro style" to always locate this choice inside an enemy camp of the past (while saying nothing about today's enemy). To fight against this double mechanism means not only critiquing the first aspect (the way in which the bourgeoisie—in general—asks questions) but also to oppose it with *another* system of questions. To do this, we require two things:

1. What I will call a *"theory of the obligatory choice"* (arbitration) whose objective would be to illustrate the device of "either/or" wherever it operates (elections, of course[2]—surveys, boxes to check, polls—*fiction*) and to demonstrate that it is a manipulatory device, hence a device of power.

2. What must be called (and not only as a matter of wishful thinking) *a definition of the people's camp in 1974*, the only way to sketch out, even roughly, a line from which we may begin to relearn how to ask questions—our own.

The obligatory choice

I must now ask a question that you must already have asked yourselves. We know that *The Night Porter* is not seen by an abstract "spectator" within the class struggle, but *principally* by a petit-bourgeois audience whose ideologies and fantasies it endorses and repeats (and, in the bargain, confers upon them the dignity of a work of art). Thus it is dangerous to assume that the reactions of a popular audience to this particular film will be the same as those of the intellectual petit-bourgeoisie. At issue here is the audience's social class. We must address it in two parts.

1. The apparatus of the "obligatory choice" is internal to bourgeois ideology. It *defines* itself according to the way in which it is taken over, internalized, by the different classes dominated by the bourgeoisie. Experienced (taken over) by the bourgeoisie or experienced (suffered) by the basic masses, it takes different *forms* (and we must work to understand these forms, investigate how films are practically received).

2. For which the electoral system is the ultimate model and guarantee. The late Murray Chotiner, the man who shaped Richard Nixon's political strategy, estimated that the electorate voted in general against something or someone, rarely for. In fact, choosing the lesser evil has become the rule in American elections. The further the electoral machine is from the masses and the actual political life of the country, the more it must make shine in its heart (*star-system*) the *minute differences* that it can still direct [*mettre en scène*] there; it deploys treasuries of energy, money and talent. The same could be said for a particularly idiotic presentation by the ORTF, minus the talent ("*L'antenne est à vous*") in which Saturday afternoon viewers vote: for one Western against another, for one cartoon against another, for one song against another. The point being that they experience these small differences like abyssal differences and their vote like an absolutely demiurgical action.

2. Another *specification*: relating to the medium of film in particular. There is a *hysteria*[3] inherent in cinematographic projection.

ARBITRATION. Let's return to our dual example. The television program about Ciano was not aiming to make the television audience reflect as much as to provoke an affective taking of sides. Let's propose the hypothesis that a popular audience, even when faced with choices that are not their own, choose one side or another. It is—as with the travesty of the bourgeois mise-en-scène of sports—the logic of the *supporter*. But it is also, once re-established, a logic of *commitment*. Inversely, the petite-bourgeoisie—in the very form of its fantasy—interiorizes the two sides, the two terms of the choice, *assesses and keeps score*. It is, to follow the sports metaphor, the logic of the *referee*. Arbitrating for a divided, hesitant, ambivalent class is a way to preserve its existence, to give it a little weight, a little meaning. Arbitration means knowing the rules of the game and enforcing them. Legalities: taking the Other at its word; the Other: the bourgeois.

This results in different *attitudes*. In the very excessiveness of "taking sides," the partisan can always see the ridiculousness of what he's supporting and positively reinvest its excess. The referee easily persuades himself of the importance of his role; the game, he thinks, could not be played without him. He easily forgets that the class struggle has no referee.

This idea that the class struggle can be monitored at a distance and arbitrated, as false as it is, abounds, even at the heart of the basic masses. Revisionism has something to do with it. Class warfare cannot be presented with impunity in terms of peaceful competition, the masses cannot be asked to judge the *less terrible manager* of bourgeois affairs on the evidence they are given without reinforcing among them the ideological hegemony of the petit-bourgeoisie (hegemony for which the general idea of "arbitration" is a centerpiece).

That is why it is futile to try and reassure oneself by saying that *The Night Porter* is only a petit-bourgeois film, nothing more. In cinema, the penetration of the dominant ideology into the heart of a popular audience means: joining of the auteur film (thought, reflexion,

3. And this hysteria can't be exchanged (not only) with the illusory mastery of the one who *knows*. Cinema uses knowledge, but only to affirm what's at its deepest core, *faith*.

audacity, signature) with the cinematic tradition of concentration-camp-porn, a "popular" tradition whose many recent examples include *Love Camp 7* or Jacopetti's fetid *Goodbye Uncle Tom*. This junction is precisely what *The Night Porter* performs.

HYSTERIA. The fantasy of arbitration (knowing the rules of the game, enforcing them and, in that game, taking the Other at his word) doesn't go without the spectator's *position*. The hysteric is prisoner to the discourse of the Other. Fiction has no better fuel than the *desire for that discourse*. It only grants the desiring spectator entrance into the rectangle of light for him to choose (an obligatory choice) between two Others (the enemy camp) the person whose discourse he will support and uphold. That is what Hollywood film-makers have always understood. Take Hitchcock. What better metaphor is there for the location of the spectator (of hysterical desire) than *North by Northwest?* A man (Cary Grant) is mistaken for an Other, an Other who is about to be murdered. To save his skin, he tries to become this Other. He doesn't succeed; the Other, in fact, does not exist: *he is a fictitious character, created by the FBI* as bait for spies (on the Soviet payroll). It's Cary Grant (and not the Other whose identity he wanted to assume) who chooses, by his own free will, to help the FBI. In the film, as in the reality that produced the film, FICTION IS A POWER STRUCTURE.

The people's camp

The fiction[4] in question here, the one that forces us to choose from within the enemy camp, must be fought against, and therefore understood. We must say why these couples, these choices, are false, why the central contradiction—yesterday or today—doesn't take place between Hans and Max, Ciano and Mussolini. It is not a

4. The famous thesis of the "neutrality of forms" requires another thesis to survive: that only one ideology exists, the dominant one. These two theses, taken together, allow two others to be crossed out: one that says that forms are not neutral, that they in turn per-form an action (in other words, that they are dialectically linked to the ideologies that invest in them), the other that affirms that something exists that resists the dominant ideology and that must be called, for lack of a better phrase, proletarian ideology. That ideology needs, will need, forms; it needs to know that fiction, for example, is not an empty shell, but a power structure, so that it can interrogate *its own* power (its ideological hegemony).

question, it goes without saying, of *negating* these contradictions, but it is urgent that we no longer tolerate, even in a film, their functioning as principal terms. It is not a question, it also goes without saying, of negating what there is to learn, what teachings we may glean, from these contradictions, but "teaching by negative example" doesn't work, is nothing more than an idle trap, unless an alternative, a positive ground, *already exists* in relation to which the negative can be situated, hierarchized, criticized and thus can become rich with teachings. Or, the question of the positive alternative is strictly, directly, always *political*. What is the central contradiction today, in France? Where is the analysis of class in French society? These questions are not too broad, too general. To the extent that film criticism would like to intervene politically in the ideological struggle, it must connect, *beginning from* (and not confining itself to) its specific site of enunciation (the cinema), to what it considers to be, establishing itself across the popular struggle, the people's camp.

To do that, it is not enough to recite "On the correct handling of contradictions among the people," to say, with Mao, that "the notion of 'the people' takes on a different meaning according to country and historical period." Or to remember that there are different types of contradiction and hence different modes of resolution. These *principles*, infinitely true, run the risk of no longer being true if they function as dogma. Mao said: "Dogmatism is lazy." Lazy if it doesn't take into account the content, actors, issues at stake in these different kinds of contradictions. Fighting dogmatism means, when critiquing a film, not shrinking from the question that has today become unavoidable: IN WHAT NAME DO WE WRITE?

In what name do we write?
Let's return once more to our point of departure: the retro style. Its "merit" was to shed light on the weakness, the lack of impact, even the errors of a *critique of principles*. A critique of principles, that only plays on moral reprobation. A critique of principles, that reproaches Malle or Cavani for the philosophic presuppositions of their films. These presuppositions are based on the most hackneyed idealism. But precisely, the struggle against idealism is eternal (Engels). A

critique of principles, finally, that is based in opposing these films to "historical truth." *But that truth is not a given.* It cannot be reduced to a formula such as, "Gradually, the desire to fight returned to the French people" (Foucault)[5] or hollow clichés such as, "The French people heroically resisted." That truth requires a body to be constructed and reconstructed, while not repressing the *fact* that the image of the French Resistance, for example, has been monopolized by Gaullism and the FCP, to the exclusion of all others. Now that extensive writing about that era is being published, now that a man like Guingouin has finally published his memoirs, it is a matter of saying: this image *can* be constructed, the image of a *maquis* organizing the people for the post-war era. It is a matter of saying: there we have the subject for a film. And to add: our comrades have done the same in Italy with *Lotta Continua*.

In what name do we write? In the name of something that is not a given, but whose seeds (embryos, scattered elements, etc.) exist, repressed, disguised, often unrecognizable because they are differently coded. How do we build upon these elements if we are not able to encourage them when they surface, to resurrect them when they are buried? That is when principles, as we sort through them, become a great, invaluable help to us, and when experience of our Chinese camarades, for example, becomes something other than a dreary recitation.

In the various challenges of the class struggle, the enemy can only score a point if there is, on the other side, a weakness. A weakness such as, for example, the lack of what could be called *a leftist perspective*, slightly formed, struggling, with an analysis of fascism. Fascism poses two questions today: one of power as an exception (bourgeois democracy's exit) and one of the eroticization of that power. On these questions, the economic tradition of Marxism, which we have inherited along with that of revisionism, falls silent. And what we know is that, if this leftist point of view can be constructed, if it *must* be, it will not be in the name of a distant dogmatism, or even of the well-worn names of Brecht and Reich, but on the basis of what,

5. See "Anti-retro: interview with Michel Foucault," *Cahiers du Cinéma* 251–252, July–August 1974.

today, in the practice of those who deal with these questions in their daily struggle, *contains* that construction.

Criticism would therefore be more heterogenous than it is today (a simple metalanguage). Neither a litany of beautiful things (the old cinephilia) nor a litany of errors (recent dogmatism). For there are films that are both beautiful and dangerous ("venomous plants," they say in China), and errors that are full of teachings.

Criticism would have the ability to determine, apropos of a film, of a mode, the concrete *territory*[6] upon which it performs its intervention, the issue in relation to which it takes a position. One would no longer say: Malle is an idealist or Malle is an academic filmmaker (which is, nevertheless, true), one would say: the actual subject of *Lacombe Lucien* is the memory of popular struggle. From *his* point of view, that of an upper-class liberal, Malle is correct: that territory, deserted by revisionism, remains fallow. Few are there to cultivate it (but there is, in France *Le Peuple Français*,[7] and in Italy, Dario Fo).

From *our* point of view: draw upon everything that could establish a leftist point of view on popular memory (reading, investigating, knowing how to translate the considerable contributions of Latin-Americans, Sanjinés, Littín, etc.).

The leftist point of view has not yet been created; it is not given. *Often, it will even need to be translated.* Let's return to the example of Malle's film and ask a simple question: is there anything, *in cinema* (in that specific arrangement of sounds and images), anything that could oppose *Lacombe Lucien?* No. But in another field, itself heterogeneous (history? literature?) M. Foucault's work on Pierre Rivière

6. The "real" subject is not the script or the theme. Determining the real subject is a power play. It's setting the film—object on a stage that it does not acknowledge: the battle of ideas where no punch misses the mark, where no object stays empty for long. A power play: one mustn't be *cut off* from the ideological-political situation. And that situation is not only what passes for "current events" but what the popular struggle informs us of, if we are not excluded from it (the famous "cultural needs of the people": who could make an assessment of "Lip and the cinema"?) That would mean having one foot in the system (there where the struggle is taking place) and one foot in the struggle (where the question of the machine is being debated; c.f. the cultural front). For from within the system, to be sure, one sees only the system.

7. *Le peuple francais,* a journal of popular history created three years ago by a group of teachers. Published quarterly.

provides a point of departure, a possibility of a counter-argument to Malle's theme of the "primitive, the plaything of an idiotic history."

That argument has already been presented (in the interview with M. Foucault). Let's briefly return to it. What is important to Malle? That Lacombe interiorizes nothing, memorizes nothing, that he can be the bearer of utterances he never understands[8] and for which he cannot take responsibility? To Malle, Lacombe is a barbarian (who answers only to nature, human and vegetal). For the revisionist, Émile Breton, however, Lacombe demonstrates "the confusion of certain strata of society who are still incapable of providing a scientific analysis of the world" (*Nouvelle Critique*, #72). He is, therefore, underdeveloped. Problem: how to consider Lacombe as something other than a barbarian (who lacks humanity) or underdeveloped (who lacks knowledge)? When Foucault speaks of Rivière, he emphasizes that Rivière writes that if knowledge eludes him, discourse does not fail him, *and neither does memory*. Alienated does not mean ahistorical.

To tell the truth, Malle poses a problem (and solves it—for the bourgeoisie) over which a leftist point of view can be constructed. This problem: How to articulate a fiction (a story) from a point of view that isn't one of "absolute knowledge" (of History)?

In Malle's system (which we have called "modernist" in these pages), it is clear that the only conceivable contrast to Lacombe is not another peasant, but a master. That, by ruse, this master might be disgraceful (the teacher in the film) or easily blamed (Malle since 1968) changes nothing. To escape from this system, we must ask a different question (Littín's, for example; cf. this issue): *how do we accurately trace a path from the perspective of someone who does not master it (does not speak, does not theorize) completely?*

This question will always require our intervention. That is what "anti-retro" means.

(*Cahiers du Cinéma* #253, October–November 1974)

8. Lacombe to Horn: "My friends don't like Jews much." Connotation: I (nature) don't see the difference (culture). The entire film depends on this; it would collapse if Lacombe were to say, "*I* don't like Jews much."

PART FOUR

ELABORATIONS

THE POSITIVE HERO

Where is the dividing line between bourgeois cinema and revolutionary cinema today? Relying on the films of the Dziga Vertov group or even of J.-M. Straub, we have been too willing to answer this question with proposals such as: it lies in the contradiction between sound and image ((What's spoken, and what's shown)), between the lived and the constructed, between the linear and the discontinuous, etc. Yet, if these contradictions are genuine, if they primarily concern the revolutionary filmmaker who must sooner or later resolve them, it is no longer a question of stating them in the abstract. If it was wrong to go after the "very idea of representation," if it was more correct to cry, "death to the *bourgeois* concept of representation!" such a cry opens an entire series of questions that are not uniquely formal but primarily *political*: Representing who? Representing what?

For us today, that dividing line cannot escape this inevitable problem, which can be formulated as such: *must we struggle to represent, in a new way, the classes that struggle or must we confine ourselves to registering the remote effects of that struggle on the fantasies (and in the forms) specific to one class*, which is conveniently always the same: the bourgeoisie?

The bourgeoisie does not have a vested interest in addressing a question that it long ago resolved. The petit-bourgeoisie, ideologically dominant in today's film productions, desperately tries to find *heroes*, rebels, who aren't revolutionary to the end; in other words, who are not proletariats. As for revisionism, it also has no interest in reopening the file labelled Zhdanov and "socialist realism" that it considers to

have been buried long ago. Today, under the fallacious cover of the "critical distance of the artist" or the "implicit," it would rather accept formalist fare than see something reappear onscreen that had disappeared from its discourse: the class struggle (officially finished in the USSR since 1936 and current object of the greatest discretion on the part of the FCP) and the *heroes* of that struggle.

Positive hero. Isn't that redundant? Isn't a hero, by definition, always positive? It is up to us to unpack this expression, explicate it, in order to avoid misconceptions. The positivity of the hero, for us, can only be understood in terms of class; *it goes in the direction of the interests of the class that is itself positive*, the only one whose liberation signifies in the final analysis the liberation of the entire society. Which is to say that the problematic of the positive hero only means something to us after a taking of sides—a taking of political sides, *for* the proletariat, *against* the bourgeoisie. What's more, it is the definition of positivity that allows us to define the heroic form itself. We mustn't take the word "heroism" in a too narrow or too rigid a sense. Too narrow: the hero doesn't merge with the "main character," the narrative-bearer. Too rigid: the hero doesn't define himself exclusively by a certain kind of behavior (courage, a fighting spirit, valor). The feudal hero is not the bourgeois hero, nor is he the proletarian hero. The solitary adventurer, the professional bound by a code of honor (as he is celebrated—even ironically—by Leone or by Kurosawa [*Sanjuro*]) has little to do with the proletarian hero. *Positivity, like heroism, thus has a class content.*

One could object that the expression "positive hero," because of its intemporal and ahistorical aspect, is perhaps neither the best nor the most appropriate. It is true that our Chinese comrades are more likely to refer to the "heroic figures of workers, peasants and soldiers," always careful to specify the class content. It is also possible that we have to gradually abandon this terminology for another. Today, it still has the advantage of *describing a problem* for us, the problem of socialist realism, of "Zhdanovism," as much Zhdanov's as the one often attributed to the Chinese. It goes without saying that this problem isn't for us a muddled and outdated episode of the history of ideas, or of revolutionary art, or even of Soviet cinema. This is a political problem that revisionism thought it had solved by burying it, by

remaining silent about it, a silence that is itself also political and which, to say the least, has elucidated and resolved nothing.

One could also say: the bourgeoisie has its heroes, too. And it is true that *it has had them*, in its struggle, long and complex, against feudalism. One could say that Robinson Crusoe and Saint-Just are heroes, fictive or real, of the bourgeoisie. They therefore are not analogues of the positive proletarian hero: the proletarian hero *knows* what class he's fighting for, while bourgeois heroes always pretend their cause is that of Mankind, of Progress, of Science in general. Hence the retrospective appearance of the bourgeois hero often as a prophet, in the realm of ideas, of something that is actually realized later on. How? By whom? We do not really know. Ultimately, Rousseau and Voltaire are the cause of the Revolution of '89. Today, one of the last avatars of the positive figure proposed by the bourgeoisie, the technocrat, doesn't escape this rule: Mattei need only look a bit further than the immediate interests of his class to appear to anticipate the general interests of Humanity.

That said, the bourgeoisie, which today no longer has the initiative of struggle, shaken by a severe ideological crisis, unable to propose even the slightest positive figure, is forced to leave it up to the petite-bourgeoisie to patch up the cracks that this crisis has created (a patching-up that depends on the side towards which the petite-bourgeoisie swings, towards which it radicalizes itself: to the left or to the right). It tries to discredit, cast suspicion on the very ideas of the hero and positivity. Or it instead tries to provide evidence that the two are incompatible (and they are in fact incompatible *for it*) *either by proposing a heroism without positivity, or a positivity that does without heroism*. On one side, the theme—fascinating—of the "lost soldier," on the other, left-leaning, the "model victim." Sometimes an unemployed hero, sometimes a reluctant one. The dominant cinema today seems to be marked by these two major strains: hence we must review them, critique them in order to define, even by negative example, what the positive hero might be.

Lost soldier, etc. This strain perpetuates the tradition of Hollywood cinema and corresponds today to what has come to be known as "commercial cinema" (neo-Westerns, neo-film noirs). We know that in this tradition, the "hero" is the object of a cult, a fetishization, particularly

because the *actual stake* (meaning the political, economic, social stake) of the brilliant actions we see him perform is unclear. That stake (class conflict) is either repressed or disguised in psychological and sexual rivalries. In Walsh's films with Errol Flynn, for example (*They Died with Their Boots On, Silver River, Gentleman Jim*), the hero is never reduced to the motives that compel him to act or to the causes that he seems to serve; there is always a surfeit of energy in him that cannot find a cause up to his standards. Here we have one of the star-system's roots: the fetishization of behavior going hand in hand with silence about (or the repression of) what really motivates (really: meaning in relation to the class struggle) that behavior. This concept of the hero as pure waste, unproductive expenditure, culminates in the character of the mercenary, the cop, the professional, who performs a relay between old, naively imperialist American cinema and newer films that are more perniciously (c.f. *The Visitors*) or overtly (c.f. the advertising created around the film *The Mechanic*) fascist. The themes are: the lost soldier, the unemployed torturer, the out-of-work "hero," the contradiction between civil society and the army, the bad conscience of the boss who is forced to shoulder the burden of an idiotic society (see J. Yanne's second film): in short, the general theme of "heroism" without positivity, of unutilised expertise (expertise in killing).

Model victim, etc. This more recent current is a reflection of the radicalization, the "leftization" of the petit-bourgeoisie. The latter has the tendency to subjectively experience its current societal situation within the opposition of executioner/victim. What it has had to renounce in the past several years is its fantasy of arbitration. The history of French post-war cinema has largely been the increasingly difficult search for characters who, without being heroes, nevertheless occupy, because of their profession, a position of mastery. Cayatte's films are in this regard the most exemplary: the lawyer, the doctor, the judge, the policeman, in contact with "all sorts of people," in other words, with all classes of society, have been kinds of bourgeois positive heroes. The crisis that is currently shocking ideological systems prohibits that fantasy of arbitration: the petit-bourgeoisie must choose its camp, and it does so with the greatest panic, abandoning "average characters" for model victims. Hence these films (that we have called "modernist") in which there is indeed some positivity (the discourse

of the filmmaker who, in general, defends a point of view, a thesis) but not heroism. The principal character of these films, the *catalyst* [*embrayeur*] of the story, becomes the involuntary bearer of the truth, especially because he himself is reduced to the state of the marginal wreck, the "hero despite himself." *Family Life* (see the review in this issue of *Cahiers*) is the latest—and most accomplished—of these films.

Individual/Society. A hero without positivity (bad conscience) versus positivity without a hero (scarred unconscious), the cult of the boss versus the dissolution of the personality... We mustn't overestimate these contradictions to the point that they become the principal contradiction. We must resolutely unmask the fascist current and critique the leftist current *politically*. And to perform this critique, it is essential that we amend what these two currents have in common, their ideological base: the couple, *individual / society*. This opposition, internal to bourgeois ideology, serves to mask, to render unthinkable the division of society into classes and, a fortiori, the struggle in which they are caught. In its place, a false contradiction in which two abstractions, the individual and the society, face off against one another in the guise of two totalities (the large social whole and the small individual self) that continue to mutually include and exclude themselves, the whole being always a little less or a little more than the sum of its parts. Based on this individual/society "contradiction," both the shooter and the schizophrenic are heroes; that is what finally unifies them. We need only read the way in which the bourgeois press reported the Tramoni case: the killer *and* the victim were above all else the victims of the *same* society: all executioners, all victims.

Avant-garde/Masses. Here is something that can help us to define, even negatively, the positive hero. He is not the hero of the individual/ society contradiction, a contradiction that means something only within bourgeois ideology, he is the hero of the avant-garde/masses contradiction, which only means something to the proletariat who struggles and organizes in and for that struggle. Here, two remarks:

1. It would be wrong to think that an intra-theoretical investigation, disconnected from any taking of a political position could ultimately arrive at this contradiction. Developments in a potential science of the text or of narration haven't allowed us, at *Cahiers*, to propose the urgency of the work to be done on the theme of the

"positive hero"; it has instead been developments in the class struggle on the cultural and ideological front. An academic investigation into the historical contexts of the problem—and not only in cinema— would not be particularly relevant, any more than a "rereading" of Soviet, or even Chinese, cinema would. The positive hero certainly poses specific, formal questions to the revolutionary filmmaker, but he poses them first to the revolutionary, filmmaker or not, in so far as the contradiction that he condenses, the one that opposes the avant-garde to the masses, liberates the essential question today for the Marxist-Leninist movement: the *connection to the masses*.

2. The connection to the masses: something that torments revisionism, that the Chinese cultural revolution loudly reaffirmed. We begin from that torment and reaffirmation. On the one hand, the concrete experience and the theoretical texts of our Chinese comrades (in *Pékin Information*, number 24, 1972, Sou-Si states: "The history of literature and of proletarian art is the struggle between class theory and the theory of human nature").

On the other hand, the stale spectacle of revisionism that waits for the bourgeoisie to rot and contemplates—with all due detachment— all that decadence. See in this regard what Maurin has written about *Last Tango in Paris*. Revisionism seems to say: if the bourgeosie has the good sense to commit suicide, what's the point of showing those who make them do it: the violence of the struggling masses and the concentration of that violence in the form of the positive hero.

Positive hero: the *conscious* hero of an *explicit* struggle. We must insist on this point because the trend is, on the contrary, towards *unwitting* heroes and *implicit* struggle. How to make that struggle explicit? That is the filmmaker's problem, his specific problem. No more is it the abstract question: must we represent x or y/this or that? But: who to represent? For whom? Against whom? *How?* That is where the "artistic" criteria intervenes that Mao talks about in his "Talks at the Yenan Forum on Art and Literature," specifying clearly, "It is impossible to place an equal sign between politics and art, even between a general concept of the world and methods of artistic creation and criticism. We negate the existence not only of abstract and immutable political criteria, but also abstract and immutable artistic criteria; every class, in every class society, possesses its own criteria, as

much political as artistic. Nevertheless, any class, in any class society, puts the political criteria first and the artistic criteria second."

Which is to say that the work of this group (which we already know will try to assess the issues represented by the names Eisenstein, Vertov, Brecht, the Peking Opera, the Dziga Vertov group, or of issues of identification and *typing*, which we will soon return to) must provide elements of a response with a view to films that are, that will be, militant films forced, as long as they utilize fiction, to collide with the problem of the representation of classes in struggle.

(*Cahiers du Cinéma* #244, February–March 1973)

OPERATION "SCRATCH"

We have often lamented that French cinema doesn't talk about France and the French. That is beginning to change. Take the three "cinematographic events" that are *Rabbi Jacob*, *Lacombe Lucien* and *Chinese in Paris* and you will see what they have in common: their subject is France's image. Their mission: tell the French what they look like, hold up a mirror. Question: what image of France does Pompidolian power require today, in 1974? The de Gaullist ideology, with its aura of grandeur and its pathos, is quite dead. Something pretty low, pretty slimy, is emerging that must be called by its true name: "Pompidolian ideology." It knows that its official discourse is not credible, that the "Information Commission" and its puppet, Lecat, are a joke. It must find another way to popularize the Pompidolian politic. It needs active servants, talented minions; it is seeking and beginning to find them.

Ultimately, there is no discrepancy between Pompidou's *political* discourse and the ideological discourse of his filmmakers. *Rabbi Jacob* is a commentary on the aphorism, "Racism does not exist in France." *Lacombe Lucien* is a metaphysical variation on the Touvier affair. *Chinese in Paris* is an illustration of Pompidou's speech in which he told the French people that they're lucky to have so many refrigerators. Pompidou is certainly a good screenwriter. We only need [Marcel] Dassault to finance it, and there will always be some embittered

paranoiac (Yanne) or a post-'68er in full regression (Malle) to add their talent or lack thereof.

France's image, its experienced, subjective image. What is at stake there is a new social *typing*: the Frenchman, the non-Frenchman and the average Frenchman. The *old* typing, the Gaullist legacy, based on patriarchs and gangsters (Gabin, Delon) is in decline. When Oury manages to make de Funès, a stubborn and racist CEO, the only "positive" character in his film, he is making a point. When the only "positive" character in *Chinese in Paris* is a con man, Yanne is also making a point. At least he is trying to.

This is not an aesthetic problem. Not entirely. Pompidou has reason to be concerned. France's image, in 1974, is very bizarre, very problematic. *Geographically*, for a start, with the "awakening" of what bourgeois power had thought was dead and buried: national minorities. New words must be reckoned with: Occitania, Basque Country. France is again becoming a fragmented body. Marcelin knows something about that. Then, *historically*, and this is what hurts the most, for the past thirty years France's image has been that of a poorly repressed divide, the image of something increasingly unthinkable: the Nazi occupation, a collaboration that was not suffered but desired, demanded by Vichy (read Robert O. Paxton's book). Leave Paris, go back to the past, and you will see that "France's image," strictly speaking, *goes to hell*. Serious problems for Pompidou: who says that he won't sooner or later need to bring together as many people as possible, behind him, to his right?

Bourgeois humanism

What follows, in terms of the active ideologues of the regime, is a strange operation that I call "Operation *Scratch.*" Oury tells us: scratch the surface of the racist (the French are racists, it's become pretty hard to deny it) and you'll find Mankind (which is undeniable). Malle follows up: scratch the surface of the fascist (the French collaborated) and you'll find Mankind (those Frenchmen were still men!). With Yanne, another step in the escalation. His reasoning has two stages; it's a syllogism. First stage: scratch the surface of the communist (the Chinese are communists. At least they claim to be) and you'll find Mankind (the Chinese are men. How about that!). Second stage: But Mankind is abject (the French, for example).

That is what bourgeois humanism is all about. Ugly territory in which Oury has taken some steps, Malle reigns (the new "boss" of French cinema), and Yanne threatens to spread out. With the difference that Yanne once believed in Mankind and no longer does. He despises everyone who doesn't manage to prove him wrong. His deception is limitless. When we look closely at it, we see that he suffers (one day, when we have time, we will make a detailed study on the Christian metaphors in the oeuvre of Jean Yanne).

Which leaves the Chinese, and their role in this swampy fable. It is important to realize that the (bourgeois) humanism that gets high on the abstract idea of Mankind needs racism like it needs its shadow. It needs different people (either inferior or superior, that isn't the issue) to reveal the Mankind that is only ever the mask of the Western bourgeois. Yanne needs a mass of Rousseauist and naive Chinese like Malle needs a mass of young, "native" peasants. To discover its truth (even an abject truth), the bourgeois always need his *good savages*. Humanism (bourgeois humanism), racism: same fight.

P.S. That said, what threatens to disqualify Yanne is not his neo-Poujadist delusion (of the kind: to be recognized by the Pope), it is also that he doesn't have the (artistic) means to match his delusion. Luckily for us, Yanne is a terrible filmmaker. Chinese in Paris *is a failed, filthy, ugly and sleazy film.*

<div align="right">(<i>Libération</i>, 7 March 1974)</div>

SOFT CRITICISM OR MASS DEBATE

What is film criticism? A (soft) practice that consists in opposing *one* object to *one* other object, one text to one film, one signature to another, one star-system to another (see "Le masque et la plume"[1]). What purpose does it serve? Plastered on the walls of the screening room's entrance, criticism is increasingly an advertising support, an element, a relay, in the bourgeois system of production and the

1. A French cultural radio program created in 1955, broadcast on Sunday evenings, dedicated to critiques of literature, theater, and cinema.

consumption of films. Where does advertising begin, and criticism end? It is becoming increasingly difficult to say. What is certain is that, even when it is negative, criticism *valorizes* the product it discusses. Because, precisely, it agrees to discuss *one* product: "A film exists, I experienced it" (most often in a private screening), because it agrees to be the parasite of the trickle of the "films coming out." And yet, the "films coming out" are only one small tip of the cinema iceberg.

A different kind of criticism is and has always been our idea at *Libé*. It isn't only about badmouthing bourgeois films, proving that they are bourgeois and becoming outraged that they exist. It is also about ensuring that criticism isn't a practice that runs parallel to the system but one that can, *at certain moments*, in certain places, meet it, *confront* it. A criticism that doesn't remain plastered to the screening room's entrance, but that enters into it, as well.

Yanne's film has achieved at least one thing (seriously!): it has shown us the limits of what criticism can *do*, traditional criticism that speaks about an object that it never encounters. Well before the film's release, comrades knew that the film was not about aesthetics but rather politics and that it required that the question of *other* forms of criticism be asked. This has at least one precedent: the sabotage of the fascist film, *The Green Berets*, several years ago. In short, it was a heated issue, at *Libé*, among others.

Let's take stock of what has been done and said. Not to valorize Yanne (whom we despise) but because there will be other films like *Chinese in Paris*, and we mustn't be beaten to the draw. It's been a relatively thin record: a couple of tracts, a bottle of ink thrown at the screen at the Rex, a letter from Jurquet to Pompidou in which HR, with the arguments of a leftist Gaullist, demanded that the UDR (Union of Democrats for the Republic) stay away from the PCC (Parti Communiste Chinois), and even here, in *Libé*, not only several slightly hysterical texts, but an invitation to boycott.

How to intervene?

What's at stake here is the capacity of the extreme left to delineate, to organize a *mass debate* about a subject that it has chosen, with its own weapons and its own way of being *credible*. That broadly exceeds cinema's domain, but cinema is a part of it. By asking ourselves the

question, "How to intervene?" regarding Yanne, we feel at a bit of a disadvantage; a film cannot be robbed as if it were a bank. There are obstacles we must avoid. For example:

—When we consider commando actions against a film, we must *simultaneously* be able to fight against the formal idea of bourgeois freedom (argument: "No one is forcing you to watch this film!") and for the idea that no art exists outside of class. An idea that is far from common.

—When we challenge a mass-market, *comedy* film, we must expect to be confronted with the argument, "People want to laugh, relax, not think," and know that we mustn't respond to that argument with moralizing contempt, unfortunately all too common, that "shames" the audience for enjoying themselves.

—As for the idea of a boycott, we have to fight for it to *make its way*, knowing that at this point it has no chance of succeeding against a film for which the system has mobilized all of its resources (media hype, release in 35 theaters!). We mustn't cut corners.

—As for film debate, it must have a mass character. And not wind up in a *special* page of *Le Monde* for *specialists* in Franco-Chinese relations. We continue to believe that the anti-French aspect is the most noxious one in Yanne's film.

To those who say that this exceeds the frame of criticism, we must say that there is only one critical "frame," the one drawn by power. It is up to us to draw another. Up to us to demonstrate (this is the ideological struggle) that we can give some substance to the common perception that "every film is political." Common, but to whom?

(*Libération*, 14 March 1974)

THE ORDER OF THE GAZE

In 1931, in a short text entitled, "*A Brief History of Photography*," Walter Benjamin writes: "Whether people come from the left or the right, they will have to become accustomed to being inspected for signs of provenance. And they will have to scrutinize others in turn."[1] In

1. Thanks to Esther Leslie for her translation.

Germany in 1936, when Nazism won, at the same time as it won political power, a monopoly on the gaze, on the "right of the gaze," on the archive (hence the document), Benjamin adds—prophetically—that there was a "new form of selection in front of the camera: the ones who emerge victorious are the star and the dictator." He then surmises something that we quickly forget: that an image is not given, but taken (don't we say, "taking the shot," don't we talk about "photo hunters"?) and that this taking implies a power relation, a relation to power. Seen from a B-52, a Vietnamese field that is simultaneously filmed and bombarded is somewhat unique in that no reverse shot is taken from its perspective.

Such a reminder, even if blunt, is useful if we want to contextualize Marc Ferro and Pathé-Hachette's project, contextualize it in history, and also in the history of thinking about filmed documents. This thinking hasn't progressed much, remains dominated by idealist, obscurantist conceptions of history as well as cinema.

In these concepts (still quite prevalent, on television, for example) a "filmed historical document" is the (fantasmatic) result of a sort of *desquamation* (desquamation: the fall of the superficial part of the epidermis in ribbons, scales). The document is the fallen object of a history that, on its own accord, falls, as it were, in rolls of film. The film is the skin of history. Not only does this happen automatically (ravishing, determinative divinity), but history naturally registers itself on the filmic medium. It is clear what this concept represses. On one hand, the fact that, as Marx reminds us, "history accomplishes nothing, does nothing." On the other, that it is people—including struggling people—who decide what pictures to take. And that they always do it from a specific point of view.

Picture-taking/perspective [*prises de vue/point de vue*]—inseparable. Double "referent" that comes to inscribe itself in images as the thing that signs them, historicizes them, politicizes them. To give meaning today to images taken yesterday (and by others), is to account for this double referent. Let's not forget that the events of the first part of this century were, most often, filmed from the point of view of camera owners (hence from industrialized, often imperialist countries). Those who had the monopoly on the image-taking proclaimed (using "theory," as well) that the shots taken (by them) were objective because the eye of the camera couldn't lie. In fact, they

needed to discourage the others—the filmed—from finding who, what point of view, what interests, were hiding behind the lens.

But things are beginning to change. Benjamin's concept has been realized: everyone looks, everyone films. Everyone: those who just yesterday were only minor characters, shadows, exotic or erotic extras in the films of masters. When, for example, the Palestinians take charge of their own filmed memory (an archive in their own name), they no longer end up in the images of others. They are becoming filmmakers, editors.[2] This is just one example among many, but it means this: the idea that a document is always objective, true, neutral, can no longer be a means of intimidation. No "raw" document exists. A document always returns to two realities, of the filmed and the filmer: *Idi Amin Dada* teaches us as much about the ideas its authors have about Africa, politics, and cinema as it does the boss of Uganda.

Marc Ferro must take all of this into account. He knows that a document, like every image, never says anything specific, that it is a projected, moving surface, offered to the eye in a blink of an eye and that there exists, behind that eye, a historically located and desiring subject who wants to read it. In other words, every image can be manipulated by another point of view, even an opposing one. Facing that manipulation, Ferro reacts by utilizing the soundtrack to complete, explicate, even critique the image (falling a bit into that idea that an image can be *negated*.) But that is not enough.

Let's return to the image of the B-52. The bombarded/filmed field, once it has become both an eviscerated quagmire and an exposed piece of film, provides us with a little knowledge (and that is where Ferro the historian can always intervene, describe the bombs and the rice paddies, call them by their names, etc.), but that image—presented as a feast for the eyes—is also the clue, the visible proof of power, the power of filming/destroying. Now more than ever, we must take that power into account. Here, it's politically that a specialist (a historian like Ferro, but a film theorist as well) must intervene.

(*Le Monde diplomatique*, April 1, 1975)

2. C.f. Serge Le Péron's article, *Le Monde diplomatique*, January 1975.

NOTE ON THE FILM AUDIENCE

We could put in our two cents about the Mozart-Bergman encounter, an encounter that took place, as we know, in the firmament of Art. But we could also do something entirely different: look, listen, not to Mozart sung in Swedish but to the audience on a weekday afternoon, on the Champs-Elysées, of *The Magic Flute*. And propose this modestly but decisively:

Just as there are negative teachings and proof by contradiction, we are beginning to see audiences that are "on the defensive." Audiences that define themselves principally by the fact that if they go to the movies, they have no choice but to see *The Magic Flute*. A double promise is made: it will be beautiful, enchanting and, above all, it will not be dirty, or shocking, or violent, or hermetic, or political: no bad surprises. *An audience that is constituted more by what it excludes than what it desires.* Listen every morning, on Europe 1, to how François Chalais manages the audience's concerns (to the tune of: "Finally, a film that we can see with our children, without blushing, without risk of leaving the theater covered with shame and sperm!"). Manages them next to Power (the silent majority finds its voice: Chalais, on TV, whines against porn). The reactive bleat quickly becomes an invitation to repression.

Also, knowing what the *consumption* of films means today means that we don't kid ourselves about the peaceful coexistence between different film genres and audiences. The ghettoization is illusory. The ones who speak loudly and forcefully (about porn, for example) are not necessarily the ones who go to see the films they are speaking about (loudly and forcefully). The impact of a film on those who haven't seen it (but who have seen its posters and publicity) has not been adequately studied. That impact nevertheless exists. Every moral order knows it, and plays upon it.

(*Cahiers du Cinéma* #264, February 1976)

MAY '68: FROM FORGETTING TO AMNESIA

Speaking of the "new philosophers," Gilles Deleuze correctly observes: "It's whoever spits on '68 the most." In film, the passage from post-'68 to pre-'78 has been accompanied less by spitting than by a double phenomenon, one of forgetting (which is normal), the other of amnesia (which is dangerous). For if forgetting is a positive, healthy thing (as Nietzsche would have it), it is not so for amnesia.

1. The majority of French films have been incapable (leaving aside militant cinema) of doing anything other than sprinkling tired, familialist stories (like *The Slap*) with slight notations, clues, mini-characters, meant to indicate to the spectator: we screenwriters, we filmmakers, are well aware that May '68—which, incidentally, we are completely incapable of representing—happened, and we'll be sorry if you, the audience, think that we aren't. With the notable exception of *Tout va bien*, French cinema has been incapable of *staging* May '68, that is, of making it the subject of a film. Even Jonah' whale arrived eight years later, seriously wrinkled.

2. French cinema, by losing the popular audience, also lost the old division of genres that corresponded to that audience: fiction, documentary. For an audience that has become almost uniquely petit-bourgeois, cinema is committed to the rapid circulation of general, doxal ideas, with hasty, naturalistic stories. It abandons the double possibility of the *raw* (documentary) and the *cooked* (fiction) in favor of the ignoble *boiled* that has been inherited by television dramas. By cooked, I mean theatricality, staging, the studio, lights and makeup (the ultimate: d'Autant-Lara's *Gloria*); by raw, I mean the incongruous power of 16mm and direct sound, the camera held in the hand like a scalpel or a pen, without lights or makeup (see Kramer in the United States).

3. And so, May '68 does not give rise to scenography but, in turn, has revived interest in the past. The impossibility, without being ridiculous, of commemorating '68 has shifted interest towards the major dates of the official history of the French left since 1789. Under pressure first from the extreme left, in reaction to the provocations of "retro style," "cinema-and-history" has emerged. Hence the distressing discovery of the a-geneological character of French culture, the crass ignorance of the historical reality of workers' struggles, etc.

4. The extreme left could merely point in a direction where only the Union of the Left had the means to go: the quick manufacture of a French cinema of quality that corresponds to received ideas and a leftist imaginary. That's the moment when we pass from forgetting to amnesia, to repression. For while what has been forgotten is not necessarily repressed, amnesia takes the form of covering up (through myths and simulacra) of what must be absolutely silenced. The gaps are bridged with long, great strides: the Resistance (*The Red Poster*), the Algerian War (*The Question*). It would be completely logical that a filmmaker from the FCP would undertake narrating the Nuit des Barricades from Séguy's point of view. And here, it is clear that reestablishing the truth (of the conflicting relationships between the FCP and Manouchian, between the FCP and Alleg) is necessary but completely insufficient. If these films are bad, deceptive, and apolitical (they do not connect the spectator to any conflict, any cleavage), it is because they participate in the very nature, in the logic of the FCP, which is, more profoundly, the logic of every institution: to manage the amnesia of its members.

5. Let's return to forgetting. We remember Borges's story, *Funes the Memorious*: a boy who remembers everything dies young, asphyxiated. Today we are hungry not for historical reconstructions (the best of which, as experience proves—*The Taking of Power by Louis XIV* or *Barry Lyndon*—are the least teleological, the most opaque, the least manipulable), or for major-issue "current events" stories (predigested in the media and naturalized in film) but something simpler: dated films, contemporary films. What is a contemporary film? Quickly, a film that, for a time, forgets everything filmed before it, that bases itself on the fact that the spectator knows nothing, that any complicity with him must be ruled out, that the filmmaker is not to be taken at his word but that he must make (filmically) his case, what he's playing with. If Bresson had not made *The Devil, Probably* in this way, the film would have had no impact. What was true of Vertov's films in 1925 remains true of Godard's most recent works: they do not manage amnesia, they stand out against the blithe backdrop of forgetting.

(*Le Monde diplomatique*, October 1 1977)

The "Pierre Fournier" program[1] is a survey probe that brings back two or three things from daily Soviet reality that we were aware of but have never *seen*. In this it is, as they say, a scoop. But it is also, in the fullest sense of the word, a *film* in which, with humor and seriousness, the author asks many of the questions that so troubled *Cahiers* at one point in its history. What is the extortion of images? Can one injure with images? In "image-taking," what—politically—matters more, the image or the taking? Must the story of the taking be told, or should we begin from the image? Moscow was a good place to experiment: several men and two women in particular (Olga and Oktobrina) agreed to answer questions concerning, loosely, their lives, their dreams and even their appreciation of the "Soviet system."

It was not without its problems: the film begins (very powerfully) with the misadventures of the faux-naif filmmaker as he "attempts" to film in the street and everyone (from the police to simple passers-by) stops him, criticizes him, threatens the objective, pulls down the curtain. Apparently, for the average Soviet, image-taking can only mean espionage. We fear that "Fournier" is only using these mis-adventures to dramatize his scoop and that he forgets the essential question: why have certain people agreed? "At this point," Oktobrina responds, "one risk more or less won't make any difference." "You're going to get me in trouble," worries Olga (annoyed by the "stupidity" of the questions). At that moment, towards the end of the film, we touch upon a truth, a truth regarding cinema, that then involves us. Fournier's trick is to have dubbed all of the dialogues between him and his Russian interlocutors with voices that are slightly detached, soft and Moulletian, voices that sound silly. Fournier doesn't deceive his Moscow "actors" in order to let the French TV viewers in on the secret of this deception; he adopts a comic tone (no voice over, and so much the better) that at first is annoying, then intriguing, and then stands out as a solution to the problem that is both simple and not metalinguistic. As such, it is very moral.

1. The program was broadcast on TF1 on December 11, 1980. "Pierre Fournier" is obviously a generic name.

The event in whose context this excellent film must be placed is the sale of several minutes of film of the trial of the Gang of Four by the Chinese government to a large American network. What does this mean? Among other things, this: that the West (and the USA is the Far West) has become the only great *terminal* of the world's images.

(Cahiers du Cinéma #319, January 1981)

FEAR OF THE LIVE BROADCAST

On February 17th, "Twenty years, and for what?" a program broadcast live from the Palace by Channel 2, was "quashed" by a young CGT hit squad. On the 18th, the press (with the exception of—as you might imagine—*L'Humanité* and—for other reasons—*Libération*) denounced it as a crime against freedom of expression. It is tempting, given the extreme baseness (that's a euphemism) of the current politics of the FCP (regarding drugs and immigration), to join that wounded choir. And yet some frustration remains. What did we actually witness? On one side, those in charge of the program immediately threatened to shut it all down, as if it were impossible for them to imagine that they could turn it around, that the duration and the live broadcast didn't necessarily work in the rioters' favor. On the other: the protesters were in fact unable to do anything more than shriek and interrupt the broadcast before they allowed themselves to be politely led out of the studio. On both sides: mission accomplished. On both sides: the bare minimum of a mission. United in the same fear of the live broadcast.

How we have fantasized, feared, theorised, ranted and raved about the powers of live television! Not so very long ago, we seriously questioned information as an "ideological State apparatus," discovered that terrorism was (the degree zero) of information. Godard, in *Here and Elsewhere* , said powerful things on the subject. And now, at the beginning of the 1980s, we have become more cynical, hence better TV viewers. We know that "While I am at it, Hi Mom!" and "Unemployment: We've had enough!" are equally meaningless messages if

there's nothing more to say (or do). What does a "live" broadcast say when it has been hijacked in someone's favor, when it has been captured, by violence or by deception? The era when smashing a ritual was enough to create an event is, I fear, behind us. We no longer want to evaluate Elkabbach's outraged speech or the young CGT members' slogans, we would like to see them play with live television, act a little like artists. The troupe on February 17th—contesting and contested—was mediocre, no better than the film on Chopin that served as its replacement. The channel ought to belong to people who know how to invent something—live. That invention is perhaps the most political thing.

(*Cahiers du Cinéma* #319, January 1981)

"THE SHOW MUST GO ON"

Zeal, or declaration of war? By honoring The Last Métro *so exclusively, not only have the Césars emboldened its success (the film has sold 830,460 tickets to date), but they have achieved something they perhaps hadn't intended: inspiring a feeling of uneasiness in the media.*

What? One film so mercilessly dominated French cinema in 1980 to such a degree that it made the other three nominated films (nothing less than *My American Uncle*, *Loulou* and *Every Man for Himself* look like stooges?) That's suspicious (we think), for it's one of two things: either all the voters (a thousand film professionals, apparently) spontaneously agreed, or else they're sending a message from "the profession" to the rest of the world: we love Truffaut's film, and we love it *only*, it reassures us, and we want to make that known. They succeeded. Perhaps a bit too much.

An imitation of the American Oscars that lacks its actual grandeur, the Césars ceremony, invented by Georges Cravenne in 1976, intends to deliver annual proof that French cinema doesn't lack talent that is "praiseworthy on an international level" (as *Le Film Français* so charmingly puts it). And yet, the Césars have struggled to earn a little dignity, a minimum of credibility. We have seen them to be—and we were right—the ritualized version of a ecumenically

creepy parade of television guests (with Tchernia, with Drucker, then Ruggieri: always the same). But the Césars do not target a cinephile, snobbish, or enlightened audience; they seek to reconcile the general public with a glorious idea of French cinema, the idea of a cinema that is simultaneously high-quality and commercial, a cinema of the respectable and exportable auteur. In short, it needed to make us love the establishment once again, it needed to re-create pathos, mimic suspense, invent ritual where pathos, suspense and ritual had disappeared with the "cinema crisis," that relentless and unverifiable chimera, and especially the malevolent and combined effects of the Nouvelle Vague and May '68. The profession has been abused; the Césars must be its great revenge. Let's admit it (even though it's hardly thrilling).

But it seems that 1980 has witnessed a curious phenomenon: four films by auteurs, praised by critics, loved by cinephiles, were *also* commercial successes. 1980 will perhaps be the year that a reconciliation between the audience and the great auteurs of French cinema begins. Half a million Parisian spectators agreed to gamble with Resnais with *My American Uncle*. Three hundred thousand went along with Pialat's bizarre tale (*Loulou*). More than two hundred thousand joyfully welcomed the return of Godard, whose enemies had too hastily condemned him to marginality, to video or the museum, and who reached, with *Every Man for Himself*, a new audience. Finally, following the relative failure of *Love on the Run*, Truffaut finally dares to confront the subject that haunts him (the occupation, how can one sing during the occupation?) and, consequently, reaches nearly a million viewers. What's more, in New York, Godard and Pialat's films have hardly gone unnoticed. And so there was plenty to celebrate, and strictly from the point of view of French cinema's international glory, the Césars should have been inspired to mark the occasion by equitably recognizing the four films.

Why, then, did they crown, in such an ostentatious fashion, *The Last Metro* and *The Last Metro* alone? Is it because it occupies a special place in French cinema, that of a virulent critic become a respectable, traditional, even pious filmmaker? Do they recognize themselves in their hatred for extremists, aesthetic as much as political extremists, and in their preference for the middle ground? Is Truffaut

that reassuring? We are not so sure. In a landscape as flawed, as devastated, as changeable as French cinema, the position of the middle ground is a strange one. Where is the middle ground when the extremes have disappeared? A location like any other, as strange as any other, the entire Truffaut-paradox is there, the ambiguity of his situation: he is the only one who has made "normal" films, who has constructed, through calculation and intelligence, a cinema, a career-resembling those of the past masters whom he admires so much (Renoir, Hitchcock). "Normal," he is in the minority because yesterday's norms (that the cinema is a profession, a long perserverance) have become today's exception.

The Last Metro gives the illusion that a Saturday night cinema is still possible, a happy, easy, and familiar cinema. It is an illusion, but Truffaut knows how to create it like no one else. What interests him, and always has, is not correctness of tone (that's Pialat) or truth (that's Godard), but verisimilitude. Otherwise, he would not have made that magnificent book with and about Hitchcock. How far is too far to go to give the spectator the illusion of being part of a large family, gathered together, reconciled beyond every contradiction, beyond the breaches of time and History that separate them? How to create the illusion of that universal reconciliation between the auteur and his audience, audiences of all ages, actors and their roles, extras and stars, the past and the present, the living and the dead? How to paint that picture that is too good to be true? In *La Nuit Américaine*, Truffaut already had the ethic of a director of a company whose only agenda was, "The Show Must Go On." At all costs. The crisis of cinema doesn't stop *The Last Metro* just as the Occupation didn't stop Marion from continuing to run the theater. The Show must go on. The Cinema Must Go On. French cinema *must* continue. What the ten Césars risk obscuring is that this kind of illusion is created under the specific conditions of cunning and the cult of the dead that are the most secret parts of Truffaut's cinema and that, luckily, have nothing reassuring about them.

(*Libération*, February 6, 1981)

IMAGE-PROOF

THE SMILE OF RICHARD DREYFUSS, THE STAR

Richard Dreyfuss, the star, has reason to smile. *Jaws* is currently the highest-grossing film in cinema. Paradoxically so, in fact, since the number of tickets sold in Paris has, over the past four weeks, fallen drastically: 309,158 spectators in the first week (including me, S.D.), 241,160 in the second, 177,785 in the third, 124,155 in the fourth. This free fall is part of the program: actually seeing the film is merely

the final step in the bludgeoning process (advertising, fashion, t-shirts, etc.). It is, in itself, irrelevant.

There are other reasons for Dreyfuss's smile. It's a smile for the set photograph. Its function is to be distributed in movie magazines, ridiculous media, that would prefer a photograph of a scene from the film or, even better, a photogram pulled from the film itself. Its function is to say, with a smile, that the machinery (special effects, scenery) established for and at work within the film is real, that the cage is real. The set photograph is Hollywood's way of revealing not a working process (behind-the-scenes) but the reality of what will be wasted *for* the film, and, *via* this waste, of the *power to waste* that is the final word of the imperialist metropolis when it comes to sounds and images.

(*Cahiers du Cinéma* #265, March–April 1976)

THE DOG AND THE ROPE

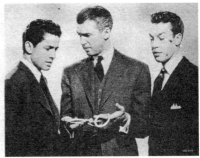

Let's assume: the history of cinema is the history of several states of the human body. Of the *filmed* body, which is to say, a body unlike any other. The film photograph, which major American studios take the trouble to create as a discrete object, speaks to us of the genealogy of that body (it is neither a sample nor a duplication, but a flash theory of the entire figurative system). We can best read the delirium of its origins in the modes of its *display*. For where does this body come from? It gradually emerged from the background of the nitrate

image where it pulsated (a burlesque, popular, leftist operation: Harry Langdon) before it became frozen in the foreground of the acetate scene (a serious, petit bourgeois operation: Alfred Hitchcock's *Rope*), like an answer to the child's game that begins with asking, animal or mineral? And between these two realms, nothing. Or rather, a genocide. Behind the too-neutral, too-polished wall of *Rope* we find everything we had to forget (left in the background of the image and sealed off from our gaze) for the star's body (here Farley Granger, James Stewart, John Dall) to emerge—indisputably. Yes, but in what state! Well-dressed bodies, faces chosen based upon their ability to reflect: returning light, down to the very strand of hair, eyelash! Whereas in front of Langdon's wall, it's something quite different: something remains of the primitive indistinction between the figure and the background, the body and its shadow. And what emerges is not the image scrubbed of all suspicion, the Hitchcockian image, but a parodic, uncertain response: in a word, the *carnivalesque*. Between high and low, the human beast and the domestic animal, shadow and light, coat and clothing, Landgon has yet to make a choice: he buys time. Time that the protagonists of *Rope*, the professor and his two students, lose while contemplating the knot in which all of cinema, once it begins to speak, will tangle and lose itself—and us along with them.

(*Cahiers du Cinéma*, Film Photos, Special Edition #2, 1978)

A NICE LEG

Who is the monster in this *tableau vivant?* Neither Harpo Marx, whom we recognize on the left, nor the anonymous starlet we see on the right, sitting on a piano. It's a leg. Anyone who looks at this photo for some time is bound to discover this superfluous leg that brings to five the number of legs shared by the tableau's two figures (and still, I'm only speaking here of the visible legs). A ludicrous discovery. A gag. But this laugh does not exempt us from the enigma the photo conceals. For just when we discover this contraband leg, we then realize that the strange couple to which it belongs *might not have seen it yet.* Terrible revelation: the leg is there only for us; seeing it, we're taken aback by a secret not yet noticed by those it holds together, the very secret of what holds them together, of what binds them and which they innocently flaunt! Even if we suppose that they have seen this leg, they have no idea what it's doing there. Even if we imagine, outside of the frame, someone for whom it makes sense (imagine Groucho, since nothing shocks Groucho), it is clear that Harpo's gaze only suggests good will, the patience of someone who gladly bears an experience we know nothing about, except that he might laugh at it later on, in turn. As for the starlet, she is

motionless *just in case*, like someone who holds a pose too long and whose gaze and smile have been fixed to the point of rictus and stupor by waiting. It is clear that they know nothing about the monstrosity created by the act to which—with their smiles—they contribute.

For this leg-monster (without which Harpo would stupidly collapse on the edge of the piano, bringing the woman along with him in his fall) is an extension of the two bodies, the continuation of Harpo's arm and the implied thigh of his partner. It doesn't belong to either of the two but it holds them together; it assures the good standing of the tableau vivant. Unnoticed by them, it unites them, transforming them into a monstrous *duovidu*. And we recognize this monstrosity as the Hollywood star system, every time it reveals a glimpse of its truth. What truth? It's not so very difficult to imagine (it makes an impression through *seeing*). There is with every comedian, and notably with the Marx Brothers, a play on sexual difference, with, on either side of the "normal" figure of Chico, a pervert (Groucho) and a schizo (Harpo). One who doesn't want to understand and one who doesn't understand anything about sexual difference. Here, Harpo's femininity is discretely accentuated: the rolled up trousers, the hairless leg, the long hair, up to the round eye that rhymes with the dots on the dress. The woman multiplies all of femininity's signifiers: from the too-blond hair to the gloves, from the furs to the jewelry. One extra leg is enough—a female leg but a mannequin's leg, ideally smooth and gleaming—to ratchet all of the signs of sexual difference *up a notch*: the feminine tilts into the inanimate (the marionette, the prosthesis— we could also say the phallus) and the masculine into the feminine, according to the well-known equation: castrated man/fetishized woman. Without it, no Hollywood. One notch higher, and we find ourselves in the unconditional monstrosity of marionettes in a row, as evidenced by the other photograph, absolutely terrifying.

(*Cahiers du Cinéma*, Monsters, Special Edition #5, 1980)

May '68's promise of better days to come quickly proved false. Too bad for those—filmmakers, activists—who discovered that film could be a tool, a weapon, even a little war machine. All the better for those who, by chance or by calculation, sometimes by a miracle, recorded some images and stole some sounds. The sixties had sparked an interest in direct cinema (the technique was perfected); '68 provided an opportunity to intervene, to witness, to endorse, to denounce, to complain, to mark out territories, to masquerade as Lenin, to convince, to educate, to intimidate, to organize, to raise awareness, to abuse animation, to flatter, to lie. Here is a history of direct cinema in ten images: there were others, but for *Cahiers* these are the ones that matter.

Le Moindre Geste (1971). An erratic film. Fernand Deligny is one of the decade's great, overlooked auteurs. The idea of a "cinéma de terrain" owes a lot to him. Because in his films, in the Cévennes, Deligny has certain ideas about therapy, about releasing children (schizophrenics, autistics) into the maquis, drawing close to them in their madness or their wandering. It's already cinematic. Jean-Pierre Daniel spent a great deal of time making this film.

Editor's note: "Ten images" in the original piece published in the *Cahiers*. The four other ones respectively dedicated to *Reprise du travail chez Wonder, Oser lutter, oser vaincre, 50,81%,* and *Nationality: Immigration* were captioned by Serge Le Péron.

Histoires d'A (1973). A forbidden film. For the first time, a film reports an important phenomenon *at the right moment* (the struggle of women for control over their own bodies, for abortion rights). The situation creates the film, the film's prohibition creates an audience, the audience must politically organize in order to see the film, the film creates the situation. And its authors (Charles Belmont and Marielle Issartel)? With valor, they carry their film like the firebrand that it is.

Kashima Paradise (1974). An exotic film. An entire series of marvelous encounters: between the authors (Yann Le Masson, cameraman, and Benie Deswarte, sociologist), between the spontaneous and the

considered, between the authors and Japan, between their French extreme-leftism and the Japanese "giri," between the residents of Narita and the police, etc.

Here and Elsewhere (1970–1975). A watershed film. Five years of thinking for Godard, who begins the film in the Middle East with Gorin and finishes it at Grenoble with Miéville. We are in the middle of the decade: militant cinema will win no more victories. In fact, after reviewing the images that he recorded five years earlier and elsewhere, Godard discovers that what counts is the *and*. Shock. The OLP will never use the film as propaganda, but *Cahiers* will give it a world tour.

How Yukong Moved the Mountains (1976). A traveling companion-film. Despite Zhou Enlai's support, Joris Ivens and Marceline Loridan

aren't sure how to assemble the sounds and images that they brought back from China. Yukong raises mountains but has very little to show for it. The directors have greatly underestimated the double, triple, quadruple play between power and the Chinese masses. Sad case of a traveling companion who ends up misunderstanding the images along the way.

Origins of a Meal (1979). A genre film. Its author, Luc Moullet, has always believed that hunger is the only real great subject, because it predates all the others. In his perverse project of illustrating every cinema genre, Moullet had to encounter the militant genre on his route. The film is all the more unstoppable because it has nothing at stake, the point of view being that of absolute knowledge.

(*Cahiers du Cinéma* #323–324, May 1981)

TWO EMERGING ACTORS[1]

Marlène Jobert and Jean Yanne

Jean Yanne and Marlène Jobert will grow old together—in our memory. Actually, they're growing old together already, on the grass in this photograph. The woman poses conspicuously, whereas the man looks composed, beside her, surrounding her. She affects gazing at a faraway point, ideal, unknown. He affects looking nowhere, thinking of nothing in particular. A trap: in fact, the man has awkwardly extended his arm and, without touching her, holds this woman prisoner. A trap: the woman transforms her acceptance of the trap (in which she struggles) into apparent indifference. In fact, they are thinking about each other, but Pialat has arranged them in a mise-en-scène where it seems they are not. If Jean Yanne and Marlène Jobert are heartbreaking in *We Will Not Grow Old Together*, it is because they emblematize for the decade that trap of desire that was experienced by the petit-bourgeois: that for men, women can only be

1. From the ten selected by the editors of *Cahiers*. (N.d.É/Editors' Note)

possessed, and that the more they are, the more men are convinced that women elude them. He suffers, interminably. In this photo, placed behind her, a voyeur, he knows that she is thinking about him *and* he sees that she is looking somewhere else. That is enough to feed an unforgivable resentment.

Dominique Laffin

1978: Things between men and women are still not going well. The decade resounds with the stubborn *no* that women have pit against the ruses of men, their cheap theatrics. It's always the same no, the same hysterical scenario. But it's never the same body, the same actress. What Dominique Laffin suddenly brings to French cinema is a *gaze*. More exactly, a way of turning the eye, of turning with the eye, of producing a scenography. Between tears, "the crying woman" already looks to the place where there is nothing more to contemplate than the failure of the script that Lacan summarizes like this: I demand that you refuse what I am offering you... because: it is not that. She withdraws from what she offers, always, from the man who thinks he sees her: she looks through him. This gaze, which sways, carries the head like dead weight, this head which rolls carries the rest

of the body like something inevitable. Her gaze no longer has the provocative fixity of the great hysterics at the beginning of the decade (the salamander, the "whore")[2]: in 1978, it is also heavy with a "What's the point?" that inscribes the attrition of feminist discourse. (*The Crying Woman*, Jacques Doillon).

(*Cahiers du Cinéma* #323–324, May 1981)

2. Trans. note: c.f. Alain Tanner's *The Salamander* (1971), Jean Eustache's *The Mother and the Whore* (1973).

PART SIX

HERE AND ELSEWHERE

CARTHAGE, YEAR 10

"Manjun, who intended to visit Layla's country, steered his camel towards his beloved when he was awake. But when he was absorbed in thoughts of Layla, he forgot his own body and his camel. The camel, having left her young behind in the village, took advantage of this to retrace her steps. When Manjun became lucid again, he noticed that for two days, he had reversed course. And so the voyage lasted three months. Finally, he cried out: 'This camel is a disaster for me!' He got down off the camel and set out on foot."
— Rûmi, *Le Livre du dedans/Fihi Ma Fihi*, p. 43
(French translation Eva de Vitray-Meyerovitch)

History, Framework, General Ideas
From October 14th to the 23rd, the 6th *Journées Cinématographiques de Carthage* (JCC) were held in Tunis (Tunisia). Carthage Year 10, then, since this festival has taken place every two years since 1966, alternately with Ouagadougou.

The introduction to the awards ceremony reflected the disappointment and negative reviews that were widespread throughout the festival, in the non-Marienbadian corridors of the Hotel du Lac.

The jury "believed it was its duty to lament the fact that the current distribution and production conditions in Arab and African countries seem less able to to support the emergence of films that reflect the current demands of the economic, political, and cultural liberation of the Arab and African people less than they have in

previous years. This decline and this deficit can be seen in many of the films presented at this festival."

We wholeheartedly add: "in the majority of the films."

JCC's brand, of being "dedicated to Arab and African cinema," has not always been so pronounced. It has a history. Tahar Cheriaa, the festival's "father," who in 1976 became a simple "advisor," recalls in the very interesting third issue of the *CinémArabe* journal that in the beginning (1965) it was a "large festival with a particular focus on productions from Africa, the Arab world, and Mediterranean countries. Its third-world specificity was not immediately apparent, since in 1966 the competition was still open to all countries (a Czech film—Jaromil Jireš' *The Cry*—was awarded the Silver Tanit). A retrospective reading of the various awards' texts is, in this regard, instructive.

While in 1966, the emphasis was placed, relatively abstractly, on the labelling of "new cinema," in 1968 this short passage appears, and is repeated verbatim in 1972 and 1976, claiming an identity for the festival: "The JCC is unlike other festivals. It intends to demonstrate a specific concept of what cinema is: a tool that may serve the common struggle of that enormous part of the world called the third world. It should help those populations who have finally been called to determine their own destinies to become aware of themselves and the problems they experience today."

While in 1968, reference is made to "supporting a cinema that casts a clear-sighted gaze on sociological realities," in 1970, the expression, "national cinemas" (that old chimera, a source, we will see, of all kinds of ambiguities) makes an appearance. It is revived in 1974: "The development of national cinemas in third-world countries and the intensification of the struggle against colonialism and imperialism increases the importance of the JCC, which is a unique meeting place for Arab and African cinema, and the point of convergence of socially engaged cinema."

And yet, in 1976, there was a change in tone: "The fact that this event has taken place for ten years is the most obvious proof of its opportunity and the necessity of its survival."

Survival? Surviving could mean two things: to continue to struggle (even if circumstances are unfavorable) or else to continue out of

habit, to manage its image. The unanimously recognized weakness of Carthage '76 can be explained (and treated) differently depending on whether we see it as the passive, mechanical reflection of a more serious and general crisis ("decline and deficit") that affects all cinematic production in Arab and African countries, or as an active reflection, aggravating and accelerating that crisis, moving in the direction of a liquidation (if not of the festival, of at least its specificity).

Both types of analysis prevailed in the non-Marienbadian hallways of the Hotel du Lac. If it is difficult for us to choose a side in this chicken/egg dialectic, it isn't forbidden to note certain symptoms.

Carthage threatened from the outside? The ridiculous Sheraton festival in Cairo, about which our newly official agent, Danièle Dubroux said (*Cahiers* #270, p. 45) all the negative thoughts it deserved and the meeting of Afro-Arab filmmakers in Algiers from the 1st to the 17th of October (overlapping with the JCC for several days) seems to provide evidence that an alternative to Carthage is possible, desirable, even necessary, *elsewhere*, in other African capitals and for extremely different reasons.

Carthage threatened from the inside? This year, a mini-power struggle preceded the opening of the JCC. There had been talk at a high level (the highest level being in this case M. Mahmoud Messadi, the Tunisian Minister of Cultural Affairs *and* the president of the board of directors of the JCC) of eliminating the usual debates that oppose (or at least engage), after each film in competition, the films' directors and an audience comprised of the Tunisian public, critics, guests and local cinephiles. While in 1976, the debates seemed (to me) to be weak and convictionless, it appears that this was not always the case, and that previous sessions saw remarkable interventions (some that left their mark, such as Med Hondo's, for example). Eliminating the debates could only have one goal: to minimize the *shock wave* that a film—even, and especially, a bad one—can produce in a demanding audience, and in engaged critics, for whom the JCC is an important landmark.

Another minor scandal: the decision, for the first time, to triple the price of tickets, thereby excluding the very poor. A decision that was also reversed: from 100 millimes, the price of admission rose to only 150.

These two measures put the JCC at risk: of transforming it into a closed-door mega-conference, one that is dedicated to the third world but that starts by excluding the Tunisian public from its discussion. And yet, and this is one of the JCC's very positive points, for ten days that public is able to see what it otherwise would not: films, films from the West, political films, Western political films and—the paradox is clear—African and Arab films, be they political or not. The audience can spread out in seven theaters (more or less requisitioned) in the heart of Tunis: the Coliseum (beautiful theater, terrible projection), the Mondial (ugly theater, good projection), which was rebranded the Hani Jawharié theater during the festival, the Ibn Rachiq Maison de Culture (mediocre theater and projection, debate site) for the films in competition and the El Qods, the Rio, the 7th Art and Cinematheque for the other films: films from the rest of the world (Information section), a very well-attended homage to Latin-American cinema and a retrospective of Tunisian films (amateur and television).

I will discuss only the Arab or African films that I was able to see (I won't address certain films screened at Carthage that *Cahiers* has already extensively discussed—*Nationality: Immigration* (Bronze Tanit), *Chergui*, and not least *L'Olivier* which was awarded the "Prix Hani Jawharié").

Third risk, and a more considerable one: the selection. Article 6 stipulates that "the films are chosen by the festival's board of directors, or proposed by competent authorities from an African or Arab country, or by a producer—or director—from an African or Arab country."

It seems that Carthage '76 marked the triumph of the "competent" authorities. How else can we explain that in the face of the increasingly obvious weaknesses of the films, some films are added to boost the quality of the festival, such as *Chergui* (Special Jury Prize) or *La guerre du pétrole n'aura pas lieu*, despite the fact that Morocco was already "represented" by the here-again-despised *Maroc 76*, which no selection committee could, except in a case of mad devotion for Hassan II, have reasonably selected?

Official cinema

These films are characterized by the fact that they celebrate and glorify, with greater or lesser "objectivity," the established Arab-African regime. It's about advertising, directly or indirectly, and

maintaining (the JCC thus becomes a legitimate medium) a touristic-political brand image. Formally, these films are structured like takeover bids, and their directors spontaneously discover the tics and tropes of the worst kind of Esperanto cinema. These films can be supported from the minimal perspective of supporting every African film in principle, to the superegoic and jaded tune of "this film deserves credit for simply existing," but that support is not a real support: it is a step towards formalizing the minimal cultural politics that consist, for each regime, of having their own filmmaker-griots or audiovisual minions.

This category includes, in addition to *Maroc 76*, Mohamed Ould Saleck's *Let's Create the Mauritanian Nation Together*, which, in keeping with the film's poster, ought to have been called: "Let's paint Moktar (Ould Daddah)'s portrait together." It also includes Braham Babaï's ambitious film entitled *Victory of a people* (*Tunisia*), which would have been more appropriately named, "Victory of Bourguiba." Its montage of archival documents feigns objectivity for about five minutes before it mutates into a "life of Bourguiba," which we would advise the French TV stations to buy in anticipation of the death of the Supreme Fighter. A circumscribed and predictable itinerary in which the richness of the (signifying) material goes, as it usually does, hand in hand with the poverty of the signifier (Bourguiba *arrives* in Tunisia, as he arrives in each shot of the film). Certain signs are intended to create the effect of objectivity: the (discreet) presence of Ferhat Hached, the great figure of Tunisian trade unionism, gone too soon. This has to do with a sort of historical tourism, irremediably servile (we are a long way from *And Tomorrow*, also by Babaï, which was made several years ago and is now feels dated).

Another kind of tourism: *Carthage en fête* (H. Ben Amar, Tunisia), a beautifully filmed, ecumenical celebration of Carthage as a (multi-) cultural site. The Sudanese short film *Jeunesse* (Gudalla Gudara) is a very different matter, which shows disciplined youths building roads in apparent joy (the film is silent) or, in an artsier vein, *Vaisseau du désert* (Libya), a cheap imitation of a Gervais ice-cream commercial, replete with beautiful shots of camels in a sandstorm, screaming in terror (shots which, rumor has it, were filmed in a studio).

It would be a mistake to consider these films as "national" films. If a national cinema were in fact established, it would be *against* these

films which, apart from their political subservience, are forced, given the lack of cinematographic praxis in their respective countries (an accumulation of production experience to draw upon), to adopt the techniques of film advertising in the West, for which a Reichenbach (for experience) or a Rossif (for editing) are currently the insurmountable—and immediately exportable—examples.

A coded cinema

Every debate on cinema's "social impact" inevitably stumbles on the sorry (and slightly hypocritical) observation that the majority of the African film audience is subjected to the worst kinds of commercial (industrial) cinema: Hollywood, post- and para-Hollywood, American, French, Italian, Indian, Chinese, *Egyptian* especially. As with all serial production, this cinema is extremely *coded*. Any commitment, wherever it comes from, to promote a "national" cinema that would remain popular (that would accept the audience as it is, that wouldn't lose it, that would arouse interest—via cinema—in major national problems) returns to the question: *can codes be nationalized* the same way movie theaters are?

That is where the difficulties begin. For as far as national codes go, only one kind, at least in the Arab world, exists: Egyptian. Songs, dances, and abject familialism. Three films, two Egyptian and one "Libyan," have actualized this question. One other, Algerian, demonstrates the difficulty of nationalizing (in this case, "Algerianizing") these codes.

The Egyptian selections were some of the festival's greatest disappointments. The Carthage audience faced one ambitious but botched film (*The Dawn Visitor*) and one film whose selection—by the office of Egyptian tourism!—was viewed and discussed in the non-Marienbadian hallways of the Hotel du Lac as a provocation (*Madness of Love*).

The Dawn Visitor, by Mamdouh Shoukry (who died shortly after the shoot) opened the JCC, with a fantastic reputation preceding it. Twenty minutes of the version that was screened had been amputated by the Egyptians; the plot, already complex, became Borgesian. Just recently appointed to his post, a young prosecutor, slick but nervous, investigates the death of Nadia, a woman, a journalist *and* a

Marxist (as soon as the word "Marxist" was uttered, the Egyptian censor found the film despicable). He discovers over the course of the investigation that the entire country is corrupt. No one killed Nadia (who had a heart condition), meaning that the whole world (the whole world = the system) contributed to her death. "I understand why we lost the war in '67," the young prosecutor thoughtfully concludes, scavenged by a twirling camera and shredded by merciless editing.

The attempt to use the recipes of an extremely coded cinema to say what that code *cannot* say—investigation, analysis, accusation—is clear. Is an Egyptian Z-movie possible?

Or even: to what extent can we outwit these codes? To what extent can we make them say what they structurally silence? My answer (my personal opinion) is that we can only *exceed* these codes. And this in two ways. One, popular, consists in undermining them with excessive comedy, satire. Comedy is always the symbolic death sentence for codes (by excess and not by "perspective," by the letter and not by the mind). The most coded cinema, the most normative there is—Hollywood cinema—has the greatest opportunity to explode these norms (c.f. Chaplin, Fields, the Marx Brothers), to "extenuate" them, as Baudrillard would say. And so, there is more politics in Salah Abouseif's *Al-Qadia 68* than in Mamdouh Shoukry's too-serious film, just as there is more politics in Dino Risi's *A Difficult Life* than in all of Rosi, Damiani, and Petri combined.

The other method of destroying codes consists in excessive logic. All coded cinema sooner or later produces indigestible, unpopular, labyrinthian and hyperrealist products by an excess of rigor. It is, all things being equal, what Youssef Chahine's *The Sparrow* is to the Egyptian familial drama or what Lang's *Beyond a Reasonable Doubt* is to the social and psychological drama. Excessive comedy or an excessive logic: in both cases, *dead labor (industrial labor and its workers) taken literally in what are called "codes."*

Those who were disappointed by *Visiteur de l'aube* tended to appreciate it more after they had seen Nader Galal's *Madness of Love*. An upper class Egyptian couple (he, a business man, always somewhere between Milan and Zurich; she, with nothing to worry about except a wholesome, chubby little boy) run the Rossellinian risk of drifting apart, loving each other less and, who knows, cheating on

each other. The filmmaker, after being exposed by an audience that had justifiably turned surly, shamelessly claimed that he had wanted to address a universal theme (broken homes) and could just as easily have used a poor family to do so. But look, he didn't want to be dogmatic and, in order to illustrate that it is a "broader" problem, he set it in a "wealthy" environment. In fact, the film is a love story between two offices of tourism, Egyptian and Tunisian (one section of the film takes place in Sousse, in a palace).

Still, the screening led to a little *happening** that was extremely significant. On the balcony of the Colisée theater, critics and cinephiles watched the film—literally—from on high, with that joking and indignant pleasure experienced with films seen "in the second degree." The Tunisian critic Khemaïs Khayati observed that the heroine changed her dress twenty-five times. Downstairs, in the orchestra, the audience's reaction, although just as intense, was nonetheless *different*. For the popular audience is right at home in this film, and being *right at home*, it does the housework; moving very quickly from a satisfied reaction (when it recognizes a star or a Tunisair airplane) to a cry of disgust (when Tunisia is slandered or when the plot is too trashy, or when it drags on).

What to conclude? That everyone—the "informed" audience as much as the "alienated" one—reacted, and rather strongly. The problem is that the discussion with the director did not reflect that reaction. Nader Galal was barely criticized for not having "chosen" to discuss Tell El Zaatar. Yesterday's fans became indignant censors. Totally futile indignation. The only response that challenged this film was the boycott, but so long as you agree to debate, the debate must at least be at a useful, meaningful level. Useful means not feeling superior to such a film, but gaining a deeper understanding of how such a film is possible. How: what economy, what technical and social division of labor, etc. Questions that were never asked at Carthage.

There is no point in perpetuating this cleavage between a *jouissance* that is considered "naive" about codes (in the popular audience, supposedly "incapable of defending themselves," which is anything but certain) and a *jouissance* considered "knowledgeable" about the same codes (in the public intellectual, someone who "can't be fooled," which is anything but certain). We have always thought, at *Cahiers*,

that there is no "second-degree vision." We have always thought that was a myth that encouraged laziness and insincerity, that prevented any materialist discussion of cinema and replaced it with ideologist, macroscopic, sterile critique.

That is what appeared, in a teratologic form, with the horrible Libyan film, *Green Light* by Abdellah Mesbahi, the most maligned, but also the most commented-upon film in the non-Marienbadian hallways of the Hôtel du Lac. What was it about?

A family (assumedly Libyan). A narrow-minded and violent father (Orgon psychologically, Gerald Ford physically). The mother seems worn-out and profound, but stripped of power. The son is fundamentally soft and takes two hours to realize that "it is right to rebel." A daughter goes to university, where she is loved by a modest student (Amar). All this in affluent surroundings, to say the least (Tunisian eyes recognized the great hall of the Tunis Hilton playing the role of the living room in the family home.) The father is parasitized by Ibn Soussi, a massive, creepy character wearing an unbelievable wig: he is this Orgon's Tartuffe. He is surrounded by two henchmen and a charlatan. The daughter is courted/pursued by a certain Marzouk, an amorous, lecherous figure who, despite the elegance of a fifty-year old man worn down by pleasure, is in cahoots with Ibn Soussi. Only positive character: a religious, honest, and proper man: he is for a progressive Islam, serious and reasonable. His Gaddafist discourse is opposed to seances of possession conducted by Ibn Soussi and his acolytes. The family is visited by uncles and Tunisian cousins, pudgy and modernist pleasure-seekers who only contribute to the ideological-sexual troubles into which the family sinks. During a dance performance, the father promises his daughter to the odious Marzouk. General alarm. It requires a trip to Tunis (songs in the Carthage ruins) and many twists and turns before: 1) the son, rebellious at long last, stabs the odious Marzouk (in the back) and allows his sister to marry the modest Amar; 2) a sort of "revolution" breaks out, signalling the triumph of good religion and the panicked defeat of the bad.

The interesting thing about this film is that it tries to *cohere* ideologically. How to articulate the frivolous, puritanical (hence lewd) and pro-family/musical narratives of Egyptian cinema along with Gaddafist ideologems: Arab nationalism, serious and normative

religion? (For the film has a code we must read: Amar = Muammar (Gaddafi) and Ibn Soussi = Senoussi). *Green Light* answers the question in a screwball way, and yet it is a new question, a question for the future. For with the schemes of a (Moroccan) filmmaker who uses (Libyan) petrodollars to make a name for himself, an Egyptian aesthetic to reach the Arab masses (where the religious right is stronger than ever), Tunisian scenery (according to the equation, Tunisia = modernist bordello) to impress Carthage's audience and critics, a specifically Arabic Espéranto attempts to take shape (at the debate, Mosbahi pretended to speak *only* Arabic, for which he was savagely exposed—in French—by Borhane Alaouié, a member of the jury) from which we have, evidently, nothing to expect, and everything to fear (imagine films produced by the Shah of Iran or King Khalid!) We must reframe the problem of national cinema in relation to that possibility. And question it.

For example, Algerian cinema. The film by Ghouti Bendeddouche, *The Net (Ech Chebka)*, has as one might suspect, no relation to the three aforementioned films. Except for one essential thing: it also reflects an effort—by Algeria, by l'ONCIC—to establish a minimum of coordination between national themes (principally the agrarian Revolution) and Esperanto-based codes. Which, given Algerian cinema's originality and progress (in the domain, at least, of distribution), takes place under less farcical and more dignified conditions.

Tenes. Hard-working fishermen (beautiful documentary moments) sell their fish to a cannery boss (Khelifa). One day, the hero, Maâmar, rushes to the scene of a car crash and finds a beautiful passenger (blonde, urbane) who provokes a sort of crisis in him. Not only does he desire her, but he immediately measures the (class) divide between them. He's completely possessed by it, bullies his wife, beats up Khelifa and sets off for Algiers where, for three years, he lives his life, looking for the shadowy and beautiful stranger. He returns to Tenes where, in the meantime, the OPA (Office of Algerian Fisheries), inspired by the agrarian revolution, has begun to fight against Khelifa. The State has set the stage for the struggle, but it is missing a mass leader. Maâmar is that leader. With his uncle Rabah, he rounds up the fishermen and organizes them, with the goal of taking over the cannery. In turn, his wife, now abandoned and grown

more mature, takes charge of the women's rebellion. They go on strike while Maâmar fights with a knife, under the watchful eye of the masses, Khelifa's henchmen, whom he throws to the sea. The two leaders reconcile. Final shots: they leave together and walk across a red net. In the next shot, they are transformed into two small trawlers, then a myriad of birds.

This hybrid, slightly schematic film confronts a problem specific to Algerian cinema: how to film (how to fictionalize) a revolution from above? How to convey the good will of the state through individual revolution, and vice versa? The answers are tinged with traces of Soviet cinema and a discreet puritanism (not much to refer the film to the serious struggle for power that Algeria is currently facing). Coming from a country that took a giant step towards nationalizing distribution (or at least towards maintaining a certain control over it), the film demonstrates that *production* (even if performed by salaried filmmakers) does not automatically follow and find its own formal autonomy.

Immigrant cinema

Two films dealing with Maghrebi immigration in France. One is a Tuniso-Franco-Libyan coproduction (*The Ambassadors*), the other is Ali Ghalem's *The Other France*.

The second film is arguably one of the least rebellious films in cinema history. While it is much better made than *Mektoub?*, it is a film that runs like clockwork, in which everything happens at exactly the right moment: the arrival in Paris, discovering work (here, on a construction site) and racism, work accidents and unionization, solidarity, etc. The film is comprised of three types of sketches: little slices of daily life (with Arabian music in the background), discussions (where the question of unionization is asked, then abandoned), working gestures (the most interesting, because slightly enigmatic, part of the film). Regarding immigration itself, the film oscillates between two possibilities: analysis (sadly nonexistent) and history (sadly skeletal), and chooses neither.

The film proves one thing. Immigration is no longer simply the absolute repressed of French cinema, nor is it solely the domain of militant filmmakers. It can provide a frame for "genre scenes." French cinema is starting to "blob" immigration, to "naturalize" it,

to make it a theme like any other. Which means that it erases any slight hope of analysis.

The problem inherent to this kind of film is that it wants it both ways (this is also immigration's problem). Here (in France, in Paris, in the Latin Quarter) it is relatively easy to challenge/blame (weakly) the audience, let's say, of *Le Nouvel Observateur*. That audience is, as audiences go, the least interesting of them all because it has, when confronted by immigration, more of a symbolic debt to pay than a real desire to learn something it doesn't know. For that audience, saying good things about the film amounts to doing a good deed.

The Other France simply tells that audience what it already knows, in the terms in which it wants to know it. Sydney Sokhona has been the only one until now who has tried to consider his films (*Nationality: Immigration*, then *Safrana*) not solely in relation to the Parisian audience (to confirm them in their bad conscience) but rather to the idea that *sooner or later* one will have to find the means (political, economic *and* aesthetic) to say what emigration means for those who remain in their home countries. And to know that in order to reach and convince them, he must supercede the regimes, associations, and—*last but not least*—the mythologies that immigrants repatriate with them. A problem that is much more difficult, and new.

For by foregoing analysis, films "about" immigration are reduced to addressing only one aspect of the phenomenon, the most apparent *and* thus the most photogenic: racism.

Such is the case for Naceur Ktari's film, *The Ambassadors*, the much-anticipated Tanit d'Or winner of these 6th JCC. This is a much more substantial film than Ghalem's. In it we follow the journey of an immigrant worker (played by Sid Ali Kouiret, excellent, already the main actor in *The Net*) from his home village to the Goutte d'Or neighborhood where he discovers abject, rampant, routine racism. And from there, following several murders, the necessity to unite instead of relying solely on one's own strength, to oppose racist violence with the organized counter-attacks of immigrants.

What is striking about this film is that it doesn't attempt an analysis of the phenomenon (the kind that we still see from Med Hondo or Sokhona). Racism is faced as a given, the only given. It refers only to itself and splits all of the film's extras into two camps,

poor Whites and Arab workers, each driven by no internal contradiction. Racism here is the work of a series of crazed, thuggish, fascist, poor whites and leftover OAS bigots. The actors playing these roles (Rispal, Cuvelier) have the unhappy air of those who sacrificed themselves to play the nasty characters in an amateur production, that end up stripping them of all credibility, without making them Brechtian.

A (difficult) question on the choice of racism as *subject* for a film. What purpose does a film "about racism" serve? Not to convince the racists (racism is delusional, hence unreasonable, because it primarily is the desire to no longer have to reason). Rather to *arm* those who, for all their antiracism, most often have only a negative (hence reactive and insecure) definition at their disposal: "But I myself am not racist."

We can arm them in two ways. We can arm them by *analysis*. We must continue to illuminate the link between the racism of lower-class whites (violent, filthy, visceral) and that (structural, clean, abstract) of upper-class Whites. It takes both. Until now, anti-racist films have abstractly challenged the "System," Capital, Imperialism and forgotten the active, violent carriers of racism. Ktari can be blamed for having bent the stick in the other direction.

The other way to arm the public consists in reiterating that the only real antiracism is in *action*, in the practices that—by being communal—allow for the recognition of the other, of what he is fighting against (with reason), of the common struggle and a bit of the path to tread together. Ktari's pessimism (his only white, non-racist character is a young teacher, but she is precisely, and not by chance, outside of desire, outside of the narrative, hence external, short of the problem) runs the risk of being demotivating.

Black African Cinema

The coupling of "Arab-African" is anything but straightforward. If, like every classification, it has been able to provide a service (to define one bloc—black and white Africans—against another—non-African and developed), it nevertheless covers a fundamental heterogeneity. Not much of a (popular) audience for black African films, which lack—in Tunis—music and songs. Only a few significant films (with the exception of *The Child of Another*). One relatively undecidable, although boring, film by Ola Balagun (*Ajani*

Ogun, Nigeria), spoken and sung in Yoruba (the misadventures of a young peasant whose fiancée and land are stolen by a corrupt politician). Its undecidability lies in the fact that, while it is sung, the film remains extremely static. Thus it no longer refers to the musical comedy aesthetic, but, with its simultaneously hesitant and outré acting, to that of the Guignol (a direction to explore).

Corruption is (along with maraboutism), the subject of most African films. In *The Black Star* by Djingarey Maïga (Niger), the hero, a public official on the brink of success, falls in love with a prostitute, leaves his wife and immediately sinks into degradation. He alone is blind to the fact that his new girlfriend only dates Whites (she herself is bullied by an unappealing foreign aid worker). Nevertheless, he ends up returning to the fold.

Although low-budget and hideously photographed, the film has, initially, the power and logic of fantasy and operates like a waking dream. The dreamer is a simultaneously tyrannical and naive figure who makes every possible mistake with the utmost seriousness. When he tries to corrupt a judge (to speed up his divorce), the judge cries, "I am incorruptible!" In the film, it is said that this judge has replaced another who was thought to be corruptible. The film must simultaneously declare that corruption exists and exonerate the regime, which is a difficult task. Everything is ruined by morality's return, a double blow dealt both to the hero who had forgotten all about it and the spectator, who unfortunately has long since cracked.

Here, a notation. Just as Arab films seek *pathos*, African films are smitten with *logic* (see, for example, the very interesting *Letter from My Village* by Safi Faye.) They ask the question, "What should we film?" more than "What shot should we concoct?" Which makes them austere and unattractive, but also potentially fascinating.

One film, a strange one, takes this logic to the limit: *Borom Xam Xam*, shot in (and for) Senegal by a Frenchman, Maurice Dores, and dedicated to a medicine man whose life, practices and dreams are imperturbably rendered, one by one. The film's power derives from the way it destroys along the way every label that could, out of laziness, have tied it down. Up to a certain point, it acts as a Rouchian document on the gestures of the medicine man, the real-time operations (expertise? magic? who knows?), the words actually pronounced,

etc. Suddenly the film, with the same seriousness, begins to illustrate the dreams, fantasies, narratives of the healer, snatching from the spectator any possibility of succumbing to a Rouchian hum.

Two films

Two films apropros of which it is no exaggeration to speak of *work*. Films that have a clear idea of their material and that work at its *transformation*, the first in the sense of diversion, the second in the sense of exhaustion.

Diversion. *The Armies of the Sun* by Shadi Abdel Salam, a short film centered around the last Israeli-Arab war, seen from the Egyptian side. Soldiers, returning from the front, are interviewed. The camera insistently fixes on tired faces, blinking eyes. The microphone records the soldiers' words, monotone, rushed. The applause that greeted this film belongs to a misunderstanding: they were applauding the subject of the film, not the actual sounds and images that, far removed from any doxa, say something else: the perverse pleasure that the film-maker takes in capturing the impact of a war, its traces over faces, over voices. The war becomes that immediate off-screen space, menacing and natural, where one always already is and from which one never recovers. (Fabrice at Waterloo, forever) except in the form of its shards: shells, images.

Exhaustion. From Taïeb Louhichi (Tunisia), *The Sharecropper*, a medium-length film, screened out of competition and at the very last moment, that is interesting because it is exemplary, that gradually wins over the audience and brings us into its landscape. And it is indeed a matter of landscape, since the entire film takes place in the field that Naceur, the sharecropper, tends for an owner. The landscape *becomes* at once the stage and central issue of the film: everyone and everything passes through it. From that landscape, everything becomes visible, comprehensible, possible: the owner who comes to inspect it, the family that brings food, the telegram that announces the death of someone from a village in France, those who expatriate and those who return, those who submit and those who—like Naceur—revolt.

Why is this short film exemplary? Because it has a correct idea of its *economy*. Adapting its subject and shooting with available resources (which we imagine are meager) and semantically exhausting

that field (not the imaginary richness of the off-screen space). Scene and issue, the field must simultaneously be won as a stage (a political question) and staged as an issue (an aesthetic question).

In Carthage as elsewhere, the future belongs to logical films.

(Cahiérs du cinéma #272, December 1976)

6th FESTIVAL OF NEW DELHI

Presentation of the IFFI

The 6th IFFI (International Film Festival of India) was held in 1977 from January 3rd to the 16th, in New Delhi, just as it was in 1952 (in Bombay), 1961, 1965, 1969 and 1975. This truly enormous event consolidates many of the scattered traits of film festivals: simultaneously an exercise in ideological-political prestige *and* an intense film marketplace, a space of cultural exchange *and* popular participation. More than two hundred films were screened in fifty theaters, which themselves were spread out over the 1,484 square kilometers of Delhi, one of the most sprawling cities in the world. Whether in the Marienbadian hallways of the hotel Ashoka or a yellow rickshaw, the journalist (now a *delegate*) can scarcely identify with anything other than an electron experiencing the void at the heart of matter. Gigantic, the IFFI is indescribable. Along with the films in competition and an extensive information section, retrospectives were devoted to Satyajit Ray, François Truffaut, Akira Kurosawa, Andrzej Wajda, Norman McLaren, David Lean, etc.

The IFFI was held several weeks before some of the exceptional measures taken by Indira Gandhi on June 25 1975 that had led to a generalized silencing (of the press and of the opposition) were lifted. Along with programs for the screenings—which were often terse—delegates also received self-congratulatory governmental brochures. These were intended not only to acquaint them with Indian cinema, but to paint a rosy picture of the current political situation (which was complicated even further recently by the resignation of Minister Ram and the general alarm surrounding the resistible ascension of Indira's son, Sanjay).

Every international competition (athletic or artistic, Olympic games or film festival, all the same) is, as we know, driven to provide evidence that the government that organizes (or chaperones) the competition has things sufficiently in hand… to organize that competition. These days this tautology has value as a political enunciation. Guaranteeing the festival scene implies that control over the entire political scene. This was obviously the case with the IFFI, whose ambition to figure among the great festivals of the world (A-list) was explicitly affirmed, and who did not shy away from any expense (royal welcome) to demonstrate it.

That said, the IFFI has a uniqueness that allows it to avoid a raw demonstration of prestige (advertising for a political regime, such as Tehran). It is the meeting place of two genuine powers: State interests and the Indian film industry (likely the world's leading film industry, at least its most prolific). It's not the State that finances festival; the Indian public, by its massive attendance in theaters, finances the festival (and hence, the *delegates*). Nuance.

Parenthesis on Indian Cinema

In 1975, the Indian film industry produced 470 films, 223 of which were in color. These films were projected in 8,607 theaters. They break down linguistically as follows: 118 in Hindi, 88 in Telugu, 77 in Malayalam, 70 in Tamil, 38 in Kannara, 36 in Bengali and 44 in Marathi, Gujarati, Punjabi, Asamiya, Oriya, etc. The three capitals of Indian film are Bombay, Calcutta, and Madras. The industry is entirely subject to the law of free enterprise, which means that it is a *jungle**. The pursuit of a quick profit is of the utmost.

Indian cinema, which has existed since the beginning of the century, is an *overcoded* cinema. Its export-based vocation (to Asia, white and black Africa) orients it towards socio-musical or mythological melodrama. Bringing order to Indian cinema is no easy task. In 1960, a State agency, the Film Finance Corporation, was created in order to finance ambitious projects and quality films. It does not seem to have achieved its goal. One specialist, N. Narayan, remarks (in the journal *Filmfare* on January 7, 1977) that in the fourteen years of its existence, the FFC financed 116 low-budget films, while the industry produced 4,867 films in the same amount of time.

The law of the jungle that governs the film industry becomes complicated due to the excesses of various State governments (India is, basically, a federation) that crush films with taxes and subjects them to capricious and incoherent censorship. It is understood that, under these conditions, the entire internal debate over Indian cinema revolves around the question of knowing if the State should take the situation in hand (and eventually nationalize, as it already has with film exportation). But can a jungle be nationalized?

It's not certain that the State can easily subjugate the Indian film industry, make it serve its ideological ends. Indian cinema is relatively autonomous due to its absolutely popular character, to its quantitative importance, to its long history, to its commercial vitality. Film is, in India, the dominant medium. Through it (and not through television, which is still uncommon, or through the press, which is suppressed and often Anglophone) debates over national concerns take place, even if they are horribly distorted. As an ideological vector, cinema *cannot* be disregarded. Official discourse about cinema inevitably stumbles upon this problem. "Through films," writes the critic, M. Shamin, "we reinforce our nationalism, popularize our system of secular values, restore the people's faith in God and even explain the advantages of family planning." And Indira Gandhi: "Unfortunately, the formidable potential represented by film as a medium of artistic creation, of the diffusion of education and of wholesome entertainment, has not been entirely or adequately realized in our country. It is a particularly urgent need at a time when our people are engaged in the gigantic task of transformation and social progress."

In India, in official and informed discourse, as in the discourse of the industry, with differing intonations, the art/commerce contradiction is experienced, articulated, with emotional sighs and unspeakable ulterior motives. Indian audiences are always regarded as big children whose drives must be urgently sublimated, at the risk of mortal danger for the collectivity. The industry is the site of that sublimation. For the State, a double bind: on one hand, it must encourage films that advocate a socialistic ideology, planning, based on discipline and civic responsibility (India is covered with moralizing posters: "Nothing can replace work," etc.). On the other, it mustn't discourage a profitable industry that spreads throughout a large part of the third world.

Hence a certain pride. One critic (Amita Malik) writes: "From Isfahan to Mauritius, Algiers to Singapore, there are few places in the world where Indian films are not seen and loved. It is one of the industries that brings the most currency to India, and also the most international goodwill." And, a little later on, with a hint of exaggeration: "From *Cahiers du Cinéma* to *Sight and Sound*, from the new *Sri Lanka Journal, Cinema India, Cinema Africa* to the most prestigious international newspapers, everyone is talking about Indian cinema."

At the same time, the levying of Satyajit Ray by European critics (including André Bazin) on Indian opinion is still felt as an interference. To indulge that international opinion (for which Indian cinema = S. Ray), the IFFI showcased the author of *Pather Panchali*, who was both member of the jury and the object of a tribute. But he is always accused of "accentuating poverty," of ignoring improvements to the standard of living, the regime's successes and accomplishments.

*Note on the Indian audience: Sexandviolence**

The organizers of the IFFI found themselves caught in a double bind. On the one hand, they they needed to draw audiences in large numbers. On the other, they had to prevent them from seeing what they mustn't see under any circumstances: *Sexandviolence*, the monster with two heads (the same one that haunts Mr. Foyer's nights). Simultaneously with Indira Gandhi's ban on "any kind of violence" onscreen, a surge of films on New Delhi screens harbored the monster: American, European, etc. What was the solution? The trick of *blind-booking**.

India has had, traditionally, a gigantic black market for film. Entire halls, rows, seats are purchased broadly and then resold by a series of intermediaries. Seeing a film belongs not only to leisurely cinephilia but to a social practice that includes the *struggle for life**. Cinemas are huge and modern, comparable to theaters. They resonate like cathedrals do, and the screens, often convex, generate optical effects. In the festival context, the struggle against the most blatant manifestations of this black market were vivid. Special envoys ensured that, in the queues, each person could hold only one space at a time. *Blind-booking* entails the audience knowing nothing about the film they are about to see (title and director) except for its

nationality. That is why it quickly became impossible to procure a seat for *Surreal Estate*, simply because of its being a "French movie."* Western films, suspected to contain *sexandviolence*, were viewed in large numbers (one recent Fassbinder caused a scandal); Eastern films, known for their puritanism or political seriousness, were massively snubbed.

There is something paramnesic and retro to us about the Indian public's mode of adherence to cinema. Retro in the sense that, all things being equal, the situation must have been somewhat similar in Europe and especially in the U.S. when film was the dominant medium, the vehicle for the dominant ideology. Nothing goes, but everything goes (disguised) within the codes of the sociomusical melodrama. As J.-L. G. says, the spectator "does all the work," while the filmmakers need only turn up the heat. Sex and violence, which are missing *as such* (not represented) in Indian films, are also *actually missing*. Between the moment when a fist is formed and a jaw is bloodied, there is—on the screen—the evidence of a cut (censorship or self-censorship) and—in the audience—a collective cry that indicates where the violence lies: in the cutting and pasting. Between the lips that draw perilously towards each other and those that draw apart, satiated, there is—on the screen—a fatal lack, but, in the audience, something resembling a collective orgasm. In that sense, one could say that the Indian film industry obeys a (more than) pornographic logic whose every stage has yet to be explored. It's in its *star system*.

Let's return to the IFFI. Which films to see? The choice must be made, Gordian-style. In my case, I tried to see only films produced in Asian countries. Somewhat by chance. Hence the notes that follow.

Three films by Satyajit Ray.
Three films that challenge the image of a miserabilist Ray. They are set in affluent circles: villagers (*Teen Kanya*, 1960), farmers (*Monihara*), Calcutta intellectuals (*Charulata*, 1964). The last two are drawn from stories by Rabindranath Tagore. All are centered around a female character, always *inadequate*, destined for resistance, neurosis, or madness. *Teen Kanya* is a domestic comedy (Indian cinema seems principally domestic: aimed at families, it presents families, a role that in the West is currently reserved for television). A mother wishes to arrange the marriage of her son, a great student. To

do this, she is prepared to stoop to any level. He fights back ("we have good reason to fight back") by, without even consulting her, marrying Puglee, a true tomboy, mischievous and intractable, who escapes on their wedding night. Depressed, the student heads to the big city. To make him come back, the mother fakes an illness. Once he's returned, the student finds Puglee mellowed, loving, ready to accept the forced marriage.

In *Monihara*, a fairy tale, a wealthy jute farmer has married a beautiful but sterile woman who will accept nothing from him but jewelry. The plantations burn; he is ruined. The farmer heads towards the city to try to secure a loan. Moni, convinced that he is going to ask her to sell her jewelry, loses her head and runs away with all of her gems. Once he's obtained the loan, the husband returns with a jewel that's even more beautiful than the others. He cannot find Moni; he falls apart. In his frenzy, he sees a black silhouette approaching him: a skeleton's hand tries to grasp the last remaining jewel.

In *Charulata*, the century's liberal Indians become active, try their hand at politics, dream of England, write journalism, literature. Bhupatti Dutt takes care of everyone and everything (another recurring theme: the maternal). Only he does not "see" his wife, Charulata, who, a Bengali Madame Bovary, adapts very poorly to the decorative inaction to which she is confined. Again, the man loses everything: he is betrayed by those whom he trusted and his wife, out of spite, solely to prove that she exists, publishes a story in a literary review without telling him anything about it. A sort of dubious reconciliation follows, *in extremis*.

It is clear that there is only any overlap in these three films on the level of the plot. *The woman is jobless/The man loses everything*. It is then a matter of picking up the pieces, if it is not too late. Ray's style of filming is driven solely by a logic of the displacement of partial objects, sometimes trivial (shoes in *Teen Kanya*, slippers in *Charulata*), some-times noble (jewels in *Monihara*, books in *Charulata*). Hence a certain enigmatic sluggishness which does not sit well with the Indian public. Otherwise, he deals with the same themes that other filmmakers do: the woman can only *be* a child or *have* a child (To be or to have). A spoiled child or tyrannical mother, but a woman, never.

Another Bengali film, K. Anwar's *Good Morning (Suprabhat)*, representing Bangladesh. An opportunity to measure the distance between Ray and the rest. The film is steeped in good intentions. A village. A train passes. A young man arrives. He finds himself ensnared in the village's contradictions, which are not minor. A young woman, Lilly, is being forced either to marry or leave the village, because she has just spent a year in prison for having killed a man who wanted to rape her. The young man, whom we see is politicized, sensitive, in love, stays in the village, marries Lilly, becomes the schoolmaster, and disseminates new ideas. Village politics get the better of him. His death is ordered, organized, realized. Lilly gives birth next to his dead body. A sunrise. This film, sad and flat, nevertheless is one of those films, clamored for in Dhaka as well as Delhi, that deal with "real problems." These problems are, as the critic Dileep Padgaonkar reminds us, "the erosion of the caste system and feudal values, the persistence of religious prejudices, the trauma and excitation that accompany changes in castes in a traditional society, etc."

Chomana Dudi

B.V. Karanath's *Chomana Dudi* was far more substantial, for me the greatest surprise of the festival (it goes without saying that there would have been other pleasant surprises if we had had the opportunity to see *more* Indian films). The Kannada language is spoken by eighteen million people in the South of India (Mysore province). Kannada cinema appears to be extremely interesting (its most famous representative is Girish Karnad).

Chomana Dudi is about a harijan (untouchable) family living before 1947. One card preceding the film and another following it attempt to relegate the scenarios to an immemorial past. This hypocrisy fools no one. Choma has a dream: to tend some land of his own. Which is, by definition, denied to harijans. Because of this unreasonable dream, he loses everything. To resolve a debt of two rupees, Choma sends his two older sons to work for a major English (and despicable) landowner. But everything goes wrong. One of the sons falls in love with a Christianized girl (the conversion to Catholicism is one way for harijans to own a piece of land—which the Church is all to happy too grant them) and marries her. The other

devotes himself to drink. They don't repay the debt. The first goes to live with his wife's Christian family, the second returns to the village and immediately dies of malaria. The debt remains, compounded. Choma sends the English landowner his daughter, Belli, and one of his two younger sons. The child falls ill but Belli is protected, supported and then seduced by the English landowner's foreman. She can then repay the debt, and returns to the village. Choma's other young son drowns in front of everyone: no one comes to his rescue because he is an untouchable. Desperate, Choma is tempted to convert to Christianity, but he encounters his deities along the way; they shame him, and he gives up the idea. When he returns, he finds Belli and the foreman entwined in an embrace. He chases them away, frees his remaining two steers, sets his cart on fire, locks himself up with his drum and plays it until he dies. For his only joy was to play the drum all night long, and watch his entire family dance.

This kind of synopsis runs the risk of making the film seem like a mawkish melodrama, based on an inferiority complex. This is not the case. The sequence of misfortunes is always more logical than what the spectator is able to anticipate. The characters are taken seriously on equal terms, even if their status changes over the course of the film (some who seemed to be central disappear). Oversimplification is avoided: Belli does not hate the foreman who seduces her, she fears her father but resists him, too: she is a complex character. Miserabilism is ignored: Choma, when he plays the drum, is not only seeking relief from his sorrows, but plays violently, expresses something irrepressible, a resistance born from oppression, and that includes his family—without pity. In a word, the film is unpredictable, always more precise, closer to raw denotation, than what its audience could ever imagine.

A Vietnamese film

Blind-booking caused there to be few attendees for Hai Ninh's *Em bé Hà Noi* (*The Little Girl of Hanoi*), since the Indian spectator correctly suspected that there probably wouldn't be much *sexandviolence* in this Vietnamese film from 1974. It did contain violence, in fact, but the violence of a quotidian war, simultaneously consistent and unpredictable, diffuse and arbitrary. It shows the heroism of a populace

under bombardment, its ability to organize, its abnegation. A little girl, lost in Hanoi, is retrieved by the driver of a weapons truck, whom she tells (a complex, recurring story) about how her mother heroically died in the bombing of a nursery school, how she found her paratrooper father; we understand that she has understood the meaning of the war, the validity of its combat.

It is difficult to judge edifying films. In the triple sense of moral, national, or socialist edification. One tends to find one's own doxa, imaged, in them, without seeking to explore that very deeply. Hence a certain ennui. One is somewhat obligated to love these films transversally, as if despite themselves, when they are affected by a slight excess. Here, there is a breathtaking scene in which a makeshift hospital is bombed at the very moment when an operation begins. This kind of film has an uncertain relationship with the reality it plugs into, between the idealization that belongs to propaganda and the naturalism of the everyday. "Thematic" (and thetic) films, but without a "subject" (without filmic "material").

Kaneto Shindo is not Henry James

For *Kenji Mizoguchi, The Life of a Film Director*, blind-booking was a disappointment. The hall emptied out as it became clear that, although Japanese, the film would present only the old, tired faces of innumerable interviewees. Only one spectator in the back of the hall was riveted to the austere screen: me (S.D.). Indeed, those old faces belonged to Yoshikata Yoda, Kinuyo Tanaka, Michiyo Kogure, Ayako Wakao, Kazuo Miyagawa, etc. And the man they were speaking about, tirelessly, was Kenji Mizoguchi.

The premise Kaneto Shindo (author of the formidable and un-Mizoguchian *The Naked Island*, and *Onibaba*) adopted for the film is classical and flat. Reconstruction of K.M.'s career from its beginning (1922, *The Day When Love Returns*) to its end (1956, *Street of Shame*): a parade of testimonials, survivors, traveling companions, etc. Overlapping interviews, rare excerpts from films. The tone is unfortunately that of hagiography. It confirms what we had already suspected: of all the filmmakers having worked in an industrial production setting, Mizoguchi probably had the most extreme demands in terms of his *means of production* (first and foremost the actors),

asking the impossible of them (they still shudder thinking of it), and living on set himself (a significant anecdote: so he would not have to leave the set, even to urinate, he was equipped with a portable urinal. Mystique of shooting and urethral eroticism). In this way we learn interesting things, about technique, the construction of the sets, etc.

Shindo's approach, very respectful, stumbles upon this fact: about Mizoguchi, just as with anyone else, there can be no final word. The testimonials blend together, contradict one another, hesitate, overlap badly. When he tries to extract from Kinuyo Tanaka (K.M.'s favorite actress) the admission that she is probably the only woman whom Mizoguchi ever loved and she endlessly avoids the question, we see how this could be the *subject* of a wonderful film, à la James ("The Figure in the Carpet"), an infinite number of forever unsatisfying questions and answers. But that would have required, instead of hagiographic fervor, iconoclastic passion.

That said, it is time to rise up, for Mizoguchi is on the way to becoming, if not an accursed director, at least, and this would be worse, simply a name in cinema history. His films—outside of the Cinémateque Française—are absolutely invisible. Even the most famous of them aren't included in any cine-club. Scandalously, Mizoguchi enters into the dictionary but exits from darkened theaters. There is no reason to accept this as a given fact.

(*Cahiers du Cinéma*, #274, March 1977)

CAHIERS IN NANTES

First Nantes screening of *Here and Elsewhere*. Afterwards, someone in the hall describes how beautiful, important, etc. the film seemed to him. But he says it so emphatically that it draws, from another spectator, a shout that comes from the film itself: "Turn down the volume! " There could be no better summary of what made this *Cahiers* weekend in Nantes (18–20 February, with J.N., S.T. and S.D. in attendance) a success. 1) The films were not used as "pretexts for debate"; the dishonesty of cine-club metalanguage was largely avoided. Instead, the films were viewed as objects calling for debate,

extending themselves within it, gaining a hold over it. 2) There was much discussion about sound.

The common thread of five of the six films presented by *Cahiers* in Nantes (the sixth was Comencini's *The Adventures of Pinocchio*) was that each "turned down the volume" in its own way. And that none took sound (noises, voices, speeches) for granted. Let's state it clearly—and return to it from time to time—the famous articulation between artistic experimentation and ideological struggle, obstinately sought by every past and future Cultural Front, *happens*, in film, in the soundtrack, in *sound work*. The nodal point, painful, of non-return, between political utterances and filmic material, is sound. This weekend confirmed it for us, and the audience in Nantes perhaps got a first impression of it.

What is Francis Reusser's *The Big Night* (which we haven't discussed enough, in *Cahiers*) really all about? The slow revelation that the element in which Léon, Léa and their eternal debate are soaked, the element of language, is simultaneously a channel of communication and an immersion in jouissance.

"How can we demonstrate that?" wonders Reusser. By the intervention of *other* voices (the young Palestinian girl of *Here and Elsewhere*, the poet whose recorded voice stutters). A stutter allows us to hear two voices. The truth begins with three. Not to make them ridiculous in any way, to criticize or "demystify" them (too simple and too easy to laugh today at yesterday's militancy, to suddenly believe that one hasn't been fooled). Reusser's film is one of the rare, serious films of this moment: it doesn't throw out the Revolution-baby with the Language-bathwater.

In *Here and Elsewhere*, J.-L. G.'s voice is forced by another voice (A.-M. M.) to admit how several phrases in Arabic, so apparently anodyne that someone has forgotten to translate them, makes all (*all* without exception) of the other phrases of the film (*in* and *off* voices, activist speeches or songs, scenes of daily life or pedagogy) sound too loud *in extremis*, just like an Internationale-answering machine. Again, one sound doesn't criticize another (that was the illusion of *Wind from the East*, the dialectic's charade), but—and this is much more important—allows it to be heard. For a sound to be truly perceived, it requires another—next to it—faint, weak, in a word, dominated. Which in turn...

In *Fortini/Cani*, a block of aphasia (not of silence), fifteen minutes of "landscapes," of home movies, is carved out of the heart of another block—of language—and, just like a cavern, a pyramid or a mastaba, allows that block to resonate, to make itself *heard*, to "sound hollow." Hollow like Fortini's voice in the desert of his paradoxical position, of his exposed stance. Hollow like something which is not, excepting unanimity and deceit, to be filled, but *heard*.

In *Je, tu, il, elle*, it is, in the magnificent truck scene, the stubborn presence of the auteur-performer Chantal Akerman, located between us and him. C.f. the cover of issue 275 (him, the chauvinistic truck-driver, actor Niels Arestrup). The truth begins with three, to be sure. Her presence makes the truck driver's speech *audible*, audible not because it is primarily or solely meant for us, but because it passes through a third party. Not a hostile (feminist), derisive third party, or a charming or fascinating third party, but an undecidable smile, a presence, as it were, at the *start*.

In *Safrana*, it is the slow, calm, *composed* voice of the Côte-d'Or French farmers, the voice of denotation, of description itself (and aren't farmers—Louison, in *Sur and sous la communication*—the only ones still able to "tell what they are doing"?) that allows us to hear that famous "right to speak" captured by the four Africans at the end of *Nationality: Immigration*.

So many different tactics that deal a serious blow to the ideology of communication (the happy and complete transmission of "messages" from a zombie transmitter to an ideal receiver). Films that, if they are taken seriously, restrict metalinguistic debate and the litanies of the cultured ("whom is this film addressing?" etc.). *We need films today that turn down the volume.* That demand that we prick up our ears as much as our eyes. Looking back on this weekend in Nantes, it seems obvious that we must engage these sounds. And it is possible that the weekend's audience was able to grasp that fact. For there was a full house at the Salle Paul Fort, thanks to the continued efforts of the irreplaceable Alain, Phillipe and Marie-Annick Jalladeau.

And so, to be continued.

(*Cahiers du Cinéma* #275, April 1977)

EDINBURGH FESTIVAL
HISTORY/PRODUCTION/MEMORY

"Truth about the past is only possible when it doesn't trigger emotions. Otherwise, it is impenetrable. We must live in the present."
— A. Zinoviev

*1. Cinema-and-history strikes again**
During the 31st EIFF (Edinburgh International Film Festival), from August 22nd to the 27th, a series of screenings, seminars, and debates took place under the supervision of Claire Johnston on the theme, "History/Production/Memory." A chance, then, to revisit some films (old: various Vertov, new: *Moi, Pierre Rivière, Civil Wars in France, L'Olivier, La Cecilia*) and discover others (various English films, silent and sound, documentary and activist, from the Grierson schools and Ealing studios, plus Ken Loach's latest TV series). Also a chance to take stock of a debate that is now three years old at *Cahiers* and that returned to us, translated into English, tinged with a rétro perfume.

One idea dominated the Edinburgh debates: History is not an empirical given, it's a discourse, a bridge *constructed* towards the past to serve the present and its conflicts. This idea was asserted even more intransigently in that it sought to exorcise English intellectuals' well-known taste for empiricism (from Hume to John Lewis). It quickly became clear that to claim that "the proof of the pudding is in the eating" ran the risk of nothing less than being lynched.

The theoretical references, then, were French: principally Althusser (for "theoretical practice" and Ideological State Apparatuses), Derrida (against the centered subject and the abasement of literature) and, in a flimsier way, Lacan (but a truncated Lacan, reduced to a game of ping-pong between imaginary and symbolic, without the insistence of the real).

The position of *Cahiers*—as guests—was, consequently, out of sync. *Cahiers* was recognized as having been first to introduce in their columns the issue of "cinema-and-history," but underhandedly reproached for departing from an orthodox position (*simultaneously* Althusserian and M.-L.: c.f. the defense of *Tout va bien* against *Blow*

for Blow) in favor—via interviews with Foucault and Rancière—of a highly suspicious spontaneity, tethered by the trappings of "popular memory."

In fact, *Cahiers* can be legitimately reproached for recklessly using words such as "history," "memory," and "the past," words that refer to disproportionate realities. One reason for this lies in the leftist mythology in which History (reduced to the idea of subsultory advances towards Socialism) and memory (the individual attachment of subjects to that progress) were for so long taken together and subsumed under the auspices of the Party (yet to be built), the custodian simultaneously of plans for the future and heroic traces of the past. The notion of "the past" (the having-been-there-of-things), so essential to understanding the cinematic phenomenon, is itself a more recent introduction (see Comolli's latest texts).

But the Edinburgh debates must also be criticized for having glossed over (using the slightly contemptuous label of "post-'68 romantic idealism"*) the historical conditions of the appearance of this debate, in the extreme French left and in *Cahiers* in particular. And this in favor of a purely theoretical struggle. It's a familiar consequence of positions that are too narrowly Althusserian. Always effusive when it is a matter of wielding the concept of History, but providing neither the inclination, nor the curiosity (a minimum inclination towards the past, a desire to see it more closely, to excavate it—without which all debate remains anemic), nor, *a fortiori*, the desire to film. Accordingly, while devoted to cinema, the "History/Production/Memory" event forgot… cinema, even in its title.

2. Memories

Thus, the taboo word (but also the nodal word, the fly-in-the-theoretical-ointment) in Edinburgh was "memory," insofar as memory implies someone (a subject or worse: a class) remembered. Consequently, two confusions: a) between collective memory (doxa regarding the past) and individual memory (a personal biography), b) between memory that is opposed to forgetting and memory that is conquered over repression.

And so a (rapid) assimilation was sought between the analytical cure and the Revolution, which would have the common goal of

"re-articulating the past." A passage of Marx's was called to the rescue: "The tradition of all dead generations weighs like a nightmare on the brains of the living. And just as they seem to be occupied with revolutionizing themselves and things, creating something that did not exist before, precisely in such epochs of revolutionary crisis they anxiously conjure up the spirits of the past to their service, borrowing from them names, battle slogans, and costumes in order to present this new scene in world history in time-honored disguise and borrowed language."[1] (*The 18th Brumaire*).

Marx's statement is entirely clear: it is not a question of remembering, nor of making history, but of evoking, of borrowing, of *disguising oneself.* The weave of collective memory is a fabric of disguise. The question that haunts the new social actors on the "new stage of history" is not so much "where do we come from?" as "what are we repeating?" We see this in communist hagiography, in which every peasant revolt of the past is a prevision and an anticipated rhyme with the workers' revolutions of the present (c.f. the *Noveccento* sleight of hand), just as we saw '68's student movement mimic the struggles of workers in the past rather than ask, "Where do we come from?" (i.e., studying the historical reality of students' struggles since the Middle Ages). The collective memory, popular or not, feeds on these ostentatious disguises far more than on a scrupulous study of the past (which it of course doesn't exclude, which, in the best of cases, it even revives). It is not archaeological. It is carnivalesque or it is nothing at all.

As for individual memory, it differs greatly depending on whether it is based in forgetting (à la Resnais) or repression (à la Straub). For what is forgotten is not necessarily what is repressed. One can re-member what was forgotten; one can only *reconstruct* what was repressed and eternally returns. "The restitution of the subject's wholeness, as I told you just a moment ago, presents itself as a restoration of the past. But the accent is always placed more on the side of reconstruction than on the side of revival, in the sense that is commonly called affective." (Lacan, *Séminaire I*, p. 20).

The conditions for access to the past are themselves historical, more or less inhibited, prohibited. Realism, in terms of historical

1. Translation by Saul K. Padover from the German edition of 1869. (marxists.org)

reconstruction, involves not providing these access conditions of as a matter of course, especially when one knows that they are, like a path whose track disappears, subject not to forgetting (which is a positive force) but to amnesia and to that institutionalized amnesia that belongs to States and Parties (and to the historians who are too often in their pockets).

Let's return to *Fortini/Cani* (screened in Edinburgh). The historical truth (the Alpes Apuanes massacres) is neither a given nor a construction, it is presented simultaneously with the path that leads to it, a difficult, zigzagging path, but one that is concrete because it deals with the *biography* of the Fortini subject. It is a matter not of naturalist triumphalism (the massacres as if you were there—but in what position?) or of haughty resignation (all of that is only discourse, delirium…).

3. Days of Hope*

It's in this sense that there is nothing realistic about Ken Loach and Jim Allen's television series, *Days of Hope* (1975). The script is completely inspiring. Between 1916 and 1926, three characters: Sarah, her husband Phillip—a conscientious objector—and her brother Ben, who, a naive farmer, after the triple experience of the army, prison, and strikes, ends up joining the Communist Party while Phillip, who has become an important Labour figure, realizes, on the eve of the general strike of 1924, that his party is already poised to betray the workers. The film ends with the failure of the general strike and the statement according to which the objective role of the Labour Party and the TUC is to surrender the workers to the bosses.

In a film such as this one, the writing (a periodization and a breaking-down of the story from a militant, leftist point of view in this case) is what acts as doxa and *guarantees* the images that, in turn, merely illustrate. The camera always sides with the spectator's intellectual advancement over the story's test subject-actors, filmed with that swirling proximity that is unique to television dramas, which is also the mark of a complete lack of a vantage point on the part of the filmmaker. Hence a certain agitatory value (major controversies followed the film's broacast on TV in England) and almost zero political value. Luckily, there are moments when this is reversed,

where the images guarantee the thesis. I'm thinking of the very powerful moment when Philip, forced to enlist in the army and sent to a disciplinary batallion, refuses to move, and the soldiers seize him and make him perform like a marionette, while screaming, all of the gestures made during the obstacle course. At that precise moment, since, for fear of ruining the effect, Loach can't cheat *the time that it takes*, the images cease to illustrate a thesis (even a sympathetic one) and start to enter into—as writing, obligatory path, path of the soldier and the camera—the logic of the army (a logic that suddenly seems more twisted and frightening in its efficacy: forcing gestures upon bodies without worrying about the rest) far better than any antimilitarist discourse could.

4. Ealing Studios

Not all of the films in Edinburgh were historical reenactments (costume dramas); there were also films that bore witness, even involuntarily, to their own eras.

"Dated" films, such as two produced by Ealing Studios (both in 1947) by Robert Hamer (*It Always Rains on Sunday*) and Charles Frend (*The Loves of Joanna Golden*), starring the same actress, Googie Withers. Golden age of "English quality," before Ealing's decline and the elimination of English cinema, which has today become zombie-like. Of all the cinema(s) of the forties and fifties characterized by familialism, the studio system, and verbal incontinence (which we find as much in Egypt [*Determination*] as in Portugal [*The Tyrant Father*] or the USA [Minnelli's domestic comedies], English cinema is by far the least exciting. There is a certain reluctance to film, a refusal of demonstration and bravura, cluttered, gray studios and the precipitous rush of poorly-synched dialogue. A sociologist would easily see in it the reflection of English society immediately after the war: lost illusions, a devastated country, narrow destinies in which the fiction seems like an adventure, a desirable but dangerous excess (threatening the family), come too late, after all has been decided. And, in fact, a return to the norm (but a joyless norm) is just what the two aforementioned films describe.

Nevertheless, there's something touching in these films. Less the historical situation to which they refer than what the studio

machinery implies in terms of servitude and *cinematic* problems. It is precisely because the studio film is dead (or at least no longer viable) that these films suddenly appear visible to us. Visible *because* they are dated. But being called dated is far from a flaw. What is negative is when a film, at the very moment it appears, already seems old, out-of-date. But a time comes when that question is no longer relevant, because the film is, by any definition, an old film (such as, let's say, *Breathless* is today). Which begs another question: does it carry its date along with it? And with what specificity? That date is found not in what is permanent but in what has changed (in this instance: the studio system).

5. Vertov

It is difficult, while watching *Enthusiasm, The Eleventh Year, Three Songs About Lenin* and especially, *Forward, Soviet!* all in a row, not to conclude that there is, in cinema history, every (major and minor) filmmaker on one side, and Vertov (and maybe Godard) on the other. Impossible not to see the extent to which the Vertov experience, foreign to the rest of cinema, without successors, has once again been buried, forgotten.

Vertov has little to do with "History/Production/Memory," but his films were here, paradoxically. If there were ever a filmmaker who was resolutely foreign to everything that re-peating (re-constructing, re-membering) entails, it is Vertov. The only temporal scansion that can be found in his films is that of a before/after (the Revolution) that is much closer to advertising and myth (as is indeed Eisenstein, c.f. Narboni on *The General Line/Old and New, Cahiers* #271) than it is to genealogy.

The key idea that animates Vertov is completely different: not the historicity of things but their *contemporaneity* (simultaneous *and* heterogenous). Something exists that allows every fragment, every image, to be assigned a common indicator: they belong to the same continent (as to a "sixth part of the world"). They are contemporaries. Consequently, their own history—where do they come from? where are they going?—is calmly negated. The extreme heterogeneity of images (every register, every close-up, every camera movement, every figure) is sustained only by the gaze in front of which they

unfold, without their ever seeing each other (this is what Godard will film, to the letter, in *Here and Elsewhere*).

Vertovian montage is therefore neither the articulation of *in* and *off* (via doors or glances), nor even the Eisensteinian riddle that produces concepts, but—completely paradoxically—the operation that keeps fragments at a distance from each other (the Vertovian theory of "intervals") to better safeguard their proximity to what must be called the great Other, the thing for which, the one for which, they make sense. Don't forget the leitmotiv of *Three Songs*: "If Lenin could see us, *now*." The extras, enclosed in the images, file past the body of the master, while the images file past the gaze (itself extinguished) of the master (himself deceased).

We can understand why, after 1968, Godard sought out Vertov as a source. For what Vertov struggles to impose, with enthusiasm and meticulousness, what, after 1944, was refused to him, is quite simply an anticipation of the current media system (Western, not Soviet): an audiovisual machine that sees everything and is seen by everyone. Vertov, the sorcerer's apprentice. He dreams a total and transparent power; he will be crushed by a total but opaque power, a power that is afraid of images. Godard finds himself confronted with this (non-pacifist) coexistence of images nearly fifty years later. A co-existence, that is to say a degraded, meaningless contemporaneity, a sort of obligatory and indifferent juxtaposition. The Godard-experience is the sadder, less enthusiastic reprise of the Vertov-experience, but on the same level of radicality ("when everything goes, nothing goes"). Basically, the same fantasy, to be only a purveyor of images, to respond to the social demand. Except that today, the contemporary has ceded to the bric-à-brac of what coexists, and the spectator, disarmed and incredulous, tired and vaguely perverse, knows that he is being duped.

Vertov is not interested in history, if history means development, evolution, resolution (or, conversely, involution). He attempts that unique thing that consists in arriving nowhere, in spite of cinema, the art of time. Each image must be revived by another before it has had the time to begin to change. Hence a hatred for narration, the refusal of any connection [*embrayage*] that would be born within the image. Each shot is like a roll of the dice.

Also, the Vertovian "fragment" is a unique thing within that "cinema history" with which it seems unconcerned. This is because it participates as much in photography as cinematography, not really belonging to one or the other. It is, for lack of a better term, the "moving image." And not just any movement. Like a little machine animated by a mechanical movement, an oscillation, a circling around the same spot, one movement that never blends into another. The Vertovian fragment is like one of those cartoons in which a character falls, and the image itself shakes.

It is this search for the contemporary that makes Vertov's films so precious today. Precious *also* as historical documents. If he had asked the question of enlightened activists (what would you choose from the past to aid in the struggles of the present?), he would have yielded to the bleak, teleological and pious fictions in which Soviet cinema soon mired itself. He would not have begun *Three Songs About Lenin* with the image of that veiled woman from Central Asia, contemporary of those factories that she does not see.

6. Conclusion: A history of the camera-gaze?

Vertov's films are not a landmark in cinema history, but a turning point in media history (hence, of cinema history). In old newsreels, what strikes and attracts us is less the knowledge (the "information") they contain (although they can be, for a historian, extremely precious) or the cause they once served, than it is the voice of the speaker (and how much it betrays the feeling he has of being right). Neither history, nor memory, nor the given, nor the construct, but the past— that impossibility of cinema, its real. Not only "the having-been-there of people and things," but all of that for a camera. It is in the moments of great rupture within that being-there-for-the-camera that cinema comes closest to history. And those moments have names: yesterday, *Forward, Soviet!*, today, *Six fois deux.*

In Edinburgh, we were able to see (beautiful) English documentaries bearing witness to the war in Spain (and from the Republican side). The information that they continue to provide, the emotion that they continue to inspire in the spectator, are nothing compared to the expressions of the International Brigade fighters who push each other aside for a place in what they assume to be the camera's

frame (a friend), raise their fists in the air and then go off to war. It is this confidence towards the camera (and towards us, who are there by accident, by an eternal imposture) that has forever been lost, replaced by an other whose face is not yet known to us.

<div align="right">(Cahiers du Cinéma #283, December 1977)</div>

BONDY FILM FESTIVAL

1. Propaganda is not singular

The 3rd Bondy Film Festival tells us, in its very title, how important it is to distinguish between propaganda and counter-propaganda. One follows the other, in reaction to it. Propaganda begins with a lie; counter-propaganda must block the effects of that lie, with the help, *eventually*, of the truth. There is no symmetry between the two. A combination of political, fundamental reasons (Nazi propaganda does not think or act like the propaganda of bourgeois democracies) and also tactical reasons that adhere to a temporal discrepancy: the oldest English and American films screened at Bondy date from 1940, while the oldest German films go back to 1934.

This simple observation thwarts the slightly lazy, doxal idea that one might have when coming to Bondy, according to which *all* propaganda must necessarily use the same methods, lie according to the same rhetoric, mobilize using the same energies (the same low blows). Nothing of the sort. Over the course of the festival, not only did we encounter Nazi propaganda in all its irreducibility (less deceitful than it was delusional), but inside the Allied camp, increasing differences (in methods, and especially in enunciation) between American and English propaganda (we were not given the opportunity to watch Italian, Japanese, Soviet, or Vichy films that would have effectively completed the portrait).[1]

These films, seen today, not only reflect Nazi or Allied politics but also anticipate the evolution of the machines that deployed them:

1. We owe many of the films screened at Bondy to the *Österreichisches Filmmuseum* in Vienna. Guy Allombert was in charge of organizing these events.

the collapse of German cinema, a defeat from which it will not recover; the rise of American cinema (1947 is a record year for the Hollywood industry); the decline of English cinema. All things that are already visible (and visible perhaps there more than elsewhere) in the cinematic poverty that accompanies Nazi delusions, the unbreakable faith in spectacle[2] that underlies the American epic (the famous series, *Why We Fight*), the doubts and warped enunciations that were already eroding English cinema.

What is a propaganda film? (At issue here is explicit propaganda, assertive and confident of its legitimacy, not disguised propaganda, hidden or shameful, or political advertising.) One could say that it is a small apparatus that *calls*, at minimum, two imaginary interlocutors, two *others*: the good and the bad (propaganda is always dualistic). The good other is the one who must be won over, convinced or reassured, the future adherent or ally of tomorrow. The bad other is, of course, the enemy, who must be exposed, destroyed, exterminated. In the propaganda film, an exceptional violence is intertwined with a system of enunciation that can be found—in a colder, *cooler** form—in all of classical cinema,[3] where it is a matter of simultaneously condemning (the bad other) and pandering (to the good other). Or else, extending this to the level of infantilism that

2. American propaganda has already entered the era of the scoop*. The question of point of view, still present in the series *Why We Fight*, will recede. In one of the first films made in Germany after the end of the war, *Die Todesmühlen* (*Death Mills*, 1945), we see American soldiers "liberate" the survivors of the death camps who look at them, stupefied. Unbearable moments. The first reaction of the American authorities is to force the entire German civilian population who lived near the camp—men, women, children—to parade down a long line of coffins *half-full* of what no longer can even be called cadavers. This is a typically American idea: the spectacle as catharsis, a lesson, an idea whose manifestations over the thirty years that follow will not always be as adequately camouflaged by a "good cause." With Capra, we still know how to answer the question, "Why do we fight?"; later on, we will no longer even know how to answer the question, "Why do we film?"
3. Early cinema, "classic" cinema, is contemporaneous with the era of propaganda. There isn't a single important filmmaker who did not face it. Only one outmaneuvered the problem: Chaplin. Another had to accommodate himself to it: Mizoguchi. In a certain way, these are the two most important filmmakers. The others dabbled in it: either directly (Renoir, Capra, Eisenstein, Vertov) or with precautions (Lang, Lubitsch, McCarey, etc.). The cinema of today follows the cinema of yesterday just as the era of advertising follows the era of propaganda. We do not entirely know what a great advertising filmmaker will look like. However, the most lucid and radical product of cinephilia (a demand for writing, increasingly paradoxical, necessarily haunted by *dogma*) is indeed the questioning of propaganda (Godard: *Here and Elsewhere*).

these films most often reach, it is about *snitching* and *sucking up*. When it is only about condemnation, it is called "observation"; when it is only about flattery, it is called servitude or panegyric; but when the two are united, propaganda begins (never very likeable, always slightly despicable).

With all the requisite precautions and without seeking to over-generalize (we did not see all of the films at Bondy, and these films were only one part of everything that was filmed to propagandistic ends between 1933 and 1945), we can nevertheless differentiate between three substantially different enunciative arrangements, corresponding to a geopolitical divide: Germany, USA, Great Britain. I will speak more specifically here about Nazi propaganda and English counter-propaganda, located, we will see, at opposite poles from each other.

2. Nazi propaganda: monologic delusion

What is striking in the majority of these films is that it seems as if there is *no one* for them to convince (any longer), and *no one* to fight (any longer). Paradoxically, you could say that propaganda is simultaneously widespread and at its zero point. Ideology is not inva-sive and the debate of ideas nonexistent. Instead we catch ourselves yawning at a bleak parade of images that have no reverse shots, armies that encounter no enemy, arguments that belong to no polemic. The most terrifying thing about Nazi films is not the enor-mity of their lies,[4] their bad faith or their delusional interpretations, it's the disappearance of *every kind of other*. Not only the bad other, the enemy (non-Aryan or democratic), but primarily and most radi-cally the good other, that Nazified German populace that itself has also disappeared from images. Nazi films assume a silent spectator.

4. And they are capable of lying beyond all expression. One gets the impression that it is only belatedly, after all has been lost, that Nazi propaganda mutates into the production of *faux films*. In the striking *Der Führer schenkt den Juden eine Stadt* (*Theresienstadt. The Führer Gives a City to the Jews*, 1944), the Theresienstadt deportees agree—were they deceived by promises, ignorant of what awaited them?—to stage (silently) their life in the camp. Their lives seem austere but not too difficult; they play football, they listen to classical music. It is about presenting the international public something that will reas-sure them. Of course, the filmmaker and actors will all be eliminated. (Bazinian) limit of cinema: because we see them onscreen, we can be certain that all of them are dead.

What that spectator is presented with is not a mimicking performance (as is found in socialist, Soviet or Chinese films) of adherence or awakening (no positive hero, then, no shift). It is, far more cynically, the spectacle of its own submission. Nazi propaganda's German audience is invited to see itself in the form of the hysterical *and* regulated crowd, and to recognize itself in the "all for one, one for all" form of that crowd. We find ourselves in a primitive era in the history of audiovisual media: the image is not problematic (not yet). The mere fact that a power was able to gather together millions of people in one place (a stadium, Nuremberg) dispenses with questioning the quality of the commitment of the crowds presented there (sincere, manipulated, bought?) This is the lesson of the Nazi propaganda films: *the other is foreclosed.*[5] That is precisely the way in which it is Nazi (and not democratic, bourgeois or even imperialist). Individuation is impossible, and consequently, fiction (even an oriented one) is impossible, in so far as every fiction needs *singular bodies* to exist. That would explain why the only coherent Nazi films are montage films (Leni Riefenstahl) and why the narrative fictions are, in contrast, particularly inept (Veit Harlan).

In a broad range of military-hygienist films, such as *Soldaten von morgen* (Alfred Weidenmann, 1941), we witness the athletic training of a myriad of blond children who transform *in extremis*, through cross-fading transitions, into soldiers who perform the gestures of war. Chamberlain's portrait—a metaphor for the bad other—regularly returns to designate the target. The paradox, in such a film, is that it must be seen, but certainly not watched, that its every disparity (differences in bodies, in frames) is immediately reabsorbed in a reaffirmation of the physical norm, where difference can only be experienced as a hallucination, an optical illusion.

In the newsreels that punctuate the Reich's success and commemorate its rise to power, such as *Gestern und heute* (*Yesterday and Today*, Hans Steinhoff), *Wort und Tat* (*Word and Action*, Ucicky) and

5. According to Lacan, foreclosure (*Verwerfung*) is "a mechanism that consists in a primordial rejection of a fundamental signifier outside of the symbolic world of the subject. The foreclosed signifiers are not integrated into the subject's unconscious. They do not return 'from the interior,' but at the heart of the real, singularly in the hallucinatory phenomenon" (Laplanche and Pontalis).

Ein Volk, ein Reich, ein Führer, all three from 1938, the order of exposition is always the same. There is a before and an after. Before: chaotic images, awash in dramatic music, in which we see—in Weimar—workers, farmers, the unemployed, "agitators" (leftist politicians, that is). After: long excerpts from Hitler's speeches, recalling the past, shouting towards the future (here, no music). Before: a savage, negative individuation. After: *a single voice.*

Here we brush up against the limit of this cinema. Any voice *other* than Hitler's verges on sacrilege. Insofar as it is not the signified (what is said) that matters, but rather the signifier (a particular voice that gives the crowds something to which they can attach their desire, to relinquish themselves of it), Hitler's voice is irreplaceable. When the signifying *One* begins to ravage the population, to make them delusional, leading them towards the worst, it is also reflected by the rarefaction of images and the monopoly of the voice over.

Does this mean that the bad other is nowhere to be found? Of course not. It returns but, like everything that has been foreclosed, it returns in a hallucinatory form, in the real. In the opening images of another hygienist film, *Die englische Krankheit* (*The English Disease,* Kurt Stefan, 1941), a mock-up of a map of England is visible on the horizon. On it is superimposed a ring of hunchbacked, fraudulent characters, afflicted by scoliosis or rickets. A voice explains that rickets, a specifically English affliction, in fact hereditary, is one of the secret weapons England is utilizing to contaminate the German people who, as everyone knows, are clean. Once the mythological origins of the illness have been presented, they are forgotten, and we move on to a medical film, focused on rickets *in Germany,* that gives advice to mothers. The montage of scientific discourse and racist delirium is absolutely terrifying. The other does in fact make its return, but in a sub-human, microbial form: the germ. This short, twelve-minute film is in fact a disaster movie.[6]

The battlefields themselves are empty. In *Sieg in Western* (*Victory in the West,* 1941), a sweeping documentary that retraces Nazi victories

6. If the germ belongs to the series of *objet a,* we know that it is an "object-cause of desire." In Nazi ideology, every desire is assimilated as a malady (hence something to be cured).

in Holland, Belgium and France until the collapse of the lamentable Maginot line, we witness the progress of an army that we are reminded from the beginning is destined to conquer. Combat, extremely violent yet dignified, filmed by professional cameramen (without ostentation, à la Hawks), is reduced to the destruction of machinery and spectacular explosions. It is as if the German troops had encountered no one. No hysteria, no speeches, an entirely martial restraint (the courage of French soldiers is even recognized, in passing). But France is only a name on a map. There is an inability to conceptualize the adversary, to inscribe it, which is more terrifying than all of the cries of hate combined. The famous shots in which German troops march down the nearly empty Champs-Élysées are presented as triumphant. Today, any army invading a country would take the trouble to pay extras, or to import proxies by the truckload to "appeal to the common man" in front of the television cameras' lenses. But today, we have definitively entered into the era of simulacra. Which was not, at the time, the case.

From the above, and independent of genre, we can see what Nazi propaganda stumbles against: the body is *cumbersome*. It is only manageable when it is caught in its erection and metaphorized. One film from 1936, a veritable ideological-poetic rant, the ridiculous *Ewiger Wald* (*Enchanted Forest* by Hanns Springer and Rolf von Sonjevski-Jamrowski) asserts: "The people stand upright, like the forest, for eternity." The identification of the human body with the tree is total, from the first habitants of the forest whose cadavers were housed in hollowed-out logs to the occupation of the Rhineland, symbolized by the image of an African solider from the French army, guarding (to the great outrage of the voice over) a devastated, sick forest, whose trees no longer grow upright. German history becomes a series of intrusions of bad others into the good forest, from Roman soldiers to the French with the Vikings in between, sloppily filmed.

3. English propaganda: paradoxes of enunciation
 One of the most beautiful films seen at Bondy was *London Can Take It!* It dates from 1940, is eight minutes long, and was codirected by two major names in English documentary film, Harry Watt and Humphrey Jennings (who is undoubtedly an important filmmaker).

An American journalist, a certain Quentin Reynolds, addresses the audience seriously: as a neutral observer (the USA has not yet entered the war), he has decided to send his fellow citizens a "new kind of dispatch"*: a film. A film to convince Americans of the heroism of the people of London, the daily heroism he has witnessed. A two-part film follows. Night falls over London. Then, "Here they come..." the German bombs ("the German bombs are creatures of the night"*), the fires that erupt at random across the city. A commentary drily describes, in the frequentative form ("bombs *would* be dropped"*) what could be described by the image: the firemen's improvisations, the underground become a refuge. In the morning, the residents of London, the camera, Quentin Reynolds's voice, and the Queen (who we see assessing the damage) all seem to take stock of the past night's destruction *simultaneously*. The populace goes to work, passing in front of the destroyed buildings. The commentary alternates humor (in front of a gutted storefront: "In the morning, the shops are open... some even more than usual") and pathos (condemnation of German brutality, dignity of the Londoners who knowingly engage in "the war for democracy," necessity for the Americans to enter into the war).

If I have detailed this short film at great length, it is because it allows us to grasp what, in English propaganda, far from the grim delusions of the Nazis or the American spectacular, makes the most *modern* sound (we think, for example, of Robert Kramer's *The People's War*).

Primarily because in this era of non-suspicion of images and their power, *London Can Take It!* inscribes the possibility of the lie, or at least of the special effect. When German airplanes bomb London, the commentary specifies: "Those are not Hollywood sound effects." We already have the insight that the image, even when drawn from life, cannot be confused with the *real inscription*, with the *hic et nunc* of what it traces—and demonstrates. And it is indeed because the filmmakers don't "force" their material, that they speak beginning from what they record (night, day), that the ideological utterances lose their pathos and gain real conviction. The fact that it was possible to make this film *in this way* is a kind of proof that what it posits is true, that it indeed about a war "for democracy," that this word is less devoid of

meaning here than it is elsewhere. Where the Nazis ramble, where the Americans seek a coherent strategy of fact, the English, in their best films—have a certain inclination for the truth. That is why the enunciation of their films is never simple, that the efficacy of *London Can Take It!* stems from the fact that an American speaks but does not advocate for the English, because he is, like us, confronted with the spectacle of their resistance. This is also why there are—unthinkable in Nazi films—brief bursts of narrative[7] in these films, bits of categorization, an obstinate singularity of bodies and attitudes that arises from a tremendous sense of civic responsibility. For those who know how to look, it is clear that five years later the English will not choose Churchill, even though he is a national hero, but a Labour government. The *hic et nunc* captures History before and after.

Another of Jennings's films confirms the modernity of his approach. In *The Silent Village* (1943), he reconstructs in the Welsh village of Cwmgiedd the massacre of the civilian population of another small village, Lidice, in Czechoslovakia. The motive is clear: prepare the English population for the fact that they could be occupied. The two villages, the Welsh and the Czech, have something in common: they are miners. The Welsh miners, now actors, *rehearse* [*répéter*] in both senses of the word: they rehearse in view of the possible resistance to come, they repeat what has already occurred—to others, to others who resemble them (the class struggle is calmly reasserted). As for the play that they rehearse, it is familiar because it is about the assassination of Heydrich and the taking of hostages that, four years later, will inspire Brecht and then Lang for his *Hangmen Also Die!* (On Hollywood's treatment of this episode, see Comolli's text in the previous issue).

Curiously, the film says something clearly today that it did not say as clearly at the time. In fact, to maintain the parallel between the two villages, it plays on language. One day, the schoolmistress

7. But these bursts of narrative are nothing next to what Capra achieved in *The Battle of Britain*, the fourth part of *Why We Fight*. There, the passage from *stock shot* to fiction occurs naturally, without warning. During the Blitz, Capra inserts a little sketch, magnificently filmed, in which we see a middle-aged couple return home in the morning to find that their house has been half-destroyed. Nevertheless, the man closes the gate behind him (a Keatonian gag, since the fence has been uprooted). In their devastated kitchen, clipped dialogue, very English. Him: "Don't you think you should spend some time in the country?" Her: "Out of the question, I'm home and I'm staying."

announces to the children that it will henceforth be forbidden to speak Welsh (Czech) and that they must speak English (German) in public. But she begs them not to forget their language and to speak it at home as much as they can. The paradoxes of enunciation lead us very close to another truth: that of the colonial relations between London and Wales, yesterday *and* today. There is something Straubian in these simulations that are simultaneously political explications, mobilization exercises and universal messages. What is striking is the obligation that a filmmaker like Jennings assumes to include and inscribe the other (including the bad other) in his films, to fight it *without negating* it.

Other films, less endearing than these, more rushed, and more fractious,[8] are equally characteristic of this approach. In a short film from 1943 (*Invincible?*), it is a matter of *pure* propaganda: images against images, speech against speech. It begins with a Vichy newsreel extolling German victories on the Eastern Front, and at times sounds a "Wait a minute!"* that opposes it to other information, other images. The film becomes (unintentionally?) comic because the French commentary of the pro-German soundtrack is dubbed by a voice that speaks English in a caricatured French accent. The humor of this play on languages is slightly dark: how do we not actually read in it, behind the ridiculousness of a Charles Boyer accent, contempt for a defeated and (this is how it implicitly appears in every film at Bondy) *shirking* country?

(*Cahiers du Cinéma* #287, April 1978)

CAHIERS IN DAMASCUS

The format of the "Semaine des *Cahiers*" in Damascus (Syria) was finalized in Paris with Omar Amiralay, filmmaker and organizer of

8. Example: *These Are the Men*, by Alan Osbiton and Dylan Thomas (1940), which uses long shots of Hitler, Goebbels, Goering or Bormann's speeches dubbed with an *other* text, an imaginary text in which they *themselves* articulate their mediocrity, their stupidity, their failure. A basic and heinous way of considering the other and its discourse *nevertheless*.

the Damascus ciné-club. The following agreement was made: *Cahiers* would come with four films that they liked and that they would defend, if need be, before the Damascus public, and the cine-club would show other films, disliked by *Cahiers* (such as Costa-Gavras's *Z*, or Vanessa Redgrave and Roy Battersby's film on Palestine, which Comolli had already seen and hated in Valence) but expected to fuel passionate debate. The services of the Quai D'Orsay would allow us the use of the diplomatic courier, (thank you, M. Plessis) and, in Damascus, the French cultural attaché would be at our service. The "Semaine de *Cahiers*" would also be an opportunity to organize a retrospective of several Syrian films. The entire event would be called, boldly, "Cinema and Politics," and the four *Cahiers* films would be *Here and Elsewhere*, *La Cecilia*, *L'Olivier*, and *La Machine*.

0. Prohibitions

From April 24th until the end of the month, there were indeed passionate, serious, closely followed debates, and the large Al-Kindi movie house was full every night, as expected. But what was less (expected), at least by us (Omar A. did have some idea of it) was that the repression that has recently swept Syria (*Le Monde*, #10,377) would have its way with this unfortunate "Festival in Damascus" whose debates deserve even more credit for simply having taking place given that their pretexts (the films) became increasingly restricted over the course of the festival.

Four banned films! The power to censor also works through the grapevine. One day, we learn that *Here and Elsewhere*, which had just been approved by the censors (like every film screened in Syria, even and especially in a "cultural" and non-commercial context) has been banned. The reason seems to be this: on eleven occasions (I think) we see Brezhnev, and what's more, a laughing Brezhnev, in the company of another low-life: Nixon. The censors, trying to please the Minister of Culture whose ties with pro-Soviet milieus are well-known, thought it smart to censor the image of Brezhnev. The proposition was initally made to cut the eleven offending images, then to redact them. Then, after a final, particularly unsuccessful effort by Omar A., total prohibition. The obligation to make the announcement (in an outraged

tone) to the audience on the first night. The obligation to try to "narrate" the film to an audience that will not see it.

It was then *Ali: Fear Eats the Soul*'s turn, submitted by the friendly cultural services of the FRG. The film was banned, it seems, for its "insult to the Arab people." Then *The Palestinian*, the terrible English film by Vanessa Redgrave and Roy Battersby, was overlooked for three days and screened behind closed doors, then banned because there was no way for it not to show the Syrian army's ambiguous (to say the least) role in the slaughter at Tell-el-Zaatar. How could we be shocked, under these circumstances (we no longer were, at any rate), when *L'Olivier*, which didn't consider it necessary to hush up the role of Hussein of Jordan in the Amman massacres, was, in turn, banned from the festival. Finally, *last but not least*,* the two *Cahiers* films that weren't censored (*La Cecilia*, *La Machine*) were placed under house arrest in Damascus and the screenings planned for other cities (Homs, Alep) cancelled. We would indeed go to Alep, but as tourists. Alep is, incidentally, a completely magnificent city.

These prohibitions were a surprise only to us. They were accepted with a hint of resignation. It is clearly the lot of the cine-club (accent on club more than cinema), a place where one comes to face off (hence come together) around an absence of films. In the press, on television, allusion was made to the debates (dubbed "seminars"), but never to the prohibited films. We were left with publicly condemning such practices, and whipped up rancorous applause simply by remarking that three of the four banned films involved Palestine.

These prohibitions that surprised only us (they were the answer from the top to the meeting's theme: cinema and politics) are nevertheless the risk that Omar A. runs. A minimal(?) risk compared to the political event created by the brutal fact of several hundred people coming together every night at the Al-Kindi theater to utter the word "politics." Uttering the word "politics" is political. Behind this calculation is the determination (expressed by Omar A. towards the end of his interview) to assemble a sort of large, democratic front of filmmakers. The presence of two journalists from *Cahiers du Cinéma* (Comolli and myself) was simultaneously a warning to the authorities, an opportunity to articulate Syria's various approaches to cinema,

a moment when a dialogue between Paris and Damascus (and, between the lines, the West and the third world) took place, with all of its difficulties.

1. Model thinking

One of the great misunderstandings between here (France, or rather Paris) and elsewhere (the third world, for example Syria), when it comes to discussing cinema, arises because the dominant thinking (in Damascus—as in Meknès or Carthage) is a paradigmatic way of thinking. It's never really the film that is judged, but its standing as a possible model, good or bad.

There are several reasons for this, all understandable. First, the dialogue of the deaf between abundance and scarcity, between Western cinephilia, especially French cinephilia (Paris, world capital of the consumption of all kinds of films) and the impossibility of a Syrian cinephilia (paucity of films, State monopoly on importation, censorship). Then there is the fact that the cine-club (in Damascus as in all of the Arab world) is, par excellence, in itself a political space, and that in this space political lines and discourses face off, are presented, staged. Politicized students, fledgling or already-active apparatchiks, use the cine-club as a site of intervention and the films as pretexts. We mustn't overlook the fact that if any place exists where censors or future censors can learn how to recognize a dangerous film, it is indeed there, in the cine-club. All of which makes the ciné-club an extremely vibrant, intense space (as opposed to the French ciné-club, which has abandoned all of its drives), but doesn't help the films.

For all of these reasons, and other, more profound ones (dependence, cultural imperialism), model thinking triumphs because there is something in it for everyone. The rare cinema enthusiast asks if *La Machine* could be considered as a model for the French cinema aesthetic, the activists demand confirmation that *Z* is the model (to follow) for French militant cinema. And the censors (don't) ask if *Ali: Fear Eats the Soul* is in fact the model for what the Syrian masses must not see, at all costs. In this, cinema disappears, the film will have disappeared, despite the ritual cries of those who demand, by diversion or apoliticization, that we finally talk about the film, about its aesthetic, its form. But that cry itself is formal.

It is because these films (including the worst of them), such as they are made and consumed in France, practically no longer function as models but as single hits, exceptions, unique adventures, that it is so difficult to practice a system of inquiry in which the film is perceived neither qualitatively (the rarity of "subjective" reactions such as "I liked that film...I enjoyed it") nor quantitatively (given the scarcity of films, the impossibility of comparing them) but *statistically*. And so the debate speakers no longer speak from a love of cinema (which does not mean, of course, that it doesn't exist) but from a position sometimes real, often imaginary, of *responsibility*, concerned only with the sorting that needs to be done between good and bad models. This situation is more evident in Damascus than in Paris, where it exists nevertheless. As cinema loses the general public, as films are seen by those who exercise, somewhere within the cultural machine (programmers in every genre, "relay-elements" in the old Maoist terminology), a responsibility. It's the unfortunate performance of cinephilia being tortured by the discourse of responsibility (cultural or otherwise).

Consequently, this model thinking that allows everyone to speak encourages the most general, the most abstract discourses. Double-speak prevails and Marxist babble becomes Esperanto. Under the guise of the politicization of location (the conditions of enunciation), thinking about cinema does not progress one bit. For model thinking is so sterile only because it is doubled by a total lack of curiosity about the *production* itself, which remains always exaggeratedly shrouded in mystery. Concrete, if not materialist questions, concerning films' mode of production (in the broad sense), gestures and practices, do not find their place. Everything is reaffirmed (the master-signifiers) but nothing is critiqued.

Under these conditions, the role and the place of *Cahiers'* discourse had to deflect. It especially had to provide information about the conditions of production in France, and to assume the role of lecturer (even *Positif* would have fit the bill). We also had, at the risk of becoming unpopular and disappointing, to refuse the problematic of the model, never allow itself to get caught up in it. And we eventually had to be steadfast in the face of the doublespeak of local Marxists (from the Syrian Communist party, very pro-Soviet, extremely

dogmatic and antagonistic). Which is what, over the course of these days in Damascus, what Comolli and I, with mixed fortunes but in the final analysis a certain amount of success, did.

2. Film-Z

The festival's most highly anticipated debate (26 April) centered around the film by Costa-Gavras, which I saw again for the occasion. Curiously, the film passed in Damascus for a "militant" film. Although accustomed from day one to refuting that the film was even political, we had not predicted that we would have to prove that it was not militant, as well. But beyond these constant and inevitable vacillations of vocabulary, we can see the origin of this miscalculation. Accustomed to the way in which cinema always depends so heavily on the State, the Damascus audience could only imagine that a film with such a flagrantly political theme would be located outside of the State's control, hence somewhere between agitprop cinema and militant cinema. We repeat that the film is a relatively banal commercial product and, moreover, that it illustrates a political problem (Greece) that divided no one in France.

The most definitive argument countering those who, in Damascus as in Paris, persist in seeing in *Z* (or in other leftist narratives) the peaceful coexistence of revolutionary content and a wholly accessible form, is that this form/content relationship only functions idyllically when the content is not *really* a problem, doesn't really divide anyone. As soon as there is a real problem, the beautiful neutrality—indifference—of content and form comes undone. Imagine a film made on *Z*'s model that places Arafat (played by Yves Montand) in Lambrakis's place; do you think that those with a pro-Zionist view would like the film on the basis that it takes an accessible form? Nonsense!

That said, after watching the film again, we think that Narboni's earlier text (*Cahiers*, #210), as decisive as it was, overestimated the film by accusing it of not being political (and, *a fortiori*, Marxist-Leninist!). In 1978, its "cabaret revue" aspect has a certain charm. It satisfies the cleavage that exists in all of us (particularly if that *us* is on the left) between indignant reprobation for corrupt regimes and brutal methods and an infantile jubilation in witnessing, from the sidelines of that regime, the comedy of its power. There is a *Guignol*

quality to *Z* that elates the audience. As with the Guignol puppet theater, there isn't a single scene (arranged, chopped, sloppily filmed) that doesn't show someone (ultimately, anyone) who doesn't have the upper hand over someone else. This joyful and irresponsible generalization of power relations ensures that there is more pleasure in mocking flouted power than in subscribing to the cause and fate of the noble Lambrakis (his death makes the narrative possible but immediately exhausts it). In so far as this cleavage is *popular* and in that Costa-Gavras plays most often with that cleavage (see, recently, the horrible *Section Spéciale*), *Z* is a popular film. Thanks to *Z*, some leftist intellectuals, not that in love with cinema, were able to share in some simple pleasures. Except that these few carnivalesque elements, so very tepid here, can be found in any *Django* or *Trinita* on the Grands Boulevards.

3. The word Palestine

That three of the censured films are the work of Western pro-Palestinians (from Vanessa Redgrave to Danièle Dubroux, from Jean-Luc Godard to Dominique Villain) clearly reflects the extent to which the Syrian regime ensures that as little as possible is known about Palestine. Syria's position in the Libyan war, largely ignored by the Syrian masses, is in line with the liquidation of the Palestinian cause by the Arab regimes, and that liquidation is in line with a generalized turn to the right in which Arab unity, if it exists, comes not only from the top but is also reactive. And it does exist: fifteen days after the Damascus festival, an Arab police convention was held in Damascus on the theme, "Arab security is indivisible."

It follows that Palestine—the *word* Palestine—is both the required password (sentimental, unifying) of every discourse and a taboo subject. As if it allowed for everyone to signify *everything*. As soon as it is utilized, it is to say something else. For power, to distract from the Syrian reality, and for the opposition, to speak even so about Syria under the pretext of Palestine. Actual Palestinians (and, by extension, the films devoted to them) pay the price for this double rule. Unfamiliar with these (highly political) language games, pro-Palestinian European intellectuals are always placed in the position of the naive idealist and ruthlessly manipulated. They are always

driven to endorse something that they condemn, precisely on behalf of their pro-Palestinian convictions. In 1974, in Meknès, the pro-Palestinians from *Cahiers* (I was one of them) endorsed Hassan II's Saharan policy, as they say, objectively.

It is difficult, under these circumstances, to evaluate a film such as Vanessa Redgrave and Roy Battersby's *The Palestinian*, which was briefly screened (and triumphantly welcomed) in Damascus before Al-Saiqa, more perceptive than the censors, ratted it out to the top. A self-congratulatory film that could have been made three, five, or eight years ago, more or less, with complete contempt for everything that isn't abstract exultation for the Cause, a film that one could argue was purposefully made to upset Godard by taking the opposite position of everything that he wrote in his letter to Jane Fonda ("Study of an image," *Tel Quel* #52), based on a photograph. After three hours of political tourism, Vanessa, in battle fatigues, dances with a Kalachnikov in front of the fedayeen.

That said, because it allows us to understand the role of the Syrian army in the events in Libya, the film seems like a mini-scoop. That misunderstanding, if it is a misunderstanding, makes sense. Where information is rare (blocked, censured), any film that comes from somewhere else runs the risk of raising, without even having intended to, a corner of the veil. That is how mediocre, conformist, timid films suddenly begin to function as firebrands.

An all the more unpredictable phenomenon in that here, in France, we no longer expect information—that is to say, what appears to us as denoted ("what happened in the world")—from cinema (not even from the Gaumont newsreels). Film has a different purpose. We expect film to help us unpack the obvious, operate on meaning, i.e., connotations. Conversely, in a country such as Syria (where the press is muzzled, the radio is submissive and television servile), film can play that role and *inform*. This linguistic crossover contains the entire dialectic between rich and poor, North and South, here and elsewhere. For what I denote here, for a stranger living somewhere else, is connotation. And *vice versa*. Denotation's relativity.

A part of Syrian cinema has to involve the *unavoidable* Palestine. But with a sleight of hand, talking about Palestine in order not to talk about Syria is also subject to Syrian censorship...on the question of

Palestine. And so this policy only encourages a sentimental or historical approach to the problem (the Balfour Declaration rather than Tell-el-Zaatar). Thus we were able to watch Amin Benni's *The Long Day*, filmed during a mass demonstration in occupied Palestine (1976): grim, apparently rare archival documents scroll past while a voice over laments that the Geneva Convention was not respected. In a much better film—Mohammad Malas's *Memory*—we see an old woman continuing to live with her memories and her sixteen cats in a destroyed Kuneitra, a film with a slightly esthete tenderness.

A final word on "the word Palestine." There's no guarantee that by making it the password for every discourse, the cipher of every hope, the exchange of every desire, we (a very large "we" that encompasses all of us, including the intellectuals and Arab filmmakers, exiled or not) haven't further ghettoized the Palestinian people and their struggle. By locking them up in the management of their brand image (down to the press kit, including Vanessa). Locking them up in the logic of terrorism, which would like for the word Palestine to be pronounced (at all costs), which is the most terrible of language games.

4. National cinema

Interventions, debates, discussions revolve around the notion, vague to us, of "national cinema." Does this mean a national Arab cinema (in the sense that one speaks of an "Arab nation") or a national Syrian cinema? No one seems to want to eliminate this ambiguity, a sign that it is useful. And yet, it is beginning to become clear (see my report on Carthage 1976, *Cahiers* #272) that an inter-Arab cinema is possible, the result of a vague bricolage of petro-dollars, scattered talents or ambitions, dialects and locations. I continue to think that it's a cinema from which we cannot expect much (*Sun of the Hyenas* is a recent and unfortunate example of this cinematic Esperanto). At the same time, another, totally dominated cinema exists, a cinema of *geographical anchoring* demonstrated in certain films by Chahine, Alaouié, Smihi, Amiralay, each in its own particular way.

On one side, the reinscription, in Arab locations, of certain effects of the imperialist cinema code; on the other, the implacability of actual inscription. On one side, a cinema larger than the national context; on the other, a cinema that is still too singular, particular, limited,

anchored. Between the two, what is indeed lacking is a "national" cinema of Morocco, Libya, Kuwait, Lebanon, Syria, etc., a cinema that would refer each time to the specific cultures and the no less specific conditions of production belonging to each Arab State.

But as opposed to Egypt (who has had a cinema machine since the twenties, now in decline, but that was once remarkable) and Algeria (where the experience of a properly Algerian cinema is being played out), it is difficult to see where a regime such as Assad's would find the ideas, the means and the desire to promote—even from the top—a "Syrian" cinema. Meaning: how it would find a way to put its thirty filmmakers to work instead of paying them to do nothing, for fear of having to censor them.

The question of the possible emergence—or not—of national cinemas in third-world countries is a political question through and through. I see at least two aspects to it.

First: *is there* at the end of this twentieth century, given the forms that cultural imperialism has taken, the evolution of the media and its role, *sufficient historical space* to allow for national cinemas to emerge, fifty years late? Nothing could be more uncertain. A production machine (by that I mean the *fabric* that is created by studios, talent, dreams, profits, an audience, codes, etc.) cannot be improvised.

Second: *what is the cultural capacity of the current dominant classes* in these different countries? Is there any interest, for military bureaucracies or petit-bourgeoisies tied to the State, in providing the means to promote a form of expression, film, that is economically uncertain and ideologically dangerous, in places where American soap operas or karate films *seem* sufficient to address the people's imaginary? There too, nothing could be more uncertain. The lesson of twenty years of cinema following "decolonization" is that systems of the State—particularly in the third world—are afraid of images, don't know how to use them to serve their domination, and in the absence of knowing how to manipulate them, find it more reassuring to prohibit them, to hinder them, to rarefy them. This is as true for China (which produces fewer films than it used to) as it is for Syria (see, in this issue, the interview with Amiralay), Tunisia (which prefers to rent out its landscapes as scenery) and Iran (which co-finances international megaproductions that it prohibits on its own territory).

The result is that in order simply to work, filmmakers are reduced to *exile* (most often ending up in German television or INA [the French Audiovisual Institute]).

5. Syrian cinema

Two sectors: one public, the other private. From the latter, condemned to ultra-rapid profits, to bungling and the bleak reprise of effects that have already been produced by every B-movie cinema in the world, it seems that we can, at the moment, expect nothing. The public sector is in the hands of an Organism of the State that produces few films and distributes them badly (sometimes banning them: *Everyday Life in a Syrian Village*.) For in fact, this division refers to another that illustrates it: the division between fiction and documentary. As ambiguous as these terms are (the reader of *Cahiers* has always known that the only true documentary is streaked with appeals to fiction and the only true fiction streaked with documentary exactitude), their opposition, in the case of Syrian cinema, seems real. It is indeed a matter of two paths, two modes of production, two attitudes regarding cinema's possibilities.

If cinema must "walk on its own two feet," we submit that the fictional leg is currently the weaker one. There are profound, historical reasons for this. To produce good narratives (rich, complex, and engaging), a well-oiled production machine and an unblocked society are necessary. Narratives require specific conditions in order to develop. They arise from from putting a dominant ideology in a crisis situation (America is the best example of this), from a consensus expressed through *public opinion*. When public opinion is lacking because it is repressed, when it has no outlets (the press and others), everything that gives the narrative power, its element of social revelation, disappears in turn (see, in contrast, "the largest democracy in the world," India, a hyper-moralistic, hence hyper-functional society, where the work of a Satyajit Ray continues to be the shocking exception).

Conversely, the documentary path, because it necessitates, in the final analysis, only the *desire to take a closer look*, because it transforms filmmakers into ethnologists of their own national reality (see the interview with Omar Amiralay), raises political problems from the start. In places where limitations on or suppression of the media

deprives the people of an image of their own lives, documentary cinema (and, more broadly, the audiovisual) risks playing an unprecedented role, encroaching upon that monopoly that the States failed to assume, that of reckoning, describing, *mapping*. That is its political dimension. In new countries (but what is new is the idea of the nation-State; the people are themselves old), it seemed as if documentary cinema might provide both a source of information and a tool of social engagement. That has undoubtedly been the gamble of someone like Rouch. Nothing proves that it can, one day, be won (with the possible exception of Mozambique, whose audiovisual politic seems to build on far more interesting foundations, and should be tracked).

Turning to the films screened in Damascus, on the fictional side: two films. One, inept, by Mohamed Shahin (*The Jungle of Wolves*, 1977) and the other by Nabil Maleh (*The Progressive Gentleman*, 1975), better filmed. Two whistle-blowing films, the first on real estate speculation, the second on generalized corruption. In both, the positive hero is a journalist who, it is difficult to see why, has decided to become honest and speak the truth. They then pretend to discover in the film what is clear to every viewer from the very first shot. Their efforts have mixed fortunes: success in the first film (the speculator escapes, his thugs are incapacitated by the hero-journalist-karate expert), shameful failure in the second, a grand Chabrolian meditation on impossible purity. In both films, the hero, who is young, is either bought off or squarely courted by the man (older, "arrived") whom he wants to take down and who forces him to confront his self-justifications. This familial aspect, "amongst ourselves," is ultimately what strikes us the most; it gives every rebellion an Oedipal dimension so significant that everything else fades into the background.

This fictional genre, in which the hero speaks in the name of an invisible poverty, has the benefit of bringing the class struggle to the center of Damascus or Beirut's social world. There, the hero, squeezed into light-colored costumes and with a glass of whiskey in his hand, casts a gloomy, sorry glance over all of it. The audience targeted by these films, the petite-bourgeoisie of the cities, are enchanted by seeing in these Arabic-speaking films the reproduction of a way of life

they aspire to, with as an added bonus the thrill of defying censorship. The authors claim that they are outwitting the censors and that their films, in that context, are explosive powder. The ruse is a convenient scapegoat. And if there is powder, it's smoke and mirrors. (But we have to admit that if there is a ruse in this context, which is foreign to us, we'd be the last to know.)

On the "documentary" side, apart from the two previously-mentioned films about Palestine and a short film by Nabil Maleh, a heavy-handed metaphor entitled *The Rocks* (workers cut *stone* but continue to live in houses made of *dried mud*...), two good films, *Childhood* by Marwan Mouazen (1975) and *The Chickens* by Omar Amiralay (1978).

Childhood is a short film about the lost children of Damascus. Not only are the children surprising, serious, and funny, as we might expect, not only is the film non-judgmental, non-prejudicial, it tackles its subject in a way that is both warm and sharp, without metalanguage. At the film's end, "the children" (the sociological case) appear not only as a group but also as a gathering of singular characters, each with their own language and dreams. The censors banned the film for several years and only permitted it when preceded by a title card that read something like, "Thank God, all of this belongs to the past, the State has taken care of all of these children." Just before the film was screened, Mouzaen edited out the card...

The Chickens, by Omar Amiralay. The Syrian State encourages the residents of a pilot-village (Sadad) to abandon their traditional activities and resolutely throw themselves into chicken-raising and the production of eggs. The breeding grows gigantic, then experiences a recession. The film closes with a shot of farmers facing an enormous, empty henhouse.

What makes *The Chickens* a very good film, confirming Amiralay's stature as a great filmmaker, is that it can be read, as they say, "literally and in every sense." The film is neither a subversive riddle nor a film à clef (naïve methods for tricking the censors) but an extremely knowing interweaving of multiple levels of reading, all of which are evident. It is the excess of readability, the excess of meaning, that ends up troubling us, just as it does with other film-makers—Ferreri, Buñuel—whom the film can't help but evoke.

On the one hand, the film is a "true" documentary that earnestly relates (with statistics, supporting interviews) something that actually happened. On the other, the film chooses a side (and the audience, understanding completely, laughs wholeheartedly), not only through the choice of a wide angle, but also through the fact that the chicken-raising, once it becomes teratological and unfilmable, denounces itself. What's more, the film has an obvious mythical dimension. Myth of the passage from human to animal, myth of the passage of quantitative to qualitative. At what moment does the propagation of chickens, instead of becoming a sign of success, provoke uneasiness, or laughter?

What allows for the interweaving of three readings (documentary, satire and myth) is the film's very paradoxical *temporality*, the rigged time of its factual exposition. Something between the pluperfect and the future anterior, an oscillation between the feeling of being placed in front of already accomplished facts and witnessing a future insanity. The illusion of the present gives way to a logical temporality in which men and chickens would form an improbable rhizome.

(*Cahiers du Cinéma* #290–291, July–August 1978)

BERLIN FESTIVAL

This text will not escape the rule that dictates that every account of a festival begin with several general considerations and apologies regarding the impossibility of seeing everything, of hearing every-thing, and of saying everything, and the critic's obligation to dive resolutely into the aleatory. No way not to go crazy for it all in Berlin. Especially when the festival is an enormous vitrine: a Western vitrine facing East, a cinematic vitrine in a world where cinema is growing rarefied. A vitrine in which one can see, this year, in addition to the films in competition (organized for the last time by Wolf Donner, whom Moritz de Hadeln, from Locarno, will replace next year) and the Young Cinema Forum (organized by Ulrich Gregor), a large information section, relentless film market, a selection of Scandi-navian and Indian films, a retrospective of Rudolf Valentino films

(curated by Kenneth Anger), a series of musical comedies from the Nazi era, a selection of recent German films, etc.

Separate out the films already distributed in France (*The Green Room*, *Nosferatu the Vampyre*) or about to be (*Messidor...*) or already shown at the Semaine de *Cahiers* (*Flammes*) or seen elsewhere (*The Chickens*, *The Adventures of a Hero*, *The Hypothesis of the Stolen Painting...*) to go looking for the rare film, less obvious and more difficult, with word of mouth as it is practiced at the Kunsthalle de la Budapesterstrasse as a guide. Word of mouth through which a festival's entire population, a wandering race, knows and recognizes itself, jaded, worn out by the use and abuse of a word like "interesting," a population of "stalkers" on the lookout for the film-that-will-not-go-to (or won't-be-ready-for) Cannes and thus could grace the multitude of *other* festivals to come.

But the frenzy that ensues (in fact channelled by the festival) is however misleading, for a large number of its films don't have much of a life outside of this kind of festival. The festival that ought to serve as a film's springboard is often both its point of departure and its final destination. The springboard indeed exists, but no great leap follows. In this cinematic simulation, films are no longer defined by the audience they reach but by the number of festivals at which a tribe, always the same tribe, sees them.

The competition, Chahine

Mediocrity in the competition and in the awards that feted Peter Lilienthal's anodyne *David*, presumably not to be outdone by *Holocaust*. The same good intentions (tolerance and love between peoples) certainly play a part in the awarding of the Golden Bear to *Alexandria... Why?*, Youssef Chahine's most recent film.

An ambitious film, likely to become a milestone in Arab cinema history, an Egyptian-Algierian coproduction, not yet presented in Egypt, already rejected in Syria and supposedly scheduled to be shown on Algerian television, *Alexandria... Why?* is at once a "timely" film (very much in sync with Sadat's politics) and a film "without a net." A labyrinthian and tangled story that evokes *The Sparrow* (with less rigor but more spirit), it is a sort of autochthonous commentary resembling the great, epic frescoes of Lawrence Durrell. In Alexandria, during the Second World War, young bourgeois Egyptians discover life, love,

(American) cinema and (nationalist) politics. One of them, the one belonging to the less wealthy family, also discovers his theatrical vocation: at the end (very beautiful), the family pitches in for him to go and study in the United States. A story that Chahine readily admits is semi-autobiographical.

A film simultaneously cosmopolitan and local, in which Chahine demonstrates multifaceted courage: 1) by clearly scoring the derision and impasses of a chimeric nationalism, most often verbal and dangerous nevertheless; 2) by inscribing the departure of a Jewish family as wrenching and idiotic; 3) by implying a homosexual episode between one of the young bourgeois (actually the most fanatically nationalist) and an English tommy straight out of a T.E. Lawrence novel; 4) by sharing with the audience the pleasure of making a film, of telling a story, of referring to the American cinema of his adolescence (metonymized here only by "Esther Williams's rear").

During the press conference, Chahine was introduced as such a happy and unique exception to an abject cinema (Egyptian) that the German audience, not very knowledgeable, was entirely ready to make him a martyr, which forced Chahine, slightly irritated, to come to Egyptian cinema's defense (as Satyajit Ray has done with Indian cinema). His film belongs in its own right to a tradition (criticized but not sufficiently examined) in which the principles of filming and editing have as a reference point less Western scenography (the play of inside and outside the frame) than a musical découpage of space and time (pulsations, modulations, refrains, etc.).

Outcast

One of R.W. Fassbinder's most recent films, *In einem Jahr mit dreizehn Monden* (*In a Year of Thirteen Moons*) recounts the final days of a transexual, Elvira, between the moment when her lover leaves her and her suicide. Elivra dies of not being able to talk to anyone, not even her ex-wife and daughter, to whom she appears one final time dressed as a man (an extraordinary scene). You may be irritated or less than seduced by Fassbinder's style (which is my position), you may be indifferent to his stories (which is not my position), you may be repulsed by his obstinate redoubling of the ugliness of German scenery (here, Frankfurt) with a corresponding ugliness of camera movements, but

the fact remains that Fassbinder's recent films seem more solid to me than his older ones, in that they no longer seek to seduce or convince (gone are the didactic and Brechtian gestures and traps). This could be because a filmmaker's exhibitionism changes meaning when he never stops working. Shamelessness is no longer an issue when the filmmaker himself gains speed and accumulates more filmic material than he can measure or contemplate. Like Godard before '68, Fassbinder has become a little factory, with his raw material, his specialized workers and his immigrants; the filmmaker is no longer the author of an oeuvre as much as he is the *little boss* of his little world.

Another outcast, the Albert of *Albert—warum?* by Joseph Rödl, one of the few good films of the competition, dedicated to "those who cannot defend themselves." Albert leaves the asylum and returns home to his farm to discover that he has lost everything, and is now only tolerated there as a handyman. In the village, he is callously provoked and acts in ways that confirm in the others' minds that he is in fact mad, and that lead him, here also, to suicide. This very understated film is worthwhile primarily because of the unforgettable presence of the "actor" Fritz Binner, who has since died and become conflated with his role. Around him, others (characters *and* actors) are less aggressive (that would be too easy) than they are caught in the coercive stranglehold of their rites of normalcy, rites that Albert unleashes and puts to the test by simply being there.

The film also leads to a more general observation: German filmmakers are the only ones in Europe today to go up against *territorial* fictions while simultaneously asking the very question of the imaginary (the search for the right body in the right place, interior exile, non-place, utopia, etc.) from a point of view that is not imperialist (USA), but ex-imperialist. In West Berlin, an artificial city, kept at arm's length by the State (which financially encourages filmmakers to come and work there and lavishly subsidizes the festival), an experimental space shared by humans and commodities, we cannot fail to be sensitive to that.

American withdrawal

Another territorial narrative, the film scandal of the festival, Michael Cimino's *The Deer Hunter.* Curiously, the film was advertised

as pacifist, or, at least, intended to unleash in the audience the cold horror of war. A familiar and naive tune, not to mention a sleazy one, already sung by Peckinpah and other filmmakers of cathartic violence. It could be summarized as follows: let's make a film against war, *for example* the war in Vietnam; the war is atrocious, people are tortured, *for example* the North Vietnamese torture; but in war there is also courage and grandeur, *for example* the "deer hunter" character (Robert De Niro), branded, traumatized, but the film shows how he learns to defend himself.

For while the cold horror of war is indeed in this film (and an economic, unswollen way of filming it: at times, we think of Walsh), there is also a lesson: this horror of war must be overcome, coldly. Sang froid must be learned, and it is best learned in contact with the enemy, the eternal gook, hieratic and cruel, with an inhuman calm. De Niro's entire journey consists of becoming master of the game of Russian roulette, whereas his friend Nick (Christopher Walken) becomes its fascinated victim and master drug addict (the film would have tilted in an interesting and entirely Conradian direction if he had been the central character of the film). For the audience to understand such a lesson, the Vietnamese (North or South, it makes no difference) had to be filmed in exactly the same way as the Koreans of yesterday or the Japanese of before-yesterday, with a candid lack of differentiation and a quiet racism. If inhuman coldness is entirely on the side of the Vietnamese, that means that the American soldiers, human, all too human, naive, emotional, endowed with an unhappy conscience, will to have to go against all that and become animals, reluctantly and in turn. Those who (like myself) think that the Americans needed no example to napalm or become inhuman at My Lai tend to find the film rather fascinating. Perhaps that is not exactly the right word: the film primarily demonstrates a withdrawal and a return. A withdrawal of America into itself and an unbridled refusal to understand anything, to analyze anything about the situations into which it is thrown and mired by its own imperialism, a return to gunboat diplomacy (see *Midnight Express*) whose detour through the Orient merely serves to teach martial arts to overly sensitive boys. John Wayne can die happy...

Outraged, the Eastern European delegations (except Romania) withdraw from the festival, taking their films with them. The

third-world delegations file a statement of protest but do not withdraw. Algeria, independently, files a statement of protest but does not withdraw. The reaction is understandable, although dictated by diplomatic imperatives. Impossible, though, not to think that there is a strong chance that Soviet anti-Chinese propaganda films (they exist, but Sovexportfilm does not sovexport them) are made in exactly the same way (and not as well) as this *Deer Hunter*. There is, then, nothing much to brag about.

Nor is there with Paul Schrader's *Hardcore*, which seemed to me to be a delayed by-product of the great Premingerian power machines of the sixties in which the entire (double) play of the filmmaker brushed up against the limits of the Hays code, toyed with censors who were still very easily antagonized. The disappointment comes because we expect Paul Schrader, spiritualist theoretician of the cinema, Calvinist and Puritan, to resolutely (meaning stupidly) take his subject seriously. In which case the film's religious ideology (something along the lines of: sin being everywhere, it's in pornography *as well*; let's film it, then) could have been brought into play cinematically as it is in Hitchcock, Preminger or even Brian De Palma today. But Schrader's determination to win on every battlefield, and the flatness of the filming (with the exception of the violent scenes), transform the enterprise into a Hollywood game of playing doctor, simultaneously sinister and lewd. As in *The Deer Hunter*, everything is seen through the most reactive character in the story (here, George C. Scott, who is very good, although under-used) and every other point of view doesn't carry much weight.

Three Indian films

Good, in general. (Putting aside *The Elephant God*, which seemed to me to be a minor diversion in the work of Satyajit Ray). To start: the same type of moralizing stories in which an individual delays the moment when he will enter into society. A man fails to follow the rules without challenging them; like a stubborn child, he simply doesn't do what he should do: he doesn't work, doesn't get married, or if he does marry, he neglects his wife, barely scrapes together a living or survives. He is then harassed by everyone else, parents, mothers, neighbors, superiors, friends, animals, and the social pressure is so great that he

ends up settling down. Stories of getting in line, then, that are insepa-
rable from India, from a society of stifling conformism. Indian
cinema wouldn't be such an empire in the third world, Asia and
Africa, if this cinema, on top of its technical savoir-faire, stopped
moralizing, familiarizing, and imposing castes on all human conflict.

From this common scenario, the filmmakers, of course, diverge.
In Shyam Benegal's *Kondura* (the most "artistic" of the three; his film
is plastically splendid), the hero, more or less visionary, more or less
of an imposter, becomes a sort of saint and settles down at the top.
But only catastrophes follow. Mrinal Sen's *Oka Oori Katha* (*The Mar-
ginal Ones*) has more of a Western take on the situation. A father and
his son, utterly lumpen, live on petty theft, on the margins of the
village, develop a true anti-productivist ethic, and assert their right
to laziness (if to work is to die of hunger all the same, it is better to
do nothing). Mrinal Sen, a leftist (and a very surprising scenographer
as well), eventually has his characters discover the virtues of work, but
only in the sense that work involves a social practice that is able to
raise consciousness. The most unusual film of the three is, however,
Adoor Gopalakrishnan's *Kodiyettam* (*Ascent*), a film shot in Kerala,
hence in the Malayalam language. Here, the story is individual *and*
collective, quiet *and* complex throughout, with a concern for never
forcing the subject, never skipping a step. The hero, a bit simple
although entirely opaque, spends two hours at the center of universal
reprobation feeling responsible for everything that happens in his
life. In the meantime, we have the opportunity to process a ton of
information, to understand the local geography and the uses of time,
in short to see the material of the story grow dense. Nevertheless, as
time goes on, the more obvious it becomes that the destination mat-
ters less than the generation of a certain filmic material *along the way*.
This kind of film also gives weight to the argument that South Indian
cinema (in Tamil, Telugu, Kannada, Malayalam, etc.) is superior to
Northern (in Hindi, Bengali, Marathi, Gujarathi, etc.) because it is
less enslaved by the musical comedy model, more modest and more
serious. That this kind of cinema can be, in the states where it is
made, even the slightest bit popular, is a reason to celebrate.

Appropriately, the most endearing films of the Festival were selec-
tions by the *Forum du Jeune Cinema* in which Ulrich Gregor was able

to place side by side, with discretion and taste, very different films that run the gamut of "youth" cinema, from African ethnography (Safi Faye) to video art (Ed Emshwiller).

The common thread between many of these films, none of which are, strictly speaking, works of fiction, is that they begin from an existing filmic material and analyze it, focus on it and follow its every direction until it is exhausted. This is as true for Raúl Ruiz's *L'Hypothèse du tableau volé* (*The Hypothesis of the Stolen Painting*) (see *Cahiers* #290–291) as it is for Luc Moullet's *Genèse d'Un Repas* (*Origins of a Meal*), which is discussed in this issue of *Cahiers*, and for Hellmuth Costard's *Kleine Godard* (*The Little Godard*) (already screened in Edinburgh in '78 and in Rotterdam in '79, see reviews). Same for the films made by Thome-Beatt, Klopfenstein, Gagliardo, Pezold and Nekes, to name only the ones that I saw.

Beschreibung einer Insel (*Description of an Island*), the film by Rudolf Thome, author of *Made in Germany and USA* (famous for having inspired the righteous anger of Jean Narboni in *Cahiers* #285), was highly anticipated and, apparently, a disappointment. I speak cautiously here, not having understood the entire film, whose linguistic overlaps between German, American, pidgin English and the language of the island of Ureparapara, combined with the hesitations of the "simultaneous" translation (which became aphasic) made the film more opaque than expected. But it is not inconceivable that this opacity was just what Thome and his codirector and American actress Cynthia Beatt intended. A group of young Germans (three women and a man) land on an island in the New Hebrides and ask for accomodation. They explain their goals to the residents: to compile as much information as they can about the island (flora, fauna, customs, stories, legends) and include all of it in *one* book. From that point on, the film becomes a generalized neither/nor. Neither a pure adventure film (despite Stevensonian episodes), nor a critical observation (despite having everything necessary to support a finding of neocolonial masturbation, and condemn it), nor a mystical experience (despite the group's neo-hippie babble), nor an abstract game between two abstract groups (although there are mirror effects and exchanges from one community to another), nor finally the story of an impossible utopia (as the book seems to have been written).

And so? All of these films are possible but no one prevails over the others. After three hours (for the audience) and six months (for the characters), the group of Germans leaves Ureparapara with nothing better to say than, "We'll miss the beach every morning." Nothing definitively took place but the place, and this is the minor scandal of the film: that it would adhere so closely to the *superficial* nature of the experience without condemning that superficiality. In its false transparency, it could be that *Description of an Island* is the most accurate film ever made about the final chapter (the most lackluster chapter of the aid workers, of the *peace corps*, of the tourists) of the relations between the West and their "good savages."

Night, food

Geschichte der Nacht (Story of Night) is an hour-long film, coproduced by INA and directed, after one year of shooting, by the Swiss-German author, Clemens Klopfenstein. It is one of the most beautiful films that was screened in Berlin and one of the most difficult to discuss. By definition, its subject, night, is inexhaustible. The film deals with night in cities, small and large, towns and metropolises, quiet or noisy, dead or restless. Everyone recognizes what they can: New York, Istanbul, Greece, perhaps Belgrade... Klopfenstein's montage, non-systematic, non-metaphysical (we are far from *News from Home*, which the film can't help but evoke), also remains very mysterious. For to film the night is suddenly to rhyme the filmed night with the actual night of the movie theater, to make the film spill over into reality (I admit that I deliberately missed the last metro and walked through Berlin in the middle of the night, in spite of the snow). It also brings our attention to that improbable moment in the history of cinema between "silent" and "speaking," the moment when our auditory hallucinations materialized.

Giovanna Gagliardo's *Maternale* is a sort of perverse feminist project in the icy context of high-quality Italian cinema. It is a very original film. The director makes no secret of the question that haunts her: how do you break the chain in the mother/daughter relationship, in which the daughter can never free herself except by becoming a mother in turn? A serious question to which, luckily, the film does not limit itself, since it begins by showing us, in a way that

is both funny and unexpected, a mother (Carla Gravina) in an upper middle-class family, literally obsessed with food, putting all of her energy into feeding (spoon-feeding) her semi-paralyzed daughter. When Carla Gravina, hieratic, is followed by a Jancsian camera (Jancsó, Gagliardo's longtime collaborator), it is the funniest and most successful shot of the film. Later on, the daughter recovers, emancipates herself, and the mother disappears, sinking in the final shot into a dark cellar. This section is more conventional. The film in fact says something more paradoxical than the feminist discourse it evokes: that love may also exist between mother and daughter (love in the Lacanian sense of "yum-yum").

Toilette, Hurrycan

In *Toilette*, Friederike Pezold comes up against an inexhaustible other: her own body, which she dresses and undresses while filming herself on video. The result is visible on a television screen filmed in close-up. The intention is clear: rediscover the human body almost *ex-nihilo*, beginning from the video image and very tight close-ups whose undecidable content ultimately becomes funny or agonizing. We don't know exactly what we are seeing (is it a fold, a pleat, a hair, a pore?), although we are sure it is indeed something.

As for Werner Nekes's *Hurrycan*, it takes the question, "What is it?" even further. Through a variety of techniques ranging from stroboscopy to superimpression, from ultra-rapid montage to intermittent images, it creates composite bodies that animate a kind of violent scissiparity. In the final section of the film, in color, a small movie theater made out of papier-mache opens out on to a little skylight through which we can see masks worthy of James Ensor exhale smoke, make faces, and stick out their tongues to the audience.

These two very different films (the continuous video recording is the polar opposite of Nekes's artisanal work) produce the same effect: figuration starts from scratch and we are invited to the birth of new monsters, but we're invited as if to the guignol, to a childish shooting gallery, where, despite all appearances, the cinema breaks with that mix of voyeurism and narcissism to which it is usually limited and returns to its beginnings: with a simple curiosity.

Naples

The *Kingdom of Naples*, screened on the sly at the Marché du Film (and already overlooked last year at Cannes) is a completely astonishing film by Werner Schroeter. It dares to reconstruct, year by year, the life, survival and death of a poor family, in Naples, from the Liberation to the end of the boom. Almost every character dies, always stupidly, at the wrong time, melodramatically, alongside History. Of all the films that are obsessed with the entanglement of individual histories with History (*Souvenirs de France*, *The Conformist...*) *The Kingdom of Naples* seems to me to be the most inspired and the most convincing, perhaps because it is the most quietly cruel, the one that avoids aesthetically exploiting or despising its characters because they fail to address a History that they do not understand. Schroeter shows this entanglement but never valorizes any of its terms (no particular-general dialectic with him, but a series of *entirely historical* accidents, which include holes and hollows).

(*Cahiers du Cinéma* #299, April 1978)

MINUTES OF A SYMPOSIUM

On May 12th and 13th, in the intellectual desert of Cannes, a symposium was held entitled "Creation and Techniques," organized with the support of the National Syndicate of Film and Television Production Technicians and chaired by Claude Renoir. The symposium's goal: to respond to a supposedly growing need "for designers and technicians to compare and to exchange individual practices that issue from sometimes contradictory experiences in the same career, if not in the same oeuvre." Many guests attended, but viewers native to Cannes were few. The results were disappointing, but the disappointment wasn't really surprising: it was virtually inevitable that creators and technicians, before confronting anything, would flaunt everything that separates them, beginning with the ideas that they have about themselves. After this first symposium, a sign of what "doesn't work" in the profession, let's hope that others follow that are both tougher and more concrete.

1. Day one (morning). Are technicians merely executants?

The question was asked in such a way that the answer could only be: No! An indignant no. The proof? The editor feels stage fright (says Jean Ravel, editor), a sign that the work involves a human factor rather than simple execution. And yet, it is clear that this is a painful question, and that it must, then, be a real one. A decent part of the morning (from 9:45 to 11:30) is spent trying to find a less pejorative word than "executant." Ravel defines the editor as the director's "partner" in a sort of chess game with no victor. Ken Adam (set designer) speaks of "obeying while creating" and Ricardo Aronovich (cinematographer) of "freedom and symbiosis." These pious formulas are unsatisfying, as unsatisfying as "cinema's great family without borders." At 10:54, Ghislain Cloquet (cinematographer) introduces the good word, "craft" [métier] and someone in the room speaks, in English, about "craftsmanship." Cloquet's intervention (which, sadly, will remain a dead letter) has the advantage of addressing the French cinema crisis in terms of a crisis of craft, hence of professional training. Towards noon, Thierry Derocles (editor) provides the only critique of technicians by a technician: they lack sufficient historical perspective on their work. An interesting idea, but quickly abandoned. Too bad.

In fact, it's the filmmakers, very present and more accustomed to making speeches, who take charge of the question, but from *their* point of view, which is of course totally different. According to Claude Autant-Lara, adamant, "You need a commander," that's all. For Conchon (screenwriter), who unctuously asks him if the filmmaker would change the concept of his film if he were working with the best cinematographer in the world, the author of *Gloria* responds proudly: No. It is the directors (and not the technicians) who implicitly challenge the representativeness of the technicians present at the symposium. Rouffio remarks on the absence of sound men, operators and electricians in favor of the filmmaking triangle: director-cinematographer-editor. Moreover, as the debate progresses, the notion of the technician begins to break down and differentiate: Cloquet explains very clearly how, on set, the director-cinematographer forms a royal couple, a veritable "two-headed monster" (wherever certain cinematographers also work as cameramen and camera

operators). Ken Adam, from his end, explains how the hierarchy (the word is finally uttered at 11:22!) of technicians could start to change, how American directors are more and more dependent on special effects. At one point, we are almost on the verge of speaking frankly about the fundamental non-coincidence of authors and technicians' interests: Mikhalkov-Konchalovsky: if the film is good, the cameraman is considered good, if it is bad, the cameraman is already looking for work while the director is still editing the film. Someone quotes Mankiewicz's line: "We won/They lost"...

Finally, two painful questions (re: the nature of the relationship between technicians and filmmakers, the internal hierarchy among technicians) are abandoned in favor of a more general and less compromising approach to framing the problem. We wonder if film production as it exists today could build crews that would be something other than a disparate collection of individual talents. Could a producer be anything more than "simply a manager of funds"? (Marcel Martin, 12:07). Don't we have to talk about the lowering of the professional qualifications of the owners that leads to laziness in and mistakes by filmmakers? Mustn't we reevaluate professional credentials that no longer have any meaning? (Robert Sussfeld, production manager, 11:53). It is Alain Corneau, speaking about his own film, *Série noire*, who says the most sensible things: only an advance selection of technicians, a crew capable of "creating a style," will allow us to avoid the worst. We must then fight to hold on to the possibility of realizing that choice, thus fight against coproductions and compulsory crews.

N.B. At no point are unions, or money, discussed. There is, in fact, no mention of either throughout the symposium. Hypothesis: neither money nor unions exist.

2. Day one (afternoon): Narrative evolution and technical evolution. Is screenwriting independent of technical understanding? Scenery, image, sound: "technical constraints and/or freedom for the mise-en-scène.

The strangest and weakest part of the symposium. Everyone strives to disparage their own work, secretly expecting that their sense of humor will make them look good. Hence speeches that ring false. Two presentations compete for the most banal, one by

Mikhalkov-Konchalovsky and one by Conchon. M.-K., probably under surveillance by someone from the KGB at the back of the hall, says that every technical innovation means little, in the final analysis, compared to the overwhelming simplicity of Charlie Chaplin's face. Propaganda for the human to the detriment of the technical (and to the detriment of historical truth: we know that Chaplin was a staunch technician). M.-K. declares himself in favor of "scripts of steel" to appeal, as a part of a State cinema, to the minister of Culture.

At 3:22 p.m., George Conchon lowers the level of debate even further with palinodes on the wretched status of the screenwriter, "the hollow voice that can still make itself heard," a thankless profession with no real freedom, although it may be exhilarating. The very disagreeable feeling that Conchon is conducting a sort of guided tour of the "marvelous world of cinema" for absolute beginners. Vexing. He talks about Faulkner's failure as a screenwriter, probably to suggest the idea that we compare him to Faulkner and insists on disowning his "failed marriage" with Chéreau (whom he does not name), probably so his bosses won't hold him responsible for the commercial failure of *Judith Therpauve*, a failure due, as we know, to Gaumont's ridiculous concept of the "major motion picture."

At 3:48 p.m., the debate falls apart. As in the morning, the filmmakers arrogantly hammer away at the work of the screenwriter, poorly defended by Conchon. John Boorman intensifies the humorous witticisms against writing, however unconvincing they may be: "I am against good writing. Good writing is extremely dangerous,"* against too much technical perfection: "It's so beautiful it makes you sick," "Who needs Dolby sound?," etc. M.-K. repeats that a script should be appealing, so that it may seduce.

The idea of technical evolution itself begins to become suspect. Reduced, according to Luc Béraud, to the invention of the tape splicer (4:59), for Ravel to faster montage than ever before due to the evolution of the spectator's eye under advertising's influence. Only Derocles attempts to answer the question by discussing the linkage of video and film, the possibilities of editing on the film set itself, of the possible disappearance of film editing in favor of direct editing on video.

3. *Day two (morning). Actors and technology. Is the actor bullied by the technical? Or vice versa?*

Elia Kazan's long (10:06–1:41), highly anticipated presentation, strafed by photographers, peppered with emotion and anecdotes, has the advantage of examining the question from all sides without being too careful. Except it isn't the question that was asked (the actor vs. the technical) but another, which we never escape (the actor vs. the director of actors). At 10:33, Kazan let drop the dreadful thesis ("odious," the Chinese would have said circa the Gang of Four) that the director is, during a film, "a temporary God." At times, Kazan places the accent on "temporary," while being more invested in the "God" aspect. But a worried God, who creates worry in the actor. "For the screen there is no substitute for *discomfort*. Is that acting? In films I think it is."* There is something powerful in what Kazan says: he doesn't try to erase what can be violent and warped in cinema, violence and torsion that made him the first to create stars (Dean, Brando) of a different type than Hollywood had previously made. A temporary God has, of course, the need of a good crew, the kind that wants that film and that God, meaning the one whose desire for that film and that God is the strongest. At 10:45, Kazan stops talking and Henri Virlogeux begins to speak while the journalists start to leave, no doubt with the (naive!) idea of having "covered" the symposium. Too bad, since Virlogeux's much shorter presentation (nine minutes) attempted to answer the actual question, spoke well of the fragility of the actor, of the envy that the apparent simplicity of the technician's work inspires in him. Virlogeux seemed to me to hit the right note when he alluded to the horror that seizes the actor when he hears the cameraman say, "He's out of frame!" The actor's entire self likely resides in that *he*.

But yet again, the symposium's great lesson (that directors misuse their monopoly on speech, that technicians misuse their silence) holds true. From 10:55 to 11:35, Francesco Rosi, thinking that he's Drucker's Sunday talk show guest, drowns the symposium in his anecdotal babble. We are asked to go into raptures over Rosi's tours de force that mix professional and non-professional actors and gain from the latter results that are at simultaneously comic and unprecedented. We learn that you must be shrewd to non-professionals—all the while having a truly amorous relation to them—in order to give

them the sense that they're creating something, while... (chuckles). No point in rambling on about the kind of films that this produces.

At 11:52 the debate we thought was dead is revived. Coline Serreau comes to the defense of actors and asks a question: must filmmakers simply choose actors well, or must they, also, direct them? Does good casting exempt the filmmaker from the actual direction of actors, understood as an intersubjective experience in which the filmmaker attempts "the most difficult thing in the world": to make an actor better? Coline Serreau attacks Tavernier (absent) and Corneau (present) for their declarations in favor of the first solution, herself obviously in favor of the second.

From then on, it is clear the actor/director relationship will be discussed, and nothing else. Volker Schlöndorff intelligently resolves the debate by rendering it irresolvable. First, he quashes the professional/non-professional distinction by arguing that a film is always a document about the person—whoever he may be—who finds himself in front of the camera. A seductive idea, but one that is exclusively from the filmmaker's, or even the film critic's point of view. He then argues that the actor is a child, always considered as such and a prisoner of that status: "Actors should refuse the shameful role of the son—even if they find good fathers." And on that Oedipal note, we go our separate ways.

(N.B. At that moment, I wonder if, as long as we are considering things from a Freudian perspective, we could go even further. If, while making a film, the Author is always placed in the position of the father and if the actor is always the child, it's obviously the technician who occupies the third place, that of the mother. From there, the always exaggerated, mystified and mystifying relation to the mother-technology. It cannot be touched, even in words, without the tongs of savoir-faire (which belongs solely to technicians and makes them perverse, in some way). The author, whether demiurgic or not, is supposed to bend technology to his thinking, by a show of force, by making the actor the support and witness of this mysterious operation. This is how films are made... Obviously, as soon as a filmmaker refuses to play the game, begins to question technology, to flirt with it, he can no longer have the same relation to actors. Schlöndorff in fact signals—as a joke?—to a horizon that only a very few madmen consider: *to make the mother*

speak in front of the children, and not the opposite. I'm thinking of course of Godard, rigorously absent from the symposium's discussions, and whose name will not be uttered until the final day, at 4:34 p.m., by a tourist who happens to be walking by.)

4. Second day (afternoon). The communication marketplace. Is television a solitary pleasure? "Reflected" images and media bombardment. Is the director nothing more than an executant?

The inevitable farewell session on prospects for the future, marked by a pervasive fear ("jitters" would be more correct) of television. Most paradoxical is that even television's advocates and minions (on that day, Maurice Failevic) defend it joylessly and from a reactive, bitter, and vaguely shameful perspective. Any speech beginning with slogans such as: "TV exists, whether we like it or not," means only one thing: TV doesn't exist, shouldn't exist. Unloved, poorly defended, never presented as desirable and always feared, television is assumed to be cinema's undoing (despite the refutation imposed by the American example).

Luigi Comencini opens fire by focusing on an actually crucial phenomenon: in the past, film was able to use the audience and critics' reactions; there used to be *feedback* and *communication*. Today, television prohibits this *feedback**, deprives the audience and critics of their former privilege and bombards them solitarily. According to the author of *The Adventures of Pinocchio*, this isolation is desirable for those in political power who are suspicious of film, which always blatantly disrespects them. After Comencini, Boorman explains that he makes his films in such a way that they can't be shown on television, by placing his actors on the edges of the screen. Bitterly, he concludes: "TV diminishes everything."* Claude Renoir, president of the symposium, explains his unfortunate phrase, "solitary pleasure."

Yet this is what emerges from this umpteenth debate over cinema vs. television. Television is understood to solicit scandalous and abnormal pleasures, whereas cinema is suddenly credited with being a social, congenial, healthy pleasure (a reversal that is slightly retrospective: at one time, cinema was judged to be asocial in relation to the theater). In fact, the hostility of most of the filmmakers (particularly the television filmmakers) comes from the fact that it deprives them

of a narcissistic image of themselves, known as the "relationship with the audience," and how it makes them, an atrocious possibility, technicians, executants, in other words, people who don't know where their work is going. We have come full circle.

It is up to someone outside of the world of cinema, to the sociologist Pierre Bourdieu, to cast the greatest suspicion on the symposium that he had until then attended only as an observer. He asked if "production relations on set resemble other relations" and especially if "the mystification of producers weren't one of the conditions of the production of films—and of the audience." He does not push the provocation any further. Although these questions couldn't be any more real, the provocation goes unnoticed.

<div align="right">(Cahiers du Cinéma #302, July–August 1979)</div>

ROTTERDAM 1980

Proem. It's an old question: how do you report on a festival? How do you talk about that valuable work of *accommodation* between vision and insight, the unexpected and the familiar, the unprecedented and the routine, the need to "put the film back in context" and the desire to judge it nevertheless (according to the soft line, belonging to festival-goers, between the "very interesting" and the "not uninteresting" or the hard line, belonging to cinephiles, between the "abject" and the "sublime")? About that drift between familiar, babbled, imagined, neglected languages, the languages of films, of subtitles, of headphones? About the hazards of programming, happy surprises, mouths and ears? Generally, an order is simulated after the fact (by discussing films one after another) where one never existed. And yet, a festival is a place where it is possible to see a *collection* of films, where it is possible to love their wild coexistence and the fact that they are, without their knowing it, contemporaries of each other. Thus a strange feeling of being—and for a while—the only viewer whom all of these films share. It is sometimes impossible to do anything other than guess at the enormous presence of an unknown referent behind a film (as in Parajanov's *The Color of Pomegranates*).

You always need time to "enter" into a film, into what it narrates, what it wants, sometimes what it hides. But a festival's elementary grammar is something else; we accomodate not what a film says or believes it is saying but the way in which it *targets* the spectator, the way it draws the angle from which it wishes to be seen from the start. From the very first images. Hence, cinema is universal.

And so, in 1980, at the 9th International Festival of Rotterdam, one could feel targeted by the films in two ways. Sometimes on a right angle, frontally interrogated, perpendicular to the image, facing characters looking into the camera, positioned as judge, witness, arbitrator. Sometimes on an obtuse or acute angle, aslant in an entrelac of bodies and fictions, of "scenes" providing ever-changing "slots" for the spectator's eye. *Head-on or askew, then.* Two ways of targeting the spectator that largely correspond to two current inclinations of cinema. Of the *auteur's* cinema. A spectator riveted to his spot, frozen in his posture, or a spectator taken for a ride, with anxiety and delight, to who knows where. The few movies that I saw at Rotterdam, apart from their singularities, belong to one tendency or the other.

Head-on

Lehman. It took Boris Lehman, a Belgian filmmaker born in Lausanne, three years to complete *Magnum Begynasium Bruxellense*, the comprehensive record of Béguinage, an old neighborhood in Brussels. Nothing ethnographic about this project (although the film presents itself as an anticipatory document of something that will soon disappear), or rather, beyond ethnography, there is a cosmological dimension (the film is divided into seven days) to Lehman (as there is to Akerman, another Belgian author). The photography is sumptuous (black and white, with inserts in color) and the risk that it forces the film to run of a certain morbid beauty is almost always dissipated by a Lehmanesque device, more devious than it seems: in *Magnum Begynasium Bruxellense*, above the narratives we imagine are about to surface and beyond the pure architectural survey, in the absence of any commentary, any voice over or guard rail, there is a powerful footlight effect, the kind created wherever there is *reconstitution.* A footlight effect that ruins the documentary effect. A short film by Lehman, *Symphony*, takes the same line. A mentally ill

man is filmed alone, at home, still living (imitating, soliloquizing), thirty years later, as a hunted Jew. He has become claustrophobic and lives out his dream with the harrowing diligence of an hobbyist. The concept, which is a bit limited, nevertheless works because Lehman's filming is at its strongest when he captures a passerby in the street going along his way, somewhere. Paulhan said that literature allows us to see the world as if we weren't a part of it. And cinema?

Van der Keuken. Disappointment with Johan van der Keuken's most recent film, *The Master and the Giant,* written in collaboration with Claude Ménard. A very ambitious film, whose author probably dreamed would be a bridge between his previous work and his current preoccupations. Johan van der Keuken revisits his familiar themes, but without the North-South triptych's slightly naïve third-worldism, that made them worthwhile, with a turn towards mythological fiction. Here, the place of the South is taken by the gestures of life and work collected in Tunisia; the North, pale figures, ostensibly wearing make-up (with the kind of "character production" that Johan van der Keuken seems to be the most uncomfortable with). In terms of form, it's not that ideas are lacking, but rather that the link between those ideas most often remains intellectual. That's what the filmmaker actually claims: "The majority of narrative films... boil down to showing people coming and going... Those movements are what propel the film forward. Real screenwriting exists in those connections, those transitions. I eliminated all of that. When those types of movements appear, they immediately become subjects." Which perhaps explains *Master and the Giant's* "student film" aspect, in which one gets the sense that the film was storyboarded shot by shot, Hitchcock-style. But what would Hitchcock be if he couldn't film doors?

Rainer. One knows (or rather, one suspects) that Yvonne Rainer has directed two or three of American cinema's major films in recent years (*Film About a Woman Who...*, *Kristina Talking Pictures*). She is one of the rare few, with Rappaport, who has continued to pursue the tenacious project of an independent *and* fictional cinema. (In the US, an auteur cinema of the European model can only exist against everyone, at the expense of real heroism, and is financed more and more in Europe by the ZDF!) Coming from the world of dance, Yvonne Rainer works just as closely with language. Hers is an idiomatic cinema, difficult

to subtitle, only slightly more comprehensible, even for those who believe they understand English. And so there was great interest in Rotterdam for the world premiere of *Journeys from Berlin*. Minor disappointment or major fatigue? The film examines how a certain number of American (we are tempted to say, "typically American") voices, bodies, and texts confront the history of contemporary Germany, of the boom, terrorism and *Berufsverbot*, a history evoked by scrolling text against a black background. The elements do not form a puzzle, do not converge. A couple reads (voice-over, household sounds) texts about terrorist women in history. The voice of a young girl reads her journal from the fifties. A woman who wanted to commit suicide talks endlessly, in a greenish spot that might be a hospital, to someone seen from behind, who keeps changing. This last section (the film theorist Annette Michelson, whom we have already seen in Snow's *Rameau's Nephew*, is completely great in it) is comedically the richest due to an irregular, false frontality in which the place of the person listening (the analyst, if we must) is held by a series of various extras. It is difficult to say more right now about a film as complex and serious as this, but there is an abiding sense that we are seeing and hearing political questions discussed for the first time from a woman's perspective.

Boková. An hour-long film, *I Look Like This*, confirms our positive feelings about Jana Boková, a Czech working in England. In London, a dating service incorporates new technologies and utilizes video. Lonely hearts record tapes that a company, Video-dating, shows to other singles at their request. The fateful encounter is replaced, or at least preceded, by the viewing of a tape. Five people cross paths, register, answer questions, watch images of themselves, talk about them and about their solitude—and with humor and dignity. And it's towards the fictional, mean-spirited possibilities of the concept, towards that humor, that Bovoka leads her audience. There's something very endearing about this film: the incorporation of personal ads as templates for narratives, but local narratives, serious but not grim, inseparable from the everyday, *à l'anglaise.*

Parajanov. Already seen in France but screened in Rotterdam in a splendid print, this older Parajanov film resembles, quite simply, nothing we have ever seen before. On one hand, it is terribly removed from us (the reconstructed life—in tableaux—of a great Armenian

poet: Sayat Nova, 13th century), in that each tableau, each image is encoded and probably over-encoded by several cultures and several languages (Armenian, Georgian, Turkish). We would need to imagine a genre foreign to cinema, a filmed hagiography, wherein each shot functions as an icon, a fetish and a cultural treasure (think of Syberberg). At the same time, we are able to understand something about the film because of the splendor of a self-sufficient material imaginary, (colors, textures, elements), and especially by an apparatus that raises each shot to the status of fetish, meaning that all of the film's elements look back at us, shining, twinkling. Everyone looks at Sayat Nova, who (like Bresson's pickpocket) looks only at the camera. The most impressive, and the most contemporary (one thinks of Garrel) thing is the slight trembling, the seductive awkwardness with which the characters hold the pose, as if it were an aleatory game, taking the form of an uncertain scenography, based on stopped or starting behaviors and gestures. As if the image were in itself a *toy*. The fact remains that we will never see the real *The Color of Pomegranates* that Parajanov intended; we saw the mutilated and cropped (by the inescapable Yutkevich) version.

Aslant

In Rotterdam, in 1980, what about fictions? There were few. Some French films and some Polish films. I won't speak about the French films, because they are already familiar (To *Graduate First* and *Simone Barbès*, we must add the very good film by the Frenchman who has emigrated to San Diego, Jean-Pierre Gorin, *Poto and Cabengo*, which we will discuss later on). There's still, if not a style, at least a sensibility unique to French filmmakers that can be better perceived, by contrast, in a festival: the power that French cinema has always had of being located somewhere *between analysis and the novelistic*. As for the Polish films, they were for me the festival's pleasant surprise.

There was *Without Anesthesia* and *Camouflage* (already seen in France). But there was also a group of younger filmmakers, working alongside each other (the famous "Zespół Filmowy X" of which Wajda was a part), dealing with the same filmic material (narration, actors—almost always remarkable), running the same risks (looming censorship) and drawing a *raw* portrait of their country, as evidenced by the films' titles: "without anesthesia," "kung-fu." There was—rather

far from *Cahiers'* tastes, to be sure—a common approach to cinema characterized by the fact that the building blocks of these films aren't shots (or frames) but "scenes"—particularly in the sense of the domestic quarrel. These films could be television melodramas, with the same repulsive elements (sordid spaces in which characters and cameras swim more than they move about) and the same force of impact (a serious approach to the situations described and a clear awareness of the political stakes). In this cinema there *must* always be movement, the camera must always give the physical sensation of taking a shortcut to reach the actor at the moment when he "staggers" under the blow. But this movement already belongs to the characters, it's the very subject of the films: constantly moving in order not to fall down, offering no foothold, having no low guard, knowing how to slip away. With varying degrees of talent, Feliks Falk, Agnieszka Holland, Janusz Kijowski develop the same scenario (in the sense, also, that a scenario is a fantasy—here, of persecution): a man stops knowing how to move, (how to move with others, with institutions, with himself), is placed on the sidelines, left behind and, because socialism is involved, becomes a danger to himself and others. The weight of the collective, the socialization of life (both warm conviviality *and* shame-ridden censorship) is an iron weight.

The power of this cinema (a post-*Man of Marble* cinema?) is that it has abandoned talking about anything other than what it knows. Anything other than the inglorious survival of officials, large and small, of intellectuals: artists, researchers, teachers, educators. That is what Polish cinema (at least *this* Polish cinema, because another does exist—romantic, costumed, esthete—that continues to be uninteresting to us) talks about. In that respect, it is quite simply a step ahead of other cinemas (in France, it's in the Sautet's version that the theme, "the managers also come undone" can be addressed, but the non-intellectual ones.)

Of the three films, the most conventional, the flattest, is *Chance*. At a high school, a clash—including and at the expense of the students—between the literature teacher and the gym teacher. Play rehearsal or athletic training? It demonstrates how an institution (scholarly or otherwise) is only able to function by assimilating the drives of its servants, whom it then rejects (end of film): a student attempts suicide (scandal, the gym teacher leaves, the way he came).

The most obviously skilled cinematically, the best filmer (the least frenetic as well) is Kijowski, who, for *Kung-fu*, appears to have had to deal with censorship. It is about a doctor who, we don't really know why, is shunned, gradually cornered, reduced to a shadow of himself, his defensive reactions contributing to his making matters worse. The metaphor of kung-fu is explicitly presented as the key to the film. Kijowski retraces with choreographic precision how a wounded subject, floating between large (the institution where he works) and small families (although marriage is another institution, never a refuge), acts out, throwing himself in the middle of other people to give as much as to receive blows.

The most appealing of the three films, though, was Agnieszka Holland's *Provincial Actors*, the life story of a second-rate theater troupe. The night before he is to appear in an important role, the troupe's principal actor is stricken with stage fright that degenerates into a crisis of confidence, first under the stern gaze of his wife, who in turn… As comfortable with describing the slow processes of erosion as with capturing powerful moments of haste (unforgettable scenes: the suicide of an elderly man, the visit to a childhood friend who has become bourgeois). As comfortable with describing, from a woman's point of view, a man's collapse as with plunging that woman into her own personal hell, always through a woman's eyes.

Epilogue
The Rotterdam Festival is a good festival because it is not too big. Or too small. Because above all, what defines its two organizers, Hubert Bals and Monica Tegelaar, is the desire to *present* films. Tautology? Not at all: that desire is uncommon, particularly in the small world of festival organizers. If we do not pay attention, if we leave it to the FIAPF to restructure festivals according to the logic of the Olympics (one large festival in every continent), the festival-as-cinema showcase + marketplace is likely to prevail at the expense of local audiences' (a Dutch audience, for example) ability *nonetheless* to see films that are rarely distributed in their regions. This Olympicization of the cinema is in fact not a sign of good health, but of a wish to limit the free circulation of films even further. The average festival (there is also Edinburgh, Locarno, Figueira da Foz) risks paying the price. And yet, it is clear to anyone who

has been to Rotterdam that it is one of those rare places where a film-maker can come and feel at home—with or without a film. That is the gamble (discovering young filmmakers and remaining friends with them) that this festival has taken for what soon will be ten years.

It is noticeably difficult in cinema to sustain any *average* project. Festivals as much as films. Festivals have multiplied in order to compensate for obvious deficiencies in distribution (apart from France, the European landscape is desolate and distressing). But they are currently suffering the effects of the logic that is dividing cinema into large, venal machines and small subsidized experiments. The "art-house" film as a project that is *also* commercial has emerged only in France. Devoted by vocation to the discovery of young auteurs, Rotterdam cannot remain in balance. It must either become a larger festival (which is far from desirable) or appoint, above and beyond the simple task of presentation, a production arm (a project with Godard is already underway) and a distribution arm—that would be not only Dutch but European. Furthermore, to neutralize the disastrous freezing effect that Cannes creates (every film likely to be selected at Cannes abandons other festivals, which then become depleted), the Rotterdam Festival will, in 1981, gain a foothold in Cannes to show its films there as well. To be continued, then.

(*Cahiers du Cinéma* #310, April 1980)

RUSSIA IN THE THIRTIES

A Soviet presence, not only in Afghanistan, but on the Adriatic coast during this 16th *Mostra de Pesaro* (a "mostra" is not a female monster, but something like a "monstration"). An important Soviet delegation (of historians, filmmakers, ideologues, informants) came to supervise the event, dedicated this year to two periods in Soviet cinema history: the thirties and the seventies. One week of screenings, three symposia and, to round things off, the screening of Tarkovsky's latest film, *Stalker*. Observation: while the seventies were completely forgettable, the rediscovery of the "Soviet thirties" was thrilling. It was a pivotal decade because it saw both the passage from silent to talking pictures

(a progressive passage) and the establishment of the doctrine of socialist realism (a passage that was also progressive, and a doctrine that we mustn't forget is still in place). In the thirties, the preceding era's most powerful concept, the idea of *montage*, was embalmed, then abandoned. It will not return. And yet, we know that, as Godard again said recently, "montage was what had to be destroyed, for it allows us to *see*." And the audiences in Pesaro came there to see. To see that destruction. The most frivolous of them giggled at each appearance of Stalin's signifier (written or imaged) in the corner of a shot. Those who were more profound tried to date that "turning point," to find signs of glaciation, the beginnings of the sclerosis. In fact, by 1936, year of the first Soviet Constitution enacted by Stalin and year of the first film referring to Gerasimov, the future champion of socialist realism, the game was already over. But what a game!

The challenge of sound

In the USSR, the passage from silent to talking pictures posed problems that can by no means be reduced to the establishment of the Stalinist aesthetic. In the USSR, as throughout the world in this era, the reining-in of cinema, its normalization, its evolution towards a model called "classical," is an ampler, deeper phenomenon, tied to the rise of imperialism and its ability to subjugate cinema. "Classical" cinema is an industrial, moralizing, verbose and linear cinema. This is the cinema that prepared for war. And it was in the aftermath of war that modern cinema was born (but only in Europe, not in the empires, either American or Soviet). The Soviet delegation, who had come to anxiously defend, without really believing in it, the doctrine of socialist realism in the event it was attacked, was far removed from such a problematic. That is why it inspired, in addition to a certain disgust, profound pity. We had to do without it. In fact, the Soviet passage from silent to talking pictures was unique because it was exceptionally visible, and because it was experienced by all of its actors (the politicians, the filmmakers, the public) in an entirely *conscious* way. It was everyone's concern. We must also see the violence of the Zhdanovian reaction as a backlash—also theoretical and proactive—to developments in cine-montage in the twenties. Between 1930 and 1935, it seems that there is a reversal of alliances:

after Lunacharsky's departure in 1929, politicians leave to their fate those members of the avant-garde who had placed themselves at their disposal, adapting their research (on montage, discontinuity, the figure and eccentricity) for a *promotional* exaltation of the regime. In the genre of "jostled spectator, battered psyche," *The General Line* already marks an impasse. Politicians will make an "alliance" with mainstream audiences, who had to put up with the power of the avant garde without ever loving it. Outplayed, some filmmakers fare better than others. Between 1929 and 1938 (*Alexander Nevsky*), Eisenstein travels and doesn't complete a single film. During the same period, Vertov is demoted, then thoroughly trampled. The passage from silent to talking pictures is this reversal of alliances. The most extraordinary thing about it is that *everyone* wanted sound cinema—but for different reasons. The politically powerful to peddle their discourses and establish their positive heroes, the filmmakers to expand their cinematic investigations of montage to the realm of sound, and the general public—who is also the great silent figure of this story—to at long last hear actors speaking—or better yet, *singing*—in its own language. Exit *l'écriture*, enter speech. A tangle of contradictory interests, a unique situation in the history of cinema: filmmakers wanted to work with noise, politicians wanted to guarantee their discourse, and the general public wanted to rediscover its songs. We are far from the Western hesitations and distress (Chaplin in the USA, Clair in France) that greeted the "irruption" of talking pictures.

Two sides of the story

For it was a political decision to take the time to retrofit the country's studios and theaters with sound equipment, without foreign aid. It took five years. Five years during which every intermediary form (sound versions of silent films, silent films with a complete or partial soundtrack, sometimes dubbed with a symphonic score) could emerge. These were the best films screened in Pesaro. In the USSR, like everywhere else, the first years of talking pictures were the most inventive, and have lost none of their freshness. In a remarkable presentation at one of Pesaro's three symposia, Bernard Eisenschitz cited a declaration by Pudovkin to the Film Society of London in 1929 that was characteristic of filmmakers' state of mind at that time: "I anticipate

a cinema in which sound and human speech are woven into the visual images like two melodies, or even better, interwoven by an orchestra. Sound will correspond to a film in the same way that an orchestra currently corresponds to a film. [...] But we must never show a man and reproduce his words in exact synchronization with the movement of his lips." During the same time period, more pragmatically, comrade Stalin said to some filmmakers (to Aleksandrov, who recounted it later): "The entire world pays close attention to Soviet films and everyone understands them. You can't imagine, you filmmakers, the responsibility of the work that is in your hands. Pay serious attention to each of your heroes' acts, each word. Remember that your work will be judged by millions of people. [...] Study sound film in detail. This is very important for us. When our heroes discover speech, the power of influence that films have will increase enormously." It is clear that these two sides of the story differ, that there was a misunderstanding. It's the story of this misunderstanding that was reconstructed, in part, at Pesaro.

Listening: Kozintzev, Trauberg and Shengelaia
In 1931, Karl Radek devotes a famous article in *Izvestia* to two films. He skewers one and defends the other. The first is Vertov's *Enthusiasm* and the second Kozintsev and Trauberg's *Alone*. *Enthusiasm* was not screened in Pesaro (an absurd omission), but *Alone* was. In both films, the sound work is quite advanced. Vertov tries his hand at a sort of "audio billboard" (the film has as the subtitle *Symphony of the Donbass*), while Kozintzev and Trauberg tell the story of a young schoolteacher sent to the Altai, struggling with with feudalists and the laxity of the president of the local council (performed very well by Gerasimov). Radek gives his support to *Alone*, whereas he sees in Vertov's film only the "cacophony of the Don River basin." Sign of the times: it's the end of the Vertovian dream of a cinema without acting? For us, in 1980, what is magnificent about both films, one with acting and the other without, is that the belief in a socialist future is coupled with the discovery of a new continent: sound. The same trust (it will be equally betrayed) is placed in them. We remember the beginning of *Enthusiasm*, the close-up of the ear of a woman telegraphing. *Alone* is no different:

there is, on the one hand, a sound score, out-of-sync, hyperreal, half-dreamed, a world into which the heroine (Elena Kuzmina, very beautiful) is not only plunged, but voluptuously submerged, and on the other hand, an orchestral score written for the film by Shostakovich. This initial sensuality of sonic material will be lost in Soviet cinema five or six years later, in favor of tepid dubbing and pompous music. That it went hand in hand with the creation of luminous female characters (in Dovzhenko, in Barnet) does not seem accidental. Once again, the "liberation of sound" is accompanied by the awakening, the development of female figures.

We find, paradoxically, this theme of listening in a silent film from 1932 that was one of Pesaro's pleasant surprises: *The Twenty-Six Commissars*, by Georgian Nikoloz Shengelaia (one of his two sons directed a film about the painter *Pirosmani*). Rarely has listening, the *act* of listening, been *seen* as successfully as in this film. The action takes place in Bakou in 1918: the Bolsheviks, in the minority, leave the city to Mencheviks who rush to place it under an English protectorate. But the English only want the oil, and deport and then execute the twenty-six Bolshevik commissioners who remain in Bakou (a tremendous scene in which they are shot in the middle of the desert, in the hollow of a sand dune). The long deliberation scene in which the Party is placed in the minority is fascinating because, in order to film the people who speak, argue, become enraged, challenge each other and grandstand, Shengelaia is forced to break the action down until it becomes abstract, to impede his message's transitivity with unexpected effects of écriture. Moreover, we are still in an era where, in Soviet cinema, the passage from one shot to another is not based in the gazes of the characters (that famous suture), but rather the substance of what they say—here, on cards. The eyes, fiery or duplicitous, feverish or frightened, remain turned towards the interior of the characters they emblematize. And so we reach an intensity that rests on an incessant auditory hallucination, which already belongs, in this silent film, to talkies, but which the talkies will leave behind.

Music. Savchenko and Donskoy

That way of *filming listening* is already a vestige of the past. Work on sound material will take a back seat, and if some make sound the

narrative concern of their films, it is the very particular sound that is music. And so *The Accordion* (1934), Igor Savchenko's first full-length movie and one of the very first Soviet "musicals," was a pleasant surprise. On a kolkhoz, the best worker is also the best musician. Elected secretary of the Komsomol chapter, then to the Soviet local, he thinks it smart to give up music and hides his accordion in a barn. A mistake: life becomes bleak and the young koulaks disrupt the town by also playing music (but a feverish, suspicious music). Just in the nick of time, the hero retrieves his accordion and "with his songs of faith and hope, routs the enemy and wins back his fiancée" (*dixit* Jay Leyda). The film's failure in 1934 tends to prove that the corny edification (but what edification isn't?) that pervaded the recuperation of music (and dance) was unconvincing. Today, what is striking about *The Accordion* is the very particular, very original way that it animates dances and songs, varies the angles, arrests the surges, solders them together with a very successful kind of *Sprechgesang*. What's happening, as they say, is sensuality, flirtatiousness, Ukranian summer nights, etc. Music sets them straight but isn't itself set straight.

Music is also the subject of Donskoy's first film, *Song of Happiness* (1934), codirected by Vladimir Legoshin. Apart from Donskoy's strengths, which are familiar to us from his following films (he is a fantastic narrator), what is striking in this film is that we are still in a world where sound is a pleasant surprise, an ephemeral entre-deux between noises (that recede) and speech (that approaches). The key to *Song of Happiness* is the question, "What sound can you make?" It's the story of the sound of a flute that ends up overtaking all others, the story of a small farmer who thinks he has killed the boss of his koulak in a fistfight, flees, wanders, and goes to prison, where his musical gifts are discovered and encouraged: he becomes a virtuoso, is consumed by remorse, changes his name and his appearance, learns *in extremis* that he in fact never killed anyone (the Party knew all along but told him nothing), returns to normal life and gives his first concert. As is often the case with Donskoy, the populist, sensitive, rather apolitical approach (he became a completely official filmmaker for this very fact), preserves the film's freshness. The metamorphosis of the little savage into a performing monkey in a tailcoat is, as they say, "too good to be true": today, as yesterday, one may enjoy it without really believing.

Raizman's talent

Miles away from Savchenko and Donskoy, at the other end of the cinematographic spectrum, we meet an important filmmaker, Yuli Raizman, and one of his minor films, *Men on Wings* (1935), which is little-known, unappreciated (even by Mitry who, in my opinion, is wrong), and a delight; Raizman was one of the first Soviet filmmakers to shoot systematically with direct sound. What he expects from sound is very close to a Western, American, even "Mac-Mahonian" conception of mise-en-scène: to guarantee a visual and auditory *continuum* in which it is impossible to cheat. The sound neither comments on nor doubles the image: it *proves* it. Everything must be in the mise-en-scène: in the arrangement of objects, the salience of the sets, the unexpected elegance of the characters, their momentum or their immobility. And for this, it must be said that Raizman is a great director who reminds us of Hawks (circa *Dawn Patrol* or *Only Angels have Wings*) or Grémillon (*The Woman Who Dared*). A story of love and dignity in an aviation school, stoicism and courage, the love of an older man for a younger woman (a student) whom he loves: it is also a world in which one is honest about one's feelings, even if one doesn't know how to express them. Hence Yuli Raizman is a very American filmmaker (weak protests from the Soviet delegation), for whom cinema history generally remembers only one film, *The Last Night* (1936), which was also screened in Pesaro and was a disappointment. It is a very brilliant film in terms of everything related to topographical description: a Petrograd neighborhood on October 17, transformed into a battlefield: the last night of the old world, rioting, separated families, stray bullets, muddy chaos and class hatred. Conversely, there is something unpleasant and theoretical, dry, about the development of the positive heroes: the pivotal character is a tireless, jumpy, and mischievous mother who goes through the film understanding nothing, like the Pink Panther in a kerchief. The final scene, astonishing, does not lack for humor: an armored train, spiked with rifles, arrives in a station where Reds and Whites are fighting: friends or enemies? No one dares approach the train stopped on the platform. Only the unflagging mother approaches the cars and asks the soldiers off-screen: "So, boys, who do you want to shoot at?" Laughter. They're the good guys, of course.

Barnet's genius

Two films, the very popular *Outskirts* (1933) and the supposedly minor *By the Bluest of Seas* (1936). Since Boris Barnet's cinema has not yet been seriously studied (although the National Film Theater of London devoted a tribute to him in July), we will keep to superlatives. It is no longer enough to add Barnet, always *in extremis*, to the official list of Soviet cinema's glories, or to say that he has always been loved in *Cahiers* and elsewhere (Godard wrote a beautiful text on *Bountiful Summer*), it must be said that he is a great filmmaker, venerated (and not by accident, to be sure) by figures as various as Tarkovsky and Iosseliani. He is undoubtedly the most liberated and inspired figure in this intermediary period between silent films and talkies (which is why he seems so modern to us). With Barnet, every sound is brought into play, with equal concern given to invention. The thread of *By the Bluest of Seas* (a sort of "a girl in every kolkhoz," with less cynicism) is, nevertheless, tenuous. Two men are shipwrecked in the Caspian Sea and are saved by fishermen from the same kolkhoz to which they had been sent. On an island, they meet Machenka (Elena Kuzmina, always beautiful), with whom they fall in love. And so they are rivals. Aliocha loses his mind and becomes sloppy in his work; Youssouf denounces him in front of everyone. The three talk it over while sailing. A storm hits: a wave washes Machenka away. She is believed dead. Consternation and a funeral ceremony at the kolkhoz. Machenka appears, alive and well. The men summon her to choose between them. She admits that she has a boyfriend elsewhere and that she loves him. The two return to their boat. As in many good films, nothing much happens in *By the Bluest of Seas*, although everything happens at breakneck speed. You need to see the passage, out of nowhere, from silence to music, from muteness to noise, or the transformation of a glassy sea into a tempest. You need to see the camera marry the movement of a wave or go completely underwater (rarely has the sea been filmed so beautifully). You need to see it because it cannot be put into words. Barnet, like Griffith, Fuller, or even Bergman (Bergman circa *Summer with Monika* or *To Joy*) is the filmmaker of what is experienced and decided in the *moment*. He says nothing other than the wonder of being alive, in the sunshine, exposed to every gust of wind, every sound, every affect. As

Mitry correctly says (on page 424 of his *History of Cinema*, Volume IV): "The same images sometimes signify the same thing, sometimes signify different things, and the same ideas are sometimes signified by images that say what they show, sometimes by images that say the opposite of what they show." Unforgettable, the moment when Youssouf, prostrate on the beach, sees Machenka rising up from the water, whom he thought was dead, and looks at her for a long time as if in a dream, then, as if he had seen a ghost, takes three steps backwards before rushing towards her. How to talk about this *same* movement of retreat by Machenka when she returns to the kolkhoz and asks, "Who is dead?" The most precious aspect of Barnet's art may reside in that "montage of compulsion," in that rush of momentum and flight.

Figure, type, folklore.

This survey of the thirties could, I realize, be accused of formalism. We must be able to conduct this survey from the point of view of the films' historical referent or their "context." What do they narrate, and how do they distort the history of the USSR? We must approach this systematically, one day (in the same way that, in the sixties, the truth about the conquest of the West was reestablished versus American legend.) For now, we need only say that it is clear that this cinema, made from the victors', meaning the survivors, point of view, frequently lies, by force, by fear, by blind conformity or by deliberate omission. Rarely has cinema failed to reflect the society that produced it to such a degree, and this, irony of ironies, in a country where the theory of reflection in art has stifled every other and continues to dominate today. An obvious irony. At the thought that the Gulag was established in this very same era, that in this same era it was the lives (and deaths) of millions of people, the mind begins to reel: no trace of it in the films. That said, a brilliant critic or anthropologist would perhaps be able to perceive its echo, certainly not in the films' subjects, but specifically in their *forms*. Obligatory formalism, then. We must assume that there is always something in common between a type of political power and the way in which, simultaneously, the cinema viewer's place is assigned. Especially in the thirties, when propaganda reigned supreme. For example, while watching a film such as Sergei Gerasimov's *Seven Brave Men* (1936),

an Arctic, *boy-scout** and understated story, we begin to suspect that the film is the "sound," proper, ideal face of the Gulag. Behind the daily heroism of a small group of meteorologists on a mission in the great North, we must also see Siberia, forced labor, and the camps. The more iconolatrous this cinema becomes (culminating in Chiaureli's post-war films, which have become hard to find), the more we must imagine the unfigured massacres. Writing will bear witness to them in time (Solzhenitsyn), not cinema. The more that types become codified, the more the ideal is illustrated, the more we must imagine that another kind of codification is expelling from the social body (and from authorized images of that body) negative types. The more we see ideal images occupying the entire screen, the more unsettled we should become. If we were to reposition cinema in a history of figuration, Soviet cinema would be the most fascinating to study. We would see in it, better than anywhere else, the passage from an inter-rogation (optimistic in Vertov, carnivalesque in Eisenstein) of the human figure to a policy of typing. In the twenties, the question is how to insert the human figure into the chain of representations, somewhere between the animal and the machine (c.f. the *Cahiers* texts on *The General Line*, #271); at the end of the thirties, the only remaining chains are between men. Then, the list of authorized subjects is progressively reduced until it reaches, in current Soviet cinema, the point of an insignificant provincialism. We have passed from the figure to the type and from the type to folklore. For what was striking in the films from the seventies that were shown in Pesaro was, even more than their unevenness of talent (there were some very good filmmakers, like Vasily Shukshin), what I will call the *auto-folklorization* of that cinema.

Tarkovsky, the "stalker" and faith

It is perhaps as a result that I was moved by Tarkovsky's last film, *Stalker*, whose ambition, if not its very existence, contrasts with the cunning restraint of current Soviet production. It is that cinema's logi-cal fate: it continues to have [a] universal vocation because the Soviet dream, even and especially when it has become a nightmare, continues to affect the rest of the world (and not only Afghanistan). The disen-chanted satire of "true socialism" against the background of

alcoholism (à la Danelia), the shrewd rereading of the great literary classics of the 19th century (à la the Mikhalkov brothers) is one thing; the mourning of the Soviet dream is another. Will it ever happen?

In *Stalker*, Tarkovsky imagines that in the wake of a fallen meteorite, and for reasons that aren't entirely clear, an entire territory has been evacuated and then abandoned: this *no man's land** is guarded by terrified soldiers who fire on anyone who tries to enter it. This area is the "Zone," a fossilized industrial landscape that has once again become wild, nauseating and beautiful, exciting the imagination and feeding superstition. Near the Zone lives the "stalker," a poor outlaw who, for a little cash, escorts those people who, out of curiosity or thrill-seeking, are willing to try their luck and cross to the other side. The film begins in what Zinoviev calls in his novels a "greasy spoon": the stalker takes on two "tourists," a writer devoid of inspiration and a doctor who is called simply the Professor. The film is the story of their journey through the Zone, ending with their return to the greasy spoon. They gossip, clash, grow frightened, then suspicious, indulge in a deceptive "truth game." They progress with great difficulty through a landscape of forest and metal, of odorless flowers and murky tunnels. According to superstition, a place exists somewhere in the Zone where one's every desire may be fulfilled. But once the threshold of this enchanted room is reached, everyone refuses to enter. The truth comes out: they prefer their current lot; they distrust a brighter future. We learn that the stalker's entire life, all of his *jouissance*, depends on being in this Zone, on being the master of a kind of large-scale treasure hunt, infantile and complex. He's a *smuggler* who only lives for the trust that is placed in him. And yet, during this journey, nothing happens, and the stalker bitterly concludes: "They don't believe in anything... That organ... with which we believe... has atrophied!"

The film's theme, therefore, is faith. Blind faith. The film's mise-en-scène rigorously embraces this perfectly obsessional question: what's behind the door? And what if it were even worse? It is important to note that the film's three protagonists are not young men: cruelly, the camera presents them as wasted, wracked, *marked*. On the other hand, the stalker has a family: a wife (who believes in him, although she thinks him simple-minded) and a paralyzed little girl

who is rumored to be a mutant. While we must, with good reason, distrust grand metaphors (at *Cahiers*, we prefer the literal), we must also acknowledge one metaphor that succeeds, "literally and in every sense." The Zone, which is obviously, like Kafka's castle, simultaneously a real place and an idea, a territory and a word, will be endlessly interpreted. But I see the power of the film in its literality, in the persistent trajectory of these men who, it's clear, wear and carry with them all the fatigue of that Soviet dream become nightmare, a nightmare from which one cannot awaken. We will perhaps never see a film about the Gulag, a *Soviet* film, but the stalker and his companions already come from there, from that unfigurable location, and from that word that has been removed from the dictionary. We know, ever since Syberberg and Wajda, that the work of mourning is inseparable from an interrogation of figuration itself, of its fraudulent idols. That is where Tarvokvsky, in his violent refusal of naturalism, in his prophetic inspiration, interests us. Besides, it was always his subject: *Andrei Rublev* is the story of a painter, and through science fiction *Solaris* asks the same question as *Stalker*. Science fiction is indeed the only surviving film genre in which questions this serious can be brought into play. Not only in the USSR. Don't forget that *Stalker* is *Alien*'s contemporary.

"Pragmatic and a little sad"

A word in closing on Pesaro's Soviet delegation. They came with certain things to say absolutely and others to avoid at all costs, and were a disappointment. They had to say, despite all appearances, that the thirties were in absolute continuity with the twenties (strange Marxists, for whom the idea of rupture is a terrifying thing!). Above all, they had to reaffirm the dogma of socialist realism against petit-bourgeois nihilism (the head of the delegation, the ineffable Baskakov, in fact attacked *Cahiers*, Straub, Godard and *Number Two* in a funny article that was translated into Italian). They especially had to justify their choice of films. Why no film by Iosseliani? someone asked. He's a very good filmmaker, was the answer, but he could in no way "represent Soviet cinema." This "representation-ism" is in fact a fundamental trait: nothing exists because everything represents, there is nothing to study because nothing exists. Hence evasive responses

when, driven solely by their historical drive, the Pesaro audience asked questions about bygone filmmakers, little known or *officially* minor. Hence also a couple of tantrums by Lino Micciché, the head of the festival, when the doublespeak went too far. Anecdote: Bernard Eisenschitz used, while speaking about Stalinist cinema, the word "sclerosis." The delegation looked pained. "I don't much like that word," said one historian (named Zak), "I prefer another one." But he neglected to say which one. "I don't like that word either," answered another historian (a certain Youreniev), "I would say instead that that cinema was pragmatic... and a little sad. Laughter."

<div align="right">(Cahiers du Cinéma #315, September 1980)</div>

FOR A BLACK POSITIVE IMAGE*

In a book entitled (not by coincidence) *To Find an Image*, the critic James Murray writes, "The three goals of Black cinema are: the refutation of the lies of Whites, the reflection of Black reality and (by way of a propaganda tool) the creation of a positive Black image." Witnessing the choice of films presented in Nantes (most for the first time in Europe), discussing them with the filmmakers in attendance, reading the literature devoted to Black American cinema, it became clear that the third part of the program has—for fifty years—been the order of the day. It is even the essential element of this program, because the "creation" of a positive image is much more than a "propaganda tool" and the very possibility of a Black cinema—created, seen, and enjoyed by Blacks—depends on the existence of positive Black figures (heroes, most often).[1]

Refuting White lies about Blacks, fighting against biases, against amnesia requires the care, the patience of a William Miles

1. The issue exceeds the framework of Black America; it is about the forms within (and against) which a dominated population lives with the fact that it is dominated and the image of that domination. The issue risks becoming obsolete in France, a country for whom one can no longer reasonably speak of "popular" culture; this is not the case—far from it—in the U.S., about which it must be said that culture, if it were stripped of its exogenous elements and reduced to its WASP components, would be a sorry thing.

(*Men of Bronze*), or the introduction, at the end of the seventies, of large-scale televised docu-dramas (*Roots*). It is possible to describe Black reality, with warmth and sympathy, from a White perspective (Shirley Clarke's *The Cool World*, John Berry's *Claudine*, Martin Ritt's *Sounder*), as from a Black perspective (with rather profound differences between a Marxist-oriented analytical approach—à la Gerima—and a culturalist and populist approach—à la Hudlin). For these questions, I would refer to Le Péron's text. Here, I would like simply to indicate two or three insights drawn from Nantes with respect to the avatars of this "positive Black image" throughout History.

1. These avatars are inseparable from a cinema that is produced, directed, acted, consumed and distributed by Blacks. In essence: two prosperous periods (the twenties and the seventies) and periods of decline. But while a Black American cinema has never really managed to sustain itself, that doesn't mean that it has never existed. In Nantes, we discovered Oscar Micheaux, who, between 1918 and 1930, was the one-man-band and total auteur of a cinema that was dealt a fatal blow by the talkies. "He maintained," writes his biographer Pearl Bowser, "that by using positive Black images, he could educate and strengthen his audience, all while entertaining them." How so? Based on *Body and Soul*, the only film of Micheaux's screened at Nantes, it is difficult to say. Especially as it involves a particularly devious positivity. The singer Paul Robeson, then world-famous, plays a country minister who is worshipped by his flock but is in fact a convicted felon, lecherous and despicable. This "hero" takes advantage of a young girl (a remarkable storm scene in a forest), abducts her, abandons her (she dies). His impunity depends on the blindness of his victim's mother, who loves him without his knowing it (Micheaux's great candor in the portrayal of sexual fantasies) and whose savings he steals. In the end, he will be exposed and will repent. But that's not all: the abused young girl was also in love with a simple and honest man, played by... Paul Robeson. We see what "creating positive images, educating, entertaining" signifies concretely: to make Paul Robeson play *every* role, as if he were, as a famous and admired Black man, the only one worthy of being filmed, as if the glory he acquired outside of the cinema exonerated him to such a

degree that he could take on every role, play every double game, materialize every cleavage.[2]

2. In the forties, Hollywood learned how to win back the Black audience, and Micheaux shoots only minor films (he dies in 1951). In 1940, a Black actor, Clarence Muse, who since 1928 had been playing small, stereotypical roles in White narratives, writes and finances a film entitled *Broken Strings*. Clarence Muse represents, according to the critic Lindsey Patterson, "one of the last cinematographic relics whom certain Blacks would rather forget, and whom others would like to preserve as evidence of Black endurance in less illustrious times." *Broken Strings* testifies to these less illustrious times.[3] Its Uncle Tom side makes it nearly unbearable today even though it is, in cinematic terms, a little film that is full of invention, funny and as unpredictable as a good B movie. Seen through the lens that concerns us here (a positive Black image), the scenario is completely revelatory. A famous Black concert violinist (played by Muse himself) loses, following a car accident, the use of one of his hands (I admit to no longer knowing which one): it remains paralyzed. His career destroyed, he ekes out a living by giving violin lessons to neighborhood kids. A visiting surgeon is determined to restore the use of his hand, but the operation is expensive. The musician's children play in clubs, in the streets, to earn the necessary funds. But they play swing, music that their father, raised on classical music, abhors. He agrees nevertheless to go see his son when he participates in a competition. The son swings like a madman and wins the competition. Overwhelmed by enthusiasm, the father stands up, applauds, and recovers the use of his hand. Miracle. In the final shot, identical to the first, he is once again a classical violinist. As in *Body and Soul*, the positive image is a divided character (caught between two musics, two cultures) and is symbolically castrated, besides. To

2. Another disturbance: one that emerges from the filmic material itself. The light, film, emulsions of silent cinema, its grain and overexposure, end up multiplying the cleavages and uncertainties by "whitening" the characters, by dematerializing them. (This is particularly clear in one social melodrama of the era, *The Scar of Shame*, screened in Nantes).

3. This inglorious era is the same one in which Dooley Wilson, the Black pianist in *Casablanca*, the one to whom Ingrid Bergman said "Play it again, Sam"*, stands out because his role, as small as it is, is a fully-fledged role in which he acts as a pianist and not as a Negro [Noir]!

remain virtuosic in a kind of music that does not belong to him, he must pay a high price: the accident that forces the hero to face his own music (Black music), *his* repressed. A warning shot inside a fantasy of reconciliation between the races, the return of the repressed at the service of repression. Such a story speaks volumes about how difficult it was at that time to create a positive Black image that was anything other than a tangle of symptoms.

3. The sixties was a decade of major Black mobilization, maximum politicization.[4] As always, it took some time before cinema could address the considerable changes that would subsequently affect the Black image. It suddenly became very positive (*Black is beautiful*). At the same time, Sidney Poitier received an Oscar (for *Lilies of the Field*) before the success of *Guess Who's Coming to Dinner* in 1967 made him the official good Black of Hollywood fictions. To satisfy an audience that had become less manageable and more concerned about its image, the industry promoted films for which the term "blaxploitation" was coined: Black films, in the double sense of the term, with Black cops (Cotton, Shaft) as positive figures. But the most important film of this era, a unique film, remains *Sweet Sweetback's Baaadasssss Song*, written, produced, directed, scored, and acted by Melvin Van Peebles in 1971. This almost legendary, often plagiarized film, never before screened in France, is itself heroic: the only Black film made outside of Hollywood to have enjoyed enormous popular success. The theme is simple, centered around three basic drives in the ghetto, according to Van Peebles: run, fight, and fuck. Sweetback earns his living performing as a stud in a whorehouse; he finds himself, almost inadvertently, knocking out two White cops who were beating up a young (militant) Black man. From there, he escapes, runs, and never stops. He runs to the Mexican border, where to the audience's great surprise (they still believe in the tragic ballad) he crosses over, throwing into the Rio Grande, towards the cops who stay on the other side of the border, the bloody corpses of the dogs who had been chasing him. It is almost impossible to describe this unpredictable, astonishing film. Van Peebles builds up spectacular

4. Reverend King's non-violent march on Washington was in 1963, the Black Muslim movement rose in 1964, the Black Panther Party was created in 1966.

scenes, and he plays with *every* kind of spectacle: anamorphosis and tableau vivant, sex and violence, he plays with perspective and with the screen, etc. Everything is churned, cited, left in the shot, as if, in his endless run, the auteur-actor were also recreating, with a swagger, the history of cinema.

The film has been widely imitated, but without much success. In fact, the power of conviction, the sympathy, that emerges from *Sweet Sweetback's Baaadasssss Song* comes from the way in which Van Peebles, he too, goes about creating a positive Black image. For Sweetback is not the hero of the struggle of Blacks against Whites, he *becomes* that. He creates himself before our very eyes. And if the film attains a sort of universality (which means that when screened at Nantes, eight years later and in a very different context, it wins over the festival audience), it is because Melvin Van Peebles, more seriously than it seems, tackles the theme and myth of the hero. He is a true hero in the Blanchotian sense: Blanchot argues that the problem of the hero is that he "comes to possess an origin only at the moment when he bestows upon himself a beginning."[5] And indeed, Sweetback has no origin (no family), no psychology (he doesn't talk much), no personal reason to revolt (he's not the one being beaten). Similarly, Van Peebles's acting, sober, slightly sad, stripped of all hysteria, contrasts with the vitality of the script and the frenzy of the direction. "Heroism knows nothing of conscience" (Blanchot again), and what we witness in the film is the fabrication, the *montage*, of a heroic body about which we know practically nothing (except the little that is verifiable: his sexual power and his physical endurance), an unnatural body that belongs to no naturalist space, a body that places itself in motion and never stops, a marionette that is manipulated by no one, but is instead automanipulated. The strongest scene in the film in this sense is the one in which Sweetback, on the brink of death, hunted in the desert, creates a plaster out of dirt and a bit of his sperm, taking his self-generation to the limit.

4. A positive but baroque Black image (it was a disappointment to the Black bourgeoisie, Van Peebles says, but was loved in the ghetto and by the Black Panther Party), an erotic hero who becomes erratic,

5. Maurice Blanchot, *The Infinite Conversation* (U of Minnesota Press, 2002), 370.

Sweetback is undoubtedly the most contemporary narrative of the Black movement at its apogee. An image without a future, like (for the moment) the movement itself. With its *blockbusters*, Hollywood reclaims the Black audience (and increases the number of supporting Black roles, such as Yaphet Kotto in *Alien*). In 1975, a film such as *Cooley High* by Michael Schultz says a lot about the erosion of the previous decade's themes of struggle, the progress of the ideology of integration, the advance of petit-bourgeois tastes. The film was distributed in France with the title, *Cool*. A deception—and a significant deception—because the film is not a thriller but the adventures of a few students at Cooley High *School*, in Detroit, a sort of Black *The Pom Pom Girls*. Schultz is the only Black filmmaker working regularly in Hollywood today, which earns him either envy or condemnation. The film narrates the dreams, the disappointments, the flirtations and the fights of a small group of Black adolescents in a large industrial city. It takes the goodwill of his teacher and the death of his best friend for Preacher, the hero, more sensitive, more intelligent than the others, to reach, *in extremis*, adulthood. He leaves, a small backpack slung over his shoulder. Thus it is a coming-of-age story, of the *young mister** something kind. It is relatively well-filmed, often funny, sometimes just, and in the final analysis relatively depressing. Here, naturalism, so foreign to Black American culture, produces, instead of a positive Black image, an amnesiac, well-meaning, empty image.

This survey of several archetypes of the Black positive image demonstrates that this image refers more to the psychoanalytic category of the *subject* than it does the naturalist illusion of the *ego* or any reconciliatory discourse. *Sweet Sweetback's Baadasssss Song* is dedicated to "All the Brothers and Sisters who have had enough of the Man*." In the *broken english** of American Blacks, *The Man** is not Mankind, but Whites. Perfect example of returning humanist babble to its sender (who is also its inventor), simply by the ironic hijacking of a capital letter.

(*Cahiers du Cinéma* #308, February 1980)

NEW YORK, NEW YORK

American cinema is also a regional cinema. Almost everywhere are filmmakers, videographers, experimenters who would like to go their own way. Someday we will describe the *geography* of this American cinema that ignores Hollywood, who ignores it. New York, Babel of the 20th century, is one of its (little) cinematic capitals. It has, of course, its experimental cinema milieu (Mekas is still there). But it also has its madmen and madwomen making auteur films, narrative films that have in common their being unthinkable outside of New York. For the New York way of speaking, of walking, of being funny or of suffering, these are rare documents, irreplaceable films. They are, of course, about the New York intelligentsia, the one Woody Allen mocks, rather cheaply, in fact, in *Manhattan*. For several years, Yvonne Rainer, who comes from the world of dance and has forgotten nothing of her first profession, obstinately makes, for and against everyone and everything, magnificent films. They are named *Kristina Talking Pictures, Film About a Woman Who...* and *Journeys from Berlin*. Coming from France, Jackie (formerly Jacqueline) Raynal developed a short film for years (*New York Story*) that foreshadows others. We must add Mark Rappaport, who is better known in France (*The Scenic Route*) and whose last (but not best) film, *The Impostors*, ought to find distribution. These three Rs are somewhere between New York and Europe, all speaking of and starting from an interior exile. A good reason to make them beloved.

(*Cahiers du Cinéma* #316, October 1980)

GDANSK 80

For one week, the former Free City of Danzig was the capital of film and politics: the 7th Festival of Polish Film (fictional) was held there. It was a great success with the audience, an occasion for Polish filmmakers to meet, to be counted, and to fight with one another (behind closed doors), a pretext for several intrepid foreign journalists to shuttle between MKZ headquarters and the festival site. All of which

will be discussed in the next issue of *Cahiers*. But after a week of screenings, of press conferences, of aching ears (due to headphones), of silence and chit chat, we may also point to some preliminary conclusions reached by the average observer. Not a specialist of history and Polish society, but someone who takes pleasure in the necessity to "start from the films" that he sees.

This average observer notes two discrepancies. First discrepancy: the Polish films from 1980 are clearly inferior to those from 1979. In 1979, festival-goers were struck by the "it can't go on like this" aspect of those bleak and rigorous films entitled *Without Anesthesia, Kung-fu, Provincial Actors* or *Camera Buff* (these last three films absolutely must find a distributor in Paris—we mustn't be afraid to organize protests outside of the Film Polski offices). We have not felt such a sense of *urgency* in cinema for some time. And the political events that followed were not really a surprise to anyone who had seen these films. This is not a year for cinema; it is instead a year in which filmmakers are beginning to measure the consequences of a process that they had anticipated. How do they organize, what position do they take, what kind of relationship do they establish with the workers' movement that, several hundreds of feet from the festival, has begun its race against the clock with Kania?

That is where the second discrepancy can be felt: in their discourse, in their attitude, filmmakers are (for the moment) clearly in retreat from the new, evolving situation. They are even pessimistic. But rather than hold it against them, we must stigmatize that tireless reflex we have to always wish that cinema be "current" with political events, while we know quite well that these are two processes with different *speeds*.

(*Cahiers du Cinéma* #316, October 1980)

GDANSK, DAY BY DAY

8 September

Against all odds, the 7th Festival of Polish Film (fictional) opens in Gdansk. Among its "sponsors," the shipyards, and among these, the famous Lenin yard. Since last year, foreign journalists are invited to

Gdansk, invited to judge the year's Polish output in its entirety. The "'80 vintage" (23 films), everyone will agree, are disappointing compared to the "'79 vintage." Polish reality surpassed fiction, and fiction cried, "Truce." The films are screened at NOT (Dom Technika Not), and, from NOT, we can see the shipyards whose workers have been back at work for a week. MKZ headquarters are several minutes away from there, and the trade unions (new, free or independent, it isn't quite clear) that are preparing for the future. For one week, will Gdansk be a cinema hotspot? We will see. "We" in this text will almost always be a trio (not infernal) composed of Anne Head, Ignacio Ramonet and myself. The order of the week will be to see the films, understand what is being said, guess what is not being said, decipher the festival gazette (*Gazetta Festiwalowa*, bilingual and with a beautiful blue logo) each day. We will even attempt to form an opinion.

Zanussi, Part 1. Straightaway, we watch Zanussi's *The Contract*. Because of the simultaneous translation, we understand none of the dialogue, which seems scintillating. The film is a satiric charge against the Polish intelligentsia, privileged and disgusting, in the killing-game-where-no-one-is-spared genre. No one, especially not Leslie Caron, who plays a sort of negative guest star, snobbish and French, kleptomaniac because neurotic, etc. As with Altman, whose name is mentioned, Zanussi plays a single note with brio while pretending to lose himself in a labyrinth of twirling appearances. The film closes on a shot of a deer looking into the camera, which reminds us of the dead fish in *La Dolce Vita* and, as with Fellini, is a discreetly Christian gesture. *The Contract* was shot at the same time as *The Constant Factor*, and Zanussi considers the films to be heads and tails of the same coin. One film about the Pharisees and one film about a righteous man. It is as if Zanussi had drawn two films from the couple that breaks apart in *Camouflage*, one the faux innocent and one the faux cynic. We need to watch *The Contract* again with subtitles, but it strikes me that Zanussi is settling into the role of moralizing sermonizer, a role that is not without its dangers.

The Contract was a success with the audience, who came to see it in large numbers. Its description of corruption was frank (a bibliophile doctor accepts bribes in the form of bills slipped into books). It was applauded, it made them laugh. It must be said that the festival hit

the ground running. Wajda wrote the editorial of the gazette's first issue. Its title: "The duty to speak the truth." According to Wajda, speaking the truth is "the only way to escape the current crisis, to restore mutual trust between people, as well as between society and the authorities, and to give free reign to the creative resources of Poland as a nation." An exhilarating plan, but not a simple one.

9 September
Questions of vocabulary. In 1979, the Gdansk Festival was dominated by important films such as *Camera Buff, Kung-fu, Provincial Actors*, by Kieślowski, Kijowski, Holland. There was also *Without Anesthesia*, and before that, *Camouflage*. An entire movement, quickly christened the "moral anxiety movement." Or even: moral *disquiet,* moral *unrest,* moral *uneasiness,* moral *concern,* moral *tensions,* moral *revival,* moral *renewal* and even moral *peace.* Only morality remains; it is clear that between those who say "anxiety" and those who speak of "peace," there is already a serious difference in the political appreciation of the ongoing process, proving that vacillations of vocabulary are never insignificant. The movement began with a focus on releasing the Polish language from its wooden prison. One year later, in the aftermath of the strikes, it is possible to write (in the gazette, of course): "Today, in Gdansk, for the first time in a long time, "class" means "class" and "worker" means "worker." The Poles have rediscovered the charms of denotation.

That said, the moral anxiety movement did not produce a significant film this year. Probably because anxiety itself is no longer what it once was. Take Leszek Wosiewicz's *Smak wody*, which is an estimable but forgettable film. A forty year-old woman learns that she is pregnant: crisis, rediscovery of others and of herself, in private life, in work, a trip to the sea, etc. In the East, this kind of cinema, centered around anti-star female characters, responsible-but-vulnerable (and vice versa), has become a real *genre*: individual crises bring added soul to a society without fundamentally challenging it.

More aggressive is Barbara Sass's *Without Love*, in which anxiety turns to frenzy. A young journalist is ready to do anything to succeed. And yet, she fails. At first glance, we are reminded of Agneszka circa *Man of Marble*, but, instead of being the sorcerer's apprentice

to a truth that then changes her, the heroine of *Without Love* (Dorota Stalinska, who received the prize for best actress) remains a relatively limited psychological type.

Debate in Wrzeszcz. At the start of the festival, we have to suspect that the link between cinema and politics is less intense, in any case less conspicuous, certainly less passionate, than we had expected, coming from Paris. Gdansk '80 will not be Odeon in '68. Not yet believing it, we go to Wreszcz to attend a debate between filmmakers and young workers from the naval yards. The filmmaker is Kazimierz Kutz, and his film, *The Beads of One Rosary*. He is amenable to the gentle criticism of the young workers, who haven't yet seen the film. He explains to them that the worst kind of censorship is the kind that comes *afterwards*, once the film has been completed: films with deliberately bad distribution, poorly-chosen theaters, botched publicity, too few copies generated, etc. More than production, it's distribution that is the site of censorship. Suddenly there is a heightened awareness in Poland of the role of the media, of what it has been until now (a sorry thing), of what it could be. Yet the film, here, is *first and foremost* a medium. Walesa's leitmotiv to all those who wish to help him: give us a printing press. At the end of the Wrzeszcz debate (of course, it was not a very intense debate, it had the eternal sadness of every organized meeting between artists and workers), an actress in the film, an old woman dressed in a Silesian folk costume, begins to speak, her eyes laughing. She sings, then tells stories: how she had saved her entire life to buy a Fiat 600 and, once she finally got one, had become too fat to sit in it. Polite laughter.

10 september

Visit to MKZ. Hotel Morski. Mme Komorowska receives the foreign press at MKS headquarters. We are in an empty room, sandwiched between a sink and an armoire. Many people pass through the hallway, appear, disappear. Next door, Walesa's desk is being decorated, hastily. Rumor has it that Wajda is there, come to see Walesa before he soon has to speak at the cocktail party given by the Association of Polish filmmakers, of which he is the president. Multilingual and devoted, Mme Komarowska tells the story of the strike, which is also the saga of "Lechek" Walesa. To the

questions that particularly interest us ("What has the role of intellectuals been and what will it become? What differences are there between '56? '70? '76? Who had the idea to demand that the negotiations be broadcast live to the factories?"), she has answers at the ready. The movement of free trade unions (but we should say "independent and self-organizing") was established long ago, has nothing adventurous about it, doesn't "do politics." It is tied to intellectual groups (the KOR? Mme Komorowska smiles carefully) and they make no mystery of the fact that Walesa has received special training in recent years. The question of information is critical. In the strike's bulletin, *Solidarity*, mimeographed by students, are poems written by the workers (there are two in October's *Le Monde diplomatique*, p. 9). In the aftermath of victory, more than any attempt at torpedoing, delays or provocations, it's *disinformation* that should be feared the most.

Suspicion. End of the afternoon. In the lobby of the Hevelius hotel, a meeting with the filmmakers we were most eager to see: Kieślowski and Agnieszka Holland, who arrived with Wojciech Marczewski and Piotr Szulkin. A different story. To our questions (will they be too invasive?) they responded *a minima*. Clearly, the persistent question of the alliance between workers and intellecutals irritates them. It's the *entire* Polish culture that raised a red flag, says Kieślowski. A group, "Experience and future," published an informal report (*On the Polish Situation*, 1978) and certain filmmakers (Wajda, Zanussi, Kieślowski) participated. The filmmakers were thus not pre-empted by a phenomenon that they had anticipated in their films, and two crews shot fifteen thousands meters of film on the striking shipyard workers. The film, entitled *Workers '80*, is currently being edited. Filmmakers are all the more aware of their responsibilities now that television has been largely discredited (its boss, the unscrupulous Szczepanski, has just been suspended). The majority of filmmakers are in favor of a free trade union, which in fact was foreshadowed by the Association of Polish Filmmakers, which is Wajda's baby, to some extent. But nothing could be worse than a false liberalization. It's easy for the system to allow some more offices to be created and even easier for it to take back what it gave, Szulkin tells us. No one believes in the irreversibility of the phenomenon.

Prudence? Suspicion? But it is our job to be suspicious! was the response. Coldly. We then referred to some of Walesa's disaffected remarks about the support of intellectuals and the interview was cut short. On the way out, Kieślowski snapped something like, "Your cars are better than ours, and still you envy us!" Which infuriated me, since I don't have a car.

11 September
Is the gazette written in code? As if echoing our bewilderment of the night before, the gazette publishes a text entitled, "Alliance." But it is about the alliance between workers and writers, which was declared earlier than the alliance between workers and filmmakers. Is it meant to shame the filmmakers? Knowing what is being said in a text like that, what signal is being given, really *reading the* gazette would require more training, more cunning. Nevertheless, the queues that form to buy *Trybuna Ludu* aren't interested in being informed (they already are), they want to know what's going on at the top, and they can only do that by reading between the lines of a rhetoric that must never be taken literally. And in that art of determining if information is in the utterance, the enunciation, or the format, I think that they (the queues) are much more subtle than we are.

Filmmakers carry weight. An interview with K.T. Toeplitz, journalist, writer and acclaimed screenwriter, provides several facts. Under Gierek, there has been a relative enrichment of Polish society, at the cost of catastrophic debt. Intellectuals and artists are no longer really the ones who, in 1956 or in 1970, found themselves naturally connected to social movements. They are less radical, and if radicalism does exist, it is instead moral or religious (hence the weight of someone like Zanussi). But in an under-informed society, filmmakers are at the heart of that society's contradictions because they are expected to reflect them, to give them a body of images. Any film with an explicitly political and historical subject has every chance, regardless of its author's point of view, of having a huge audience, of being a popular success. That is what happened with *Man of Marble* or *Camouflage*. And this importance makes them cautious. It also makes them more exposed to becoming corrupted by a State on which they

absolutely depend. They are called the "spoiled children of the regime." In fact, the oldest of them are firmly established, and the youngest, as they should, protest. In general, they are skeptical and fear the worst. We can divide them roughly into three groups: those to the left around Wajda (the X group) or Zanussi (the TOR group), and those to the right, ultranationalist, anti-democracy and Moczarist, around Filipski (and the group Profil). The center would be Kawalerowicz (and the Kadr group).

Kawalerowicz disappoints. Aptly, Kawalerowicz's last film, *Encounter on the Atlantic*, with a script by Boleslaw Michalek, was screened that afternoon. It is a terrible film. An extremely frivolous Polish *jet-set* flail about on a boat returning from Montreal. A professor of some renown thinks he recognizes another passenger as a man he once injured professionally. Remorse, fear, the need to justify himself consume him: he becomes sicker and sicker and, as he has a heart condition, dies (during a polka dance on the dock). Was he mistaken? We will never know, since the other man ultimately conforms to his role. A nice subject, à la Gombrowicz, some might say (but will some say?). Except that this metaphysic of executioner/victim and vice versa is ill-timed at Gdansk, in 1980. Kawalerowicz has lazily constructed the kind of old-fashioned modern cinema, careful and vain, that the passengers of his boat would appreciate. In short, we are annoyed by this ship of wimps.

I understand that in a society where a lack of information and censorship reign, parable acts as a weapon and metaphor as dynamite. But I also know (if I didn't, I wouldn't be writing for *Cahiers*) that ontological realism exists in cinema and that a film is judged not by what it signifies "on another level" [*sur un autre plan*] but what it brings into play "shot by shot" [*plan sur plan*]. The irritation that I feel with Kawalerowicz's film I often feel with films that come from the East: they are the inexorable development of a parable that certainly doesn't need an hour and a half to be understood. Where does this come from? Pervasiveness of the literary model, imposed by the official aesthetic, fear of *playing* with cinema. I understand that Kawalerowicz's boat represented Poland, but the vanity of this message comes from the fact that we feel at every moment that Kawalerowicz has no desire to film Poland as Poland or the boat as a

boat, the two limits between which a metaphor may live, that is to say, breathe.

12 September

Nostalgia. Series of reflections on the previous day while watching *Golem*, Piotr Szulkin's first full-length feature. From Meyrink's novel, only an enigmatic series of scenes centering around dehumanization and media manipulation remains. Certain plastic effects are very successful. And yet I think about how far we are from the sixties generation, from the first Polanskis or Skolimowskis. What's striking while seeing, for example, *Barrier* again is that Skolimowski believes it is still possible to produce what I will call *cinema happenings*, with no literary guarantee. A cinema happening is that minimum of play between what the spectator knows and does not know, between what he sees and what he does not see, the vertigo of someone who knows he will always land on his feet (thematic, literary feet), quite simply the pleasure of cinema. Today, Polish cinema, also wrought by the aesthetic of the soap opera or the televised drama, hit by a sharp drop in attendance, looks a little like the workers of Gdansk: serious, cautious, not formally adventurous (its best films currently owe more to the theater than they do to cinema). It's what conversely makes *Man of Marble* a rather exceptional film: Wajda's film is also the story of two cinema "forms": Soviet iconography and the American wide-angle, with Wajda, the Pole, *in-between* the two.

Very good documentaries. I found these "cinema happenings" elsewhere, that same day, in an unexpected program of documentaries screened in a small theater, next to the Leningrad, in old Gdansk. The hall was packed and some had to sit on the floor. The films had until now been banned. The lift of the ban was just as underhanded as its imposition because it was unannounced. Every film in the program was remarkable. Which begs the question of whether Warsaw's most interesting productions come from Varsovie's Documentary Film Studios. Perhaps because it is there, in the documentary, that taboos can more easily be broached, that the sponsee turns most easily against his sponsor, in this case, the State. Every socialist power encourages documentary, not out of love for the document but because it is the only means of controlling filmmakers (at least you

know what they're talking about, while with the formalists...) As a result, it feeds the viper in its heart. Watching Bohrdan Kosinski's *Zegarek* (1977), in which we witness the election of a model worker through a bogus vote, we think of Eustache's *La Rosière de Pessac.* In Kieslowsi's *Talking Heads* (1979), a series of heads in close-up. It begins with a baby and finishes with a 100-year-old. Beneath each head, a number: the year of his or her birth. Each comes with a face, more or less ravaged by age, by work. They answer a single question: what are their hopes? The young speak of "trust," the adults of "democracy," the elderly of "humanism": it is as if Poland had been x-rayed. In Marcel Lozinski's *Próba Mikrofuno* (*Microphone Test*), a cultural leader is tasked with creating radio programs inside a perfume factory. He asks the workers a question: you who, theoretically, own this factory, do you feel that you matter to the management? The unequivocal response: we don't matter at all. The management becomes alarmed: should they continue the program? Hilarious debate between managers in white coats: Why tell them that the factory belongs to them? That only confuses them. Or even: Why ask questions if you don't know the answer? The last film, entitled *The Workwomen,* by Irina Kamieńska, was the most gripping of them all. In an unbelievably decrepit textile factory, unrecognizable women, deformed by work, drunk with fatigue. They only speak during their lunch break, or rather, they spill their guts as one does when one knows there is very little time for it. The work continues and the film does too, in silence. Nothing to add. It was the first public screening of the film, the most beautiful film seen at Gdansk.

This interminable day was far from over. We have lunch with Agnieszka Holland, and are no more satisfied than we were by the previous day's interview. Alarming rumors are circulating: the official unions are beginning to put pressure on their members, threatening to take away their social benefits, to force them to pay back their loans, etc. Walesa knocked on the table and spoke of a general strike. A muted war is beginning: it will not end soon. Filmmakers are finding confirmation of their pessimism. Agnieska Holland whispers and tells us to have high expectations from the Forum that will bring all of the filmmakers together tomorrow behind closed doors. There are films to liberate, the question of distribution to raise. As for

Holland, she is finishing a film entitled *Fever* (*Goraczka*) that recounts an anti-Russian plot in Warsaw, in 1905.

A hated film. You could have heard a pin drop if a pin could have found a place to drop during the screening of Ryszard Filipski's *Zamach stanu* (*Coup d'État*), the most controversial film of the festival, if not the most despised. *Coup d'État* meticulously recounts Pilsudski's return to power between 1926 and 1932. Poland was then a parliamentary democracy, difficult to govern. It is a dry and boring film, carefully constructed by someone who must love playing with little tin soldiers. The press conference, longer than the film itself (three hours), was heated: Filipski, alone against everyone, fought with the same arrogance he used to play the role of Pilsudski. He is the sole representative of what ultimately is a rather orthodox perspective on that watershed (and, I suppose, rarely filmed) moment in Polish history. In *Coup d'État*, the people are despised, the parliamentary left ridiculed, and an almost exasperated Pilsudski maintains an increasingly authoritarian power. More arrogance in Filipski's statement published by the gazette: "Today," he says, "it is difficult to find a filmmaker who doesn't claim that his role the year before was 'prophetic.'" *Coup d'État* is included in the awards, the jury "having taken into consideration the importance of a subject that is presented in a controversial fashion." This will be too much for Kieślowski, a jury member who issues a "votum separatum" and disassociates himself from the jury. We would need to have a better understanding of Polish history to gauge what was offensive in Filipski's film: was it its anti-democratism, its ambiguous treatment of the figure of Pilsudski (who is for the Poles rather a patriotic, positive figure, the hero of the war of 1920 against the Bolsheviks)? What is certain is that the representation of History, its reconstitution, its imagery, are here actual *stakes*. It is easy to understand why: that History is not always written.

Zanussi, Part 2. That night, the first Polish screening of Zanussi's *The Constant Factor*. Once again, the theater is packed. After having seen the film, Zanussi's argument seems to be: if there were even only one chance that *only one* righteous man still exists in this country, that would be enough. That probability is then filmed like a singular destiny, which, in the final analysis, is a matter of grace. God sends the young hero of *The Constant Factor* a great number of trials (his

mother dies, he experiences the villainy of the world, he loses his job, he causes an accident in the final shot, etc.) but all in order to test him. Each time the hero (who aspires to purity: his dream is to climb the Himalayas) would like to escape into the ideal, something, nothing, brings him back down to the material, in other words, the mundane: a funeral pyre in India, a tartine devoured by his dying mother, an earthworm on her tomb, etc. Consequently, because he plays both sides (the stations of the cross of the hero who is "not of this world" and the clinical fact of the society that "doesn't understand him"), Zanussi is able to produce relatively strong effects, confirming that old rule that those who believe in heaven are often the least uncomfortable with filming the physical world. Zanussi arrived in a rush to answer the audience's questions. He resembled a *clean** and rushed theologian who comes to test the understanding of his flock. They hadn't realized that the film was metaphysical and stubbornly asked him, "How could such an 'innocent' person exist in our society?" Zanussi's position was something to the effect of: it is because things are going so badly in Poland that it is *also* a chosen country "Today, in Poland," he says in a text from the precious gazette, "I am proud to be a filmmaker. I think many of my foreign colleagues could be jealous." Hence *The Contract*'s xenophobia. Hence also Kiesolwski's short statement. Americans weren't mistaken, and commissioned a film about another Pole, Karol Wojtyła. There's a return here to an unfriendly Slavophilia, the consequences of which our comrade Toubiana had to bear this year in Cannes (See *Cahiers* #316).

13 September

The Forum disappoints. The foreign journalists visit Malbork Castle, built a very long time ago by teutonic knights, destroyed, and reconstructed. Meanwhile, the Polish filmmakers gather to hold their Forum, behind closed doors. Which lasts five hours and doesn't keep its promises. "Courage becomes cheap as confidence grows," Kijowski might have said. The gazette worries: if everyone is in the avant-garde, where is the mainstream? Suspicion, towards each other and towards the events, is as strong as ever. The creation of a filmmakers' union is announced, "independent of employer, the administration of the State and political organizations." But that, we already knew.

A large number of filmmakers have joined this union since September 11th. Such a large number that we wonder if the event is as decisive as it seems. The gazette pulled off a coup: it published a transcript of an interview between Wajda and the workers during the strike, previously published by "Solidarity." Shrewdly, through errors in formatting, the gazette gave the impression that it had a "scoop." But that was a lie.

Wajda at the yards. Question: "*Man of Marble* was shot over ten years ago. Today, as you have said, the dreams contained in your film have become a reality. The authors of our current events are those who have never been men of marble. Instead, they bring flowers to their graves, every year. Their geneaology is experiencing a change. The genealogy of the leaders of the strike. From your perspective, how do you view these people and their motivations?"

Wajda: "I think there is continuity. I'd like to make a sequel to that film, because I understand that what we need the most, what's most important, is a sense of continuity. Life doesn't start from nothing; everything has roots somewhere, and at a particular moment. I don't think that we have suddenly become honest. [...] That's why I would like to continue this film, because I think that I managed to say something true in it, that I showed a worker who valued his honor, his ambition and his class consciousness. That's why I would like to see what his son looks like. I think that it's significant that he's the son of a 'man of marble,' that he won't betray his father, that, in other words, he will continue his father's cause."

14 September

Vomit versus the slick. Return of moral anxiety in Tomasz Zygadlo's *The Moth.* A journalist hosts Radio-Telephone, a nightly phone-in program. He believes in his social mission until the day he begins to suspect that he is merely an alibi for the system, a trashcan for his listeners. He keels over, vomits, raves, and goes mad. Roman Wilhelmi's crazed stares will earn him a best actor award. The film is most interesting in its scenes of daily labor, when the actor begins to spin in his glass-enclosed, sound-proofed studio as if in a cage, dancing with the telephone in full view of the laughing technicians, in a trance and entirely alone.

A far cry from *Wizja lokalna 1901*, Filip Bajon's second feature-length film (re: the first, see *Cahiers* #315). Where *The Moth*, shot in black-and-white, is pallid, unclear, Bajon's film is neat, circumscribed, in a word, slick. Polish cinema oscillates between these two poles, between the blunt portraiture of present-day life and the cunning reconstruction of History, between the literal and the metaphorical, between vomit (there's a lot of vomiting in films about moral anxiety) and the slick. But evidently, the meticulous is an easier sell; like wine, it travels better, it's a successful export. *Wizja lokalna 1901* recounts a famous episode in Polish history. At the turn of the century, in a section of Poland under German rule, a group of children refuse to learn their catechism in German. Two classes, indomitable, go on strike. The film describes how the authorities try to diminish them and how they don't really succeed. An ideologue, played by Jerzy Stuhr, a popular actor of the new Polish cinema, arrives from Berlin, full of the Hegelian theory of the State, and lectures everyone. What I liked about the film is that the triumvirate (children, parents, teachers) is always complex. The parents support their children in the name of their own hatred of the occupier, the teachers have their reasons, or rather their techniques of power, and the children have their own obstinacies, strange ideas about what they are doing (persuaded that God will no longer understand them if they don't speak Polish, they go one night into the open country to wait for a sign from him, but a sign never comes and they fall asleep: the scene is quite beautiful). What I liked less was exactly what impressed others in Gdansk: the too-sleek photography, the hyper-realistic effects created by the use of a single lens for the entire film, and especially an ending in which we see the Germans machine-gun a flock of symbolic geese (these geese would be Poland) in slow motion and in silence. This "filmed cinema," with all of its talent, is geared towards the West. When questioned, Bajon did not hide the fact that he was thinking seriously about America. That wouldn't be bothersome if it didn't cause him to embrace this film festival aesthetic.

Hic et nunc. The highlight of the day was, however, the screening of *Workers '80*. This is the film, or rather the *rushes* of the film, that Kieślowski had told us about. The film, directed by Andrzej Chodakowski and Andrzej Zajaczkowski, is a very simple reportage on the

important moments in the negotiation between the strikers and the government, that is to say between Walesa and Jagielski. Once again, the hall was packed. Walesa was there (next to Juniewicz, vice-minister of Culture) and responded to a long ovation with a short speech that was answered by a Polish hymn. What was moving was not only being so close to the *hic et nunc* of the film, but the sense that in these images the players in this historic moment, aware that they are being recorded by the shipyard workers (see *Actual* #12 p. 96, photo 35), are no longer able to lie (as much), to connive or corrupt, that they imperceptibly and before our eyes become *actors*, period. In effect, the audience wasn't listening to the dialogue (they already knew it by heart), but discovering the attitudes of the actors. The images had a two-week delay in relation to the soundtrack. Walesa's casualness and brio. The courage of Jaglielski, who confronts, hedges, lies, surrenders. The listlessness of his collegues, who leave him to act out the negotiations on his own. Which is a good thing, because once he is filmed, he feels that he has become an actor, able to declare: "Here, we are in line with 1956 and 1970. We are continuing our saga."

15 september

Kutz coronated. It's the day of the awards. Since yesterday, we've known that the grand prize will go to Kazimierz Kutz's *The Beads of One Rosary*. In a telegram, Walesa expressed his support for the film. Under Gierek, Kutz was a cutting-edge filmmaker, thanks to a series of films shot in Silesia, the most famous of which is *Sól ziemi czarnej* (*Salt of the Black Earth*). He practices a frontal and powerful cinema that always engages the spectator, thereby avoiding the traditions of both vomit and the slick. The hero of *The Beads of One Rosary* is Habryka, a retired miner who obstinately refuses to leave his house for an HLM. His entourage (wife, daughter, Party) pressure him to yield. In vain. His argument is that the HLM are poorly constructed and therefore uninhabitable. Around his house, an enormous construction site overtakes everything, demolishes everything. To be done with it, the Party gifts him with a sumptuous, ultramodern apartment. He moves in with his wife and immediately dies. Kutz puts a lot of bitter words that have no model in the mouth of the elderly, model worker. This play between utterance and enunciation,

specific to every Astra operation since the world began, is quite funny. There is a bit of demagoguery in this film, a certain freshness and a real talent for scenography (the entire last section, the old couple moving into the futuristic house, is reminiscent of Tati). Finally, it is possible that the film was successful because it naturally inscribed religion as an element in its characters' lives (Habryka is not a believer, but his wife is). Curiously, in the pallid or bloody slices of life cut by Polish cinema, we never encounter a religious *subject*, which makes us worry: Is the catholic church powerful enough to dispense with images of its power? That's a little suspicious.

Wajda's way. It is also a day full of Wajda. First, we have breakfast with him, then we see *The Orchestra Conductor*. As for breakfast, there's not much to say: Wajda answers every question quickly, without looking at us, with a very certain sense of what mustn't be said. He revealed much more in *The Orchestra Conductor*, to which I will not return (see *Cahiers* #311). Still, it seems like Wajda's great theme is the hypertrophy of the self, vanity. What was once a characteristic of his style, his signature, has gradually become his subject. The films gain in actual opacity what they lose in bombastic contortions. Vanity is in front of the camera more than it is behind. Zanussi always opposes the guileless to the crooks; with Wajda it's trickier: on one side are those who enjoy with their power (a power that is always charismatic: the man of marble, the journalist in *Without Anesthesia*, the old maestro in *The Orchestra Conductor*), who are intoxicated by that power and exposed to a catastrophic deflation (accident, plot, death), and on the other side are the envious, the un-charismatic, the resentful. The first are rather old, belonging to the past, the second are rather young. It is clear that Wajda is on the side of the first, of those characters who believe in themselves and their position, of those frogs who fancy themselves as oxen, and that he is merciless towards the embittered youth. Because the first have retained a remnant of childhood that saves them, something to the effect of, "it's impossible that I am unloved." In *The Orchestra Conductor*, Gielgud's death, while waiting in line to attend his own concert, listening to the young people talk about him with admiration, is unforgettable. There is in it an accent of truth that suddenly touches us. There is the Wajda-conscience of Poland, the one that wants to reconcile the

generations, the people and the State, Poland and the universe (which adds up to a lot of people), and there is also the filmmaker who, with every film, *saves his skin.*

16 September
Kieślowski the bitter. Warsaw. We have dinner at the house of a journalist (Oskar Sobanski) who announces major news. At eight o'clock that evening a Kieślowski film that had been banned for five years will air on television, entitled *The Calm.* A young worker (Jerzy Stuhr, in his first major role) is released from prison. Difficult re-entry. On a construction site, the foreman hires and befriends him. Everything would be fine, keeping to a cycle of work-vodka-sleep, if the foreman weren't involved in trafficking (the brick trade, already). The workers find out, go on strike and beat up the hero of the film, whom they think is colluding with the foreman. We quickly see why the film was banned: not only is it of a strict realism that idealizes no one and that recalls the English "free cinema" of the sixties, but, as with everything I've seen from Kieślowski, an active pessimism emanates from the film, a raging desire, despite everything, for that twisted reality.

17 September
Provisional report. On the propeller plane flying from Gdansk to Warsaw, I wondered why the crushing majority of Polish films are more interesting for their themes, their actors' performances, than for their vision of cinema, timid and traditional. One always feels as if one is watching a series of images that don't *target* the audience, that refuse to "play cinema" with them. Of course, people will say that a Polish audience, eager for films, is much more active than a Western audience and that it doesn't need to be seduced, or solicited even less, because it knows how to read between the lines and decode every message. This is true. There is no art/commerce dichotomy in Poland in the sense that we understand it: it is an auteur cinema, almost inevitably. But what creates the auteur is less the singularity of an aesthetic project (after Polanski, after Skolimowski, it's Zulawski who emerges as the great exile) than the organization of labor. The filmmaker's responsibility moves in one direction: towards the top,

towards the bureaucratic authorities, towards the State and the caprices of censorship. Because they have no control over the distribution of their films (where one encounters an audience or one doesn't), filmmakers have created a sort of blind aesthetic. Every film is a test: for the filmmaker who sees just how far he can go, for the censor who is afraid of losing his position. As a result, the audience *additionally* witnesses a dialogue that does not target it, and creates its own idea of what is being hidden. The spectator *overhears* the film. In this world that ignores seduction, there is a generalized over-ideologization. That is the impasse of a state-controlled cinema. But we must be able to emerge from that impasse. Gdansk 80 was disappointing; Gdansk 81 should be thrilling. We hope that there will be a Gdansk 81.

(*Cahiers du Cinéma* #317, November 1980)

THE AMERICAN DOCU-DRAMA

In the summer of 1979, fifty-three people gather at the Ojai Valley Inn, California. They have been invited by Los Angeles Academy of Television Arts and Sciences for a two-day symposium. Subject of the meeting: the docu-drama. There, assembled for the first time, are historians, television critics, screenwriters, producers and executives from the major networks (ABC, NBC and CBS who, appropriately, helped to finance the event). There is a major writer (Gore Vidal), a well-known humorist (Art Buchwald) and a lawyer who specializes in media (Ken Kulzick).[1] What was said in Ojai will be published in issue #3 of the television review, *Emmy*.

The importance of the docu-drama phenomenon is so great that it strikes even the participants of the symposium. *Roots* and *Holocaust* have

1. Kulzick is blunt: we must expect increasingly close ties between docu-drama and the Law. If only because: 1) There will be an increasing number of docu-dramas. 2) Interest in recent history is growing. 3) Autobiographies of living personalities are increasing. 4) Legal heirs are becoming more ferocious with each passing day. 5) There will be more lawyers who specialize in media in order to become "rich and famous." 6) There will be more and more trials, hence new scenarios. Ultimately, in the docu-drama chain, the lawyer may become an increasingly creative link.

proved that it is the form par excellence, the only form, even, through which the general public can take an interest in major issues. Hence the docu-drama has an immediate social function, of visible, almost verifiable repercussions. Given the "terrifying power of television," that is an immense responsibility. Is is sustainable? The fifty-three guests in Ojai Valley all influence, in one way or another, more or less directly, docu-drama production. Over the course of the symposium, after some initial clashes, a sort of collective goodwill emerges, a self-righteous superego of the group, a soporific discourse on the gravity of the docu-drama, a sharing of resolutions too good to be true.[2]

A bad image

For the docu-drama's image is not very good. The docu-drama is poorly regarded, often judged from on high by irresponsible critics. The press (the "press-haters"*, they're called) don't respond well. At one point in the symposium, the producer David Susskind publicly tears up, after reading it out loud, the critique that Gary Deeb (from the *Chicago Daily Tribune*) wrote about the series, *Blind Ambition*.[3] if we listen to him, the hostility of the press is a real threat to the future of docu-dramas. In fact, the American critic, always more intellectual than the works he critiques, often misses, in his concern for not seeming naïve or vulgar, the most significant and, finally, the most durable things that are produced by American culture.

The image that the authors of docu-dramas have of themselves is not very good, either.[4] There is in the docu-drama simultaneously an enormous power and an equally enormous division of labor, an extreme dilution of responsibilities, of incessant limitations. In the research he conducted last year in the USA, Serge Le Péron found subjects who were aware that they were working under the

2. The organizer of the symposium is none other than David L. Wolper, responsible for *Victory at Entebbe*. He's a go-getter.
3. *Blind Ambition* is an eight-hour CBS docu-drama based on John Dean's account of Watergate, starring Martin Sheen and Rip Torn in the role of Nixon.
4. Even the term "docu-drama" inspires shame and disgust. We would like to find another, nobler and less ugly term (tele-history, a fiction based on facts?). There are many different kinds of docu-dramas, ranging from strict reconstructions to the "what if…" genre (what would have happened if?). It seems to me that in its anti-aesthetic lameness, the word docu-drama is still the best.

same conditions as B-movie filmmakers of the past: same constraints, same pressures, same need for speed and adaptation: a jungle where no "author" can survive (but where an author can be formed, the hard way). Only difference, but a substantial one: docu-dramas touch millions of people, and their version of facts becomes *the* version. Hence a mixture of raging pride (they, at least, reach an audience) and terror in face of the powers of a machine in which they are both slaves and sorcerer's apprentices.[5]

Between myth and fact

At the beginning of the symposium, Gore Vidal reminds us with malice that History is "what we choose to remember." He adds that the massacre of several millions of Filipinos by the American army at the beginning of the century is not even considered a fact (it is "a non-fact") because the American people decided not to remember it. Conversely, there are facts that one cannot forget, that one must set at a distance, exorcise. That is the docu-drama's function. It must *exorcise* Watergate. (By banalizing, demultiplying it: the dream being that the three major *networks** would propose three concurrent versions; by comparing them, we would forget, in turn, the trauma that was the referent.) The Filipinos must not be exorcised. The short history of the docu-drama is already teeming with "nudges" given to historical truth, of forced *happy endings*, of necessary simplifications. It is *decided* for *Roots II* that in it Alex Haley, the hero/author of the book, will be married only one time and employed in two professions, while it is well-known that he married twice and had dozens of jobs. It is *decided* that Peter Boyle is asked to minimize Joseph McCarthy's tics and signs of physical collapse in *Tail Gunner Joe*. These are decisions always made at the top, sometimes anticipated in a screenwriter's self-censorship. These distortions seem enormous to us. They are created by the very people who speak with gravitas about their respect for the facts. (In Ojai Valley, someone even proposes calling docu-dramatists "artists

5. The authors (screenwriters, directors, producers) of docu-dramas are not anonymous ants under orders, feeding a cold Orwellian Machine. Enough of that cliché! They are people who, in an impossible situation, "do their best," with convictions and ideas. If the Hollywood of yesterday or the television of today are in fact machines, it's because they have known how to utilize and grind out artists and not zombies.

under oath"). The docu-drama is not the American equivalent of "the camera exploring time"; it is much more than that. And we are the ones who tend to speak of History with a capital H, whereas Americans speak more pragmatically about "facts." The docu-drama asks a question that concerns the future of the *fictional form* in our societies. What does it mean to *continue* to produce legend in a society where there are available facts?[6] How is a myth constructed over the smoking rubble of facts, that are seen and understood by everyone? A new question (that neither socialist countries nor the third world are far from asking and that terrifies Europe because, if as Duras said [to Kazan], "the political event is European," Europe is not very proud of its recent myths). The docu-drama is the site of a double desire: on the one hand, according to historians and educators, the docu-drama will inspire our audience to refer to facts and the books that record them. On the other, producers and *network executives* quietly predict (but don't strike "too much") that the docu-drama will allow the public to experience History as pathos, as legend, which means not experiencing it—not really.

Docu or drama?

The situation may be irreversible. The docu-drama boom correlates with two or three very loaded circumstances. 1) The historians present in Ojai are blunt: students no longer read history books. 2) The documentary genre is noticeably losing momentum (except on PBS, a marginal channel where the work of someone such as Wiseman makes an exception). 3) "News"* is limited, incomplete, insufficient. We no longer live in an era where, facing writing's decline, we predicted (generally with too much joy or too much fear) the rise of the image. We live in an era where, among the images (numerous but not very diverse) that circulate, the ones that linger most, the ones that *hold* an audience, are the ones that know how to interpellate.[7] Either through the seduction of advertising or through

6. At the end of *The Man Who Shot Liberty Valance*, the journalist concludes: when the legend is better than the story, you print the legend.
7. Historians actually seem resigned to this state of affairs. They know that their work serves as primary material for the *networks** and that their intervention takes place afterwards, once the audience is hooked and it is a question of cutting through the polemic or pointing towards "complementary readings." Some even propose that docu-dramas are entitled to two critiques, one of their aesthetics and one of their treatment of History.

placing the spectator in the position of a survivor-voyeur of a "drama" that concerns him.[8] If, fundamentally, documentary is something that happens to the *other* and if fiction is conversely something that happens to the self (but to a disguised self), docu-drama is a kind of new horror of what happens to *us*. A very American "us," in other words, very exportable. From documentary, the docu-drama has preserved only the first two syllables, and from drama it has preserved its double meaning of theater and catastrophe. Time will tell towards which side of the hyphen it will swing.

(*Cahiers du Cinéma* #319, January 1981)

HONG KONG JOURNAL

Summer 1980. It was tempting to use a trip to East Asia to learn a bit more about one of the most active cinemas in the world: Hong Kong's. Hence these travel notes (a blend of anecdotes, film reviews and embryos of thought). From this also two parentheses, one in Beijing and the other in Manila.

1 August
 A New Wave in HK? For two years, Leung Noong Kong has been a "programming research executive"* at HKTVB, one of two television channels in Hong Kong. He met me in a new district, in the far north of the city, to tell me what he knows about HK's "emerging cinema." The office is on Broadcast Drive, an aptly-named media avenue: the offices of RTHK, the rival channel, are across the street. The two channels offer four programs, two in English and two in Cantonese (in HK, Mandarin, the Chinese of Beijing, is not spoken, but Cantonese is: this linguistic barrier is fraught with

8. But a drama only concerns him if it opposes two points of view, if it can give rise to a for or against. Democratic ideology and political strategy of the networks. This eliminates a large number of subjects from the start. Even with *Roots*, some thought that there weren't, in this film about slavery, enough sympathetic White characters! Clearly, the docu-drama ultimately meets up with the poll, which has always been called a "photograph of [public] opinion at a given moment." That photograph could very well come to life, if it could find robots that would prevent any "human factor" from being introduced.

consequences). Leung, who was once a film critic and worked for three years in London radio, has a theoretical bent. Marxism interests him and, through *Screen*'s English Althusserians, he has become familiar with "modes of production," "signifying practices" and "paradigm shifts." He knows what he's talking about and he knows that he knows. The portrait he paints of the relationship between cinema and television in HK has an, "Oh, if you had only come yesterday!" side to it. Three years ago, they were experiencing a mini-golden age of television, but now it is essentially over. Just a year ago, there was still talk of the possible emergence of a "new wave" in HK, but it has not materialized. The West, for whom HK cinema means only kung-fu films (improperly rechristened as karaté), the myth of the Shaw brothers or, for the more cultured, the name of King Hu, didn't know about it. A shame. A shame, because the question of the relationship between cinema and television, which today is an essential question *everywhere*, has been addressed in HK in depth. Leung explains how a combination of trends might have produced a new wave. On the one hand, the advanced age of commercial filmmakers (or the Industry, as they say here), and the studios' (Shaw and others) inability to foster a new generation. On the other, television's relative openness to the personal work of young authors, who were generally trained abroad (England, USA). It's only logical that these young television creators (Ann Hui, Patrick Tam, Tsui Hark, Allan Fong are the names that come up most often) would try to work for an Industry that was ailing, and was therefore ready to give them a chance. It appears that I've arrived in HK right at the moment when the first results of this wild grafting have become abundantly clear: they are a disappointment. On the one hand because the Industry is completely incapable of doing anything other than making a quick profit, and hasn't the slightest concern for quality. On the other hand because this new generation, raised on television, has no cinematic tradition to build upon that is strictly Chinese. Their identification with China is itself problematic. Born after the war, raised in HK, having learned about cinema in the West, they only felt that they were again becoming Chinese in the seventies: the Cultural Revolution, Nixon's visit and the entrance of Beijing to the UN created a panicked identification with China. After the fall

of the Gang of Four, everyone fell back into the political apathy that currently characterizes HK. I have already encountered the speech, sometimes plaintive and sometimes cynical, that I will continue to hear over the course of my trip: Hong Kong is a colony of the English crown: "A house is not a home, a colony is not a country."* HK has all of colonization's defects (arrogance of the English administration, lack of elections, lack of political life) plus one: it can't even dream of its own liberation. A "free Hong Kong" is unthinkable. Its fate is, sooner or later, to be returned to China. The date has even been fixed: 1997. Here, when speaking of China, so close and so yet so far away (Guangzou is a hundred kilometers away), they say "Mainland China,"* literally the main land.

2 August

Heroism. HK summarized in three figures. More than four million residents, 6,000 films in 70 years and... 2,000 cinephiles. Culturally, it is a very weak city, to the despair of its intellectuals. I arrived with a couple of addresses in my pocket (thanks to Pierre Rissient and Tony Rayns), including the contacts of the "staff"* of Hong Kong's International Film Festival. In a City Hall office overlooking the stretch of water that separates the Hong Kong side from the Kowloon side (life in HK can be boiled down to the constant passage from one *side** to the other, by boat, by tunnel or by métro), four people who heroically organize said festival every year. Funding comes from the Urban Council, which strives only for a bit of cultural prestige for a city that, otherwise, would have nothing to show for itself but *shopping centers** and a couple of junks. In 1980, for its fourth year, the festival presented a retrospective of martial arts films. The year before, it was Cantonese cinema from the fifties. The goal of the festival's organizers is not very mysterious: "There is at this moment no professional group, no specialized institution studying Hong Kong cinema. And yet, as time passes, its films and materials are deteriorating and disappearing, and the task of studying, evaluating, and preserving the Hong Kong cinema tradition has become urgent." And so, Albert Lee, Freddie Wong, Law Waiming and Lau Shinghon take great pains to restore to HK its own cinema, a cinema that is ignored and disdained, a history that is little-known and misunderstood.

Their publications are slick and sumptuous, their approach to film relatively structuralist. It contains at the same time a slightly stilted populism and unexpected theoretical references (Lacan, *Cahiers*). On the boat that takes us to the island of Lamma (where I will be squatting for the next week), Law Waiming tells me that he translated the editorial battle between *Cahiers* and *Cinéthique* into Chinese. I tell him that that debate is now a bit retro.

The Cantonese Phantom of the Opera. I see my first film in a densely populated neighborhood in Kowloon. The Film Culture Center is a film school, more theoretical than it is practical, a sort of mini-Censier that isn't very functional. But it is one of the rare places in HK where cinema is something other than a quick profit or an ephemeral drug. The film is entitled *The Spooky Bunch* and its author, who has been passionately discussed since my arrival, is Ann Hui. Born in 1948 and famous for her TV movies, she made her transition to the industry with a thriller, *The Secret*. *The Spooky Bunch* is her second film, and was only produced through the support of a local star, Siao Fong-fong. It is an entirely thrilling farce set in a theatrical community. A Cantonese opera troupe watches its members one by one become possessed by spirits. Misunderstandings and gags ensue. In the end we discover that the spirits of soldiers have come to exact revenge on the descendants of the people who sold them poisoned medicine in the Sino-Japanese war. The film is full of brio and the possession scenes are hilarious. The familiarity between "ghosts" and "real" characters is a bit like *The Ghost and Mrs. Muir*, but more vibrant. Through this film, I discover—and it's a shock—Cantonese opera. I find out that it is, whether onstage or filmed, one of the major genres of HK's traditional cinema. But while the opera of Beijing is well-known, studied, copied, exported, Cantonese opera has not progressed since the death, in 1959, of its greatest representative, Tang Ti-sheng, the brilliant librettist. It was a genre rich in ghosts, in positive and unforgettable heroines, in social criticism. Will we see *The Butterfly and Red Pear Blossom*, *Princess' Tragedy* or *The Purple Hairpin* one day? We certainly hope so. Cantonese opera on film suffered the same fate as Cantonese melodrama: it was too local, too slow to resist, in the sixties, the internationalization of HK cinema. The success of Ann Hui's film is not unrelated to the discreet resurrection of the genre.

4 August

Beijing wants to manipulate. Cheung Chin was one of the first students in Censier's post-'68 film department, and he remembers it well. He speaks French and is an invaluable guide. He introduces me to Allan Fong, who is right in the middle of shooting a film. It is unusual in that it is being produced by what in HK are called "leftist companies." Through these puppet entities, Mainland China produces films that are shot in HK and then distributed, in HK (where these companies own several theaters) and sometimes even in China. The leftist studios have come a long way. They have ten years of commercial failures behind them: everything they were able to produce was too insipid and ideological for HK's tastes and yet too violent and trivial for the supposed tastes of the Mainland Chinese. They eventually fell back on travelogues. Today, they appeal to young talents coming from television, such as Allan Fong. Given the Mainland's evolution, a compromise between the ideological moralism of the mother country and HK's sense of show business is no longer completely unimaginable. But for the moment, no one really believes in it, and Beijing regularly loses money. Allan Fong studied in California and has American cinema in his head. I ask him what the older Chinese cinema of the thirties, forties, fifties, etc. represents for him. Is there a lineage? The answer is a definitive no. After 1949 and especially after the Cultural Revolution, the influence of Chinese cinema on HK cinema was not exercised through films but through filmmakers who, for various reasons, left the Mainland and came to work in HK. It's this generation that is still active today, although they are now very old. They have adapted to HK and rarely speak about the past. I suddenly wonder if HK's cinema possesses its own logic and future or if its success isn't due to a very paradoxical situation: after 1950, HK was able to handle the enormous stock of popular literature (such as martial arts stories) that the official Chinese cinema, subject to the norms of Yenan, could no longer integrate. HK *profited* from the situation. The colony became a substitute for Beijing in supplying the immense Chinese diaspora with images (from Taiwan to Singapore, USA in Indonesia). And so it developed a cinema that was simultaneously Chinese *and* Esperanto. A Pyrrhic victory, then, for it lost its soul.

Kung-fu in real-life. I go for a walk with Cheung Chin in Wan Chai, and a melody wends its way through the automotive uproar. It's coming from the courtyard of a playground, enclosed by fencing. We go in. Called "Martialand," it's a type of a martial arts festival that still takes place in certain neighborhoods (Cheung explains). Surrounding an uncordoned ring are percussionists (hence the music), organizers, referees, young people in sweatsuits. On cement bleachers, the audience waits, and will wait for a long time for the festival to begin. Spirits are high; announcements come and go over the loudspeakers that make everyone laugh. There are fighting matches (a sort of French—or Thai?—boxing) and kung-fu demonstrations that pit the local team against an invited Canadian team. There is a dance of dragons, the Northern dragon and the Southern dragon, frightened and frightening, rolling on the ground and rising up again. The program is very long: boys and girls, stiff and serious, fill the waiting time between matches by performing, alone, kung-fu gestures. They draw figures in the space that are impossible (for me) not to see as a kind of writing for which their bodies are simultaneously characters and brush. The sequencing of gestures (just as how Chinese writing has a required order of strokes) speaks the threat and the exorcism of an invisible other that is always kept at a distance. This cannot be seen in films, because everything there is truncated, chopped, retracted by montage, or else it is too fast. What is kung-fu? "A coordination of bodies, of hands, eyes, and feet," an 80-year old man assures us: Hon-Sang Siu, who teaches at the University of Hong Kong. He adds that his students' motivations are, in descending order, the desire to stay in shape, to belong to the Chinese culture, to have fun and—*last and least*—to be able to defend against an attack.

Kung-fu on film. Back on my island, I immerse myself in the HK festival's catalog on martial arts. Fascinating reading (in what follows, I borrow from the studies of Sek Kei, Ng Ho and Roger Garcia). One thing is clear: in the actual China (the one of monasteries and secret societies), and in books or in films (where history and mythology blend inextricably), martial arts has gone in two directions: one force moves towards the interior (in Chinese: *nei gong*) and one force moves towards the exterior (*wai gong*). The great debate over martial arts' betrayal of its philosophy in favor of

the commercialization of its combat techniques is an old debate that cuts through China's history. It cuts through, for example, the history of the temple of Shaolin, a rich fictional vein that's always tapped. At the beginning of the 18th century, in service to the emperor (against an enemy that was perhaps already Russian), monks developed secret combat techniques that made them almost invulnerable. They served as a half-religious, half-secular order, at once respected, envied, feared and vilified in the eyes of the emperor who, in 1736, burned down the monastery. Consequently, Shaolin became a site of political resistance to the Qin dynasty, and the 19th century is rife with wars waged against them by other orders (and that introduced other combat techniques). At the dawn of the 20th century, in the context of China's semi-colonization, these techniques served Chinese nationalism, with Canton as a center and the Boxer revolution (1900) as a high point. From there, the historical thread extends to cinema: soon Chinese cinema begins to make martial arts fantasy films (*Burning of the Red Lotus Monastery* dates from 1928). In 1950, in the context of HK's Cantonese cinema, the genre explodes. There is one essential character, completely unknown in France, named Wong Fei-hung, a martial arts teacher who became (twenty-five years after his death) the hero of 85 films, played by the actor Kwan Tak-hing, who would become identified with him for thirty years. These antiquated, flat films are documents of what Cantonese post-war culture may have been like, at a time when both opera and melodrama saw their Golden Age. A Southern culture (as, let's say, Naples is the South in relation to Milan) made of tea houses, domesticated birds, fireworks competitions, dragon jousts, a pragmatic world that has its feet on the ground and speaks Cantonese (sounding nothing like Mandarin). Huan Fei-Hong's films are still aired on television; everyone has seen them, and many of today's martial arts instructors made their debuts in them. Towards the mid-sixties, the Wong Fei-hung series was forced to cede to a faster rhythm, to a lesser degree of realism, more blood, and above all, to far less Confucianism.

Resistances. It is often said in France, out of sociological goodwill, that kung-fu films are for their audiences a way to forget their living conditions or to say no to the dominant culture. Like every opiate,

they are at once alienating and a response to alienation. This is true. But in general, that argument dispenses with going any further. One might ask if, after all, there aren't (weren't) any good kung-fu films. One might want to know more. Because martial arts in China have always been aligned with resistance, resistance to a pressure that has often changed its face. Resistance to foreign invasion, resistance to the great imperial Chinese culture, resistance to "foreign devils" and "long noses," resistance to the moralization of cinema, which has always come from the North, namely from Beijing. Needless to say, the condemnation of martial arts films by Mainland ideologues was categorical ("the martial arts fantasy film accentuates individual misfortunes in order to obscure class contradictions; it propagates the feudal and superstitious belief in reward in order to blunt the people's determination to resist, and it promotes the unrealistic pursuit of the Tao in distant mountains or monasteries in order to divert people from the current struggle," according to an official history of Chinese cinema dating from 1963). Finally, there is the resistance of Cantonese culture, from the South to the North. And today? I would tend to say: resistance of the colony's residents to the severity of a life in which everything is temporary.

August 5
 A cleavage. Private screening of Patrick Tam's *The Sword*, another first film by a brilliant television director for a major company, Golden Harvest. Will it succeed? A strange situation where a young filmmaker must prove himself absolutely in a genre as coded as kung-fu or swordplay. Will he subvert it, or simply fulfill his contract? Golden Harvest is HK's second largest company, more modest (ten films a year) but more modern than Shaw (forty films per year). Tam had to rewrite the script four times. The heroes of the film are less men than they are swords (one benefic and one malefic), simultaneously weapons, phalluses, fetishes and legacies. I don't like the film's hybridity, its advertising aesthetic, its sub-Morriconean music, its stilted actors, its rivers of blood. It reminds me a little of the Western when Peckinpah arrived on the scene: we've lost our naiveté, but since we don't know what else to do, we exaggerate. At the end of the film, during a colossal fight, the bad guy, having exhausted his

resources, transforms himself into a sort of human projectile and charges (the good guy, back against the wall), his sword in front of him as if it were an arrow. Resisting this assault with all his strength, the other literally *slices* him into two pieces that, luckily, fall to the ground outside the frame. Watching the notion of "cleavage" being taken literally here, it is difficult not to feel a little psychoanalytic. The exaggeration allows us to see, in the form of a gag, the code's role of prohibiting representation. In this case (and this goes for every martial arts film I see), everything that relates to sexual desire (in HK, English and Chinese puritanism align to make this city—despite its undeserved myth—a *clean* place where everything is sacrificed to economic profitability).

August 6

Meetings. Chris Marker is in town. He retraces his steps and shoots "randomly," not unhappy to be finished with the experience of *A Grin Without a Cat.* Plus, his friend Terayama is also shooting in HK. The festival staff arrange a lunch. Marker tells me that HK (which he doesn't much like) has changed a lot. He's coming from Okinawa and is going to China, where he hasn't been since *Sunday in Peking.* During the meal (it is very hot), various subjects are discussed: the mysterious death of Bruce Lee, the rumor that the red guard did some filming during the Cultural Revolution. What about these films? Will we ever see them? What are they doing with them? Are they being archived? I am shown a press clipping of a Chinese newspaper that talks about the fire at one of the Cinémathèque Française storage facility. Why preserve them, anyway? Cinema will perhaps have been the collective dream of the 20th century. Marker goes to take pictures at Cat Street. We split up.

That night, in the festival office, I come across Lau Shinghon, interviewing a very old Chinese filmmaker. Li Pingqian is 80 years old: he has seen everything, done everything, made innumerable films (the most famous is *The Awful Truth,* but I never found out if it is a remake of Leo McCarey's film). I remember only one thing from what I was told that he said: in the '30s, in Shanghai, they saw films by Lubitsch, Sternberg, almost simultaneously with their release in the West. Afterwards (sigh)… Lau Shinghon is deeply interested

in old Chinese cinema; he fights for those films to be recovered, pre-served, screened, seen, loved. He himself has only seen one silent Chinese film. In HK, he says, cinema exists because it is, given the exiguity of the territory, the *only* pastime. The word "escape" here assumes its full meaning. It also explains the headlong rush into the Industry: even though the market is saturated with kung-fu films, the Shaw brothers continue to produce them. Their motto seems to be: fast and bad.

August 7

Visit to King Hu. If there is one Chinese filmmaker who is familiar to the foreigner, it is King Hu. His real name is Hu Jinquan, and he was born in Beijing in 1931. In France, he was discovered by the excellent magazine, *Positif,* several years ago. According to a common scenario here, he arrived in 1949 in HK for several days and stayed thirty years. He worked first as a designer, actor, and screenwriter with the Shaws, for whom he directed his first film (*The Sons of the Good Earth,* 1964). Curiously, his films were not distributed in France but made the rounds on the festival circuit, where they were not very well liked. In the office where he greets me, I count no less than nineteen diplomas hung on the walls. King Hu's most famous film is *A Touch of Zen* (1969), which I saw in Berlin, in 1979, on a cold night. His last two films, *Raining in the Mountain* and *Legend of the Mountain,* shot simultaneously in Korea (1977–1979), were commercial failures. Since then, King Hu has been in search of a fresh start. Nevertheless, he remains, everyone agrees, HK's most admired filmmaker because he has proven that with slightly more money, time to shoot, care, talent and erudition (obviously, this is no small task), *swordplays** on the level of the best Japanese Jidaigeki can be produced in HK. He welcomes me in his Fai Po Street office with the greatest kindness. I tell him how shameful it is that the majority of his films are unknown in France: he seems resigned. He promises to show me (when I return from China) *Raining* and *Legend.* Then, we talk about all kinds of things. About HK, which is not really a city but "a borrowed time, a borrowed place"* where no contract can extend past 1997. But then, where to go? Where to work? There are plenty of possibilities for coproduction with mainland China, but they are risky: the mainland

has no foreign exchange, inflates costs and has no accountability for exploitation. In Beijing, 30 million HK dollars a year are swallowed up to leftist finance companies, but cinema has not yet been retrained as an industry. And then, there are too many bad memories tied to the Cultural Revolution. On the way out, I tell King Hu that I have been invited to see a film made by one of China's best filmmakers, Zhu Shilin, who died in 1967. I know that film, he says; I was assistant set designer on it. Do you know how Zhu died? During the Cultural Revolution, one of his old films (*Sorrows of the Forbidden City*, 1948) was re-released in Beijing. Liu Shaoqi defended it but Mao attacked it. The film became a political concern and Zhu, already ailing, died of grief. This, obviously, is not the only bitter tale I am told of the ex-GPCR [Great Proletarian Cultural Revolution].

Reading films. I go into the first moviehouse I see, on the frenetic Des Voeux Road where a "kung-fu comedy" entitled *By Hooks or by Crooks* is playing, directed by Karl Maka. Two weirdos are the parodic heroes. It should be noted that along with bloody and serious kung-fu (the only kind seen in France) there is also a kind of kung-fu comedy where everything is ridiculed mercilessly, rendered burlesque and trivial, according to a nihilism that is characteristic of HK. I thought the film was very bad and left before the end. Still, I took note of the fact (which made me smile inside) that every film screened in a HK theater is subtitled not once but twice: in English and in Chinese. Don't forget that Chinese writing is understood by all of China. Natives of Beijing, Shanghai, and Canton will understand each other in writing, but not in speech. Hence the subtitles. What was for many years in France (to say nothing of the USA or Italy) synonymous with vicious snobbery is, in the context of a hyper-popular cinema, here the rule.

8 August

The inescapable Shaw brothers. Until now I've met only with the cinephile intelligentsia, young filmmakers. Their problems are somewhat universal. But the bulk of HK's cinematic production still comes from the studios of the famous Shaw brothers. Impossible not to go see them, where they are, in the far north of the city, in the "new territories" where they built their *Movieland*. They built it (in

1961) in such a way that everything that they need is there, on site: untouched natural scenery, bits of cityscape in stucco, laboratories, etc. My contact at Clearwaterbay Road is Chua Lam, one of the house *executives*, officer in charge of handling foreign journalists, whiskyphile and first-class calligrapher. He comes to pick me up in a small Volkswagen that belongs to the studio and drives us across it. The lot resembles a construction site, but dormant and clean. Extras are learning how to shoot a bow and arrow (they are terrible), while workers nail real branches onto fake trunks to create the idea of a garden. For us, obsequious glances. Everything is created on site: frescoes and dragons are manufactured in plaster. In a closely monitored room, all of the costumes are warehoused, lined with their photographs and sorted according to era and origin: they are used until they're completely worn out. Some, authentic, came with refugees from the Mainland who continue to pour in, even today. With the Shaws, it takes four days to create the sets and a little over a week on average to make a film, meaning to be over and done with it. The self-sufficiency of the studio is fascinating. One often hears, with a mix of disapproval and nostalgia, of dream factories, serial production, of vanished B or Z movies, etc. Shaw Movieland is one of the last places on earth where the dream is manufactured in this way. A slight feeling of unease grips the visitor when shown the dormitories where the employees sleep. Of over 1,300 people on Shaw's payroll, 300 never leave the studios.

Run Run Shaw's success came from his beginnings as a movie theater manager (in Singapore), then a distributor, then finally a producer. He knew both sides of the movie business. Today, out of 40 films a year, thirty are kung-fu films and the others are melodramas or thrillers, sometimes semi-documentaries. The dominant ideology in Shaw Movieland is that there's no reason to stop doing what you know how to do as long as it's working. Right off the bat, there is something defensive in what Chua Lam says to me: Here, we don't make art, we don't even look for quality, *voi ch'entrate*... Does it affect him? Because of abject populism, I tell him, it often happens that a popular or reputedly minor production ages better than a reputedly serious work, that you never know... He looks at me with distrust. The Shaws don't have a good reputation, they aren't even very smart,

they can't sense what's popular: unlike the others, they haven't diversified their activities, they haven't learned to do anything other than kung-fu (they even abandoned their attempts at foreign coproductions). Will it be time, at Run Run's death, to change course? It isn't certain. For now, the Shaws' power lies in their stagnation: they make films for the Chinese diaspora throughout the world and for the immigrant workers in rich countries. And yet that diaspora is shrinking: in Vietnam, the installation of the new regime caused the loss of the market; in Indonesia, every attempt is being made to de-culturize the Chinese community (without the films we're making, Chua Lam tells me with pride, it would be completely de-Sinicized). A curious mix of artisanal determination and bleak exploitation (no unions at Shaw Movieland). For the company's biggest problem is its own reproduction. It must recruit from outside HK's cultural desert. At one time, an acting school was attached to the studio, but it fell apart. Today it is towards Taiwan (hysterical guardian of all Chinese culture) that one looks to find fresh faces and, who knows, create new stars. That's why all of their films are shot silently and, to make them exportable, dubbed in Mandarin. A version dubbed in Cantonese is only made when the subject might possibly interest a HK audience. As for recruiting new filmmakers, Chua Lam explains Shaw's calculation, a calculation as old as time. To the young, they say: prove to me that you can make at least *one* commercially successful film and for the second film we'll give you complete freedom. Either they fail and are forgotten, or they succeed and there is every chance that they will play the game. QED.

Zhu Shilin. That night, Lau Shinghon teaches a class at the Film Culture Center and asks me to come. He'd like to introduce me to his students and will show a film that is close to his heart, Zhu Shilin's *Festival Moon* (1953). To convince me, he shares that he considers Zhu, in his best films, to be as good as Ozu. I'm trembling with joy. The screening of the film is Homeric (the film has shrunk!), the students stoic. But after the film, Lau has to fight hard to convince them that it is a good film, important for Chinese cinema, important for them. The belief here (but not only here) is that an old film *cannot* be superior to a new film. This forging ahead is entirely HK's style: the future is troubling and the past is unspeakable. Zhu's film,

which I find very beautiful, unexpectedly sheds light on HK and its history. Its subject is this: every year, during a party, employees are expected to offer gifts to their bosses. One of them, the film's hero, very poor, lives in fear, goes into debt. When he finally adds his gift to the pile, the boss doesn't even see him. A bitter ending, with a sad song and a shot of a spinning globe, introducing the idea of the solidarity of the exploited. The film was produced for a "leftist" company of that era, Feng Huan, with the goal of increasing public awareness of social issues in HK. Zhu Shilin is in fact the major representative (Sadoul cites him) of a neorealist school that was exported from the Mainland to HK after the liberation. His influence would have been significant. Reconstructing Zhu Shilin's career, I felt that I understood something about the history of Chinese cinema, a history of exiles and drifting if there ever was one. Zhu was born in 1899 and began working in Shanghai in the thirties. China has always had two cinematic centers: Shanghai and HK. Two poles: the more idealistic and serious North, the more popular and commonplace South. Zhu was invited to HK in 1946 in order to influence the cinematic work being done there (considered frivolous): he stayed there for good. Today, Lau Shinghon fights with the Urban Council to mount a Zhu Shilin tribute in 1981.

9 August

I leave tomorrow for Beijing, where I will stay for one week. Tonight, there is still enough time to see *The Butterfly Murders*, the first film by Tsui Hark, who also began in television. I had heard a lot about this film, which represents something new for HK: the use of magic as a theme and special effects as a sophisticated technique. The story is extremely complex, and I am lost from the very first shots. The idea, very beautiful and deliberately Hitchcockian, is that engineered butterflies attack and kill: their victims are torn to shreds. Only one character moves through the story with aplomb and seems able to navigate it. It's undeniably skillful, but the hard labor of "one idea per shot" eventually grows tiresome. One wonders: what's the point?

Hong Kong does not belong to itself. To live in HK and to see films there essentially amounts to the same thing. Whether it be between the characters that inhabit the screen or the residents of the actual

city, it's the same feeling of a blind space in which people slip past each other, without making eye contact and sometimes without seeing each other. That space is rendered neither logical nor erotic (it's the same thing) by the mise-en-scène of a glance. Zhu Shilin and the realists must have had great difficulty importing the spatio-temporal *continuum* to Hong Kong, *one scene one cut**, depth of field. And did they succeed? Apparently not. HK and its cinema are jungles, aberrant spaces (one need only refer to the city's urbanization) that one moves through, wary and numb, while rushing to work or to combat. Bodies are disassociated from space, don't belong to it. HK is decidedly a colony, a city of immigrants, a dead end. Kung-fu itself belongs to HK's culture; its recent surge is the only thing that HK has produced. Kung–fu isn't about fighting, just the opposite: the horror of body against body and its erotic ambiguity, phobia made martial art. Bodies are plunged into a space to which they do not belong. And sounds, voices are also totally disassociated from the bodies to which they are brutally attached. Another dispossession. This double dis-affiliation, the negation of any physical anchorage, of any possibility of "real inscription," is likely what makes the kung-fu film a universally and spontaneously popular form. But beware: not a populace anchored in its own culture (language, territory, memory) but the *global populace of today*, unmoored, displaced, exiled. HK, the colony, speaks to the ex-colonized of the entire world, hence to immigrants.

13 August

Beijing. First advertisements. For an aesthete who is a bit of a theologian, tormented by the question of mass media, walking around Beijing is a pleasure, then an enigma. Advertisements, the first ones I've seen in a long time, preside over certain intersections at the center of the city, on Chang'an Avenue or Wangfujing. They coexist bizarrely with billboard slogans, white letters on a red background, invariably ending with the characters, "wan sui!" (long live!). These advertisements have the antiquated charm of beginnings. They are satisfied with claiming that a product is good, in English and in Chinese. They evoke Magritte's paintings (but are less brilliant). They are, in fact, the degree zero of ads, ignorant of what they are aiming

for, targeting no one, not knowing who or how to seduce. If, as I have thought for some time, cinema was initially contemporaneous with the era of propaganda before it was with the era of advertising (and more indexed by it every day), Mainland China is the only place where one can currently see, with the naked eye, the passage from one rhetoric to another. There is more than the Deng Xiaoping effect in this: the Chinese tend to be the best businessmen in the world, and "when China awakens" implies: one day, it will know how to sell—how to seduce.

The city, where everyone can and must see them, is teeming with official images. Images of politicians, incidentally all dead: Mao, Zhou, Liu. But be warned, these are not images but emblems of a vast social treasure hunt, images that "signal" (if not to say, "work the streets") before they even have an opportunity to exist as images. In the train station, in the metro, never a giant photo of Mao without one of Zhou Enlai, and if Liu Shaoqi is there too, all the better. Liu, whose life story is reconstructed in photos on large glass panels for the edification of passersby. I am told that these are widely mocked.

14 August

Beijing. The ultimate mummy. The morning I am to leave, Tiananmen Square is packed with crowds. Snaking lines: counted, controlled, discharged from buses. It is one of the three days when Mao's mausoleum is open to the public. Three days a week. "For how much longer?" I wonder, as I sneak into a queue. I am spotted, removed from the line, asked to show my passport, to write my name in a big book and am officially added to a group of German tourists who have just arrived. The mausoleum is a recent construction, obviously Stalin-esque, vaguely pastel. The mise-en-scène is as follows: visitors shuffle along for a while at the bottom of the steps, outside and in double file. They enter into a peristyle where a red carpet skirts a giant statue of Mao. It is a Mao in white marble, who watches, his legs crossed, the human stream that divides before him, materialistically, into two rows. Behind the statue, a giant tapestry evokes a green and infinite expanse, a China embossed by mountains and furrowed by rivers. The two channels of the stream, moving faster now, converge behind the statue on the threshold of a smaller room and split

off again on either side of the thing under glass: Mao mummified, covered up to his chest by a red blanket, his face waxy, bloated, drawn inward. The visitor can then only toddle towards the exit, pushed by the others (he wants to yell, "Don't push!" but doesn't), not very sure of having seen anything. He has been transformed into a living travelling shot, a human zoom. All of it, I say to myself once back in Tiananmen Square, all of it is deliberate: that visit that can only go too quickly, that acceleration of human particles surrounding the mummy of the leader is, in the fullest sense, a mise-en-scène and not the least. How long will it take for China, mainland China, to create other *mises en scène*? That will come, but not right away (I am told from all sides).

16 August

Hong Kong: morality comes from the North. Return to the *unflânable*, the speedy Hong-Kong. The friends I've made are in a sort of distress that I've become accustomed to. "We have nothing to be proud of," Law Waiming tells me, on an overcrowded Lamma Island beach. In 1967, echoing the Cultural Revolution, there was a wave of panic in HK: the colony saw itself already reabsorbed by the Mainland. Some of its young people became radical and pro-Chinese. The alarm didn't last long, and was followed by innumerable disillusions. It was nevertheless the only political experience, simultaneously aberrant and heroic, of that generation that is now in their early thirties.

This is, in fact, a cyclical phenomenon in HK: periodically, waves of morality and earnestness coming from the North stall and are then "recovered." For example, when Japanese troops seized Shanghai (1936), then Canton (1938), Chinese filmmakers quite naturally returned to HK with the idea of promoting the production of patriotic films, social-realist and "high-quality." The most important filmmaker of the era, Cai Chusheng, led the movement until HK was seized by the Japanese, Christmas Day 1941.

Between 1948 and 1952, in the aftermath of Mao's victory, HK vibrated anew with all kinds of efforts aimed at raising the aesthetic, political, and ethical standards of local production, at fighting against feudal ideas, superstitions and popular myths (muyushu). The subsequent waves were called: *unification movement, clean-up movement,*

collectivization movement, self-improvement campaign (already Liu Shaoqi-ist). The signatories of the "clean-up movement"'s manifesto set the bar for civic conscience very high: "We solemnly pledge not to participate in productions that would not be in the interest of the nation or that would have a negative influence on society. We will do everything we can to bring honor—and not shame—to the Cantonese film industry." It is 1949. At the same time, the "self-improvement campaign" recommends "the four abstinences" to film workers: don't throw any parties, don't give any gifts, don't gamble, don't drink (too much). The critic is not forgotten: under the collective pseudonym of the "seven critics," film reviews emerge that respond to three demands: "What is our point of view?" "Where does our analysis begin?" "What is the correct line for criticism to take?" It's a familiar tune to all the future pro-Chinese of the world, those who will translate the *Cahiers-Cinéthique* polemic into Chinese some twenty years later like those who, in France, nourished it.

Result of this "clean-up"? Four or five years of a realist current in HK cinema (to which the Zhu Shilin film that I saw belongs) and, certainly, very good films. And after that? As soon as it became clear that HK, because of the retreat of the People's Republic into itself and the principles of Yenan, lost its natural marketplace (Canton and the Cantonese-speaking province of Guangdong), as soon as the local industry was rebuilt (thanks to clever figures like Shaw), the moral influences of the North began to fade. In the mid-sixties, HK modernizes, flourishes, Americanizes, even becomes more Japanese (Shaw sends his employees to study Samurai films, in Japan), reboots the frenetic and exportable genre of kung-fu, forgets China. An entirely relative omission: HK is of course tied to China (it is simultaneously a vestibule, a window and a safety valve). Inextricably. The kung-fu revival and the cultural revolution are contemporaneous and must be read simultaneously: in Beijing, high ideals and hysterical speeches; in HK, sadistic violence and over-dubbed rumbling. The violence of the Cultural Revolution, repressed in Beijing's discourse, is visible in HK, and the politicization of the colony, unspeakable in HK, is audible in the propaganda of the mainland. Quid pro quo. It is as if the People's Republic felt a phantom pain in HK, like someone who has lost a limb.

18 August

Allan Fong invites me to his shoot. It's happening at the Mayfair hotel, on the Kowloon side. In order not to upset Beijing (who is producing the film via a "leftist company"), he chose a relatively universal theme: a poor family forces the elder sister to marry a wealthy man so the younger brother can go to college; she makes the sacrifice. Fong seems sincere and serious, but he is not very optimistic. In the enormous dining room being used as a set, lots of children in their Sunday best, extras, filmmaker friends, technicians. The technicians, between takes, watch yet *another* social-melodrama soap opera on television. There is a receiver in each corner of the room. They shoot, of course, without sound.

19 August.

A masterpiece. King Hu shows me his last two films, *Raining in the Mountain* and *Legend of the Mountain*. While *Legend* seems as ambitious as it is unsuccessful, *Raining* is by far the most beautiful film that I've seen in HK. The story alone is something to celebrate. During the Ming Dynasty, an invaluable "scroll"* (roll of parchment) is kept in the temple of San Pao. Everyone covets it. The monastery's old abbot must choose his successor: which of these "papabili" with shaved heads will be chosen? The best disciples are in the running. The secular powers-that-be make shady alliances with them, promising their support in exchange for the scroll. There is, on one side, the province's general and his police lieutenant; on the other, a rich collector and a professional thief whom he passes off as his wife (Hsu Feng, wonderful, as all the actors are, in fact). Of course, no one is taken in, especially not the old abbot who, to everyone's surprise and as in the best Zen apologues, chooses as his successor an obscure monk whose virtue he alone recognizes. Chu Ming—that is his name— proves to be a true leader, revolutionizes temple life, resolves problems one by one, mixing cleverness with charisma, tolerance with authority. Those who coveted the scroll are killed or deterred; the thief is seized and officially becomes a nun. In the final shot of the film, while the others watch in horror, Chu Ming burns the scroll while declaring: because this object's value lies in the meaning of the sutra written there, we will make copies and distribute it.

This humor belongs solely to King Hu, all of whose films are reflections on power (not the least of which is religious power). *A Touch of Zen* was already a large-scale meditation on the illusion of power *and* the power of illusion, always imbricated. There is something Mizoguchian in the way that King Hu observes, with stoic detachment, amused skepticism, that struggle for power and its toys. The difference being that this struggle is a dance, and dance is King Hu's strong suit. He knows it and says it outright: "I have always considered the action of my films to be dance rather than combat. Because I am interested in the Peking Opera and especially in its movements and actions, although I think it is difficult to express them in a satisfying way on set, where the physical limitations are too great. Many people in HK have misunderstood me; they have remarked that my action scenes are sometimes authentic, sometimes not. In fact, they always refer to the idea of dance."

Thus, again, humor. Each shot in *Raining in the Mountain* appears simultaneously as a *shock* (the film's plastic beauty is practically unbearable) and an *enigma* (where are we? what do we want?). By the time the spectator—in the theater—has had enough time to recover from the shock, to "come back," the characters—onscreen—have deciphered the riddle and are ready for the next shot. When the viewer has "caught up with" the characters, he finds them immobilized, "*left high and dry,*" as if they were waiting for him. Between the time of astonishment and understanding, between the camera, the characters of the film and the thinking audience, an actual *ballet* is created, simultaneously very intellectual and very physical, jubilation that brings to mind the cartoon, but without the cartoon's cold nihilism (because of the humor that always accompanies the filming of actual bodies, even and especially when they seem delivered from the laws of gravity).

22 August

Return to Shaw. This time, it's to preview two studio films. Which do we choose? First, out of pure cinephilia, *The Kingdom and the Beauty* (1958) by Li Han-hsiang. Two reasons for this choice: it is a *remake** of Mizoguchi's well-known film, *Yokihi* (*Princess Yang Kwei-Fei*), and Li Han Hsiang is one of China's most renowned filmmakers.

The film's origin: Run Run Shaw and Masaichi Nagata coproduced the story of that Chinese empress that Mizo filmed in 1955. Without much enthusiasm, if we are to believe Yoda, who talks about the difficulties he had with the script, difficulties due in part to his ignorance of Tang Dynasty-era China. The Shaws had, however, sent many instructions on the costumes and sets to Japan. In vain: it was impossible for them not to see that Mizoguchi's film was implacably Japanese, that the actors had mannerisms, ways of lowering their heads that could only be Japanese. The decision was then made to re-sinicize *Yohiki* and to entrust the *remake* to the most prestigious filmmaker then under contract to the Shaws: Li Han-hsiang. *The Kingdom and the Beauty* is far from being unworthy of *Yohiki*, but its aesthetic is entirely different: we are swept back to an art of the *vignette* that cinema (after Dwan or Freda) gradually abandoned. In which beauty (of the sets, of the costumes—especially of the colors) is apprehended all at once, experienced more than elaborated, ad nauseam. One has to wonder if this doesn't touch upon a fundamental difference between the two cultures, between China and Japan: Japanese culture (thus cinema) is a culture of the frame (thus of framing), of the angle (thus of violence), of detail (thus of the fetish). It seems that China is a completely different matter: a culture of the animated, dancing *tableau vivant*. We need to watch, of course, many more Chinese films, especially old ones, to really begin to make this comparison. We hope that this will one day be possible. In the meantime, we must point out that Li Han-hsiang's version of the fate of the empress Yang Kwei-Fei and the emperor Wei Song is clearly less feminist than Mizoguchi's version, which isn't very surprising. In it the empress is a vulgar schemer and the emperor a sentimental mess. Li's sympathies tend towards the manipulated, starving, lost soldiers: their revolt at the end of the film is an impressive cinematic moment.

More kung-fu. Title of the second film I see at the Shaw's: *The 36th Chamber of Shaolin*, by Liu Chia-Liang. In HK, Liu has become a perfect example of the good commercial filmmaker, serious and competent. He belongs to a family of martial arts instructors from Canton who, from father to son, from master to student, trace back to Wong Fei-hung himself. He was raised in that very particular world ("martial arts artists" belong to secret societies, they form a

special group) and knew no other. One of its scholars (and one of the best experts on HK cinema), Roger Garcia, thinks Liu is illiterate. Hired by the Shaws in 1965 to coordinate fight scenes, he was one of the first instructors to cross the threshold and move into directing (with *The Spiritual Boxer*, 1976). What effectively happened was this: in HK, a rookie filmmaker, not very sure of himself, would usually call upon an experienced instructor in order to assure that the performance of the fighting would be strong, since those scenes are the most important ones to the audience (just as in France, it would be the director of photography in France or, in India, the musician). Liu Chia-Liang's films are marked thematically by complex stories of filiation and marked technically by a concern for realistic fight scenes. It's that sincerity that makes a film such as *The 36th Chamber* worthwhile (which has nothing to do with the slightly empty sophistication of the young filmmakers who come from television, and are always ready to outdo or subvert a genre that they don't know well). The story of *The 36th Chamber* is not very original: in Canton, the Tartars humiliate the Chinese. If they learn martial arts, they will be able to defend themselves. The hero, San Te, flees to Shaolin where, through stubborn persistence, he is accepted by the monks and allowed to study with them. He stays there seven years, grows strong, returns home, takes his revenge and in turn, starts his own school. I'm passing over the film's weak points: slack narration, overlong presentation, a flat epilogue. That said, the film includes one extraordinary section, in which San Te perfects his training while moving from one "room" to another. The Shaolin monks have in effect staged a Ruizian itinerary, a theory of the fragmented body, an unfolding of what a human body can do. A room is assigned for each organ or each weapon: a *wrist, head, eye, leg, boxing, swordplay, baton** room, etc. San Te is regularly the worst and then the best of students. He finally reaches the 35th room (the most horrific, filled with animated mannequins) and it is up to him to create the 36th, available to to every Chinese person who wants to defend himself. We can see in this terrible training a metaphor for the production of the actor in the Shaw factory. We may also see in it another meditation on this constant of popular culture: the body of the invincible hero as *montage*.

27 August

Filipino milestones. In several years, the Philippine Islands will be named "Maharlika." So Marcos has decided. Soon a major international film festival will be held in Manila that will be the Cannes of Asia. So the "first lady" Imelda Marcos has decided. Until then, "Metro Manila" is a vast urban web, hideous and formless (but not lifeless, despite a sham curfew that has lasted since 1972), that produces 150 films per year. That is no small feat. Lesser known is the fact that twenty years ago, it produced more than 200. Where are they? Are they good? Where can we see them? I bombard my only "contact" in Manila, Agustin Sotto, film critic, with these questions. He is a very isolated—and very patient—man, because he has gotten it into his head to become the historian of Filipino cinema. And yet, here, that history interests only a few, always because of the idea (characteristic of poor countries) that old films *can't* be better than new ones. He knows that a *single* Filipino silent film still exists, and he is looking for it; he also knows that four films exist from before the war, and he is looking for them. In Manila, in the provinces, in Hawaii, everywhere. And yet, Filipino cinema exists, will exist, did exist, that is certain. From 1934, Sotto tells me, it created a studio system with stars, yearly contracts and musicals. The three "majors" were named Semapaguita, LVN, and Première, and were run by women. There were famous filmmakers, like Gerry de Leon, whom Sotto hopes one day to prove, with the films to support it, was an important one.

For the European cinephile audience, Filipino cinema has had a presence ever since two films by Lino Brocka, *Insiang* and *Jaguar*, were screened at Cannes. Brocka is the great filmmaker of the seventies, and his position in the cultural life of the Philippines is central. The others are named Ishmael Bernal, Mario O'Hara, Mike de Leon. In closing, I think the Jalladeau brothers, who organize the Three Continents Festival in Nantes, should be interested in the future Maharlika.

28 August

Meeting with a fighter. Lino Brocka is not a deserving-young-filmmaker-of-the-third-world arrogantly fighting against the bad

(commercial) tastes of his audience. He is certainly a fighter and a good filmmaker, but he is first of all a major figure, very well-known in his country and the informal leader of all those who, for several years now, have sought to shake up Filipino cinema. Omnipresent and indefatigable, at once a man of theater and television, his films are not only stolen from "the system" (they generally lose money) but from their own era. I meet Lino Brocka for a seemingly endless lunch in which he paints a cheerful and dialectical picture of his situation. He is very conscious of the importance of that situation (he is the only Filipino filmmaker who is internationally known) and well aware of the ambiguities that necessarily follow that (he is also in some way essential, untouchable to the Marcos couple, although he is also constantly attacked, slandered by a literature of "gossips"* who thrive in Manila). But he is very determined, for himself and for others, to take full advantage of the situation. How? By expanding, by forming, halfway between theater and cinema, a *troupe* (just as King Hu, in another context, was able to do in HK: I believe that this notion of a "troupe" is essential to the development of cinema in third-world countries). What I like about Brocka's discourse is that it is not a matter for him of rejecting Filipino popular culture (he is himself too populist for that), or of using it cynically under the pretext that it is the only kind of culture that can be understood, but of making it *move*, which is something else entirely. For example, there is an important production of *comic books* in Tagalog, full of scenarios that express, naively, the dreams and obstacles of Filipino society. I subscribe to all of them, Brocka tells me, and even if only one out of fifteen are any good, I am inspired by it.

(*Cahiers du Cinéma* #320, February 1981)

IN THE SOUTH: SOCIAL MELODRAMAS

A considerable portion of India's film production is shot in the four major languages of the South: Telegu, Tamil, Kannada and Malayalam. Like the country itself, its cinema can only be understood in the context of the opposition, the silent war, even, between the Aryan North

and the Dravidian South. Today, it seems that the South is where, following the Bengali boom of twenty-five years ago (*Pather Panchali*, Ray's first film, dates from 1955), a new demand and a new style have been created that is shaking up—even if only slightly—Indian cinema.

A movement that it would be rash to equate with a "new wave." The European new waves of the sixties emerged from the collapse of the film industry; here, in contrast, commercial cinema is still popular, very powerful, very conformist and very cynical, and, at least in terms of its songs and dances, its two strongest points, fairly sophisticated. Television is far too weak to act as a form of replacement any time soon, and Indian society is too stuck to evolve rapidly in its relationship to images (a fundamentally religious and iconolatrous relation). Thus it takes a good deal of courage and obstinacy to produce what Indians call "serious films," meaning films without music, without dance, slow-paced social melodramas, in black and white, based on stories characteristic of those societies still yet to be urbanized: conflict between city and country; convergence of classes, castes, and religious taboos to crush or discourage any individual revolt; the decisive role of women, sometimes as guardians of the social order, sometimes as protestors, etc. Because religion, in South India, is not a remote institution, a forgotten cultural fundament or a personal relation to the sacred, it is pure power, and a power that is (to us) terrifying, cynical, and naked. It goes without saying that these films tell stories found nowhere else in the world (rivalled only by African cinema).

Of the four languages cited above, Tamil (state of Tamil Nadu, capital Madras) and Telugu (state of Andhra Pradesh, capital Hyderabad) are the ones in which the production of "serious films" has been the most difficult. The reason is that the bulk of commercial cinema centers around studios in Madras, a city that today has the allure of Hollywood in the thirties and where identical films are shot assembly line-style in different languages. These past few months, in a sign of the times, it has been filmmakers coming from the North (Shyam Benegal and Mrinal Sen) who have produced the best Telugu films.

Conversely, there is much to expect from the two other film industries in full expansion, Kannada (state of Karnataka, capital

Bangalore) and Malayalam (state of Kerala, capital Trivandrum), where there is still much to discover. In 1979, thirty films were made in Malayalam, six times more than the films made in Polish. It seems possible for an independent sector to develop there, through the aid of the States, the creation of cooperatives, and even some private capital. In 1970, *Samskara* (*Funeral Rites*) was produced, a Kannada film that had, for the South, the same impact that Ray's films had for the North. Directed by a veteran filmmaker, Pattabhi Rama Reddy, the film particularly bears the mark of Girish Karnad, an actor and screenwriter, who in the seventies became Kannada cinema's one-man-band. *Samskara* is a vitriolic film about India's caste and religious system, incomparable: every Kannada film that follows is contained in this film: those made by Karnad (*Kaadu—Forest*, 1973), B.V. Karanth (the admirable *Chomana Dudi*, 1976) and the young Girish Kasaravalli (*The Ritual*, 1977) simply went further in that direction.

As for Malayalam cinema, it naturally reflects the particularities of Kerala, a land of culture if ever there was one, historically a meeting-place, today blessed with the highest literacy rate in India. It has stories of emancipation, often feminist, that are found nowhere else. Its two principal representatives are Aravindan and Adoor Gopalakrishnan. Gopalakrishnan is the confident spokesman for "serious films" *made in** Kerala: Like all of those of his generation, he came up through the cine-club movement (very active for the past twenty years) and the Pune school. He then founded a cooperative, Chitralekha, and vigorously supported a local industry that belonged to Kerala, resisting the sirens of the "all India film." His best work is, by far, *Kodiyettam* (*Ascent*, 1977), the story of a man who awakens very, very slowly to the need to live with others and accept a minimum of social engagement.

Kodiyettam's qualities are those of all the "good" films from this Southern cinema, where what matters is sentiment and duration. It can take a long time to tell a very simple story, whether it be about awakening or erosion, degradation. But in both cases, we sense the pleasure in telling stories, the accumulation of notations, of characters given and taken away, the unhysterical portrait of the quotidian. The best quality of this cinema escapes what characterizes the

dominant cinematic output throughout the rest of the world: the violence of bodies and time's ticking clock. Certainly, these qualities are the result of relative poverty and a measure of formal invention. A transitional condition, because studios are already no longer equipped to process black and white: technologically, they are forging ahead. But between the risks of folkloric cinema and "all India films," there is space for a cinema that, instead of reabsorbing its subjects in song and dance, gives voice to unique sounds, languages, and accents.

(*Le Monde diplomatique*, March 1, 1981)

THE PORTUGUESE POLE

I

We have for many years become accustomed to speaking of cinema in terms of *centers*. Some empires of images still do exist around the world, unevenly ossified or nearing extinction: Los Angeles, Paris, Moscow, Bombay, Hong Kong. Their strength lies less in production than in reproduction, by swallowing up what is created in the margins or in exile. That is every center's fate.

We have also become accustomed to dreaming of a cinema that would forget even the idea of a center, a filmmaker who, like the camper or the anti-social, would not outweigh his images. This utopia, that of a *territorial cinema*, is very useful, not because it is viable, but because it causes things to shift.

What is important in cinema is neither the vampirism of the Center or the multiplication of centers, but *lines of flight*. What would Hollyood be without the sum of those who have fled it? Without the muted dissent of those who have been shattered by it? Everywhere he goes, a filmmaker is a continent of images. That is also cinephilia.

Then one day, we learn that Manoel de Oliveira, 72 years old, has spent the last several months shooting *Francisca*, a novelistic epic. Oliveira is an exile from the interior, a major filmmaker in a country that is too small for him, who, as a consequence of its smallness, has

been slow to accept him. Then we learn that twenty kilometers away, in Sintra, Raúl Ruiz is shooting a film tentatively entitled *The Territory*. Ruiz is a true exile, a political exile. He has left Chile, worked in France, and today he wants to make, quickly, a real film, an adventure film: *The Territory* is a movie about cannibalism. Finally, we learn that Wim Wenders has decided to use Ruiz's technical crew (including the great Alekan) to shoot a story that is precisely about flight: the flight of a film producer who abandons his crew. Wenders is somewhat of a voluntary exile, just like Robert Kramer, who wrote the film's dialogue day by day. Its title is *The State of Things*.

Three filmmakers, three exiles, one small country (Portugal), one player (Paulo Branco, involved in the production of all three films is the one who runs the most on that line). A "Portuguese connection"? It isn't certain: Lisbon is not becoming a center, but something like a pole that, for a time, magnetizes us.

II. SHOOTS

1. OLIVEIRA, *Tobis, revisited*

Early 1981. In Tobis Portuguesa's unheated studios in Lisbon, Manoel de Oliveira is finishing the shoot of his latest film: *Francisca*. The morning of my arrival, the crew is setting up for scene 103, one of the saddest in the script (the bedridden heroine is dying and says terrible things). Scene 103 is also shot 103, since the film is constructed Mizoguchi-style according to the principle, "one scene, one cut." They have been shooting very slowly for more than four months, with direct sound (Jean-Paul Mugel) in the studio and on location. This seemingly endless shoot has been slightly infuriating for the freezing yet patient crew, who are aware that they are contributing to an exceptional film, the first in some time that Oliveira has shot in a peaceful environment. The actors warm up at the Tobis-bar, a small cafe-restaurant lost in the midst of newer buildings. The Tobis studios must at one time have been prestigious: today, one seldom shoots there, for security reasons. There are sonic and meteorological breaches: as soon as an airplane passes overhead (the airport is not far away), they must interrupt the take, even if it is a good one. *Francisca* is entirely financed by the IPC (Portuguese Film

Institute); the official Portuguese film community seems to have admitted the existence of a great filmmaker in their country for once and for all. It's about time: Oliveira is 72 (but seems to be in good health).

"You love me, I swear"

Francisca, conforming to Oliveira's inspiration, will be a novelistic film (non romantic). The material is drawn from history and culture specific to Porto (far removed from Lisbon). This time, it deals with a childhood episode from the life story of Camilo (Castelo Branco), the author of the novel *Doomed Love*, an episode recently recounted in Agustina Bessa Luís's recent novel, *Fanny Owen*. The action takes place in the mid-19th century, in Porto, in the aftermath of Brazilian independence. The actors belong to that part of (more or less) gilded youth that professes the most skeptical views when it comes to women and politics. Among them are Camilo and Jose Agusto, his friend. A young and beautiful woman, Francisca, triangulates their relationship. But in a very twisted way, "à la Oliveira." Because he wants to prove to his friend that he is capable of love, Jose Agusto seduces and then steals Francisca away. Will he love her? He abandons and betrays her. She complains in letters to a third, the letters fall into the hands of Jose Agusto who, although he believes that he has been betrayed, marries Francisca. For he discovers that she loves him. Hence the fantastic sentence (on page 83 of the screenplay): "You love me, I swear!" I won't reveal the end of the story, but the reader can guess that it isn't a happy one. One cannot not compare *Francisca* to *Doomed Love*, yet we already know that Oliveira has not abandoned exploring situations that are only about desire and its alienation, passion and its cold exaltation.

A crazy, massive project

Something rare: Oliveira is always ready to talk about what he is working on. Not as an auteur bursting with his own importance but as an experimenter curious to know how other people do it. His relative estrangement from cinema across the globe doesn't explain everything: he has the true awareness of an artisan. During a meal at the Tobis-bar, he talks to me about the subject of *Francisca* (a subject

that touches him personally: he is a distant relative of the film's hero), of how difficult it is to find the proper distance between the camera and the actors, a distance without sentimentalism, without expressionism, without close-ups, with nothing other than sound in lieu of a reverse angle. Abruptly, I ask him about Portugal. It is a country, Oliveira says, that is full of suspicion, where losing is preferable to winning because winning runs the risk of losing later on. The result is a lack of tragedy, a dullness to life. I then ask him then to talk about the crazy, massive project for which he has just asked for IFC support: the "just after the fight" portrayal of the four great battles that were lost by Portugal over the course of its history. We will see Viriathe conquered by the Romans, the "Battle of Toro" that was lost against Charles Quint, the battle of Alkacer Kebir that was won by the Arabs and, more recently, the colonial African wars. It's a very expensive project, Oliveira admits: they will have to use the Portuguese army as extras. It will finally give them a mission.

2. RUIZ

Slowness for Oliveira but speed for Raúl Ruiz, who outruns them all while shooting a film in Sintra whose provisional title is *The Territory*, but whose auteur, smitten with theology, is threatening to call *The Eucharist*. Cannibalism is actually the film's theme. Roger Corman even gave the film money because of it. The story (based only on my reading of twenty lines of synopsis, since R.R. dissuaded me from knowing more) is very simple: Ruiz says that it is his first classical narration, without trickery, without parody. During a trip to the mountains, a group of Americans lose their way, become prisoners to a "territory" from which they cannot escape, are inescapably led towards cannibalism. The film is shot in English and some of its actors are well-known (Isabelle Weingarten and Jeffrey Kime, whom we have already seen in Arrieta's *Flammes*). It's as if the entire film were shot and edited in Ruiz's head, or as if he had completely improvised it. The speed of its execution and the economy of the shoot, a shoot "à la Corman," are striking. Every night, after a day of shooting, the work continues: Alekan feverishly prepares the special effects for the next day (the negligence of the Portuguese labs means that one rarely sees rushes, hence the anxiety), Ruiz works on the film's musical

themes with his regular musician (Jorge Arriagada), and on editing with his wife (and editor) Valeria Sarmiento. He listens to the day's sound with the two young (and enthusiastic) sound engineers, Joaquim Pinto and Vasco Pimentel, who have casually introduced direct sound to Portugal as if it were no big deal. This is how the idea of a "film in progress" whose every phase is conducted simultaneously—or almost—begins to grow.

3. WENDERS

"A director and his crew are forced to interrupt shooting the film they are making for lack of funds, and wait for the money to arrive from the USA. While they wait, they start envisioning another film and the director decides to leave for Los Angeles to track down the mysterious producer." Such is the point of departure of *The State of Things*, produced by Gray City (New York) and Road Movies (Berlin), shot in Sintra, L.A. and Hollywood in 35mm black-and-white (photography: Henry Alekan) and scored by Mink de Ville. The casting is illustrious: Patrick Bauchau (the director), Samuel Fuller (director of photography), Paul Getty Jr. (the screenwriter), Isabelle Weingarten (Anna), etc.

III

The "Portuguese pole" has a center, the Portuguese Film Institute (IPC), whose operations are modeled on the French CNC and without whom nothing in Portugal really gets done. For some time, the IPC has been focused on a new phase in its history. Essentially, it's a matter of *normalizing* the situation they inherited. After 1974, there was a chaotic (and often ill-fated) politicization of filmmakers, coupled with the Institute's asphyxiating nationalization. At one point, the State found itself the sole producer. Despite their good will, it was all the more difficult for the filmmakers of the day (A.S. Santos, A.P. Vasconcelos, etc.) to make their films because they belonged to a generation—the Portuguese New Wave of the late sixties—that, with a few exceptions (such as Paulo Rocha), could not, under Salazar, make *his* films in time. So much so that the great films of that generous, talkative, and troubled era were made by

mavericks (Oliveira or Reis's *Trás-os-Montes*). In 1981, the collapse of discourse, the end of difficult superegos, the return of the right to current affairs and the energetic action of certain officials (such as Vasco Pulido Valente) allowed for the return of a relative autonomy to the media and, within it, to cinema. This is how the IPC will redefine its role. Two of the principal officials whom I meet in Lisbon, Sa da Bandeira and Helena Vaz da Silva, define it as: serving as a mediator between filmmakers and those in political power, returning the films shot before 1975 to their authors, supporting and financing prestigious projects (such as *Francisca*), moving towards foreign co-productions, doing everything it can to reconcile Portuguese filmmakers with their audience, promoting a festival in Estoril, more "in" than the one, although excellent, in Figueira da Foz, etc. Basically, for Portuguese cinema this normalization amounts to facing *normally* the problems inherent to the national cinemas of small countries, often destined for foreign prestige and native neglect. No Portuguese film can actually compete commercially with the Indian films (to say nothing of the American ones) that fill the theaters in the heart of Lisbon. The situation is all the more difficult because Portuguese cinema, even when reduced to six films per year, is a cinema of auteurs, of isolated inventors, of obsessional bricoleurs. The common ground of all good Portuguese filmmakers (from Oliveira to Reis, Paulo Rocha or a newcomer like João Botelho), is their artistic integrity, in the most romantic sense of the word. It is also a certain relation that they hold to the history of Portugal, a relationship of powerful, archeological, and voiceless mourning. If Portuguese filmmakers have not been able to talk about the aftermath of April 25th (the best document on that era—*Torre Bela*—was made by a foreigner, Thomas Harlan), they are beginning to be able to speak about the past through the most modern art forms. The (upcoming) films by Bothelho and Paulo Rocha that I was able to see confirmed this idea. It's this idea that the IPC officials will need to support *as well*.

(*Cahiers du Cinéma* #322, April 1981)

ANSWERING MACHINE CHRONICLE

I. A NOTE ON TELEVISED DEBATES

Having become, since 1968, both social rite and incendiary scene (a scene where, aided by censorship on both sides, something is always likely to *happen*: a mini-happening, such as the recent intervention of the two-bit nazi D. de M. during a debate concerning the military, or the opposition of the Grand Orient de France to the broadcast of a film devoted to freemasonry), the televised debate is always rich with teachings. Who's pulling the strings? What strings are there to be pulled? And what are they made of?

It is not enough to say that it is an opportunity for some to *take the floor* (and to give voice to a new and radical discourse at all costs: strategy of the left), for others to *hold the floor* (cloud the issue, obstruct, occupy airtime: strategy of the right), and for the spectator to enjoy (while counting punches) this ludic and depoliticizing mise-en-scène.

We must also say: the televised debate is *a machine that sorts out what, at any given moment, constitutes or does not constitute mass debate*. It is a precious indicator (precious for those who are able to utilize it, primarily political operatives) for knowing what discussion public opinion considers acceptable (what it finds problematic, what subjects allow for debate, tolerance, a plurality of opinions) and what it wants to know *nothing* about (i.e.: the army, the taking of hostages, prison) because it is afraid. Do you think that it is irrelevant to Chiraponiac to know what people are afraid of?

Let's take one example. Giscardian television, with the noblest of intentions, devoted its "Dossiers de l'écran" on July 1st 1975 to a

serious issue: prison conditions. Or, more precisely: "Why are there prison riots?" Six people were assembled. Three to take the line of the political system in question (Bonaldi, deputy director of Health; Reffetin, sentencing judge, and a magistrate, Nicot). Three to take the line of experience and/or subversion: Livrozet, leader of the CAP; A. Lazarus, doctor; and a former inmate-who-has-paid-his-debt-to-society, Bouloux. In a sense, the program's main event was Livrozet's presence, and the opportunity he was given to benefit from a significant platform.

Let's skip the course of the debate itself, the points that were made by both sides (even if some were naive and immature, such as Bonaldi saying to Livrozet—whom he did not look at once during the entire program: "I don't talk about Freud to an inmate who's holding a chamber pot full of feces in his hand!"). What is even more serious, is that on Guy Darboy's switchboard (the equivalent to the voice over, the voice of truth and of polling), the telephone calls are categorical: 99 percent of people agree on one point: prisons are necessary, it's normal for conditions there to be difficult, and riots are totally unacceptable.

Rarely has the discrepancy between the theme of a debate (why prison riots?) and public opinion (which is settled) been so flagrant. Where Livrozet tries to ask, "Why does a riot begin?," where Jérôme tries to return to the question, "How docs a riot begin?," a majority of TV viewers say from the very beginning, "No more riots!" And they also say: "We don't want to hear anything about it!"

Questions. Did Darboy/Jerome anticipate such a divide? That would be Machiavellian, but it isn't clear. They may very well have thought, motivated by the need to pull off a journalistic scoop, that it would be risky but interesting to raise a question on television that, seldom raised by the masses, rattled the repressive machine (c.f. Bonaldi) and mobilized a section of the extreme left (for whom everything in the realm of "discipline and punish" is the order of the day). Thus the program amounts to bringing questions before the silent majority that were until now brought by a raucous minority.

TV wins at this game. It wins twice. First, it seems much more tolerant, more liberal, more intelligent, more "leftist" than TV viewers as a whole. TV as the final bulwark against intolerance, the

last studio where one can still chat! Gold star for Giscard. Then, it ensures (it delivers proof) that the question of prisons, above all else, frightens people. That it isn't "popular." Which for Poniachirac is a good sign: continue, fearlessly, with your repression.

As for the audience, things are less simple. How much weight should we give the 99 percent who are in favor of repression? One thing is certain: if prisons are (along with asylums or hospices) something that we absolutely don't want to talk about, it is because every family (and TV is viewed as a family) *has at least one person locked up.*

That is why every battle that has been fought on fronts dubbed "secondary" since 1968—insofar as they touch upon the subjective conditions of the survival of the familial apparatus—is far from popular. The school, the asylum, the barracks, the prison, the nursing home, *relieve* the family—who do not want to see them make their return through the window of their television screens. With that non-popularity, the right (Porachiniac) is having a field day (see below).

2. A CHRISTMAS STORY

December 25, 1975, on A2, G. Coulonges's *La simple histoire d'un merveilleux poste de télévision* (A simple story of a magical television set). Direction: A. Ridel.

A grey and joyless small town in the provinces. On a bench, four elderly people. What are they talking about? Television, the passage of time, ungrateful children, television. One doesn't want it under any circumstances (he only likes books), one has it (with all three channels), one has it on a smaller scale (with only one channel), and one, too poor, doesn't have it at all. Everything will change for her (Orane Demazis), the heroine of this simple tale.

One day, her son (and a formidable daughter-in-law) arrive to force the gift of their old television set on her (they have just bought a color model). The old woman's life is considerably changed. A simple soul, she starts to talk, to chat with the people who appear on the screen. Is it a miracle? Jacqueline Huet, the weather guy, Pierre Doris respond.

To her friends on the bench, this old woman in direct communication with the television becomes a subject of concern mixed with a

hint of disapproval (are they jealous because the TV hasn't said any-
thing to them?). They eventually warn the son, who, to "take her mind
off things," makes her come to the city to visit him, meaning to visit the
family. In front of the family TV, the old woman tries—in vain—to
resume the dialogue. Dejection of the family and visit by the son to a
"psychosomething" who asks him, face to face, "Have you tried talking
to the television? No? So how can you be sure it won't answer back?"

From there, things move very quickly. The old woman returns
home and dies, broken by the experience. After the burial, the chil-
dren try to swipe everything of hers that they can. The son turns on
the TV, in a daze. An announcer (J.-M. Desjeunes has just finished
reading the news). The son dares to speak (about his mother) to the
announcer (who quite willingly answers: "Yes, we know your mother
well"). Miracle? Better: the dead mother then appears onscreen,
smiling, addressing the announcer, saying, referring to her son, "He's
a good boy, you know…" *The end.*

What is this little Christmas story an example of? For one thing,
that television *knows* exactly what it is doing: managing the crisis of the
family unit. Taking charge of what the family has become incapable of
not excluding: children and above all the elderly. And if the nursing
home is—in reality—the abject location where families come to relieve
themselves of what is already dead to them, it is up to television—in
the imaginary—to reassure everyone. And it is all the more readily dis-
posed (that is the meaning of this Christmas story) to do so because the
elderly are such a good audience, because they have such a tenderly
naive and absolutely un-Brechtian relationship to the images proposed
to them, such a *personal* relationship, that there isn't too much to worry
about when it comes to the places where they see those images.

It is also an example of something that can only be outlined here.
The acronym ISA (Ideological State Apparatus) has been too lazily
used, with no attempts to understand it in greater detail. But chances
are that *in every ideological phenomenon, something comes into play in the
order* of what J.-P Oudart in these very pages ("A power that does
not…") called the *answering machine,* a subject that deserves a column
of its own (see next issue).

(*Cahiers du Cinéma* #264, February 1976)

3.

"In the same way, the impression made by a thing on the optic nerve is perceived not as a subjective excitation of that nerve but as the objective form of a thing outside the eye. In the act of seeing, of course, light is really transmitted from one thing, the external object, to another thing, the eye. It is a physical relation between physical things. As against this, the commodity-form, and the value-relation of the products of labor within which it appears, have absolutely no connection with the physical nature of the commodity and the material [*dinglich*] relations arisine out of this. It is nothing but the definite social relation between men themselves which assumes here, for them, the fantastic form of a relation between things."

— Marx, *Capital*. Volume One, p. 165
(Penguin Classics, Ben Fowkes, trans.)

"Something's always happening at Galeries Lafayette!"

What does this mean? It means that in department stores, we will find what we *desire*. It also means that department stores have a monopoly on offering us these objects. It also means that they've held this monopoly for a long time, even before we were aware of it. When you have *one* desire, department stores have already satisfied many others. Hence a retrospective effect: we arrive late, we are placed before the fact of an already-established power. And the answering machine's message says this, too: *the very act of its recording* will be forever concealed from you, forever replaced by a false present. This message thus shields the reality of power (of its acts), its mode of reproduction (institution + reproduction are replaced by the repetition of an untraceable origin: something is "always" happening because nothing has happened [power hides the moment of its "seizure": it is not a despotic power]). It does not present itself as a decision, but as something that endorses itself, repeats itself, on the condition of promising, with each new turn of the wheel, something new, an event, chance, passion, love, soft nougats, etc.

Direct connection of the subject to fantasy (to merchandise's erotic power of attraction): short-circuit of the desiring relation, since desire directly finds its object. Generalized perversion.

"Always happening…," in its undecidability, could mean: the Management organizes little skits for the customers (games, promotional sales, bonuses). Or even: customers see each other, talk to each other, watch each other, etc. (store as social site). Or even: something is happening between sellers and buyers. (Memory of the 19th century: the department store as location for high society.) Space of jouissance and not only of desire.

Space of jouissance: it disappears, it's forgotten, it's placed between parentheses, which is just fine because it always functions, *permanently*. Permanence, perpetuation of capitalist *jouissance*. In a violently segregated space (nothing more repressive than a mall: cops, surveillance, security goons), where nothing is really won or lost, and where economic exchange is not the only rule, not by a long shot. Space of jouissance as a blind spot of capitalist exploitation that supports the regime, since the mise-en-scène of the marketplace, the mode of distribution of value products and their very form shields the system of reproduction of proletarian labor and the system of monopolistic distribution. The marvellous capitalist, the merchandise that dances by itself, shields the work of "dead labor." Dead labor thrives on life: the capitalist institution demands that you bring to it your drives, lend it something that will not be returned to you, or rather something that will be mysteriously traded before your very eyes, the one-franc coin that, just after it is swallowed by the pinball slot, makes its return—from the inside of the machine—in the form of three little metal balls whose erratic course defines the space of jouissance on a slanted platform where nothing can be won except a replay. Extra time (Again!) The perpetuation of a surplus *jouissance* [*plus-de-jouir*] whose object (*objet a*) Marx singles out in the form, enigmatic, of the *fetish*.

Following Marx's text to the letter, the commodity fetish is an object that *gives us the eye*, thus it functions in a privileged way as the driver of desire through the relay of the scopic impulse. The voice formulates the apparatus' demand and assures that there will be a response to your needs, which are, in a certain way, *met in advance*.

[with Jean-Pierre Oudart]

4.

This man has good reason to be proud. Through the power of a game show ("The Inspector Investigates," produced for TF1 by Jean-Luc Godevais), he, a mere TV viewer like so many others, has just been transformed into an inspector and, as we can see by the photo, an absolute master of media (note the hand that holds the pen). The concept of the show is this: a police drama is invented and performed by actors who file through the inspector-contestant's office. It's his job to grill them. His job to say who the killer is. If not, he loses. He must simultaneously be brutal, inflexible and wily as he confronts the suspects. He must be a reflection of every cop played by true, talented actors, who are—as worn-out inspectors, polymorphic Maigrets, poorly-dubbed Untouchables—the heroes of the small screen.

We often wonder, with the emotion that accompanies every question destined not to receive an answer, what cinema's impact is on those who consume it. Not its influence, but its propaedeutic value, what there is in it that can be imitated, *mimicked*: attitudes, gestures, tones and grains of the voice, sartorial tics, etc. Television may provide an answer. In that it invites its contestants to emerge from the general consumption of images of police and police practices and reproduce them in a televised game that is also *their* game.

These *simulation* exercises, in so far as they give the contestant the illusion of fabulous power (being seen impersonating a cop by all of France), and objectively prepare him to learn how to exercise repression, demonstrate how the little portable cinematheques in the heads of television audiences may today become operational.

(*Cahiers du Cinéma* #265, March–April 1976)

5. A GRANDPA IS BEATEN

A persistent myth: that on television, there would be only a set of questions and answers. Nothing could be further from the truth: what matters in television is neither questions nor answers, but the *stage on which they are performed.* The debate of ideas and its ritual (the survey, a level playing field, etc.) is a simulacrum. What plays out is never a debate, but a *scene.*

This was particularly evident in the case of the "Philippe Pétain" program, because, on the switchboard, *there were no questions.* The audience weighed in on the proposed theme with the sole purpose of putting "pressure," behaving not as a collection of citizens each endowed with a "personal opinion" but as a lobby of ideas. Their only aim: inscribe a visceral cry somewhere. Hence there were 80% visceral cries and 20% (very old) questions.

Television achieved its goal as soon as it had *simulated* a debate on a stage that it had already *actually* chosen and imposed. In the case of the program, "Philippe Pétain," this stage belonged the Pétainist himself. The only questions asked were the ones that, for twenty years, have *only* been asked by Pétainists. We know them well: a mix of backwards geopolitics (Pétain, sidereal strategist), conceited morality (Pétain, sacrificial elder, sold soldier) and resentment ("there were excesses on both sides"). As for the conceptual system, it was the boilerplate argument: Pétain did the right thing, and anyway, he was old, and the resistance committed atrocities, too.

What we must recognize is how the program had *necessarily* to reach that point. Then we can see that the fiction of "liberal debate" is itself very useful. Initially, TV decides: "Let's dare talk about it, let's

dare have this debate, let's dare dredge up the past." It acts as if people are actually curious about Pétainism, want to discuss it calmly, to know more, to understand something. As a result, it lures us with its Giscardian image: the only forum where intolerance is prohibited, the love of truth is cultivated and the dirtiest laundry collectively cleaned. Nevertheless, it wasn't very hard to see and to know [*(sa)voir*] that this was not the case, that the communist Resistance fighters would not participate, that the non-communist resisters would refuse to sit at the same table (table = stage) as a Girard. They had said as much, right away: Noguères in *Le Monde* and Lévy on television. They felt obligated to describe the way in which the debate appeared to them to be rigged. Lévy even intelligently pointed out that the Resistance fighters, being busy with resisting, didn't have the time to create their own images, their archives, and had nothing to oppose—*in terms of media* (as if they felt that, today, that's the only thing that counts)—the Pétainist archives that, weakly annotated, were used to introduce the debate. Hence the stage imposed on everyone.

The point was not to impose a discourse (that would be too much), but to occupy speaking time (Isorni who lives from it, Auphan and Girard who have waited thirty years for it) with the traditional Pétainist discourse. That discourse presented itself from the start on a familiar stage, that of an exhausted lumpen-morale, assured that it would *no longer* find anyone to *politicize the debate* on the other side. Over time, yesterday's Resistance fighters have lost the right and the credibility to speak politically today about what they did yesterday, some, such as Lefranc, having become the extreme right of today. The final intervention thus consisted of disqualifying—before he had even opened his mouth—Robert O. Paxton, the only person who was able to speak calmly, competently, about Pétainism's political content, probably because he is too young and too American.

After that, the film "about Pétain" consisted only of the introduction of official and, of course, rare documents. After roaring that one out of every two French people today don't know who Pétain is (Pétain, never heard of him), they presented a film that assumes his history to be entirely familiar. For the knowing audience: slight touches, connotations, the recognition of beloved or hated images.

For the unfamiliar: comfort in the idea that Pétain, decidedly, is something like a *screen memory*.

Regarding the interminable and occasionally touching clash of the old-timers that followed: to his worshippers as well as those who despise him, Pétain is only a signifier: he hides something. For some, he made a shield of his elderly body to give his people time to breathe (the thesis: *Pétain as saint*). For others, he interposed that same elderly body to hide the truth, delay the Resistance and sell out the country (the thesis: *Pétain as puppet*). The result was a program dedicated to *an individual who will never be discussed*. As if, for both sides, Pétain was only, from 1917 to 1945, a meek and colorful phallic emblem, immaterial in itself. It is this emblem that Isorni has, once again, saved.

Let's be clear: it would not have been a bad thing to disrespect Pétain, to spit on his grave a little, to have the youngest people who know something about Pétain (a Gérard Miller, for example) speak. For it is one thing to treat Pétain as a screen, another to understand how that screen functions as a constituent part of the French State's plan. So we must talk about Pétain, about that original blend of charisma and senility, try to understand how, wanting "to pass, high, over the bar of castration" (in the words of Daniel Sibony), a portion of the French public who overrun the switchboard with their screams, handed over that bar to an old man whom they were sure wouldn't enjoy it too much, allowing him to sing under the occupation.

P.S.—Of course, the program's real subject (the political issue) is not understanding the Pétainist phenomenon, or the why and how of collaboration. Those debates are real, but not very current. The true debate involves a subject that is otherwise more serious, more misunderstood, and more contemporary: *purging*. In other words, the abuse of something that resembles a civil war, while France is effectively violently cut in half.

(*Cahiers du Cinéma* #268–269, July–August 1976)

VOLLEYS

TENNIS' TELEGENIC ADVANTAGE

The reasons behind tennis's sudden rise, as sport or as spectacle, are various. Television actively participates in it; tennis is in fact one of the sports that translates best to the small screen.

Saturday, July 14. While watching the Davis Cup's lackluster doubles semi-final with Noah/Moretton against the Czech duo Kodeš/Smid, I couldn't help thinking that at least tennis has an advantage when seen on television. It is, as they say, the sport that "loses" the least and "gains" the most. For someone who loves both tennis and moving images (and even more for someone who enjoys watching movement within images), there are great moments to be had on the small screen. *Great moments* for everyone: Borg falling to his knees after beating Tanner in five sets at Wimbledon, Pecci crouching, breaking into a run while slowly raising his arms after match point against Connors at Roland-Garros, or even (but this match may not have been televised; it too was at Roland-Garros, against the Australian Cash, and Jacques Tati narrated it, or better yet: mimed it) Connors accompanying a lucky shot with a friendly gesture towards the net, as if to say, "You are my friend!" It's with gestures like that one that Connors won over the crowd at Roland-Garros. But there are also an infinite number of subtle movements, down-time, minuscule events, without significance, or on the contrary, packed with meaning (we'll never know), of *tiny moments*, perhaps for only one television viewer (but that isn't important) that the camera, strict but fair, captures at the moment they appear and that offer themselves, if one wishes, to be read. If we were to take

every sport on television one by one, we would soon see that many of them translate badly or not at all. Impossible to reproduce what goes on within the peloton at the Tour de France: we are forced to obsess over the final kilometers and the finish line.

Several factors play a role in tennis's telegenic advantage. First of all, everything that happens on the court is immediately visible by everyone: as in a bullfight, the time of seeing, the time of under-standing, the time of judging, the time of reacting, are nearly conflated. We see, at the moment it occurs, one match happen or come undone, a strategy succeed or fail, a body slacken, reflexes wane, tics invade, an intention impose itself. The "replay" is not what it is at the track, there to make manifest something that couldn't be properly seen, but to allow us to aesthetically re-enjoy something that was perfectly seen once again.

Next, it's tennis, more than many other sports, that produces the clearest, most legible emblematic image of modern sport: a violent telescoping (that derails all discourse, somewhat) of money, the body, and power. There are billions of dollars at stake on the court (spon-sors on the players' jerseys, the BNP ball-boys and girls), but there is also the exhibition and testing of trained bodies, making propaganda out of their training (moralizing training: the greatest player in the world, Borg, doesn't party, he is "serious").

Finally, there is a third reason, that refers more to the medium's aes-thetic: that ideally, it would be possible to make the limits of the court and the borders of the frame coincide: ultimately, out balls would be "out of frame." Cinephiles find this to be food for fantasy, at least that variety of cinephiles, still common, whose cinematic pleasure depends on the back-and-forth between what's in and out of frame.

All of these reasons perhaps explain why tennis appears more and more to be one of the richest spectacles that can be seen today. With one restriction: tennis is still very "white." One day it must be asked to what extent tennis is an essentially "white" game and the extent to which it will no longer be. For now, it suffices to say that, although (or because?) it remains so white, tennis has recently become more savage. The manners of the tour are changing. The monsters are finished with gentlemanly tennis, with the contemptuous elegance of those who have "class for others." Of course, we enjoy watching Ashe,

Smith, and Panatta, but it is clear that Connors's two-handed backhand is another story. We are at a pivotal moment in tennis: it is reinventing itself before our very eyes.

And so, we must go back to the beginning: if tennis translates best to the small screen, how can the small screen best render these changes in the game? Vicious circle. Everyone is beginning to realize that one effect of the media is to modify what it broadcasts in return. In this way, the increasing coverage of tennis on television risks changing the game itself. And always in the direction of what is most spectacular. Television, inevitably, necessarily warps things. For example, when the cameras are always positioned on the bleachers at the back of the court we certainly get a good picture of the match's tactical play, but we lose everything concerning how the ball is struck, the violence of the physical engagement and even the effects of the ball's trajectory. Seen from above, looking down, tennis satisfies the referee in us, but to the detriment of something else. Borg's game seems dull and facile because, from that angle, the lift he gives his shots goes almost unnoticed. In order to capture another truth, one would have, at times, to do as the BBC sometimes does: film at the player's level, but behind him, at an angle, and pan, in slow motion, to discover another tennis, not impeccable geometry seen from above, but a curved, rigged space seen from below, where air is at a premium. This is only one of many points. One day we must (and not only in tennis) imagine new and newer ways of placing the camera (and the microphone) and of accompanying the body in its images.

(Libération, 16 July 1979)

PERFORMANCE ANIMALS

The big loser of the McEnroe-Connors match, filmed by CBS and rebroadcast yesterday evening until late into the night by Antenne 2, wasn't Connors, who lost in a fifth set tie-breaker after more than four hours of a gut-wrenching match, but the commentator from French television who exhausted himself trying to convince us that he was "following" what, clearly, went too quickly for him. If he had

only, humbly, kept quiet! I understand that television, of all places, is the one where such a deep fear of images reigns that we would feel obligated to comment on all of them, but still, those prone to commentary (which is almost always babble) must nevertheless understand that if they insist on talking so much during the match, they had better show more technical competence (like the inhuman Darmon) or more skill in pathos.

Particularly because yesterday, at Flushing Meadow, it wasn't only images that came to us, but *sounds*! Of the ball, of Connors's yelling, of McEnroe's invectives toward the referee, and of the planes incessantly flying over the court (LaGuardia airport is right next door). When a plane passed overhead, the image of the two players tilted toward a kind of silent movie, a sort of improbable choreography, as if they continued to clash with each other outside of time. Intense moments in a difficult match where the players demonstrated the same bad temper (bogusly dished out by McEnroe, bogusly held in by Connors: both are in fact cold-blooded animals), the same will to win, to the point of rage. War in the American family, as the CBS camera showed us by filming only the "celebrities" in the crowd, and among them the parents of the players. Curious, indeed, how the CBS technicians, by the way they position the camera, pick up the sound and present the image, unconsciously discover the American melodrama. After match point, it's not McEnroe who is filmed but his father, a fat man with a cold and wicked stare, McEnroe Sr., Mr. 10%. If Connors had prevailed, we probably would have seen Mrs. Connors, who yelled at her son a short time ago, "Kill him, baby!"

The way the two men, while sometimes acting as if they're breaking away from the game (as if they suddenly realized that they are also performance animals), became war machines in the end was striking. Terrible moments when, from one side of the court to the other, it wasn't only the ball that passed over the net but a racquet thrown by McEnroe at Connors (a 250 dollar fine), out of pure hostility. The players took risks, missed easy points, won impossible ones. The play was sad, sober, without swank or sentimentality. At this level and after three hours of play, one wondered if the match had become a physical and moral affair. The winner won't be the one who can return every shot, it won't be the one able to stave off

exhaustion, it will be the one who wants it to be over. At that level of acrimony, you would want it to be over. McEnroe is a great player because he knows that in due time he will become himself again; like a drowning man who calculates with calm horror how long he will stay underwater.

<div align="right">(<i>Libération</i>, September 8, 1980)</div>

THAT INIMITABLE "SEVENTIES" DIALOGUE

On the court, the tennis pro plays against four adversaries: the other, the public, himself, and time. In time, under the public's watchful gaze, he becomes an other to himself. It's what we call "aging." Through television, we have watched Jimmy Connors age; at 28 he has become the veteran of this 1981 Masters. He was at one time, six or seven years ago, the best player in the world and also the one who behaved the worst on the court. Once he was no longer the strongest player, he turned comic, and the public began to laugh with him and love him. At Roland-Garros, where he has never won, he has been the only one who knows how to smile with his audience.

Saturday, at Madison Square Garden, on that sky-blue and rubberized court that reminds us of one of David Hockney's pools and amidst the rumbling of a disaster film, yet another Connors made an appearance: bearded and serious, alone with himself and with the idea that Borg, whom he has not faced for some time now, remains within his reach. The greatest moments of tennis and television in this semi-final were those in which Connors, in close-up, his eyes fixed, seeing nothing, heard the call on a play decided against him as if in a bad dream, allowing the echo of the verdict to reverberate within him and walking like a sleepwalker, without hope, towards the judge's chair, as if moved by an automatism in which all sense of meaning has been lost. There was a loneliness in Jimmy Connors on Saturday night, the loneliness of a cartoon character who thinks that as long as he doesn't look down at the abyss that lies beneath him, he cannot fall.

Borg and Connors have played against each other many times. Their dialogue was the most beautiful one of the 1970s because it

was a true dialogue. It is clear that today they have nothing more to say to each other, tennis-wise. Their meetings unfold according to an increasingly immutable script: Connors rushes Borg, doesn't solidify his advantage, is outflanked, comes back with courage and tenacity, then surrenders.

Today, the psychological element (Connors has not given up, Borg does him no favors) is the only part of their dialogue that remains; the tennis element is both gorgeous and annoying (the long exchanges at the rear of the court, like furious citations, Borg's lift and Connors's flat play). That's why, over the course of this semi-final, there was so much irritation, very little peace, even less concentration and, curiously, few faults and almost no double faults. Because each only did what he knows how to do. There was the sense that something stronger than the two players was driving them to reenact a shared script, a script of failure for one, and victory for the other. Failure and victory being equally difficult, Borg no longer gives the feeling of playing as if his life depended on every shot and he knows that he is no longer untouchable (this year, both McEnroe and Lendl have beaten him).

On the small screen, there was something fascinating about this semi-final, something about Madison Square Garden, about the reactions of the crowd and the way in which CBS filmed all of it.

The cameramen opted for wide shots of the stadium at the expense of close-ups or inserts that would often have been welcome. Americans don't have the same idea of what is spectacular as we do, and they see tennis more like a boxing than bullfighting Mass on the clay of Roland-Garros. Their aesthetic choices (let's not be afraid of the word: there is a televisual aesthetic, especially powerful because it is practiced unconsciously) are therefore different. And so, because Borg and Connors adopted a clay court style, we missed many shots because the cameramen didn't have time to reframe them.

As for the sound, conversely, the acoustics in the stadium were such that for the entire match there was a kind of marine swell, an unleashed conch, as if all of the noise of the city, amplified by a hyperrealistic technology, had come to die on a blue rectangle under a glazed look in the players' eyes.

(*Libération*, January 19, 1981)

A RISKLESS, SOULLESS MASTERS

Weak match, weak score, weak emotions for the Masters final, which failed, once again, to keep its promises. But what promise could an "invitation-only" tournament, decided in two winning sets, on a kind of linoleum, with players paid in advance, really have?

As soon as it became clear that there would be no American in the final, the crowd at Madison Square Garden became cold and correct, assisting without malice in Lendl's execution. While the best experts thought that the match was doomed to a sort of eternality and acclimated to the idea of five sets and a sleepless night, it all ended quickly and was forgotten even more so.

There were many long rallies in the first set when Borg systematically played on Lendl's returns (his weak spot), accelerating at the perfect moment, always maintaining the game's initiative, dominant but without excess, in the second and third sets. He needed only to increase the pressure without changing tactics, and Lendl came undone and surrendered fairly quickly, irritated by a first serve gone suddenly slack and discouraged by the speed of play.

Ivan Lendl should have been the star of this match, as he was the star of the year 1980. He is obviously a very gifted young man. At twenty, he earns more than 500,000 dollars per year, has earned victory for his country in the Davis Cup, plays in every tournament (he has won seven: Houston, Toronto, Barcelona, Basel, Tokyo, Hong Kong, Taipei). Is he one of tennis's future greats or is he already an automaton?

In light of this Masters final, we are right to lean towards the second conclusion: like many players from the East (Fibak, Taróczy, Metreveli, Nastase being an exception), he tends to adapt his play to the other, to try to beat him at his own game, but he brings nothing personal to the match. We asked ourselves, watching him this year at Roland-Garros, if he had a soul. The question remains.

With respect to his body, in a short amount of time he has gained muscle mass in which he seems to float, just as he appeared, several years ago, a super-talented weakling, to float in his black t-shirts. There is something lost and cruel in his gaze, a hatred that hasn't yet found what it should fix itself upon, a rage at the idea of losing rather

than a mad desire to win. Lendl remains a bizarre mix of talent and arrogance. The future will tell what will come from it.

That said, the frustration that we felt at the end of this 1981 Masters was with the competition itself. The Masters has existed for ten years, four of which have taken place in New York, where it has become a major event. The competition matches up the eight players who have accumulated the most points over the course of 92 organized tournaments in thirty countries (including, for the first time this year, mainland China and its Canton tournament, won by Connors).

These eight players are the eight supposed "masters" of worldwide tennis, which is roughly the truth. Be that as it may, the Masters is not a real tournament, but rather an exhibition with lots of money (each player receives 300,000 dollars before even having begun to play) and egotism at its center.

It corresponds perfectly to the demands of American television, which for several years has called the shots in tennis. Everything that once allowed for a match to be almost interminable, a limitless countdown (to the great joy of obsessives, those specialists of "remaining time") has been excised to produce matches that are shorter, faster, and easier to program for television. Disappearing simultaneously are those charms of the great old tournaments (the grand slams) that still exist; the risk of a favorite being "knocked out" in the first round (we know how this haunts Borg), the chance for a marathoner to combat exhaustion or an unknown to shine (no one has forgotten, except Pecci himself, the Borg-Pecci final at Roland-Garros in 1979). This acceleration is the downside of tennis's success. It is not in itself a bad thing, but it is meaningless unless it frees up possibilities for new opportunities and adventures. On Sunday, that was not the case.

(*Libération*, 20 January 1981)

Index

Berg, Alban, 273
Bergman, Ingmar, 27, 71, 212–214,
222–223, 268, 277, 334, 374, 486
Bergman, Ingrid, 493
Berlinguer, Enrico, 165
Bernal, Ishmael, 540
Berry, John, 492
Bertheau, Julien, 229
Bertolucci, Bernardo, 333, 334, 335
Bessa Luís, Agustina, 546
Between Heaven and Hell, (Fleischer),
69, 70
Beware! The Blob, (Hagman), 189–190
Beyond a Reasonable Doubt, (Lang), 405
Bicycle Thief, The, (*Ladri di biciclette*),
(De Sica), 265
Biette, Jean-Claude, 6, 26, 202, 237, 310
Big City, The, (*Mahanagar*), (Ray,
Satyajit), 327
Big Gundown, The, (*La resa dei conti*),
(Sollima), 107
Big Night, The, (*Le grand soir*), (Reusser),
193, 195, 424
Big Sky, The, (Hawks), 35, 36
Big Sleep, (Hawks), 31, 36
Bigger Than Life, (Ray, Nicholas), 324
Binner, Fritz, 458
Birds, The, (Hitchcock), 93
Bismarck, Otto Edward Léopold von, 212
Bitter Victory, (Ray, Nicholas), 324
Black Star, The, (*L'étoile noire*), (Maïga),
412
Blanchot, Maurice, 67, 243, 322, 493
Blier, Bertrand, 264–264
Blind Ambition, (Schaefer), 515
Blind Child, (*Blind Kind*), (Keuken),
318, 320
Blind Venus, (Gance), 59
Blizzard, The, (*Gunnar Hedes saga*),
(Stiller), 301, 302
Bloom, Claire, 225
Blow for Blow, (*Coup pour coup*),
(Karmitz), 426
Blue Panther, (*Marie Chantal contre Dr.
Kha*), (Chabrol), 51, 52
Bluebeard's Eighth Wife, (Lubitsch), 94,
95, 96

Bob & Carol & Ted & Alice, (Mazursky),
193
Body and Soul, (Micheaux), 492, 493
Bogarde, Dirk, 73, 109
Bogart, Humphrey, 35
Boisset, Yves, 23
Boková, Jana, 475
Bonaldi, Aldo, 554
Bond, Ward, 295
Bondarchuk, Sergei, 255
Bonitzer, Pascal, 16, 240, 317, 321, 342
Bonjour Tristesse, (Preminger), 40–42, 89
Bonnes Femmes, Les, (Chabrol), 51
Bontemps, Jacques, 310
Bonus, (*Premiya*), (Mikaelyan), 21,
219, 222, 273
Boorman, John, 468, 471
Borg, Björn, 565–567, 569–572
Borges, Jorge Luis, 64, 65, 376
Bormann, Martin, 442
Borom Xam Xam, (Dores), 412
Borowczyk, Walerian, 272–273
Borsalino and Co, (Deray), 165
Bortoli, Barbara De, 333
Bory, Jean-Louis, 130, 341
Bossuet, Jacques Bénigne, 147
Botelho, João, 549
Bountiful Summer, (*Shchedroe leto*),
(Barnet), 486
Bourdieu, Pierre, 6, 472
Bourguiba, Habib, 403
Bowser, Pearl, 492
Boy, (*Shōnen*), (Ōshima), 283
Boy with the Green Hair, The, (Losey),
128, 129
Boyer, Charles, 97, 442
Boyle, Peter, 516
Branco, Paulo, 545
Brando, Marlon, 231, 247, 250, 469
Brassens, Georges, 263
Breakfast at Tiffany's, (Edwards), 56
Breaking with Old Ideas, (Li Wenhua), 21
Breathless, (*À bout de souffle*), (Godard),
431
Brecht, Bertolt, 128, 309, 324, 355,
367, 411, 441
Brezhnev, Leonid Ilyich, 443

Brennan, Walter, 32
Bresson, Robert, 15, 22, 27, 85, 216,
 270, 271, 285, 376, 476
Breton, Émile, 357
Bride Wore Black, The, (La mariée était
 en noir), (Truffaut), 119
Bringing Up Baby, (Hawks), 32, 35
Broca, Philippe de, 337
Brocka, Lino, 540, 541
Broken Lullaby, The, (Lubitsch), 97
Broken Strings, (Bernard B. Ray), 493
Brontë Sisters, The, (Les sœurs Brontë),
 (Téchiné), 240
Brooks, Mel, 210
Brooks, Richard, 99, 100, 115
Brown, Helen Gurley, 53
Broyelle, Claudie, 152
Buchwald, Art, 514
Buñuel, Luis, 161, 183, 202, 268, 283,
 311–313, 334, 454
Burlesque on Carmen, A, (Chaplin), 211
Burning of the Red Lotus Monastery (Xin
 huo shao Hong Lian si), (Yu), 524
Bussières, Raymond, 193
Butterfly and Red Pear Blossom, (Die
 ying hong li ji), (Ti-sheng), 521
Butterfly Murders, The, (Dip bin),
 (Hark), 531
By Hooks or by Crooks, (Xian yu fan
 sheng), (Maka), 528
By the Bluest of Seas, (U samogo sinego
 morya), (Barnet), 486

Cabaret, (Fosse), 212
Cabinets de physique au XVIIIe siècle, Les,
 (Rohmer), 299
Cagney, James, 33
Cai Chusheng, 534
Calderon, Gérald, 279
Calm, The, (Spokój), (Kieślowski), 513
Camera Buff, (Amator), (Kieślowski),
 498, 500
Camille, (Cukor), 110
Camouflage, (Barwy ochronne), (Zanussi),
 476, 499, 500, 503
Camus, Albert, 154, 268
Cancer, (Rak), (Belmont), 178

Capital, (Das Kapital), (Marx), 557
Capote, Truman, 100
Capra, Frank, 435, 441
Caprioli, Vittorio, 184
Carabineers, The, (Les carabiniers),
 (Godard), 244
Cardinal, The, (Preminger), 90
Carmen, (Bizet), 273
Caron, Leslie, 499
Carradine, John, 295
Carrillo, Santiago, 154
Carthage en fête, (Amar), 403
Casablanca, (Curtiz), 493
Cash, Pat, 565
Cassavetes, John, 27, 231
Cassenti, Frank, 221
Castel, Lou, 275
Castelo Branco, Camilo, 235, 236, 310,
 546
Cattle Queen of Montana, (Dwan), 291
Cavani, Liliana, 156, 213, 341, 342,
 348, 354, 352
Caven, Ingrid, 307, 308
Cayatte, André, 111, 177, 178, 212,
 241, 364
Ce gamin-là, (Victor), 181
Cecchi, Suso D'Amico, 218
Cecilia, La, (Comolli), 28, 171–174,
 193, 194, 426, 443, 444
Ceiling Zero, (Hawks), 31, 35, 37
Chaban-Delmas, Jacques, 152
Chabrol, Claude, 50, 51, 92, 139
Chahine, Youssef, 405, 450, 456, 457
Chalais, François, 374
Chamberlain, Arthur Neville, 437
Chance, (Szansa), (Falk), 477
Chance Meeting, (Blind Date), (Losey), 73
Chapier, Henry, 131, 135
Chaplin, Charlie, 16, 25, 210, 211,
 225–228, 405, 435, 468, 481
Chapman Report, The, (Cukor), 87, 110
Charulata, (Ray, Satyajit), 327, 418,
 419
Chayefsky, Sidney (Paddy), 178
Chéreau, Patrice, 468
Cheriaa, Tahar, 400
Chesterton, Gilbert Keith, 224

Grant, Cary, 35, 353
Grant, Kathryn, 44
Gravina, Carla, 464
Grease, (Kleiser), 169
Great Dictator, The, (Chaplin), 228
Great McGinty, The, (Sturges), 303
Great Race, The, (Edwards), 56–59
Great Wall of China, The, (*Beim Bau der Chinesischen Mauer*), (Kafka), 201
Green Berets, The, (Wayne, Kellogg), 131, 370
Green Light, (*Al-daw' al-akhdar*), (Mesbahi), 407, 408
Green Room, The, (*La chambre verte*), (Truffaut), 228, 229, 456
Gregor, Ulrich, 455, 461
Grémillon, Jean, 485
Griffith, David Wark, 16, 269, 289, 486
Grin Without a Cat, A, (*Le fond de l'air est rouge*), (Marker), 526
Grisolia, Michel, 232
Grizzard, George, 43
Gudara, Gudalla, 403
Guerre du pétrole n'aura pas lieu, La, (Ben-Barka), 402
Guess Who's Coming to Dinner, (Kramer), 494
Guingouin, Georges, 355
Guitry, Sacha, 15, 95, 147, 251, 254
Gun Hawk, The, (Ludwig), 68
Gurley Brown, Helen, 53

Hached, Ferhat, 403
Hadeln, Moritz de, 455
Hagman, Larry, 189, 190
Haiti, The Path of Freedom, (*Ayiti men chimin libete*), (Antonin), 198
Haley, Alex, 516
Haley, Bill, 169
Hamburg Syndrome, The, (*Die Hamburger Krankheit*), (Fleischmann), 268
Hamer, Robert, 430
Hangmen Also Die!, (Lang), 441
Hanson, Lars, 301
Hardcore, (Schrader), 460
Harder They Come, The, (Henzell), 185–186

Hardy, Françoise, 68
Hardy, Oliver, 278
Hardy, Thomas, 267
Harlan, Thomas, 233, 234, 235, 549
Harlan, Veit, 437
Harris, André, 146–148
Harrison, Rex, 111
Hartley, Leslie Poles, 128
Has, Wojciech J., 64, 65, 66
Hassan II, 402, 449
Hatari!, (Hawks), 31, 46
Hatzfeld, Jean, 10
Hawks, Howard, 13, 16, 19, 55, 31–46, 96, 114, 133, 244, 293, 299, 439, 485
Head, Anne, 499
Hearts and Minds, (Davis), 204
Heaven Can Wait, (Beatty), 231–232
Heaven Can Wait, (Lubitsch), 232
Hellman, Monte, 16, 27
Henzell, Perry, 185
Hepburn, Katharine, 35
Here and Elsewhere, (*Ici et ailleurs*), (Miéville, Gorin, Godard), 28, 170, 187, 207, 283, 318, 378, 392, 423, 424, 432, 435, 443
Here Is Your Life, (*Här har du ditt liv*), (Troell), 93, 94
Herman Slobbe/Blind Child 2, (Keuken), 319
Herzog, Werner, 232, 233
Hesse, Hermann, 302
Heydrich, Reinhard, 441
High Noon, (Zinnemann), 107
Hill, Terence, 231
Histoire(s) du cinéma, (Godard), 8
Histoires d'A, (Belmont, Issartel), 391
History of Cinema, Volume IV, (*Histoire du cinéma*), (Mitry), 487
History of Sexuality, The, The Will to Knowledge, (Foucault), 194
Hitchcock, Alfred, 16, 19, 25, 51, 93, 116, 229, 353, 381, 387, 460, 474, 531
Hitler, Adolf, 113, 123, 283, 349, 350, 438, 442
Hitler: A Film from Germany, (*Hitler, ein Film aus Deutschland*), (Syberberg), 283

Patsy, The, (Lewis), 54
Patterson, Lindsey, 493
Paulhan, Jean, 4, 65, 100, 134, 474
Paxton, Robert O., 368, 561
Payne, John, 291
Pecci, Victor, 565, 572
Peckinpah, Sam, 47, 50, 105, 113, 114,
 163, 459, 525
Penn, Arthur, 115
People's War, The, (Kramer), 440
Perceval le Gallois, (Rohmer), 237
Père Noël a les Yeux Bleus, Le,
 (Eustache), 251
Perec, Georges, 157, 158
Perrault, Charles, 123
Perrin, Laurent, 270
Persévérance, (Daney), 3, 5, 6, 7, 8, 9
Pétain, Philippe, 560–562
Petri, Elio, 139, 144, 165, 208, 405
Peyrefitte, Alain, 151, 152, 341
Pezold, Friederike, 462, 464
Pialat, Maurice, 238, 254, 380, 381, 394
Pic, Roger, 186, 187
Picard, Raymond, 14
Piccoli, Michel, 274
Pickpocket, (Bresson), 15, 85, 198, 216,
 270, 271
Pigsty, (Porcile), (Pasolini), 108, 248
Pilsudski, Józef, 507
Pimentel, Vasco, 548
Pink Panther, The (Edwards), 56
Pinochet Ugarte, Augusto, 163
Pinto, Joaquim, 548
Pirosmani, (Shengelaia), 257, 483
Pisier, Marie-France, 229
Placido, Michele, 275
Playtime, (Tati), 269
Plummer, Christopher, 247
Pocket Change, (L'argent de poche),
 (Truffaut), 230
Poitier, Sidney, 494
Polanski, Roman, 65, 80, 505, 513
Politoff, Haydée, 238
Pollet, Jean-Daniel, 66, 67, 68, 69
Pom Pom Girls, The, (Ruben), 496
Pompidou, Georges, 149, 153, 344,
 367, 368, 370

Pontalis, Jean-Bertrand, 437
Pontecorvo, Gillo, 26
Porgy and Bess, (Preminger), 41
Portugal (Scenes from the Class Struggle
 in), (Kramer, Spinelli), 205
Poto and Cabengo, (Gorin), 476
Preminger, Otto, 13, 33, 37–46,
 88–91, 114, 223, 224, 271, 460
Pretty Baby, (Malle), 240
Princess' Tragedy, (Dinü hua), (Ti-
 sheng), 521
Princess Yang Kwei Fei, (Yōkihi),
 (Mizoguchi), 216, 537
Private Property, (Stevens), 63
Procès à Baby Doc, Duvalier Père et Fils,
 (Daney), 10
Producers, The, (Brooks), 210
Professionals, The, (Brooks), 100
Progressive Gentleman, The, (Al sayyed al
 takadoumi), (Maleh), 453
Promised Land, The, (La Tierra
 Prometida), (Littín), 20, 162–164
Provincial Actors, (Aktorzy prowincjonalni),
 (Holland), 478, 498, 500
Pudovkin, Vsevolod, 16, 481
Punishment, The, (La punition),
 (Rouch), 127
Purple Hairpin, The, (Zi chai ji), (Ti-
 sheng), 521

Question, The, (La question),
 (Heynemann), 21, 22, 376
Queysanne, Bernard, 157, 158
Quiet Man, The, (Ford), 294
Quine, Richard, 52, 53
Quint, Charles, 547

R.A.S, (Boisset), 333
Radek, Karl, 482
Rainbow, The, (Raduga), (Donskoy),
 289, 290
Rainer, Yvonne, 474, 497
Raining in the Mountain, (Kong shan
 ling yu), (Hu), 527, 536, 537
Raizman, Yuli, 485
Rameau's Nephew' by Diderot (Thanx to
 Dennis Young)..., (Snow), 475

Ramonet, Ignacio, 499
Rampe, La, (Daney), 4
Rancière, Jacques, 5, 179, 427
Rappaport, Mark, 474, 497
Ravel, Jean, 466, 468
Ray, Nicholas, 11, 25, 47, 95, 114, 246, 247, 324–326
Ray, Satyajit, 12, 327, 328, 414, 417–420, 452, 457, 460, 542, 543
Ray, Susan, 326
Raynal, Jackie, 24, 197, 497
Rayns, Tony, 520
Rebel Without a Cause, (Ray), 325
Red Beard, (*Akahige*), (Kurosawa), 260
Red Poster, The, (*L'affiche rouge*), (Cassenti), 21, 22, 376
Red River, (Hawks), 33, 35, 36, 37
Reddy, Pattabhi Rama, 543
Redgrave, Vanessa, 443, 444, 448, 449
Reich, Wilhelm, 355
Reichenbach, François, 404
Reis, António, 200–202, 310, 549
Reiser, Jean-Marc, 348
Rellys (Henri Bourrelly), 279
Remick, Lee, 40, 267, 268
Rémy, Pascal, 270
Renaud, Tristan, 135
Renoir, Claude, 465, 471
Renoir, Jean, 5, 15, 16, 37, 46, 89, 126, 229, 254, 343, 381, 435
Resnais, Alain, 65, 66, 157, 285, 346, 380, 428
Restless Breed, The, (Dwan), 292
Reusser, Francis, 195, 424
Reynaud, Fernand, 278
Reynolds, Debbie, 21
Reynolds, Quentin, 440
Ride the High Country, (Peckinpah), 47, 113
Ridel, Armand, 555
Riefenstahl, Leni, 437
Rilke, Rainer Maria, 67, 68
Rio Bravo, (Hawks), 15, 31–37
Risi, Dino, 23, 165, 217, 218, 405
Rising of the Moon, The, (Ford), 295, 296
Risk of Living, The, (*Le risque de vivre*), (Calderon), 279–280

Rispal, Jacques, 411
Rissient, Pierre, 520
Rite, The, (*Riten*), (Bergman), 277
Rite of Spring, (Acto da Primavera), (Oliveira), 301, 313
Ritt, Martin, 492
Ritual, The, (*Ghatashraddha*), (Kasaravalli), 543
River of No Return, (Preminger), 41
Rivette, Jacques, 13, 26, 27, 237
Rivière, Pierre, 159, 180, 356, 357
Road to Fort Alamo, The, (*La strada per Fort Alamo*), (Bava), 49
Robbe-Grillet, Alain, 66
Robeson, Paul, 492
Robin Hood, (Dwan), 290
Rocha, Glauber, 75, 76
Rocha, Paulo, 548, 549
Rocks, The, (Maleh), 454
Rödl, Joseph, 458
Röhm, Ernst, 350
Rohmer, Éric, 13, 66, 237, 299, 315
Rome, Open City, (*Roma città aperta*), (Rossellini), 244
Romero, George A., 115–117, 268
Rooftree, (*Tvärbalk*), (Donner), 81–82
Roots, (Chomsky, Erman, Greene, Moses), 492, 514, 516, 518
Rope, (Hitchcock), 387
Rosi, Francesco, 23, 139, 186, 405, 469
Rosolato, Guy, 322
Ross, Herbert, 214, 215, 216
Rossellini, Roberto, 59–63, 183, 237, 285
Rossif, Frédéric, 44
Rouch, Jean, 66, 79, 235, 254, 453
Rouffio, Jacques, 177, 178, 466
Rounders, The, (Kennedy), 50
Rousseau, Jean-Jacques, 190, 194, 363
Roy, Jean-Louis, 75
Royal Scandal, A, (Preminger), 41
Rozier, Jacques, 238
Rude journée pour la reine, (Allio), 334, 336, 339
Ruggieri, Eve, 380
Ruiz, Raúl, 252, 462, 545, 547
Russell, Ken, 213
Ryan, Robert, 114

Sadat, Anwar el-, 456
Sadoul, Georges, 301, 531
Safrana or Freedom of Speech (*Safrana ou le droit à la parole*), (Sokhona), 410, 425
Saga of Gösta Berling, The, (*Gösta Berlings saga*), (Stiller), 301, 302
Sagan, Françoise, 41
Saint Joan, (Preminger), 38, 41, 43
Saint Joan, (Shaw), 42
Salaire du zappeur, Le, (Daney), 4
Salamander, The, (*La salamandre*), (Tanner, Alain), 191, 396
Salazar, Antonio de Oliveira, 548
Saleck, Mohamed Ould, 403
Salò, or the 120 Days of Sodom, (*Salò o le 120 giornate di Sodoma*), (Pasolini), 283
Salt of the Black Earth, (*Sól ziemi czarnej*), (Kutz), 511
Salut, Jerusalem, (Chapier), 131
San Francisco, (Dyke), 115
Sanjinés, Jorge, 78, 356
Sanjuro, (*Tsubaki Sanjūrō*), (Kurosawa), 362
Sansho the Bailiff, (*Sanshō dayū*), (Mizoguchi), 60
Saragossa Manuscript, The, (*Rękopis znaleziony w Saragossie*), (Has), 64
Sarmiento, Valeria, 548
Sass, Barbara, 500
Satan Never Sleeps, (McCarey), 59, 86
Saturn 3, (Donen), 274
Sautet, Claude, 163, 477
Sauvegrain, Didier, 270
Savchenko, Igor, 483, 484, 485
Scar of Shame, The, (Peregini), 493
Scarface, (Hawks), 37–38
Scarpelli, Furio, 218
Scenes from a Marriage, (*Inför Scener ur ett äktenskap*), (Bergman), 223
Scenic Route, The, (Rappaport), 497
Schatzberg, Jerry, 28
Scheider, Roy, 169
Schell, Maximilian, 225
Schlöndorff, Volker, 470
Schmid, Daniel, 309
Schnitzler, Arthur, 273
Schrader, Paul, 270, 271, 277, 460

Schroeder, Barbet, 112, 159, 160
Schroeter, Werner, 259–262, 465
Schultz, Michael, 496
Schuman, Robert, 152
Schwitters, Kurt, 194
Scola, Ettore, 217, 218
Scopitone, (Perrin), 270
Scopone Game, The, (*Lo scopone scientifico*), (Comencini), 23
Scorsese, Martin, 28
Scott, George C., 460
Scott, Ridley, 248
Searchers, The, (Ford), 297
Seberg, Jean, 42, 92
Secret, The, (*Fung gip*), (Hui), 521
Secret, The, (Tanizaki), 68
Sédouy, Alain de, 146, 147, 148
Séguy, Georges, 167, 376
Seixas Santos, Alberto, 548
Sek Kei, 523
Sellers, Peter, 56, 278, 279
Séminaire 1, (Lacan), 428
Semprún, Jorge, 154, 155
Sen, Mrinal, 327, 461, 542
Sergeant York, (Hawks), 36
Série noire, (Corneau), 467
Serpent's Egg, The, (Bergman), 212–214
Serrault, Michel, 263, 264
Serreau, Coline, 470
Seven Brave Men, (*Semero smelykh*), (Gerasimov), 487
Seven Deaths by Prescription, (*Sept morts sur ordonnance*), (Rouffio), 177–179
Seven Women, (Ford), 197
Sex and the Single Girl, (Quine), 52–54
Seyrig, Delphine, 197
Shahin, Mohamed, 453
Shakespeare Wallah, (Ivory), 267
Shakespeare, William, 305, 306
Shame, (*Skammen*), (Bergman), 212, 268
Shameless Old Lady, The, (*La vieille dame indigne*), (Allio), 336
Shanghai au Jour le Jour, (Broyelle, Chomienne), 152
Shapiro, Mikhail, 74
Sharecropper, The, (*El khammes*), (Louhichi), 413

Shaw brothers, 519, 525, 527–530, 535, 537, 538, 539
Shaw, George Bernard, 43
Sheen, Martin, 247, 249, 515
Shengelaia, Giorgi, 257
Shengelaia, Nikoloz, 483
Shindo, Kaneto, 422, 423
Shock Corridor, (Fuller), 181
Shostakovich, Dmitri, 74, 483
Shot in the Dark, A, (Edwards), 56
Shoukry, Mamdouh, 404, 405
Shukshin, Vasily, 488
Siao Fong-fong, 521
Siberiade, (Sibiriada), (Mikhalkov-Konchalovsky), 254–257
Sibony, Daniel, 6, 562
Siegel, Don, 92, 93
Sign of Leo, The, (Le signe du lion), (Rohmer), 299
Signs of Life, (Lebenszeichen), (Herzog), 233
Silence, The, (Tystnaden), (Bergman), 212
Silent Village, The, (Jennings), 441
Silver River, (Walsh), 364
Simone Barbès ou la vertu, (Treilhou), 476
Simonet, Martine, 270
Simple histoire d'un merveilleux poste de télévision, La, (Coulonges), 555
Sinatra, Frank, 42
Singin' in the Rain, (Donen), 111
Sir Arne's Treasure, (Herr Arnes pengar), (Stiller), 302
Sirk, Douglas, 12, 216, 309, 324
Siu Hon-Sang, 523
Six fois deux/Sur et sous la communication, (Godard), 193, 283, 320, 433
Sjöman, Vilgot, 71, 98, 99
Sjöström, Victor, 300
Skeffington, Frank, 298
Skolimowski, Jerzy, 65, 82, 83, 84, 228, 505, 513
Skorecki, Louis, 6, 10, 13, 197
Slap the Monster on Page One, (Sbatti il mostro in prima pagina), (Bellocchio), 138, 139, 142, 143, 146
Slap, The, (La gifle), (Pinoteau), 192, 375
Sleeping Man, The, (Un homme qui dort),

(Perec, Queysanne), 157–159
Slightly Pregnant Man, A, (L'événement le plus important depuis que l'homme a marché sur la Lune), (Demy), 238
Slightly Scarlet, (Dwan), 291
Smak wody, (Wosiewicz), 500
Smid, Tomas, 565
Smihi, Moumen, 450
Smith, Stanley, 567
Snow, Michael, 283, 284, 473
Sokhona, Sydney, 410
Solaris, (Solyaris), (Tarkovsky), 490
Soldaten von morgen, (Weidenmann), 437
Solemn Communion, (La communion solennelle), (Féret), 21
Sollima, Sergio, 106, 107
Solntseva, Yuliya, 255
Solzhenitsyn, Aleksandr, 488
Something Different, (O něčem jiném), (Chytilová), 84, 85, 86
Somewhere Beyond Love, (Delitto d'amore), (Comencini), 164–166
Song of Happiness, (Pesnya o shchastye), (Donskoy, Legoshin), 484, 485
Song of Love, A, (Un chant d'amour), (Genet), 175, 176
Song of the Scarlet Flower, (Laulu tulipunaisesta kukasta), (Stiller), 300
Sons of the Good Earth, (Da di er nu), (Hu), 527
Sontag, Susan, 324
Sorrow and the Pity, The, (Le chagrin et la pitié), (Ophuls), 211
Sorrows of the Forbidden City, (Qīng gōng mìshi), (Shilin), 528
Sotto, Agustin, 540
Sounder, (Ritt), 492
Sparrow, The, (Al-asfour), (Chahine, Youssef), 405, 465
Special Section, (Section spéciale), (Costa-Gavras), 446
Spencer Mountain, (Daves), 50
Spencer, Bud, 231
Spielberg, Steven, 169, 247, 269
Spirit of the Time, The, (De Tijd Geest), (Keuken), 322

Serge Daney became the editor of *Cahiers du Cinéma* in 1974. In 1981, he left *Cahiers* and wrote about visual culture for *Libération*, turning his attention to television and coverage of the Gulf War. He collaborated with Claire Denis on a documentary film, *Jacques Rivette, le veilleur* (1990). He died of AIDS-related causes in 1992.